Principles of Cinematography

A Handbook of Motion Picture Technology

LESLIE J. WHEELER FRPS · FBKS

Fellow of The Society of Motion Picture & Television Engineers

FOUNTAIN PRESS

13–35 Bridge Street, Hemel Hempstead, Hertfordshire, England

Fountain Press,
Model and Allied Publications Limited,
Book Division,
Station Road, Kings Langley, Hertfordshire,
England

First Published 1953
2nd Edition 1958
3rd Edition 1963
Second Impression 1965
4th Edition 1969
Second Impression 1971
Third Impression 1974

ISBN 0 85242 080 3

Printed in Great Britain by
Aberdeen University Press

Contents

Uneven development—Yellow stains—Technical terms—Factors affecting image quality—Photographic speed and grain size—Developer temperature—Developing time—Developer exhaustion—Fixing—Washing and image permanence—Film condition immediately after processing—After-treatment of processed film

List of Illustrations

9

Introduction to the Fourth Edition

THIS book was first published in 1953—a year during which the feature film industry was still recovering from the second world war, when television in England was relatively a one-channel black-and-white infant—and the word 'Bingo' had not yet become a threat to many provincial cinema circuits. Since that time the film industry has passed through a storm which might easily have wrecked a less sturdy craft and it is currently enjoying a revival—it has also learned to live in harmony with and make considerable contributions to the television industry. During the intervening years the growth of the television industry in particular has greatly extended the use of 16 mm. film and has consequently brought about the development of 16 mm. apparatus of such high standards that work in this gauge is fully recognised as professional cinematography.

During the same period the feature film industry has concentrated very successfully upon the production of wide-screen spectacular films in really beautiful colour and, in many cases, with full stereophonic sound. Such pictures as 'My Fair Lady', 'The Sound of Music' and 'Romeo & Juliet' are representative of the technical excellence and story-content which, together, can ensure a permanent future for the motion picture industry.

Many important developments have occurred since the third edition of *Principles of Cinematography* was published in 1963 and it is timely that the fourth edition should now be produced. As with the earlier editions, it is still true that literary work in this field generally falls into one of two sharply divided spheres—either as advanced academic treaties read only by scientists, or as popular general outlines of 'movie making' which rarely help the technicians of the Industry. The purpose of this book is to bridge the vital gap between these two extremes.

It is important for the reader to understand the scope of this book: it is confined to an explanation of the fundamental principles governing the equipment and processes involved in the art of cinematography—and recognising those variations required when the 'end product' is to be used either in the cinema or for television.

Motion pictures may be either black-and-white or in colour; in shape they may be either of the so-called 'standard format' or any of several wide-screen ratios produced by a number of techniques; they may be recorded on film from 8 mm. up to 70 mm. in width—or they may be recorded magnetically by 'Videotape'; they are usually reproduced at speeds ranging from 16 to 25 individual frames per second and with the accompanying sound recorded either magnetically or optically. This book deals with the mechanics of cinematography—with the theory and purpose of camera, printer, projector and associated mechanisms, the basic design of processing equipment and the techniques of sound recording and reproduction as they apply to cinematography.

13

INTRODUCTION TO THE FOURTH EDITION

This fourth edition includes new additional chapters dealing with colour film emulsions, film editing and special effects. The chapter dealing with sound recording has been modified to place due emphasis on the importance of magnetic recording and, of course, all other chapters have been thoroughly revised and brought up to date.

By definition the book is confined to the *principles* and fundamental design of equipment, its purpose and function and does not, for example, set out to be a guide to the use of a particular camera or any one manufacturer's equipment. However, the reader will find frequent reference to well known apparatus and many pictures of famous equipment.

The author wishes to take this opportunity of recording his grateful thanks to the many individuals and companies who have so readily provided information and illustrations for this edition. In particular he wishes to thank Mr. Tom Chatwin and Micro Cine Limited, Mr. Gordon Craig and Kodak Limited, Mr. Eric Edwards and Visnews Limited, Mr. Bernard Happe and Technicolor Limited, Mr. Baynham Honri and Pinewood Studios, Mr Norman Leevers and Leevers-Rich Equipment Limited, Mr. Roy Osborn and Westrex Limited, Mr. Peter Rigby and Robert Rigby Limited, Mr. Dennis Robertson and Bell & Howell Limited, Mr. George Stanwix and Pathe Equipment Limited and Mr. Freddie Wright and Evershed Power Optics Limited. For the continued use of data supplied to earlier editions thanks are also due to The British Broadcasting Corporation, Marconi's Wireless Telegraph Company Limited, Newman & Guardia Limited, Rank Precision Industries Limited and W. Vinten & Company Limited.

<div align="right">

LESLIE J. WHEELER
</div>

Acton, London W.3
November 1968

Chapter 1

General Principles

Fundamentals

THE first attempts to record a representation of movement consisted of static illustrations, and the first crude 'moving pictures' were simply mechanised lantern slides. Both of these existed years before either photography or flexible photographic 'films' were discovered. Modern cinematography is basically a recording process used to store information which can be reproduced at any time and as many times as may be required.

In recent years technical developments have been so rapid that cinematography is now only one of many systems which record and store pictorial information. In cinematography the recordings always exist in recognisable form whilst in other systems (such as magnetic video tape recordings for television) the stored information may be said to exist in coded form. In every case the system succeeds in ultimately reproducing the illusion of moving pictures.

It is no longer possible to consider cinematography as a process completely divorced from and different to television. Happily, the reverse is also true. Interdependence between the two techniques can be readily demonstrated: on the one hand, cinematography now often employs a 'closed circuit' television monitor screen system to display pictures indicating a view-point and the field of vision covered by the cinematograph camera whilst making a feature film in a conventional film studio. On the other hand, television relies very much on the supply of conventional motion picture films for a large part of both the entertainment and the news content of transmitted programmes.

It is therefore very important to understand the purpose of this book. As the title implies, it deals only with the principles of cinematography—but it recognises that cinematographic processes are now used in other arts and sciences and, where applicable, the use of cinematography in those activities will be discussed.

Certain early and pre-photographic techniques must be mentioned in this chapter but, because all forms of modern cinematography depends upon *the photographic image*, it is essential for us first to consider this basic 'common denominator' since it exists throughout the entire range of complicated and interrelated activities which are discussed in later chapters.

We need not study the theory of photography very deeply because many authoritative works are already available on this subject—notably *The Theory of the Photographic Process* by Dr. C. E. K. Mees, and *The Ilford Manual of Photography*. However, the full understanding of this book is only possible if the following principles concerning the formation of a photographic image are included.

All every-day objects which are not themselves self-luminous are only visible because they reflect light. The sun is the natural source of light which usually illuminates exterior objects and scenes although, in professional filming, this is frequently supplemented by arc lamps and reflectors. Interior scenes and objects are usually illuminated by some form of tungsten, carbon arc, quartz-iodide or similar artificial lighting equipment.

It is not possible to make photographic emulsions equally sensitive both to daylight and to artificial lighting. Because of this the degree of camera exposure and the film emulsion's response to colours varies with the type of lighting which is available. This is true both for so-called 'black-and-white' monochrome films and for colour films—the latter being specifically designed for use either in daylight or in artificial light, and they can only be used in lighting for which they were not designed when special colour-correcting filters are also used.

The fundamental technique for recording a simple *exterior* photograph is as follows: light from the sun illuminates the scene which is to be recorded; the lens in the camera is arranged to focus a sharply defined inverted image of the scene at a plane near the rear wall of the camera body; a shutter is normally located between the lens and the rear of the camera so that, by actuating a suitable mechanism, the inverted image of the scene passes to the rear of the camera for a very short time. If a piece of film, coated with a light-sensitive 'emulsion', is supported in the 'focal plane' at the rear of the camera whilst the shutter makes the 'exposure' it becomes possible, by suitably treating the film, to obtain a *negative* image of the scene. A negative image is one in which white, black and all the tones of grey which represent the scene are reversed to that, for example, a white cloud appears black in the negative.

It is important to realise that a chemical change occurred within the film emulsion immediately it was exposed to the rays of light passing through the camera lens. A monochrome film emulsion is a suspension of thousands of minute silver bromide crystalline grains which would automatically blacken (or tarnish) if exposed to light for a considerable time. This may be proved simply by leaving a waste piece of film in a lighted room or in the direct rays from the sun. Unfortunately, the exposure given to a film by rapidly opening the closing a camera shutter is not, in itself, capable of producing a *visual* change—it merely produces a *latent* image. However, if an exposed film is then taken into a dark-room and immersed in a suitable solution, known as the *developer*, those silver bromide grains which were exposed to light will be *reduced* to metallic silver and, of course, will then become black.

Since *only* those grains which receive light can be developed, and the density and concentration of the resultant blackening will depend upon the intensity-

distribution of the light as it varies across the emulsion, a negative image of the scene will be formed. If the amount of exposure and the degree of development have been correct, the distribution of the densities will bear a truly proportional relationship to the amounts of light reflected by all sections of the original scene.

Other sections of the film—corresponding to dark areas in the camera image—will not have received any illumination during the camera exposure. Because of this they will remain unaffected by the developing solution and, in fact, will still contain silver bromide grains which, if left in their present state, would automatically blacken if the film were taken into daylight. To prevent this the film must first be immersed in water, to remove all traces of developing solution from its surface, and then be placed in a *fixing* bath. This is basically a solution of sodium thiosulphate, and is capable of dissolving only those sections of the emulsion which were *not* reduced to metallic silver. The film will now consist of areas of nearly transparent film base plus areas of varying degrees of density which, together, form a negative image of the scene. It now only remains to thoroughly wash and carefully dry the film.

Once dry the film may be placed in contact with a sheet of printing paper—that is paper which has been coated with a light-sensitive emulsion somewhat similar to that on film but for one important difference: whereas the emulsion on a camera film must be panchromatic (or sensitive to all colours and capable of recording those colours as shades of grey) a printing emulsion need only be sensitive to blue light (the effective colour in a tungsten filament printing lamp). The emulsion surfaces of both the film and the paper should face each other. Light is then directed on to the film side of this combination so that the paper is exposed through the film—and thus by amounts inversely proportional to the densities of the film emulsion. By processing the paper in a manner similar to that given to the film, a *positive* image of the scene is produced. A positive image is one in which white, greys or black tones representing the original scene are produced as corresponding white, greys or black tones in the image.

Obviously, if positive printing paper is replaced by a positive-type printing film, then a film *transparency* similar to a cinematograph release print can be produced by the same basic technique. When enlargements of the image are required the negative is placed in a projector rather similar to the optical lantern, and an image is thrown onto a large sheet of sensitive paper. The process of development and fixation will be dealt with in greater detail when we consider the operation of continuous motion picture processing machines—the foregoing very brief resume being sufficient at this stage to establish the outline of the photographic process.

The requirements of motion pictures: a brief historical survey

Modern cinematograph equipment is more readily understood by tracing its development from those early inventions which may now appear to be relatively simple. Much research work has been done in many attempts to establish the exact history of cinematography—and many inventors have contested their claims in this

connection. The following survey in no way pretends to unravel this problem—it is merely included to illustrate the development of basic principles. However, we should remember that, at the time of their inception, many of these inventions were considered as nothing more than ingenious novelties by a public still absorbed by the marvels of the optical lantern!

Motion pictures only became possible because of a peculiar characteristic of the human eye known as 'the persistence of vision', or retention of image. This characteristic is easily understood by the following experiments and examples of modern devices which, like the motion picture, depend upon it for their success.

If a glowing cigarette is taken into a darkened room and is whirled in a circular path, an observer will see a continuous glowing circle of light. It is quite obvious that no such circle actually exists and yet, because we cannot 'forget' the light given by the cigarette immediately after it has moved to another position, we continue to 'see' the glow until it again returns to that position during the next revolution of the hand. By such time the impression—which will then be fading—is again stimulated so that the eye *appears* to see a continuous circle. This effect was elegantly described by Hopwood in 1899 as follows: 'we continue to experience the visual effect of light after it ceases to act.'

A practical example of a device which depends upon this characteristic is found in the neon directional arrows often used to indicate the entrance to cinemas, etc. Two neon arrows are mounted in the same plane but are displaced in the direction indicated by the arrow heads. Each arrow is illuminated alternately but the visual effect is that of a single oscillating arrow apparently moving towards the indicated direction.

Returning to the whirling cigarette analogy, an important point concerning the design of projectors and screen brightness should be noted. If, after observing the imaginary glowing circle in the darkened room, the normal room lighting is then switched on, the appearance of a circle ceases to exist and we realise that we have, in reality, been observing the path of a single point of light. This experiment shows that the persistence of vision is not of equal strength for all levels of lighting contrast. As will be explained later, *flicker* in projected motion pictures is also dependent upon the contrast between the darkness of the surrounding auditorium and the brightness of the screen—together with the frequency of the interruptions of the light beam.

We can now understand that the appearance of continuous motion can be achieved without actually recording the *entire* cycle of movement. A very good example of this is given in the 'Mutoscope', invented by Kasler in 1895 and seen in Figure 1.1. This instrument is still occasionally used to provide 'coin operated' entertainment on seaside piers etc. The mechanism contains a series of pictures (at first drawn or painted but later photographed) which were mounted radially upon a central rotating hub. A spring leaf was so positioned that it held successive cards stationary for a short period although the central hub continually rotated. Somewhat crude 'moving pictures' were seen through a large magnifying lens although, of course, the observer really saw a series of still pictures, each of which

was held in position for a brief period and was then quickly removed from view. The observer only *appears* to see a continuous moving picture because the impression of the first picture is still retained by the eye whilst it is being moved forward and the second of the series takes its place. By moving from one picture to the next, in a series of intermittent forward movements, the entire sequence may be observed and will appear to be as one continuously *moving* picture.

Instead of drawing each picture individually as was at first necessary, it became possible to photograph actual moving objects and to record a series of instantaneous

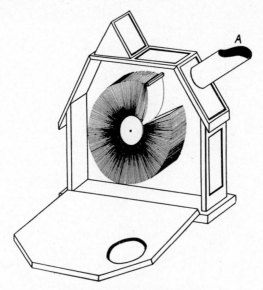

Fig. 1.1. Kasler's Mutoscope

'moments in time' so frequently that, when displayed at the 'taking speed', the illusion of continuity could be achieved. In effect this is what is done in any cinematograph camera and, therefore, a motion picture may be said to consist of 'a series of still photographs recording the instantaneous positions of moving objects at very brief intervals of time.'

We can now appreciate the problems which beset the early inventors of cinematograph apparatus, and which had to be solved before motion pictures as we know them today became possible. Firstly, a continuous supply of light-sensitive material had to be fed through a camera so that any number of still pictures could be shown in very rapid succession. Secondly, methods had to be devised to rapidly and accurately move away sections of material immediately they had been exposed and to replace them by unexposed sections. This change-over had to occur whilst the camera shutter was closed. Picture vibration persisted as a serious defect for some years, and could only be overcome by precisely locating each individual section of

photographic material during exposure in the camera. Finally, apparatus was needed to exhibit positive prints made from these photographic negatives, and the obvious choice was an adaptation of the optical lantern.

It should be noted that the words 'light-sensitive material' have been used. This was especially to draw attention to the fact that the basic idea of motion pictures was conceived some time before emulsions were first coated on to flexible celluloid supports or films.

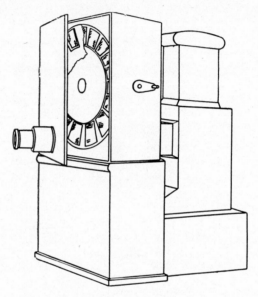

Fig. 1.2. Demeny's Phonoscope

One of the earliest attempts to photograph motion and reproduce it to simulate a moving picture was made by Demeny in 1892 and the apparatus for projecting the results, known as the 'phonoscope', is shown in Figure 1.2. A series of 24 glass plates, each bearing a record of the instantaneous position of some moving object, were mounted on a disc which could be *intermittently* moved forward to bring successive pictures in line with a light beam and projecting lens. The disc supporting the glass plates moved in steps and was actuated by a continuously rotated handle at the side of the machine.

The method used by Demeny to create intermittent motion was particularly ingenious and, undoubtedly, was a forerunner of the Maltese Cross—a mechanism almost universally employed in 35 mm. projectors today and described in detail in Chapter 6.

With the introduction of photographic emulsions coated on transparent film support the progress towards modern cinematograph cameras and projectors became rapid. Two major improvements immediately became available; firstly an infinite

number of pictures could be taken on rolls of film and, secondly, such films could be easily wound on to spools and stored.

The earliest attempts to produce motion pictures on this new material involved driving the film by friction, but it quickly became apparent that some more positive form of traction was essential. The natural development was to perforate holes along each edge of the film and to pass it over wheels carrying teeth—in a manner similar to a chain passing over a sprocket wheel. It was from this likeness that wheels carrying teeth with which to move perforated film became known as 'sprocket wheels' in the motion picture industry.

Standard dimensions for film perforating

Although the introduction of emulsions coated on flexible film promised to solve many of the early problems, a state of affairs soon existed which threatened to stop further progress for some considerable time. Each inventor had his own ideas concerning the most attractive size and dimensions for the actual pictures recorded on the film, the shape to cut the perforations in that film and also the width of the film. It is salutory to recall that, as early as 1899 Maskelyne produced a 'wide screen' picture on film 2¾ in. across and known as the Mutagraph. At the same time Demeny and Skladowsky used films 60 and 65 mm. wide respectively.

During the same year six camera manufacturers each standardised on a particular film width which was different from all the others. Five different shapes of perforations were in use, and the distance or pitch between perforations varied from one manufacturer to the next. It must not be imagined that each camera manufacturer actually made his own film—the usual practice was to purchase film cut to the required width and only then to perforate it to suit a particular type of camera.

If films made by one company were always projected on machines made by that company this state of affairs presented no great hardship. However, once motion pictures seemed likely to become established as a popular form of entertainment, small cinema circuits were built and operated in a manner rather similar to present-day practice.

In those early days the equipment manufacturer was frequently also the 'film producer' and, once his machines were installed in a number of cinemas, he was certain of holding all the trade from those houses. Naturally, this practice was quickly turned to profit and many peculiar situations existed.

It was fortunate that at least one film producer found ways to overcome these monopolies because, by so doing, he showed the wisdom of standardisation throughout the industry. A film had been made which quickly became popular and was 'playing' to ever-increasing audiences in those houses equipped with one particular type of machine when the owners of another projector, not capable of showing the film, hit upon the idea of making a special optical printing machine capable of accepting film perforated to suit their competitors' projectors and to print from this on to film perforated to suit their own equipment.

Once this had been done most manufacturers realised that the time had come

to standardise on one size of film, carrying one type of perforation located along the film length at regular standard intervals.

Since those early days standardisation has become internationally recognised, and any departure from the accepted dimensions of film or equipment must first be agreed with the International Standards Organisation in consultation with the appropriate national standardising body—for example, The British Standards Institution, The American Standards Association, etc.

The early cinematograph camera

The first successful motion picture cameras employed all the basic principles of their more advanced successors and one model of the period around 1905 is shown in Figure 1.3. Typical machines were made by Newman, Prestwich and Williamson

Fig. 1.3. The Prestwich Camera

in England, by Gaumont, Lumiere and Pathe in France and by Ernemann in Germany.

An unexposed roll of film was mounted on a central bobbin within the upper light-tight box (beautifully made in polished hardwood). The leading film edge was taken through a felt-lined light-trap and fed over a large sprocket wheel, the teeth of which engaged with the film perforations. Contact between the film and the sprocket was maintained by a pair of jockey rollers, spring-loaded to press against the sprocket wheel. A loop was formed in the film between the sprocket and a vertical channel in which it was held flat during exposure. This channel—always known as the 'gate'—was formed in two sections, one fixed solidly to the camera body and the other arranged to open on a hinge to simplify film threading in the channel. That section of the gate which opened was behind the film and carried a

spring-loaded pressure pad to hold the film flat and in the focal plane of the camera when the gate was closed.

A second loop was formed in the film between the exit from the gate and the underside of the central sprocket, and a further pair of jockey rollers maintained contact between the film perforations and the sprocket teeth. From this point the exposed film passed to the lower light-tight box where it was wound into a smooth roll once more.

Film was intermittently advanced through the gate by a simple link-and-claw mechanism whereby the claw tips first engaged with the film perforations to pull down enough film to accommodate one picture, and then retreated away from the film to travel upwards in readiness to repeat the cycle of operations.

Geared to the claw mechanism, but rotating at right angles to it, a disc shutter was arranged to interrupt the light passing from the lens and so to prevent exposure whilst the film was moving forward. The shutter consisted of a flat plate having an aperture cut away to enable light to pass only when the film was stationary in the gate. Both the claw and shutter are shown beside the camera in Figure 1.3 at various positions they would occupy relative to each other.

Thus the action of the camera was as follows: firstly, the shutter would intercept light from the lens, the claw tips (at the top of their stroke) would then engage with the film perforations as shown at A, Figure 1.3. The claw then moved the film downwards and through the gate by an amount equal to the height of one picture, as shown at B, Figure 1.3. It then disengaged from the film perforations and the shutter opened as shown at C, Figure 1.3.

From this moment and until the claw and shutter again reached position A, the film would remain stationary in the gate whilst receiving exposure. A further condition of the claw and shutter is shown at D, Figure 1.3, where the claw has returned half way along its path back to the top of the cycle and where the shutter has completed half the exposure.

The film moved through the gate by a series of intermittent forward motions interspersed by periods of rest. However, it was necessary to isolate this intermittent movement and to prevent it being transmitted to the supply or take-up rolls—where the film must travel perfectly smoothly. Film was therefore required to move *continuously* forward both on to and away from the central sprocket. To achieve this, free loops were provided in the film path both above and below the gate, and these continuously varied in length when the camera was running—during exposure the upper loop became larger whilst the lower loop became smaller, and this condition reversed itself during 'pull-down' when film was being moved through the gate by the claw. On leaving the central sprocket film was fed through a light-trap into a spool-box similar to that containing the unexposed material, and wound on to a central bobbin—the ever-increasing roll diameter being accommodated by a friction clutch driving mechanism.

This typical camera of the period 1905-1915 has been described in some detail at this stage solely to give a clear impression of the fundamental principles. Modern cameras include many elaborate refinements and details of these appear in Chapter 2.

The manufacture of motion picture film

The following twelve basic operations are necessary even to produce a roll of monochrome (black-and-white) cinematographic film—obviously, the process becomes even more complex when films are being manufactured to record pictures in colour: (1) manufacturing the film base or support which, in many cases, may include antihalation dyes. (2) Preparing the emulsions, the subbing and any super-coating which may be applied as a 'top coat' to reduce static, abrasions or undue friction in the camera gate. (3) Coating the subbing, the emulsions and then the super-coat onto the film base and in that order. (4) Drying the film. (5) First photographic

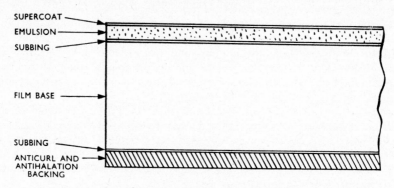

SUPERCOAT
EMULSION
SUBBING

FILM BASE

SUBBING
ANTICURL AND
ANTIHALATION
BACKING

Fig. 1.4. A Cross-section of Modern Film

testing of the product. (6) Slitting the 'parent roll' into a number of much narrower rolls of the required width. (7) Perforating these rolls. (8) Edge-numbering to indicate intervals of one foot (30.48 cms. or precisely sixteen frames on 35 mm. film and forty frames on 16 mm film) progressively throughout each roll. (9) Second photographic testing to establish sensitometric quality. (10) Mechanical testing to check film width and perforation dimensions. (11) In some cases adding a magnetic oxide sound recording stripe. (12) Final packing into tins and labelling.

Emulsion preparation is essentially a chemical operation of an exceptionally high standard and is carried out under very exacting conditions. Although some of the emulsions used throughout the motion picture industry will be discussed when considering sensitometry and film processing (Chapters 3 and 4), the actual chemistry of photographic emulsion formulation is not within the scope of this book.

In the early days most picture emulsions were coated on to nitro-cellulose base to produce a 'film' which, incidentally, was highly inflammable and dimensionally unstable. Present-day techniques employ tri-acetate or polyester base (slow-burning, non-inflammable and dimensionally stable) and require at least six quite separate coatings before a so-called 'film' is produced. Only one of these coatings is the light-sensitive emulsion. Figure 1.4 illustrates a cross-section of a piece of modern photographic material.

The main central area is the film base itself and represents by far the greater portion of the total thickness. Above the base is first coated a layer of subbing—consisting either of an etching solution or organic solvents necessary to give the base a 'tooth', or of a diluted gelatin solution in organic solvents which deposits an extremely thin gelatin layer intimately mingled at the inter-face with the cellulose acetate of the base—in either case its purpose is to firmly and evenly secure the emulsion to the main support. The emulsion layer itself is coated above the subbing and, in a monochrome film, is the characteristic yellowish coating consisting of microscopically small crystals of silver halide suspended in gelatin. The diameter of the *largest* grains of an emulsion is less than one-ten-thousandth (0.0001) of an inch.

The final coating, known as the super-coat, is applied above the emulsion layer. This is a very thin, perfectly clear solution applied to the emulsion after it has set but before it becomes completely dry. Many people believe a super-coat is capable of protecting the emulsion from scratches—this is not true: its purpose is certainly to protect the emulsion from the effects of those *slight* abrasions or stresses which are not sufficient to cause visible damage to the emulsion but which could (in the absence of a super-coat) cause black marks on development. A super-coat also serves to lubricate the surface of the film and so to reduce friction between it and the camera gate mechanism. Incidentally, many laboratories apply a solution very similar to this super-coat after processing positive prints. This is essentially to assist so-called 'green' prints through projectors during the first runs of new copies and to minimise friction in the projector gate.

If no further coatings were applied the layers described so far would cause the material to curl very severely because one side of the film base would remain unprotected and become subjected to changes in moisture to a far greater extent than the other. To prevent this a second subbing layer is applied to the underside of the film base and, in actual fact, both upper and lower subbing layers are applied at the same time during manufacture. Finally, this lower subbing layer is used as an undercoat to accept the combined anti-curl and anti-halation backing material. These then are the layers which go to make up a modern film—something which is far more complicated than the original orthochromatic negatives used, for example, to photograph Queen Victoria's funeral in the days of Friese-Greene!

One of the final operations in film manufacture is to apply an anti-halation backing and the purpose of this is illustrated in Figure 1.5. When light falls on an emulsion it is affected in a number of ways—most of it is absorbed by the silver halide grains without appreciable deviation from its original path and thus forms the required image. Some of it is scattered within the emulsion and also in the silver grains immediately surrounding the sharply focused image. This produces a minute scattering effect known as *irradiation*.

Still more of the light will pass completely through the emulsion and be refracted as it travels through the film base. On reaching the further surface part of it will be reflected and returned to the emulsion surface some distance away from the original image. This produces the effect known as *halation*—so called because, if a

point source is photographed, this imperfection produces a circular halo around the image of the point.

All the effects of light which passes through the film base can be cured by applying a light-absorbing or anti-halation backing to the film. The effects of

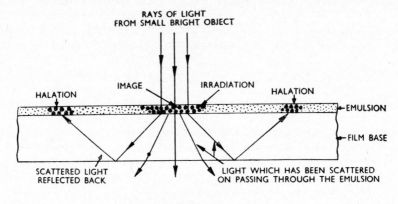

(a) UNBACKED FILM

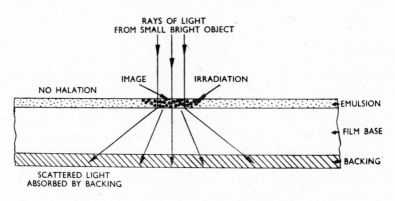

(b) BACKED FILM

Fig. 1.5. The Effect of Irradiation and Halation

irradiation are minimised when the emulsion layer is made very thin and when it only contains very fine grains—it can be reduced to an absolute minimum by incorporating a water-soluble dye in the emulsion and this is often done with sound recording emulsions when an amber-coloured dye is used. In positive picture emulsions a yellow dye is often used but, in all cases, the dye has no effect on the final photographic image and is completely dispersed once the film enters the developing solution.

Film manufacturers always closely guard the patented techniques employed in their coating machines. However, the basic general techniques are usually as follows. Coating begins with what are termed 'parent-rolls' of film base. These are frequently 42 in. (106–7 cm.) in width and well over 2,000 ft. (609·6 metres) in length and are always coated whilst still at these dimensions. Because of this the 'yield' from one parent roll must be of the order of 60,000–70,000 ft. of 35 mm. film or an equivalent volume of other widths such as 16 mm. or 70 mm.—and this is why it is impossible for a film manufacturer to make small 'specialised coatings' of unusual emulsions to meet individual requirements.

Figure 1.6 shows one basic arrangement of a film coating machine. The roll of uncoated film base is mounted in position A, and the leading edge is threaded under

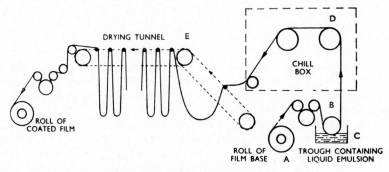

Fig. 1.6. Film Coating Apparatus

a coating roller B which is supported above a trough of warm emulsion C. The temperature and viscosity of the emulsion—combined with the speed at which the film base passes through the emulsion—determine what is known as the 'emulsion coating weight' which, in turn, controls the ultimate thickness of the dried emulsion layer. The actual coating roller does not remain immersed in liquid emulsion, but is only momentarily dipped below the surface at the beginning of coating. It is then slightly raised so as to produce an accurately controlled meniscus of emulsion to form the only contact between the main trough and the film base whilst coating the entire roll of film. The trough of emulsion is fed from a main storage vat, and the flow-rate from this vat is accurately controlled to maintain the meniscus so that, in fact, it acts as a liquid brush on the film base.

The film then passes vertically upwards and over a chilled roller D to cause the emulsion 'set'. From this point it passes to the first of a series of rollers E which are continually moving very slowly to the left in a large drying tunnel. Amongst other considerations, the thickness of the emulsion will depend upon the film speed through the emulsion trough, and this must be relatively fast. On the other hand, the film must dry out very thoroughly and exceptionally slowly. To permit this the mechanism transporting the film along the drying tunnel must move much

slower than that at the coating head. Obviously, intermediate mechanisms capable of absorbing this speed difference must be employed between the chill box and the drying tunnel.

Once coated the parent roll of film must then be slit to produce the many rolls either 16 mm., 35 mm., 65 or 70 mm. wide according to requirements although, in practice, only slittings of the *same* width are made from any one parent roll. A slitting machine consists essentially of a shaft supporting the film in roll form as it was supplied from the coating machine, two sets of rotating knives arranged rather in the fashion of mangle-rollers—but accurately spaced to cut the film into strips of the required width—and provision for spooling up the individual narrow rolls after slitting. Film base is not entirely homogeneous, and the spooling operation must be accurately adjusted to avoid uneven pull on the slitting knives. The width of cinematograph film must not vary by more than 0·002 in. (0·05 mm.); it will therefore be appreciated that the setting up and operation of a slitting machine is a very highly skilled piece of work.

We must now consider the most important mechanical stage in film manufacture —perforating—a subject which caused so much controversy during the early days of motion pictures. The average cinema magnifies the film image more than 350 times, and because of this, any errors in perforating would immediately cause 'picture unsteadiness' on the screen.

For many years all motion picture films have been perforated on machines incorporating the classical designs which were developed by the Bell & Howell Company. This company established the basic dimensions of so-called negative perforations and current International Standards still refer to 'BH1870'. The original design work carried out by Bell & Howell resulted in the standardisation of perforations in negative film in which each perforation is separated from its neighbour by a 'pitch' of 0·1870-in.

In recent years one significant variation in the design of perforating machinery has been introduced. Whilst the time honoured method of advancing film through a perforating head has been by means of a 'under foot' or shuttle, recent designs replace this mechanism with an exceptionally accurate intermittent sprocket wheel similar in principle to the intermittent advancing mechanism used in cinema projectors. It is debatable whether the reduced load which results from spreading the driving force over several perforations engaged with a sprocket wheel results in greater accuracy than that achieved by advancing the film by a mechanism which precisely repeats the 'forward stroke' on every occasion.

Figure 1.7 shows the cycle of operations and the various parts of the 'head' of the classical Bell & Howell perforating system. Diagram A shows the essential parts of the mechanism—the punch legs, the pilot pins and the shuttle. *The pilot pins*, which accurately locate the film both before and during the perforating operation, are tapered near their extremities to permit easy entry into perforations which may not be accurately presented beneath them. The *punch legs*, usually cut from separate plates but 'ganged' together for final milling and grinding, are shorter than the pilot pins and, since they are moved at the same time and by the same mechanism, do not

enter the film until it has been accurately located. The *shuttle* is somewhat like the 'under foot' of a sewing machine since it engages with the newly made perforations and advances the film in readiness for the next perforating operation.

The perforating cycle is therefore as follows: the pilot pins enter the perforations, (b), Figure 1.7, and at the same time the shuttle moves to the right. The pilot pins continue their downward motion and, if 35 mm. film is being made, the punches make four perforations in each side of the film whilst the shuttle comes to

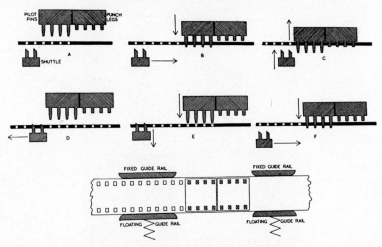

Fig. 1.7. System of Film Perforating

the end of its traverse, (c), Figure 1.7, the punches and pilot pins then move upwards clear of the film, and the shuttle pins move into the perforations, as at (d). The shuttle then moves to the left, carrying the film with it, as at (e), and by an amount sufficient to locate the four perforations which have just been made immediately below the pilot pins. The shuttle then moves downwards and clear from the film, as at (f), and the cycle of operations is repeated.

Film is guided in the perforating machines through a channel formed by two pairs of *guide rails*, (g), Figure 1.7, one pair on each side of the perforating head. The complete guide rail assemblies are mounted in a sliding bed, to permit easy removal and adjustment, and are fitted with fine 'screw thread' controls for re-setting the rails parallel to the main body of the punches. Those rails at the rear of the perforating head are termed the *fixed rails* and are held rigidly in their beds, but those in front of the perforating head, termed the *floating rails*, are spring loaded and move sufficiently to accommodate all variations of film width likely to be encountered.

From these considerations it will be apparent that two major errors can occur in the perforating operation. Firstly, since four perforations are made at one blow of the punch, the three spaces between them are therefore formed automatically and

depend upon the construction of the punches. However, the *fourth* space is only made by drawing the film forward sufficiently to place the last perforation directly beneath the right-hand pilot pin, as at (f), Figure 1.7. If the film is not moved forward by the correct amount this fourth space cannot be equal in length to the other three. This defect is termed *uniformity error* and tends to isolate the perforations

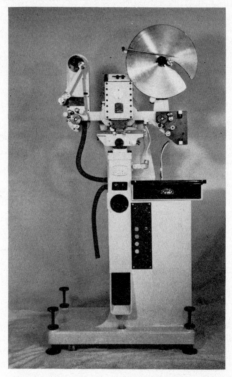

Fig. 1.8. A Typical Perforating Machine

into groups of four. It may be caused by either of two errors in adjustment—or by a combination of both errors—the stroke of the shuttle or the distance between the pilot pins and the punch legs may be incorrect. It is interesting to note that, when 16 mm. film is being made, some manufacturers only form one perforation at a time because, under these circumstances, uniformity error is completely eliminated.

The second major perforating error occurs if the film does not travel absolutely parallel to the main body of the punches. This defect is known as *squareness error* and takes place when the channel formed by the film guide rails is not parallel with the perforating head, and so forces the film to travel through the machine at an angle to the punches. A typical perforating machine is seen in Figure 1.8.

Any machine designed to perforate film will only repeat a fixed set of conditions for a relatively short period—and will then require adjustment to take up wear due to the continual vibration and the oscillating head. Some idea of the amount of work perforator punch legs must perform can be gathered from the fact that an average first-feature film contains over one and a quarter *million* perforations!

Manufacturing tolerances must therefore be established for all the dimensions of perforated films, but these must be sufficiently close to the chosen standards to ensure that a high degree of image steadiness is always maintained in the final screen picture. A typical series of tolerances is shown in Figure 1.9 and demonstrates

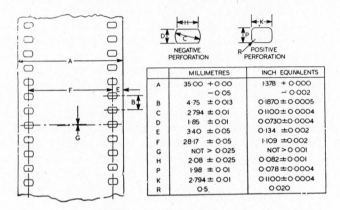

	MILLIMETRES	INCH EQUIVALENTS
A	35·00 + 0·00	1·378 + 0·000
	− 0·05	− 0·002
B	4·75 ± 0·013	0·1870 ± 0·0005
C	2·794 ± 0·01	0·1100 ± 0·0004
D	1·85 ± 0·01	0·0730 ± 0·0004
E	3·40 ± 0·05	0·134 ± 0·002
F	28·17 ± 0·05	1·109 ± 0·002
G	NOT > 0·025	NOT > 0·001
H	2·08 ± 0·025	0·082 ± 0·001
P	1·98 ± 0·01	0·078 ± 0·0004
K	2·794 ± 0·01	0·1100 ± 0·0004
R	0·5	0·020

Fig. 1.9. Film Dimensions

that adjusting perforating machine is, indeed, a highly skilled operation. Dimension B, known as the film *pitch*, is especially important and this is held within plus and minus 0·0005 in. (0·0127 mm.).

Figure 1·9 only illustrates a *typical* set of tolerances and must not be applied in practice without first consulting the latest appropriate National or International Standards involved. Each width of film is perforated to several different standards to satisfy different requirements which, in certain cases, also vary from one country to another. When referring to *any* standards it is therefore vitally important to check that the document is up to date and is applicable to the material under test.

Before motion picture film is ready for sale it must pass through yet another stage, known as edge numbering. The purpose of this operation is two-fold: firstly a series of numbers are printed on the edge of the film at intervals of 1 ft. along its entire length and, secondly, included with these numbers are a series of code letters so that the type of film may be identified.

Some manufacturers mechanically print edge numbers and code identification by means of an indelible ink which remains impervious to the action of processing solutions. Others create a 'latent image' photographic exposure through an optical

numbering machine. In this second process the edge numbers only become visible after the film has been developed—but it has the great advantage that the risk of ink splashing into the picture area of the film is eliminated.

The purpose of the footage numbers is mainly to assist film editors in locating precisely any frame or picture throughout the film—in the case of 35 mm. film 16 pictures are accommodated along every foot of its length and, therefore, one isolated picture can be located from a certain footage number plus a given frame number (from 1 to 15) ahead of that footage number. In the case of 16 mm. film 40 frames or pictures are accommodated in one foot of film, and any one picture can be located by the given footage number plus any picture number from 1 to 39.

To overcome the tedious business of actually counting all these pictures, sprocket wheels large enough to accommodate 40 frames around the circumference are used in 16 mm. editing machines and the side-faces of these are engraved with frame numbers. If the film is applied to the sprocket so that the footage number is synchronised with frame No. 40 then any frame *between* footage numbers is automatically located. Similar sprocket wheels 16 frames in circumference are used in 35 mm. editing equipment.

The code letters and their associated numbers printed together with the footage numbers not only identify the type of material but also enable film manufacturers to locate the particular batch or mix of emulsion from which the film was made, the position that roll of film occupied in the parent coating before it was slit and the perforating machine through which it passed. Thus it is possible to identify all the machinery used to make any roll of film, and also to positively identify the type of emulsion coated on that film.

Motion picture negatives can be subsequently printed in such a way that the edge numbering is printed through on to the positive film and, therefore, one can identify the type of negative from which a print was made without ever actually handling the negative at all.

Sequence of operations in film production

We can now begin to consider in detail the specific mechanisms and processes which are used in film production; it is therefore timely to give a brief outline of general motion picture studio practice.

Cinema feature films and films ultimately intended for television transmission are not made by shooting the story in the sequence of the script—a freedom which incidentally, cannot be enjoyed when live television transmissions are being tele-recorded on to film. The main difference between camera work for films and for direct television is that, in film production any amount of time may be taken to set up a complicated piece of camera work, and the scenes which precede or follow it in the final story may be taken at any time during the production schedule whereas, in live television, a sufficient number of cameras and intercutting electronic monitoring equipment between these cameras must exist to transmit a continuous story in true script order. Live television plays are made more flexible and their limitations

are reduced by electrically inter-cutting 'film sequences' between live transmissions so that, for example, a 'cut away' from interior live action to an exterior filmed scene and then immediately back to the interior live action is readily achieved during transmission.

However, our present purpose is to consider film production methods as such, and here the technique is usually to employ two or more *stages* in a film studio and to work alternately from to the other according to a *shooting schedule* prepared from a *break-down* of the original script. Thus all those scenes occurring on one *set* are photographed on one stage (regardless of their actual order in the story) whilst another set is being constructed on the second stage. When work on the first set has been completed the unit *moves over* to photograph all the scenes required on the set previously built on the second stage. Whilst this is being done the first set is *struck* (or dismantled) and replaced with the third set required by the shooting schedule. In this way all the interior scenes are photographed by a team known as the *first unit* whilst if possible, and at the same time, a *second unit* will be away from the studio photographing any location exteriors which may be required to complete the story. Incidentally, it is usually also the responsibility of the second unit to photograph so-called *background plates* which may be needed for rear projection of exterior scenery during composite trick photography in the studios.

Eventually prints of all the scenes are edited and re-assembled to produce a *rough cut* of the story in the chronological order laid down by the original script. There are many more details connected with rehearsals, acting techniques, post-synchronising, special effects and similar activities which, if discussed at the moment, would only confuse our understanding of the broad principles.

Modern film production involves two main processes: the making of pictures showing the *action*, and the recording of *sound* to accompany those pictures. Although originally made separately and on different machines, these products must eventually be combined—or married—into a single film and so that, by using a suitable projector, both picture and sound will reproduce in perfect synchronism. Furthermore, although original sound is now almost invariably recorded on magnetic sound film, it is still general practice for the final *married-print* as used in the public cinema to be 're-recorded' and transformed into a photographic sound track —usually on the variable-area system.

There are many reasons—not all of them technical—why magnetic sound tracks are not widely used in public cinemas and, even so, why considerable improvement is achieved when they *are* used during the early stages of studio work. This anomaly has been overcome in some major cinemas in large cities—for example multi-track magnetic stereophonic sound *can* be reproduced when such 'wide-screen' productions as 'The Sound of Music' or 'My Fair Lady' are given a so-called *first run* in a London west end situation. Incidentally, 'magnetic sound' is almost universally employed when films are specially made for television transmission.

However, the various sound recording techniques will be fully discussed in Chapter 7; at this stage we need only to recognise these differences and also the fact that, whatever type of sound recording is used, it remains on a separate film

completely independent from the picture material during all stages of production in the studio. Here again we must recognise a difference in technique, particularly when television news-films are being made. Television news is often recorded on 16 mm. 'combined cameras' in which a magnetic sound recording stripe exists along one edge of the photographic film—and both the photography and sound recording take place in the camera.

The projectors used in studio review theatres are different from those in public cinemas—studio projectors can accommodate two separate films, one carrying the picture and the other carrying the sound, whereas standard cinema projectors only accommodate one film carrying both the picture and sound combined.

Clearly, with a technique involving the shooting sequence quite unrelated to the story sequence—and also a process which involves many lengths of picture film quite separate from matching lengths of sound film—some method of scene identification must be recorded at the beginning of every shot if the editorial staff are to be able to recognise and assemble the material correctly.

Although started together, the picture camera and sound recording machine may not attain full speed at the same instant but, once at full speed, they become electrically interlocked and remain in synchronism throughout the *take* (the term used to describe each individual attempt to record a given scene).

For editing purposes a *clapper boy* was originally employed to hold a title card in front of the picture camera immediately it and the sound recorder had interlocked at full speed and before the actors played their scene. This card, carrying all the necessary scene identification, was mounted on a board above which a thin section of wood was hinged at one end. The boy would slap the two boards smartly together, announce the scene-and-take numbers, and then quickly walk out of the field of view. The picture camera recorded visually the data on the card *plus* the moment at which the boards came into contact whilst, at the same time, the sound recorder registered the abrupt noise of the boards making contact, followed by the oral announcement identifying the scene.

This was only one of several methods used to obtain synchronising marks on both the picture and sound negatives. Modern studio equipment contains automatic apparatus for ensuring synchronism and the clapper boy now only displays a scene numbering title board and announces the take-and-scene numbers. However, even under modern conditions situations can arise—particularly if complicated *process shots* are being made with several cameras in action at once—when it is still necessary to employ *clappers* to record synchronising marks on all the films simultaneously.

Rolls of picture negative are fed into the camera from film magazines usually large enough to accept 1,000 ft. (304·8 metres) of stock. Film magazines accommodate both the unexposed and exposed material; they are the modern equivalent of the early wooden spool boxes and are fitted with light-tight *traps* designed to close automatically on removal from the camera body. A magazine can be removed from a camera without disturbing its general arrangement and whilst in brilliantly illuminated surroundings.

When a roll of film has been exposed, or a section of a partly used roll must be

processed immediately, the magazine may be removed from the camera and then unloaded in a dark room. The film is then wrapped in protective paper and sealed in a light-tight can for transfer to the processing laboratory. Here it passes through a continuously operating processing machine which automatically develops, fixes, washes and dries the film and is capable of handling any length, and any number of lengths, without interruption.

The picture negative is then transferred to a printing machine capable of making a positive copy of the images and which will be similar to the film used in a cinema. This positive copy is immediately developed and the picture negative is then placed in a film store for future use in making up the final completed film if the test print should prove acceptable to the director of the picture.

Before proceeding any further we must return to the 'set' to trace the course of the sound recording up to this point. In film production sound is recorded via a number of links known collectively as a *sound channel* and naturally, the first of these links is the microphone (an instrument designed to react to incident sounds by creating an electrical current varying in proportion to those sounds).

Studio microphones are supported on elaborate extendable tubular equipment mounted on mobile trolleys—the whole unit is known as a *microphone boom* and can be manipulated to follow an actor across a set or, by rotating the microphone from a remote control unit, to *favour* one or another actor during conversation. To obtain the best recording quality from all areas of some sets it may be necessary to use more than one microphone—an obvious example being the recording of a *music session* when a full orchestra must be employed to perform the score written to accompany the picture. The output from a microphone is very small and must first be fed into a *pre-amplifier* and then, via a *mixing panel* into a main amplifier; at this stage it is of sufficient strength to operate the sound recording head. A mixing panel permits adjustment of the volume and quality of sound from each microphone so that a correctly balanced output may be achieved. The presence of several microphones on a set does not necessarily mean they will all be used at once—they are more likely to be 'faded in' alternately as the artists walk beyond the range of one and into that of another.

The actual film stock used in a recording channel depends upon the type of record being produced. In Chapter 7 we see that three main types exist—magnetic recordings capable of immediate reproduction or *play-back,* and either variable-area or variable-density photographic recordings which require processing and printing in a manner similar to picture films before sound can again be reproduced. All modern studio recordings are made via the magnetic system although, in recent years, it has become possible to use narrow un-perforated magnetic *tape* instead of magnetic film. Such a tape can be arranged to travel through a suitable recording head in perfect synchronism with the photographic film tavelling through the picture camera. The choice of magnetic film or tape is often governed by the existing investment in film-handling equipment.

As previously explained, synchronism between sound and picture must be assured. This is often done by recording a synchronising *frequency* or constant

pitch note on the sound track itself at the same instant and via the same equipment as is used to illuminate a small 'fogging lamp' in the picture camera.

Magnetic 35 mm. sound recording film consists of a coating of ferric-oxide on a tri-acetate or polyester support. The coated area may extend across the complete width of film, it may be confined to that area between the two rows of perforations, or it may only exist as a relatively narrow stripe towards one edge of clear 35 mm. perforated film base. The second and third alternatives are often favoured because oxide coating can be carried out during manufacture *after* the film has been perforated and this avoids the high rate of wear created when punches and dies are required to perforate through magnetically coated material.

Because magnetic film is not affected by light the use of photographic dark rooms and associated techniques are not necessary. This means that, during recording, the sound channel may be exposed to light and, in some studios, the opportunity is taken to write track-identifying marks on to the film with a coloured wax pencil. Magnetic sound film recordings can be erased and the material may be used again many times—it is therefore essential to adopt a technique which makes the most economical use of the film and, particularly, avoids the cutting of parent rolls into short lengths equivalent to individual scenes.

When a scene is being *shot* each attempt to secure a perfect result is known as a separate *take* and, in some cases, many takes may be necessary before an acceptable result is achieved. It is rarely possible for a film director to select with certainty one particular take and only call for that alone to be printed. Usually several takes are selected at the time of shooting and prints of these are rushed from the laboratories to the studios for screening on the following day—because of this the inspection of these prints is known as *viewing the rushes*.

This technique could mean that, so far as sound recording is concerned, as many as 20 takes may be recorded on one parent roll of film—but that, for example, only takes 5 and 17 have been selected for printing and inclusion with the daily rushes. To overcome the loss of magnetic film which might otherwise occur, technicians in modern sound departments transfer or re-record the 'wanted' takes on to new rolls of magnetic stock and in such a manner that the editorial department can assemble the corresponding picture prints made by the laboratories into rolls which will synchronise with these re-recorded sound tracks. Naturally, all original recordings—whether approved or not—are preserved until the entire picture has been completed. Only then, and when any possible call for hitherto unused material has passed, will original recordings be *wiped* or erased, and the film returned to general stock for future use.

Apart from the actual *floor shooting* of recognisable scenes in the script, many other operations are necessary to the completion of a modern feature film. A number of these concern the special-effects department where, with the aid of optical printing machines, all the well-known scene and tempo adjusting techniques are employed. Amongst these are such effects as the simple *fade-in* (when the scene gradually appears from a previously black screen), or the *fade-out* (when the scene is gradually obliterated until the screen is completely black); the *lap-dissolve* (when

the fade-out of one scene is superimposed upon the fade-in of the next scene); innumerable *wipe-effects* (when one scene appears to be wiped off the screen by a line revealing a new scene in its wake), and countless other devices including physically impossible situations created by the *travelling-matte* technique. In all these it is important to realise that the studio cameraman is not called upon to create the effect at the time of shooting—he is merely required to expose sufficient negative both before and after the main body of the scene to provide material to cover the running time of the special effect.

In a similar manner, many sounds other than spoken dialogue are needed to add realism to a modern feature film. Apart from the obvious requirement of a music score to intensify the atmosphere of dramatic situations, the many *incidental* sounds such as telephone bells, footsteps on a gravel path, clocks chiming, off-stage traffic noises, etc., etc., are all added after the floor shooting has been completed— usually during *sound-effects* recording sessions often carried out in the sound dubbing theatre—and often designated simply 'FX'!

For many reasons it is not always possible to record first-quality dialogue on the studio set. When this occurs the original sound recording is employed as a *guide-track* eventually to be replaced by a *post-synchronised dialogue track*, shot under the acoustically perfect conditions of the dubbing theatre. One obvious example of the need for this technique is when important dialogue occurs between dancing partners in a busy and complicated tracking shot through a ballroom.

Thus, for many reasons the ultimate result will be represented by a number of picture negatives plus an equal—or usually much greater—number of sound recordings. Just as all the picture negatives must be welded together into one master containing all the wanted scenes and transitions in their correct order, so must all the many sound films be re-recorded into one composite track containing all the wanted dialogue, music and sound effects needed to complete the story. The final operation of merging all the sounds together is known as *sound-dubbing* and, during this work, the master track of each reel in the final picture is produced on magnetic sound film. The process employs a large number of sound reproducing machines, each carrying one film and all being electrically connected to the picture projector. In some studios as many as eighteen sound films can be reproduced simultaneously and all will remain in perfect synchronism. Due to a highy complicated electrical network it is possible during this process to adjust the frequency response, balance and general quality between the various recordings and so to produce a very uniform and pleasing result. It is only after this stage that a *photographic* sound track is made and used for printing the many copies of the picture in the form it will be released to the public cinemas.

The final composite picture negative represents a very valuable investment, and to use it for printing the many release copies would be extremely dangerous. Insurance against possible damage is achieved by first making a fine-grain master positive from the original picture negative, and then using this positive to create a high quality duplicate negative. It is this duplicate negative which is used for printing all the release copies of the picture.

Ultimately the copies used in public cinemas consist of picture images married to accompanying photographic sound tracks and both created on one piece of film. The relevant positions of both picture and sound on conventional *release prints* are shown in Figure 1.10. The total width of the film is 35 mm. and, with the emulsion towards the reader and the sound track on the right-hand side, this width is divided up as illustrated.

Films may be edited on an instrument such as the *Moviola*. In effect this is a miniature picture and sound projector capable of running married or un-married films both forward or backward—or stopping instantly on a selected picture or frame. Most instruments can also run at speeds much lower than normal projection

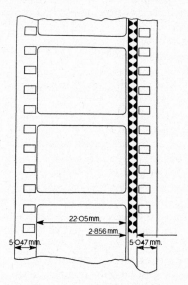

Fig. 1.10. A Married Print

speed—a great help when cutting film to create special dramatic emphasis. The picture is usually projected on to a ground-glass screen or viewed through a magnifying lens; it is therefore quite small but this is inevitable since, to prevent excess heat, only a low-power light source is fitted to this type of equipment.

The sound and picture films will still remain as separate items during the editing process and, therefore, must be edited in perfect synchronism. It is particularly during this work that the synchronising marks at the start of each shot, together with the edge numbering mentioned earlier, are found to be of great value.

The final edited duplicate picture negatives and dubbed photographic sound negatives are ultimately passed to the processing laboratory chosen to manufacture the many release copies of the film. Laboratories must provide several types of picture printing machines as well as quite separate and different sound printing

machines. The reasons for this will become apparent when the purpose of printing equipment is discussed in Chapter 5. They must also have at least five continuous processing machines—basically these may be similar in design, but are each required to perform different tasks. The developing solution and machine speed suitable for processing black-and-white picture negatives are different from those most suitable for processing picture positives and both of these are again different to the solutions and speeds needed when processing colour films. Of equal importance, all of these are different from the optimum requirements for processing photographic sound negatives.

Married release prints are usually made up in the following manner: firstly, a picture image is created on a new roll of raw (unexposed) positive by passing this film together with the duplicate picture negative through a *positive release printer* but, before printing begins, the synchronising mark previously made by the editor at the head of the negative reel is duplicated on to the head of the new positive film. After printing the positive is re-wound and threaded together with the photographic sound negative into a sound printing machine. Films are threaded into this machine so that the synchronising mark previously transferred from the picture negative to the positive now coincides with a similar mark also supplied by the editor at the head of the sound negative—synchronism between sound and picture in the final print is thereby assured.

However, the synchronising marks are only *in line* with each other for convenience; they represent an arrangement which provides for the sound to be printed a definite distance in *advance* of the picture. The reasons for this will be apparent when projector mechanisms are discussed in Chapter 6; for the present it is sufficient to know that a system is employed which maintains synchronism right through every stage of the process.

After each printing operation the picture and sound negatives are re-wound and again passed through their respective machines together with rolls of positive release printing stock. This cycle of operations is continued until the required number of copies have been made. Clearly, the all-important duplicate negatives undergo considerable use and in many laboratories, apart from regular inspection and cleaning, negatives are often treated with lubricants and preservatives to ensure against possible damage.

The use of film in Television

Television is essentially a means whereby animated visual displays of events, together with their accompanying sounds, can be made available in the home instantaneously and at precisely the moment they actually occur; it has been said that television provides 'instant domestic talking pictures'.

This ideal of immediate availability is only achieved in practice on comparatively rare occasions and for relatively short periods. Such a situation is largely unavoidable because events worthy of transmission frequently take place when the potential audience is otherwise engaged—they may be at their place of work or they may even

be visiting a cinema! However, to limit programmes to genuine so-called 'live transmissions' would seriously deplete the service and would also fail to recognise television as a system capable of much wider application for the provision of entertainment, education and items of general interest.

Indeed, the range of programme material considered to be suitable for television is believed to be so wide that the British public may shortly be able to select from two B.B.C. and two I.T.V. programmes (all simultaneously available) together with the possibility of several meter-controlled closed-circuit systems. In America the public already have a much wider selection at their command.

Television must provide a wide range of programmes including factual reporting of news; grandstand views of sporting events; discussions by the leading authorities on current affairs; exhibitions of the arts—such as ballet, painting, music, etc.; educational programmes for schools; light entertainment such as variety shows and comedy plays; drama and opera; farming, agriculture and industrial development— together with a host of other material all likely to interest a significant proportion of the viewing public.

Clearly, only a small part of this formidable demand can be satisfied by 'live transmissions' radiated at the actual time the events take place. The larger portion of such requirements is secured by the use of *recorded* programmes and, fortunately, there are three main techniques available for this purpose.

Many programmes are filmed in their entirety and result in a product similar to conventional motion pictures as used in the cinema. It is precisely because of this that a brief survey of the use of film in television must be included in this book. Equipment known as *telecine* apparatus exists in the television system whereby filmed records can be translated to provide the necessary television signal for transmission. Incidentally, the development of telecine apparatus made possible the transmission of complete feature films originally produced for and by the cinema industry. One obvious programme ideally suited to conventional cinematograph techniques is the television newsreel.

Other programmes which may eventually be recorded on film may be *originated* via television cameras (as opposed to film cameras) and the electronic signal representing the scene to be recorded is then displayed as a pictorial image on a cathode-ray tube. This is then photographed on to cinematograph film in a *telerecording* camera. The significant difference between motion picture film images photographed either by cinematograph cameras or telerecording cameras is that, in the former the image is a continuous range of tones whereas, in the latter, it is formed by a series of horizontal lines of information representing the line-structure which is characteristic of any television image displayed on a cathode-ray tube.

The third system of recording programme material is that known as video-recording, or video-tape recording. This technique usually secures the television signal in terms of magnetic flux and in nearly vertical lines arranged across a 2 in. wide roll of magnetic recording tape. Although the frequency employed when transmitting picture or video signals—also the arrangement of those signals on the tape—are very different from audio or sound signals, the basic principles of video

and audio tape recorders are similar. We are concerned with the use of photographic film in television and systems of video-tape recording are therefore not discussed in this book. The following eight main points illustrate the important part played by film in any television service:

News film. Topical news events occur at all times, but the items of wide public interest must be collected together for transmission at set programme times each day. This is most conveniently done by a team of picture cameramen and sound recordists going to news locations—usually to secure combined picture and sound recordings on 16 mm. motion picture film.

Feature inserts. Many full-length dramas and similar entertainment require both interior and exterior scenes for the full enjoyment of the story. Whilst the interior sets may be constructed in the television studios and the actors may be present to give a 'live performance' at the time of transmission, it is clearly impossible also to have the same actors simultaneously present at inaccessible exterior locations. For such programmes the exterior scenes may be recorded on motion picture film—sometimes several weeks before the day of transmission—and this can be reproduced via telecine to 'intercut' with the live scenes in the studio as required.

Re-scheduling. This term is used to describe any event (or entire programme) which, originally, takes place at a time which is inconvenient for immediate transmission. Such a programme may be filmed and can then be fitted into the transmission schedule as required and, incidentally, valuable studio space may thus be used to greater advantage.

Repeat transmissions. Any items which are to be transmitted more than once must be recorded. Apart from actualities such as a coronation ceremony or a football match, this is also necessary to avoid expensive re-staging in the case of fictional entertainment programmes such as plays, etc. (It must be admitted that this function can be easily satisfied by using video tape.)

Editing. Many programmes cannot be staged either in the required sequence or so that only precisely selected and approved material is transmitted. The convenient solution to these and similar problems is often to pre-film the programme and thus provide the freedom to edit and transpose the material as required. (This facility is at present more easily achieved when motion picture films are used instead of video tapes.)

Sale of programmes. In recent years television services have become almost world wide. During this same period programme content has become more ambitious and more expensive to stage. Both these facts provide strong reasons to sell and exchange programmes—a practice which, via film, can be readily achieved even when interchange occurs between countries operating different line-standards for transmission.

Programme analysis and assessment. Production crews working on the studio floor and, of course, the performers themselves, cannot measure the success of their work during the actual transmission. The value of such assessment is very great indeed and film telerecording sometimes provides this facility in the most widely acceptable form.

Contributions to archives. All film recordings of historical value are preserved for long-term storage, and film recordings of important personages are preserved to compile biographic appreciations, etc.

To appreciate the selection of certain film stocks for use in television and, particularly, in the telerecording systems, it is first necessary to consider the television signal. In Britain the system must ensure electrical interlock between transmitter and receiver via the 50 cycle A.C. mains. All television systems which display so-called 'full information' as opposed to 'suppressed-field' images, transmit a number of 'fields' and a number of 'frames'; invariably two fields added together constitute one frame and the basic purpose behind this technique is to display a limited amount of information across the entire picture-receiving area as quickly as possible—and then to fill in the gaps in the information during a subsequent display.

In television language this technique is referred to as the *lace* and the *interlace* of the two successive fields which, together, constitute one frame. Relating the vertical line structure to the horizontal speed at which the scanning spot travels enables one to derive a measure of image resolution. With the 625-line system this becomes equivalent to the distribution of approximately 1,250,000 *dots* over the effective image area—it also calls for a film emulsion resolution to maximum signal frequency of the order of 40 lines per millimetre.

Whilst the more recent British television system employs 625 lines at a picture rate of 25 frames per second—derived from 50 fields per second and operating on a 50-cycle A.C. supply, the American television system employs 525 lines on a 60-cycle A.C. supply. Because of this the British system can more easily transmit conventional motion picture films than can the American—all films originally made for cinema exhibition are taken at the rate of 24-pictures per second; films taken for British television are shot at 25-frames per second, whilst those taken for American television are shot at 24-frames per second.

In Britain it is acceptable to televise a 24-frame per second cinema film at 25 television frames per second since the resultant increase in image movement rate is not perceptible. Similar and inevitable raising in the pitch of musical notes via the accompanying sound recording are only detected by the most critical ear. The American system is not so fortunate and can only transmit conventional cinema films *or* films specially made for television by employing special scanning techniques; the odd-numbered film frames must be scanned twice and the even-numbered frames must be scanned three times. It is essential to be able to interchange British, American and other television programmes, and *film recording* is a unique and universally acceptable medium for overcoming the major problem of line standards conversion which obviously exists between the systems employed by various countries.

From the foregoing analysis we can appreciate that 35 mm. film should be used when high picture quality is essential. This is not only because 35 mm. film must yield better effective image resolution than 16 mm. (in the ratio of the picture size when comparing images on the same type of emulsion) but also because intermittent

film-moving mechanisms and mechanical tolerances in 35 mm. equipment generally result in picture steadiness of a higher order than can be obtained with comparable 16 mm. equipment.

A little consideration will show that, even if film perforating and mechanical tolerances in the 16 mm. system are all maintained equal to those in the 35 mm. system, final image steadiness must still remain in favour of 35 mm. because the image on the larger film and, therefore, any inaccuracy in that image, is magnified to a smaller degree to achieve equal image size on the television screen. However, the important considerations of economy in some programmes, and the portability of equipment in others, often lead to the use of 16 mm. film.

Economy becomes a major factor in selecting film size in telerecording work and, of course, this must be related to the type of programme which is being recorded. The telerecording of an important national event which is likely to be used many times and which has great historical value would undoubtedly merit the use of 35 mm. film. Telerecordings of events of only passing interest—such as a football match—rarely call for the highest picture quality or have any lasting value and, in consequence, these are invariably made on 16 mm. film.

The higher quality of 35 mm. film should be used for *insert* material used in television plays and also for the production of prestige programmes such as 'This is the B.B.C.' (photographed by Mr. Ken Westbury) or, 'An Act of Faith'—a very high quality documentary film shot for the B.B.C. by Mr. A. A. Englander and showing the rebuilding of Coventry Cathedral.

Television news programmes invariably use 16 mm. film because the nature of the subject cannot justify the extra cost of 35 mm. material—it is often said that nothing is so dead as *yesterday's* news—and also because the camera equipment must be light-weight and very portable. The question of weight and bulk is also important on foreign location work such as David Attenborough's 'Zoo Quest'—which often required the camera team to carry their equipment many miles into the jungle—and 16 mm. clearly becomes the natural choice for all such programmes.

Industrial standards

The foregoing very brief outline of the motion picture industry and its association with television indicates that apparatus, processes and raw materials must all be rigidly controlled and standardised if the end-products are to be acceptable to world markets. As long ago as 1916 these ideals were especially realised by C. Francis Jenkins—an American who made many brilliant contributions to the advancement of cinematography. Largely due to his efforts the Society of Motion Picture Engineers came into being with the object 'that we should recognise our responsibility to fix standards with due regard for the interests of all concerned'. In more recent years the Society has widened its interests to include television and, in consequence, is now known as the Society of Motion Picture and Television Engineers.

When the Society was formed only one thing was standard throughout the industry—and that was flexible film base! Since its beginning the Society has more

than justified its intentions, it maintains a high standard of technical knowledge as a criterion of membership, it publishes a valuable monthly journal recording the latest advancements in the theory and practice of motion pictures, and it has also standardised much equipment, mechanisms and the practices used throughout the industry. Many standard dimensions relating to the manufacture of cinematograph film and equipment have been originated by this Society—and these have formed the basis of National standards prepared by the American Standards Association—they have also greatly helped towards the preparation of similar standards by the British Standards Institution. Such standards are of great importance to all people interested in the theoretical aspects of cinematography and will be considered in detail as and when they apply to the various mechanisms and processes described in this book.

In recent years the International Standards Organisation has extended its interests to cover world wide standardisation throughout the film industry. Any country having its own National Standards Organisation is eligible for membership of the I.S.O., and at a recent conference attended by the author the following countries were represented and were all actively engaged in establishing international agreement on various technical aspects of cinematography: Austria, Belgium, France, Germany, Italy, Japan, The Netherlands, Sweden, the United Kingdom (Gt. Britain), the United States of America and the Union of Soviet Socialist Republics.

Whilst in Britain the standardising body is the British Standards Institution, the recognised technical society is The British Kinematograph, Sound and Television Society. This organisation was originally the London branch of the Society of Motion Picture Engineers, but in 1931 it became an independent organisation known as the British Kinematograph Society. More recently it has expanded also to serve both television and sound engineers and so, like its American counterpart, now favours an all-embracing title. It is therefore not surprising that the aims of the B.K.S.T.S. are very similar to those of the S.M.P.T.E. The activities of the British Kinematograph, Sound and Television Society cover technical lectures and discussions, scientific reports in a monthly journal, demonstrations of new apparatus and methods and the general advancement of motion picture and television practices. Membership of the B.K.S.T.S. is by nomination and ballot into one of three grades : student, associate or active; beyond this the Fellowship is a matter of special award by the governing council and for outstanding and sustained contributions to the industry.

The British Kinematograph, Sound and Television Society works through its many committees in close co-operation with the British Standards Institution—particularly in the matter of proposed modifications to existing standards or the introduction of new ones. It has always been interested in the education of young members of the industry—and has shown this in a very practical manner by organising many series of lectures especially directed towards this goal.

Chapter 2

The Cinematograph Camera

General considerations

A considerable variety of first-class cameras are currently available. To some extent this is undoubtedly because the optimum requirements for *all* purposes cannot be conveniently embodied in a single camera. However, the purpose of this book is to consider fundamental principles and not to provide operating instructions for specific equipment—a function more correctly the prerogative of the manufacturers themselves. Because of this, details of particular cameras are only described when either the mechanism is unique or an unusual need is satisfied.

Professional cinematography is no longer confined to work with 35 mm. film but extends also to the 16, 65 and 70 mm. gauges. Cameras to satisfy some of these requirements may be powerd by spring or electrical motors, and the latter may be battery or mains energised to operate over a range of speeds or to interlock at a constant speed in synchronism with sound recording equipment. High speed cameras may expose several thousand frames per second, whereas cameras for time-lapse cinematography may only expose one frame in several hours!

Some cameras embody either optical or magnetic sound recording facilities to produce so-called *combined-negatives*, whilst others only generate a synchronising electrical pulse which is impressed on sound recording apparatus remote from the picture camera. Cameras which do not provide any means of synchronising with sound recording equipment are still available—16 mm. variations are especially valuable in television news coverage (when weight and portability are important factors) and 35 mm. versions are used when filming background plates for feature film production.

The film capacity of conventional cameras may be 100, 200, 400 or 1000 ft. (30·5, 61·0, 121·9 or 304·8 metres) but, for the special requirement of television known as *telerecording*, this may extend to 2400 ft. (731·4 metres). Whilst some cameras are fitted with a single *zoom* lens providing an infinitely variable field of view within wide limits, others are equipped with turret mounts usually to accommodate three lenses of selected focal lengths. Similarly, many camera shutters are set at 45° to the optical axis and embody a mirror surface providing view-finder images entirely free from parallax.

45

In some high-speed cameras the film moves so rapidly that the conventional intermittent motion through the exposing aperture cannot be employed. Under these conditions the image is usually refracted through a rotating glass prism so that, during exposure, it moves vertically downwards at the same speed as the film. Unfortunately perfect synchronism between image and film movement can only be maintained whilst the prism rotates through a very small angle and, beyond this, exposure must be cut off to prevent image distortion. High-speed cameras therefore give a proportionally shorter exposure and require more light than would be the case if a conventional mechanism could safely be employed to operate at such speeds. Inversely, these are also valid reasons for *not* using optical compensation in cameras operating at normal speeds. High-speed cameras employing optical compensation must therefore be considered non-standard for the moment and will not be discussed until much later in this chapter.

The basic mechanism of any conventional camera, together with many of the refinements outlined above are more readily understood by first considering several important early inventions and experiments.

Basic requirements

The essential requirements common to all camera mechanisms are briefly as follows:

(1) The surface finish of all film-contacting parts (whether movable or stationary) and the hardness of these surfaces must be such that film scratching is avoided and that particles of film base, emulsion or loose dirt cannot become embedded in their surfaces. When felt or velvet are used in light-traps, etc., these must be readily accessible for cleaning. Painted surfaces within the film path should be avoided— black finishes to metal should be achieved by chemical treatment because paint is liable to chip or flake off in use.

(2) Provision must be made to house the roll of unexposed film and also to automatically and smoothly wind up film which has passed through the camera. Film *take-up* must avoid cinching or any tendency to cause stress-marks on the emulsion or base surfaces. Of necessity such housings must be in the form of light-tight containers, preferably designed to be removable from the main camera body and in such a manner that automatic light-traps restrict fogging to the minimum film length required to thread the mechanism.

(3) To satisfy the requirement of intermittent film motion at the exposing gate, one or more positive feed and hold-back (or take-up) sprockets must be provided between the film rolls and the intermittent mechanism. This is to isolate the constant pull of the take-up reel from that section of film which is under accurate control by the intermittent mechanism, and also to provide a steady pull on the film supply reel. Engagement between the film perforations and the sprocket teeth should be positively controlled by rollers or guide-ways designed to bear only on those film areas which will not be occupied by the picture or the sound track.

(4) The intermittent mechanism itself must be designed to move the film forward by an amount equal to the effective height of one picture (or, in some types

of wide screen photography, to this height plus a wide frame-bar), bring it to rest and disengage from the perforations to return to the top of its stroke in readiness to repeat the cycle. To achieve great accuracy several cameras include an associated system of pilot pin registration designed to control the position of the film during exposure.

(5) A continuously operating rotary shutter should be provided and positively geared to the intermittent mechanism. The shutter aperture may be variable either during or prior to setting the camera in motion (this is not obligatory) but, in any event, its aperture and speed of operation must provide an adequate exposure each time the film is brought to rest.

(6) Provision must be made to accept a range of objective lenses in positively pre-set mounts so that, if a turret is provided to accommodate several lenses, any one lens may be mounted in any position on the turret without further adjustment or calibration.

(7) Although the calibration of lenses is not properly a function of camera design, it is preferable that lenses be selected which are scaled to indicate apertures in terms of light transmission (T-stops) as well as in so-called F-stops (increments in effective diameter of the lens aperture as related to the focal length).

(8) Ancillary equipment such as a view-finder must be provided to accurately sight the camera and to indicate the field of view embraced by the objective lens.

(9) When the camera is designed to operate at a range of speeds means must be provided both to adjust the speed and to accurately measure it continuously in terms of 'frames per second'. Such provision is also essential on single-speed cameras.

(10) Finally, the amount of film consumed during a 'take' should be measurable —preferably by means of a combined frame and footage counter—and, if economy is practiced in this respect it is essential that the amount of film still available in the unexposed roll shall be indicated.

The intermittent movement

The heart of any cinematograph camera is the intermittent mechanism, and all other considerations should rank as secondary to the requirements of this unit. It has been shown that, to maintain the illusion of smooth motion in the reproduction, at least 10 to 14 pictures must be presented to the eye every second. The exact number depends upon the contrast within the image and also between the image and the surrounding viewing conditions.

Because of this it was thought wise to establish the speed of early silent films at something safely above this requirement and, in fact, a speed of 16 pictures per second was chosen. Assuming the complete cycle of the intermittent mechanism took place in 1/16th of a second, approximately half this time was occupied by the mechanism returning to the 'start' position after moving the film forward by one picture length. This being so, the actual *pull-down* took place within 1/32nd of a second. Since film must be absolutely stationary immediately before, during and

also just after pull-down, this mechanism had to accelerate the film from rest and up to maximum linear speed within half the period allotted to pull-down—that is within 1/64th of a second.

The distance to be travelled by the pull-down is the length of film represented by one picture plus one frame-bar (the space between pictures) which, in the standard 35 mm. format, is 0·750 in. (18·85 mm.). A little consideration will show that, at the centre of the pull-down, the film will be travelling at a speed of 4 ft. (1·22 metres) per second. All maximum linear speeds quoted here assume a straight-line acceleration and are therefore approximations: the precise maximum speeds vary considerably between the design of one intermittent mechanism and another.

The mechanism must therefore fulfil the following requirements: to acclerate the film from rest up to a speed of 4 ft. (1·22 metres) per second and then to immediately retard the speed to zero—the whole movement to take place in 1/32nd of a second over a distance of 0·750 in. (18·85 mm.) and repeating continuously 16 times every second.

The foregoing conditions only apply to the so-called 'silent speed' of 16 frames per second. When operating at 'sound speed' or 24 frames per second the conditions become more severe and may be stated as follows: to accelerate the film from rest up to a speed of 6 ft. (1·83 metres) per second and then to immediately retard the speed to zero—the whole movement to take place within 1/48th of a second over a distance of 0·750 in. (18·85 mm.) and repeating continuously 24 times every second.

The situation becomes even more acute when films are made for television. Pictures transmitted over the British television services are presented at the rate of 25 per second and, therefore, films for inclusion in television programmes should also be exposed at this frequency to maintain correct image movement. The requirements of the intermittent mechanism are then as follows: to accelerate the film from rest up to a speed of 6·25 ft (1·90 metres) per second and then to immediately retard the speed to zero—the whole movement to take place within 1/50th of a second over a distance of 0·750 in. (18·85 mm.) and repeating continuously 25 times every second.

Some readers may imagine these requirements are approaching the limit of mechanical strength in film perforations. This is not so—conditions far more severe frequently exist when film is used for telerecording. Certain telerecording systems employ a very fast pull-down mechanism which completes the film movement in 1/750th of a second (1·33 milli-seconds). When applied to 16 mm. film this implies a maximum film speed of approximately 38 ft. (11·6 metres) per second at the centre of pull-down!

Most cameras contain intermittent mechanisms which are considerably more efficient than the basic pull-down times quoted for 16, 24 and 25 frames per second. These times indicate the *slowest* movements which are acceptable to provide adequate film exposure times—it is also an advantage to provide time for the film to settle down (or for pilot pins to register it) before the shutter opens and exposure begins.

48

Add to the above facts that, under these conditions, the mechanism is expected to position the film within an accuracy of 0·001 in. (0·025 mm.) and it is not difficult to realise why this section of the camera is considered to be so important. By following the development of the intermittent mechanism the progress made in general camera design will also become apparent.

When such a course is adopted it becomes difficult to imagine the conditions which existed in the early days of the industry. The growth of the motion picture industry took place in an amazingly short period. In considering these early mechanisms it is very important to remember that the pioneers who invented them could only judge the quality of their cameras from the resultant prints screened by their equally uncertain projectors. As would be expected, the improvements to camera and projector mechanisms were both gradual and inter-dependent. In fact, at the outset, the mechanisms used in the cameras were often identical with those used in the projectors.

Early mechanisms

One of the earliest cameras to enjoy a measure of success was manufactured by Demeny and employed the eccentric pin, or *dog-movement*, seen in Figure 2.1. The mechanism consisted of a spring-loaded gate channel F through which film D passed to the underside of guide roller B and then directly to a constant-speed

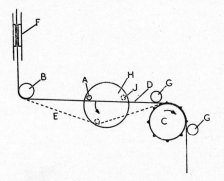

Fig. 2.1. The Dog Movement

sprocket C, where it was guided by rollers G. Between guide roller B and sprocket C a circular flange H, carrying eccentric pin A, made one complete revolution for every picture-length drawn forward by the sprocket. The mechanism was so adjusted that pin A would just touch the film as it formed a straight line between roller B and sprocket C. The eccentric pin rotated in the opposite direction to the sprocket, and the film was pulled through the gate F at a speed and by an amount depending upon the combined action of this pin and the sprocket.

This action formed the film into a looped path E and the eccentric pin then passed out of contact, on reaching position J, and remained out of contact until it again occupied position A. The loop so formed became a reservoir of film supplying sprocket C. Whilst the loop was being consumed the eccentric pin travelled from J to A in readiness to re-form the loop once more. Considerable tension was applied to the film in gate F because this was the only means provided to bring the film to rest after the *dog* had formed the loop.

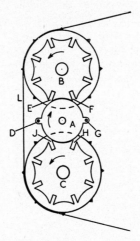

Fig. 2.2. The Double Maltese Cross by R. W. Paul

This mechanism certainly provided an intermittent motion of the film at the gate, but it suffered from many serious disadvantages. At that time the variations in film shrinkage were so great that pictures could not be kept in step with the perforations and consequently, on projection, sometimes appeared to slowly creep up or down on the screen.

Demeny's intermittent mechanism has been described in detail because a modern instrumentation camera employing an improvement based upon the same principles has been marketed by W. Vinten & Co. Limited—a very well-known and long-established British company of cinematograph engineers who have joined forces with the Mitchell Camera Corporation of America to form the subsidiary Vinten-Mitchell Limited—a fitting outcome for two companies who have been manufacturing precision equipment almost as long as the industry has been in existence. Naturally, an instrumentation camera is not intended for motion picture work—it is expressly designed to photograph instrument test panels, etc. However, it is an important example of the continuing value of early designs and principles.

Another early mechanism is also of considerable importance, since it was a forerunner of the very successful Maltese Cross movement used in present-day projectors. When dealing with early inventions it is always dangerous to acclaim a

particular person as the originator. In fact, judging from the number of law suits in those days, it seems likely that doubts existed even at the time when some of the first patents were issued. However, we are sure that the well-known British pioneer Robert W. Paul, used the double Maltese Cross shown in Figure 2.2.

This mechanism was used both in cameras and projectors and the action was as follows: the centre pin-wheel A was the driving member and, if rotated in the direction indicated, the pin attached to extension D eventually engaged with slot E, cut in cross B, and caused it to rotate to position F. At the same time the pin attached to extension G engaged slot H cut in cross C, causing it to rotate from H to J. Sprocket wheels were attached to the shafts supporting both crosses and film was drawn tightly between them as shown at L.

The sprocket wheels both rotated in an anti-clockwise direction and film *between* them was utilised as the 'gate' of the camera or projector. It was held under no more tension than the guiding effect supplied by the sprockets themselves, but it is likely that some type of 'back-plate' was also used to maintain a measure of control at the focal plane.

Unfortunately, this very neat and compact arrangement had several disadvantages. It required exceptionally accurate workmanship before two crosses would both 'mesh' perfectly with a central driving pin-wheel and, supposing this to be accomplished, it could only succeed with film perforated to equal accuracy and remaining free from shrinkage. These objections could be minimised by spring-loading one sprocket with respect to its driving cross, but the aim was to gain adequate control over the film without using complicated gates or tensioning devices.

During the early pioneering days many ingenious mechanisms were adopted for use in motion picture cameras—but all these have since been rejected in favour of the claw mechanism.

Claw mechanisms

Figure 2·3 illustrates an early claw mechanism used by the Williamson Company and it is mentioned here for two reasons. Firstly because it was an attempt to obtain something approaching a straight-line motion of the claw tip whilst in engagement with the film. Secondly because it forms a link between early and many present-day intermittents. The main claw lever E was attached to an eccentric pin A, mounted on a rotating disc B. Part of the claw lever was shaped to form a segment of a circle and a curved slot C was cut therein. This slot travelled over a stationary pin D and the combination between the circular motion at A and the curved oscillatory motion at C constrained the claw tip F to travel in the path indicated by G. This path is approaching the shape of the capital letter D which, for many years, was considered to be the ideal path for a claw mechanism. It was argued that the claw should enter the film perforations at the top of the straight back of the D, pull the film down whilst following this stroke, and then retreat outwards and upwards from the perforations in readiness to repeat the cycle.

One of the most important features of an intermittent claw mechanism is to

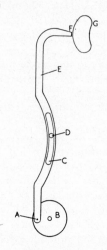

Fig. 2.3. An Early Williamson Intermittent

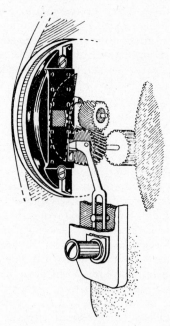

Fig. 2.4. The Auricon-Cinevoice Claw Mechanism

ensure that the claw tip remains stationary with respect to the driven-edge of the film perforation whilst it is engaged with that perforation during the pull-down action. In other words there should be no 'sawing-action' between the claw tip and the perforation. It is extremely difficult to design a claw path to satisfy this requirement but, in more recent times, it has been recognised that the main problem was associated with the desire to maintain the pull-down in a straight-line path. The pull-down can be in a *curved* path (merely by changing the shape of the lower section of the gate channel) providing the upper part of this channel remains straight and in the true focal plane. This modification was introduced by the Mitchell Camera Company and their camera employed a curved claw path in conjunction with a similarly curved gate section—so that no lateral action occurred between the claw tip and the film perforations during pull-down.

The principle of an eccentric pin-and-slot action was modified many years later and used in the modern 16 mm. Auricon Cinevoice camera. The Auricon is used extensively in television work—particularly in news reporting—because it is a versatile *combined* picture and sound recording camera of reasonable size and weight. The Auricon claw and shutter mechanism is shown in Figure 2.4. The eccentric pi is attached to the top of the main claw lever at a point remote from the claw tip and driven in an anti-clockwise circular path. The pin is mounted on the off-side plane face of a helical gear arranged to drive the 173° shutter through a meshing gear to provide an exposure of 1/50th of a second at a film speed of 24 frames per second.

In the lower region of the claw a parallel slot is formed to engage with a stationary pin. This combination constrains the claw and, together with the eccentric pin, creates a sinusoidal movement at the claw tip. This means that the depth of engagement between the claw tip and the film perforation varies during pull-down and, because of this, the lower face of the claw tip must be exceptionally smooth. In practice Auricon claw tips are made of hardened and tempered tool steel with precision lapped surfaces.

A very exhaustive study of intermittent mechanisms carried out by Arthur S. Newman led him to standardise on a *simple link claw* as the basis for the camera produced under the name Newman Sinclair and which, incidentally, is still in use today. The theory behind the Newman claw is seen in his analysis of claw motion shown in Figure 2.5. The basic mechanism consists of a main lever L anchored to an eccentric rotating pin K, mounted on a disc J. At a point O a secondary lever N is attached by a pin-joint and oscillates about a fixed centre M. The claw tip is indicated at P.

This mechanism is very important indeed and the principle is used in several present-day 16 mm. cameras. It has the advantage of simplicity in construction since it is made with pin jointing throughout, and consequently is very silent in operation. Newman considered any mechanism including cams, sliding members or reciprocating parts was unlikely to maintain an accurate path and would certainly increase manufacturing difficulties and costs.

The divided circle S indicates 16 selected points in the rotation of the eccentric

53

pin on disc J. By plotting the path of the claw tip when pin K is in these positions the outline shown at T is produced. Note that the speed at which the claw moves while engaged with the film is indicated by the separation of the vertical lines 6, 5, 4, 3, 2, 1, 16, 15, 14, and 13. This mechanism causes film to move first slowly from rest, accelerate to maximum speed at the centre of pull-down, and then retarding to zero at the end of the stroke. It is important to realise that the claw assists in *retarding* the film motion—this allows the tension in the film gate to be kept to a minimum.

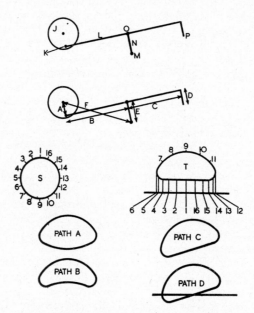

Fig. 2.5. Newman's Analysis of Claw Motion

The claw path may be altered considerably by varying the proportionate dimensions of the three components. The claw stroke is dependent upon the throw of the eccentric, but is not *equal* to this throw because the main claw lever does not remain parallel to the film path. The height to which the claw is lifted away from the film is controlled by the lengths B and C. By decreasing B and increasing C a greater lifting movement will be obtained, and vice versa. Altering the length of link E causes the straight section of the D path either to curve inwards or outwards. Lengthening the link will tend to produce path A, whilst shortening it will produce path B. Increasing the distance between the two fixed centres, that is dimension F, will tilt the right side of the path upwards (as indicated in path C), whilst shortening dimension F will tilt it downwards. The claw path should be so adjusted that the straight back of the D path is at a slight angle to the film plane in order to obtain

maximum advantage from the decelerating claw action towards the end of the stroke.

A still further variation of the simple claw unit is employed in one professional dual-gauge (35 mm. and 16 mm.) camera, and also in many 8 mm. amateur cameras. The principle of this mechanism is to oscillate the main claw lever in a purely vertical manner as shown in Figure 2.6 and not to employ the conventional 'D-shaped' path for the claw tips. This only becomes possible if the claw lever is made in two parts and so that the upper section can be spring-loaded to automatically *fold back* immediately following the pull-down and as the main lever begins to move upwards.

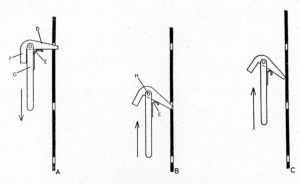

Fig. 2.6. A Spring-Loaded Oscillating Claw

As shown in position A, Figure 2.6, the claw is just about to pull the film downwards in the direction of the arrow. The hinged tip D is spring-loaded at E and a small projection F is provided to engage with the main body of the lever G. This forces the mechanism to act as one solid piece of metal so long as it is travelling downwards and is under the tension of film in the gate. After the downward stroke has been completed the claw begins to move in an upward direction as shown at B. The small nose section will then immediately hinge about point H and so cause the claw tip to disengage from the perforation. This will cause spring E to become compressed and, because the tension in the film gate is made greater than the force of this spring, the film will not move upwards during this part of the cycle. After the claw tip has moved some distance the relationship between it and the film will be as shown in diagram C, Figure 2.6.

In some 8 mm. cameras any tendency for the film to follow the upward movement of the claw is prevented by a fixed spring pawl arranged to fit a perforation just above the claw stroke and only to pass film in one direction. In other cameras a positive-acting pilot pin is used to accurately register the film during the return stroke.

The professional dual-gauge 35/16 mm. camera employing the principle shown in Figure 2.6 is the French Cameflex camera manufactured by Eclair. This camera

55

employs a dual film gate and removable aperture masks so that a single intermittent mechanism carries both the 35 mm. and 16 mm. claw pins. The 16 mm. film path is in the centre of the 35 mm. gate and, when not in use, the 16 mm. claw pins are arranged to 'idle' behind the 35 mm. gate channel. This system can only be used if the conventional film gate is replaced by one of an entirely different design. In the Cameflex the rear half of the gate, plus a considerable gear train and all the film guiding sprockets are accommodated in the film magazine. Whilst this makes for very easy and rapid camera re-loading, it does mean that reserve film magazines are exceptionally costly.

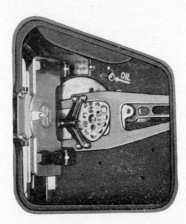

Plate 2.7. The Arriflex 35 mm. Claw Mechanism

Courtesy Rank Precision Industries

The use of this intermittent mechanism in cameras primarily intended for amateurs would cause them serious restrictions. Unlike professional workers, the amateur often relies upon the ability to rewind film in the camera in order to create trick effects. (As explained earlier, all professional effects are usually made by the laboratories and not in the studio cameras.) Clearly, the claw mechanism shown in Figure 2.6 cannot be used if the mechanism is also required to run in reverse. The only solution to this problem is to remove the film from the gate whilst rewinding is in progress. Trick effects employing rewind techniques in the camera can only be created with ease in those cameras having a positive claw mechanism capable of moving film equally well in both directions.

Before leaving intermittent motions created by claws alone and passing to those which employ both claws and pilot pins, it is essential to discuss in some detail the very elegant claw mechanism used in the 35 mm. Arriflex camera designed by Messrs. Arnold & Richter of West Germany. The high degree of picture steadiness obtained with this mechanism mainly depends upon two important factors: firstly a single claw pin is used to engage with perforations only on one side of the film—

such a pin can therefore be *full-fitting* once it is completely seated into the perforation although, of course, it is tapered at its extremity to permit easy entry. Secondly the claw is moved by cams so designed that it will enter the perforation and *dwell*

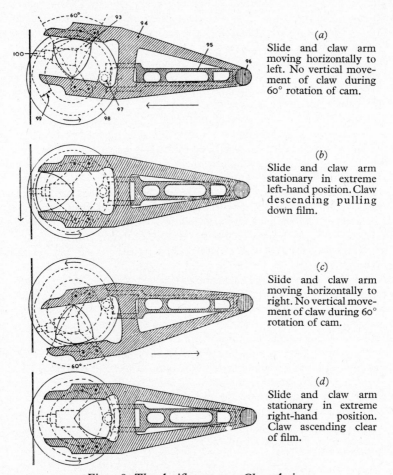

(a) Slide and claw arm moving horizontally to left. No vertical movement of claw during 60° rotation of cam.

(b) Slide and claw arm stationary in extreme left-hand position. Claw descending pulling down film.

(c) Slide and claw arm moving horizontally to right. No vertical movement of claw during 60° rotation of cam.

(d) Slide and claw arm stationary in extreme right-hand position. Claw ascending clear of film.

Fig. 2.8. The Arriflex 35 mm. Claw Action

for approximately 1/150th of a second (at 24 pictures per second) before pull-down commences—similarly, after pull-down is complete, the claw will dwell for a further 1/150th of a second to allow the film to come positively to rest before it withdraws from the perforation. In this manner the claw pin is also acting as a register pin both immediately before and immediately after exposure.

Plate 2.7 shows the horizontal fibre claw lever onto which is riveted a cast-iron

yoke designed to accept a *replaceable* claw pin. Figure 2.8 shows the complete mechanism but with the yoke and claw pin indicated by dotted lines, more clearly to show the all important driving cams. All sections of the mechanism are designated by numbers in the upper diagram (a), Figure 2.8, and thus the claw pin is indicated at 100. The action is obtained from two cams: the Lumiere-Type cam 93 causes the actual pull-down, whilst the grooved cam 99 causes the whole mechanism to move into or away from the film perforations.

The so-called Lumiere cam 93 is almost an equilateral triangle—it is in fact cardioid in shape since each side is an arc centred on the opposite corner of the plate—it is known in the industry as a 'Lumiere Cam' to perpetuate the name of the Lumiere Brothers of France (two early pioneers in the design of cinematograph equipment). Two important points now arise: firstly, this shape will always fit exactly between two parallel faces (or cam-followers) whilst it is continuously rotating and secondly, when so fitted and rotated—assuming the faces of the cam-followers are horizontal—it will cause them to move downwards whilst rotating 120°, then hold them *perfectly stationary* whilst it rotates through a further 60°. It then moves them upwards whilst rotating another 120° and, lastly holds them *stationary* again for a final 60°. Naturally, an exactly similar but horizontal motion could be created by arranging the cam-followers vertically. It is this *dwell* at the top and bottom of the stroke which is the essence of the Arriflex mechanism.

In Figure 2.8 the cam-followers are formed by the parallel jaws of the main fibre lever 94. This lever is pivoted at point 96 and, if no other mechanism existed, the Lumiere cam 93 would cause lever 94 to oscillate vertically about point 96. The remaining mechanism is designed to move point 96 either to the left or to the right and in synchronism with the vertical movement of lever 94. This horizontal movement is created by mounting point 96 on to link 95 (housed in a groove in the main camera body so that it can only move in a purely horizontal manner). Link 95 is fitted with a pin 97 travelling in the grooved recess 99 cut in flange 98. The groove or channel 99 is, in fact, a cam creating horizontal movement in link 95 and therefore at point 96—the anchor pin for claw lever 94. The complete action of the mechanism can be seen by referring to the four diagrams in Figure 2.8, together with the accompanying captions.

Pilot pin registration

Some claw mechanisms are not only designed to move film through the exposing gate, but also to assist in bringing it to rest at the completion of pull-down. Even so, there can be a tendency to 'overshoot' the claw pins due to residual power transferred to the film during the pull-down stroke. In some cameras the two sections of the gate are so arranged that tension on the film is removed during pull-down, and then re-applied as the claw pins retract from the perforations. Such action tends to clamp or register the film in an accurate position immediately before exposure. This technique is used in the 35 mm. Debrie Super Parvo studio camera and is known as an *intermittent pressure plate*.

58

Other cameras are designed always to keep the gate tension to a minimum and to rely on a secondary mechanism to accurately register the film. Such a mechanism usually takes the form of one or a pair of pilot pins arranged to enter the film perforations immediately before exposure, to remain in engagement securely holding the film in position during the entire exposure, and then to dis-engage from the

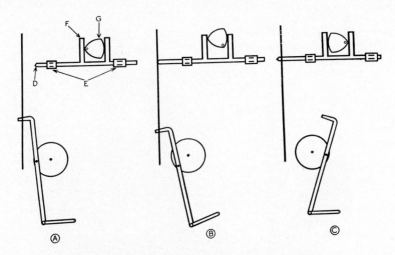

Fig. 2.9. The Principle of Pilot-Pin Registration

perforations as the claw pins re-enter immediately prior to pull-down. Pilot pins are sometimes known as register pins, and the system as *pilot pin registration*.

The basic principle of pilot pin registration is seen in Figure 2.9. In diagram A the claw is mid-way between the start and end of the pull-down stroke and film is moving through the gate at maximum velocity.

The pilot pins D, seen generally as a horizontal mechanism above the link-claw, are therefore drawn away from the film. These pins are attached to a shaft free to move horizontally within fixed bearings E. The central portion of this shaft carries a cam-follower F which is machined to fit the cardioid or Lumiere-type cam G. This cam is designed to cause pilot pins D first to disengage from the film perforations and move to the right, then to remain motionless for the duration of pull-down. The pilot pins then travel to the left, enter the film perforations and remain motionless for the period of exposure. This movement is synchronised with the motion of the claw pins so that the pilots only enter the film perforations when the claw pins are moving out of engagement or, after the exposure has been made, re-treat from the film once more as the claw pins re-enter at the top of their pull-down stroke.

Three stages in the combined cycle are seen in Figure 2.9; that at A shows the film engaged by the claw pins as described previously; that at B indicates the moment

of change-over when pull-down has been completed and the claw pins are moving out of engagement whilst, at the same time, the pilot pins are taking control of the film to hold it accurately in register with the aperture. Diagram C indicates the condition during exposure and shows the pilot pins in full control of film registration and the claw tips returning to the top of their stroke in readiness for the next cycle.

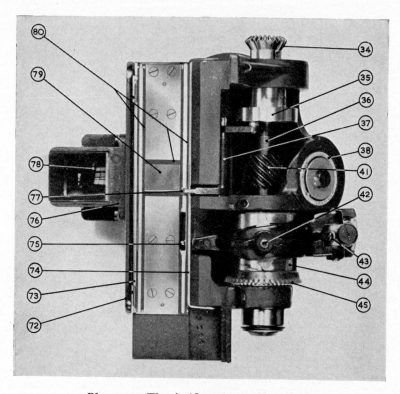

Plate 2.10. The Arriflex 16 mm. Claw Action

Courtesy British Broadcasting Corporation

The foregoing explanation merely indicates the *principle* which, of course, is capable of many variations in practice. One very unusual embodiment of pilot pin registration is found in the 16 mm. Arriflex camera as shown in Plate 2.10. Incidentally, it would be interesting to know why the 16 mm. version of the Arriflex is fitted with a pilot pin when the 35 mm. version is not—it may well be that other design features such as compactness, etc., brought about this change.

In Plate 2.10 the claw pin is indicated at 75 and is seen to enter the film from behind the fixed gate channel. The pilot pin is shown at 77 and is arranged to enter

the film from the opposite side. In practice this means that the claw enters the film from the *emulsion* side whilst the pilot pin enters from the *base* side. It is important to note that, although the claw engages the perforation which is situated one frame below the aperture, the pilot pin engages the actual perforation at the base of the aperture.

The entire intermittent mechanism is arranged on a single shaft 36, mounted vertically in ballraces. It is driven by bevel gear 45 engaging with a similar gear on the motor shaft. Helical gear 41 transmits drive to the camera shutter, and bevel gear 34 drives a camera speed indicator.

Pull-down claw 75 is formed at one end of a very stout arm supported by a universal joint 43 at the opposite end. Thus both vertical and horizontal motion can occur. This arm is enlarged over its central region to form an annulus or ring surrounding a double cam 44. This cam is formed with a groove to accommodate roller pins 42 which are fixed in the claw lever. The groove is shaped to create the vertical claw movement whilst, because the cam is not perfectly cylindrical and is also mounted eccentrically on shaft 36, a horizontal movement is also created. The combined action of the double cam causes the claw tip to follow a substantially vertical rectangular path.

Pilot pin 77 is formed at the base of a tube 37 which is supported by a pillar attached to the main casting. The arm formed at the top of tube 37 carries a guide roller to engage with the pilot-operating grooved cam cut in the underface of disc 35. This groove causes tube 37 to rotate slightly on its supporting pillar, and so cause the pilot pin to enter or withdraw from the film perforations. Naturally, the pilot-operating cam and the double-claw cam are so phased with each other that the principle of pilot-to-claw action outlined in Figure 2.9 is preserved.

One cannot help feeling that the 16 mm. Arriflex intermittent mechanism is the very antithesis of the design preferred by Arthur S. Newman!

The Bell & Howell shuttle mechanism

The success of any pilot pin system and its ability to control the position of film during exposure usually depends upon the accuracy of sliding shafts, stationary bearings and any cams or followers used to create the pilot pin motion. One novel design intended to minimise these variables is the Bell & Howell Shuttle Gate which, although used in printing machines and not in camera equipment must be mentioned in any review of intermittent mechanisms.

It is unusual because the pilot pins remain stationary throughout the entire pull-down cycle whilst the *gate* and the film therein oscillate bodily in a horizontal direction—so placing the film alternately in engagement with the fixed pilot pins or the claw pins. Figure 2.11 shows the action of this unit. The main Plate F supports pilot pins 1 and 3 located respectively above and below the exposing aperture. These pins are rigidly fixed to the main plate and do not move. Two claw pins are provided in the 35 mm. mechanism—one behind the other as indicated at 2 in the figure. The claw pins oscillate in a purely vertical direction as indicated in positions

B and D. It is essential to understand that the nose of the pilot pins over-laps the nose of the claw pins—as seen most clearly at D— and that the film is always under control either by one or both sets of pins. Because of this tension in the gate-channel is not necessary until the moment it closes completely onto the pilot pins.

As shown at A, Figure 2.11, the film gate has just moved to the left and the film is located on the pilot pins. The gate continues to move to the left until the back-plate comes into contact with shoulders on the aperture plate, as shown at B. This action clamps the film rigidly in the gate channel. By this time the claw pins have

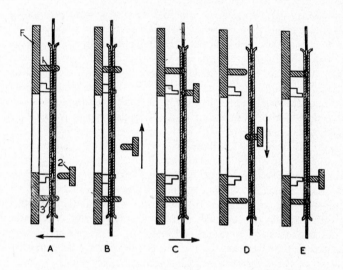

Fig. 2.11. The Bell & Howell Shuttle-Gate Intermittent

started to move vertically upwards and, during this part of the cycle, the film is being exposed. The claw pins complete their upward movement, exposure is terminated and the gate moves to the right as shown at C—thus transferring the film from the pilot pins onto the claw pins. The claw pins now move downwards as seen at D and advance the film by one frame. The gate then moves to the left as seen at E and transfers the film from the claw pins back onto the pilot pins. The cycle is then repeated.

In the 16 mm. version of this mechanism the pilot pins are separated by a distance equal to five 'pitches', as the interval between perforations is termed. Due to such control over a considerable length of film, and also the accuracy with which the pins are manufactured, conventional edge-guiding in the film gate is not neces-sary. The film remains freely suspended on the pilot or claw pins except when the gate is closed during exposure and the film comes under pressure from the aperture plate.

The Mitchell and Newall mechanisms

It is logical to conclude this analysis of conventional intermittents with a description of the pilot pin and claw system used in the American Mitchell and British Newall mechanisms—undoubtedly the doyens of professional cinematograph

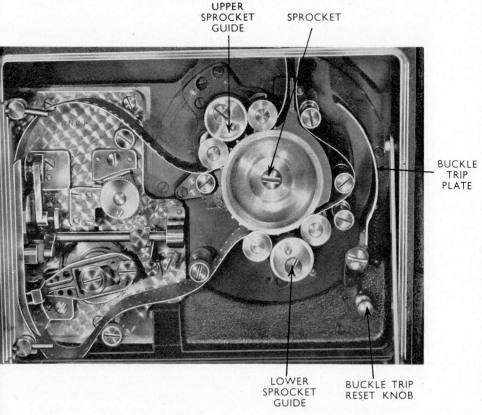

Plate 2.12. The Newall Camera Intermittent Mechanism

Courtesy Rank Precision Industries

cameras for many years. In both cases the principle is to employ a pair of horizontally acting pilot pins immediately below the exposing gate and in combination with a double pull-down claw engaging four perforations—two on either side of the film.

The layout of the Newall mechanism is shown in Plate 2.12. The pilot pins are ground, lapped and polished to within 0·00005 in. (0·00127 mm.) and the pin adjacent to the sound-track side of the film only fits the perforation in the vertical

direction whilst the pin on the opposite side fully fits the perforation in both directions. This arrangement is designed to accommodate any transverse film shrinkage within I.S.O. tolerances.

The dimensions of the double pull-down claws are held within 0·0001 in. (0·00254 mm.) and variations in their stroke must not exceed 0·0005 in. (0·0128 mm.). With such refined tolerances it is not surprising that any relevant movement between the claw pins and the film perforations during pull-down has been eliminated.

For many years designers strived to achieve the traditional D-shaped pulldown; the Mitchell and Newall cameras overcome this difficulty quite simply by curving the lower section of the film gate over the region of pull-down, and to a radius taken from the pivoting point of the claw mechanism. Since the claw path and film channel are curved to corresponding radii the pull-down becomes *effectively* straight.

A further important point is that the claw pins engage perforations one picture length ahead of the pilot pins. Since 35 mm. film is perforated by punches which make four holes along the film length in each operation, and because this amount is also equivalent to one picture length, any effects of uniformity and similar perforating errors are reduced to a minimum.

Standard and short pitch perforations

For many years the internationally agreed 35 mm. film pitch—or distance between one perforation and the next—has always been 0·1870 in. (4·750 mm.). This standard was originally set when all motion picture films were manufactured on a nitrate support or base. With the introduction of triacetate and polyester as base materials it became apparent that the great improvement in dimensional stability offered by these new bases could, in fact, become a disadvantage in some stages of film production. This is particularly true when printing on many of the long-established machines used throughout the industry. Whilst this problem could be overcome by modifying printing machines, such a solution would involve an enormous amount of money because there are thousands of printing machines in use throughout the world.

To fully understand the problem it must be remembered that film dimensions change considerably both during and after processing. As would be expected, film pitch becomes slightly longer whilst the material is actually passing through the processing solutions, and then shrinks to something *less* than its original dimensions during the subsequent drying operation.

When these changes in perforation pitch occur in camera negative films they can become very significant. Motion picture printing (to make positive copies for projection) is frequently done on equipment in which the processed (and shrunk) negative is passed in contact with the new (unprocessed and therefore unshrunk) positive stock in intimate contact around a continuously rotating printing drum. At this point it is essential that slippage cannot occur between the two films—and the dimensions of the printing drum and its associate equipment were carefully

chosen especially to accommodate the processing shrinkage known to occur in nitrate-based negative films.

The average negative shrinkage due to processing can be calculated and was allowed for in establishing 0·1870 in. (4·750 mm.) as the standard 35 mm. negative pitch for nitrate-based film. However, with the introduction of triacetate and polyester film bases the shrinkage due to processing became considerably less.

The most popular continuous printing machine of the type referred to above is manufactured by the Bell & Howell Company and the printing drum in this apparatus was designed to accommodate processed negatives which are approximately 0·3 per cent shorter in pitch than the unprocessed positive films with which they are brought into contact. A simple remedy to this problem was to perforate triacetate and polyester based films to a pitch dimension slightly shorter than the standard used for nitrate based products and so that, after processing, all types of bases would shrink to approximately *equal* final dimensions.

The differences in pitch which are being considered are of the order of 0·0004 in. (0·009 mm.) and, therefore, they become significant not only in the printing operation but also in the design of camera intermittent mechanisms—particularly those which are built to the accuracy of the Mitchell and Newall equipment previously described.

At the present time it has not been possible to modify all film cameras and printing machines to favour the so-called 'short-pitch' film and, indeed, this would be unwise whilst so much film perforated to the standard dimensions remains in libraries and studio vaults and may be re-printed many times in the future.

Because of this film stock manufacturers currently offer 35 mm. negative stock perforated either to the original standard pitch of 0·1870 in. (4·750 mm.) or to the so-called 'short-pitch' of 0·1866 in. (4·740 mm.). Parallel to this the Mitchell camera company have recognised that, to achieve the very highest standard of screen picture steadiness, the cameraman should ideally select either standard or short-pitch negative according to the printing equipment used in the laboratory employed at the time. This in turn has led to a refined Mitchell camera intermittent mechanism known as the 'Vari-Stroke Movement'. As its name implies the pull-down stroke of the claw can be adjusted to precisely mate either with film perforated to the standard or to the short-pitch dimensions. There is always a very small difference between the absolute pitch of any one batch of film and that of the next—even when both are perforated to the same basic dimensions. The Mitchell Vari-Stroke Movement can be adjusted to compensate for all such variations. It is important to realise that such adjustment is always worth while because it ensures the camera noise—or more precisely the 'film noise'—is reduced to a minimum.

The Marconi fast-pull-down mechanism

This mechanism is used in a special 16 mm. camera designed for the television industry. Film is employed for two main purposes in television: either as ready-

3

made motion pictures (which may have been photographed essentially for television or may be existing cinema-industry material), or it is used to *record* the picture displayed by a cathode-ray tube. The transmission of existing motion pictures originates from a *telecine* projector whereas, the recording of television images takes place in a *telerecording* camera. The purpose of telerecording a programme on to film is so that it may afterwards be transmitted via a telecine projector at any convenient time and may virtually constitute a 'repeat performance'.

For many reasons it is not possible merely to place a cinematograph camera in front of a television display tube and expect to record a high quality image. It is not our purpose to describe television systems in detail but, to appreciate the Marconi camera mechanism, a certain apparent digression is essential at this point.

The image displayed by a television receiver is formed by a single spot tracing out a series of horizontal lines across the face of the cathode-ray tube. The spot is an electron beam which causes the fluorescent inner coating on the tube face to glow in proportion to the energy of the beam. Different fluorescent tube coatings result in images which remain reasonably distinct for different periods—the *decay time* of an image is very important in telerecording and tubes are selected for long or short *afterglow* periods.

Although the older British monochrome television system employs 405 horizontal lines, for various reasons connected with synchronising pulses, etc., only 377 lines are displayed to the viewer. It is not possible for a single spot to trace this pattern in numerical order at current picture frequencies and, at the same time, to provide a flicker-free picture without fading. Because of this the spot first traces out all the odd-numbered lines (1, 3, 5, 7, 9, etc.) in the pattern and then quickly *flies back* to fill in the picture by tracing out the even-numbered lines (2, 4, 6, 8, etc). The first pattern is conventionally known as *the lace* and the second pattern as *the interlace*, whilst each pattern is known as a *field*. Both the lace plus the interlace must be completely traced within 1/25th of a second. Thus we can see that this particular television system consists of 25 pictures or 50 fields per second. Unlike conventional motion picture work, the television image is not interrupted by relatively long periods of darkness—the only interruption in display is the time taken by the electron beam to fly-back from the bottom right-hand corner to the top left-hand corner of the tube.

The television display or pattern may be photographed on to film by a conventional camera mechanism in two ways: the first method is to record either the lace *or* the interlace but not both, and the time taken to move the film forward in the camera may then be as long as 1/50th of a second—the time required to display one television field. This system is known as *suppressed field* telerecording and, as would be expected, does not yield pictures of the highest quality or maximum resolution. The second method of telerecording requires a special film camera having an intermittent mechanism which moves film forward in the very short period of time taken for the spot to fly back from the end of one field to the beginning of the next. This system is known as *full-information* telerecording and, to be effective so far as British 405-line images are concerned, requires a camera pull-

down mechanism which operates within 1·33 milli-seconds, that is 1/750th of a second. Of equal importance, such an intermittent must then *dwell* or leave the film stationary and exposed to the image for the remainder of the cycle. These requirements have been achieved in the Marconi camera with an extremely ingenious mechanism invented by Mr. Arthur Kingston. Since developing the prototype equipment subsequent production models have also been made by Rank Precision Industries (Great Britain) Limited.

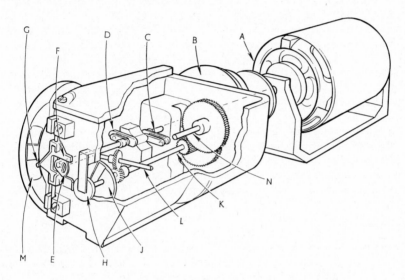

Fig. 2.13. The Marconi Fast-Pull-Down Mechanism

The purpose of the mechanism is to create a claw pin cycle such that the speed at which the driving member rotates is intentionally non-uniform. This is because, during pull-down the claw must move exceptionally fast and yet, during exposure it must move very much slower. This requirement can be satisfied by driving a spindle very rapidly during a small part of each revolution and considerably slower during the remainder of the same revolution.

Differential rotation can be achieved in the following manner: imagine two spindles, each fitted with a plain flange at one end and mounted in line so that the flanges face each other. A pin mounted eccentrically on one flange is arranged to engage a slot cut across the diameter of the other flange. If one spindle is rotated the other will rotate at equal speed and such a device is a form of dog-clutch. However, one spindle is now moved horizontally so that, although still parallel to the other, it is no longer in line with it. The rotation of the *driven* spindle will now be irregular although the *driver* is rotating at constant speed. If the pin flange is the driver the slotted flange will rotate faster when the pin approaches the centre of the

67

slot, and will slow down as the pin moves towards one end of that slot. This principle is used in the Marconi fast-pull-down mechanism shown in Figure 2.13.

A three-stage accelerator creates the fast-pull-down action. The claw pin G, mounted on a shuttle F, is driven by a 96° cam E. The polarised synchronous motor A drives cam E through two link-mechanisms C and D. Cam E rotates at twice the film speed of 25 frames per second and, therefore, claw G must make one *idling stroke* without engaging the film perforations. By this means the effective pull-down angle is reduced to 48°. The claw is moved into or away from the film perforations once per frame by the cam wheel H driven by cam J.

The links C and D are based upon the principle of differential rotation described above and, in fact, are two similar units driving in cascade. Each unit increases the pull-down acceleration by 2 : 1 and, since the claw idling-stroke effectively reduces the 96° cam to only 48°, the total reduction produces an effective pull-down angle of only 12° in the complete cycle. At a speed of 25 pictures per second this is equivalent to an actual time of 1·33 milli-seconds—exactly the fly-back time in British 405 line television.

It is well appreciated that television systems exist which operate at different line and picture frequencies and that, for such systems, the present mechanism would require modification. The intention has not been to survey telerecording equipment in general, but only to illustrate one particular and very elegant inter-mittent mechanism used for telerecording purposes.

The camera shutter

Photographic exposure is defined as $E = I \times T$ or in simple words 'Exposure is the product of the Intensity of the light multiplied by the Time it is acting upon the film emulsion'.

Changes in the degree of exposure given in a motion picture camera can there-fore be made by adjusting the lens aperture (thus changing the *Intensity* of the light) or—in most cases—also by adjusting the shutter opening (thus changing the *Time* of the exposure).

From the artistic point of view, a cameraman may prefer one or the other method depending on the degree of depth-of-focus he wishes to employ. Shutter adjust-ment may be possible whilst the camera is running or may need to be made when the mechanism stationary. Whilst the average maximum shutter opening is 175°, this varies considerably from one camera to another. Factors controlling the choice of a given maximum opening are usually governed by the design of the intermittent mechanism. However, with some wide-screen techniques using relatively low-efficiency lenses, it is sometimes obligatory to employ a rapid pull-down mechanism in combination with a wide-aperture shutter to compensate for low light trans-mission through the lens system.

Factors such as these explain the use of a shutter having a maximum opening of 215° on the 65 mm. Panavision studio camera, and one having a maximum opening of 195° on the 35 mm. VistaVision camera. All other 35 mm. cameras have

shutters giving maximum openings of between 170 and 180°. The maximum opening of 16 mm. camera shutters also varies: the Bolex cameras having a maximum of only 143° whilst the Mitchell and the Maurer extend to 235°.

Shutter 'cut-off' efficiency

The efficiency of the basic *segment-disc* shutter is illustrated in Figure 2.14. When speaking of efficiency in relationship to a camera shutter we refer to the time taken either to completely open or completely close the camera aperture. Obviously, the change-over period when the aperture is neither completely open or closed must be regarded as lost time. A shutter which completes this change-over quickly is said to have a high efficiency.

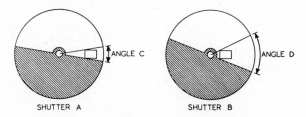

Fig. 2.14. Shutter 'Cut-Off' Efficiency

In Figure 2.14 shutters A and B are both of equal size but, in the first case the centre of shutter A has been placed at the maximum possible distance from the exposing aperture—the shutter need therefore only rotate through angle C in order to completely cover the aperture. In the second case, the centre of shutter B has been placed close to the exposing aperture and, consequently, the blade must rotate through the much greater angle D in order to completely cover the aperture. The most efficient shutter will therefore be that of the greatest acceptable diameter which can be accommodated in the camera body, and will be mounted with its centre of rotation as far as possible from the gate aperture.

Variable aperture shutters

The normal opening in a rotary shutter is approximately 175°, or just under half the circumference. Quite obviously, any alteration from the selected opening would change the exposure given to the film. The ability to control exposure by this means is a decided advantage for two main reasons. Firstly because a lens working at high aperture, and critically focused upon some foreground object, will not 'resolve' clearly the objects at a greater distance. This is known as a lack of *depth of focus* or *depth of field*. Such an exposure results in a sharply focused object of interest, plus a background which is often so badly out of focus that it appears as circles of light

69

festooned across the scene. The effect is not necessarily objectionable in black-and-white pictures and, in fact, is often considered to improve pictures by throwing the centre of interest into relief and 'removing' all definitions from the unimportant background.

Whether this effect really is good cinematic art will never be decided but, it is quite certain, a similar result produced on *colour* film is definitely objectionable. Unfortunately, all the colours in the background form into bright circles rather like balloons and over-lap at the rim to produce further colours to add to the confusion!

The only cure for this effect is to close the lens diaphragm and thus increase the depth of field of the optical system. Increasing the shutter opening will then compensate for this otherwise reduction in exposure—but this can only be carried to a certain limit beyond which the shutter fails to provide a 'closed' period long enough for the film pull-down to operate. However, if the set-lighting is arranged to give an adequate negative when the shutter opening is only some $140°$ and the lens aperture is high, it might then be possible to reduce the aperture (thereby increasing the depth of field) and to compensate for the reduction in exposure by adjusting the shutter to the full $175°$ opening.

The second main advantage provided by a variable aperture shutter relates to 'special effects'. The well-known *fade-out*, during which the scene progressively darkens until it is eventually opaque, may be produced by merely closing the lens diaphragm but—as explained previously—this would cause the depth of field to progressively increase. An alternative method, which does not change the depth of field, is to gradually close a variable aperture shutter whilst the camera is running and until all light is prevented from reaching the film. Taking this one stage further we can produce the *lap-dissolve* transition. A lap-dissolve is really the fade-out of one scene superimposed on the fade-in of a second scene.

Lap-dissolves are produced in the camera by gradually closing the variable aperture shutter at the end of the first scene, stopping the mechanism when the shutter is completely closed, covering the lens whilst re-winding that amount of film used to complete the fade-out and then, after lining up the camera onto a second scene, starting the mechanism again and gradually opening the shutter vanes. Both the fade-out and the lap-dissolve are usually produced on the optical printing machine, but this outline of some of the possibilities of the variable aperture shutter will indicate its general application in the studio camera.

Many designs can provide the movement of one blade relative to another and whilst both are rotating at high speed but one example, shown in Figure 2.15, is sufficient to illustrate the principle involved. Shaft J is positively geared to the camera mechanism and makes one revolution each time the film moves forward one frame, it is therefore geared 'one-to-one' with the intermittent claw. The main shutter blade is rigidly mounted on this shaft as shown at S and together with the gear wheel A. Freely mounted on Shaft J is a second gear B, exactly equal in size and tooth pitch to gear A but, attached to *this* free-running wheel, is the auxiliary shutter blade T which must rotate with respect to the main blade S. Both gear B

and shutter T are free to rotate on shaft J and only use this shaft as a supporting bearing.

Referring to 'position 1' Figure 2.15, gear A is seen at the top of the diagram. Gear B is directly behind A and, since both gears are of equal size, gear B cannot be seen in the figure. The shafts supporting gears A and C rotate about fixed centres. Gear A meshes with gear C; gear C meshes with D; gear D meshes with E and, finally, gear E meshes with B—that is, the gear *behind* gear A. It is important to

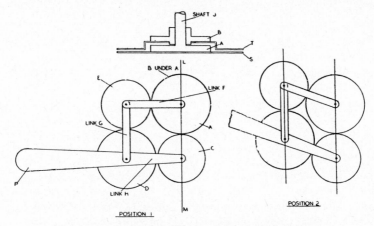

Fig. 2.15. A Variable Aperture Shutter Mechanism

realise that E does *not* mesh with gear A. Gears D and E are mounted on bearings in the link system F, G and H. These links, together with line L–M, passing through the centre of A and C, form a parallelogram which may be adjusted by the control lever F. The mechanism is seen again at 'position 2' after lever P has been raised to the upper limit.

To fully understand the mechanism it may help to assume that gear A is stationary, now since gear C is mounted on a fixed centre and is in mesh with A, it must also remain stationary. If lever P is then moved from position 1 to position 2, gear D *must* rotate about gear C. This rotation will be transmitted to gear E and, through E, to gear B. Thus, moving lever P causes gear B to rotate with respect to gear A and, obviously, this operation may be carried out with equal success when the camera is running.

Mirror shutters

All cameras must be equipped with accurate means of sighting the instrument visually to precisely select the field of view to be recorded on the film. In general such devices are known as *view-finders*. When the optical system of the view-finder is completely independent from the objective or taking lens, corrections must be

made to prevent this separation causing *parallax* errors. These errors can be completely overcome, but usually only by making the adjustment of the view-finder tedious or the mechanical coupling to the objective lens costly. The field of view displayed by such view-finders must be adjustable to match each objective lens provided with the camera, and also to compensate for changes in the distance between any objective lens and the subject. Naturally, parallax errors due to the separation between the view-finder and the objective lens will be negligible when focused at infinity, but will become increasingly apparent as the focal distance is reduced.

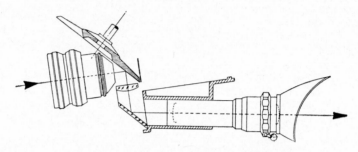

Fig. 2.16. Principle of the Mirror Shutter

View-finding problems become more acute when images must be precisely framed within the picture boundaries and, therefore, the acceptable degree of precision varies according to the purpose for which the camera is used. Cameras may be arranged so that the view-finder can be *racked-over* to sight directly through the objective lens (as in some versions of the Mitchell and Newall cameras), or a system of gears or links may provide automatic compensation whilst the objective lens is being focused.

All these complications are overcome when a *mirror shutter* is fitted to the camera because the view-finder remains in constant use during the actual filming and, of greater importance, the view-finder image is created by the objective lens itself—thus completely eliminating all parallax errors. As shown in Figure 2.16, mirror shutters must be mounted at 45° to the lens axis and film plane. The reflecting surface may be an optical glass mirror or highly polished stainless steel.

In this plan diagram the opaque section of the shutter (the shaded area) supports the mirror and is shown preventing film exposure during the pull-down action. At this time light passing through the objective lens is reflected through 90° by the mirror shutter and imaged by a field lens on to the ground-glass screen in the view-finder tube. From here it is viewed through a focusing eye-piece which may be locked in any selected position. Spring-loaded shutter vanes are usually provided to close the eye-piece when it is not in use—this prevents stray light in the reverse direction possibly fogging the film.

The scene may be viewed all the time it is being photographed but, of course, it will be seen as a flickering image interrupted 24 times per second by the shutter.

This condition can be improved by including a narrow black segment across the centre of the mirror surface—thus raising the flicker frequency to 48 per second.

Because the scene is viewed through and may be focused by adjusting the actual *taking* lens, it is essential that initial viewing and focusing is carried out with the lens at full aperture. If this is not remembered it may happen that a scene appears sharply focused because the use of a small aperture (necessary for the actual exposure) has increased the depth of focus to the system.

Zoom lenses

The so-called 'zoom lens' is one which enables the cameraman to reproduce the effect of a *tracking shot*, without actually moving the camera forward or backwards. A tracking shot is one by which the audience experience the sensation of smoothly moving towards or away from a scene as if they were viewing it from a moving platform. Without a zoom lens this effect is produced in the studio by laying metal tracks (somewhat similar to railways lines) along which the camera is driven and whilst an asistant 'pulls focus' as the camera moves towards or away from the subject.

A zoom lens can also be used in the static condition at any pre-selected focal length. It therefore also provides the cameraman with the equivalent of virtually an infinite choice of focal length lenses within a wide range and in a single lens system. Because of this some cameras are no longer provided with a turret in which to accommodate a selection of fixed focal length lenses. Although it is true that zoom lenses rarely approach the image resolution which can be achieved with equivalent fixed focal length lenses, they have become increasingly popular and are now used with greater frequency in feature film production—and are very widely used in filming for television. Variable-focal-length lenses (zoom lenses) have been in use since 1932—when Taylor & Hobson in co-operation with Bell & Howell introduced the Bell & Howell Cooke Varo lens. This was capable of infinite variation in focal length from 40 up to 120 mm. At that time the three elements of the lens (which must be moved relative to each other in order to create the zoom effect by changing the focal length) were each moved independently and, initially, this resulted in a very complex piece of apparatus. Some years later Dr. F. G. Back introduced the 'Zoomar' lens—in which all the elements were automatically moved relative to each other and by the operation of a single movable barrel. More recently Piere Angenieux of France has introduced a wide variety of extremely successful and high quality zoom lenses which can be operated either by a single lever or by an auxiliary electrical motor.

The very advanced Mitchell BNCR 35 mm. camera (the initials indicating it is a Blimped Noiseless Camera with a Reflex shutter) has a built-in zoom-drive motor which is energised by a remote hand control containing a rheostat so that the *speed* of zooming can be adjusted. This camera accommodates an Angenieux zoom lens capable of infinite variation in focal length within the range 25 up to 250 mm.

Naturally, it is virtually essential for any professional camera to be fitted with

73

a mirror shutter if a zoom lens is to be used to its best advantage. Mirror shutters of the type generally indicated in Figure 2.16 are fitted to both the 35 mm. and 16 mm. Arriflex cameras, the 35/16 mm. Cameflex, the 35 mm. Debrie Super Parvo Model V Reflex, and the 35 mm. Mitchell Type R-35 Reflex cameras as well as the Mitchell BNCR previously mentioned.

Electronic view finders

It is well known that the production control team in any television station can enjoy the use of any number of 'monitor screens' placed at remote points from the production area and so that many people may see precisely the image which is being obtained by the television camera.

It is therefore not unnatural for feature film directors and their associated technicians in film studios also to want to see precisely what the cameraman is filming at the moment he is operating the camera. Parallel to this it is obviously less fatiguing for the camera operator to view a relatively large television-type monitor screen rather than to continuously employ the conventional optical view finder attached to the camera. Whether it is wholly good for many people to view (and therefore to have the opportunity to criticise!) exactly what is being filmed is debatable—and some cameramen have decidedly adverse views on this topic.

However, there is no doubt that, when intelligently used, electronic viewing systems can dramatically accelerate film production and, therefore, greatly contribute to economy. One well-known system, known as 'Electronicam' was developed by Arnold & Richter in West Germany and can be incorporated with the Arriflex range of cameras. This system employs an extremely compact Vidicon (television-type) camera which is built into and virtually 'looking through' the reflex optics of the camera. The Mitchell type S35R employs a similar solid-state Vidicon tube and both systems provide continuous 'TV viewing' as an aid to the cameraman.

It is then not a great step to link the TV-type pictures obtained from several motion picture cameras and to 'edit-while-running' the pictures secured from cameras placed at various points around the film studio.

Camera apertures and image dimensions

For some time now spectacular feature films have been produced in so-called *wide-screen* formats, and such names as Cinemascope, VistaVision, Panavision and Todd-AO, have become well-known—far more than when wide-screen pictures were first introduced in 1899! (see Chapter 1, 'Standard Dimensions'). Whilst the interesting words used to describe these processes are known to all, the actual picture dimensions and methods of presentation are rarely explained. Since most wide-screen techniques involve changes in camera apertures, in boundary lines etched on view-finders or the use of special lenses, it is essential to mention these systems in this chapter.

The term *wide-screen* is misleading because this is only true of some processes.

It is more correct to collectively describe these techniques as *large-screen presentations* of—as yet—non-standard formats. It is also important to understand that these systems offer the viewer a greater range of subject matter from which he must select at any given instant—because he cannot possibly observe both the extreme left and right edges of a wide screen at the same time! In this respect large-screen presentations involve audience participation to a far greater degree than otherwise.

A little consideration will show that they can only be wholly justified when the audience is required to follow important action across the screen and against a *static* background (or when stereophonic *sounds* persuade the audience to change its view-point) because, in all other situations, equal pictorial information can be conveyed within the standard picture format. It is for these reasons that stories photographed in 'wide-screen' usually involve many complicated exterior shots, spectacular historical sagas, etc.

There are three basic techniques involved in wide-screen cinematography, and these have been combined in various ways to produce the six most popular systems in use today. Before describing these it is essential to define two terms. The first is an *anamorphic lens*, and this refers to a lens which produces a distorted but perfectly sharp image. It is used in wide-screen photography to compress the width of a semi-panoramic view into a relatively smaller image than could otherwise be obtained and to do this without compressing the image height. An example of this effect is the photography of a circle by an anamorphic lens—the resultant image would be an ellipse with its major axis in a vertical direction.

The second term is to *squeeze, non-squeeze* and *un-squeeze*. These are all used to describe the effect upon an image caused by certain optical devices. An anamorphic camera lens is said to *squeeze* the image on to a smaller width of film; to produce the correct shape on projection a similar lens operating in reverse must *un-squeeze* the film image. Non-squeeze wide-screen work is to produce the required picture ratio by methods other than those involving anamorphic lenses.

The six popular wide-screen methods can now be described as follows:

Method No. 1. This is certainly the easiest and cheapest system to use—but one which tends more readily to reveal the grain structure of photographic emulsions. A perfectly standard 35 mm. camera fitted with normal lenses is used, but the height of the image is restricted. A normal camera aperture is 0·866 in. (22.00 mm.) wide and 0·629 in. (16·00 mm.) high and, when used to produce a wide-screen effect, the ground-glass in the view-finder is etched with horizontal lines indicating the boundary beyond which the image must not extend if it is to appear in the final result. The image in the camera gate will, of course, extend beyond these etched lines and, therefore, so will the image on the film. However, when a positive copy is made a mask is fitted in the printing machine aperture to cut off the unwanted upper and lower areas of the negative and only to print that area originally seen between the limiting lines etched on the camera view-finder.

Thus a somewhat smaller than usual image results on the positive film, but it will be in a wide-screen ratio of height-to-width. In order to fill the large screens

associated with this general technique, such an image must be magnified considerably more than is usual—hence the original observation concerning image grain when using this system.

Unfortunately, some wide-screen techniques seem to have learned but little from the early non-standard days of cinematography or from the principles of C. Francis Jenkins—because prints from the negative just described may be called for to satisfy any of *four* aspect ratios, namely: 1·33 : 1, 1·66 : 1, 1·75 : 1 or 1·85 : 1 and, naturally, these can only be produced by inserting the appropriate mask in the printing machine. Of even more importance is the use of a correspondingly etched 'safe-boundary' rectangle on the camera view-finder!

Method No. 2. This technique produces the well-known CinemaScope format. It uses a conventional 35 mm. camera employing a standard four-perforation pulldown mechanism—the only difference being a special 2 : 1 anamorphic lens attachment which horizontally squeezes the image produced on the film. The camera requires a picture-aperture 0·866 in. (22·00 mm.) in width and 0·735 in. (18·67 mm.) in height and, to provide safe tolerances, the ground-glass in the view-finder is etched with a rectangle measuring 0·839 in. (21·31 mm.) by 0·715 in. (18·16 mm.). The camera aperture itself is, in fact, in the ratio of 1·175 : 1 but, when this is multiplied by the squeeze-ratio of 2 : 1 as will occur on projection, a final screen image is produced having an aspect ratio of 2·35 : 1.

The above two systems are ones in which a standard 35 mm. camera may be used; in all the others to be described below non-standard equipment is employed.

Method No. 3. This technique results in the so-called VistaVision process and, quite simply, obtains a large wide-screen picture by turning 35 mm. film horizontally on its side and photographing the height of a scene *across* the film instead of conventionally parallel to the film edge. In this process the length of film normally occupied by *two* standard-format pictures is used to record a single VistaVision image. The full width of film between the perforations is used for the picture image, and on projection, the sound is reproduced from a separate film. The actual camera aperture is 1·483 in. (37·72 mm.) by 0·991 in. (25·17 mm.) and, of course, both the camera and projector mechanisms are operating 'on their side'.

It is possible for VistaVision negatives to be reduction-printed on to standard 35 mm. film with integral sound tracks. Such prints may then be handled on conventional projectors in cinemas which may not be equipped with special VistaVision machines. Although the VistaVision technique is relatively simple and straightforward in principle, it involves considerable expense in equipping cinemas and has consequently failed to become universally accepted.

Method No. 4. This technique produces the so-called Technirama format and, like the VistaVision process, employs a camera operating 'on its side' to give a picture arranged on the film at right angles to the conventional position. Two important differences now occur: firstly the camera aperture is even greater than VistaVision and, in fact, is 1·496 in. (38·0 mm.) by 0·992 in. (25·20 mm.) and,

secondly, a 1·5 : 1 optical squeeze via an anamorphic lens attachment is also employed. This system ultimately results in a screen picture having an aspect ratio of 1·85 : 1. It can be used in conjunction with 70 mm. release print film on which the picture is printed in the conventional position with its major axis at right-angles to the film edge. The projector aperture used in conjunction with such a 70 mm. print is 1·913 in. (48·59 mm.) by 0·868 in. (22·05 mm.). Incidentally, the ground-glass in the Technirama camera view-finder is 1·302 in. (33·07 mm.) by 0·837 in. (21·26 mm.), considerably smaller than the camera aperture. This is necessary to restrict the important action always to be within the smallest projection aperture used in the several types of prints which can be made from this negative.

Method No. 5. So far conventional 35 mm. film has been used as the negative in all the systems described. The remaining two processes both use a 65 mm. negative film in special cameras, and prints from these are made on to positive film which is 70 mm. in width. The pictures are therefore arranged in the conventional manner and the films travel vertically both through the camera and projection equipment. The reason for using a positive film wider than the negative is to provide space for the sound tracks—because the picture on the camera negative occupies all the available space on the 65 mm. film.

The first of these two processes does not use anamorphic lenses and, therefore, may be described as un-squeezed photography. It is generally known as the Todd-AO process and employs a camera aperture 2·072 in. (52·63 mm.) in width and 0·906 in. (23·01 mm.) in height. Because release prints from these negatives can be made both on un-squeezed 70 mm. or on squeezed 35 mm. positive, and the effective area on these are not equal, the ground-glass in the camera view-finder must be masked to restrict important action to the boundaries of the smaller area— these maskings are 1·913 in. (48·59 mm.) in width and 0·868 in. (22·05 mm.) in height.

Method No. 6. With the exception of Cinerama and Cinemiracle techniques (both of which rely on projecting three conventional 35 mm. images side-by-side onto the screen), this last system could be described as the 'biggest of the big'. It employs a 65 mm. negative in a camera having an aperture identical to that used in the Todd-AO system (5 above), but, in addition it employs an anamorphic lens attachment to produce a squeezed image in the ratio of 1·25 : 1. This system is known either as *M.G.M. Camera-65* or as *Ultra-Panavision* and, in both cases, requires a 70 mm. positive film from which the image must be un-squeezed during projection.

Typical camera layout

The traditional lay-out of a professional studio camera is illustrated by the Mitchell NC camera shown in Plate 2.17. It will have been realised that camera bodies, film paths and general assemblies vary quite as much as the intermittent and other mechanisms we have been studying. Even so, the general principles are embodied in all camera designs and can be recognised by reference to the figure.

Both the unexposed and exposed film is usually stored above the camera body in a kidney-shaped casting known as a magazine. This is usually attached to the main camera body by a hold-down screw either as shown in the figure or passing

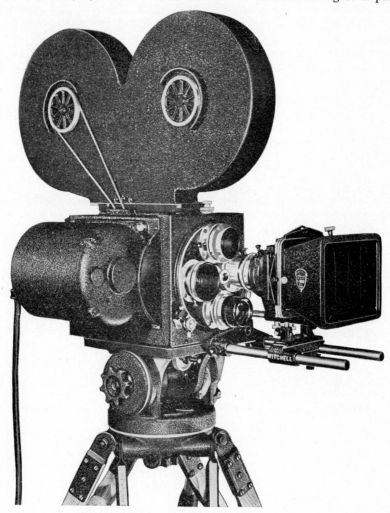

Plate 2.17. The Mitchell N.C. Studio Camera

Courtesy Vinten-Mitchell Limited

centrally between the two film compartments. In recent years it has become fashionable to 'hand-hold' cameras in order that the cameraman may secure fast-moving shots of a highly dramatic character. Cameras have been especially designed

with this technique in mind and, particularly, the centre of gravity is arranged to create a comfortably balanced camera when the whole unit is supported on the cameraman's shoulder. With this type of equipment the film magazine is often located *below* the camera mechanism chamber.

In conventional studio equipment the magazines usually have an unexposed film capacity of 1000 ft. (304·8 metres) in 35 mm. cameras and 400 ft. (121·9 metres) in 16 mm. cameras although, for television newsfilm work many hand-held 16 mm. cameras only accommodate 100 ft. (30·48 metres) within the camera body. Film is usually supplied on a 2 in. (50·8 mm.) plastics core having a key moulded at the centre to engage with the magazine hub. In some magazines special collapsible metal cores are used in the take-up compartment whilst, in others standard plastics cores are used. Whilst most magazines could accommodate a full roll in both the feed and take-up compartments at once, others are designed so that the supply and take-up areas over-lap—the space in the take-up compartment only becoming sufficiently large to accommodate the full roll as the supply roll becomes smaller.

The magazine cover may be either a single door, hinged where the magazine joins the camera body, or it may take the form of two circular discs which screw into suitable openings in the magazine castings. The latter method ensures absolute safety from light fog and eliminates errors in locating lock fasteners, etc. Some magazines are fitted with automatic light traps (through which the film is led to the camera mechanism), arranged to open only after the magazine is located on the camera body and clamped into position. In all cases the magazine is threaded before it is attached to the camera and adequate loops are left between the inlet to each film chamber. Corresponding apertures in the top of the camera body permit these loops to enter as the magazine is located in position. If automatic light traps are not used, close-fitting rollers or felt pads are fitted to the slots through which the film enters and leaves the magazines. However, this method can lead to scratches on the negative, due to an accumulation of dust on the surface of the rollers or pad.

The camera body, usually of cast aluminium, contains all the essential mechanism although, by comparison with early models, it is greatly reduced in size. It is almost universal pratice to use a central sprocket to act both as a feed and take-up control. The film gate may be mounted in an accurately machined horizontal slide to enable the film channel to be moved laterally away from the optical axis of the camera and, at the same time, to introduce a focusing screen in precisely that plane previously occupied by the film. In the figure this operation is controlled by the 'shift-handle'. With the rapid growth in popularity of mirror shutters, this 'rack-over' system of focusing is becoming obsolete.

Non-standard cinematography

Cinematograph processes and equipment were quickly recognised as tools which could aid industry and research. Because of this two important non-standard techniques must be discussed before closing this chapter. In both cases, they depend

79

upon the effects created by projecting film at a speed different to that at which it is taken.

If film is exposed at the rate of several hundred frames per second, but is afterwards projected at the standard rate of 16 or 24 frames per second, movement becomes apparently much slower than actually occurred during photography—in other words *slow-motion* pictures are made. This technique is known as *high-speed photography*.

On the other hand if film is exposed very slowly—perhaps one frame every hour—but is afterwards projected at standard speed, movement is apparently much quicker than occurred during photography—in other words very *fast-moving* pictures are made and this technique is known as *time-lapse photography*.

In the first case high-speed photography is used to reveal movements so rapid that the eye cannot normally detect them. Examples being the action of an electric razor, the beating of a fly's wings, the perforating of motion picture film, etc. In the second case time-lapse photography is used to speed up any movement which occurs so slowly that it would be impossible to detect or uneconomical to wait for. Examples of such being the growth of plants, the changes in cloud formation, etc. Quite a different application of time-lapse photography occurs in industry when analysing a series of operations in a mass production factory and when it is required to co-ordinate manual operations. In such cases it is helpful to expose single frames at the rate of, say, one every 5 seconds throughout the working day—by this technique a whole days work-action can be recorded on only 144 ft. (43·9 metres) of 16 mm. film.

High-speed cameras

Any camera speed higher than normal projection speed must produce a slow-motion picture and, for conventional trick effects, speeds up to 64 frames per second are quite common in standard equipment. The term *high-speed cameras* refers to a mechanism designed to cope with speeds far in excess of this and, in fact, covers any speed from 100 to 18,000 pictures per second. Speeds even higher than this are obtainable with so-called strip or streak cameras, but these fall into a category known as ultra-high-speed cinematography and will not be considered here.

It is possible to use conventional intermittent-claw film movements at camera speeds up to 300 pictures per second. However, the intermittent claws and pilot pins (when fitted), together with the film gate and associated mechanism must all be specially designed and, particularly, most carefully balanced. A camera of this group is the Vinten Type HS300.

At speeds above 300 pictures per second it is not advisable to employ any form of intermittent film movement. The loading both on the film perforations and the claw pins would become so great that unsteady pictures would be unavoidable—quite apart from the high rate of wear which would take place. Because of this picture speeds between 300 and 18,000 per second are obtained by allowing the film

to move continuously past the exposing aperture and arresting movement optically —usually by a rotating glass block or prism.

The principle of *optical compensation* is seen in Figure 2.18, and the purpose of all such units is to optically move the image in synchronism with the film movement. When light is travelling at right angles to an optically parallel glass plate it will pass through this plate without changing direction—as shown in Diagram C. However, if the light travels at any other angle towards the glass plate it will be

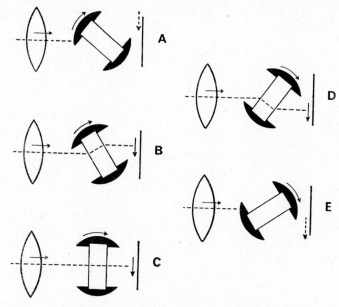

Fig. 2.18. Principles of Optical Compensation

refracted as it passes through the glass, and emerge in a different position, as shown both at B and D. Naturally, the same is true if the light-beam remains fixed but the glass plate rotates.

Unfortunately the angle through which the glass plate may be rotated is small and, beyond this, the image becomes distorted. Masks or barrel-like shutters must therefore be fitted to the ends of the glass plate to prevent exposure beyond a restricted angle of rotation. Naturally, the duration of exposure (as opposed to the masked period of the complete cycle) is relatively short, and this is one reason preventing the use of such a system in conventional motion picture cameras.

In Diagram A, Figure 2.18, the masks are still preventing exposure to the film because the glass plate is at such an angle that a distorted image would result. In position B light is passing from the lens to the glass plate, it is then refracted as it travels through the glass and again when it passes beyond the glass, so that it

emerges parallel to but displaced above the original axis. As the glass plate continues to rotate the degree of refraction or displacement becomes less until, in position C when the glass is at right angles to the optical axis of the lens, no refraction or displacement occurs at all. Further rotation of the glass plate causes refraction in the opposite direction, as seen at D. This is allowed to continue until a point is reached when image definition would become unacceptable. Beyond this point the light is again cut off by the masks at either end of the glass plate.

Naturally, the thickness of the glass plate, its refractive index and the speed of rotation must all be such that the downward movement of the image is synchronised to the speed of the film.

This principle is used in the well-known range of Fastax cameras manufactured by the Wollensak Optical Company of America. Fastax 35 mm. cameras are available to record up to 6,000 pictures per second; their 16 mm. cameras will record up to 9,000 pictures per second; and the Fastax 8 mm. camera will handle any speed up to 18,000 pictures per second. At such speeds the subject lighting must be synchronised with the camera exposures and, for this purpose stroboscopic discharge lamps or high-intensity sparks must be used—conventional tungsten lighting would not provide sufficient illumination for these extremely short exposures even with films of the fastest emulsion speeds currently available.

Time-lapse cameras

Time-lapse cinematography is the inverse of high-speed work. In this technique the camera speed is much lower than the projector speed and, therefore, the effect is to greatly speed-up the apparent motion which is being studied. In investigating plant growth for example, exposures may be made at the rate of only one picture per hour and for many days at a time and so, of course, automatic ancillary equipment must be provided for this type of work.

It is usually necessary for an auxiliary still-camera-type shutter to be fitted in front of the camera lens so that this may be fired at any required moment quite independently from but synchronised with the camera mechanism. At the moment of exposure considerable studio-type lighting may well be required but, clearly, this could not remain in constant use for many days. Quite apart from the cost of such a technique, there are many subjects which are adversely affected by the heat from such lighting equipment. The lighting problem is therefore usually overcome by an electronic timing mechanism which energises the lamps a pre-determined short time before each exposure, and automatically extinguishes them as soon as each exposure has been completed.

Because plant growth would be retarded if the specimen were kept in a studio and away from sunlight, techniques have been devised to overcome even this difficulty. It is possible to use an electrical timing unit—such as an intervalvometer— to operate relays and motors so that a series of pre-arranged functions can be carried out automatically. For example, curtains may be drawn across the windows of a greenhouse, the studio lights may then be automatically energised, the camera

mechanism advanced by one frame, the auxiliary shutter fired and re-set, the studio lights extinguished and, finally, the curtains drawn back once more to allow sunlight to reach the plant again.

Equipment arranged to perform most of these functions is seen in Figure 2.19. Here an Arriflex 16 mm. camera is fitted with an auxiliary 400 ft. (121.9 metres) magazine and a special still-camera pre-setting shutter is mounted on the bar

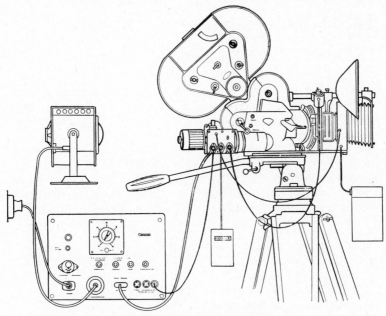

Fig. 2.19. Time-lapse Equipment

supporting the matte-box and sunshade. The electric motor drive is replaced by a special unit capable of remote manual or electrical control to rotate the film mechanism 'one frame at a time'. A distant-reading frame counter is electrically operated by pulses from the camera.

A time-lapse intervalvometer provides an electrical pre-set exposure sequence giving intervals from two seconds up to three hours. Alternative types of lighting are illustrated: the electronic flash-gun and conventional spot lights. Lighting units up to 500 watts can be operated directly from the intervalvometer and, of course, when several larger units must be used to cover a considerable area, these should be connected to the unit through switching relays.

For many years photographers liked to think that the poet Robert Burns had them in mind when he wrote 'oh wad some Pow'r the giftie gie us to see oorsels as ithers see us'. It would seem that modern cinematographers could now well write 'oh what equipment here erected—to show you what you least expected'!

Chapter 3

Film Emulsions

BEFORE considering any motion picture film processing equipment it is essential for us to appreciate the wide range of emulsions which are involved and which, of course, each require different processing techniques in order to achieve the optimum characteristics they are intended to yield.

Motion picture films naturally divide into two main groups—those suitable for cinematography in colour and those suitable for filming in black-and-white. Each group is sub-divided into two further classes: those films used in the *negative-positive* system and those used for *reversal processing*. In addition, there are special black-and-white emulsions especially suitable for optical sound recording.

The *basic* list of film types is at first sight somewhat alarming and is as follows:

(a) Black-and-white negative/positive systems require:
 a.1. Camera negative films.
 a.2. Release positive films.
 a.3. Duplicating master positive films.
 a.4. Duplicating negative films.

(b) Black-and-white reversal systems require:
 b.1. Camera reversal films.
 b.2. Duplicating reversal films.
 b.3. Duplicating master positive films.
 b.4. Duplicating negative films.

(c) Colour negative/positive systems require:
 c.1. Camera negative films.
 c.2. Release positive films.
 c.3. Intermediate negative films.
 c.4. Panchromatic separation positive films.

(d) Colour reversal systems require:
 d.1. Camera reversal films.
 d.2. Internegative films.
 d.3. Release positive films.

(*e*) Sound recording systems require:
 e.1. Variable area recording films.
 e.2. Variable density recording films.

The basic theory of black-and-white filming in the negative/positive system has already been mentioned in Chapter 1 and a typical emulsion has been illustrated in Figure 1.4. *Reversal* systems of cinematography depend upon very different processing techniques and require special film emulsions. The black-and-white reversal system is described below.

Reversal emulsions

A reversal emulsion is one which, after normal exposure in the camera, can be so treated during processing that a *positive* image is finally obtained instead of the normal negative—it is most important to understand that this positive image is therefore on the identical film support and is part of the original emulsion which was used in the camera.

In the normal black-and-white reversal process film is first developed to a negative in the usual manner, but is then passed through a bleaching solution which is only capable of dissolving away the metallic silver formed during the previous development. The bleaching solution does not attack the undeveloped silver halide which, since it did not receive exposure in the camera, could not be reduced to metallic silver by the developer. After bleaching the film only carries unexposed silver halide grains plus some of the bleaching solution itself and, therefore, must be thoroughly washed until all traces of the bleach are removed—in some processes a special *clearing bath* is used to accelerate this process.

The silver halide which remains is then exposed to white light and the film is passed through a second developing solution. This produces an image which is complementary to (or the inverse of) the original image which was obtained in the first developer—that is, it produces a positive image. The stages of reversal processing are shown in Figure 3.1. An original subject A is represented by alternate rectangular areas of black and white material. The condition at B indicates the film used to photograph this subject *after* it has passed through the first developing solution. The areas of opaque emulsion correspond with areas of white material in the original subject. Black areas in the original have had no effect upon corresponding areas of the emulsion and these consequently remain as unaltered silver bromide grains.

The film is then passed through a bleaching solution to dissolve away the metallic silver from those sections which received exposure and became developed. On leaving the bleaching bath, as shown at C, Figure 3.1, the film consists of areas of unaltered silver bromide grains, corresponding to the black areas in the original subject, interlaced with areas of transparent film base, corresponding to the white portions in the original. Once the bleaching solution has been thoroughly removed areas 4, 5 and 6 will correspond to areas 1, 2 and 3 in the original subject. The film

is then *exposed to white light* so that the remaining silver grains may be reduced in a second developing solution and so produce the final result as shown at D, Figure 3.1. The film must then be fixed and washed in the usual manner.

The final appearance of a metallic silver image, and particularly the density and granularity of that image, is related to the size and distribution of the individual silver grains. The larger the grains are, or the more concentrated their distribution becomes, the more readily will they react to the developing solution. Because of

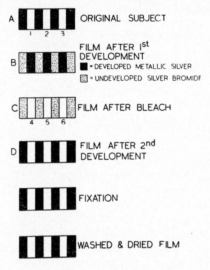

Fig. 3.1. The Black-and-White Reversal Process

this the *first* grains to become fully developed are always those larger ones which are most likely to cause the appearance of *graininess* in the image. However, when film is developed to a positive by the reversal process, these large and highly sensitive grains are generally all developed in the first solution—and subsequently dissolved away in the bleaching process. The resultant pictures are therefore composed of the smaller less sensitive grains and, consequently, often appear to have a finer grain structure than might be the case if conventional negative/positive methods had been employed to photograph the same subject.

The foregoing argument is only true to a certain extent—particularly over those areas where exposure *has* taken place. If a small section of the film remains unexposed during the original photography neither the large or the small grains would be removed during the bleaching process and, therefore, large grains would still be present during the second exposure and these would be the first to develop during the second development process.

It is very important to realise that the amount of silver available to form the positive image is dependent upon that amount which is left after the original

camera exposure has been bleached away. If the camera exposure is very slight, only a small proportion of the total grain distribution will react to the first developer and a large number will remain after the bleaching operation. Similarly, if the camera exposure has been heavy then a high proportion of grains will react to the first developer and a correspondingly low or thin grain distribution will survive the bleaching operation and remain available to form the final positive image.

This explains a major and important limitation of reversal emulsions. Optimum positive images can only be achieved when optimum exposure occurs in the camera; tolerances on exposure are only very slight and, unlike conventional negative/positive processes, no variation or adjustment is available during a subsequent printing operation whereby a poor negative exposure can be overcome. Many years ago, when 16 mm. reversal emulsions made cinematography available to the amateur, a system of second-exposure compensation was used largely to correct errors in original camera exposure but, when 16 mm. film became a professional gauge used by documentary and television cameramen, this technique had to be abandoned. One interesting reason for this decision is that, when a fade-out is created in the camera any system of second-exposure compensation would automatically *correct* the reducing exposure and so cancel out the intended effect!

Although black-and-white reversal emulsions yield a positive image on the original camera film, further copies can be obtained by printing from the original on to *duplicating* reversal film. This is a very fine-grain and relatively slow emulsion which is reversed during processing so as to produce a positive duplicate copy in one operation. If a great number of copies are required it is possible to first make a duplicate *master positive* and, from this, make a fine-grain duplicate negative from which any number of release positive prints can be made—but the exposure and processing of every step in this process must be exceptionally well controlled if acceptable final prints are to be achieved.

Within the televison industry opinions are still divided on the advantage or otherwise of using reversal emulsions. In so far as television newsfilming is concerned, the British opinion tends to the belief that the inherent restriction on exposure latitude makes reversal films unattractive. (This opinion could be influenced by the poor average quality of the British weather!) Further, and because so many copying and sound-transfer techniques are well established with the negative/positive system, the interchange of television film material between countries appears to be more complicated when reversal stocks are employed. These arguments become less important when equipping a new television station and, in any event, do not apply so widely on the European Continent.

Machinery for processing reversal emulsions, and the fundamental sensitometric control techniques, are similar in principle to those used in conjunction with conventional negative-positive processes.

Colour film emulsions

It is not our intention to discuss colour perception or colour photography in detail. Many authoritative works already exist to supply this information and, since the

principles of colour photography are identical to those of colour cinematography, it would be both presumptuous and wasteful to embark here on any more than is essential to the understanding of motion picture techniques and equipment.

Fortunately, all visible colours (when they exist in the form of light rays as opposed to coloured pigments) can be reproduced to the eye by the partial or total

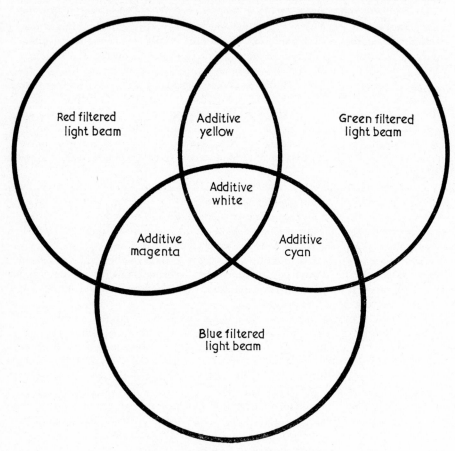

Fig. 3.2. Additive Colour Mixing

combination of three *additive* primary colours. These three *primaries* are red, green and blue. When red and blue rays of light are added together in equal intensities we see the colour known as *magenta*, when green and blue rays of light are added together in equal intensities we see the colour known as *cyan*, and when red and green rays of light are added together in equal intensities we see the colour known

as *yellow*. When the primary colours are added together in different proportions we can reproduce light of all the intermediate hues and, if all three additive primaries are mixed together in approximately equal intensities we then see white light.

It is very important to realise that we are discussing the addition of three separate

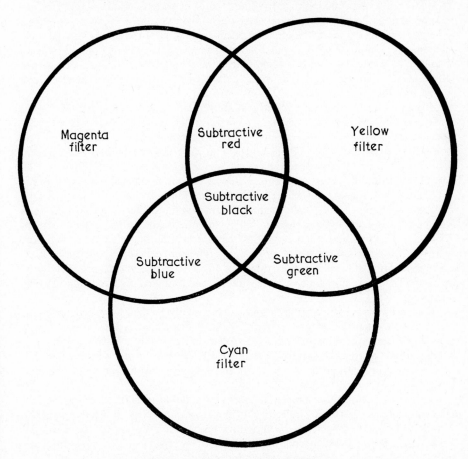

Fig. 3.3. Subtractive Colour Mixing

beams of light; the most convincing way to appreciate this is to carry out a series of simple experiments. To do this one requires three separate light sources—such as battery-operated hand torches or slide projectors—and a supply of coloured gelatin filters. The three light beams should be focused on to a screen and brought together so as to overlap at the centre in the clover-leaf pattern shown in Figure 3.2. One light beam is then covered with a red filter, the second with a green filter and

the third with a blue filter. The resultant colours produced by adding these primaries together are indicated in those sections of the diagram where the circles overlap.

At this point it will be useful to remember that the primary *additive* colours are those used when mixing together light beams of various colours—and they are *not* the same as the primary colours used when mixing paints or pigments together. The primary colours used when mixing paints are red, yellow and blue and, because equal parts of all three produce *black* when mixed together, the mixing of pigments is known as *subtractive* colour mixing. One could therefore say 'Lights *add* together ultimately to *transmit* white light whilst paints *subtract* on combination ultimately to *reflect* black'.

Referring again to Figure 3.2 it is important to note that a red filter *absorbs* both green and blue light—that is, it only transmits *one-third* of the visible spectrum. Similarly, a green filter absorbs both red and blue (again only transmitting one-third of the visible spectrum) and a blue filter absorbs both red and green. Thus, since each of these three filters is capable of absorbing two-thirds of the visible spectrum, the combination of *any two* of them in front of a *single* light source must absorb all colours and will result in total darkness.

A very different result is achieved if we combine three filters of yellow, magenta and cyan over a single light source. This experiment can easily be demonstrated by laying the three filters in a clover-leaf pattern over an illuminated viewing box. The result is that components of white light are selectively *subtracted* by each filter and each combination of filters as shown in Figure 3.3, and it will immediately be apparent that it is not until all three filters are combined that total darkness is achieved.

The great importance of these two experiments is that they have revealed valuable properties of two sets of filters. We have found that each of the red, green and blue filters absorb two-thirds of the spectrum and only transmit one-third—whereas each of the magenta, yellow and cyan filters does precisely the reverse; they each absorb only one-third of the spectrum and transmit the remaining two-thirds.

It is essential to understand that the three additive primaries (red, green and blue) in Figure 3.2 are inter-related with the three *subtractive primaries* (magenta, yellow and cyan) in Figure 3.3. Adding together any two individual beams of light which have been filtered by the additive primaries *reflects* one of the subtractive primaries. Similarly, filtering a single source of white light by a combination of any two subtractive primaries *transmits* one of the additive primaries. The performance of the six filters used in these experiments is summarised on page 91.

It can now be appreciated that, instead of coating a single panchromatic photographic emulsion on to a base, it should be possible to coat a *sandwich* of three emulsions so that (*a*) each emulsion is capable of responding to one of the three additive primary colours and, (*b*) this condition might be secured by introducing between these layers of emulsion selected filters of the three subtractive primary colours. Under these circumstances it should be possible to record all visible

colours in proportions of three primary colours and to isolate these recordings in the various layers of the sandwich.

This is exactly what is done in modern colour photography—but one additional and vital step must also be included before any colours will be revealed at all.

COLOUR OF FILTER	COLOURS ABSORBED	COLOURS TRANSMITTED
Blue	Green and Red	Blue
Green	Blue and Red	Green
Red	Blue and Green	Red
Yellow	Blue	Green and Red
Magenta	Green	Blue and Red
Cyan	Red	Blue and Green
Yellow and Magenta	Blue and Green	Red
Yellow and Cyan	Blue and Red	Green
Magenta and Cyan	Green and Red	Blue

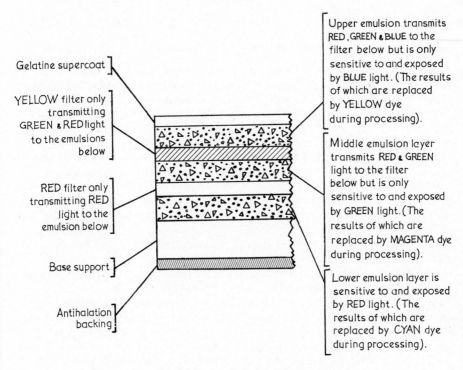

Gelatine supercoat

YELLOW filter only transmitting GREEN & RED light to the emulsions below

RED filter only transmitting RED light to the emulsion below

Base support

Antihalation backing

Upper emulsion transmits RED, GREEN & BLUE to the filter below but is only sensitive to and exposed by BLUE light. (The results of which are replaced by YELLOW dye during processing).

Middle emulsion layer transmits RED & GREEN light to the filter below but is only sensitive to and exposed by GREEN light. (The results of which are replaced by MAGENTA dye during processing).

Lower emulsion layer is sensitive to and exposed by RED light. (The results of which are replaced by CYAN dye during processing).

Fig. 3.4. Typical Integral Tripack Colour Emulsion

Without this addition all that has been done so far is to record colours in terms of *grey photographic densities* and to separate these into convenient layers of emulsion. Fortunately the use of so-called *colour-couplers* (either built into the emulsions or available in the processing solutions) have made it possible during processing to actually replace the developed silver with appropriate dyes so that, in effect, the ultimate result is a sandwich of three dyes distributed in the shapes of the images and in such intensities that the required colours are achieved when the sandwich is viewed as a whole.

Figure 3.4 illustrates a typical combination of emulsion layers and dye filters as used in a modern colour emulsion, together with captions describing the functions of each layer. Naturally, the number of solutions through which such a film must pass during processing are much greater than those required to process either black-and-white negative, positive or reversal emulsions—but the basic principles of all such machines remain identical.

It will now be apparent that, even when filming in the black-and-white systems, a number of different film emulsions are involved. The manner in which these are related is quickly understood from so-called 'printing flow charts' and the illustrations which follow are based upon a series of such charts issued by General Film Laboratories of Hollywood, California.

35 mm. Black-and-white systems

Figure 3.5 shows the conventional steps involved when making feature films in monochrome and in passing from the original camera negative to the final cinema release prints. The starting point is of course the 35 mm. negative which was exposed in the camera. As explained in Chapter 1, the film Director and his associates require to see 'daily rushes' or 'daily work prints' each day throughout the production. It should be noted that although these 'dailies' are normally provided in the 35 mm. format and simply by contact printing, they can also be provided in the smaller 16 mm. gauge by a process known as reduction printing (see Chapter 8).

After the original negative has been cut to match the edited daily work prints (at the end of the floor shooting) it is possible to make a complete release print directly from the original negative. However, this would be most unlikely for two main reasons: (*a*) it would prohibit the introduction of any transitional effects such as fades and lap-dissolves and, (*b*) it would be very dangerous to use the extremely valuable original negative for repetition copying.

It is more usual first to make a *master-positive* from the edited original negative and, from this, to make either a 35 mm. or a 16 mm. *duplicate negative* (depending on the gauge of film required for final exhibition). All the necessary *effects* can then be introduced during these intermediate stages and the main release copies may be taken from the duplicate negative so that no great risk or loss would be involved if the duplicate negative became damaged.

This relatively straightforward technique involves four quite different film emulsions—the original camera negative, the master positive, the duplicate negative

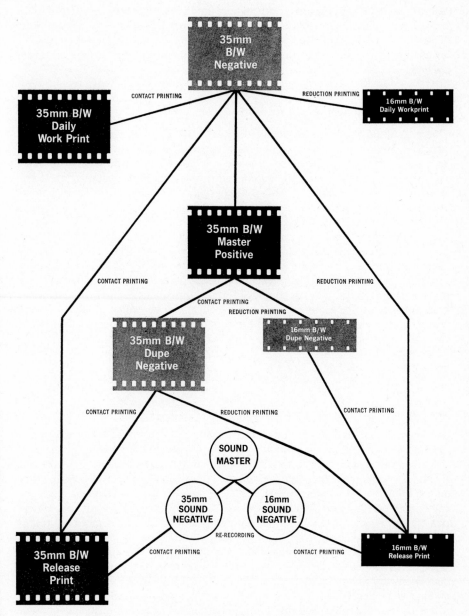

Fig. 3.5. Black-and-White Negative/Positive Systems

93

and finally the release positive print. These emulsions have very different characteristics and consequently require different processing techniques to be employed. Their inter-relationship is discussed in considerable detail in Chapter 6 (Sensitometry) and it is sufficient at this stage to list the following basic characteristics of each one.

Black-and-white negative emulsions

These emulsions are intended mainly for use in motion picture cameras and are all panchromatic—that is, they respond with exposure to any colour in the visible spectrum. They are available in a wide range of *speeds* (this term is fully explained in Chapter 6) so that some may require quite a lot of light to illuminate the scene which is to be photographed, whilst others can successfully record an acceptable image when only a surprisingly small amount of light is available.

The reasons for these differences are related to the grain-size of each emulsion. Unfortunately it is basically true that emulsions containing large grains (or composed of grains which tend to clump together) are necessary when very fast photographic speeds are required. Conversely, if a slow photographic speed can be tolerated (in conditions of high scene illumination) then emulsions containing only much smaller grains may be employed and, consequently, noticeably superior image quality will be achieved. For reasons which will be explained later, negative emulsion are always processed to yield images of relatively low contrast. For future reference it will be helpful to record that such emulsions are processes to *gamma values* of between 0·5 and 0·75. The term gamma need not concern us at this stage and is fully explained in Chapter 6.

Black-and-white master positive emulsions

These emulsions need not be fully panchromatic since they are always used when printing from a negative—and this is usually accomplished in printing machines which are illuminated by a tungsten filament lamp. Master Positive emulsions are therefore usually only blue-sensitive, but they must be of extremely low granularity and thus yield an exceptionally high degree of image resolution or detail. They are sometimes protected by a gelatin supercoat to minimise the risk of mechanical damage during the printing and processing operations. A master positive print is used as an intermediate step towards making a duplicate copy of the original negative. It is therefore very important that they should faithfully record all the discrete changes in the density of the original negative in such a manner that, when combined with a duplicating negative emulsion in a subsequent printing operation, an undistorted reproduction of the original negative image is secured. Because of this it is usual practice to develop master positives to yield images of relatively medium contrast and, for future reference, it is useful to record that master positive emulsions are usually processed to gamma values of between 1·3 and 1·5.

Black-and-white duplicate negative emulsions

These emulsions are usually fully panchromatic in sensitivity (although they are normally only exposed in printing machines which are illuminated by tungsten filament lamps). The reason for this is to give as much speed as possible to an emulsion which, above all else, must be of extremely fine grain and have the maximum resolving power or image sharpness. Duplicate negative emulsions are frequently coated on to film base which contains a grey dye—this is to reduce to a minimum the possibility of halation during printing (see Figure 1.5, Chapter 1). It is useful to record that duplicate negative emulsions are usually processed to gamma values of between 0·60 and 0·70.

Black-and-white release positive emulsions

These emulsions are used in combination with the processed camera negatives or, more usually, with the processed duplicate negatives during a printing operation and so become the copies which are actually projected in the cinemas. They are only sensitive to blue light but have a very fine grain structure and thus a high resolving power which yields good image definition. It is important to note that, in most cases, these films not only carry the pictorial image but also the variable-density or variable-area photographic sound track. They are available both with clear or grey-dyed bases and are usually processed to gamma values of between 2·3 and 2·6—thus they yield images having a contrast considerably higher than that found in any of the previously mentioned emulsions.

Black-and-white reversal systems

Figure 3.6 shows the conventional steps involved when using the monochrome reversal technique. As explained previously, the original camera film is processed to yield a positive image and, if no further copies are required, it could be edited and projected. However, this would only satisfy the minimum requirements and, when used professionally, the steps shown in Figure 3.6 are usually essential. Two basic systems are available and the choice of one or the other depends very much on the number of copies which will eventually be required.

If the number of copies are low it is more economical to edit the original and to make copies directly on to reversal duplicating film to produce the so-called reversal composite prints. The use of similar material to make mute daily work prints is applicable to both systems illustrated in Figure 3.6 and the inclusion of this facility provides means for extensive editing without risk of damage to the original.

It should be noted that sound recording commences with a 'sound master' and, in the above system, a *positive* photographic sound track must be made on a separate film. The sound master is usually a magnetic recording (either on magnetic sound film or tape) and because the majority of projectors still only reproduce sound via photographic tracks, it is necessary to re-record from the magnetic original on to a photographic system (this system is fully described in Chapter 9).

The alternative system shown in Figure 3.6 is often used when a large number of copies is required. In this process a duplicate *negative* is made from the original camera reversal film and, after editing, positive prints from this are then made on conventional fine grain release positive film. When this is done the photographic

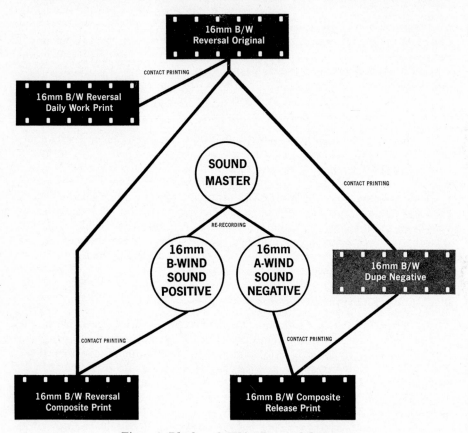

Fig. 3.6. Black-and-White Reversal Systems

copy of the magnetic sound original must also be in negative form so that both picture and sound appear as positives on the final composite prints.

Black-and-white reversal emulsions

Although these emulsions are primarily intended to be processed by the reversal system, they *can* be processed to yield a negative image. However, when so used they usually have a lower photographic speed than can be achieved if the same

material is reversed. This dual characteristic is not equally true of emulsions designed as negative materials—only some of these will reverse satisfactorily. All reversal emulsions intended for use in motion picture cameras are fully panchromatic and the final positive image is always of a very fine grain structure—as explained previously, the grain size is always superior to that which could be achieved on an equivalent negative emulsion or when the reversal film is only processed as a negative.

The effective photographic speeds of reversal emulsions are slower than their negative equivalents and the exposure latitude is more restricted. The effective *reversal gamma* is of the order of 1·2 to 1·5 but this is not very meaningful to the cameraman (although it is vital to quality control in the laboratories) because contrast control is not flexible in a manner similar to that by which negative emulsions may be processed to a relatively wide range of values to suit individual requirements. Reversal emulsions must be processed to fixed conditions in order to preserve sufficient silver halide after the bleaching operating and to form a satisfactory final positive image.

Black-and-white duplicating reversal emulsions

These emulsions are similar to those used in the camera but with the important difference that they need only be sensitive to blue light. This is because they are only used in a printing operation and in order to make copies directly from reversal camera originals. Naturally a duplicating reversal emulsion can also be used to make a direct copy from a positive print, and this technique is sometimes used when the original negative of that print is not available.

It is important to remember that, on projection, the position of the emulsion will be facing the light source when a positive print or a duplicate from a camera reversal is being projected. The emulsion will be facing the lens of the projector when either a reversal original or a direct duplicate from a positive print is employed. Because of this great care must be taken to ensure that films are not joined together if the position of their emulsions does not coincide on projection. If the emulsion position alters during projection the equipment will need to be re-focused in order to maintain a sharp image on the screen. This hazard is particularly likely when a film has become damaged and an *insert* is urgently required.

Colour negative/positive systems

Figure 3.7 shows the flow-chart covering the many processes which lead to the four possible end products—35 mm. and 16 mm. colour positive prints and 35 mm. and 16 mm. black-and-white prints.

Starting with the 35 mm. colour negative in the camera one may elect to print either a 35 mm. or 16 mm. daily work print in colour or to be satisfied with a 35 mm. black-and-white print. In most cases a 35 mm. black-and-white print is acceptable

4

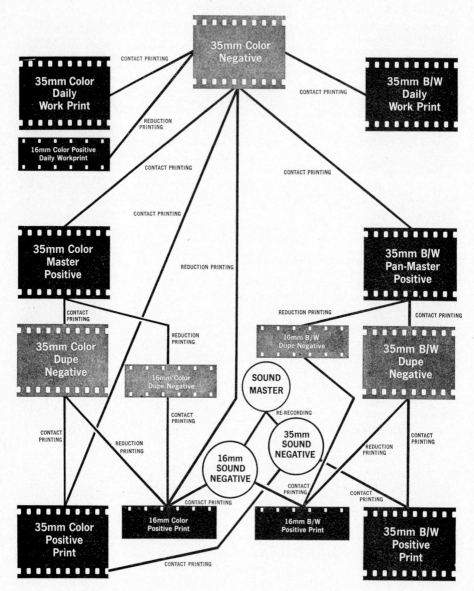

Fig. 3.7. Colour Negative/Positive Systems

providing good liaison with the laboratories guarantees that the original colour negative is in first-class condition and will ultimately yield good colour prints.

Once the original negative has been cut to match the work print the conventional steps via the master positive and duplicate negative lead to the 35 mm. colour release prints. This path is shown to the left of Figure 3.7. It should be noted that 16 mm. colour prints may be obtained either by first making a 16 mm. colour duplicate negative by reduction printing from the 35 mm. colour master positive or by reduction printing directly from the 35 mm. colour duplicate negative. The second method is preferable because fewer printing operations are involved and are therefore more likely to preserve high image colour quality, definition and mechanical steadiness.

If 35 mm. black-and-white prints are also required from the original colour negative the path to the right of Figure 3.7 will be followed, and here it is important to recognise that the black-and-white master positive must be made on a panchromatic emulsion since the image is derived from a coloured original. Beyond this stage the black-and-white duplicate negative and release positive prints are made on conventional materials common to the black-and-white negative/positive process. Again, two alternative methods are available when making 16 mm. black-and-white reduction prints but, if possible, a reduction directly from the 35 mm. black-and-white duplicate negative is preferable.

Some readers may wonder why either the 16 mm. colour or black-and-white duplicate negatives (derived from 35 mm. master positives) are shown when, in both cases, it is suggested that superior results on 16 mm. are obtained by reduction printing from the respective 35 mm. duplicate negatives. One obvious reason is geographical—the 35 mm. material may still be required in the country of origin whilst reduction prints are called for elsewhere. A second reason could well be because both 35 mm. and 16 mm. copies are required simultaneously—and great economy in laboratory time could then be achieved if prints in both dimensions can be prepared together.

As in the previous system, it should be noted that the original sound is recorded on magnetic film or tape and optical negatives are made by re-recording. This is so that optical sound tracks may be printed alongside the picture images on any of the release prints. It is quite likely that 35 mm. colour prints and, particularly 70 mm. Panavision and similar wide-screen prints may carry *magnetic* sound tracks—and these may be in full stereophonic or monaural sound. In such cases the re-recording process is more correctly described as a sound transfer process because the sound master is used to directly produce magnetic tracks on the release prints.

Colour negative emulsions

All colour negative emulsions consisting of integral-tripacks similar to Figure 3.4 produce an image in which the colours are complementary to those of the original—and thus a pink flesh tone appears as a blue-green in the negative. The range of photographic speeds available with colour negatives is currently both lower and

more restricted than can be enjoyed with black-and-white negative emulsions. This presents no great hardship to professional feature film makers so far as interior studio shots are concerned, but it can be restrictive when exteriors are required in unfavourable weather conditions.

A very significant difference between colour and monochrome cinematography is that colours tend to provide their own *modelling* and, consequently, it is essential to reduce the lighting contrast in colour photography to something much lower than would normally be employed in monochrome work. This contrast must be reduced still further when colour films are intentionally made for television transmission. The precise *lighting ratios* to be employed vary both with the film stock and the processing conditions, but they will be of the order of 1 : 3 or 1 : 4 for feature film work and only 1 : 2 for television work.

Naturally, colour negative emulsions are very sensitive to change in the colour of light sources. The colour of a light source is measured in *degrees-Kelvin* and is expressed as the *colour temperature* of the light. Most colour negative emulsions are balanced either for use in daylight or for use with tungsten lamps operating at a colour temperature of 3200°K.—and film emulsions designed for one purpose can only be used for the other when suitable filters are placed either over the camera lens or the source of light.

Sunlight varies considerably both according to the time of day and the position of the sun, and also according to the condition of the sky—extremes can range from 5,000 up to 10,000°K. It is therefore frequently necessary to use colour-correction filters when exterior shooting is involved and, of course, a colour temperature meter should be employed in order to select the correct filter to match the prevailing conditions.

Colour reversal systems

Colour reversal systems are more usually employed in the 16 mm. film size although, of course, they are also available for working in the 35 mm. gauge. Figure 3.8 shows the flow-chart indicating the three systems which are generally available. These can result in (a) a black-and-white positive print, (b) a colour reversal print or, (c) a colour positive print. As shooting progresses each day's work may be assessed by (d) screening the actual camera material, (e) having a black-and-white reversal work-print produced by the laboratories or, (f) having a colour reversal print made. The choice of any of these is not influenced by the desired end-product in any way and is usually a matter of financial consideration.

The most economical and straightforward system is illustrated in the centre of Figure 3.8 where, after editing, the original camera reversal film is contact printed to produce colour reversal prints. This system is quite satisfactory if a small number of copies are required, if no elaborate special effects are needed and if the original camera material does not represent a large investment in filming scenes which might be difficult or costly to repeat. The more usual professional technique is shown to the right of Figure 3.8. Here the daily work print is edited as shooting

progresses and the original camera film is ultimately cut to match the work print. A colour *internegative* is then made by contact printing from the edited original and any number of colour prints may then be taken from the internegative without fear of damaging the original.

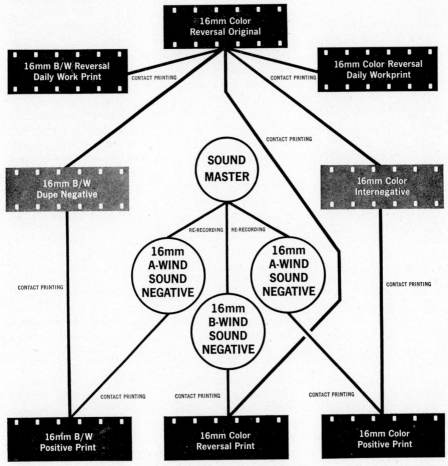

Fig. 3.8. Colour Reversal Systems

Black-and-white copies of the original colour film may be produced by first making a monochrome duplicate negative and then printing any number of positive release copies from this duplicate. All the stages in each of the three systems are carried out by contact printing and special effects such as fades, lap-dissolves, etc., may be introduced when preparing either the monochrome duplicate negative or the colour internegative.

Colour reversal emulsions

Colour reversal emulsions such as Ektachrome Type 7242 are becoming increasingly popular—particularly with television organisations which cover their news programmes in colour. This particular emulsion is balanced for exposure to tungsten illumination having a colour temperature of 3200°K., but it is also suitable for exterior photography in daylight providing a Wratten Filter No. 85 is used. When used with tungsten light the basic ASA exposure index is 125 and this falls to ASA 80 when the emulsion is used in daylight and is conjunction with the 85 filter.

Two major characteristics make this emulsion especially attractive. Firstly, it may be underexposed by as much as three stops and the results will still remain acceptable for television news coverage. Naturally, the time of the first development in the reversal processing cycle must be increased to compensate for the degree of under exposure, and so the cameraman *must* report to the laboratory exactly how far he departed from the optimum exposure. Secondly, the processing technique used with this emulsion, and known as the M.E.4 process, provides a very rapid access to finished material. Operating quite safely with the solutions at 110°F., and at a linear film speed of approximately 58 ft. (17·68 metres) per minute, it is possible to process the *first* 100 ft. (30·48 metres) of film within 30 minutes and, thereafter, similar lengths are delivered at the rate of one every $1\frac{3}{4}$ minutes whilst the processing machine remains in continuous operation.

Colour internegative emulsions

These emulsions are used to produce colour negative images from reversal-type camera originals. They are especially balanced to the tungsten illumination normally encountered in film printing equipment and, of course, must have extremely good image sharpness and very low granularity. They are therefore relatively slow emulsions which yield low-contrast images suitable for printing on to colour release positive emulsions.

Because the photographic speed of these emulsions is generally slower than the average materials used in film printing equipment, it may well be that printers must be specially equipped with high-wattage lamps, very efficient lenses and, possibly, operated at reduced speeds. As will be understood when printing machines are described in general (Chapter 7) it is also likely that the above requirements will call for modifications to the cooling systems attached to the lamphouses in some printers.

Photographic speed and exposure index

It will have been noted that various emulsions have been described as having certain *photographic speeds* or exposure ratings. So far as the cameraman is concerned, the speed of an emulsion means very little—but he is vitally concerned with the emulsion manufacturer's published exposure rating or *exposure index*.

Photographic speed is one of the factors involved in sensitometry and will be discussed in detail in Chapter 6. Basically a so-called speed rating is a number which is applied to a scale calibrating the log-exposure axis of the characteristic curve drawn to display the sensitivity of a photographic emulsion. Various systems have been devised to measure the photographic speed of an emulsion and considerable

ASA (AMERICAN)	DIN (GERMAN)	GOST (RUSSIAN)	BSI-LOG (BRITISH)	EUROPEAN SCHEINER	WESTON
10	11	9	21	22	8
12	12	11	22	23	10
16	13	14	23	24	12
20	14	19	24	25	16
25	15	22	25	26	20
32	16	27	26	27	24
40	17	38	27	28	32
50	18	45	28	29	40
64	19	55	29	30	50
80	20	75	30	31	64
100	21	90	31	32	80
125	22	110	32	33	100
160	23	145	33	34	125
200	24	180	34	35	160
250	25	220	35	36	200
320	26	275	36	37	250
400	27	350	37	38	320
500	28	440	38	39	400
650	29	550	39	40	500
800	30	700	40	41	640
1000	31	880	41	42	800

differences exist between them. They depend upon a decision concerning the effective point on a film characteristic curve at which meaningful exposure is deemed to commence. Some systems measure speed from a point near the base of the curve at which the exposure results in an agreed value of contrast, others relate to a so-called inertia point (which is an extension of the straight-line portion of the characteristic curve), etc., etc.

Because of this it became necessary for film manufacturers to publish more practical information which, essentially, could be related to the resultant exposures which could be achieved under specified processing conditions—and also which could be used to calibrate photo-electric *exposure meters*. Exposure meters are instruments which, once calibrated to the exposure index of a particular film emulsion, may be used to measure the brightness of a scene and from this to indicate the optimum camera settings (lens aperture and shutter time) required in order to secure optimum picture quality.

An exposure index is therefore really an *exposure number* and is not a photographic speed value. It allows for the sensitivity of the film, the processing conditions and the latitude in exposure error which may be permitted. Various countries and individual manufacturers have established scales of exposure indices and it is important to be able to convert from one scale to another. For example, without this ability, it is of little help to know that a film emulsion is rated at ASA 64 if the only available exposure meter is calibrated in the German DIN system of rating film sensitivity. The conversion table on page 103 is therefore provided to cover most of the systems likely to be encountered.

Chapter 4

Film Processing Equipment

THE vast output of film from modern feature studios—and from some television organisations—is usually processed by Trade Laboratories specially equipped to handle very large quantities of film in the shortest possible time. Because of this, and also to maintain consistently high quality results, machines are used in which the film is processed continuously by moving through a series of tanks containing the various solutions, and then finally through drying equipment.

This type of apparatus was only introduced when the output from studios became large enough to justify its costly installation. Before then film was processed

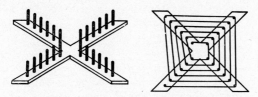

Fig. 4.1. Rack-and-Pin Processing Unit

in unit lengths; a single roll was taken from the camera and loaded on to a supporting frame where it was developed, rinsed, fixed and washed—only being removed to a drum for the final drying operation. During the early days lengths of film rarely exceeded 400 ft. (121·9 metres) but even this required quite a large holder with sufficient separation between the convolutions to achieve reasonable processing conditions.

Although these early methods are no longer used in trade laboratories, they are still necessary under certain conditions and, incidentally, were used extensively during the second World War by service departments engaged in processing combat films, etc. The main reasons for using 'unit' type processing are that short lengths of film may be developed in relatively cheap and simple apparatus which is compact, easily transported and easy to store.

A very simple method of 'unit' processing is shown in Figure 4.1. Here short vertical pillars are arranged on a horizontal cross-board so that film is wound on its

edge in a roughly spiral formation. The loaded frame is placed first in the developing bath—a shallow tray wide enough to permit easy manipulation. After development is complete the film is rinsed in water, transferred to a fixing bath and then into a washing tray through which a constant flow of fresh water is passing. To dry the film after processing it may be placed in a current of warm dust-free air whilst still mounted on the former, or it may be carefully rewound on to a drum—again in a spiral fashion.

This simple arrangement is only used when very short lengths of film are to be processed, usually not longer than 50 ft. (15·24 metres) and, even so, loading such a rack is quite a tedious business. To minimise this a rack was designed in which the vertical pillars were mounted on hinges so that all but the central four pillars folded away from the film loading path and were then raised individually as each was required. The hinges folded outwards and in such a manner that loaded film always kept the pillars upright.

Since film dimensions vary considerably with humidity, provision must be made for the overall length to increase, as it will on immersion in the processing solutions, and then for it to decrease once more on drying. Shrinkage after drying always leaves film shorter than it was before processing commenced although, with modern films coated on low-shrink tri-acetate or polyester bases, this shrinkage is now very small. To accommodate dimensional changes when using rack-type processing units one can anchor the film at the centre of the rack, but attach the opposite end to the last pillar by means of an elastic band. This band may be looped through a hole punched in the film and then passed over the pillar. This technique is not wholly successful since it assumes each convolution of film will move relative to its neighbours and by proportional amounts. Whilst this movement may occur when the film is lengthening and is in the solutions, it does not take place so readily during the drying operation. Uneven shrinkage whilst drying causes severe strain in those sections of film which touch the supporting pillars of the rack, it may also cause noticeable drying marks and difficulties in printing or projection.

This is equally true when the film is transferred to a drum for the final drying operation. It is therefore usual to spring-load the horizontal bars which form the drum to enable them to 'give' slightly towards the central supporting shaft. Even with this precaution, and with the film ends attached to the drum by elastic loops, great care is still needed and, preferably, each turn of the spiral should remain noticeably slack if undue strain is to be avoided.

Modern portable units

For some years 35 mm. film used in still-cameras such as the 'Leica' has been processed in small ebonite or plastic-moulded canisters. Although mainly intended for the enthusiastic amateur, these units did enable trade processing houses to offer individual treatment in specially selected developers and several companies still offer this service. The canister is fitted with a light-proof screw-on lid through which processing solutions can enter or be drained away without light penetrating to the

film. The film strip is usually supported between adjustable flanges so that films of various widths may be processed in one unit. Film is pre-threaded into the supporting former so as to maintain a coil or spiral of many turns or convolutions—each one separated from its neighbours sufficiently to allow the emulsion to be throughly and evenly immersed in the solutions.

The film is maintained in spiral formation by a helical groove moulded on the inner face of each supporting flange. Since the groove itself must not obstruct the flow of solution across the film, this in turn is only supported at points and by a series of radial moulded strips somewhat like a spider's web. Film is first loaded on

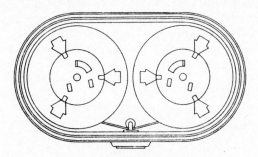

Fig. 4.2. The Morse Tank

to the spiral in a dark room, placed in the canister and the lid is then firmly locked in position; all the remaining operations may then be performed in daylight.

Units based on this principle have been designed to accommodate up to 100 ft. (30·48 metres) of 35 mm. *motion picture* film and, since it would be very tedious to thread the spiral moulded film support, special automatic devices can be arranged to perform this operation.

An interesting unit known as the Morse Tank is, in principle, similar to equipment used during the second World War for processing aerial reconnaissance films. The main difference is, of course, that whereas the war-time design accommodated films 5·5 in. (13·97 cm.) and 9 in. (22·86 cm.) wide, the Morse tank processes either 16 mm. or 35 mm. films. It will accommodate up to 100 ft. (30·48 metres) of film and, under certain conditions can be used without a photographic darkroom.

Two plastic daylight-loading reels are mounted horizontally in a moulded solution tank and processing is effected by winding the film alternately from one reel to the other. For this purpose two crank handles are supported in bearings secured to the removable lid. Solutions are poured into the tank through a light-trap in the lid, and may be drained away via a plug at the base of the tank. A plan view of the Morse tank with the two reels in position is shown in Figure 4.2 and it is important to realise that the film is wound with the emulsion side outwards on both reels. Similarly, to assist the flow of fresh solutions to the relatively short length between reels, the film must be threaded under the small central guide roller.

Approaching the problem of small unit processing in another manner J. C.

Todd produced a range of equipment based on the principle often known as *drum processing*. In these units the film is wound in a continuous spiral across the face of a comparatively large drum; when only negative black-and-white film is to be processed the drum is usually of stainless steel but, when reversal film is also handled it must be made from Perspex or similar translucent material to allow complete re-exposure to light prior to the second development and whilst the film is still wound on the drum.

Film is formed into a spiral path across the drum by means of a track or groove rather like a wide screw-thread some 18 in. (45·7 cm.) in diameter and 24 in. (60·9 cm.) in length. The drum is mounted in a semi-circular close-fitting trough containing enough solution to cover the lower portions of each film turn. When processing has been completed the film is transferred to an open framework mounted in bearings supported above the tank. This consists of four wood slats supported by crossed-members at each end and resembling the framework of a box kite. With the film again in spiral formation the drying frame is rotated in an atmosphere of warm dry air.

Continuous processing equipment

We have briefly considered techniques suitable for processing individual unit lengths of film. Whilst these are of interest to the small user and, particularly to investigators who may require rapid or secret work carried out occasionally, they cannot satisfy even the smallest commercial processing laboratory.

With the rapid expansion of television, and the great use of film in that industry, it became apparent that three types of continuous processing machinery are required. These may be roughly divided according to output as follows: small units capable of processing 500 ft. (152·4 metres) up to 1,000 ft. (304·8 metres) per day, medium-sized units handling from 3,000 ft. (914·3 metres) up to 5,000 ft. (1,523·9 metres) per day and, beyond this the commercial motion picture laboratory equipment capable of many thousands of feet daily.

Before describing any such equipment it is necessary to define a *continuous* processing machine. This is a machine designed to process any length of film—and any number of lengths of film—without the need to stop the apparatus either to join on a new roll or to remove one which has been processed. It must be capable of processing any type of film emulsion to the optimum photographic standards—but accepting the basic differences in both layouts and solutions required to process either black-and-white or colour negatives, positives or reversal-type emulsions. It must deliver film free from mechanical damage, correctly dried and washed either to commercial or archival standards as defined by recognised hypo-content tests.

In order to achieve these aims the basic equipment to process black-and-white negative films must include the following stages in this order:

(1) A film feed-in mechanism.
(2) Controlled development.
(3) Adequate water rinse or acid stop-bath.

(4) Film fixing solution.
(5) Complete washing system to remove residual hypo.
(6) Dust-free thorough drying facilities.
(7) A film-take-off mechanism.

Certain designs include a pre-wash between steps (1) and (2), and others favour the inclusion of a wetting agent between steps (5) and (6). In all machines provision should be made to prevent undue contamination of one solution by the waste products of another—usually carried over as surface liquid on the film. Obviously, many more stages are needed when processing colour film but, fortunately, the basic principles and 'mechanics' of the apparatus remain identical. Some idea of the problems involved in processing colour films can be gained from the following list of basic steps required to process a typical modern colour negative film:

(1) Pre-bath treatment.
(2) Spray rinse.
(3) Colour development.
(4) Spray rinse.
(5) First fixing bath.
(6) Wash.
(7) Bleach.
(8) Wash.
(9) Second fixing bath.
(10) Wash.
(11) Stabilizing bath.
(12) Spray rinse.
(13) Wetting agent.
(14) Drying.
(15) Lacquer protection.

Film development to a consistently high standard is only achieved when large outputs are involved by the inclusion of temperature control in the form of both heating and cooling (usually by immersion heaters and refrigeration); developers should be held within plus or minus $\frac{1}{2}°$ F. ($0.3°$C.) for black-and-white and within $\frac{1}{3}°$F. ($0.2°$C.) for colour film processing.

Developer activity (in the chemical sense) must remain extremely constant; this can be achieved either by limiting the film footage passed through a unit quantity of solution, and then discarding this entirely, or by continuously bleeding off a percentage of used liquid and replenishing with a controlled additive. The latter system is employed in all large installations and needs a resident chemist to make routine analyses of the developing constituents.

Developer activity (in the mechanical sense), or turbulation, must be sufficient to produce perfectly even results without being excessive or causing surface foaming. Because of this, solutions are usually circulated by chemical-resisting pumps or are agitated by bursts of nitrogen gas. Yet another technique to ensure even development is to spray the liquid on to the film strands rather than to immerse them in deep tanks of solution.

The prevention of solution contamination or *carry-over* by the film from one tank to another is usually achieved by some form of squeegee. This may be mechanical and, for example, in the form of rubber lips which lightly wipe each side of the film, it may be by compressed-air jets blowing against the direction of film travel, or by suction nozzles which draw off the surface skin of liquid as the film passes through them.

Film transport through the equipment must be at very accurately controlled speeds and is usually by sprocket, friction or tendency-drive mechanisms. The drive may in some cases be applied to upper banks of film rollers above the solution surface or, in other designs, it may be to the lower banks of rollers deep in the solution tanks. In every case the drive must be capable of such adjustment as may be necessary to provide developing times suitable for all types of film emulsions. Developing time can be altered either by changes in machine speed (if the requirements of fixing and drying are still satisfied), by changes in the amount of film passing through the developing solution or, of course, by a combination of both techniques.

Some continuous processing machines are designed to operate in normal room lighting. This is usually made possible by loading each film into a light-tight magazine—for which purpose a darkroom is required—but, in certain small units handling 16 mm. film supplied on daylight-loading spools, the magazine can also be loaded in daylight and without the use of any darkroom facilities.

The film path

In the larger continuous processing machines film is moved forward in a series of spiral paths—known as banks—and held in these paths by a large number of guiding rollers or sprockets. The number of rollers in any machine is related to the depth of the tanks and to the total length of the film path—and this is controlled by the activity of the solutions and the average speed of the machine. Thus the total *thread-path*, or the amount of film from the feed-in point to the take-up reel, may be under 100 ft. (30·48 metres), or anything up to 10,000 ft. (3,048 metres) or more, but this does not necessarily bear a direct relationship to the processing time in each machine. For example, a machine having a short thread-path may operate at high speed in combination with a very active developing solution, and thus achieve a time-through-the-machine approaching that of a machine having a long thread-path but operating at relatively low speeds in combination with a slow-acting developing solution. These observations reveal two very important facts applicable to all but the smallest machines.

Firstly, at any one instant a roll of film in the centre sections of a machine will be joined to other rolls both preceding and following it through the solutions, and these other rolls may well be the property of different customers. Because of this it is essential that *every* roll of film is inspected by rewinding in the dark room before processing and to locate any torn perforations or similar defects likely to cause breaks in the film path during processing. Such faults should always be removed

and the film on either side joined together by a mechanical stapling or similar system.

Secondly, film will travel through the machine by passing over a great number of guiding or driving rollers. In only a relatively small machine having a thread-path of 600 ft. (182·9 metres) the film may pass over 250 rollers. Because of this every precaution must be taken to prevent damage caused to the film by scratching or by foreign particles becoming transferred from the rollers to the film. One

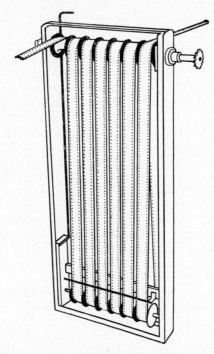

Fig. 4.3. A Processing Rack Loaded with Film

obvious precaution is to undercut the profile of the rollers so that contact with the film is only made at the extreme edges and well beyond the picture area. A second important requirement is that the film path be arranged so that, at all times, it is the film *base* and not the emulsion side which makes contact with the rollers and sprockets.

To satisfy these requirements it is almost universal practice to thread the film in a continuous spiral path and so that the base-side is in contact with the driving system. This principle is illustrated in Figure 4.3 and shows one very popular system of unit construction. Here a vertical stainless steel framework supports the upper roller assembly in fixed bearings, whilst the lower rollers are mounted in an

independent H-section framework capable of vertical movement within guide channels formed in the main assembly. Film enters the 'rack' by passing over the top left-hand roller and with the emulsion surface uppermost. It is then wound in spiral formation (under each lower roller and over each upper roller) until it passes over the last roller at the top right-hand corner. From here it passes to another similar rack but, because it travelled across the first rack from left to right, it will travel the second rack by passing from right to left. In this manner film may travel through any number of racks and always with the base surface in contact with the driving rollers.

Film guiding rollers may be formed in a number of ways: they may be so-called plain-parallel rollers, they may be undercut or releaved at the centre, they may be cambered to aid several widths of film always to 'track' in the centre of the rollers or, in one very recent design, they may be covered by a sleeve of soft rubber moulded with small upstanding 'pimples' which are quite sufficient to guide the film and which reduce the risk of damage to an absolute minimum. This last variation is used in conjunction with a tendency drive system incorporated in the machines manufactured by the Omac Company of Italy.

Since film always enters or leaves a rack by passing over the top left or right-hand roller, and providing these rollers are mounted above the level of the solutions in the tanks, it can readily pass from one rack to another in the same solution tank or, just as easily, to a further rack on the following solution tank. It is important to notice that a *keeper-rail* enclosing the strands of film is shown in Figure 4.3 just above the rollers in the lower assembly. As its name implies, this rail is a safety device to prevent loose strands of film disengaging from the lower rollers or becoming overlaid on each other. A similar and perhaps better technique is to fit a series of small guide rollers under the main lower rollers and so that the film must be positively threaded between the two assemblies.

Another very popular system of spiral formation is one employing *diabolo* lower rollers. With this arrangement the upper rollers are mounted on a common shaft similar to that shown in Figure 4.3, but all the lower rollers are completely independent of each other and merely hang in position at the bottom of each film loop. This system has the advantage that any changes in loop length due to film expansion or contraction are instantly accommodated without affecting neighbouring loops, but it requires every top roller to be replaced by a positive sprocket driving wheel. Naturally, with diabolo systems there is always a danger that a break in the film could release a diabolo roller into the bottom of the tank. This risk can be minimised by surrounding the lower diabolos with an open-work wire cage or basket into which free rollers can fall—and from which they can quickly be recovered.

A third method of mounting banks of lower rollers is shown in Figure 4.4. Here a cantilever casting or fabricated framework is fitted with ball-bearings to ensure smooth and sensitive movement along vertical guide channels. These units are particularly desirable in the film drying section of a continuous machine because, at this time, the loop lengths will be constantly changing as moisture leaving the emulsion causes the film to shrink.

Referring again to Figure 4.3 we see that, whilst film will enter the left-hand corner of one rack, it must enter the right-hand corner of the next rack and so on, the point of entry in each rack alternating throughout the machine. In this type of rack the lower rollers are mounted on a common shaft and, because of this, the film need only be driven by one sprocket wheel solidly connected to the upper shaft. All the remaining units on this shaft may be undercut rollers or bobbins quite free to rotate independently from the shaft and their neighbours. Naturally,

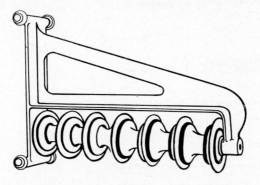

Fig. 4.4. Cantilever Roller Assembly

spacing washers or collars formed on the side faces of the rollers themselves are necessary to maintain this free movement.

Although only one roller in each upper bank need act as a positive drive and be fitted with sprocket teeth, the *position* it occupies is very important. Film entering or leaving a bank of rollers does so by only engaging the end rollers during rotation through an angle of 90° whereas, on passing over all the intermediate rollers in the bank, contact is maintained for 180° rotation. Because of this the driving sprocket is never located at one end of the bank. However, balanced suspension of the lower bank of rollers is most easily maintained when positive drive occurs as nearly as possible at each end of the shaft.

One popular arrangement which satisfies this requirement is seen in Figure 4.5. Those rollers indicated with a cross (X) are actual driving sprockets solidly connected to the driving shafts, whilst all other rollers are free-running and without sprocket teeth. Balanced drive is obtained because the position of each driving sprocket alternates from the end of one shaft to the opposite end of the next shaft and, in every case, it is the first roller in the bank over which the film will be wrapped a full 180°.

The illustration indicates a machine in which the drying compartment is at the side of the solution tanks (a method of construction favoured when space is limited) but the principle remains equally applicable to 'in-line' processing machines of conventional design. At this stage it has been assumed that all machines in which film is transported by a series of spiral racks must have a positive sprocket driving

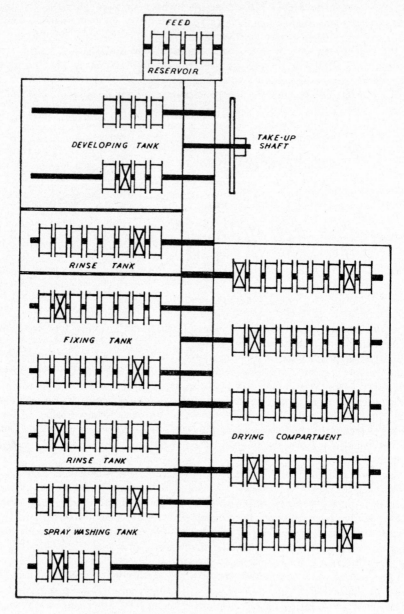

Fig. 4.5. Plan-View of a Processing Machine

at least one upper roller. This is not necessarily true: machines in which the basic drive is by a 'tendency mechanism' operate very satisfactorily indeed and with only plain friction rollers throughout the entire apparatus. Other machines propel the film forward on a cushion of air which is forced through a series of jets formed in the plain face of specially constructed hollow rollers.

Before returning to the basic design common to most processing machines it is necessary to consider the somewhat unorthodox layout of one particulary small

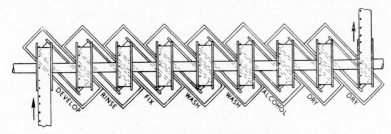

Fig. 4.6. The Lawlette Layout

machine. This unit was essentially designed to provide the modest output associated with television sub-stations which, although possibly situated in remote areas, must contribute topical film material to the main networks and do this with minimum delay. It also meets the requirements of industrial, research and similar film making organisations.

The spiral film path is retained although, for reasons of economy, space and weight, the continuous processing cycle is very simple and compact. These limitations can only be met by accepting a very low machine speed and unit-processing—in the sense that fixed volumes of solution are used and discarded before exhaustion reduces their acceptable life. The principle is seen in Figure 4.6 and, although indicating 16 mm. film, a similar unit may be used equally well for 35 mm. processing.

A single shaft running the entire length of the machine supports nine film driving sprockets above eight very small rectangular processing tanks. In the 16 mm. version these tanks each have a capacity of only $3\frac{1}{2}$ pints (2 litres) but, in the 35 mm. version this is increased to $9\frac{1}{2}$ pints (5·4 litres). The processing tanks are arranged in staggered formation and at 45° to the main top shaft. Large weighted diabolo rollers are supported by film which they form into loops between neighbouring upper sprockets. To do this one diabolo roller is supported near to the bottom of each tank.

The diameter of the diabolo rollers in relation to the upper sprocket driving rollers, coupled with the *spacing* between the sprocket rollers, is very important. The dimensions are such that a centre line through each diabolo intersects the centre line of the corresponding sprocket rollers at the maximum diameter as viewed in the plan. Film entering the machine over the further edge of the left-hand

upper sprocket travels vertically downwards in the first processing tank and for a distance of approximately 2 ft. (60·9 cm.). At the same time it gently turns through 45° and to line up with the diabolo roller across the bottom of that tank. After passing under this roller it rises parallel to the opposite wall of the tank and to reach a point immediately below the nearside edge of the second upper sprocket. Travelling over this second sprocket *transfers the film* from one tank to the next. In this manner film passes through each tank in turn, always in a spiral formation and with the base side in contact with the mechanism.

In a machine as small as this the film speed in highly active solutions is of the order of 6–8 ft. (1·8–2·4 metres) per minute. The solution in each tank is indicated in the figure—and it should be noted that an alcohol bath is used immediately before and to greatly assist the drying operation. In some models further drying capacity is made available by forming the film into a series of loops beyond the final compartment and, when this is done, the alcohol tank may be replaced by a further washing operation. Machines have been made to process colour film—merely be extending the upper shaft, increasing the number of top rollers and thus accommodating the greater number of processing tanks required for colour processes. These principles are embodied in the range of *Lawlette* machines produced by Newman & Guardia Limited. Models for both 16 mm. and 35 mm. are supplied with film magazines to accommodate either 100 ft. (30·48 metres) or 400 ft. (121·9 metres) although, in all cases the overall dimensions of the complete unit are somewhat smaller than a domestic refrigerator.

Such a compact layout is only achieved because a low film speed is acceptable and all solutions are discarded after processing a relatively short length of film. Although most recent models of the Lawlette include provision to connect solution storage vats via circulating pumps (and so to employ conventional replenishment techniques) this naturally tends to offset the initial virtue of compactness. The frequency with which solutions are changed in the basic machine depends upon the processing tolerances applicable to the work in hand—exhaustion tests made by using Ilford type F.P.3 film and Ilford Cinephen developer indicate a drop in control gamma from 0·68 to 0·66 whilst processing 400 ft. (121·9 metres) of 16 mm. film, whilst the control density dropped from 0·80 to 0·77 with a rise in fog level from 0·30 to 0·32. These figures and terms are explained in Chapter 6.

Lawlette machines are fitted with daylight-loading film magazines and no dark room is necessary. The magazine is permanently attached to the machine and contains a machine spool loaded with *leader-film* at least twice the length of the film path through the machine. Below this spool provision is made to mount the camera spool and the loading technique is as follows: The leader-film is first threaded through the entire machine. It is then broken apart at a point *within* the daylight loading magazine. The film to be processed is then mounted on the lower shaft in the magazine and its leading edge is stapled to the end of that leader film still remaining on the upper spool. The magazine door is then closed and all the camera film is wound on to the machine spool. The magazine door is then opened again and the outer edge of the camera film is stapled to the leader film previously threaded

through the machine. The magazine door is then closed and the machine set in motion. When all the camera film has been processed the leader film which follows it will automatically re-thread the machine for further use.

This brief description has introduced the term *leader-film*. This material is used in all continuous processing machines and, in appearance, is similar to conventional motion picture material. However, it is not coated with photographic emulsion and is approximately twice as thick as ordinary film. Because of this it may be used many times without the danger of breakage whilst in the processing machine. Its purpose is (*a*) to keep a continuous processing machine fully threaded in readiness for immediate use, (*b*) to follow the last roll of camera film through the machine and so to maintain this condition, and (*c*) quite often to intersect between films of different photographic characteristics which require alterations in machine speed, etc., to achieve optimum processing conditions. Naturally, such speed changes can only be made when the first film has passed beyond the developing tank, and before the next film enters it.

Conventional laboratory equipment

Commercial processing laboratory equipment often extends beyond a single workroom. Frequently the film loading area and so-called *feed-elevators* may be in one room, the main processing tanks in a middle room and the film drying area and *take-off elevators* in yet a third room. Film is then arranged to pass from one room to the next quite safely and through light-sealed apertures. To feed such a machine with chemicals main solution storage vats are accommodated in a separate area, conveniently near to another room where chemical mixing and analysis is carried out. Solutions are usually pumped to the processing machines through heavily lagged pipework to guard against temperature changes. If the machines employ air knives or suction nozzles to act as squeegees between each solution, then a considerable air compressing plant will also be installed in the laboratory.

There are three basic layouts generally found in commercial equipment. Those operated entirely within a dark room, those in which only the feed-in and developing stages take place in a dark room, and those which operate entirely in normal room lighting. It is therefore of little value in a book of this nature to give a detailed description of any one machine. Fortunately, the principles of large-scale continuous processing are common to all machines and can be described by reference to one of the relatively small modern layouts which may be easily photographed. Such a machine is the Omac daylight-operated processor illustrated in Figure 4.7 where, although all the film processing tanks are shown in the open condition and exposed to daylight, those in which development and fixation take place would normally be sealed by light-proof covers when the machine is in operation. The general arrangement consists of a series of vertical tanks assembled between the film feeding apparatus at the left and the film drying and take-off equipment at the right of the illustration.

Film transport through the machine is by a series of horizontal shafts supporting

film on rollers and in spiral formation similar to that previously described and illustrated in Figure 4.3, although in this model of the Omac range the upper shafts are of cantilever type in which the off-side remains unsupported. Providing the shafts are of sufficient diameter, are very accurately made and are supported in sturdy bearings, this design greatly facilitates the threading operation and also gives maximum access in the event of a break in the film.

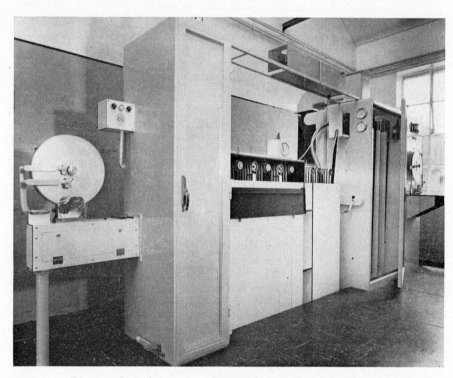

Fig. 4.7. One of the range of OMAC Film Processing Machines

Courtesy Visnews, Ltd.

The film back-plate (designed to hold rolls of film leader on their plastics cores), the splicing table and feeding elevator contained within the large vertical cabinet constitute the 'supply' end of the machine and are seen at the left of the illustration. This equipment ensures that rolls of film may be spliced together and fed continuously through the processing tanks without interruption. After passing through the last processing tank, shown towards the right of the picture, the film travels through an air squeegee and into the drying cabinet. As mentioned previously, squeegees of one type or another are commonly used not only at this point but throughout the machine where film passes from one solution to another. Similarly, although a drying

cabinet is shown at the right-hand or 'take-off' end of the machine, this could well be a complete room in which several thousands of feet of film are dried very slowly. In any event, beyond the drying area film must pass to a take-off elevator and wind up on to a conventional plastics core or spool—this unit obviously operates in the reverse sense to the feeding mechanism to enable films to be removed from the machine without interrupting the continuity of the process.

Machines of this type function continuously and must therefore remain loaded with film before and after processing actually takes place. For this purpose machine-leader of the type previously referred to is initially threaded into each section by hand. This is usually done by first raising the lower banks of rollers to a position well clear of the solutions and then, once threaded, allowing each bank to 'fill' individually and by momentarily engaging the main driving mechanism. In some commercial machines the entire rack assembly can be raised automatically and as a complete unit during this initial threading operation.

Threading a machine is inevitably somewhat tedious and, if all other operations are given due care, should only be necessary on the rare occasions when a film break occurs or, of course, after the machine has been emptied for cleaning, etc. Once a machine has been threaded provision must exist to attach the leading edge of each roll of film which is to be processed and, with the machine running at high speeds, a cemented join is not practicable. This is overcome either by using a speci-ally designed pair of riveting pliers which insert a form of staple between two over-lapped film ends, or by a machine somewhat similar to a film splicer but which inserts rivets or staples whilst the overlapped films are clamped together in registra-tion. It can also be achieved with certain types of waterproof adhesive tape. The precise technique depends on the type of film drive used in the processing machine because, if sprocket teeth engage the film perforations any overlapped film join must maintain true perforation registration whereas, if a friction or tendency drive is used, precise registration across the film join is not necessary.

Feed rolls and film elevators

Film may be prepared for processing either by first rewinding it from the camera magazine directly on to a plastics core which will then be supported on the processing machine by a circular vertical back-plate (when the feeding section of the processing machine is in a darkroom), or by rewinding into a special processing machine magazine if the feeding section remains in daylight. It is very important to note that, in any event, the film is *never* taken directly from a camera and fed into a processing machine without first passing through some system of rewinding—and during this rewinding operation it is essential to inspect the film edges to detect and remove any torn or damaged perforations.

In some processing machines the film-feed elevator is large enough to accommo-date a whole roll of film, and it is therefore totally enclosed in a light-proof cabinet. Under these circumstances it is only necessary to provide accommodation for one roll of material or one film magazine to feed into this elevator cabinet. An alarm

signal system is usually fitted to the film supply equipment and is arranged to cause a buzzer, a bell or a flashing light to warn the operator that the ingoing roll of film is *almost* exhausted (there is no point in warning him *when* it has become exhausted!).

One popular alarm mechanism consists of a simple pivoted arm carrying a roller mounted in ball-bearings and recessed so that only the extreme edges of the roller touch the film. A mercury switch attached to this arm closes only when the film roll diameter has become reduced to a predetermined size. Closing the mercury switch must then operate two circuits: firstly it must stop the supply of film before the end of the roll passes into the machine and, secondly, it must warn the operator that this has happened. It is very important to select an appropriate warning system because, if several machines are installed in one area an audible system may not readily indicate which machine requires attention. Similarly, warning systems are often fitted to other sections of the machine—for example, to indicate if the arrangement of film loops in any of the processing tanks is becoming unbalanced. It is therefore also important to select warning systems which not only distinguish between machines but also between the various sections of any one machine.

Immediately the supply of film is interrupted and brought to a halt by the alarm system the trailing end of the exhausted roll must be joined to the leading edge of a new roll. If it so happens that no further rolls of film are available for processing at that moment then a roll of machine-leader must be used to 'clear' the last film through the machine and leave it threaded in readiness for future use. Film splicing is a relatively simple operation which may be accomplished in several ways; one of which is illustrated in Figure 4.8.

This unit consists of a channel having two spring-loaded dies mounted flush with the base; the two films to be joined together are overlapped at this point. Most units are fitted with pilot pins to accurately register the film perforations during the splicing operation. The film channel is divided into two halves with a spring-loaded clamp located either side of the dies. These clamps hold the films in position after they have been registed and until after the splice has been made. Before placing films into the splicer two metal rivets are inserted in the cupped heads of the dies—to save valuable time an efficient operator will usually 'load' these dies with new rivets immediately a splice has been made and in readiness for the next operation. A heavily built punch mounted above the dies carries two pins which perforate the films, force them over the rivet heads, close the rivets and finally lock the two films together. These actions are completed in one operation and merely by closing the punch smartly over the film path. Before finally releasing the films the edges of the join should be trimmed back close to the rivet heads.

The time required by an operator to join two films together is independent of the machine speed and, generally, is well within 45 seconds. Even so, the processing system must always be continuously fed with film and an interruption or pause of even this short duration could not be tolerated. This requirement can only be met by providing a reservoir of film between the splicer and the processing tanks and on which the machine can draw when the main supply is interrupted. A film-feed-elevator is employed to provide this reservoir. The term 'feed-elevator' is obscure

since the unit really is a reservoir—it presumably derives from the fact that the lower rollers in the unit become elevated as the reservoir is consumed.

A film-feed-elevator may be considered as an assembly of film supported in the spiral formation previously shown in Figure 4.3—or as any number of these assemblies working together. However, in an elevator the upper rollers rotate about a fixed axis but the lower rollers are mounted in a carriage so as to move vertically in a

Fig. 4.8. A Film Splicing Unit

framework and along highly polished guideways—in a manner rather similar to a lift rising in its shaft. Such an assembly is enclosed within the large cabinet seen to the left of Figure 4.7. Under normal conditions of continuous operation the lower banks of rollers in the elevator remain at the bottom of their guideways. However, they cease to do so when the supply of film becomes arrested because a new roll must be introduced and since, under these conditions, the processing cycle may not be interrupted. The machine continues to obtain a supply of film by consuming that which is stored in the elevator or feed-in cabinet. In doing this the lower roller assemblies slowly travel upwards and, of course, the amount of film stored in the elevator must be such that, even at the highest operating speed, the time taken to consume the reserve supply would be greater than that needed to complete the splicing operation. Incidentally, the lower roller assembly in the elevator is weighted so that, immediately the new supply of film becomes available, it will gently fall to its lowest position and thus restore the reservoir to full capacity; to avoid undue shock or the possibility of loose film loops becoming entangled when reaching the end of its travel, the roller assembly is cushioned by coil springs or similar damping during the last few inches of travel.

The movement of this lower roller assembly along its vertical guideway can be used to provide warning signals to the operator. For example, special magazines in which the film end is positively secured are employed with the Lawley Junior processing machine so that, immediately the film supply is exhausted the lower rollers in the feed-elevator begin to rise in their guideway. After only moving a very short distance they engage a microswitch to ring a buzzer. This warns the operator to introduce a further supply of film and, should he fail to complete the task before all the film in the elevator has been consumed, the lower roller assembly

will then reach a second microswitch which, through a relay, will stop the main driving motor. Under such unlikely conditions it was thought best to over-develop that film still remaining in the solution, rather than to risk damage to the machine or breakage to the film.

Processing tanks

The material used to fabricate or construct processing tanks depends to some extent upon the size of the tanks and, therefore, upon the weight of liquid they must support. In very small machines such as the Lawlette, with a developer capacity of only $3\frac{1}{2}$ pints (2·0 litres) and also in the smaller Omac machines the tanks may be moulded or laminated P.V.C.; in somewhat larger machines such as The Houston-Fearless, The Filmline and The Lawley Junior the tanks are of high quality stainless steel; the much larger Debrie D.U.C. and similar machines favour moulded hard rubber (ebonite) tanks whilst several other manufacturers have used soapstone or specially treated teak.

The choice of materials is influenced very much by the corrosive nature of the processing chemicals—and in this respect is much more restricted when the machine is intended for processing colour films than when its use is limited to black-and-white film processing. The choice is also influenced by the methods used to circulate the solutions, the system of temperature control and also the tank drainage facilities. For example, if the installation is relatively small and transportable developer circulation is normally confined to merely that volume actually held within the processing machine—and this implies a built-in circulating pump arranged to draw liquid from a point just below the solution surface and to return it at a point near the bottom of the tank. Due to the hazards of connections made at the base of some tanks, it is preferable to return solutions via an elbow-joint near the top of the tank and leading to an internal pipe extending to a point just above the bottom of the tank. These considerations frequently suggest the use of stainless steel throughout the construction.

Similarly, some problems of solution temperature control which involve refrigeration can sometimes be solved if the side-wall of the tank can be arranged to make effective and intimate contact with a so-called 'refrigeration pack' and, once again stainless steel would be the obvious choice. In larger installations various forms of 'heat-exchange' units can be arranged to circulate the developing solutions in tubes and through water jackets which are held to the required temperature. Tank drainage facilities are also very important and may be restricted in very small machines—it then often becomes necessary to remove the complete unit from the machine for draining purposes. In such cases moulded P.V.C. sheeting or equally light-weight materials offer many advantages.

Developer circulating pumps

In most installations developer circulating pumps are required for three reasons: to circulate the solution sufficiently to maintain an even temperature throughout

the bath; to guard against the formation of small pockets of highly concentrated solution either on the film itself or near the inlet from the replenishing system; to prevent partially exhausted solutions from remaining as an intimate skin travelling with the film—it can be shown that the solution actually touching the emulsion requires considerable agitation before it can be removed completely.

To perform these functions the pumps are usually arranged to remove solution from the top of the tank and to force it in again at the bottom, care being taken to ensure that the rate of circulation or the points of exit and entry do not cause surface foaming or internal solution bubbles. The same pump may also be arranged to draw the supplies of freshly made developer from the chemical mixing room either directly into the processing tank or, alternatively, into a replenisher tank usually situated above the processing machine and so that it may in turn feed the machine by gravity. Any of these functions can be arranged to occur when only one pump is employed for each type of chemical (developer, fixer, colour bleach, etc.) and providing a three-way non-return valve system is situated between the pump and the various tanks it is required to serve. In order to do this work efficiently the pump must be capable of circulating the total volume of 'working solution' at least once every half-hour, it must remain inert to the action of corrosive chemicals and, in some colour film processes, it must operate perfectly satisfactorily at temperature of the order of $110°$F. ($43°$C.).

Solution replenishment systems

Modern operating techniques with very small machines often dispense with replenishment systems and rely upon knowledge of a *safe-exhaustion-footage*. This means that sensitometric tests have been carried out to previously establish the drop in photographic quality measured against the film footage which can be processed in a unit 'mix' of chemicals. For example, tests with monochrome films have shown that Ilford Cinephen developer diluted so that one part of developer is added to six parts of water to make a total volume of 7 gallons ($31·8$ litres) will process 5,000 ft. ($1,523·9$ metres) of 16 mm. negative film to control standards well within acceptable tolerances for television transmission. If this footage is not likely to be exceeded in less than one day or any greater period up to five days, it is more economical to discard the total volume when that footage is reached than it would be to employ chemical analysis technicians and solution replenishment systems.

However, replenishment systems must be used in all large laboratory installations, and one simple method is to use a constant-head device, rather similar to an automobile carburettor. This is located above the processing tank and is connected to a replenisher tank, thus ensuring a steady feed into the main processing solution. The rate of replenishment must be calculated and adjusted according to the rate of film travel through the machine since a given footage of film requires a given quantity of replenishment (this quantity will also vary according to the *type* of film which is being processed). Developing power, or the power of any other processing

123

solution, becomes reduced by two main causes: firstly by the solution itself becoming exhausted and, secondly, by the film carrying a considerable quantity of solution from one tank into the next. In large equipment it is necessary to provide squeegees between all tanks to ensure that only the very minimum volume becomes lost in this manner. Naturally, the formula used in developer replenishment is usually different from that of the basic solution—for example, it is designed both to replace exhausted chemicals and, in simple monochrome processing, also to counteract the bromide released from the film emulsion itself during development. Obviously, when processing colour films the replenishment of all solutions becomes somewhat more critical, but the basic principles and techniques of chemical analysis related to processed results remain similar. Fixing solutions may also be replenished in a similar manner although, of course, the exhausted fixer contains a high percentage of pure silver and great economies can be effected by first passing exhausted fixer through a *silver-recovery* unit.

Silver recovery

Although not an integral part of the film processing cycle, it is appropriate to consider silver recovery at this point because it is closely related to the economics of any processing installation. When the useful life of a fixing solution expires the bath must contain the silver removed from all the films which passed through it. This dissolved silver is quite valuable and can be recovered so that, when the quantities are large, a *silver-recovery* plant is very worth-while. The actual silver content of a bath depends directly upon the type of film which has passed through it and the amount of liquid which has been mechanically carried into and away from it by film transport. There are several methods whereby dissolved silver may be precipitated; the choice of any one depending upon the volume of liquid which must be handled by the installation. Zinc in powder, granular or sheet form may be used to precipitate silver in small volumes, although the speed of this operation is generally very slow. It is improved if the bath is decidedly acid and, if tests show it to be alkaline, then glacial acetic acid should be added until optimum conditions have been established by experiments with samples drawn off the main tank of solution.

When larger quantities of exhausted fixer are to be treated, sodium sulphide is more economical and certainly more rapid. Acid fixing baths should first be neutralised by adding caustic soda or waste developer—unless this is done very unpleasant fumes of hydrogen sulphide will be liberated during the process. Such work should only be carried out at some distance from the film processing laboratory because the fumes could contaminate developing and fixing solutions in regular use.

The more attractive technique, and certainly the easiest to handle, is to remove silver from an exhausted bath by electrolysis. Metallic silver can be deposited immediately and in useful form because it is removed in an electro-plating process and on to the actual cathode—usually the paddle or blade of the stirring device

used to agitate the solution. With this technique the saving is twofold: the recovered silver can be sold and, at the same time, the rejuvenated fixer may be returned into service. As a general guide an average of 1·0 ounce (28·4 grams) of silver may be recovered per 1,000 ft. (304·8 metres) of 35 mm. film, whilst 0·4 ounce (11·4 grams) may be recovered from a similar length of 16 mm. film.

Film squeegees and air knives

These are terms used to define any unit intended to remove surplus liquid from both the emulsion and base-side of film. Those which depend upon mechanical pressure are more correctly described as squeegees, whilst those relying on air pressure or suction are known as air knives although, in practice, the term squeegees is loosely used to describe any unit designed to remove surplus liquid. Squeegees are also used to prevent film carrying solution from one tank to another. It can be shown that under certain conditions of film speed and machine design—and apart from the solution trapped within a swollen emulsion—35 mm. film will carry as much as 1 pint (0·57 litre) of liquid from one tank to the next whilst 1,000 ft. (304·8 metres) passes through the system and if a squeegee is not applied to the film as it passes between the tanks. The loss of valuable solution is one consideration—equally important is the risk of contaminating the following solution with partially exhausted chemicals from the preceding one.

Because of this squeegees are fitted between all solution tanks in a well designed machine, and also between the final washing tank and the film drying compartment. All free or surface moisture must be removed from the film before it enters the drying area for two reasons: firstly to ensure the film will dry in the shortest possible time and with the least amount of heat and, secondly, to avoid drying marks which would occur if spots of water became 'dried into' the emulsion. If random droplets of water do remain on the film and enter the drying compartment they quickly induce local heating and, in fact, tend to *fry* that section of the emulsion beneath them. This results in a glazed spot which, unfortunately, can rarely be removed by after-treatment or by repeated washing.

One form of air-squeegee or knife is shown in Figure 4.9 attached to the wall of a small drying cabinet. It is arranged so that film passing from the final washing tank and into the cabinet must pass mid-way between the two nozzles. These nozzles are usually very fine slit-apertures fed with compressed air at high velocity—surplus water is more effectively removed by air *speed* rather than by the degree of air pressure. In this example the squeegee consists of a vertical plate supporting two air nozzles, one on either side of the film, together with a series of guiding rollers. The nozzle-angle is adjustable and the guide rollers are recessed so that contact with the film is only made at the extreme edges. A swinging jockey-roller, resting on the emulsion surface, prevents the film from blowing against the upper nozzle—apart from scratching the emulsion, this would also foul any stapled joins made between neighbouring films.

Instead of squeegees in the form of air jets which blow against the direction of

film travel, some manufacturers favour *air-suction*. Whilst this reduces the possibility of dirt or grit particles being blown on to the film due to poor compressor maintenance, it does require a very fine control on the precise location of the film between the nozzles. Surplus liquid is also sometimes removed by using rubber-lipped squeegees—these actually press very lightly on to the film surface and

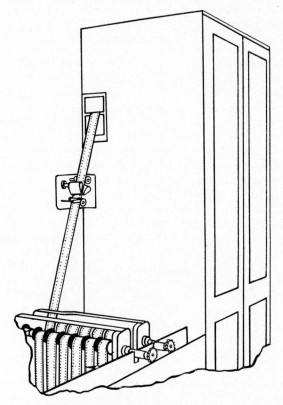

Fig. 4.9. Compressed-Air Squeegee

gently wipe the film as it passes between them. Although very simple and efficient if frequently serviced, rubber squeegees do tend to trap foreign matter between the lips and so create 'tramline-scratches' or, once the grit has been removed, may present an irregular blade-surface to the film. This latter condition permits a thin ribbon of liquid to remain on the film which, if it occurs just prior to drying, can be extremely serious.

A very ingenious system was used during early experiments by The Baird Television Company when a rapid film processing unit was used in conjunction with a telerecording camera. Naturally, the problem of removing surplus water in a

rapid process is very severe and, in this case, was overcome by passing the film through a large trough of mercury. The weight of mercury pushed against the film and forced the water away from the surface. Unfortunately a very considerable volume of mercury is necessary for this system to be effective—and the presence of free mercury in the vicinity of any unprocessed film presents a great danger due to chemical fogging—in fact, for certain purposes the speed of films can be increased by a technique employing mercury vapour!

The drying operation

Most designers recognise the advantages of drying film as slowly as possible. Because of this drying compartments are often the largest part of a continuous processing machine and, in some installations, may extend the whole length of a room. The aim is always to produce a dry film *normalised* to the correct flexibility and water-content—because, even a 'dry' film must contain some moisture or it would be brittle and snap apart on projection.

The correct moisture content is more easily achieved in a large installation and merely by steadily and slowly drying until the desired condition is reached. However, when speed is essential, or a compact machine is required, it is necessary first to over-dry the film quickly and then to allow it to pick up moisture again in the final sections of the drying area. This is because film will absorb moisture quicker than it will release it. However, rapid drying techniques must be very carefully controlled because, if taken to extremes, they tend to first dry the surface skin of the emulsion and, once this occurs, it is very difficult to dry out the under layer of emulsion between that skin and the film base. This produces the effect known as a *green film* and, incidentally, explains why the surface of a green film emulsion tends to pick-up on projection and for emulsion to build up in the projector gate during the initial running of such a film.

One point which is often misunderstood is that it is wind-speed and *not* heat which is required to dry film efficiently. Providing a good flow of air passes through the drying area the temperature need only be of the order of 90°F. (32.2°C.). It is also of great assistance to control the flow of air so that heavily moisture-laden air cannot come into contact with partially dried film. The arrangement of one relatively small drying cabinet is shown in Figure 4.10. The film path is in a spiral formation identical to that used throughout most processing machines. The important point to note is that, even in this short cabinet, a sheet-metal plate extends from the ceiling almost to the floor of the central area to divide the cabinet into two *ducts*. Air is drawn into the cabinet through the top right-hand section of the ceiling, passes down the right-hand duct, across the floor and then upwards through the left-hand duct to an exit in the ceiling.

Since the film enters the cabinet from the left and leaves at the right, it is always travelling *against* the flow of air and, therefore, is always travelling into relatively dry air. It is usually better to create an air flow by blowing into the cabinet rather than extracting or sucking air from it—one very important reason for this is

connected with dirt and dust. Unless the joints between the cabinet doors and frame-work are completely air-sealed, the dirt collected near these joints will be drawn into the cabinet (and thus on to the film) by a suction plant whereas, with a blowing system, this same dirt will be forced away from the door joints, etc. For similar

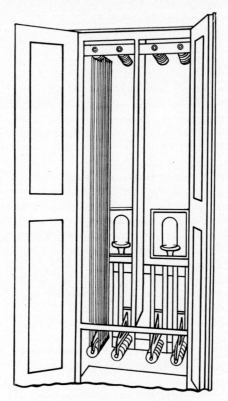

Fig. 4.10. Film Drying Cabinet

reasons all inlets to the system must be through very efficient air filters which receive frequent maintenance. Whilst in the drying cabinet the film is exceptionally vulner-able to dirt and dust which, should it impinge on the soft swollen emulsion in the early stages of drying, may well cause permanent damage which no amount of re-washing or after-treatment can completely overcome.

The appearance of drying film

With any drying system it is always important to know the exact point at which film becomes dry. Fortunately film exhibits a very definite indication which is both

positive and accurate. If a length of film is thoroughly soaked in water and then suspended from one end it will show a marked tendency to curl in a tubular fashion. This curling will cause the side coated with emulsion to become convex, and the uncoated side to become concave. Such a condition is known in the trade as a *negative curl*. If the same length of film is then thoroughly dried it will pass through two phases: firstly, it will gradually flatten out so that the tubular effect is completely eliminated and then, as drying proceeds, it will start to curl again—but this time in the reverse direction. The uncoated side will become convex and the coated or emulsion side will become concave. This condition is known as a *positive curl*.

Because of this one can estimate with considerable accuracy the position in the drying area at which the film just commences to dry. It is that position where the film has passed from its first curled state and has become reasonably flat. However, drying must continue for some considerable time beyond this point in order to produce films which have been dried sufficiently for them to be wound up with safety. The film should pass from the first, or negative state, to the reasonably flat condition by the time it reaches the middle of the drying area.

The take-up elevator

The purpose of the take-up elevator is the reverse of that of the film-feed elevator since it provides a reservoir into which film may be fed whilst the take-up spool has been stopped in order to remove a full roll of processed and dried film. While the machine is running, and when rolls of film are not being removed from the take-up spool, the lower rack of this elevator is therefore at its *top* position. When the take-up spool is stopped to allow the removal of a film, this lower rack gradually travels down the guide channels. During this time the operator must remove the full roll of film, place a new empty core or spool on to the take-up spindle and attach the end of the next roll which is coming from the drying cabinet. A ratchet and pawl or similar hold-back device is fitted to the last top roller of this assembly to prevent the loose end of film slipping back into the drying cabinet when it is cut away from the completed roll.

Constant tension take-up

It is essential that processed films are finally wound into perfectly smooth rolls which are correctly tensioned throughout and in which each convolution or 'turn' is applied to its neighbour without the possibility of slippage or 'cinching' taking place between them. The tension in any simple spring-loaded slipping clutch mechanism is dependent upon the diameter at which it is operating and, when winding film into rolls the effective diameter is continuously increasing. Because of this it is necessary to employ more refined methods to ensure the film tension remains constant and independent of roll diameter. This can be achieved electrically and by employing variable-torque motors, but a more economical solution to the problem can readily be achieved by mechanical means.

5

The principle of mechanical constant tension take-up is illustrated in its most simple form in Figure 4.11. Here a conventional bank of film held in vertical spiral formation is indicated at G—the upper rollers in the bank rotate about a fixed centre whilst the lower rollers A are mounted in a cradle which is free to move

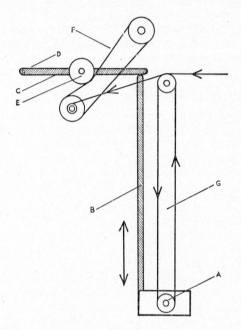

Fig. 4.11. A Constant-Tension Take-up System

vertically within a guide channel. Attached to this cradle is a vertical rod B which obviously moves upwards or downwards together with the lower cradle. The upper extremity of rod B is in contact with a lever C which is pivoted about point D. A jockey pulley E is freely mounted at a point mid-way along arm C and is arranged to bear against a belt F. This belt transmits drive to the film take-up shaft. The length of the belt is such that positive drive is only transmitted to the take-up shaft when cradle A is at its lowest position—at any other position a varying degree of slippage occurs between the driving belt and the pulley mounted on the take-up shaft. By this means a perfectly even roll of film may be formed with a constant tension throughout. The precise tension may be adjusted according to the weight of the lower cradle A or by applying weights or spring tension to lever C. Incidentally, it is always preferable to apply known 'dead' weights in a lever system of this type rather than to rely on springs which, inevitably, cannot exert a constant tension at all degrees of extension.

Methods of film transport

Having now described the main features common to all processing machines, we can consider variations on the all-important film drive or transport system. Apart from the system already discussed, there are three other popular designs at present favoured by trade laboratories: firstly, a rack system employing diabolos in the position of the lower rollers—as extensively used in some of the machines made by W. Vinten & Company Limited. Secondly, a system which is basically similar to that described here in detail, but in which drive is transmitted to the *lower* rollers, deep in the processing tanks, whilst all the top banks of rollers are free-running on their shafts. Thirdly, a system employing tendency-drive in which the film is caused to travel through the entire machine without engaging the perforations with any sprocket wheels or relying on friction between the film and driving rollers. A mechanical embodyment of such a system has been used very successfully by the Eastman Kodak Company and an electrical version of the same principle has recently been introduced by the Omac Company of Italy.

The diabolo type of film rack is similar in general arrangement to the rack previously described in detail, except for the following important points: firstly, all the top rollers are replaced by sprocket wheels so that, once the rack has been threaded with film, a positive drive is maintained—this also permits each film loop to shrink or stretch quite independently and without affecting the condition of neighbouring loops. Secondly, loop-shape is only maintained by large, heavy bobbins fitted with side-flanges and known as *diabolos*. Each diabolo is quite independent from its neighbours and, therefore, may be held in loops of different length—under certain circumstances this can provide a fine control on a precise developing condition.

In the second system, where the lower banks of rollers provide the drive whilst all the top rollers are free-running, the theory is somewhat different. Here it is assumed that any over drive will be automatically rectified because, should this occur, it means that the loop following the over-driven one will become slack and, due to its own weight, will hang free from its lower driving roller. Thus an even driving tension will be created throughout the machine. This system operates very satisfactorily but requires a high level of mechanical engineering with gears and bearings which are not affected by the chemicals of the various solutions—because of this it is also relatively expensive. The third system, known as the *tendency-drive* is so very different from the others that two versions of it will be described in detail.

The Eastman tendency drive system

In the Eastman Kodak mechanical system constant film-loop size is maintained throughout the machine and at no time is the film driven by sprocket teeth or by conventional friction-drive rollers. One may well ask why driven sprockets should not be used; the answer is that, quite apart from the advantages to normal 35 mm.

perforated film, many photographic recording processes employ film which is not perforated at all, and could therefore only be processed on a machine of this type, or by friction drive and with the attendant possibility of scratching, or by individual rack-and-tank methods. The Eastman machine is fitted with racks similar in principle to those described previously but, as seen in Figure 4.12, the difference lies in the *method* by which these racks are driven.

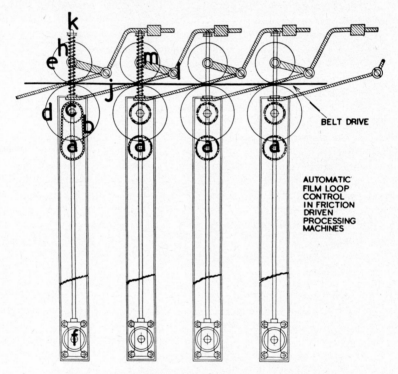

BELT DRIVE

AUTOMATIC
FILM LOOP
CONTROL
IN FRICTION
DRIVEN
PROCESSING
MACHINES

Fig. 4.12. Principle of the Eastman Tendency Drive

The rollers in this machine corresponding to the top bank of rollers in other machines, and over which the film is carried, are mounted on shafts seen at A; all these rollers are exactly alike and none are fitted with sprocket teeth. The lower rollers, shown at F, are similar in design to those previously described. Drive to the top rollers is via chain B, from sprocket wheel C mounted on a short spindle also carrying the flanged pulley-wheel D. This pulley is driven by an endless belt shown between it and the weighted roller E. It is the adjustment of contact between the belt and pulley D, by pressure from roller E, which controls the speed at which the film rollers rotate.

This adjustment can only be effected by the one variable in the system, namely, the distance between the top and bottom rollers in the film racks. It is essential to appreciate that film will become loose not because the rack preceding it is feeding film in at high speed, but because the rack *following* it is not taking film out fast enough. Similarly, film will become very tight because the following rack is taking film too rapidly, not because the preceding rack is operating too slowly.

The lower racks are fitted with thin vertical rods between F and K, passing upwards through the top of the rack framework. The upper section of each rod is fitted with a compression spring H which bears on arm J. The tension imparted to arm J may be varied by the control knob K. However, arm J is part of the control mechanism attached to the *adjacent* rack. In order to follow its use more clearly we must observe the action step by step.

If the lower rack in the first unit rises, it will only do so because the second rack is taking film at a speed higher than the first rack is receiving it. However, since such a condition will cause the lower rack to rise, rod F–K will also rise and the spring tension will be taken off arm J. Arm J will then rotate in a clockwise direction about bearing L and so lift arm M. It will be clear that, as arm M rises, the tension on the drive to the *second* rack is reduced and, because of this, the film will not be taken so rapidly from the first rack.

Let us now see what happens if tension on the drive to the second rack has been reduced more than is necessary. The lower rack in the first assembly will fall to its lowest position and, since all the racks are initially threaded to a position a few inches above the bottom, this will cause spring H to pull arm J downwards. This anti-clockwise motion in arm J will increase the drive to the second rack and so increase the speed at which the film is removed from the first rack.

Obviously, a balanced condition will quickly be reached in which the tension drive to each rack has been automatically adjusted to bring it in harmony with the neighbouring racks. The third lever on each tension adjusting assembly is merely to provide a counter-weight to the mass of the roller E.

The Omac electrical tendency drive system

The basic principle of the Omac system is to employ a separate electric motor to drive the top shaft in each bank of rollers throughout the processing machine. The type of motor used for this work is extremely important and is the essence of the design. With the exception of the drive to the *first* bank of rollers, every succeeding bank is each driven by a so-called *constant-torque* motor. The first bank of rollers is positively driven by a variable-speed motor.

The important characteristics of a constant-torque motor are (a) that it must be operated against a load and will not develop a constant torque unless this load is applied and, (b) once adequately loaded the torque (or turning force) remains substantially constant over a limited range of speeds. This range is approximately 5 : 1 and the motors used in the Omac equipment are geared to provide an effective film transport speed range of between 10 and 50 ft. (3·05 and 15.24 metres) per

minute. The necessary loading is obtained by using a variable-speed motor as the first link in the chain of motors throughout the system—that is to drive either the first bank of rollers in the first developing tank or in the pre-washing tank if such a treatment is employed. The variable-speed motor therefore acts as a so-called 'pacer' to monitor the speed at which film is introduced to the rest of the machine and, in fact, the torque motors are always striving to drive slightly faster than the 'pacer-motor' will allow. This hold-back function of the variable-speed motor raises the load on the torque motors sufficiently to cause them to function within that range of their speed/torque characteristic in which the torque remains substantially constant.

Parallel to this a system of automatic load balancing forms a very important part of the Omac system. This is best understood by reference to Figure 4.13 in which two banks of rollers, each driven by its own torque motor, are shown together with the associated electrical control system. It is very important for the full understanding of the detailed description which follows to note that film is travelling through the machine *from right to left* as shown in the illustration. Parallel numbering is used in each bank of equipment shown in the figure, but all those numbers identifying parts of the right-hand bank, and electrical components controlling that bank, are characterised by a dashed suffix. Thus, the torque motor driving the left-hand bank is labelled (5) whereas the similar motor driving the right-hand bank is labelled (5').

The lower banks of rollers in each bank are mounted on a shaft (20) supported in a bearing-block (2) which can travel vertically in guideways formed in the processing tanks. A rod (23) attached to each block (2) passes through a guiding pillar (24) and is constrained by spring (27) and collar (26). This mechanism creates tension in the spiral film formation which becomes balanced against the tension applied to the film *between* the two banks. Tension between the banks is created by the jockey roller (6) mounted on spindle (64) which is supported by arm (61). This arm is under tension by spring (63) to turn in a clockwise direction—thus creating tension in the strand of film between the two banks of rollers and, therefore, balancing the tension created by springs (27) and exerted on the bearing blocks (2).

An extension to the right of lever (61) carries two electrical contact-breakers, one to make or break contacts (52) and (52') and the other to make or break contact (7). Under normal running conditions the upward or downward movement of jockey roller (6) either 'makes' contacts (52) *or* contacts (52'). Contacts (7) will only be closed if the jockey roller (6) moves upward by an amount much greater than normal and, in fact, this only happens if a break occurs in the banks of film on either side of the jockey roller.

Each torque motor is energised via a pre-set rheostat (50) and the adjustment of this component controls the speed of the motor and, therefore, the tension between each bank and, collectively, throughout the machine. It will now be apparent that, if means can be provided to 'short-out' the rheostat to any motor this action will cause that motor to accelerate to maximum speed. It is precisely this facility which provides the tendency drive in the Omac system. Imagine that the film loops have

134

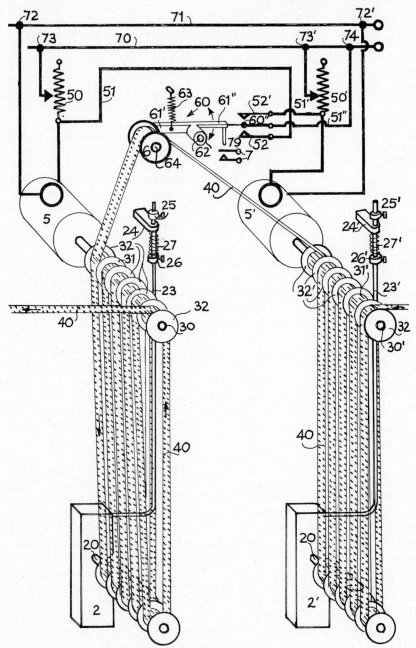

Fig. 4.13. The Omac Electrical Tendency Drive System

become loose or slack in the *right-hand bank* in Figure 4.13; this will allow jockey roller (6) to rise and thus cause contacts (52) to be closed. This shorts out rheostat (50) in the circuit of motor (5)—that is, the motor controlling the speed of the *left-hand bank*—and this motor will now run at full speed. By so doing it will take up all the slack film in the right-hand bank and continue to do this until sufficient tension has be n restored to draw jockey roller (6) downwards and so to open contact (52) once more—this restores the rheostat (50) into the circuit and motor (5) will then return to normal running speed.

Similarly, if the film loops in the right-hand bank become too tight this will cause jockey roller (6) to move downwards and thus close contacts (52'). This action will short out rheostat (50') and cause motor (5') to run at full speed—thus drawing more film into the right-hand bank so reducing the tension on the film loops. By this means balanced film tension is created throughout the entire machine.

In the event of a film break jockey roller (6) will be pulled upwards under the tension of spring (63) and will travel sufficiently to close electrical contacts (7). This causes a warning circuit to come into operation and to illuminate a red lamp over the tank where the break has actually occurred. It can also be arranged to illuminate a similar lamp on an indicator board at any remote point (for example, in a central control room) and to ring a warning bell. When a film break occurs the machine automatically stops—unless this happened film might become unthreaded from several banks of rollers before the trouble was overcome.

General safety devices

Those well experienced in operating film laboratories generally agree that the efficiency of a continuous processing machine, and freedom from film damage, breaks, etc., depends to a considerable extent upon first-class maintenance. Whilst it is true that some designs require more precise and frequent adjustment than others, the wise laboratory manager will establish a maintenance and inspection *routine*, rather than wait for trouble to overtake him. Such a routine is broken down into three groups: those items which should be checked, cleaned or adjusted on a daily basis, those which are attended to each week, and those which can safely be left for routine monthly inspection. Apart from this, it is also wise to give the entire machine a complete overhaul at least once every year.

Experience has shown that good design should include certain safety devices intended to prevent serious damage building up from an apparently small initial fault. One example of this is found in so-called *stripper plates* often used in machines which incorporate sprocket drive. When film is wrapped 180° round a driving sprocket it is always possible that a misplaced join or a torn perforation may cause film to momentarily catch on the sprocket teeth and fail to disengage. When this happens the film is carried round with the sprocket and can quickly break apart from the material ahead of this point. Thereafter the sprocket will wind film into a roll whilst that section of the machine beyond the defect will become unthreaded.

Sometimes this fault is not detected until, to his utter consternation, the operator sees a broken end of film passing from the final drying cabinet!

This fault can be prevented by mounting a short stainless steel plate just below the centre of the sprocket and between the film loop. It is usually inclined towards the pay-off side of the sprocket but neither touches the wheel itself or the film. When film becomes caught in a sprocket tooth the stripper plate is close enough to immediately force it out of engagement and to restore the correct loop formation.

Several daylight operated machines incorporate a stainless steel cover or roof over the entire processing area. On occasions vapour condensation may form on this roof, and if the machine is not mounted perfectly level on the floor, liquid droplets may run along the inclined roof and drop on the film. Obviously, it would then be possible for droplets of fixing solution to fall on to film which is still in the developing tank—thus causing staining. This can be prevented by fitting plastic separators or partitions between the top of each tank and the roof of the machine to isolate areas of possible condensation—film is then passed from one section to the next through a narrow aperture or letter-box cut in the plastic shields.

Similar machines often employ compressed air squeegees or knives as the film passes from one solution to the next. Compressed air in an enclosed daylight operated machine can build up severe back pressures which may lead to contamination by chemical fumes leaking back into film feed elevators, etc. This can be cured by fitting light-tight air vents to the roof of the machine.

Dyed backing is sometimes used on reversal and other films to minimise halation. Although this should dissolve in the developing tank, some types require mechanical assistance before they can be completely removed. This can be supplied by stationary wiping blades or pads (rather like squeegees), but a much better practice is to fit a rotating mop of sufficient diameter to dip into the solution tank—this technique helps to clean the mop itself and prevent it becoming loaded with waste backing material.

Inevitably small waste pieces of film, accumulations of sludge, etc., will collect in the bottom of processing tanks and, under certain circumstances, could block up the drainage outlet. This can be prevented by fitting wire grids slightly above the level of the tank outlet, or a short grid-covered pipe may be fitted in the tank and over the outlet. The first technique is preferable because it does not impede tank drainage whereas in the second system, although the small plug-like trap is easy to clean, it does mean the tank itself can only be drained to the level of this device and, since the tank may need to be drained daily—although it might only need to be *cleaned* monthly—it is very important that the complete volume of liquid shall be removed.

It is essential that all air inlets, either to drying cabinets or compressors, must be well filtered. Because any filter (other than a water-trap type) must collect dirt and dust, the efficiency of this unit will depend to a great extent upon regular and frequent maintenance. Some filter packs are difficult to clean and, therefore, good technique demands a complete spare set of filters which may be brought into service and to save machine-operating time during this cleaning process.

Unusual processing techniques

In recent years the requirements of Television have caused designers to seek the shortest possible processing time. This became particularly urgent when Video tape and similar developments showed that telerecorded images could be reproduced instantaneously. In general it seems that a film processing cycle of 60 seconds has currently become the goal for television usage—although many people argue that, unless the processing cycle can be of the order of 5–10 seconds, it might just as well be several minutes.

Two particularly interesting systems designed to satisfy these requirements are undoubtedly very practical and may well indicate future trends in commercial film processing techniques. One of these is known as the Kodak Viscomatic processor which, as its name implies, uses developing and fixing chemicals prepared as thixotropic pastes rather than as conventional liquids. The pastes are held in reservoirs from which they are fed through tubes to applicator nozzles. Each tube is surrounded by a temperature-controlled water jacket. The paste is spread on to the film rising over a guide roller and by a hopper or applicator rather similar to a miniature emulsion coating machine. When each chemical process is complete the paste is forced off the film by a high-pressure water jet. The Eastman Kodak Viscomat is illustrated in Figure 4.14.

Many factors must be observed in viscous processing techniques which relate more to the paste itself than to the 'mechanics' of machine design. One of the most important of these is the selection of a vehicle for the concentrated chemicals which, once it has spread, will remain inert and will not slide along the inclined film surface. Sufficiently concentrated chemicals must be available within a relatively thin paste coating, and completely intimate spreading on to the film emulsion must instantly occur without any possibility of bubbles or pockets of unprocessed areas. The advantages of such a system are the very rapid processing cycle in a compact machine, the total elimination of solution variations, chemical control or complicated solution agitation and the ability to restart processing after many days' delay.

The other recent and unusual processing technique was designed by Kelvin & Hughes Limited, in conjunction with Ilford Limited, and depends for its success upon an exceptionally thin photographic emulsion which is developed by high-pressure impingement jets of solution at elevated temperatures. The processing solutions are, in fact, atomised by venturi-type jets consisting of one central pipeline carrying the liquid under pressure, and two compressed-air lines directing heated atomising air at $45°$ to the liquid jet. Extremely active developers such as Ilford ID.57 (caustic soda/phenidone/hydroquinone) are used at a temperature of $100°F.$ ($37·7°C.$). Since the atomised spray system is one of total loss as far as the chemicals are concerned, this implies that processing must be just as consistent as the basic solutions themselves and that no replenishment or chemical analysis is necessary.

Ilford RX emulsion is used in combination with the heated spray jets because it is a thin, hardened, panchromatic recording film which can be completely

penetrated by the atomised liquid in the minimum of time. It also has the advantage that, in this system, a reversal-type image can be obtained by developing first to a conventional negative and then bleaching that image away to leave undeveloped silver halide distributed in the proportions of the positive image. The specular density of this image is very high due to the scattering effect of the fine-grain

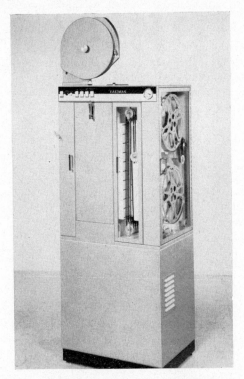

Fig. 4.14. The Eastman Viscomatic Film Processor

Courtesy Eastman Kodak Company

emulsion structure—and this is further raised by using a special projector in which a mercury-arc and restricted lens aperture combine to produce an image contrast-ratio somewhat higher than is normally obtained with the conventional silver images and projection systems. Because of this the film need not pass through the stages of re-exposure and second-development as would be normal when required to produce reversal-type images.

The very high rate of solution penetration into the emulsion, combined with atomised spray jets at elevated temperatures, has resulted in a processing machine of very unusual design. Because the whole cycle is completed in 60 seconds the total film path need only be 40 ft. (12·2 metres) and film-transport is simply by direct

139

'pull-through' from the take-up shaft. The machine consists essentially of three *horizontal* compartments, stacked one above the other, but sealed from each other except at the points where the film is transferred from one treatment to the next. These compartments provide for the basic process of development, bleaching, washing and, finally, drying.

Both the Kodak Viscomat and the Kelvin & Hughes rapid reversal machines are designed to satisfy specific requirements; the Kodak machine processes 16 mm. positive film, whilst the Kelvin & Hughes machines processes a special emulsion to a reversal image in connection with horse race results. Neither machine is intended to supersede the larger conventional equipment used in commercial film laboratories. They are mentioned here to indicate one trend of thinking in this particular field, and possible lines upon which further research may be based.

Chapter 5

General Quality Control in Film Processing

PROCESSING laboratories are inevitably in the most vulnerable position of all who contribute to film production. This is because fundamentally they receive a latent photographic image for which the most outstanding claims can be made—until it has been processed! If the results do not support the original claim the ensuing argument can become quite dramatic and it is essential for the laboratory to be in a position to prove that the film was given the correct treatment. This can only be done by operating the laboratory in a strictly scientific manner and by systems of quality control which yield measurable and indisputable data. Even so, many possible defects can occur—that these are but rarely seen on the screen is a tribute to the very high standards maintained in commercial processing laboratories.

It is therefore appropriate at this stage to provide short notes on the more common defects which may occur during processing, and also to give a list of the more usual technical terms encountered in laboratory work. The following definitions of the probable causes of defects are intended as a guide to locating the source of trouble, to emphasise the need for great care when handling any motion picture material, and also to serve as an introduction to the scope and purpose of processing quality control. They are arranged in alphabetical order for convenient reference.

Aerial fog. This defect results in an overall veiling of the image and is usually caused when developer containing hydroquinone is carried on film loops through a processing machine in such a manner that large areas of film are exposed to air during the developing operation. Aerial fog can usually be eliminated by adding 0·0002 per cent. pinakyptol-green to the developing solution, or 0·0004 per cent. to the pre-wash water before development and when such a bath is employed.

Air bells. These are usually very small undeveloped areas caused by small pockets of air being carried down into the solution by the dry film and as it enters the first processing tank. They are usually circular in shape and prevent the developer reaching any area of emulsion over which they exist. The affected area may be completely transparent or any degree of density dependent upon the stage of processing at which the air is dislodged. This defect is almost invariably caused

by a partially exhausted developer producing foam at the surface. Several 'anti-foam' solutions prevent this happening before the useful life of the developer ends. However, these solutions may not be effective if high agitation is obtained from an aerating system. Should the film become contaminated with grease or oil, development will also be retarded and a very similar defect will occur.

Blistering. If the gelatin is very soft on entering the fixing bath the sodium carbonate of the developer (as it is neutralised by the acid in the fixer) may produce sufficient carbon dioxide gas to cause blisters, or minute depressions. This also occurs when the fixer is too acid or when the rinsing time between development and fixation is insufficient. It is most likely when the hardening properties of the bath are poor or when the atmospheric conditions are unduly hot.

Broken splices. If the operation of the splicing unit, the processing machine 'tracking' and the film tensions have all been checked, it is still possible that splices may tend to break if the film encounters severe temperature changes on passing through the solutions or the drying compartments.

Cinch marks. These intermittent, abrupt markings which may appear either on the emulsion or base-side of film are caused when a sliding movement occurs between neighbouring convolutions of film, usually as it is wound on to or away from the parent roll. The defect may be in picture or sound recording cameras, processing machines, printers, rewind units, editing machines, etc. Marks across the film may also occur, particularly when single-sided rewind plates are used and if the film winds up in an uneven manner.

Developer stain. This usually occurs when partially exhausted developer or obviously discoloured developer is retained in use. It may also be expected when the sulphite-content becomes too low.

Dichroic fog. This is a stain which may appear green on reflection or red on transmission—hence its name. It is caused when developer is contaminated with ammonia, hypo or any silver bromide solvent. It also occurs when film has been stored in a foul atmosphere, by using an alkaline hypo or by films lying against each other whilst in the fixing solution.

Directional effect. An example of the defect is shown in Figure 5.1. As film enters a continuous processing machine the leading edge comes into contact with relatively fresh solution, but the reaction products caused by developing this leading portion pass to the film which follows it—thereby restraining development over succeeding regions. The effect is pronounced in very contrasty images such as the example shown. Developer which comes into immediate contact with the film is carried downwards to some extent because the film does not cut a clean path through the solution. The ability to develop neighbouring areas to an equal extent depends upon the amount of work the developer must perform. In Figure 5.1 the numerals were fully developed; this left the solution temporarily exhausted and reduced the background density immediately following the number. Directional effect may be

reduced by increasing developer circulation rate, improving developer agitation and maintaining fresh solutions.

Drying troubles. If film is dried excessively or too rapidly it will not remain flexible but will become brittle. This may cause it to roll up in a very irregular manner and tend to form into an hexagonal shape. If, on the other hand, film is dried in an atmosphere of high humidity, it will roll up very freely but, when subjected to normal humidities, and whilst still rolled up, it may buckle along its length. This occurs because the moisture in the film can only escape from the edges of the roll

Fig. 5.1. Directional Effect

and, consequently, the centre of the film remains at a higher relative humidity and tends to maintain a greater physical length than the edges of the roll.

Fixer scum. Usually produced when the fixer is somewhat exhausted and has not been used for some days; under such conditions the hydrogen sulphide in the atmosphere reacts with the silver thiosulphate in the solution to produce a metallic-like surface scum. This scum must be drawn off the surface of the liquid before it is used again.

Fixer stain. The precipitation of sulphur on the gelatin produces a yellowish stain indicating that the fixer has been incorrectly made up—and is usually too acid or lacking in sulphite. Similar effects are produced when the fixer temperature is considerably above normal.

Fogging. This term describes any density in the developed film which is not a direct result of intentional exposure. Any emulsion tends to fog if kept for a considerable time before use—this is most noticeable with highly sensitive or fast emulsions and, for all emulsions, is greatly increased by storage in over-heated vaults, by a moist atmosphere or by chemical fumes. Temperature and humidity in modern film storage vaults should be closely controlled by efficient air-conditioning plants. Fogging may occur after normal camera exposure and during development if the solution is unsuitable for the emulsion, if it contains impurities or if the processing machine lifts the film above the level of the solutions and exposes it to air for any appreciable time. Fogging also occurs if the safelight in the dark room is inadequate for the emulsion which is handled there. Fogging may occur if solutions are only used at intervals over a long period or if used at temperatures above 70°F. (21·1°C.) unless they are specially intended for high-temperature working.

The use of unsuitable materials, either in processing machines or in chemical mixing equipment, such as copper, brass, solder, galvanised pails or red rubber hose must all be avoided—any one of these will cause fogging during the developing process.

Green stains. These usually occur when a stop-bath containing chrome-alum is employed. The degree of staining depends upon the amount of carbonate and sulphite in the developer and also the activity or concentration of the chrome-alum in the stop-bath. These stains can be removed by immersing the film in a 5 per cent. solution of potassium hydroxide.

Hardening troubles. If the emulsion remains unduly soft after drying this 'failure to harden' during the fixing operation may be due to excess acid or sulphite in fixing solutions, to a low alum content or to the use of wrongly compounded alum. Under such conditions the amount of alum, acid and sulphite in the solution should be carefully rechecked.

Reticulation. Unless all the processing solutions are kept at approximately equal temperatures, the emulsion may tend to wrinkle on passing from one to the next. This effect is known as 'reticulation' and is rarely encountered if solution temperatures are thermostatically controlled. Although film can be processed in machines not fitted with thermostats, they should have some efficient system to keep solution temperatures within close limits. (Plus or minus $\frac{1}{2}°$F. or 0·3°C. is usually stipulated for modern equipment and film stocks—particularly for colour films).

Rollers sticking. Even a comparatively small processing machine is likely to contain as many as 500 rollers over which the film must pass. Hazards due to mechanical failure are therefore always present and efficient regular maintenance is essential. The use of incorrect materials, poor maintenance or poor mechanical fitting may result in a processing machine becoming stiff or even seizing up. This can usually be freed by cleaning the affected parts in dilute hydrochloric acid (1 per cent. solution) followed by a neutralising wash in 1 per cent. sodium carbonate and, finally, a thorough wash in running water.

Scratches. Foreign particles such as dirt, grit or dust, particularly in the washing system, the squeegees, the drying compartments, etc., will cause scratches on continuously processed films. Where the water supply is suspected all inlets should be fitted with efficient filters and these should be inspected and changed at frequent intervals.

Scum. This is usually a product of the fixing salts carried over into the washing water, plus colloidal materials in the water itself. Spray-washing installations are therefore free from these defects. Water should overflow from the washing tanks through holes or unions into a pipe system beyond the machine, and thus carry the scum-forming products with it.

Sludge in developers. This is more likely and most severe when developers contain borax. It consists mainly of dissolved gelatin and silver. Under normal conditions

sludge should not become sufficient to cause staining before the useful life of the developer has been exhausted.

Sludge in fixers. When this occurs whilst mixing solutions, or a very short time after doing so, it is due to bad mixing and the bath should be analysed. Such deposits are easily recognisable as differing from the normal accumulation found in a partially exhausted bath of some age.

Spots (drying). Drying spots or marks are usually caused by poor squeegees or air blowers or by very cold wash-water. Even when squeegees operate well, very cold water may harden the film and so make it impossible for the squeegee to evenly distribute the very thin layer of moisture which it must leave on the emulsion surface. Wash-water should not fall below 50°F. (10°C.).

Staining. General staining may be caused if any of the solutions are used after they become exhausted. If the washing, or stop-bath, between the developer and any subsequent solution is not adequate then local staining may occur over those areas where developing solution has remained after the film has passed into the following solution.

Static marks. These are exposures on raw film stock made by an electrical discharge (often a clearly visible spark) between the convolutions of the film. They may be caused by rapid unwinding or excessive tension and become severe if the humidity is low. All film-handling rooms should be maintained between 60 and 70 per cent relative humidity. Static marks may take several forms—usually either as 'out-of-focus' irregular shapes or in the twig-like pattern known as 'tree-static'. It is often very difficult to establish with certainty the source of the trouble, and it is useful to remember that static can be caused by perforating machines, in the gates of cameras and also in step-printers. In all these cases the defect will *repeat* at frame or picture frequency.

Streaks. These are usually caused when solutions are not agitated sufficiently. They may be overcome by circulating the developer faster—but not sufficiently to cause foaming. A similar cure is partially effected by increasing the speed at which film travels through the machine but, of course, this remedy can only be employed if the number of film racks can also be increased in order to maintain the correct developing time.

Sulphide fog. Bacteria or fungi present in a developing solution will reduce the sodium sulphite to sulphide and so produce fogging. This will not normally occur when a developer is in constant use and, indeed, may be cured from one which has been standing for some time by developing a quantity of waste film—thus removing the excess sulphide which collected whilst the developer was out of use. Sulphide fog may be eliminated if the solution container is sterilised with sodium hypochlorite before use.

Uneven development. Continuous streaks, parallel to the film edge, suggest poor solution circulation and can be eliminated by increasing the agitation and, if

145

possible, the speed of the film through the machine. Agitation by air bubbles or bursts of nitrogen gas are also found to be effective in some cases.

Yellow stains. When these are fairly transparent and 'clean' they are usually caused by developer oxidation but, when darker and dirty in colour, they are caused by silver left in the film due to inadequate fixing.

From the foregoing brief survey of some of the possible troubles which may occur as film passes through the various solutions, it will be apparent that two main systems of control must be applied if continuously high quality results are to be achieved. The first of these concerns the analysis of the processing conditions as they vary throughout the useful life of the solutions and the second, which is only possible after the first has been established, concerns the adjustment and control of those conditions to maintain a uniform performance.

Technical terms

Both in this chapter and in the next it is necessary to use many photographic terms, some of which specifically relate to processing control work and are rarely employed in other branches of cinematography. Because of this the following brief definitions are provided as a general guide at this stage. Where referred to later in the text these definitions are considerably amplified. They are arranged in alphabetical order for easy reference:

Acutance. This term is associated with the apparent sharpness and definition of a photographic image. It is therefore similar to 'resolving power' but, whereas the latter relates to a physical count of the number of lines which can be seen per unit length, acutance is a single calculation made from microdensitometer measurements of the degree of 'edge-effect' produced when photographing an actual knife-edge. In both cases the value of the measurement is subjective and is mainly dependent upon the structure of the film emulsion, the contrast of the image, the density of that image and the processing conditions.

Angstrom units. A measurement of the wavelength of light—the characteristic which determines its colour. See 'Wedge Spectrogram'.

Anhydrous. The word means anything which is devoid of liquid and is therefore extremely dry. In photography the term describes chemicals from which the water-content has been removed. Raw chemicals which contain water are said to be crystalline and, obviously, must weigh heavier than anhydrous chemicals. For example, sodium carbonate crystals are 2·7 times as heavy as the equivalent chemical in anhydrous form; hypo crystals are 1·6 times heavier than anhydrous hypo, etc. It is important to realise that no single factor can be used to convert from the crystal to the anhydrous equivalent for all chemicals.

Batch. This term relates to methods of film coating during the manufacture of raw stock. Most films are classified by an emulsion number and a batch number.

The emulsion number remains constant and designates the *type* of emulsion: the batch number refers to all that quantity of film manufactured from one *mix* of the emulsion. One aspect of manufacturing efficiency is to hold 'batch-to-batch variations' within extremely close tolerances. Studio and laboratory personnel should ensure that all the film used on one production carries the same batch number—or that batches which for all practical purposes have identical characteristics are reserved to complete that production.

Callier coefficient. The ratio between Diffuse and Specular Density. Both these terms are defined in this chapter.

Characteristic curve. These are graphical representations of the behaviour of films. More specifically, they reveal the reaction of a film to the combined effects of light and subsequent development. They exist as curves plotted on squared paper showing the increments in image density resulting from known uniform increments in exposure and under given processing conditions. By plotting families of curves, variations in image contrast and emulsion gamma can be related to developing times and temperatures. Similarly, the behaviour of several different emulsions in one standard developer can be judged and the relative photographic speeds of these emulsions can be compared.

Colour temperature. The visual colour of a light source is measurable in terms of the temperature to which a standard so-called 'black-body' must be raised in order to emit visible light of that colour. Relatively higher temperatures result in light of a blue colour whilst lower temperatures produce light of a red colour—and all other visible colours occur when the standard black-body is heated to any intermediate temperature. The basic research work carried out to establish the relationship between temperature and colour was formulated by Lord Kelvin—as a result colour temperature is measured in 'degrees Kelvin' which are the actual temperature in degrees Centigrade raised by 273.

Continuous wedge. This refers to a particular type of exposure usually resulting in a relatively long narrow rectangular image which becomes progressively darker from one end to the other. It is used in sensitometry and the production of characteristic curves—particularly in automatic plotting densitometers. As a practical example it may be 6 in. long and 0·5 in. wide; at one end it may be as light as clear film base whilst, at the opposite end it may appear almost opaque. Between these extremes the density gradually and smoothly changes from one end to the other.

Contrast. This term is frequently confused with gamma. Contrast refers to the brightness range and gradation between the highlights and shadows in a scene as they are interpreted in the resultant density differences and gradation in the photographic image of that scene. It is therefore expressed as a ratio. By the same token, one can refer to the brightness levels of two exposures in a step-wedge and the contrast between the densities resulting from these exposures. Contrast is ultimately the product of lighting, subject tone-range, exposure, development, and viewing conditions; no single factor can alone control photographic contrast.

147

Crystalline. Basically this describes any substance in the form of a crystal but, in chemistry, the 'substance' is generally a salt which has crystallised from solution. In photographic chemical mixing the term refers to chemicals in the form of crystals which contain water.

Density. This term describes the blackness of a photographic image. When light is directed on to the surface of a processed film some of it passes through the image, some is absorbed by the image, some is reflected and some is scattered. That which passes through the film is known as the 'transmission' (T). The reciprocal of transmission is known as the 'opacity' (O). The logarithm of the opacity is defined as density (D). This may be expressed thus:

$$\text{density} = D = \log O = 1/T.$$

Diffuse density. As light passes through a silver image, some of it is scattered in a random manner whilst the bulk of it travels normal to the optical axis. A measurement of density which includes both the scattered and the non-scattered light is known as the diffuse density. Because of this the diffuse density is always lower than the specular density (a measurement which does not include the scattered light transmitted through the film). A decision to measure an image in terms of its diffuse or specular density depends upon the purpose for which the measurement is being made—this is particularly true in relationship to the type of light source in film printing equipment and also whether printing is carried out by optical projection or by contact.

D–log E curve. This is the more usual characteristic curve of a photographic emulsion and is the result obtained by plotting the density of steps on a sensitometric exposure against the logarithm of exposure increments which, in combination with the processing solutions, created these densities. In the control of colour film processing a series of curves must be produced—one for each of the three primary colours of the system.

Exposure. The process of creating a latent image in a film by causing light of suitable wavelength to fall on the emulsion. Most negative films are panchromatic, react to all visible colours, and must be handled in total darkness. Monochrome positive films and some duplicating films are primarily blue-sensitive only and, therefore, may be handled with safety in rooms illuminated by an orange-coloured safelight. Exposure is the product of the intensity of light and the time it is allowed to act on the photographic emulsion, thus:

$$E = I \times T.$$

Gamma. The major portion of the characteristic curve of an emulsion is substantially straight—so that known increments in exposure cause proportional increments in density. This relationship can be expressed in terms of the angle formed between the straight portion of the characteristic and the log-exposure axis of the graph. The *tangent* of this angle is known as the gamma of the film under given processing conditions. It therefore indicates the relative contrast change to

148

be expected between brightness levels in the exposure (the input) and the resultant density differences in the film emulsion (the output). The contrast of the output will only equal the contrast of the input when the processing gamma is unity (the tangent of an angle of 45° being 1·0).

G–Bar (G). Whilst gamma is a measure of the average slope or amplifying power of the main body of the characteristic curve, it often happens that the exposure excursions made along this curve in practice are either confined to only a part of the 'straight' portion, or may well include a part of the toe or curved region. Because of this it is useful to know the average slope of that part of the characteristic curve which is actually used in practice. Measurements such as this, taken over the 'working region' are known as the G–Bar or 'gamma of the used portion' of the characteristic curve and are recognised by the prefix \overline{G}. Thus a film may have a *control* gamma of 2·0, but a *working* gamma or \overline{G} of 1·7. This is particularly true of some methods of sound recording—especially so-called 'toe-recording' in the variable density system.

Grain. Those silver halides in a photographic emulsion which, having been exposed to light and reduced to metallic silver by the developer, go to make up the photographic image. Their size and distribution greatly influence the resolving power or acutance of the emulsion. In extreme cases the combined effects of grain, as seen on the cinema screen, can produce a 'raining' effect which is said to be 'grainy'.

Grey-scale. A term often used to describe a series of uniform increments in density produced by making a sensitometric exposure in a sensitometer. In appearance a grey-scale resembles a series of small blocks or tablets of density and, assuming one is looking from the light-end towards the dark-end, each block or tablet is slightly darker than the predecessor. Grey-scales may also be generated in television display tubes to produce a resultant series of densities via a telerecording camera and these appear very similar to those created by a sensitometer. Providing the exposure increments are known in both cases, either form may be used to construct a characteristic curve for the film emulsion.

H & D curves. These are identical to characteristic curves and are so-called after the photographic scientists Hurter and Driffield who made major contributions to the sensitometric measurement and control of film processing characteristics.

Hygroscopic. Any material which is capable of absorbing moisture from the air is said to be hygroscopic. Motion picture film is very hygroscopic and reacts quite rapidly to the prevailing relative humidity.

Intensity-scale. This refers to a particular series of exposures created by one type of sensitometer. Exposure is the product of light intensity and the time during which it is operative. A range of different exposures can therefore be created either by maintaining a constant light intensity and altering the time factor or by maintaining a constant time of exposure and altering the light intensity. When the former

technique is used the sensitometer is said to be a time-scale instrument and, when the latter technique is used it is known as an intensity-scale instrument. Precautions must be taken to alter the light intensity by an intermediate modulator and not by changing the lamp brightness—only by this means can the colour temperature of the exposure remain constant.

Kelvin (degrees). Units of measurement related to the colour temperature of light sources and so-called after Lord Kelvin the scientist who first established the system of measurement. See detailed description under 'colour temperature'.

Opacity. A measure of the film's ability to stop light being transmitted through it. That portion of an incident light beam which passes through a film is known as the transmission—that which does not pass through is known as the opacity. Therefore, the opacity is always the reciprocal of the transmission. For example, if a light of 100 candle-power is directed on to a film and the brightness of the beam passing *through* the film is only 10 candle-power then the transmission must be 10/100 or 10 per cent. Under these conditions the opacity will be 100/10 or 10 (the reciprocal of transmission). Incidentally, because density is the logarithm of the opacity, in this example the density is 1·0.

pH-scale. This symbol indicates the hydrogen-ion concentration in a solution and, therefore, the degree of acidity or alkalinity of that solution. The scale is in units from 0 to 14 and pure water, which is a neutral liquid, has a pH of 7. Acid solutions have a pH below 7 whilst alkaline solutions have pH values above 7.

Raw stock. This term is used in the trade to describe motion picture film as it is received from the manufacturers, i.e. before any exposures have been made on it.

Reciprocity law failure. Any exposure is the product of the intensity of light and the time during which the light is operative, thus $E = I \times T$. However, an intense light operating for a short time will *not* produce a photographic density equal to that caused when a weak light operates for a correspondingly longer period although in both cases the product of I and T are equal. This inability of film emulsions is known as Reciprocity Law Failure. It becomes significant in photographic sound recording (where a 10,000 cycle note represents individual exposures of very short duration) and, of course, in all forms of high-speed cinematography. The recognition of reciprocity law failure has led to the use of intensity-scale sensitometers in preference to the time-scale instruments which for so many years were the basic control instruments in processing laboratories.

Relative humidity. The wetness of air in film stores, printing or processing rooms, drying chambers, etc., is of great importance. The prevailing wetness is compared or related to the *saturation* wetness for the same temperature and pressure of the air. By multiplying this ratio by 100 a 'percentage wetness' is obtained and it is this figure which is known as the Relative Humidity. Therefore a relative humidity of 90 per cent. is very nearly saturated, whereas a relative humidity of 20 per cent. is

extremely dry. Motion picture films should be handled and stored in conditions close to 60 per cent. Relative Humidity and at temperatures between 60° and 70°F. (15·5 and 21·1°C.).

Resolving power. This describes the ability of a film to record very fine detail. It is the number of individual lines which can be recognised in 1 mm. of film length. For example, an average negative material will have a resolving power of 50 lines per millimetre. Optimum resolving power is usually only achieved when photographing an object of maximum contrast and, even then, is restricted to a specific image density and processing gamma. It therefore does not represent the sharpness which may be expected at all densities throughout the image of an average scene. In recent years acknowledgement of the limited usefulness of resolving power measurements has led film manufacturers to discontinue quoting this characteristic. Resolving power measurements are only of real value in comparing different emulsions under research laboratory testing conditions.

Safelight. Illumination in a film-handling dark room or work area which does not expose or fog the film emulsion. A safelight must therefore only radiate light of a colour to which the film remains insensitive.

Sensitometry. A term describing the precise measurement of the reaction of an emulsion to light. This is indicated by a series of densities created by an accurate range of known exposures processed under controlled conditions and in a specified solution. The evidence of such measurements is usually displayed as characteristic curves plotted on squared paper.

Specular density. As light passes through a silver image, some of it is scattered in a random manner whilst the bulk of its travels normal to the optical axis. Measurements of density can be made either to include or to discard the scattered component of the transmission. Measurements which ignore the scattered light are known as the Specular Density and, therefore, are always higher than the diffuse density (the name of the measurement which includes the scattered light transmitted through the film). For reasons governing the choice of measurement, see 'Diffuse density'.

Spectral sensitivity. This relates to a film's ability to react to all colours of the visible spectrum and, particularly, to the degree of reaction to each colour. A panchromatic monochrome emulsion must react to all visible colours in such proportions that each colour is translated into a grey density tone acceptably recognised and associated with that colour. For example, in the positive print, yellow daffodils must appear a much lighter tone of grey than deep red roses, etc. In colour films it is obviously essential that the full range of the visible spectrum shall be recorded—but colour balance and saturation then become the dominant factors. Colour Balance is a measurement of the proportions of the three primary colours which are present and which can be secured in the three emulsion layers. The overall acceptance of a colour reproduction is the combination of colour intensity and hue which, in effect, is the degree of colour saturation.

Step-wedge. A series of densities arranged in steps of increasing blackness and in which the density throughout any one step is substantially uniform. Step wedges are produced by sensitometers and in television display equipment during initial calibration work. They are measured to reveal changes in image density resulting from changes in exposure and processing conditions.

Time-gamma curves. In sensitometric analysis, any one characteristic curve will establish the gamma obtained at a given processing time. By making a series of such curves for a range of processing times, the changes in gamma can then be plotted against the processing times to produce a time-gamma curve. From such a curve any specific gamma can be forecast and thus obtained by operating the processing machine at the indicated speed.

Time-scale. This refers to a particular series of exposures created by one type of sensitometer. Exposure is the product of light intensity and the time it is operative. A range of different exposures can therefore be created either by maintaining a constant time of exposure and altering the light intensity—or by maintaining a constant light intensity and altering the time factor. When the former technique is used the sensitometer is said to be an intensity-scale instrument and, when the latter technique is used it is known as a time-scale instrument. It is important in time-scale instruments for the range of times to compare favourably with the practical exposure time used in the camera or sound recording machines because, if this is not so, reciprocity law failure may invalidate some of the evidence produced by the sensitometer.

Transmission. That portion of an incident beam of light which actually passes through the film. For example, if a light of 100 candle-power is directed on to a film surface and the brightness of the beam emerging *through* the film is only 10 candle-power, then the transmission of the film is 10 per cent.

Variable area. A type of optical sound recording in which the recorded signal appears on the positive print as a central clear area enclosed by two opaque regions. The width of the central area continually varies with the frequency or pitch and loudness or volume of the sound. Frequency is recorded as the number of peaks, waves or variations in width per unit length, and volume is recorded as the amplitude or degree of change in width.

Variable density. A type of optical sound recording in which the recorded signal appears as horizontal bars of constant width but varying density. Frequency or pitch is recorded as the number of bars per unit length, whilst volume or loudness is recorded as the contrast or change in density between neighbouring bars—a loud signal causing big changes in density and a quite signal causing only small density changes.

Wedge spectrogram. A pictorial representation of an emulsion's ability to respond to various colours in the spectrum. Usually illustrated as a silhouette continuous outline extending over the range of the visible spectrum. Such an image is produced

by exposing a test film to the light produced in a spectrograph but by first passing this light through a neutral density wedge arranged so that it is opaque at the top and decreasing in density until it is transparent at the bottom. The *height* of the resultant photographic image on the test film is therefore proportional to the log-sensitivity of the emulsion at that wavelength. The wavelengths displayed in the spectrograph extend from the ultra-violet at wavelengths of 3800 Å up to the deep red in the region of 7200 Å. The colour of light is dependent upon its wavelength and this is expressed in Angstrom units by the symbol Å or in millimicrons (mμ). The relationship between these units is as follows:

$$10 \text{ Å} = 1 \text{ m}\mu = 1 \text{ thousand-millionth of a metre.}$$

Every industry requires tools especially designed to suit the needs and purposes of the work which is being carried out. Unless these are thoroughly understood—and every facility is provided to make this possible—confusion will arise and quality will suffer. The vocabulary of motion picture laboratory control methods defined in the preceding glossary of technical terms is, in a sense, one of the tools of this industry.

Factors affecting image quality

It is not always realised that the quality of a motion picture negative and, therefore, the positive print made from that negative depends upon eleven basic factors. As will be shown, some of these can be measured and controlled by sensitometry, but others are outside the jurisdiction of the laboratory and cannot always be easily recognised. These eleven major factors are as follows:

(1) Photographic speed, contrast and grain-size of a monochrome film.
(2) Photographic speed, colour balance, hue and saturation of a colour film.
(3) Initial camera exposure.
(4) Activity of the developer.
(5) Temperature variations during development.
(6) Time of development.
(7) Developer exhaustion and replenishment.
(8) Efficiency of the bleaching and fixing solutions.
(9) Efficiency of washing.
(10) Permanence of the image.
(11) Handling quality immediately after processing.

The importance of these variables, and the manner in which some of them are interdependent, are briefly discussed below.

Photographic speed and grain size

Professional black-and-white motion picture negative materials have ASA or Weston speed ratings to daylight ranging from 16 up to 800 and, to tungsten illumination at 3,200°K. ranging from 25 up to 650. At the moment we only need

consider the reasons for selecting films for artificial or studio lighting. To secure an average negative density on a film rated at only 25 Weston would require 1,600 foot-candles at f/5·6 whereas, to secure a negative of similar density on a film rated at 650 Weston would only require 64 foot-candles at the same lens aperture! Two very important points immediately become apparent: firstly, use of the faster film means an enormous saving in studio electricity bills and, secondly, the faster film requires the minimum of lighting equipment—implying much quicker lighting techniques and considerable saving in studio floor-time.

These factors are so important that studio accountants can on occasions show that the total cost of a photographically fast stock used on one production may be offset by the economics in electricity and labour costs when compared with similar items during a production made on a slow film stock. Studio accountants are not usually very artistic and clearly, there must be very good reasons for selecting films of different speed which, to the cameraman are more important than economic considerations alone. In general, the faster the photographic speed of an emulsion the coarser becomes the grain structure and the more contrasty is the image.

More precisely, and when comparing similar competitive products of nominally *equivalent* speeds, it must be remembered that speed is a complex factor depending upon the colour temperature of the light source, the relative importance of light intensity and exposure time (and their effect on reciprocity failure), the suitability of the developing solution for both film stocks and the relative developing time to achieve comparable values of gamma. Film speed is therefore a factor which can vary according to the conditions under which the film is processed—this explains the preference some cameramen have for always dealing with one laboratory.

We can now see that great economies in lighting and studio time can be effected by using a fast film—but only at the expense of image grain and contrast. Within limits it is still possible to select these factors intentionally and to advantage. For example, a wide-screen picture should obviously be made on very fine grain stock which must therefore be relatively slow and will require a high level of lighting. On the other hand, a standard format light-hearted 'teenager-comedy' is improved by appearing harsh and contrasty—therefore some cameramen may well choose a fast, relatively coarse-grained, contrasty negative for this work which is very economical to light. It is sometimes wise to vary the film stock on a production and according to the type of scene—obviously street-scenes at night photographed by so-called 'available-light' must be recorded on very fast emulsions, whereas close-up emotional scenes in the same production may well be studio-shots on a slow fine grain emulsion.

Part of the laboratory function is to accept a wide range of negative materials and to process these to maintain or enhance the dramatic effect secured by the cameraman. For various reasons the camerman may not always have a free choice in the film stock he uses and must rely on the laboratory to do all that is possible to secure the required negative quality. Under these conditions it may be necessary to depart slightly from a standard control condition either to boost or restrain the density or contrast of the negative image.

The initial camera exposure

The whole purpose of laboratory control is to create processing conditions which remain within such close tolerances that the cameraman may confidently predict the image quality. This presupposes that the cameraman is aware of the control techniques used and can usefully interpret the data supplied to him from the laboratory. Given this interchange of technical knowledge the cameraman will also know the extent to which the laboratory can vary processing in order to improve or modify unavoidable shooting conditions. One example of this is Newsreel photography of a Scottish football match because, after half-time in the depth of winter the available light is so poor that even the fastest films and widest lens apertures still produce under exposed negatives! Even without this embarrassment, it is not unknown for a cameraman to accidentally over or under expose a scene and to request processing compensation by varying the optimum developing time.

It is very dangerous indeed to consider laboratory processing as anything but a rigidly controlled system, which is *only* varied in order to salvage otherwise faulty exposures. The only method likely to produce consistently high quality is to establish known processing conditions controlled by sensitometry to achieve standard gamma and density values on all types of film stocks. The photographic speed of an emulsion—as found at a particular laboratory—is then firmly established for the cameraman and he knows that, assuming his exposures are accurate, his results should always be consistent.

Activity of the developer

The main function of any developing solution is to react with the exposed silver grains in such a manner that metallic silver is formed. The 'reducing agent' used for this purpose is usually monomethyl-paramino-phenol sulphate (Metol), or phenyl-pyrazolidone (known as 'Phenidone', a trade-mark registered by Ilford Limited who discovered this agent). Since a reducing agent alone would take a very long time to complete the reaction, a second chemical must be added to accelerate reduction. For this purpose an alkali such as sodium carbonate or caustic soda is used. It is important to remember that, whilst the speed of the reaction is largely controlled by the strength of this accelerator, so also is the final image grain-size in the processed film. Since a considerable surface area of solution is usually exposed to the surrounding air in a continuous machine, oxidation will quickly take place unless some preservative is included in the bath and, for this purpose, sodium sulphite is usually added. Finally, the reaction is controlled by adding a slight restrainer such as potassium bromide, the actual proportion of this addition being dependent on the type of film for which the developer is designed and the results which are required.

We can now appreciate that a developing solution designed to achieve the optimum image in motion picture *negative* stocks is most unlikely to realise equal quality

in *positive* printing films. Similarly, a negative developer intended to reveal the fine grain structure of a high quality panchromatic emulsion will almost certainly be slow-acting—whereas a solution designed to process the same film in a small high-speed machine can usually only do so at the expense of image grain size. This is one reason why, not infrequently, television film producers notice a difference in image quality between films processed in their own small machines and the same film stock when returned from commercial laboratories. Naturally, there are many valid reasons—particularly in television newsfilm work—which justify the use of local high-speed machines, and not the least of these is the ability to get a 'hot' news story on to the air on occasions within 15 minutes of the cameraman returning to the studio!

Developer temperature

Most film manufacturers issue characteristic curves displaying the capabilities of each stock at a range of gamma values. Together with this they recommend a preferred control gamma and illustrate a typical time-gamma curve. All this information is related to a recommended developing solution, operated at a controlled temperature. For use in commercial processing laboratories the suggested temperature is almost invariably 68°F. (20°C.). The very rapid processing cycle achieved in small daylight processing machines is usually only possible when operating specially selected developers at elevated temperatures. For example, Ilford 'Cinephen' or May & Baker 'Teknol' developers are used in Lawley Junior machines at 73°F. (22·7°C.), whilst Ilford ID.57 is used in the Kelvin & Hughes rapid spray machine at 100°F. (37·7°C.). Similarly, many conventional colour films are processed at 110°F. (43°C.).

The nominal average temperature is usually easy to obtain—what is much more difficult to achieve is a really close control on variations either side of the chosen average. Just as sensitometry can be extended from a family of characteristic curves to provide a time-gamma curve, so also can the same technique be used to establish *Temperature-gamma* or *temperature-density* curves. These indicate that variations greater than plus or minus 0·5°F. (0·3°C.) cannot be accepted if modern close limits on gamma and density are to be achieved. Temperature variation is only one of many factors which influence the final gamma and density of motion picture films—it is because so many factors are involved that the tolerances on any one must be rigidly observed.

It is always easier to maintain a large volume of liquid at a given temperature than it is a small one. Large volumes are associated with commercial laboratories where, usually, the chemical mixing and film processing rooms are air conditioned. Coupling this with efficiently lagged pipes connecting the supply from one room to the other ensures that solution temperature changes are very slow. Because of this it is essential that the solutions are circulated quite rapidly (to avoid sluggish pockets of different temperature, particularly at the bottom of large storage vats)

and that temperatures are monitored both in the machine tanks and in the storage vats.

In small daylight operated machines temperature control becomes more difficult—particularly if unit volumes of solution are totally discarded after a given footage of film has been processed. This is because the machine design rarely isolates small tanks very efficiently, because a small volume reacts more quickly to radiation losses and because washing water temperatures can influence the temperature of neighbouring solutions more easily.

In small installations temperature control is usually either in the form of (a) local immersion heaters and refrigeration units built into the machine and in intimate contact with the solutions, or (b) a heavily lagged heat-exchange water tank held to the correct temperature and through which pipes to and from each processing tank carry the solutions. This system required a circulating pump for each solution and, in some cases, only operates efficiently if the temperature in the heat-exchange tank is held slightly higher than that required in the processing tanks—thus introducing a secondary control and the need for temperature monitoring at several points. Some idea of the delicate balance which must be achieved in small installations is gained from the fact that, in a machine having a developer capacity of only 7 gallons (31·82 litres), the heat generated by friction in the circulating pump can be sufficient to raise the solution temperature by 1°F. (0·6°C.) in 30 minutes and at an ambient temperature of 68°F. (20°C.).

Developing time

There are two main factors which, insofar as developing time is concerned, govern the suitability of a processing machine for the work it must handle: firstly, the range of developing times to be covered and, secondly, the magnitude of film speed variation which can be tolerated. Very briefly, the larger the machine the faster the film will travel through it to provide a given developing time and, of course, variations in speed become less important the faster the film travels. Similarly, if a wide range of processing times must be provided, greater accuracy is obtained when relatively long developing times are allowed in slow-acting solutions.

Sensitometry is based upon the assumption that both the temperature and time of development will be accurately controlled—and that any tolerances allowed on these factors will be recognised and accepted as permissible variations which, together with similar tolerances permitted in the sensitometer, the densitometer, curve plotting and interpretation, still maintain the ultimate image gamma and densities within acceptable limits.

Developing time can usually be altered in three ways; firstly by changing the speed at which the film passes through the solution, secondly by altering the length of the film loops in the developing tank and, thirdly, by altering the number of loops in that tank. Because all continuous processing machines are required to develop a wide range of different emulsions in any order and at any time, the second and third possibilities are not used in day-to-day operation. However, they

are used during the initial calibration of a machine and when testing various developing solutions.

Several factors must be considered when selecting a range of machine speeds in order to satisfy a required range of developing times. Three major requirements concerning other sections of the machine must first be satisfied in order to establish the *maximum* linear speed—or minimum developing time. This speed must permit adequate fixing time, good washing time and adequate if not generous drying time.

The next important point concerns the majority of designs in which, because of the system of top-roller drive, a portion of each film loop is exposed to air. In such machines it is important to keep the speed relatively high, and to off-set this by increasing the number of film loops in the solution in order to maintain the required developing time. The reason for this is connected with aerial fogging and oxidation which might otherwise occur in a slow machine, particularly when considerable portions of each film loop were exposed to air for long periods.

In small processing machines most picture-negative stocks and telerecording emulsions can be processed in developing times ranging from 0·75 up to 2·50 minutes—this usually corresponds to machine speeds of the order of from 15 to 75 ft. (4·6 to 22·9 metres) per minute. In larger commercial laboratories the equivalent requirements are usually met by developing times from 4 up to 20 minutes and with machine speeds from 50 to 200 ft. (15·2 to 60·9 metres) per minute. With such a wide range of machine speeds it is clearly not possible to establish an optimum recommendation, and no single developing solution can be equally suited to all requirements.

In general it must be remembered that working a developer at elevated temperatures usually increases image grain and shortens the life of the solution. Secondly, one should select a developer which requires the machine to operate fast enough to maintain good control on machine speed variations—these are always more pronounced at low speeds and, of course, usually become more critical. Thirdly, the developing time must be economically attractive to the company concerned—whilst outstandingly constant results may be achieved at a developing time of 20 minutes, this could mean that the machine was costing money to run rather than making a profit!

Assuming that a solution has been selected and a range of developing times has been established, it is then important to recognise the accuracy with which a required speed can be maintained, and the effect of random speed variations on image gamma and density.

Speed control is best indicated by a large dial speedometer, calibrated in machine revolutions per minute, rather than in actual developing time or film length per minute. Depending upon the size of the machine, running speed may be changed either by a Variac-type resistance in the motor circuit, an infinitely variable-speed gear box, or by a system of opposed cone-pulley wheels. Some appreciation of the accuracy with which machine speed must be controlled is gained from the following test data: given a required machine speed of 35 ft. (10·7 metres) per minute to achieve a negative gamma of 0·65, speed variations as small as 1 ft. (0·3 metres) per

minute resulted in changes of 0·01 in gamma and of 0·15 in density at a face-density level of 0·80.

Developer exhaustion

In commercial laboratories developers may be made up in large stainless steel tanks, possibly 5 ft. (1·5 metres) in diameter and 3 ft. (0·9 metres) in height and holding approximately 150 gallons (682 litres). Naturally, this large surface must be protected against oxidation, and it is usual to float rigid P.V.C. or heavy polyethylene sheets on the surface of the liquid for this purpose. The tanks are fitted with electrically-operated stirring equipment to ensure complete chemical mixing, and a pumping system to circulate this volume through the processing machine tanks.

Apart from losses due to the film carrying solution with it and from the developing tank into the following tank in the system, chemical exhaustion will also take place and, particularly, the solution will gain an excess of bromide liberated from the film during the developing process. To overcome this, systems of replenishment are not designed to maintain the composition of the bath, but rather to maintain its photographic activity.

These aims are achieved in large installations by intentionally and continuously bleeding away a known volume of each solution (calculated against the footage of film processed per hour) and replacing this—plus allowances for 'carry-over', etc.— with specially compounded replenishers. Continuous bleeding and replenishment can only be achieved in conjunction with regular bath analysis, but it has the advantage of great accuracy and day-to-day reproducibility.

In smaller installations greater economy is sometimes obtained by discarding the entire developing solution after a predetermined footage of film has been processed. Naturally, bath exhaustion tests must be made to establish the footage which can safely be processed in a 'unit mix' of solution before the image qualities fall below acceptable limits.

A practical example of this technique showed that 5,000 ft. (1,524 metres) of intentionally over-exposed 35 mm. film could be processed in 7 gallons (32 litres) of developer (diluted so that 1 part of concentrated solution was added to 6 parts of water), and that the gamma only dropped from 0·67 to 0·65 whilst, at the same time, a control density of 0·75 only dropped to 0·70. These figures have only been established for one type of equipment and one brand of developer—they must not be taken to apply to any processing machine of similar capacity.

Whilst results very similar to these may be expected from similar equipment, those wishing to apply this technique should only do so after carrying out developer exhaustion tests. This is done by preparing several rolls of over-exposed film (so as to cause the developer to do more than an average amount of work), to then attach a sensitometric test strip to the end of each roll and, after processing, measure the gamma and density values as explained in Chapter 6. By this test one can establish the precise fall-off in any machine when using the 'unit-mix' technique.

The fixing˜solution

Passing from the developing tank monochrome film usually enters a rinse or acid-stop bath to arrest further development. It then enters the fixing solution—where the unexposed and undeveloped silver halide grains are removed. In this process silver passes into solution in the fixer which, as its concentration increases, slows down the rate at which the emulsion 'clears'. As a good general rule, the fixing tanks must have such a capacity that, at all times, the film remains in them for at least twice the time of clearing. Since the water carried into these tanks by the film and from the rinse bath will *dilute* the fixer, the clearing time will be further prolonged as the quantity of film passed through the solution increases.

Many systems employ two or more independent fixing tanks. This has the advantage that only the solution into which the film first enters will become completely exhausted and when this occurs the succeeding bath, still being comparatively fresh, may be used to replace the first bath. The second bath is then refilled with new solution so that, in effect, new solution is always introduced into the final stage, whilst partially used solution always replaces the exhausted fixer in the first stage.

When a hardening agent is added to the fixer it also makes the emulsion less susceptible to scratching and damage but, in so doing, it increases the need for prolonged washing. It is usually possible to maintain adequate hardening in the final bath at all times—although the hardening properties of the first bath may become weak even before that bath loses its fixing properties. Naturally, the actual rate of exhaustion will largely depend upon the average nature of the film which is being processed. For example, film which only carries a photographic sound track or a line drawing will exhaust the fixer far more rapidly than film which carries a picture record since, in the first case, almost all the emulsion must be dissolved into the solution.

Here again, different techniques are used in large commercial laboratories as compared to smaller installations. In the larger equipment vats of fixer may be pumped in to the processing machines or, what is more likely, unit mixes of fixer may be pumped *from* the processing machines and into silver-recovery units. In the smaller machines it is almost universal practice to use so-called rapid fixing solutions, such as Ilford 'Hypam' or May & Baker 'Amfix' and, as with the developing solutions, it is common practice to establish a safe film footage equivalent to an acceptable exhaustion. When testing a processing machine for fixer exhaustion it is important to use undeveloped film (so as to create a test condition slightly more severe than the fixer encounters when sound recording film is being processed), and to operate the machine at the maximum processing speed used in practice. Since the test is to establish the footage at which fixing becomes inadequate, the time factor is of paramount importance—it is for this reason that the machine must operate at the highest speed.

Washing and image permanence

After fixing the film must be thoroughly washed to remove any hypo still remaining in the swollen emulsion. Although not generally recognised as such, this is a *process* in every way as important as developing or fixing—because the future life of the film, and particularly the permanence of the image, depends upon efficient washing. The amount of washing required will vary considerably. Film which has been hardened during the fixing operation is more difficult to wash than film which has not but, of course, it is also more resistant to scratching and damage. Similarly, so-called hard water is less efficient than soft water. These factors can usually be adjusted, but the layout of the washing system is usually settled during machine design and installation.

Hard water containing calcium, magnesium, etc., may precipitate calcium carbonate or calcium sulphite in such quantities that pipes leading to washing tanks become constricted. This is particularly important when washing is by a series of spray jets—initially the water flow-rate should be measured to ensure that an adequate spray is available but, after several months use the bore of the spray nozzles may become reduced by as much as 50 per cent. Water is considered to be hard when it contains more than 0·01 per cent. calcium carbonate. Unfortunately, it is also possible for water to be too soft for film washing, and when this occurs difficulty may be encountered in tracking film over friction driving rollers, the emulsion will remain unduly soft, and the extreme edges will tend to frill away from the base. In such cases magnesium sulphate is added to the water-intake system.

It may happen that scum will tend to build up on the sides of washing tanks, to float on the surface of the water itself, and even to be carried away on the film (resulting in a fine white powder dried into the emulsion). This is usually an indication that the wash water is hard, and also that the flow-rate is too low. Washing may be wholly by means of deep tanks into which fresh water enters from the bottom and overflows from the top; it may be wholly by a series of spray jets arranged in banks across the centre of each tank or, of course, it may be a combination of both systems. Washing efficiency is increased in machines using a combined method when the spray system is the final washing compartment immediately before the drying operation.

Film condition immediately after processing

After a film has passed from the washing tanks it enters the drying compartment and, eventually, becomes dry and may be wound up on a spool or film core. Immediately after drying the film is said to be 'green' and, whilst this condition can be troublesome in negatives, it can be extremely dangerous in positive prints. This difference is because a positive print is liable to be projected for inspection or checking almost immediately it becomes available. A negative is given more time to normalise and, in any event, the heat generated in negatives by printing machinery

6

is only very small when compared with that to which a positive print is subjected during projection.

Quite frequently film is dried in the final stage of continuous processing in such a manner that the outer surface skin of the emulsion is overdry, whilst the main body of emulsion below this skin still carries excess moisture—this results in a condition almost parallel to case-hardening, but with the outer 'case' supported on a very unstable underlayer. In time the whole thickness of emulsion will normalise and the excess moisture trapped in the body of the emulsion will be given up to the outer skin. Danger from this condition is mainly created by projecting a print before normalisation has been completed. The degree to which this 'green' condition is present in a processed film depends upon the rate of drying and, particularly, upon the initial stages of drying—if these are intense a dry surface skin may be created before the moisture is removed from the inner portions of the emulsion. Once this skin is formed it becomes very difficult to remove the moisture below it. Because of this earlier warnings were given that *wind speed* and not heat is the primary requirement in drying any film to optimum conditions.

After-treatment of processed film

The term 'after-treatment' is used to describe processes and applications carried out on motion picture films after they have been developed, fixed, washed and dried. It refers to such operations as lacquering, waxing, lubricating, buffing, or polishing the film. These operations are performed for a variety of reasons, such as the prevention of emulsion scratches, the assistance of 'green films' through projectors during their initial runs, the provision of anti-static coatings to retard dirt and dust deposits, etc.

As mentioned previously, the term 'green films' or 'green prints' is used to describe films immediately they leave the processing machine or laboratory. Such films may be dried in a manner which causes the humidity content within the emulsion layer to be unevenly distributed—the surface skin being overdried whilst the remainder of the layer retains excessive moisture. Whilst this condition is present to varying degrees in all films immediately after processing, it is accentuated if the drying temperature is unduly high and the drying time is correspondingly short. The physical dimensions of the film (particularly the 'pitch' between perforations) are then less than when the film has normalised and the friction between the film and the gate runners surrounding the projector aperture is considerably higher than that encountered when films have been projected several times.

Some indication of the magnitude of this problem may be gained by considering the water absorption of motion picture films as they pass through the final stages of a continuous processing machine. It has been shown that 35 mm. positive film absorbs 200 mg./10 cm.² and 35 mm. negative absorbs 500 mg./10 cm.² This becomes more dramatic when translated into the equivalent absorption per 1,000 ft. (304·8 metres) roll. Such a roll of 35 mm. negative will have absorbed 10 lb. (4·5 kilo) of water!

The somewhat frightening term 'emulsion pile-up' is used to describe the deposit of emulsion on the runners and channels forming the 'film gate' which surrounds the aperture in a projector and through which the picture is projected. This deposit is usually compacted into a solid mass, often referred to as a 'corn', which can develop a sharp cutting edge and which becomes extremely difficult to remove without damaging the polished surface of the gate runners. Once emulsion pile-up occurs the accurate positioning of successive film images is destroyed and 'picture unsteadiness' invariably results. Apart from this visual defect, any film which is then allowed to pass over the deposit will become severely scratched; this process will liberate small particles of emulsion which may well collect around the gate aperture and thus become visible on projection. It will also create rough channels in the film emulsion and these tend to trap and embed any random dirt and dust which may be present in the atmosphere.

Because of the many hazards which may occur when handling green film, several techniques have been developed to prevent actual damage and picture unsteadiness. Quite often projectionists will wax the edge areas of a new print whilst rewinding it for an initial inspection—or they may use teak wood gate runners which have been impregnated with oil, but these are really at best only measures of 'first-aid in the field' and should not be necessary if a film has been properly handled and prepared in the laboratory. Quite a number of small portable units have been marketed for the semi-automatic application of solid waxes to the edge areas of the film during a simple rewinding operation. These are only successful if exceptionally well made and, particularly, if the wax is of very high quality. They can be very dangerous because it is very difficult to maintain a smooth, even coating of wax—usually it tends to clot and spread irregularly and, when this happens, it is quite likely to accentuate picture unsteadiness rather than to reduce it.

In large commercial laboratories *liquid* waxing and cleaning processes are usually employed. In these the entire film is immersed in what is usually a paraffin-derivative dissolved in trichlorethylene or carbon-tetrachloride—although many favoured recipies have resulted in some fifteen 'brand names' of fluids currently being used in thirty major film handling organisations recently interviewed on this topic.

Some people have expressed concern regarding the use of liquid wax treatments and, particularly, the probable effect they may have on 'head-to-film-contact' when treated films carry a magnetic sound track. The fear is obviously that a barrier of wax will remain sufficiently thick to reduce the quality of reproduced sound. It can be shown that approximately 17 grammes of wax are contained in 27·5 litres of a typical overall waxing fluid and, of particular importance, that such a volume will treat 7.500 ft. (2,286 metres) of film. The amount of solid wax deposited per foot of film is therefore as follows:

$$\frac{17}{27\cdot5 \times 7500} = 0\cdot000082 \text{ grammes.}$$

It will also be remembered that this deposit is divided between the base and the emulsion sides of the film and, since a magnetic sound track only occupies

approximately 15 per cent. of the total film width, it is most unlikely that 'wax build-up' could ever cause concern.

Although film cleaning is quite a different operation to film waxing, it is usually true that both operations are beneficial to all films during some stage in their long potential life. Because of this quite separate machines have been designed to carry out this type of operation and 'waxing and cleaning services' are offered by a number of laboratories—some of which do automatically wax all films which they develop and print themselves.

A typical machine designed for this purpose is seen in Figure 5.2, which shows the combined 35 mm. and 16 mm. Premier automatic film cleaning and waxing unit manufactured by Robert Rigby Ltd. of England. Fundamentally it consists of a series of guiding rollers which lead the film through four separate operations: (a) the cleaning process, (b) the pressure drying process, (c) the waxing process and, (d) the anti-static polishing process. The tanks containing the cleaning and waxing solutions are lowered beyond the guide roller assemblies during an initial threading up operation but, as with continuous processing machines, this unit is intended to remain threaded either with genuine film which is being treated or with machine-leader film.

Film is first immersed in the cleaning solvent held in a bath seen at the lower left-hand corner of the cabinet. It then passes vertically upwards and through a spray cleaning chamber. Immediately above this it passes through an air squeegee so as to become partially dry—but not completely dry so that, on passing to the waxing bath (seen at the lower right-hand corner) the film is still sufficiently moist to ensure maximum and rapid impregnation of the wax. On leaving the waxing bath the film is formed into a series of loops which can be varied in length to ensure that optimum drying takes place by the time the film enters the series of polishing and anti-static rollers seen at the top left-hand section of the cabinet. This particular machine has a maximum output of 140 ft. (42·67 metres) per minute.

Liquid 'after-treatment' processes are a great improvement on the solid wax techniques and do much not only to overcome the green problems associated with new film, but also to create noticeable resistance to scratching. However, when similar techniques are used to clean old film which has been projected many times liquid processes involving buffing pads or mops can sometimes cause trouble. When this occurs it is generally traced to particles of dirt embedded in the pads or mops which may well accumulate during a long cleaning session. If this happens dirt and scratches become distributed over the entire film rather than being removed. Even if the pads or mops are changed at the beginning of each roll of film it is still possible for a concentration of severe dirt some distance in the reel to become trapped in the pads and to scratch the remaining section of that reel.

Ultra-sonic techniques have been introduced to overcome these hazards. With these systems the cleaning fluid is set into intense oscillation and the film immersed in these liquids is virtually bombarded by a series of shock waves—this creates a powerful yet completely harmless scrubbing action which, in fact, can be sufficient

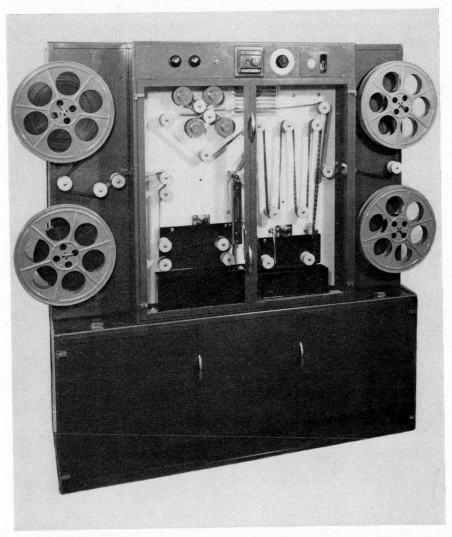

Fig. 5.2. The Premier Automatic Film Cleaning and Waxing Machine

Courtesy Robert Rigby Ltd

even to completely remove wax or grease pencil marks used on cutting copies, dubbing prints, etc.

Portable ultra-sonic cleaning machines are available both for 16 mm. and 35 mm. film, they will accommodate up to 2,000 ft. (609·2 metres) and are supplied complete with built-in frequency generators. Typical of these is the machine designed by Colour Film Services (Engineering) Ltd. of London, England. In this machine the recommended cleaning fluids are carbon tetrachloride or methyl-chloroform, both liquids being suitable for all but magnetically striped films. Magnetic films may be cleaned in Freon-T.F., or a 1 : 1 mixture of cyclohexane and carbon tetrachloride.

Chapter 6

Sensitometry

UP to this point we have considered quality only in terms of *good processing techniques*; by far the greater concern is, of course, to maintain photographic consistency in the ultimate results. From the knowledge we have already gained it is apparent that consistently good quality will depend upon three factors: film characteristics, exposing conditions and processing methods.

Any film must maintain constant photographic speed, it must exhibit little or no batch-to-batch variations so that, for example, photographing an evenly illuminated background will produce similar densities in negatives made from all batches of that film. Similarly, if it is a colour film it must consistently reproduce the intensity, or saturation and hue of all colours without detectable variations. If any speed differences do exist and require corrective processing modifications, then means to assess these differences must be available—and the results from such measurements must be made known to cameramen in a manner which they can readily interpret.

To profit from this information implies that cameramen must understand the systems used by the film stock manufacturers in classifying the speed and other characteristics of their products, that they must be able to interpret data provided by laboratories, and also that they can accurately measure the illumination of the scenes they photograph. In the past amazing results were produced by cameramen working entirely from experience whereas, today all cameramen use exposure meters to measure the subject brightness and to indicate the correct exposure.

The well known Weston and Norwood exposure meters are typical of such instruments and are very popular amongst studio and television cameramen. The S.E.I. exposure photometer is an exceptionally high quality meter having a variety of purposes apart from exposure calculations—such as the measurement of screen brightness and light transmission through film or similar materials. One great advantage of this instrument is its ability to isolate very small areas of the scene—it has an acceptance angle of less than 1° so that, when held next to the camera (and not close to the subject as is necessary with integrating exposure meters) exceptionally small areas may be measured and precise exposure of each part of the scene can be determined.

Assuming the film has been correctly exposed, it must then be processed so that the anticipated result is achieved. This requires laboratory staff to measure the

activity of their processing solutions, to control the time during which the film remains in these solutions, and to keep the solution temperatures within close limits. Since laboratories receive many types of film from different studios, they must have some means of testing these films *before* the actual studio negatives themselves are processed. Clearly, their equipment must permit adjustment to the developing technique in order to obtain the photographic conditions favoured by each customer. These changes are not normally large in the case of picture negatives but, in photographic sound recording, considerable differences in negative contrast exist between some types of recording and these often depend largely upon the ultimate printing requirements.

At this point it will be helpful to remember the many intermediate steps between the original negative shot on the studio floor and the final release positive prints seen in the cinemas. (See Chapter 1.)

It is apparent that film may be processed under a variety of conditions and, in fact, continuous processing machines should be designed to provide the greatest possible latitude in this respect. To harness this latitude to produce the optimum results when any one type of film is being processed, some form of control must correlate the characteristics of the film emulsion with those of the developing solutions and machine conditions.

For these reasons a *sensitometric control system* is applied to continuous film processing and, as will be apparent, the principles of such a system may also be used to control any photographic process. Broadly speaking, sensitometry is the study of the following characteristics of sensitive emulsions and processing techniques: (*a*) The photographic speed of the emulsion, (*b*) The gamma and contrast which are achieved with a given emulsion under known processing conditions, (*c*) The ability of a given developing solution to change the gamma produced with any particular emulsion, (*d*) The relationship between initial exposure, final density and processing time. In the case of colour film processing, sensitometry is extended to measure control densities, etc., in three separate films—representing the red, blue and green components of the negatives or the magenta, cyan and yellow of the positives.

Density-transmission relationship

To fully understand the sensitometric control process it is first necessary to define certain terms. In the year 1890 Hurter and Driffield made their classical experiments which established the relationship between transmission, opacity and density. Transmission is the term used to describe the ability of a film to pass light, it can be established for any photographic image by directing a narrow beam of light of known intensity on to a point in the image, and then measuring the intensity of light transmitted or passed through the film. The intensity of the transmitted light can never equal that of the incident beam—even when passing through clear glass—and will always be lower than the incident light value due to the absorption of the transmitting media. That part of the incident light which is lost by absorption is

known as the *Opacity* of the film image. It is therefore obvious that Opacity must be the reciprocal of Transmission. The *Transmission Factor* is the quotient obtained when the amount of light transmitted through a film is divided by the amount of light directed on to the film to cause such a transmission.

It is not convenient to assess the blackness of a monochrome film or the absorption of a colour film image in terms of Opacity although, of course, it would be quite accurate to do so. The photographic characteristics of an emulsion are usually demonstrated by plotting graphs between logarithmic axes; because of this and, fortunately, because the action of the iris in the human eye is also approximately logarithmic, it is of greater value to consider the *logarithm* of Opacity and to plot increments in film blackness in terms of log-opacity against the related increments in film exposure which caused the blackness. The logarithm of opacity—the blackness or absorption of a film image—is known as *Density*.

Therefore, if an incident beam of 100 candle-power is directed on to a film surface carrying such a density that only 10 candle-power passes through it to the measuring instrument, the transmission factor will be 0·10 (the transmitted value divided by the incident value), or a transmission of 10 per cent.

Since opacity must be the reciprocal of transmission, a film having a transmission factor of 10 per cent. must have an opacity equal to the reciprocal of 10 per cent. (or of 100 divided by 10), thus it must have an opacity of 10. Density has been established as the logarithm of opacity and so, in this case, the film must have a density of 1·0 since the logarithm of 10—the opacity—is unity.

This relationship between density, opacity and transmission is very important and is indicated in Figure 6.1. Here section A indicates values of incident light falling upon a processed film of a certain density. Section B indicates the value of light transmitted through the film. Section C indicates the transmission factor which is obtained by dividing the values obtained at B by those given at A. Section D indicates the opacity of the film and, since opacity is the reciprocal of transmission, these figures are obtained by dividing A by B. Finally, density is the logarithm of opacity and, therefore, is the logarithm of the values obtained in D—these values of density are shown in Section E, Figure 6.1.

A further important term may now be defined and, incidentally, one which is often confused with gamma. This term is known as *contrast-ratio*. Contrast is a measure of the difference between two brightness levels—no matter whether they be incident or reflected light, or levels of light intensity transmitted through a photographic image—it is also a term of great importance when film is used in television. Contrast-ratio is the anti-log of one density subtracted from another density but, since any density is the logarithm of an opacity, contrast-ratio must be the ratio of the opacities. This can be expressed as follows:

$$\text{contrast-ratio} = \frac{\text{o max.}}{\text{o min.}} \text{ (where o = opacity)}$$

$$= \text{anti-log of } (\log \text{o}_{max}. - \log \text{o}_{min}.)$$

$$= \text{anti-log of } (D_{max}. - D_{min}.)$$

169

As a practical example, let us assume that the darkest portion of a negative has a density of 2·0, whilst the lightest portion has a density of 0·3, and we wish to know the contrast-ratio of the scene as recorded by that negative, then:

$$\text{contrast-ratio} = \text{anti-log of } (2\cdot0 - 0\cdot3)$$
$$= \text{anti-log of } 1\cdot7$$
$$= 50$$

This means that the contrast-ratio is 50 to 1 (usually written as 50 : 1) in a negative having a density difference of 1·7 between the highest and lowest densities

A	B	C	D	E
VALUE OF INCIDENT LIGHT IN CANDLE-POWER	VALUE OF TRANSMITTED LIGHT IN CANDLE-POWER	TRANSMISSION FACTOR (B/A)	OPACITY (A/B)	DENSITY (LOG OPACITY)
100	10	1/10 = 10%	10/1 = 10	LOG 10 = 1
100	1	1/100 = 1%	100/1 = 100	LOG 100 = 2
1000	1	1/1000 = 0·1%	1000/1 = 1000	LOG 1000 = 3
1000	60	60/1000 = 6%	1000/60 = 16·6	LOG 16·6 = 1·22

Fig. 6.1. Relationship between Density, Opacity and Transmission

in the scene. It is now evident that *contrast* is determined by the ratio between *specified densities* and, whilst this ratio will be dependent upon the gamma to which the film is developed, it is something quite different to gamma itself.

The foregoing examples assume that certain densities have been obtained on strips of film, and that instruments are available with which to measure the light value both before and after it is modified by introducing these densities into the beam. However, if it is required not so much to measure given densities, but to produce densities of given values, then a relationship between *exposure* and resultant density will be found to exist.

This relationship can be forecast to some extent from Figure 6.1 since, if we consider the first two examples, it is seen that a change in density from 1·0 to 2·0 occurs when the light transmission is reduced to 1/10th. It is therefore reasonable to assume that a *density difference* of 1·0 could be produced if one exposure is made 10 times greater than another. (The advanced worker will realise that this does in fact happen when the film is processed to a gamma of unity.)

Exposure

Photographic exposure is the product of the intensity of the light falling upon a film and the time during which it is permitted to operate. If exposure obeyed the

law of reciprocity then a high intensity, operating for a short period, would produce a density equal to that obtained when a correspondingly low intensity operated for a long period. Unfortunately this is not so and, although in both cases the product of intensity and time may be equal, the resultant densities will not be identical. This peculiarity of film emulsions is known as Reciprocity Law Failure. In attempting to expose successive areas of film so that a series of test densities are produced it is therefore necessary to decide the precise manner of exposure to be employed.

The *type* of exposure given when testing film and processing conditions should obviously be related to the exposures the film is likely to receive under practical conditions. Once the type of exposure has been fixed, one must then decide which of the two factors shall remain constant and which shall be varied by known and accurate amounts. For example, it is possible to expose film so that successive strips receive known increments either by maintaining the light intensity at a constant value and varying the time of exposure, or by varying the intensity of the light and maintaining the time-factor constant.

Instruments designed to give precise exposures to successive small areas along a length of film are known as *sensitometers*. They can be arranged to operate by varying the light intensity—when they are known as Intensity-Scale Sensitometers—or by varying the time of exposure—when they are known as Time-Scale Sensitometers. The colour temperature of a tungsten light source varies according to its intensity and, since monochrome film is not sensitive to all colours to an equal degree, it is essential to employ a neutral-density wedge to alter the exposure in intensity-scale sensitometers rather than to vary the current passing through the lamp. For similar reasons, lamps running at different colour temperatures must be employed when films used for different purposes are being tested. (This mainly refers to the difference between blue-sensitive positive printing emulsions and panchromatic negative emulsions.) It is also sometimes necessary to insert filters in the light beam when testing films of different colour sensitivity. In a similar manner, it is necessary to make three separate sensitometric exposures when testing colour film— each exposure being suitably filtered to expose each of the three layers of the integral-tripack which forms the emulsion.

A series of increasing exposures is of little value unless the exposure increments from one step to the next are related to the resultant densities on the film. As has already been shown, linear increments in density are actually logarithmic increases in opacity, it therefore follows that the most useful exposure increments are those which also increase logarithmically. For many years the only instrument of this type which was commercially available was the Eastman Kodak 'Type-2b' sensitometer in which each exposure is $\sqrt{2}$ greater than that which immediately precedes it. The type-2b instrument is a time-scale sensitometer. More recently the Eastman Kodak 'Type-X6' intensity-scale sensitometer has been introduced to relate more realistically to the exposing conditions met with in practice.

Instruments designed to measure the resultant densities produced on a film are known as *densitometers*—such as the Western Electric Type RA–1100, the Baldwin, the Macbeth and the Eastman Kodak instruments. It is therefore possible to make a

series of known exposures, process the film, measure the resultant densities and then plot graphs to illustrate the characteristics of film emulsions as related to exposing and processing conditions.

The sensitometer

Before we can discuss any further the process of sensitometric control it is essential that the operation of the instruments used in this work are thoroughly understood. Any sensitometer consists of two main sections; firstly a source of constant illumination and, secondly, a means for controlling the effective exposure which reaches various areas of the film under test.

As we have seen, this has produced two main types of sensitometer, the first known as the Time-Scale instruments in which the illumination is maintained constant but the time of exposure is varied, and the second type, known as the Intensity-Scale instruments in which the exposure time is constant but the intensity of the illumination is regulated.

For many years the Eastman Kodak type-2b sensitometer was widely used throughout the industry in its original form as a time-scale instrument. The actual exposure times provided a range from 0·005 second up to 4·990 seconds and, therefore, only a small portion of this range was comparable to practical conditions or is applicable to present-day motion picture cameras, photographic sound recording systems and film work for television. Because of this the instruments were modified to operate as intensity-scale machines providing a series of six exposing conditions so that 1·0, 1/5th, 1/10th, 1/25th, 1/50th or 1/100th second exposures may be selected.

Since the basic machine remains unaltered, and it illustrates the fundamental principle so well, the original time-scale arrangement will first be described—after which the relatively simple conversion to intensity-scale working will be easily understood.

A cut-away view of the original Eastman Kodak sensitometer, seen in Figure 6.2 shows all the essential parts of the instrument. Obviously, if the instrument depends for its accuracy upon constant light output, the lamp L must be carefully selected. Lamps for the type-2b sensitometer are obtainable only from the Eastman Kodak organisation, where they are calibrated for colour temperature and candle-power. Since they are used as standards of luminous intensity the lamps are considerably under-run to increase their life and to maintain reliable operation. With a candle-power tolerance of only 2 per cent., these lamps have a life well over 200 hours but, to safeguard against probable ageing, all laboratories should carry spare lamps for use as 'secondary standards' if the performance of the 'working lamp' is ever in doubt.

Light passes from L through aperture O to an optically flat mirror M accurately mounted at 45°. This reflects the light upwards to the plane of exposure indicated at PL. A rheostat R controls the lamp current and may be accurately set by reference to the ammeter A. The voltage across the lamp is indicated by voltmeter V. Since

these meters must be adjusted in the dark room, safelight SL is provided and suitably filtered. Lamps of different candle-power are used for testing negative or positive films; this entails the use of double-scale meters, in order to obtain precision adjustments, and also different resistances in series with each lamp. These changes are automatically performed by selector switch LS. Filter F is inserted in the light beam to modify the characteristics of the light to the quality required for each type of emulsion—or each layer of a colour film—which may be under test.

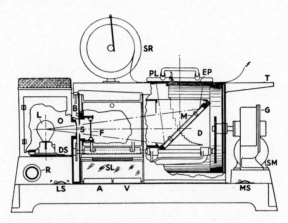

Fig. 6.2. The Kodak Type-2b Sensitometer

The increase in exposure time given to each successive step along the film is obtained by 21 slots of logarithmic increments in length, cut in a circular drum D. This drum is only closed at that end near gearbox G, so that mirror M is actually mounted within the rotating drum. Constant speed is ensured by synchronous motor SM, via a gear reduction unit housed at G. The electrical supply both to the motor and to the lamp is through the main switch MS. When this switch is closed the motor and drum rotate continuously but, since the photographic material must receive exposure only during one revolution of the drum, a shutter S is arranged to interrupt the light beam. This shutter is driven by a selector mechanism directly connected to a countershaft, running horizontally on a cantilever casting and geared to the main drum.

The mechanism operates as follows: with the main switch closed and the drum rotating, film is inserted beneath platen PL and exposing button B is depressed. When the drum reaches a point where the complete area of the film platen is covered, the selector mechanism (geared to operate in sychronism with the drum) opens the shutter S. Immediately the 21 step exposures have been made—that is, in less than one revolution of the drum—the mechanism closes shutter S once more and remains disengaged. The drum will continue to rotate but a second exposure will only occur when button B is again depressed. If *very* slow film is to be tested it is in order to

173

allow more than one revolution of the shutter. The roll of film upon which sensito-metric exposures are to be made is mounted vertically at SR and is fed under platen PL where it is held flat during the exposing period. A typical '2b-strip' produced by this instrument is illustrated in Figure 6.3, and it should be noticed that a V-shaped cut indicates the eleventh step—that is, the central step. This is a great aid when heavy exposures on contrasty film tend to obscure the first and last steps in the wedge.

Conversion of the type-2b sensitometer to intensity-scale operation has been effected by two basic modifications. Firstly, the exposure modulating drum D has been replaced by two drums, one of slightly smaller diameter than the other and arranged so that the smaller drum may be rotated by hand to a pre-set position

Fig. 6.3. A 2b Sensitometric Strip

with respect to the larger drum. A relatively large parallel slit-aperture in the outer drum is selectively modified by any one of six smaller apertures cut in the inner drum. The inner drum is first set by hand relative to the outer drum to provide exposures of either 1·0, 1/5th, 1/10th, 1/25th, 1/50th or 1/100th second across the *entire* film exposing area PL. Once set, the two drums are locked together and continuously rotated by the original gear and motor drive. Exposure modulation is then created by mounting a *carbon wedge* immediately below the exposing platen. This wedge consists of 21 step increments in density which, in effect, appears very similar to Figure 6.3. Intensity-scale exposures are therefore made by producing a *contact print* from the carbon wedge (as the negative) on to the film under test (as the positive) and, of course, the colour temperature of the exposure remains constant across the whole wedge. Illumination is by a 500 watt lamp running at a colour temperature of 2,850°K. and this may be modified by filters either to change the colour temperature or to reduce the light intensity when testing very fast emulsions.

Each step on the carbon wedge corresponds to a change in exposure of approxi-mately $\sqrt{2}$. It is most difficult and expensive to manufacture wedges having exactly equal exposure increments and, providing the actual increments are known, the fact that they are slightly different can be accommodated when the resultant sensitometric data is plotted. This is also true of the Eastman Kodak type-X6 intensity-scale sensitometer—a recent design introduced for routine testing and, incidentally, because production of the type-2b instrument has ceased.

The Type-X6 sensitometer is illustrated in Figure 6.4 and, like the modified Type-2b, it also creates test exposures by contact printing from a graduated density wedge—the main difference between the two instruments being the mechanics by which the exposure is effected. In the Type-X6 an exposing platen is

174

mounted vertically on the outer side wall of the rectangular box-like instrument. Within the main body a very accurate square-thread lead-screw is mounted horizontally between parallel V-shaped guide rails somewhat similar to a lathe-bed. The exposing lamp is mounted in a light-tight housing arranged to traverse the lead-screw at constant speed. It is powered by a 220 volt three-phase motor revolving at

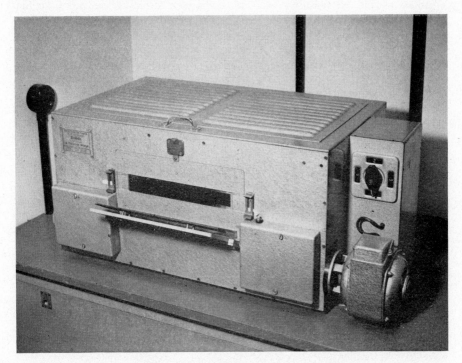

Fig. 6.4. The Eastman Kodak Type-X6 Sensitometer

Courtesy Visnews Limited

1,500 revs. per minute and so that the lamp carriage travels at 20 cm. per second. Adjustable slit-apertures attached to the lamp housing permit exposures of 1/10th, 1/25th, 1/50th and 1/100th second. Provision is made to adjust the lamp intensity and to modify the colour temperature.

As mentioned previously, the wedges in both the modified Type-2b and in the Type-X6 sensitometers produce a series of exposure increments approximately in √2 steps. It is, of course, essential that the *precise* log-exposure increments from one step to the next are known in order accurately to plot the resultant data. Each wedge is calibrated by the manufacturers before leaving their works and, should a replacement ever be necessary, the calibration of the new wedge must be employed. The steps plotted along the log-exposure axis of a graph illustrating emulsion

characteristics are nominally at intervals of $\sqrt{2}$; the variations between density increments in one carbon wedge and another are so small that, for routine comparison purposes only, sufficient data is revealed when these nominal equal steps are used. However, when the *precise* shape of a characteristic curve becomes important—or when the performance of any stage in the process is being analysed, it is then *essential* to plot the exact log-exposure increments derived from the particular wedge fitted to the sensitometer.

To simplify the somewhat tedious business of locating irregular log-exposure increments on each occasion, it is helpful to mark off a permanent scale of increments on graph paper and to cover this with celluloid—so forming a convenient scale from which the precise increments may be rapidly transferred each time a new graph is constructed. A similar aid can be obtained by engraving the increments directly on to the underside of a transparent ruler. Experience has shown that the printing of successive batches of graph paper does not always maintain constant ruling and, therefore, the use of plotting aids should be checked against the graph paper ruling—especially when a new pad or a new stock of pads of graph paper are brought into use.

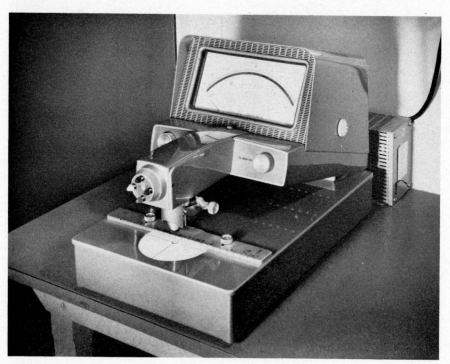

Fig. 6.5. The Macbeth Densitometer

Courtesy Visnews Limited

The densitometer

A densitometer is an instrument which measures the light-stopping ability of a photographic image directly in terms of log-opacity—that is, in units of density. For many years this was accomplished by using optical comparators in which the brightness of two concentric circles of light were visually compared and matched—typical of these was the Capstaff-Purdy densitometer manufactured by the Eastman

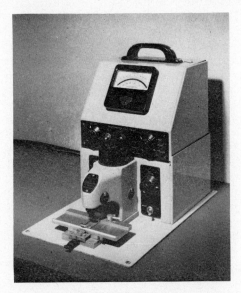

Fig. 6.6. The Baldwin Densitometer

Courtesy Visnews Limited

Kodak Company. Usually the brightness of the inner circle remained constant at a level determined by inserting the film sample below the photometric head, whilst the brightness of the surrounding field could be adjusted to match that of the central area. Adjustment of the field was by means of a large circular continuous density wedge, accurately calibrated in direct units of density. Once a perfect match had been achieved the density of the sample could be immediately read from the calibrated scale on the circular wedge.

The accuracy of readings made on visual comparators largely depended upon the individual and, particularly, upon eye fatigue. Density reading was a somewhat slow process and the reproducibility varied considerably from one operator to another. Because of this photo-electric densitometers such as the Western Electric Type RA–1100, the Macbeth and the Baldwin type MND/LD are now commonly used in the sensitometric control of films for motion picture and television work. A

typical Macbeth instrument is shown in Figure 6.5, and a typical Baldwin instrument is shown in Figure 6.6.

Photo-electric densitometers consist essentially of two parts: one section being the optical head designed to illuminate an accurately defined small area of film emulsion and to direct the light transmitted through that emulsion on to a photo-electric cell. The other section consists of an amplifier receiving input from the photo-cell and providing an output to a 'dead-beat' milliammeter calibrated directly in density units. Usually the amplifier switching is arranged to provide full-scale deflection over the three density ranges of 0–1·0, 1·0–2·0 and 2·0–3·0. The optics of the photometer are usually adjustable so that either diffuse or specular densities may be read. Density readings between zero and 3·0 can be expected to an accuracy of plus or minus 0·02. Some densitometers employ a D.C. light source and create an A.C. light beam by means of a rotating shutter or 'chopper-wheel'. In all cases precautions should be taken to prevent amplifier drift and consequent zero-shift. Calibration is usually by adjusting the lamp brightness to achieve zero-density, and the amplifier gain to secure full-scale deflection at maximum density.

In all these instruments the sampling aperture is a mechanical slit—sometimes only 0·02 in. (0·51 mm.) in width—exposure to dirt or dust which may collect on the work table of the instrument must therefore be avoided. It is possible that the intended aperture-size may become reduced and, consequently, it becomes impossible to zero the meter. Obviously the obstruction in the slit must be removed: the only danger depends upon the *method* used to dislodge it. On no account should this be done by using a metal instrument—by far the safest technique is to blow the aperture clean by means of a compressed air gun or a dental chip syringe.

Illustrating emulsion characteristics

We are now equipped with sensitometers to create accurately controlled exposures, and densitometers to measure the processed results of these exposures; it therefore remains to establish a standard technique to illustrate the relationship between *Exposures* (the cause) and *Density* (the effect) which together constitute any sensitometric control system. This is most conveniently done graphically on squared paper by plotting increments in exposure along the horizontal axis, and resultant decreases in film transmission along the vertical axis. In order to present the evidence in a practical form the units along the horizontal axis are logarithms of the actual exposures, and the units along the vertical axis are logarithms of the reciprocal of the decreases in transmission. That is, log-exposures are plotted against densities. It is our immediate purpose to show that units of log-exposure are, in fact, equal to units of density.

These conditions are more readily understood by very carefully studying Figure 6.7. This figure does *not* illustrate a characteristic curve—it is only intended to demonstrate the basic theory behind the construction of such curves. We have already seen that sensitometers either create a series of exposures in increments of exactly $\sqrt{2}$ (1·4142) or that, as in the case of intensity-scale carbon wedges, the small

variations from one step to the next are precisely known and can be accurately plotted. However, purely for the purpose of illustration, let us assume that the exposure increments are always precisely $\sqrt{2}$ or 1·4142.

Metre candle seconds

Referring to the upper horizontal scale in Figure 6.7 we see that the *actual* exposure values are shown—these are precisely described in *metre-candle-seconds*—that is,

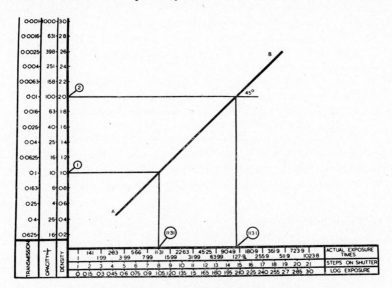

Fig. 6.7. Characteristic Sensitometric Data

a light of known candle-power operating for a known time and at a known distance from the film. For the moment let us assume that the first exposure in the series is recorded at the expreme left-hand division on this horizontal scale, and that it has a duration of 1·0 second. The next exposure in the series will then be recorded at the second division and will amount to 1·4142 seconds. The third exposure will be 1·4142 *times greater* than the second, the fourth exposure will be 1·4142 times greater than the third, and so on throughout the entire range of 21 steps.

Under these conditions the eighth exposure would therefore amount to 11·31 seconds. Let us assume that this 8th exposure caused such an effect upon the developed emulsion that it reduced light transmission to 0·10. It has been shown in Figure 6.1 that the reciprocal of transmission is the opacity, and the logarithm of opacity is density. These three factors, transmission, opacity and density are illustrated in the three vertical scales of Figure 6.7. Thus, if an exposure of 11.31 seconds produces a reduction in transmission to 0·10, we see that this is, in fact, a

density of 1·0. If the vertical and horizontal scales are similar, then a given *increase in actual exposure* (represented by a given distance on the horizontal scale) must be equal to a similar *reduction in light transmission* represented by an equal distance on the vertical scale.

Thus an increase in exposure from 11·31 seconds up to 113·1 seconds (10 times) must be represented by a distance equal to a reduction in transmission from 0·100 down to 0·010 (also 10 times). That this is true is demonstrated in Figure 6.7; horizontal lines drawn level with transmissions of 0·100 and 0·010 (or *densities* of 1·0 and 2·0 respectively) are turned through a right-angle by means of the line A–B inclined at 45° to intersect the horizontal scale at actual exposure values of 11·31 and 113·1 seconds (or log-exposures of 1·054 and 2·054 respectively) and, of course, the distance between points 1 and 2 on the vertical scale is equal to the distance between 11·31 and 113·1 on the horizontal scale.

It must be realised that, merely to establish the relationship between log-exposure and density, it has been convenient to assume that exposures from 1 second upwards are used. This is not true in practice—actually the whole series of exposures takes place in less than 5 seconds in the original Type–2b sensitometer, or less than 1 second in the modified 2b and in the Type–X6 instruments. In this instance we have only adopted convenient figures to avoid the confusion which could arise by dealing in decimal parts of a second. The *ratio* between successive exposures remains constant whatever units are employed.

Characteristic curves

Curves relating log-exposure values to resultant densities are sometimes known as H & D curves, after Hurter and Driffield, the scientists who first employed this method of representing photographic characteristics. Obviously, it would be of little value to plot opacities and actual exposure times—because the scales of reference would be widely spaced at one end and crowded together at the other. However, by taking logarithms of each scale, a uniformly distributed calibration is obtained. When logarithms of opacities are plotted they become densities. When logarithms of the actual exposure times are plotted they are known as log-exposures—this axis is popularly known as the 'Log–E' axis of the graph.

Some people find considerable difficulty in plotting characteristic curves because they are never quite sure of the relationship between the units of density and the units of log-exposure. The sensitometer gives a series of exposures, each of which is nominally 1·4142 times greater than the preceding exposure. Figure 6.7 shows that the logarithms of exposure increase as follows: 0·15, 0·30, 0·45, 0·60 and so on, that is, each step increases by 0·15.

If we now let 0·15 increase in log-exposure be represented by 15 divisions along the graph paper, we must also let 0·15 increase in *density* be represented by 15 divisions since, in actual fact, we are plotting one logarithm against another. Confusion rises because the density scale is *marked off* not in units of 0·15, but in units of 0·10. Under such circumstances it must be remembered that the *ratio* between

the two scales is still maintained although different *intervals* are numbered on each scale. In short, no matter what type of graph paper is used, but providing the exposure increments are known to be $\sqrt{2}$, the number of divisions along the graph paper which are used to represent a change of 0·1 in density must always be 2/3rds the number used to represent one exposure step. It should be noted that, although $\sqrt{2}$ is actually 1·4142, the *logarithm* of this is 0·15.

In intensity-scale sensitometers using a carbon wedge as the intensity modulator, the log-exposure increments are equal to the *difference* in density between successive steps and, of course, these are carefully measured and calibrated by the manufacturers. A typical series of densities and resultant log-exposure increments for an Eastman Kodak Type–X6 sensitometer is given below:

STEP NO.	WEDGE DENSITY	LOG–E INCREMENT
1	3·27	0·00
2	3·12	0·15
3	2·96	0·16
4	2·80	0·16
5	2·66	0·14
6	2·50	0·16
7	2·34	0·16
8	2·17	0·17
9	2·01	0·16
10	1·88	0·13
11	1·73	0·15
12	1·58	0·15
13	1·42	0·16
14	1·27	0·15
15	1·10	0·17
16	0·95	0·15
17	0·80	0·15
18	0·65	0·15
19	0·50	0·15
20	0·35	0·15
21	0·20	0·15

It is interesting to note from the table that step No. 1 on the sensitometer wedge carries the highest density whereas, on the test film made from this instrument, step No. 1 will, of course, have the lowest density. This is because the test strip is made by contact printing through from the carbon wedge. It should also be noted that the log-exposure increments are at an average of 0·15, but that they range from 0·13 up to 0·17. It is for this reason that the log-exposure scale particular to a specified carbon wedge should be marked out to produce a convenient rule as suggested when describing the Type–X6 sensitometer.

Assuming a range of sensitometric exposures has been made, processed,

measured and plotted, a curve similar to that shown in Figure 6.8 will be produced. A section of this curve, from point B up to point C, will be substantially straight and will indicate that, within this range, densities will be proportional to the magnitude of the exposures which caused them. Below point B the curve flattens out over the region of under-exposure—known as the *toe* of the curve—and there is no constant relationship between density and log-exposure in this region, but merely a steady increase in density difference as the exposure increases.

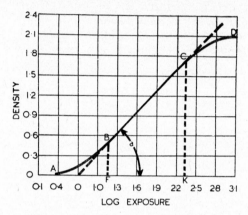

Fig. 6.8. Analysis of Characteristic Curve

Above point C the curve flattens out once more over the region known as the *shoulder* or region of over-exposure—here again the constant relationship between density and log-exposure ceases to exist and the density differences decrease as the exposure increases until they finally reach zero at point D.

Of great importance is the angle which the straight-line portion B–C makes with the horizontal log-exposure axis of the graph. This angle is indicated at 'a', Figure 6.8 and, if large because the curve is steep, it indicates that the combination between the film and processing conditions have produced a *contrasty* result. Obviously, if the conditions of exposure are maintained constant, the only way by which the curve can become steep is for the difference between the resultant densities to become large.

If angle 'a' is relatively small, and the curve is shallow, it will indicate that the combination between the film and processing conditions have produced a *flat* result in which the *same* increases in exposure as were used in the first example now only produce relatively small increases in density. The tangent of angle 'a' has been designated by the Greek letter *gamma* (γ), and is used to indicate the degree of contrast which may be expected between two exposure levels made within the substantially straight portion of the characteristic curve, and as a result of using any given film under specific processing conditions.

Thus we can appreciate that a single characteristic curve can yield the following

information: (a) The range of proportional working, where regular increments in exposure produce corresponding proportional increments in density, (b) the range of under-exposure, where light reflected from the subject is so little that the resultant densities are distorted—thus producing *crushing* of the shadows in the final print and consequent loss of detail. (c) The range of over-exposure, where light reflected from the subject is so intense that it exceeds the capabilities of the film and again

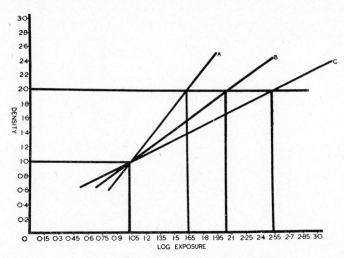

Fig. 6.9. Various Degrees of Contrast

the negative is distorted—thus producing *white crushing* in the final print and a condition when the high-lights are said to be burnt out. (d) An indication of the contrast of the film, given in terms of the gamma or slope of the characteristic curve over the region of proportional working. As indicated previously, gamma and contrast are *not* the same thing: gamma indicates the ratio by which given brightness levels will either be expanded or compressed in the film image. Contrast is a specific measurement between two brightness levels or image densities. (e) The relative speed of the film. This will be explained in detail later but it is obvious that a fast emulsion will occupy a position on the graph paper nearer to the left than will a slow emulsion.

Emulsion manufacturers obviously wish to produce materials which, over a large portion of their range, react proportionally so that increases in log-exposure produce corresponding increases in density. With modern fast emulsions this is not always possible and the *average* slope of the substantially straight portion has to be established. The *actual* increases in density which result from unit increases in log-exposure depend upon the slope or gamma of the substantially proportional section of the curve.

In Figure 6.9 three straight lines, A, B and C represent the proportional or

183

straight-line sections of the characteristic curves of three different emulsions processed under similar conditions or, alternatively, of one emulsion processed under three different conditions. Since all three lines intersect at a single point, a density of 1·0 is produced in all cases when a log-exposure of 1·05 is given. However, a density of 2·0 is produced by line A when a log-exposure of 1·65 is given, whereas this density is only produced by line B when a log-exposure is increased to 2·05, or by line C when it is increased to 2·55. It is very important to remember that, under all three conditions, steady increases in density at any point throughout the range will be obtained by correspondingly steady increases in log-exposure. That is

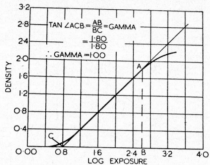

Fig. 6.10. Gamma of Unity Expressed Graphically

to say, all the emulsions are reacting proportionally over these sections of their characteristic curves.

Only under one particular condition will increases in log-exposure be *equal* to increases in density over this straight-line portion of the characteristic curve. This condition is indicated by line B, Figure 6.9, where an increase in density from 1·0 up to 2·0 is caused by an increase in log-exposure from 1·05 to 2·05. Under these conditions the relationship between density and log-exposure becomes a simple arithmetical proportion and equal increases in log-exposure produced equal increases in film density. This condition represents a gamma of unity and line B makes an angle of 45° with the log-exposure axis.

This special case is of great importance in all photographic work and is illustrated again in Figure 6.10. Gamma is defined as the tangent of the angle formed between the straight portion of the characteristic curve and the log-exposure axis of the graph. In the example, this straight line portion has been extended to cut the log-exposure axis at point C. Considering the right-angled triangle ABC, the height AB is 1·8, the base BC is also 1·8, and the required angle is ACB. Since the tangent of this angle is equal to the height AB divided by the base BC it must, in this case, be equal to unity.

Those interested in trigonometry will quickly see that any gamma value for any characteristic curve can easily be found by (a) selecting a point on the straight-line portion of the curve which is near to the toe, (b) measuring off 10 divisions to the

right along the graph paper and parallel to the log-exposure axis, (c) from this point erecting a perpendicular line and marking the point where this line cuts the characteristic curve, (d) the distance between this mark and the base of the perpendicular (in units of graph paper divisions) will now be a direct reading of gamma.

It will be appreciated that, when gamma is equal to unity, the differences in density must be *equal* to the differences in log-exposure and, therefore, the transmission range of the negative will be equal to the brightness levels of the original scene.

Film speed

Further information gained from the characteristic curve of a given emulsion concerns the *photographic speed*. Assume that two different emulsions are available and, under given processing conditions, both will produce similar gamma values. However, on plotting the curves one is seen to be much nearer the vertical, or density axis, than is the other. This condition is shown in Figure 6.11. It must be realised that both emulsions are identical in all respects other than the speed at which they react to given exposures. Curve A obviously represents a fast emulsion since comparatively low exposures have produced the required density range. Similarly, curve B represents a much slower emulsion because a range of densities equal to

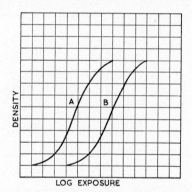

Fig. 6.11. The Effect of Film 'Speed'

those produced in curve A are only obtained after much greater exposures have been given.

It is a relatively simple matter to produce curves similar to those in Figure 6.11 and to compare film speeds and curve shapes. However, the *precise* measurement of film speed is a complex matter and depends very much on the type of exposure the film will receive in practice. It also varies with the colour temperature of the light source, the spectral sensitivity of the film, reciprocity law failure, the activity of the developing solution and the time of development.

In practical cinematography the cameraman will recognise changes in the apparent speed of any emulsion as it is processed by different laboratories. Fortunately he need not concern himself with the academic measurement of film speed —but only recognise a system of speed rating which can be applied to his exposure meter and processing laboratory. Film manufacturers always quote Weston and ASA speed ratings; these are based on the work of L. A. Jones of the Eastman Kodak Organisation and depend upon measurement of the *fractional gradient*—or the *average* tangent over the region of the curve covered by the whole subject range. Thus the speed measurement is very practical and is based upon measurements over the region where the camera exposure should ideally take place.

General characteristics

The foregoing details may be summarised quite briefly to present a concise picture of the information given by characteristic curves. Firstly, the position of the curve with respect to the log-exposure axis indicates the photographic speed of the emulsion (if it is to the left it will be fast and, if to the right, it will be slow). Secondly, the slope or angle of the substantially straight part of the curve indicates the image contrast which may be expected—the actual slope is referred to as the gamma of the emulsion but it is *not* the contrast-ratio. Thirdly, since gamma and contrast will increase if the developing time is prolonged, it is possible to plot values of gamma against developing times and so to produce a *time-gamma* curve for a given emulsion when developed in a given solution.

Time-gamma curves are only of value when the conditions of the processing solutions are rigidly controlled. The gamma obtained after any developing time depends upon the degree of solution agitation, the temperature of that solution and the age of the developer. Even if all these variables are rigidly controlled both when time-gamma curves are produced and when they are subsequently used to select any desired processing condition, it does not necessarily follow that a given gamma value will be a true indication of the practical contrast of the material. This is particularly true when the densities used in practice do not all lie on the straight section of the characteristic curve.

Naturally, it is also possible to construct temperature-gamma curves so that the optimum gamma may be selected not by altering the film speed through the processing machine, but by adjusting the solution temperature. Families of both time-gamma and temperature-gamma curves are obtained by running a series of sensitometric test strips through the processing machine, and altering either the developi time or temperature by known amounts as each new strip enters the bath. The results obtained by plotting characteristic curves of every strip then indicate the gamma changes which have been obtained. This evidence is then re-plotted on to master curves in which changes in machine speed (or solution temperature) are plotted against the resultant changes in gamma as found during each individual test.

It is not sufficient to assume that, because a change in machine speed has achieved

the required gamma value, this must necessarily be the optimum processing condition. Because not only gamma but also image grain-size and resolution will be affected, all these factors must be considered against the economical running speed of the processing machine before the optimum condition can be found.

Although most of the data so far described in this chapter has been referred to densities and grain-size (thus implying the use of monochrome film) it is equally true and applicable when testing colour films. The main difference being that three curves must be plotted each time a colour film is tested—one for each primary colour component—and that the ultimate 'densities' are mainly created by dyes rather than silver grains.

Reproducibility of tests

Selected gamma and density values can only be achieved within certain practical working tolerances. These are governed by two main groups of variables. Firstly, the inherent accuracy of the test equipment and processing machinery and, secondly, the human errors in setting, measuring and interpreting the evidence from the control system. All these tolerances and errors combine to produce overall practical limits of reproducibility which must be realistic. It is pointless to stipulate processing tolerances closer than these limits although, of course, it is possible that the working tolerances at one laboratory may be closer than at another. The twelve basic factors responsible for variations in test results and daily processing are as follows:

(1) Sensitometer accuracy, adjustment and control.
(2) Uniform processing machine speed and accurate speed setting.
(3) Variations in developing solution temperature.
(4) Variations in developing solution activity.
(5) Variations in film-path length (viz. friction drive).
(6) Batch-to-batch variations in processing chemicals.
(7) Variations in the basic volume of packed liquid chemicals.
(8) Variations in chemical mixing and dilution.
(9) Batch-to-batch variations in the film stock.
(10) Calibration of the densitometer.
(11) Accurate curve plotting.
(12) Realistic interpretation of sensitometric data.

It is important to realise that gamma and density variations under conditions of personal supervision and rigid control can be very misleading and, perhaps surprisingly, are usually twice as close as can be achieved in routine operation of large commercial laboratories, or three to four times as close as can be maintained in the smaller installations associated with television stations and similar organisations. Figure 6.12 shows the practical working tolerances which can be readily achieved with small installations and, therefore, represent the widest tolerances which should be permitted. As would be expected, tolerances become wider as both density and gamma levels increase.

Typical working conditions and tolerances for picture negative, telerecording by film and picture positive gamma and density values are summarised below. These indicate the widest permissible conditions.

Required density	PRACTICAL WORKING TOLERANCES		
	at negative picture gamma 0·65	at telerecording gamma of 1·0	at positive release print gamma of 2·40
0·40	±0·02	±0·03	±0·05
1·50	±0·06	±0·09	±0·14
Gamma tolerances	±0·03	±0·06	±0·10

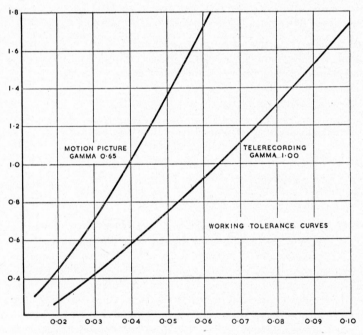

Fig. 6.12. Working Tolerances on Processing Conditions

Required negative and positive gamma values

We can now produce negatives developed to any required gamma, or contrast range, and it is timely to consider the most suitable values to adopt. For the moment we will only consider the processing of *picture* materials—the processing of photographic sound film and films for television purposes will be dealt with at a later stage.

The problem is, of course, to reproduce the entire range of brightness encountered in any subject so that the final screen image closely resembles the original. Only in very exceptional circumstances is it possible to reproduce the *absolute* brightness faithfully but, fortunately, such accuracy is not necessary. Practical limitations force the adoption of a compressed scale of brightnesses, lower than those of the average original. Providing the brightness ratios are *proportional* it is acceptable for them to be reproduced at a lower level of intensity.

The following broad stages are involved in arriving at the final screen picture:
(1) Those governed by image formation through lenses, i.e. the original photography, the use of lenses in optical printers, and the projection of the final prints.
(2) The exposure of the negative and positive films from a *chemical* point of view.
(3) The processing of both negative and positive films.

The only stages over which the laboratory has control are the development of the negative and the exposure and development of the prints. Obviously, the laboratory also controls the exposure and processing of any intermediate materials—such as the master positive and duplicate negative steps used in feature-films. The gamma and contrast of the final prints are controlled largely by the gamma of the negatives from which they have been made. A third gamma value—known as the *over-all* gamma or *reproduction-gamma*—decides the gamma-value to which any positive print must be developed.

To preserve a final brightness range proportional to the original subject, an over-all gamma of unity is required. For conventional cinema projection this over-all gamma is the numerical product of the negative gamma, the printing machine gamma, the positive film gamma, the projection factor and the screen reflectance. In America many open-air drive-in cinemas exist—here the ambient or surrounding lighting conditions greatly reduce the apparent screen-image contrast so that, for such installations, the print contrast and colour saturation must be considerably higher than would yield optimum contrast, etc., in a conventional theatre. A similar somewhat unusual condition controls the selection of print gamma, density, contrast-ratio and colour saturation for films transmitted by telecine equipment; here the optimum requirements are modified both by the characteristics of the final television display tube and also by the average room-lighting contrast in the viewers' home.

Whilst laboratories can very accurately determine the printer gamma, the ideal projection factor will be slightly different in each cinema; one must therefore assume an average projection factor in these considerations. The contrast of a projected image also depends upon the reflection characteristics of the cinema screen

and the haze-content of the auditorium. (This is why a 'no-smoking' rule is applied in some countries.) The contrast of the image as it leaves the projector (but before it reaches the screen) is in the region of 1·25—but the average reflectivity of the screen is 0·80 and will reduce this contrast to unity. The gamma of the average printing machine is of the order of 0·90–0·95. Therefore, if the negative is developed to a gamma of, say, 0·60, a print from that negative must be developed to a gamma of 2·20—because the contrast as seen by the audience is the product of negative, screen, printer and positive film gammas, i.e. 0·6×0·8×0·95×2·2 = 1·0.

It may seem likely that many combinations of negative and positive gamma values could be multiplied together with the other factors to produce an over-all gamma of unity. However, the characteristics of negative and positive emulsions set limits between which these values must remain in order to preserve an undistorted grey-scale or tone-range with minimum image grain in the case of monochrome films, or colour balance, saturation and hue in the case of colour films. The best results are obtained when the negative is developed to a relatively low gamma—usually between 0·6 and 0·75, and when the positive emulsions are developed to relatively high gamma values of the order of 2·2 and 2·4. For the American drive-in theatres these positive values are raised to between 2·6 and 2·8.

Although the ideal over-all gamma should be unity, this only yields the most satisfactory result under equally ideal conditions. Such factors as stray light, both in the camera and on the projection screen, together with reflection-losses between lens components, all tend to reduce the *apparent* contrast of the picture as viewed by the audience. To allow for these reductions the contrast of the final result is often made intentionally higher than would be required in the ideal case. Present-day practice is towards an over-all gamma of approximately 1·2. This may be expressed as follows:

gamma of (negative × printer × positive × projector × screen) = 1·20.

Because the positive print is a *married* copy carrying both the picture and sound records, the positive *sound track gamma* will be controlled by the requirements of the picture if it happens to be a monochrome film—but it *may* be completely independent if it is a colour film. It is therefore essential for laboratories to work in close contact with the studios so that the one shall be aware of the conditions enforced by the other. Modern practice is first to decide upon the over-all gamma value judged to be most suitable for both sound and picture; then to decide at what gamma to develop the positive print; it is then a simple calculation to determine the required gamma at which the separate picture and sound negatives should be developed. Whilst original studio sound is almost invariably recorded on magnetic film, the ultimate cinema release print is usually still furnished with an optical sound track.

The studio cameraman is therefore required to light his sets so that the original contrast range produces the desired screen quality in the final reproduction. In photographic sound recording (or in transferring from magnetic to photographic sound records) much more complicated values—determined by cross-modulation

or intermodulation tests—confine the choice of negative gamma and density values so closely that, in all honesty, the final combined positive conditions which reach the cinemas can only be a compromise if, as with all monochrome films, they must be limited by the picture requirements.

The foregoing remarks provide one very good reason why modern studio sound departments have abandoned photographic methods in favour of magnetic sound recordings. Apart from improved signal-to-noise ratios, extended frequency ranged and similar advantages, one of the greatest attractions is that magnetic recordings remain independent from the photographic requirements of the picture right up to the final stage when the sound is married to the picture in the release prints. Incidentally, current trends suggest that even the final copies released to all cinemas may eventually carry magnetic sound tracks.

Gamma values for photographic sound recording

Although no mention has yet been made of photographic sound recording processes or apparatus (and recognising that many feature studios now employ magnetic sound systems), it is necessary at this stage to give some indication of the sensitometric aspects of this work. Two main types of photographic sound record are used: the one known as 'Variable Density' recording may be briefly described as a sound track of constant width in which the frequencies are represented by the number of changes in density whilst the volume is represented by the difference of these densities. The other method, known as 'Variable Area' recording, maintains a constant density level and registers sound frequencies as the number of variations in the width of the track, whilst volume is recorded in terms of the amplitude of these variations.

It is a relatively simple matter to select suitable density and gamma values when processing variable-area tracks (although the *control* of such values is just as critical as that required by the density method). However, with variable-density tracks the sound reproduction depends entirely upon *changes* in density, and processing must be very carefully selected if high fidelity reproduction is to be achieved. For this reason, only the sensitometry of variable-density sound film processing is considered at this stage.

In photographic sound reproduction the relationship between the film image and the projected picture, as seen by the eye, no longer exists. The 'eye' of sound reproduction is the photo-electric cell, in which the current is proportional to the light falling upon it. Changes in the current passing through a cell are therefore proportional to the light transmitted through the sound track. To achieve faithful reproduction the *exposure* of the negative sound track must therefore be linearly related to the *transmission* of the positive print. It is therefore more useful to study the photographic characteristics of sound film processing in terms of *initial exposure* and *final transmission*, rather than as log-exposures and densities.

Once the required exposure-transmission relationship has been established it may then be maintained by reference to normal log-exposure-density characteristic

curves produced by conventional sensitometry. As we have seen, pictorial reproduction is held constant with a negative gamma of approximately 0·65 and a positive gamma of the order of 2·4—thus preserving the required over-all gamma. However, with sound track reproduction the wave form may be reproduced by any set of conditions which give a *linear relationship* between negative exposure and print transmission, although only one particular relationship will yield optimum *volume output*. This freedom only really exists if the modulation, or volume range is so small that all densities remain within the straight-line portion of both the negative and positive characteristics. Optimum conditions are only obtained after allowance for other factors—particularly frequency and volume ranges—is fully recognised.

Three factors control variable density sound film processing: firstly, the negative density maintained when *no sound* is being recorded—this will decide the range of useable density available for recording purposes and is the *unmodulated exposure* of the negative. Secondly, the negative developing technique—this controls the gamma and therefore the contrast of the sound track. High contrast development causes a greater change in density for a small change in exposure that would result from low contrast development. Exposure is controlled in the sound recorder by the characteristics of the sound itself, and the range of frequencies which may be successfully recorded will depend upon the developing technique. Finally, the unmodulated density of the print (when no sounds are recorded on the negative) may also be adjusted. The operator has very little chance to vary the gamma of the final release print in monochrome films since this is controlled by picture requirements.

A positive print may be made from a negative by one of two methods. Firstly, on a machine in which both negative and positive films are held in contact or, secondly, on a machine in which a considerable space exists between the films— the negative image being focused through an intermediate optical system. The resultant print-density obtained by the contact process will not be equal to that obtained by the optical-printing process, even when the incident light on the negative image is equal in both cases. This is because the silver grains which form the negative image will absorb part of the incident light and also scatter some of that which is transmitted through the emulsion. When a contact print is made the positive emulsion receives *all* the light transmitted through the negative. When a projection-print is made the positive only receives that portion of transmitted light which does *not* include the scattered rays.

This difference in density is also met in sound reproduction. The positive sound track is illuminated by light passing to the photo-cell via an optical system. The *effective* density of the print and, therefore, the density important to the photo-cell, will only be *equal* to the density of the emulsion as measured under conditions which omit the scattered light passing through the film because, in practice, this never reaches the photo-cell. The measurement of density to include all the scattered light is known as the *diffuse* density whereas, a similar measurement which ignores the scattered light produces a value known as the *specular* density. The ratio between these two densities is known as the *callier coefficient*. Specular density is

always higher than diffuse density. Allowance for this is made by employing a 'projection factor' based upon the optical absorption of the system.

Another source of error in making sensitometric measurements for sound processing control concerns the *reciprocity law*. The shape of the characteristic curve produced via a sensitometer at relatively low levels of light intensity is different from that produced in a sound recorder operating at relatively high light intensities. Yet a further error which must be allowed for concerns the optical system used in sound printing machines. Curves showing the relationship between negative exposure and print transmission reveal that a slightly different shape will be produced by printing machines having different optical components. The ratio between these variations and the ideal condition is termed *the printer factor*. It is constant for any one machine and once established during initial tests on a new machine should always be allowed for in all subsequent calculations.

We have only noted three possible sources of error which may lead to false interpretation of sensitometric data when controlling variable density sound recordings However, these are most generally met with in practice and may be summarised as follows:

(1) *The projection factor*—or the contrast ratio between what is put into the sound reproducing optical system and what arrives at the photo-cell.

(2) *Failure of the reciprocity law*—or the difference in density between exposures of high intensity over short periods of time and exposures of low intensity over long periods of time although in both cases, the product of intensity and time may be equal.

(3) *The printer factor*—or difference in density produced on the positive copies by various printing machines although the inherent brightness of all the negative printing apertures may be constant.

Processing variable-area recordings

When variable-area recordings are processed it is more necessary faithfully to reproduce the form or outline of the image, rather than the degree of density or tonal values. The transmission of a variable-area track is proportional to the width of the clear area, and varies with this area. The variations in the width of the positive track should obviously be equal to corresponding variations in the negative and, apart from this, transmission over the clear area should be very high, transmission over the opaque area should be very low, and the outline or envelope of the waveform should be very sharply defined.

The condition under which these requirements are satisfied depend upon the type of recording head and the sensitometric conditions prevailing at the laboratory. However, the average requirements call for an opaque area with a density of 2·1 or more and a gamma of between 2·7 and 3·0. The sound recordist, or more precisely the sound transfer engineer—because most original recordings are now made on magnetic sound stock, must control exposure to achieve the required density when the film is processed to the selected gamma, and the laboratory must maintain the

7

processing conditions and time of development to produce this gamma with the type of film and solutions selected.

The positive print is developed to a gamma of between 2·3 and 2·6, but the density is usually 0·5 to 0·6 lower than that of the negative. For example, if the unmodulated density of the negative is 2·1, then the density of the positive print should be approximately 1·5. Once the necessary conditions have been established and the requires exposure and development has been obtained, it is the responsibility of the laboratory to maintain the condition throughout the entire production.

The foregoing brief outline of the application of sensitometric control methods to the processing of photographic sound tracks has merely been included to demonstrate the various applications of sensitometry within the motion picture field. A more complete analysis of all the problems is given in Chapter 11.

Sensitometry and film in television

Conventional 35 mm. and 16 mm. motion picture films are widely used to supplement television programmes. They carry images which are visually similar to those used in the cinema. Continuous-tone images are derived from conventional motion picture cameras, whilst images built up in the form of line structures are derived from telerecordings. To synthesise a moving picture these films are projected at the rate of 25 frames per second—the television picture frequency in Great Britain—instead of 24 frames per second as in the motion picture industry. In America the television picture frequency is 30 frames per second and this raises considerable problems when conventional motion pictures which have been shot for the cinema at 24 frames per second are to be televised.

Although films originally made for television in Great Britain (whether by telerecording or by conventional cinematography) will be photographed at 25 frames per second, films exposed for cinema exhibition at 24 frames per second are also transmitted for television at 25 frames per scond. This naturally causes an increase in the speed of image movement and raises the frequency of sound reproduction by approximately 4 per cent. (this results in the pitch of musical notes rising by something less than a semi-tone and is acceptable to all but the most critical ear).

Five types of film image are acceptable for television transmission: (1) conventional motion picture camera negatives, (2) conventional motion picture laboratory positive prints derived from (1), (3) telerecordings made by filming a cathode-ray tube display (as described in Chapter 2) to produce a negative image, (4) telerecordings as in (3) but arranged to produce a direct positive image on the original telerecording camera film, (5) motion picture laboratory prints made from (3).

Gamma-control amplifiers in television transmission equipment are capable of inverting the phase or contrast relationship of the signal—in practice this means that an incoming negative image can be electronically converted eventually to appear as a positive image displayed by the television receiver. This facility may also be employed during live studio transmissions, for special trick effects, and is not confined only to film work. Because of this it is not *necessary* to make prints

from motion picture negatives before they can be utilised in television programmes although, for several reasons connected with programme acquisition and distribution, it often happens that positive film images are used. Furthermore, the presence of any dirt or dust on the film will appear as a *white* spot when negative is transmitted, but as a black spot if a positive film is transmitted. Since black spots are far less noticeable to the viewer, this is one strong reason for transmitting positive film images whenever possible.

In television the original image passes through many stages before finally emerging as a recognisable picture but, in all cases, the film is ultimately projected via a telecine machine—this is basically a special form of film projector in conjunction with a television camera. Telecine equipment scans the pictorial image information and creates an electrical version of the picture in terms of a television signal. This signal is eventually converted back into a recognisable picture when, at suitably modified strength, it energises the phosphor in the cathode-ray tube of the domestic receiver.

Apart from the widely employed factors such as log-exposure, density, opacity and transmission, sensitometric control of film for television transmission is also particularly concerned with *contrast ratios*. The definition of contrast ratio is therefore re-stated as follows: 'The ratio between the opacities of the darkest and lightest points in the film image', thus:

$$\text{contrast ratio} = \frac{O_{max.}}{O_{min.}}$$

As we have already seen, opacity is not easily measured with standard photographic equipment—but the logarithm of opacity is continually measured since, in fact, it is the unit of image saturation known as *density*. Since density is a logarithm we must take the ratio of the anti-logarithms of the maximum and minimum densities in the image in order to arrive at the contrast ratio. This may be written so:

$$\text{contrast ratio} = \text{antilog}\ (D_{max.} - D_{min.})$$

If this is applied to the well-known B.B.C. Test Card 'C', we find that, in the *positive* film version of the card, the maximum density is 2·0, whilst the minimum density is 0·3. Therefore the contrast ratio is as follows:

$$\text{contrast ratio} = \text{antilog}\ (2\cdot0 - 0\cdot3)$$
$$= \text{antilog}\ (1\cdot7)$$
$$= 50$$

Therefore contrast ratio = 50 : 1 (50 to 1).

When applied to the *negative* film version of the same test card, the maximum density is 1·30 although the minimum density remains at 0·30. The contrast ratio of the negative is therefore as follows:

$$\text{contrast ratio} = \text{antilog}\ (1\cdot3 - 0\cdot3)$$
$$= \text{antilog}\ (1\cdot0)$$
$$= 10$$

Therefore contrast ratio = 10 : 1 (10 to 1).

Figure 6.13 illustrates the several ways in which the viewer may receive mono-
chrome television pictures. At the top of the diagram we see that an original
scene is fed from the television camera during a *live* transmission via a video trans-
mitter having a gamma value of 0·4. Since the cathode-ray tube in the domestic

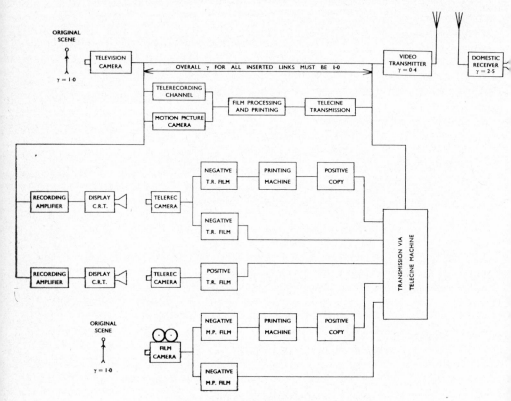

Fig. 6.13. Monochrome Telefilm Transmission

receiver has an effective gamma value of 2·5, the final screen picture will be at a
gamma of 1·0—equal to the original scene. Film is used to supplement television pro-
grammes in two ways; either originating as a telerecording or as a motion picture film.
In any event it must pass through film processing and possibly printing equipment
before reaching the telecine machine and, in all cases, the overall gamma for the
entire film-using system must be 1·0 so that, for example, sections of film may be
inter-cut with live transmissions. One example of this is, of course, the many
sections of television newsfilm material rapidly intercut with live announcements by
the newsreader.

The telerecording film chain can be arranged to produce a direct negative-image

film recording, a direct positive-image film recording, or a positive print can be made from the negative. In the first two cases we have the following four units in which local gamma or effective image contrast may be adjusted:

The recording channel amplifier.
The display cathode-ray tube.
The negative and positive film processing.
The telecine transmitting machine.

LINK IN FILM CHAIN	TYPICAL COMBINATIONS OF GAMMA VALUES						
	A	B	C	D	E	F	
(1) Recording amplifier	0·84	0·64	0·42	0·42	0·90	—	—
(2) Recording display C.R.T.	1·55	1·80	2·50	2·50	2·50	—	—
(3) Telerecording direct negative	—	—	—	1·00	—	—	—
(4) Telerecording direct positive	—	—	—	—	1·10	—	—
(5) Telerecording neg for printing	0·70	0·90	1·00	—	—	—	—
(6) Printed positive derived from (5)	1·70	1·80	2·40	—	—	—	—
(7) Motion picture camera negative direct transmission	—	—	—	—	—	0·65	—
(8) Motion picture camera negative for printing	—	—	—	—	—	—	0·65
(9) Motion picture print derived from (8)	—	—	—	—	—	—	2·40
(10) Telecine effective overall gamma correction factor	0·65	0·55	0·40	0·95	0·40	1·60	0·65
(11) Final product gamma	1·00	1·00	1·00	1·00	1·00	1·00	1·00
	A	B	C	D	E	F	G

In the remaining case the gamma of the film printing machine and also of the positive film processing must also be accommodated. When motion picture films are made for television purposes the conditions shown at the foot of Figure 6.13 will apply. Here it is possible to transmit the negative film image directly by phase or contrast inversion, or to make a positive film copy and to transmit this instead—in either case the gamma of the films plus the telecine equipment must result in a product-gamma of unity.

There are several ways of displaying the picture which is to be telerecorded; there are several types of film on which to make the recording; there are various types of telerecording cameras—some of which record a so-called suppressed-field

image, whilst others record full information; finally, there are various types of telecine equipment—such as vidicon or flying-spot image transducers. It is quite impossible to discuss all the various techniques and fundamental principles of television equipment in a book of this nature; for similar reasons, it is not possible to quote one fixed set of gamma and density values which, once achieved, would satisfy each stage of the various combinations of equipment involved in the basic methods outlined in Figure 6.13.

However, some idea of the variations which may be encountered is gained from the table on p. 197. In system 'A' a telerecording negative is printed before final transmission and, by some standards, the recording amplifier gamma is high, the display tube and film print gammas are low and the final telecine gamma correction is somewhat high. By comparison, system 'C' employs a much lower recording amplifier gamma, higher display tube and print film gamma values, and a relatively lower telecine gamma correction.

Staircase waveforms

The fact that these methods are so different is not so alarming as may be supposed at first sight. In general the required conditions to obtain an over-all gamma of unity may be satisfied by four basic calibrations. Firstly, a special signal consisting of a ten-step *staircase waveform* is fed to the recording amplifier. This signal appears as a grey-scale pattern (not unlike a sensitometric film strip) forming a series of brightness levels on the display cathode-ray tube. Secondly, the required black and white brightness levels may be secured by adjusting the gamma of the display tube. Thirdly, the film processing conditions may be established—when telerecordings are made this is possible either by filming a display of brightness levels of known increments or by mounting a grey-scale wedge in front of the display tube and when it is operating at a brightness level corresponding to peak-white. Finally, the telecine channel must be adjusted to achieve a linear output when transmitting a filmed record of the ten-step pattern originally fed to the recording amplifier.

Although much of the calibration of television film equipment is rightly the province of electronic engineers, certain aspects of the work depend upon conventional motion picture sensitometry and laboratory techniques. When a ten-step or similar staircase waveform is photographed by a telerecording camera it is usual to expose a subsequent length of film in the laboratory sensitometer. It is important that the two sections of film are obtained from the same batch of emulsion and, preferably, from the same roll. After processing the two films and plotting the sensitometric curve, it is possible to relate the steps on the staircase waveform to the sensitometric exposures. This will establish a photographic gamma value and related sensitometric step-densities which will maintain *routine* processing control for similar telerecordings providing the calibration of the electronic channel remains unaltered.

It must be emphasised that the laboratory control gamma is only a means to repeat a selected processing condition—it is *not* a precise indication of the gamma

of the telerecording—that is only available by measuring the film image of the stair-case waveform. The reason for this is due to reciprocity law failure because the time-factor in an intensity-scale photographic sensitometer is of the order of $1/25$th of a second, whereas that in the telerecording camera is controlled by the speed of the flying spot to be between 1 and 2 milliseconds.

Naturally, all laboratory stages in making positive film prints for television can be *controlled* by motion picture sensitometry, but they must be *established* by first obtaining print-through gamma values derived from original waveforms generated in the telerecording channel. It is also true, of course, that since conventional motion picture films shot in studios at 25 frames per second (for ultimate television transmission) are never associated with telerecording waveforms, these are always *controlled* by photographic sensitometry, based on experience gained from tele-recording and telecine equipment and techniques.

Chapter 7

Printing Motion Picture Film

General principles

Positive copies are made either by taking a print directly from the negative which actually passed through the camera, or by first preparing a master positive from the original camera film and then making a duplicate negative from which to print the many copies required for general cinema release.

Whilst the first method must often be used in urgent television news-film work, the second method is always used in feature studio productions and offers many advantages over straightforward copying techniques. It is very unusual for a camera-man to produce a really badly exposed negative—but it is impossible for him to produce a whole series of shots so perfectly exposed that they may be printed with equal success at one printing-light intensity. It is also impossible to include in the original negative all the transitional effects—such as *lap-dissolves* and *wipes*—which occur between scenes in the final prints. These are only some reasons why laboratory printing equipment must do far more than merely produce a straight copy of the studio negative.

Although cameras are often equipped to produce many effects, it is obviously impractical to create them during normal studio production. Film shooting schedules are not arranged in true story sequence, and the final results consist of a series of individual negatives, each containing one scene, and all of which must ultimately be re-assembled in the chronological order of the original script.

After editing the original negative eventually contains a great number of joins and would not stand up to the strain imposed by printing a large number of copies. Both for convenience and also to safeguard the original film, it is therefore preferable to use *duplicate* negatives for the 'mass production' final printing operation. A further important consideration is that original negatives represent a major financial investment and, in consequence, are always insured. Since thousands of feet of film are involved and these represent many hours of work by highly paid artists and technicians, all these factors become very important.

The usual practice in carrying film production from the original negative to the final positive stage is therefore as follows: firstly, a roughly edited positive copy is

made of each selected *take*—this may be the copy obtained from the laboratory as the daily rush print (or check-test on the previous day's shooting), or it may be a separate copy specially made for the purpose. This copy is cut and re-arranged until the desired effects are achieved. It is then decided at which points special transitions and effects shall be introduced and, quite likely, the duration of these effects will be indicated by wax-pencil lines running across the length of film involved. (This technique indicates very clearly the speed of the transition but not the *type* of transition.) Special effects, trick opticals and similar transitions are carried out on complicated and highly accurate optical printing machines which will be described later; at the moment we need only remember that such effects can be made.

The original negative is then cut to match the edited positive and also to include the trick effects, etc., as and where required. The very exacting job of cutting the negative to match the print is usually entrusted to the laboratory and, incidentally, this is one operation which is greatly helped by the visible edge numbers which are printed at regular intervals throughout all motion picture negative films. Once the exact content of the original negative has been finalised a fine-grain master positive copy is made and this, in turn, is used to produce a fine-grain master duplicate negative. With some processes it may be necessary to make more than one duplicate negative before the desired results are achieved.

If only one duplicate negative is made it is then usual to vary the exposure for each scene and so that the resultant duplicate will be well balanced to print all subsequent copies without further adjustment to the printer light value as each scene is printed. If more than one duplicate negative is being made the exposure balancing may be carried out at the most convenient stage in the process—indeed, if convenient, it may be done when the master positive is being prepared. Naturally, laboratories keep careful records of the *printer-grading* (or light intensity) used to make the first studio rush-prints and this information, together with the possible help of a *first answer print*, is all available to aid them in achieving a final balanced duplicate negative for release printing. Rolls of duplicate negative are usually approximately 1,000 ft. (304·8 metres) or 2,000 ft. (609·6 metres) in length and film manufacturers supply release positive printing stocks of sufficient length to make a complete copy of such rolls without the need to make any joins in the final version. It is of great convenience to the projectionist and, in fact, a recommendation by the Academy of Motion Picture Arts & Sciences, for the beginning and end of each roll of duplicate negative to occur at a fade-in or fade-out, or some equally helpful scene change—abrupt scene changes and, particularly, reels which end on full sound dialogue or music, should in any case be avoided.

Any film printing machine must fulfil the following requirements: (1) The exposure must be evenly distributed within the printing aperture. (2) Exposure must be consistent from one frame to the next. (3) Both negative and positive films must be moved forward in exact synchronism and, in rotary printers, image slip or printer bars must not occur. (4) Picture steadiness must be of the highest possible order. (5) Provision must exist to regulate exposure so that a perfectly balanced

print may be obtained from negatives of varying density. (6) When printing from colour negatives provision must be made to modify the colour balance by attenuating the colour temperature of the printing light.

Modern film printing machinery may be divided into two main groups. Firstly, those machines used to create the many complicated trick effects in shots which have originally been taken with normal cinematograph cameras and, secondly, those machines used to mass-produce the many copies made from matched or equalised duplicate negatives. Since the second type, or production machines, are more readily understood, these will be described first—details of the more complicated optical effects printers will conclude this chapter.

Production printing machines may be divided into six main groups:

(1) Intermittent, or step-by-step, contact printers.
(2) Intermittent, or step-by-step, optical printers.
(3) Continuous rotary contact printers.
(4) Continuous rotary optical printers.
(5) Continuous rotary contact printers to print both picture and sound.
(6) Liquid-gate contact printers.

Intermittent contact printers

The basic principles of the simple intermittent, or step-by-step, contact printer are seen in Figure 7.1. The processed negative film N, together with the unexposed positive film P, are fed over a continuously rotating sprocket wheel F and, after forming a loop, pass in close contact through a tensioned gate G in which an aperture, slightly larger than the negative picture-area, admits light from the source L, via a condenser lens C. After forming a second loop below the gate the films pass under a take-up sprocket T and then separate, the negative being spooled up at N_1 and the postive at P_1.

The two films are both moved intermittently and synchronously through the gate by a claw mechanism K, of which the various designs are as numerous as those found in camera mechanisms. Whilst the films are being moved forward the rotating shutter S obscures light from the printing aperture. Immediately the claw has completed the forward stroke, the open section of the shutter reveals the printing aperture and light is again passed to the films.

The printing speed of such a machine—in common with most other types of printer—depends upon the light intensity, the claw and shutter efficiency, and the picture steadiness which can be maintained (this, in turn, often varies with the design of the film gate). The light intensity is usually limited by the type of lamp, the method of cooling the lamphouse and the technique used to create *light-changes* or different exposure levels. Printing speeds of the order of 90 ft. (27·4 metres) per minute are normally obtained with good picture steadiness and adequate exposure.

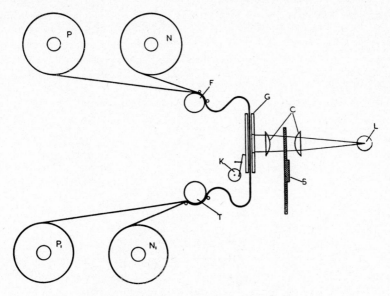

Fig. 7.1. The Intermittent Contact Printer

Intermittent step-optical printers

The term *optical printing* describes a technique in which the negative and positive films are not printed whilst in contact with each other, but are separated by a considerable distance—the image from the negative being focused on to the positive film printing aperture by a lens system between the two heads. This type of equipment offers several advantages, but also certain difficulties.

Once the negative and positive films are separated, and moved through self-contained heads by independent mechanisms, a degree of flexibility exists and a limited number of trick-effects become possible. One frequently used technique is known as *stretch-printing*—this is required when an old negative shot at the silent-film speed of 16 frames per second must be printed so as to project at the modern sound-film speed of 24 frames per second without any apparent change in the speed of image movement. By moving the positive film forward *twice* for every *alternate* frame on the negative (so that every other negative frame is printed on to 2 frames of the positive), an original negative series of frame numbers such as 1, 2, 3, 4, 5, 6, becomes a series of 1, 2, 2, 3, 4, 4, 5, 6, 6, etc., on the positive. This means that 16 frames of original negative will occupy 24 frames of final positive and this, of course, may be projected at sound film speed and yet retain the original rate of image-movement.

If the two independent printer heads are mounted so that one may be moved towards or away from the other along the optical axis (and the lens system may be

adjusted to retain sharp focus), then zoom-effects or tracking shots can be created in scenes which were originally shot from a static camera position. A further possibility is to use an interlaced travelling matte film between the negative and positive emulsions (but usually in contact with the negative) to combine all or parts of two separate negatives on to one positive in a variety of ways. The travelling matte technique is described later in this chapter.

The several disadvantages of optical printers are associated with illumination

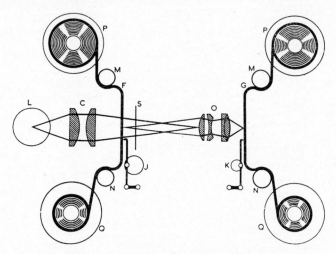

Fig. 7.2. The Intermittent Optical Printer

and contrast. When film is printed by contact both the specular and the diffuse light transmitted through the negative will reach the positive emulsion but, in optical printers, only the specular illumination will reach the positive film. Because of this copies made on an optical printer will have higher image contrast than similar copies made on a contact printer—assuming the positive film processing gamma remains unchanged. Naturally, this effect can be reduced by processing optical prints to a lower gamma than contact prints. Because the printing image is specular it will also increase the apparent graininess of the final image and, by the same token, is more likely to reveal dirt, dust and scratches on the negative.

A typical optical printer is shown schematically in Figure 7.2. Light from the source L is focused by means of condenser lens C on to the objective lens O. An image of the negative picture F is focused on to the positive film G by objective lens O. Shutter S interrupts the light beam each time the two films move forward one frame. Only simple link claws are shown at J and K but, apart from the many variations and refinements embodied in such mechanisms, it is sometimes arranged to include pilot pin registration of the negative—particularly if stretch-printing or travelling matte work is carried out on the machine.

Just as in camera mechanisms, it is necessary to provide the usual feed sprockets M, the hold-back sprockets N, the supply spools P and the take-up spools Q. Take-up spool tension is adjustable and, of course, the speed of rotation will be continually decreasing as the diameter of the exposed rolls increase—this is usually accommodated by some form of friction clutch or constant torque motor. Since the printer speed will depend largely upon efficient illumination it is essential that the optics are adjusted so that condenser C creates a cone of light which, at the plane of the negative picture aperture, will be just large enough to adequately cover this aperture and maintain even illumination across the area, but will not be so large that the intensity falls below the possible maximum. The cone of light must on no account be smaller than the diagonal of the aperture because, if this occurred, illumination would fall off at the picture edges.

A machine designed on the principles show in Figure 7.2 can also be used to make 16 mm. reduction prints from 35 mm. original negatives. This technique is used to produce many copies of studio feature films on to films of smaller width and is fully discussed in Chapter 8. When used as a reduction printer the image of the 35 mm. picture F is reduced and focused on to a 16 mm. film (at aperture G) by an objective O in such a manner that the height of the 35 mm. object is reduced by 2·15 times when sharply focused in the image plane, that is, a reduction to 46 per cent. of the original size.

Rotary contact printers

A rotary printer is one in which the films move continuously throughout the entire mechanism. Since the exposure is arranged to take place either whilst the films are in contact on a large diameter sprocket, or are under tension when passing over a curved stationary gate, the loading on negative film perforations is much lower than occurs in intermittent claw-operated printers. Perforation loading on negatives is far more important than on positives because a negative must pass through the machine many times—particularly when a large number of copies is required—whereas each positive film passes through the printer only once.

Rotary printers are therefore less likely to damage films than intermittent machines, but they may not achieve equal picture definition and image resolution. This is because very slight *optical slippage* can occur when the negative is shrunk (due to processing) to a perforation pitch somewhat less than that of the unprocessed positive print material.

The layout of one basic rotary printing system is seen in Figure 7.3. In this machine both the positive and negative films are fed from the upper supply sprocket, via a series of rollers, to the main central sprocket A which carries them in close contact past the printing aperture B. Good contact between the two films is obtained by holding them to a curved path at the printing aperture, firstly by the tension derived from the weighted idler rollers C and D and, secondly, by pressure from the polished steel shoe E. The main sprocket A is enclosed so that light only reaches the negative and positive film combination at the printing aperture B and, in this

arrangement, from the lamp at the right of the figure, via a suitable condenser lens system.

So that the light beam may pass to the printing aperture two shafts support the sprocket, one on each side of independent sprocket faces, thus leaving the central section clear of obstructions. Another method employs a system of prisms which refract the light rays through a path around a central shaft—this allows the use of a conventional sprocket wheel mounted on a solid central hub. In the arrangement

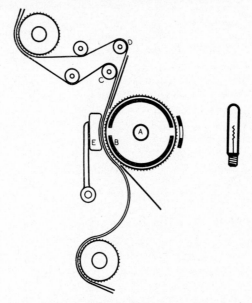

Fig. 7.3. The Rotary Contact Printer

shown the negative is first placed on the main sprocket, and so that the positive may be laid on top of the negative nearest to shoe E.

Even when using modern bases, processed film will always shrink to a pitch slightly shorter than that of unexposed material. Because of this the negative film must always take the shorter curvature, as shown in the figure, and the design of the sprocket teeth must accommodate film pitch variations within accepted toler-ances without causing either film to ride proud of the sprocket teeth or to lose contact at the exposing aperture.

The machine must provide an adequate range of exposures to enable uniform prints to be obtained from negatives of varying density. This is accomplished by adjusting the width of printing aperture B so that light passes to any one point on the film for more or less time. Thus, *exposure modulation* is by changing the time-factor whilst the light intensity remains constant. If aperture B becomes very narrow the time of exposure can be so reduced that it approaches the frequency of

the A.C. electrical mains—for example, in Great Britain it could be as short as 1/50th of a second. When this happens any fluctuations in mains supply can cause uneven exposures in the form of horizontal bars across the film. A similar defect can occur if the exposing aperture approaches the film pitch between one perforation and the next, especially if engagement between the sprocket teeth and film perforations is not perfect. The first defect is known as *shutter bars*, and the second as *sprocket-tooth-ripple*. Both are usually cured by reducing the lamp brightness so that aperture B may be operated over a wider average setting.

Sprocket design

Study of film printing equipment has presented the first occasion on which to appreciate the need for very accurate sprocket-to-film engagement. Since this accuracy also applies to an equal degree on projectors and sound recording equipment, it is timely to consider the design of sprocket teeth at this stage.

Diagram A, Figure 7.4. shows the relationship between a section of film and a sprocket wheel designed to mesh *exactly* with that film. Within the area of complete contact between the film and the teeth—but excluding those sections which are only partially engaged—every sprocket tooth is in contact with the leading edge of a perforation and, in consequence, the driving load is equally distributed between all the engaged teeth. If this condition could be maintained in practice all films would move at speeds exactly equal to that of the sprocket itself. The only variations in film speed would then be due to irregularities in the gear train, and no *flutter* would be introduced as one perforation ceased to engage or a new perforation came into contact with the teeth.

Film base will continually shrink (if only by a very minute amount) throughout its useful life although, superimposed upon this very gradual contraction, other and larger variations in length may occur according to changes in atmospheric conditions, storage, etc. These larger variations may either increase or decrease the apparent film length but, unless exceptionally severe, will not cause permanent deformation and films subjected to changes in humidity can usually be reconditioned to bring their dimensions back almost to those which existed before the changes took place. Thus, in general, processed films may be expected to become short-pitched by varying amounts and according to their age and the manner in which they have been stored.

Diagram B, Figure 7.4 indicates the usual condition which exists when film having a short perforation pitch is meshed with a sprocket made to standard film-pitch dimensions. It is important to notice that all the load is now taken by the *leading* tooth, that is, the tooth from which film is just about to strip (assuming the sprocket is rotating anti-clockwise). Any argument applied to this pulling sprocket will be equally true if the sprocket should rotate in a clockwise direction or act as a hold-back sprocket.

Although the film is only driven by tooth No. 1, its speed will be equal to that of the sprocket so long as it remains well seated down at the base of the tooth.

Immediately the film commences to strip from the tooth—and to ride up the curved tooth face—its speed will be *slower* than that of the sprocket and will remain so until the following tooth and perforation come into contact.

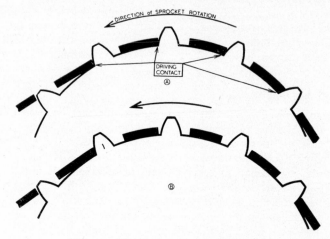

Fig. 7.4. The Design of Sprocket Teeth

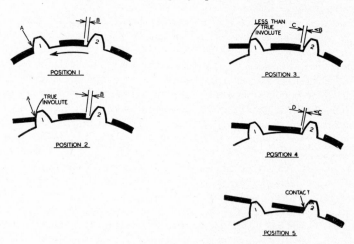

Fig. 7.5. Transmission of Drive via Sprocket Teeth

The conditions existing at the moment when the driving force is being transferred from one tooth to the next are more easily appreciated from Figure 7.5. In position No. 1 the sprocket is rotating in an anti-clockwise direction and the film is in perfect contact at point A with tooth No. 1. Because the film is slightly shorter

than standard pitch, a gap B exists between the second perforation and tooth No. 2. Obviously, as the film commences to leave the sprocket and to strip from tooth No. 1, it must slip backwards with respect to the sprocket and until the second perforation makes contact with tooth No. 2.

If the sprocket teeth are shaped as a true involute (the curve obtained by plotting the path of a fixed point on the film as it would unwind from a stationary sprocket) the film could strip as in position No. 2 and the maximum full-contact speed would be maintained throughout the entire stripping operation. Under these conditions perforation A would rise to the peak of tooth No. 1 and maximum film speed would be maintained during this movement. However, since the gap between the second perforation and tooth No. 2—as indicated at B—would also remain constant, the film would then jump backwards immediately drive was removed from tooth No. 1 as perforation A reached and disengaged from the peak of this tooth.

The remedy for this condition is to shape the curved tooth surface to something more acute than the true involute. The film will then gradually slip backwards whilst riding up the tooth face during the stripping action. This effect is shown in positions 3, 4 and 5. In position No. 3 the film has commenced to strip from tooth No. 1 and, since the tooth curvature is now less than a true involute, gap C between the next perforation and tooth No. 2 is less than gap B in position No. 2. In position No. 4 the film has nearly completely stripped from tooth No. 1 and gap D is even less than gap C in position No. 3. Finally, in position No. 5 the film is just about to disengage from tooth No. 1, the gap between the second perforation and tooth No. 2 has been eliminated and the drive is smoothly transferred to this new point of contact.

Under these conditions the film will have two speeds: firstly the maximum speed when no stripping action is in progress and, secondly, the slipping speed or that speed which exists when the drive is being transferred from one tooth to the next. The same conditions apply when the film pitch is longer than that of the sprocket teeth or when the sprocket operates as a hold-back between the sound head and the take-up spool in a projector mechanism. Three main sprocket-to-film conditions exist under which the film can move at different speeds. These are very important and are as follows:

Firstly, when the gap between the second perforation and the second tooth has not completely closed by the time the film is completely stripped from the first or driving tooth. This will give rise to three film motions, (a) a maximum speed when no stripping is occurring, (b) a slower speed during the time of stripping and, (c) a distinct jump backwards at the moment when drive is transferred to the second tooth.

Secondly, when the gap between the second perforation and the second tooth just closes at the moment when the film is completely stripped from the first tooth. This condition gives rise to two film speeds, (a) a maximum speed when no stripping is taking place and, (b) a slower speed during the time of stripping. However, under these conditions, no jump-back period will occur.

Thirdly, it can be arranged that a perforation commences to strip from a sprocket

tooth immediately contact is made with that tooth—under these conditions the film will always travel forward at a constant speed, namely the slip-back speed and, therefore, at a speed slower than that of the sprocket itself.

Although this arrangement and also that in which the film pitch is exactly equal to the sprocket will both produce a constant speed, they can only be regarded as theoretical examples and would only occur in practice on very rare occasions. The practical performance of any sprocket and film must inevitably be lower than the theoretical standard since, amongst other considerations, the shape of the sprocket teeth will only be absolutely correct for a relatively short period during their useful life and, even under such conditions, would only operate at maximum efficiency if their working faces were glass-smooth and accurately reproduced from one tooth to the next. It is also true that the pitch between film perforations must be permitted certain working tolerances—these together with the possible shrinkage characteristics impose their own limits to the practical standards which must be accepted.

Thus, even under ideal conditions, it is not practical to assume that perfectly uniform film motion may be obtained at the arc of contact between the film and its driving sprocket. However, this conclusion does not necessarily indicate that those errors which remain will be of sufficient magnitude to significantly affect the results. As far as picture printing is concerned, the effect they will have will be in terms of image resolution and apparent picture sharpness.

As would be expected, the most critical test applies to the reproduction of sound —whether it be photographically printed or magnetically recorded on perforated film. Obviously, the variations in film speed will be less in a sound-recording instrument using raw film stock than they will be in an optical sound-film printing machine using a processed negative film. The normal variations from true perforation pitch which may be met with in original recordings are of the order of 0·5 per cent. (this figure includes the variations which may exist in the original perforating and those which may occur if the film is stored for some time under adverse conditions). Within these tolerances any change in the amount of film moved forward by a perfect and imperfect engagement between perforations and sprocket teeth would be a little over 0·001 in. per engagement. Since 35 mm. film normally moves at an average speed of 18 in. per second—and assuming a 9,000 cycle note has been recorded—this requires 500 cycles to be accommodated in every inch of film. Thus a variation of 0·001 in. from constant speed would be equivalent to one half cycle variation from the fundamental frequency at the rate of 24 variations per second.

With the considerably reduced film shrinkage characteristics which are one of the great advantages of tri-acetate and polyester film base materials, some film manufacturers have modified the average pitch or separation between film perforations. This technique, known as short-pitching, relates to the belief that many printing machines still in use are fitted with sprockets which were designed to accommodate the older type film base which was known to shrink far more during processing and drying operations. It therefore assumes that it is wiser to intentionally short-pitch the modern films so that, after the lower shrinkage they undergo during processing, the will ultimately contain perforations pitched to a distance

similar to that which resulted after processing the earlier type of film base. Whilst this theory may do much to aid *processed* film to fit existing sprocket teeth, it does not recognise the dimensions of sprocket teeth used in cameras and sound recording machines which, of course, are different to those in printing equipment and were designed to operate with film perforated to the standard full-pitch dimensions. Thus, at the present time, film manufacturers produce some films pitched to suit machinery used *before* the processing stages, and others intentionally short-pitched and primarily to suit those machines used *after* the processing stages.

Before leaving this discussion of sprocket teeth design, it must be pointed out that, in projector mechanisms, the function of a sprocket pulling film from a supply spool is different from one used to create intermittent motion in conjunction with a maltese cross—and both of these are different from the function of a sprocket used to hold-back against the tension of the take-up spool. Because of this we find sprocket teeth used at various points throughout a projector mechanism are designed to different dimensions and tolerances, according to the work they must perform.

Liquid gate printing

Whilst high quality clean prints may be expected from new negatives when either contact or optical printers are used, considerable difficulties are encountered if a negative is scratched or carries dirt particles. Negative blemishes are more noticeable when positive copies are made on optical printers, and this is due to specular illumination increasing the effective contrast. Although such troubles can be reduced by diffusing the light source or by coating the negative with various lacquers, they are rarely completely eliminated.

Motion picture equipment is basically designed to transport film by contact with the support or base-side rather than the emulsion side of the material. It is therefore not surprising that scratches and similar blemishes are far more frequent on the film base than on the emulsion surface. The effect of base scratches is shown in Figure 7.6. This illustrates a cross-sectional view of a negative film as illuminated in the gate of a printing machine. Whilst parallel light from the condenser lens passes directly through unscratched areas of the base, it is severely refracted or diverted on reaching the interface of a scratch. This causes two major effects; firstly the refracted light reinforces the normal unrefracted light on reaching the emulsion at areas immediately *adjacent* to the scratch and, secondly, the area immediately *below* the scratch is considerably underexposed. Thus the area beyond the boundaries of a scratch appear darker than normal in the print, whilst the area immediately below the scratch appear lighter than normal. Naturally, many variations can result from irregular scratches in random distribution across the base of the negative.

The second illustration in Figure 7.6 shows the passage of light through a scratched negative which is surrounded by a liquid having a refractive index approximately equal to that of film base. Here we see that the scratch fails to disturb the path of the light rays and, in consequence, does not modulate the exposure of

the positive emulsion—in other words a clean scratch-free print is obtained. Liquid printing is based upon this theory and depends for its success upon the selection of a liquid for two purposes; firstly it must have a refractive index nearly equal to that of film base and, secondly, it should not contain water. This second require-

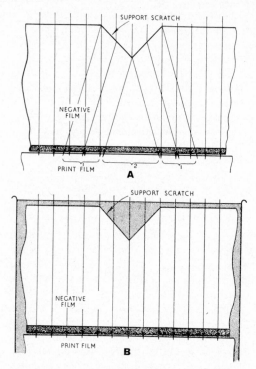

Fig. 7.6. The Effect of Scratches on Film Base

ment ensures that the liquid will not be absorbed by the film emulsion during application and, because of this, can usually be readily blown or squeegeed from the surface.

Refractive index is a term used to indicate the *light-ray bending power* of any light-transmitting media such as glass, water, film-base, etc. It is the ratio between the sine of the angle at which the light approaches the media (the incident angle) and that at which it passes through the media (the angle of refraction), both angles being measured with respect to the normal or optical axis at the point of entry. It may be written thus:

$$\text{refractive index} = N = \frac{\text{sine } i}{\text{sine } r}$$

The refractive index for tri-acetate film base is 1·478—but the refractive index of gelatine is 1·520; because of this it is not possible to exactly match both requirements in a single solution. Fortunately several liquids offer a reasonable compromise,

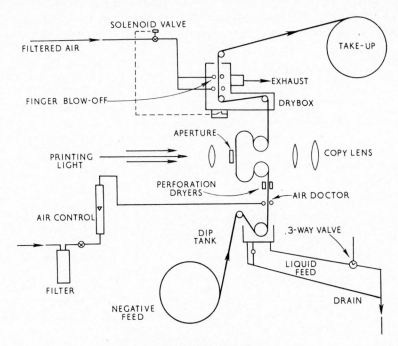

Fig. 7.7. Liquid Printing Apparatus

and one particularly favoured is perchlorethylene since it has a refractive index of 1·504, plus the all-important requirement that it does not contain water. This liquid has been used most successfully by the Technicolor Corporation who, incidentally, have done a great deal of research on liquid printing techniques.

Figure 7.7 illustrates one of the layouts developed by Technicolor. The negative film travels from a feed spool at the bottom of the diagram upwards and through the printing head to a take-up spool at the top of the diagram. By running the film in this manner the liquid can be conveniently applied by merely passing the negative via a series of guide rollers and through a dip-tank or trough containing the liquid at a carefully controlled level. Before reaching the printing gate the film passes through a pair of air-knives known as air-doctors. Doctor knives, doctor rollers or doctor blades are used in many photographic manufacturing processes and, in general, are devices to accurately control the thickness of a coating layer.

The next operation is to dry out the film perforations, and to avoid the natural tendency for an excess of liquid to collect within these apertures. After printing

the film passes into a small drying chamber where, with the added help of further squeegees, the carefully metered layer of liquid is entirely removed from the film before it is finally wound on to the take-up spool. Naturally, very accurate control systems must ensure exactly the right amount of liquid is applied to the film, and these must also be adjustable so that the ideal thickness may be maintained over a considerable range of printing speeds.

Newsreel cascade printers

Another interesting machine design has been used to make multiple copies of cinema newsreels. A newsreel is usually quite short and self-contained within one reel. Due to the urgency of the work and the large number of copies involved, special mass-production printers were designed to cope with this problem. One system used for this purpose is shown in Figure 7.8 and is known as the *cascade* step-contact printing machine.

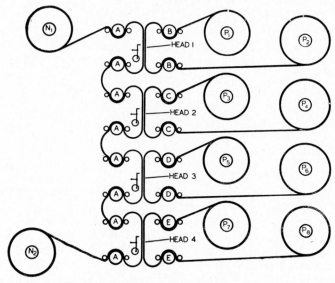

Fig. 7.8. Newsreel 'Cascade' Printer Layout

The negative film is threaded continuously through the entire machine and individual positive printing heads are arranged to make a number of copies from the negative at various points along its path. In this example only four copies are being made at one operation and, for clarity, only a simple link claw has been used to illustrate the intermittent mechanisms which move both the negative and positive films through each gate. The negative is taken from the supply spool N_1, over a

constant-speed sprocket wheel A, formed into a loop and then passed through the spring-loaded tension gate in the first printing head. It then passes to a second sprocket, after forming a second loop below the printing head. Leaving the lower roller in the first printing head the negative film is again formed into a free loop before passing to the top sprocket in the second head. In this manner the negative passes through each printing head in turn as it travels downwards towards the take-up spool N_2.

The first roll of positive film is supported at P_1 and is fed over constant-feed sprocket B, formed into a loop, passed through the gate (where it is moved intermittently and in contact with the negative film), formed into a second loop, passed over a second sprocket B and so the the take-up spool P_2. In a similar manner unexposed rolls of positive film are held in positions P_3, P_5 and P_7, and each roll passes over similar sprockets (shown at C, D and E), and is finally wound up on take-up shafts at positions P_4, P_6 and P_8.

Although when used at all present-day trends are towards newsreels in full colour (and this machine is not readily adaptable to such work), this does not necessarily mean that the mechanism is of no further interest. The ever-growing interest in 8 mm. amateur home-movies has created a large market for small package-made copies of professional 35 mm. short and documentary films. Many of these were originally photographed in monochrome so that, once a master duplicate negative has been made, it would be possible to use the mechanism shown in Figure 7.8 to produce large numbers of 8 mm. copies by a very economical and time saving method.

The Bell & Howell fully automatic printer

To maintain the high standards required in modern film production laboratory staff are constantly alert to the possibility of faulty machine operation. For example, to print one release copy of a sound film the following procedure is required: assuming the sound and picture negatives reach the routine printing department as completed work only requiring *straight* copying, the sound negative (which is usually an optical copy or transfer from a magnetic original) is loaded together with the unexposed positive stock into the sound printer. The position of the *start* frame on the negative is noted, and a similar mark is made on the positive. The sound is then printed and the roll of positive stock is rewound. This stock is then transferred to the picture printer and the start-frame on the picture negative is threaded in the machine in synchronism with the start mark previously made on the positive stock. By this means synchronism between sound and picture is ensured. In some laboratories the sound is printed by starting at the *end* of the reel and printing through to the beginning. The machine is then stopped while the negative and positive films are still threaded and the synchronising mark previously referred to is transferred to the positive stock. In this manner one rewinding operation can be eliminated.

When many copies are required from one subject dependence upon the human

element to transfer synchronising marks from one film to another, and also to thread the films correctly when such marks are supplied, become a potential source of error. With negatives requiring light-changing operations one must possibly also depend on the operator to thread grading-cards in synchronism with the films and, in the case of semi-automatic printers, to remember to pre-set the exposure-selector before the corresponding film notch passes through the negative head.

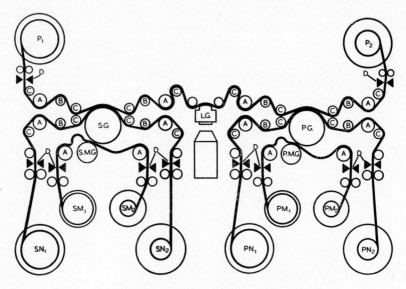

Fig. 7.9. The Bell & Howell Fully Automatic Printer

Some years ago the Bell & Howell Company introduced a fully automatic printing machine designed to overcome many of these hazards. This machine prints both sound and picture in one operation and also automatically adjusts the light-changing device. Both sound and picture negatives, together with the rolls of matte film used to control the light-changes, remain permanently threaded in the printer until all the required copies have been made. To accomplish this prints are made from either the start or the end of the negatives. The first print is made by running the negative from the start to the end, the machine then automatically stops with the negatives still threaded in the heads, the operator then exchanges the exposed positive for a new roll of unexposed material and, on re-starting, the negatives automatically travel from the ends back to the start positions whilst printing the second copy.

The operation of this printer is illustrated in Figure 7.9. Three main functions are performed by the machine; firstly, the sound track is printed on to the positive film at the sound-gate SG, secondly, a thin black line is printed on either side of the

216

sound track by passing the positive film through the line-gate LG and, thirdly, the picture is printed by passing the positive and picture-negative continuously through the picture-gate PG.

Both sound and picture heads are rotary—or continuous—and print by contact between the negative and positive films. All the sprocket wheels positively drive the films and are indicated by the letter A in the figure. Spring-loaded tension rollers are indicated by the letter B, and guide-rollers rotating about fixed centres are indicated by the letter C or remain unmarked according to their position. All films are automatically cleaned both before and after exposure and by passing them between nozzles (indicated at D), which direct jets of compressed air against both sides of the films. Compressed air is also used to maintain good contact between the films during exposure—thus avoiding any possibility of scratching due to spring-loaded tension shoes, etc.

The unexposed roll of positive film is mounted at P_1 and, after printing has been completed, the exposed roll is wound up at P_2. It travels from P_1 to P_2 by first passing through a compressed air cleaner D, via a guide roller C and under a driving sprocket A. It is then held under tension by two rollers B, one on each side of the sound-printing gate SG; adequate wrap at the printing point is ensured by two fixed rollers C, one on each side of this gate. After leaving the sound gate and passing rollers C, B, sprocket A and roller C, the film is guided through the line-gate LG—where a black marginal line is printed on either side of the sound track. The positive film then passes through a further series of sprockets and rollers similar to those at the sound gate, but mounted to guide the film through the picture-printing gate PG. Before final winding up the film passes through a second pair of compressed air cleaners D and then to the take-up spool P_2.

The sound negative passes from SN_1 to SN_2 via cleaner D, over a fixed roller C, over a driving sprocket A, under a tensioning roller B and, via guide roller C, through the sound gate in contact with and underneath the positive film. Similar rollers and sprockets guide the film downwards to the take-up spool SN_2 and here again, before winding up, it passes through a second cleaning gate D. The picture negative follows a path similar to that of the sound negative as it travels from PN_1 towards PN_2.

Sound track exposure is controlled by a matte film consisting of a variable width clear centre section, bounded by opaque marginal areas, and travelling through the sound-matte gate SMG. The gate-housing contains a prism conducting light (from a source at the rear of the machine) upwards and through the matte film. To conserve film the matte is moved intermittently through the gate SMG at one-quarter the printing speed. It passes from supply spool SM, through the air cleaning gate D around a constant speed sprocket A and then forms a free loop to permit intermittent motion through the gate. A similar path carries the matte to take-up spool SM_2. A second matte film controls exposure at the picture gate; this travels from a supply spool PM_1; through the picture-matte gate PMG to the take-up spool PM_2. This film also passes through air cleaners before and after the exposing gate.

When all printing operations have been completed the positive film will be fully

wound on to spool P_2 and the sound negative will be on spool SN_2, having automatically come to rest with the trailer still threaded in the machine. Similarly, the sound-matte film will remain threaded through the machine, but with the bulk of film on spool SM_2. Both picture-negative and picture-matte films will automatically stop whilst still threaded in the machine, but with the bulk of film on spools PN_2 and PM_2 respectively. The exposed positive film is then replaced by a roll of new print-stock—loaded on the same spool, that is on to P_2. When completely threaded the machine is set in reverse and the second positive film travels towards P_1 whilst the negatives and mattes travel back to their original or starting positions.

The layout of negatives and mattes to include adequate and correctly designed leaders and trailers, together with the timing of automatic stopping devices, is a very intricate operation only entrusted to highly skilled set-up mechanics. Once threaded and tested these films are permanently enclosed within a dust-free compartment where they remain until all copies have been made. The machine operator only removes exposed film from each top spool in turn and, after re-threading with new positive stock, engages a master switch to automatically reverse the direction of drive. Since the operator has a relatively simple task he usually controls several machines, once they have been passed by the set-up mechanics. The mechanism includes many alarm devices which automatically stop the printer if any film becomes damaged or broken.

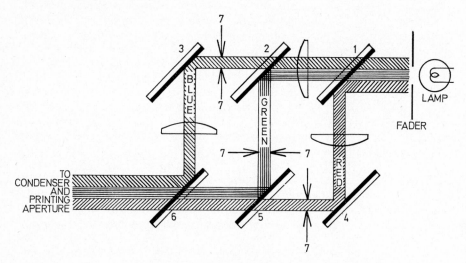

Fig. 7.10. The Bell & Howell Additive Colour Light-Valve

The Bell & Howell additive colour printer

The basic difference between printing equipment designed to make copies from colour negatives and those designed for monochrome work lies entirely in the

system of illumination—the mechanisms of film transport remaining substantially similar for both types of printing. The problem when printing from a colour negative is to isolate the three primary components of white light and then to modify the proportions of each component so that the mixed 'colour' of the effective printing light combines with the dyed images on the negative to yield the optimum colour print.

For some years modifications to the printing light were made by inserting a 'pack' of gelatine filters into the light beam and, of course, the components of this pack might well need to be adjusted as each scene passed through the machine if ideal prints were to be achieved. Such a technique was very tedious and the gelatine filters were very vulnerable to damage. The Bell & Howell Company have recently introduced a completely new additive colour printing system which not only eliminates the cumbersome use of filter-packs but also permits an infinite number of combined colour and intensity 'light-changes' whilst printing from any length of colour negative up to 2,400 ft. (731·6 metres). Colour changes at intervals as short as every 15 frames on 16 mm. film or every 6 frames on 35 mm. film are available at a printing speed of 180 ft. (54·86 metres) per minute.

The essence of the Bell & Howell system is the colour light-valve assembly illustrated in Figure 7.10. This depends upon the selective functions of six dichroic mirrors. A *dichroic* mirror is one which allows light of certain colours to pass straight through whilst it reflects light of another selected colour representing only a narrow band of the spectrum. In this system dichroic mirrors have been chosen to either reflect or transmit the primary red, green and blue wavelengths of the additive colour film process. The exact function of each mirror shown in Figure 7.10 is indicated by the following chart:

DICHROIC MIRROR	REFLECTS	TRANSMITS
No. 1	Red	Green and Blue
No. 2	Green	Blue
No. 3	Blue	— — —
No. 4	Red	— — —
No. 5	Green	Red
No. 6	Blue	Red and Green

Assuming white light containing the three additive primary colours is available from the printing lamp (shown at the top right-hand corner of Figure 7.10) we can imagine this to consist of three bundles of rays—one primary blue, one primary green and one primary red. All three components are directed towards dichroic mirror No. 1. This mirror reflects the red component but transmits both the green and the blue. On transmission the green and blue rays are directed towards dichroic mirror No. 2—and this mirror reflects the green component but transmits the blue.

The blue component is then reflected by mirror No. 3. At this stage we have split white light into three separate primary components and are thereby free to modify the *quantity* of each component which is passed to the printing aperture. These modifications are carried out by three *light-valves* indicated at 7 in the illustration. Each valve may be independently adjusted to allow more or less of its colour component to pass to the integrating section where the modified beams are re-combined. Integration is carried out by mirrors 4, 5 and 6. The overall intensity of

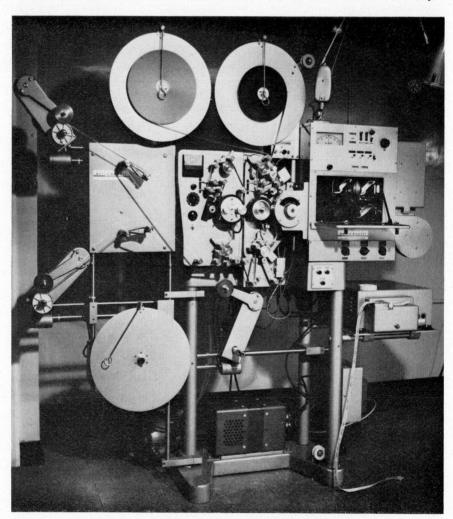

Fig. 7.11. The Bell & Howell Additive Colour Printer

Courtesy Visnews Limited

the illuminant is modified by a 'fader' or adjustable aperture shown to the left of the lamp in Figure 7.10.

For scene-to-scene colour correction during printing each primary colour may be attentuated through 50 steps, each equivalent to a change of 0·025 log-exposure. Beyond this a further 23 steps are available by means of hand-operated controls. The entire light-valve system is actuated by a punched-tape which has been prepared during a previous *negative grading* operation.

The general layout of the Bell & Howell additive colour printer is seen in Figure 7.11, where the punched control tape is clearly seen in the reader-unit below the

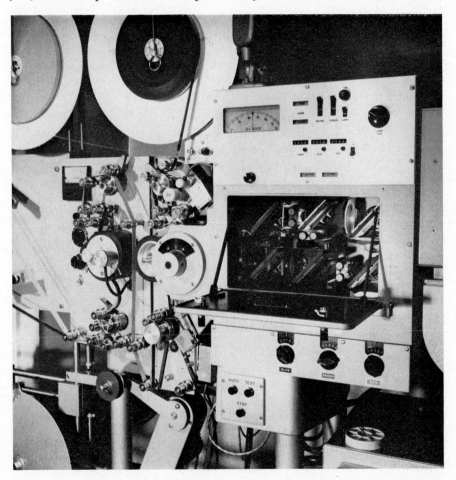

Fig. 7.12. The Bell & Howell Light-Valve Assembly

Courtesy Visnews Limited

221

lamp house at the right-hand end of the machine. A close-up view of the light-valve assembly and printing drum is shown in Figure 7.12 where the dichroic mirrors are easily recognised and the auxiliary manual controls for the red, green and blue components (beyond the 50 steps automatically provided) are shown immediately below the light-valve housing.

The principle of tape control units is fully explained at the conclusion of this chapter. In the Bell & Howell system the *next* required setting for the light-valves is established 'in memory' whilst the previous scene is being printed. A complete colour change takes place in less than one quarter of an inch when the film is printing at 180 ft. (54·86 metres) per minute. Apart from controlling the colour compensation, the punched tape system also controls the choice of six automatic 'fade-in' or 'fade-out' effects at lengths of 16, 24, 32, 48, 64 or 96 frames duration. The tape unit is energised to move forward either by a notch cut in the edge of the negative (actuating a solenoid-relay circuit) or by a transistorised radio-frequency circuit engaged by a metallic adhesive patch applied to the edge of the negative and used to engaged the sensing probe mounted before the printing aperture on the printing machine.

Grading colour printer exposure

Although we have not yet considered the grading of monochrome or black-and-white negatives to yield optimum prints, it is convenient to mention *colour negative grading* at this moment and in relationship to the Bell & Howell additive colour printer. A most advanced unit known as The Electronic Colour Film Analyzer has been designed by The Hazeltine Corporation of America and is essentially a 'companion' to the Bell & Howell printing technique because a punched paper tape from the analyser may be fed directly to the Bell & Howell printer.

The Hazeltine analyser is, in effect, a small closed-circuit telecine machine in which the film to be graded is scanned by a flying-spot scanner in a conventional television raster pattern, and the information is then displayed on a colour TV tube. The display image may be derived from negative, inter-negative, inter-positive or positive colour films and electronic 'phase inversion' ensures that a *positive* display image is always achieved.

The control circuit enables the operator to adjust the overall printing intensity plus the proportions of each of the three primary colour components. These variables terminate in controls which are calibrated in terms of the variations obtainable in the Bell & Howell colour printing machine. An automatic tape punching machine is associated with the analyser so that, once a colour printing combination has been selected the required light-valve settings may be programmed into the tape.

Grading monochrome printer exposure

When any type of positive copies are to be made one of the most important laboratory functions is to establish the optimum printer exposure. The resultant density of

any photographic image is controlled by the time of exposure and the intensity of the illumination, in combination with known processing conditions and film emulsion characteristics. In printing machines the illumination of the positive depends upon the density of the negative and the brightness of the light source. Correct exposure therefore depends upon three factors: (1) the duration of the exposure, (2) the intensity of the light source and (3) the density of the negative.

Printer exposure must increase as and when negative density increases, either by increasing the time factor or the intensity of illumination passing through the negative. In continuous printers, such as Figure 7.3, the time of exposure can be adjusted by varying the width of the exposing aperture whereas, in some intermittent contact printers, variable-aperture shutters similar to those in camera mechanisms may be used if the printing speed is not too high. When such devices cannot be employed the only alternative is to vary the intensity of the light source. Here again, two basic methods are available; light intensity may be adjusted either by altering the resistance in the lamp circuit, or by varying the aperture of a diaphragm in the light beam. Diaphragm control may be either by the continuous adjustment of an iris—as in a camera lens—or by using a pre-punched *light-band*, somewhat like an opaque length of film in which the required series of apertures have been formed.

All these mechanisms are known as *light-change* controls. Their mechanical efficiency is measured in terms of the speed in changing from one light intensity to another and, naturally, the most severe test of this nature is the time taken to change from the highest to the lowest level in the brightness range. If this period is long in relation to the printing speed then it will become visible on the screen. In general such a change should be completed within a quarter of a frame. Therefore, at a printing speed of 60 ft. (or 960 frames) per minute, the light change must be completed within 0·0004 minutes. Light changes by resistance control are only practical when monochrome films are printed; this is because changes in brightness of the lamp by a resistance (rather than changes in the *amount* of light of constant brightness by means of a diaphragm or punched band) must also cause changes in the colour temperature of the light, and this is not acceptable when printing colour materials. The selection of the correct exposure to be given in the printer is known as grading the negative, and the operator is known as a *negative-grader*.

It is usual to provide 21 exposure values on the control to a monochrome printer light source and the grader may select the correct exposure by altering two settings. Firstly, on those printers having resistance control, he is able to select any one of 21 series resistances and to vary a main control resistance also in series with these finer controls. It is usual to standardise upon one main resistance setting so that an average negative would be correctly exposed at the mid-selector position No. 11. This provides 10 selector positions each side of the average to balance the exposure for light or dark negatives and without altering the main resistance setting. Secondly, with diaphragm or punched-band types of light-change mechanisms it is again possible to calibrate the size of the diaphragm openings or the diameter of the apertures in the punched-band so that 21 steps are provided and, therefore, also to

set a main lamp resistance to achieve good exposure with an average negative when the light control is set to the middle or 11th aperture.

Due to these several variables, and the many types of light control available, the precise values assigned to printer light levels are only constant within any one laboratory and, for example, the print density resulting from printer light No. 8 at one laboratory may be equal to that achieved with printer light No. 15 at another although, in both cases, identical negatives were printed. It is most important that cameramen realise that the scale of printer lights does vary in this manner from one laboratory to another. This is inevitable since the choice of any printer light depends upon the processing solutions, the type and adjustment of the printing machine and, to some degree, technicians own personal preference for either slightly heavier or lighter positive print densities.

Aids to selecting optimum exposure

Four main courses are available to the grader when assessing the correct exposure for any particular negative: (1) inspection and selection by experience, (2) selection by comparison with similar negatives for which the correct exposure is already known, (3) by practical tests on instruments designed to make a short series of exposures covering the available range on the printing equipment (4) by scanning the negative in a closed-circuit television system and displaying the resultant positive image on a monitor screen. Suitable controls of electronic 'contrast' and 'brightness' can be calibrated in terms of printer light-changes.

Whichever method is adopted, the initial exposure given by the grader will be on the daily rushes and is subject to correction after the first viewing at the studio. Unless the grader has had considerable experience with the positive printing stock, with the equipment at his laboratory and, particularly, with the type of photography practised by the cameraman, he may well have difficulty in visually estimating the exposure setting required to yield optimum print densities.

Correct exposure is indicated with certainty when a trial print of 21 successive frames is made from each scene, and so that the exposure of each successive frame corresponds with the 21 settings in the printing machine. These test exposures are not made on the printing machine itself, but on an instrument known as a *motion picture timer*. In effect this is a special-purpose sensitometer giving a series of exposures corresponding in intensity to the steps on the printing machine. Two main types of motion picture timing devices are available; those in which the exposure is modified by varying the intensity of the illuminant, and those in which the time factor is changed.

A very popular instrument, known as the Cinex Timer, belongs to the second group—those in which the time factor is varied. The Cinex Timer contains a rotating drum powered by a hand-operated spring loading mechanism. Eleven slots are formed in the drum, each equal in width to the height of a single frame on 35 mm. film and corresponding to every *other* frame along a strip of film 21 frames in length.

The length of each slot is adjustable so that exposures may be arranged to correspond with those available in the printing machines. The Cinex Timer therefore contains a slotted drum very similar to that used in the original type 2b sensitometer—although it is much smaller. The light source is mounted within the drum and the light beam passes through a platten in which both negative and positive films are held in contact. Light intensity is adjustable and should be arranged to correspond with that used in the printers. Exposures are made by rotating the hand-turn control through one complete revolution. The first half-turn winds a driving spring which is then automatically released during the second half-turn. This causes the drum to rotate a full turn and so make the series of exposures through the negative.

The eleven test exposures are arranged to correspond to alternate exposure steps, and usually the relevant step-number (1, 3, 5, 7, etc.) is over-printed on to the positive test strip. Therefore, although the complete printing range is not displayed, the test strip provides sufficient information to easily judge the effect of choosing any intermediate step.

If the intensity of illumination in *any* timing device is considerably different from that used in the printing machines the exposure values indicated by the timer will not produce the most satisfactory results from the printer. Once again, this discrepancy is due to the reciprocity law failure in photographic materials. When such a timer is used, and the results are matched to the printing machines so that shadow densities are equal at one particular exposure, then the densities in the highlights will fail to match at any exposure level. In other words, the contrast range can only be maintained equal between both instruments so long as the intensity of the illumination in both timer and printer are also equal.

Light-changing devices

We have already noted the two main types of light-change mechanisms; those which control light intensity by altering the resistance in the lamp circuit, and those which employ variable aperture diaphragms or punched bands to control the amount of light falling on the printing aperture.

Since all optical printing machines require the negative and positive films to be separated by some distance, and employ lens systems to produce an image on the positive film, it is usual to find the diaphragm type of light-change fitted to these machines. Monochrome contact printers may employ resistance-type light controls or they may be fitted with punched-band aperture controls, usually located between the condenser lenses.

Apart from the *type* of light-change or exposure modulator, there are also three main techniques whereby *any* light-change mechanism can be activated. These are, (1) by notches punched in the edge-areas of the negative, (2) by metal clips or adhesive foil strips attached to the edge-areas of the negative, (3) by perforations punched in a slow-moving parchment card synchronised to the relatively fast-moving negative.

8

Notches cut in the edge-areas of the negative are arranged to engage a small roller, spring-urged to bear against this edge, and so that it will move towards the centre of the film when the notch is engaged with the roller. These notches are cut by a special punch, so shaped that the roller will not tear or damage the film, but will easily slide into and away from the notch. The movement of an arm supporting the roller operates a relay which, in turn, energises the light-change mechanism. This system is very positive and reliable in service, but has the one serious disadvantage that if, for any reason, the notch has not been cut in the optimum position—and is therefore causing the light-change to occur either too early or too late in relationship with the scene change—it becomes somewhat difficult to patch the negative before renotching at the correct position. In practice it is better to leave the original notch in position, but to arrange for it to repeat the existing light setting, rather than to insert a patch in the negative.

Metal clips, somewhat similar to wire staples, are usually inserted in a negative by enclosing the small area of film *between* two perforations—the legs of the staple being bent through the perforations by a simple punch and die often built into the head of a pair of pliers. The staple is almost as wide as a film perforation, but is thin enough to pass through the printing mechanism without damage. Alternatively, adhesive metal foil may be attached to the edge-areas of the negative. In both cases the purpose is to form momentary electrical contact across a suitable sensing device which, through a relay, will operate the light-change mechanism. Metal clips usually act as shorting strips between two spring-loaded contacts lightly bearing against one side of the film. Adhesive metal foil may perform a similar function but, if it is folded over the edge of the film so that it exists both on the emulsion and base-side, it may create momentary electrical contact between two metal rollers—one on either side of the film. One advantage of both systems is that the staple or foil may be easily moved to another position if the original setting is unsatisfactory.

In the third technique a roll of parchment, perforated along each edge, is driven by a sprocket wheel at a speed much lower than that of the film but at a definite ratio to it. The parchment is usually 3 in. (76·2 mm.) wide and carries slots previously punched across the central area in any of twenty-one positions—rather similar to the music-rolls used in automatic player-pianos. Guide rails, fitted just behind the sprocket wheel, carry the parchment over a series of lightly sprung relay switches. When a slot in the parchment reaches the position of a corresponding relay switch the contactor rises through the aperture and closes an electrical circuit to operate the light-change mechanism. This system has the advantage that the negative film is not subjected to any hazards by carrying or becoming part of the light-change mechanism but, since the parchment must be of high quality and very strong, the cost of the system has restricted its application.

Changes in the printing exposure—or so-called light-changes—can therefore be made by the combination of any one of five exposure modulators, actuated by any one of four triggering mechanisms—thus we have the possibility of *twenty* different light-change systems! Summarising these the exposure modulators are as follows: (1) resistance lamp control (intensity factor) varying the colour-temperature

of the light source and therefore only suitable for monochrome films. (2) Printer aperture control (time factor) only possible on continuous rotary printers. (3) Variable aperture rotary shutters (time factor) suitable for any slow-running machine including colour printers. (4) Variable diaphragm in lens system (intensity factor) usually in the condenser lens and suitable for any film printing. (5) Punched-band acting as a pre-arranged series of lens apertures (intensity factor) inserted in the optical system and particularly suitable for colour printing as well as monochrome. The timing, sensing or triggering mechanisms are as follows: (a) By notches cut in the edge of the negative. (b) By staples or clips inserted between the perforations of the negative. (c) By adhesive metal foil either on one or both sides of the negative. (d) By ancillary perforated parchment roll and associated micro-switches.

These various combinations can be divided into two main groups: those which are entirely automatic, and those which are only semi-automatic in operation. All combinations involving the perforated parchment roll can be completely automatic since the full range of printing levels are individually represented by slots at different positions across the parchment. Any triggering system can be combined with the pre-arranged apertures in a punched-band to create a fully automatic light-change mechanism. A punched band is rather similar to an opaque length of 35 mm. perforated film—but, in fact, it is usually made of heavy cartridge paper—and it is punched with apertures (similar to the old-time Waterhouse stops in 'still' cameras), and any number of apertures may be formed in any combination. The band is moved intermittently through a guide-way formed in the lens system at a position normally occupied by the iris diaphragm. All other combinations are semi-automatic and require the operator to pre-set the light-change device before each scene-change occurs in the negative. One exception to this general statement relates to an electronic computer which, for clarity, will only be described after the next section.

The Bell & Howell Model D light-change

Typical of semi-automatic equipment are the well-known Bell & Howell 35 mm. Model D and 16 mm. Model J printers. The basic light changing technique used in these machines will be described in detail because, apart from being very widely used, recent modifications can now be added to convert these printers to fully automatic operation.

The semi-automatic light-change equipment originally supplied with these printers operates in conjunction with notches cut in the edge-areas of the negative film. Since notches can only be made to one depth, they can only operate a relay system in one manner. Because of this a manual control is pre-set to load the mechanism sufficiently to bring the exposing aperture to the required position—but this does not come into operation until a notch in the film operates the relay.

Before the negative reaches the routine printing machine it must be graded. When this is done the selected exposure settings are recorded on a special Bell & Howell printer card, designed to fit into a holder mounted in a convenient position on the machine. As an example, the card may well carry a list of numbers such as

6, 4, 17, 12, 8, etc., and this would indicate that the first scene must be printed at light-value 6, the second at light-value 4, the third at light-value 17, etc. The card holder is mounted together with an indicator or pointer which automatically moves from one grading to the next as each light-change takes place. The pointer therefore indicates the *next* exposure which will come into use, *not* the one currently in use.

In practice the operator rotates a large selector-lever to any one of twenty-one numbers marked against locating dowel-holes formed in a stationary back-plate. A spring-loaded dowel pin, mounted in the selector-lever, positively locks the device in the chosen position. In the example given above the operator would first rotate the selector to position 6 and, immediately the first notch in the negative passed the edge roller, the relay system would operate to set the exposure to the 6th intensity level.

A distinct warning *buzz*, due to the operation of solenoids in the circuit, informs the operator immediately the light-change has taken place—he is also warned visually because, at the same instant, the pointer adjacent to the grading card moves forward to the next position. In the example given, the operator would then immediately set the selector lever to position 4 (the exposure required for the next scene). However, the printer will continue to operate at exposure 6 until the second notch in the negative passes through the relay control—only then will the exposure be changed to level 4. In this manner the operator is continually pre-setting the selector lever to the exposure next required, and the relay is arranged to give such an exposure immediately the circuit is closed by a notch in the negative.

Punched-tape light-changers

In converting these machines to fully automatic operation the Bell & Howell Company have made use of punched paper tape (prepared on a keyboard-operated perforating unit) to indicate the entire sequence of printer lights, and also to stop the machine once the entire roll of film has been printed. Electrical signals resulting when the paper tape is fed through a reading unit are decoded by a computer-type analyser. This analyser then controls a servo-mechanism to manipulate the selector lever on the printing machine. Thus, the conversion unit is an attachment which can be added to existing printing machines without any structural or mechanical modifications.

For the later and more refined punched paper tape system used by Hazeltine and Bell & Howell in their additive colour printing system the equipment shown in Figure 7.13 has been introduced. Here the type 6170-D programme tape punch consists of two units—the perforating machine seen at the extreme right of the picture and the keyboard unit immediately next to it. The keyboard contains three coloured indicator lamps—one to indicate when 'commands' are being set up to control each of the red, green and blue primary-colour light-valves—and 63 push buttons which provide sufficient flexibility to encode commands related to all sequences of colour correction, six lengths of fade-in or fade-out operations, a zero position with no light passing to the printing aperture (as required in A and B roll

printing techniques), starting and stopping instructions and also commands to operate in the black-and-white printing condition. The remaining three instruments shown in Figure 7.13 constitute the type 6173-D 'checker duplicator' unit which verifies the programme created on the tape and enables the operator to make modifications or corrections to any 'punching errors' which may have occurred.

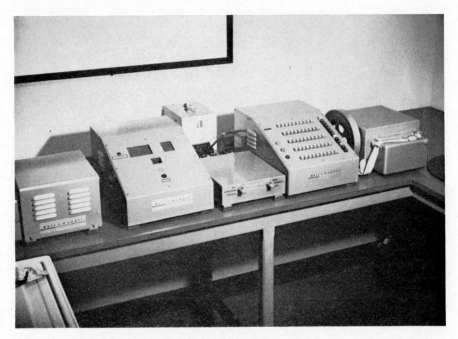

Fig. 7.13. The Bell & Howell type 6170-D Programme Tape Punch and the type 6173-D Checker Duplicator

Courtesy Visnews Limited

At first sight one might compare a punched paper tape to the wider parchment rolls used in earlier systems. However, one great difference is that the paper tape used with the adapted Bell & Howell Model D monochrome printer required holes punched in only *five* positions—it is the *combination* of holes which ultimately creates the twenty-one different resistance settings to actuate the servo-mechanism; the tape used with the Bell & Howell colour printer employs a series of holes punched in seven positions across the tape. Reverting to the requirement for monochrome printing, any five variables (such as the holes in the paper tape) may be permutated to give 32 different combinations—and a seven-hole tape will yield 128 permutations! Since only 21 are needed to operate a monochrome light-change, two extra combinations are used—one to move the paper tape forward, and the other

229

to stop the printing machine. The general principle whereby 21 different signals may be obtained from combinations of only 5 holes across a narrow paper tape will be appreciated from the following table (the author makes no apology for its resemblance to a football pools coupon!).

HOLE VALUE IN UNITS	REQUIRED PRINTER LIGHT																					CODE TO STOP
	1	2	3	4	5	6	7	8	9	10	11	12	13	14	15	16	17	18	19	20	21	
1	x		x		x		x		x		x		x		x		x		x		x	x
2		x	x			x	x			x	x			x	x			x	x			x
4				x	x	x	x					x	x	x	x					x	x	x
8								x	x	x	x	x	x	x	x							x
16																x	x	x	x	x	x	x

Let us assume that each printer light required a different value of electrical resistance in the circuit in order to cause the servo-mechanism to bring the selector lever to the required position. For simplicity, assume that the amount of resistance required is equal to the printer light number. That is, light 16 will require 16 units of resistance; light 8 will require 8 units of resistance and so on throughout the entire range. Then, if we arrange the first hole perforated across the paper tape to represent one unit of resistance, the second hole to represent two units, and so on as shown in the left-hand column of the above table, we see that by choosing the five resistance values 1, 2, 4, 8 and 16, any intermediate combination may be achieved.

When it is required to stop the printer all five holes are punched across the paper tape, since this combination is never used to obtain any of the twenty-one light settings. When no holes appear on the tape the mechanism will automatically feed forward until the next hole-combination is reached. This is exactly what is required, because it must be remembered that the system is only replacing the manual *pre-setting* of the light selector lever. Therefore, the setting created by this system does not come into operation until a further notch in the negative film activates the relay system to bring that setting into effect. Thus, the servo-mechanism may have a considerable time-lag since it is only required to operate within the time represented by the shortest distance between any two notches in the negative. It is always reading the punched information, decoding it and pre-setting the selector lever *ahead* of the negative notch which will bring that setting into operation.

Those not familiar with punched tape coding may find the following table helpful. Here the code has been extended to cover 26 combinations so that each letter of the alphabet may be assigned a certain number. From this five-position code any word may be translated into tape information and, of course, the hole-

values may be in terms of any function—such as values of electrical resistances, signal frequencies, photographic densities, etc., according to the design of the decoding and computing apparatus.

HOLE VALUE	REQUIRED NUMBER OR LETTER																										
	1	2	3	4	5	6	7	8	9	10	11	12	13	14	15	16	17	18	19	20	21	22	23	24	25	26	
	A	B	C	D	E	F	G	H	I	J	K	L	M	N	O	P	Q	R	S	T	U	V	W	X	Y	Z	
1	o		o		o		o		o		o		o		o		o		o		o		o		o		
2		o	o			o	o			o	o			o	o			o	o			o	o				o
4				o	o	o	o					o	o	o	o					o	o	o	o				
8								o	o	o	o	o	o	o	o									o	o	o	
16																o	o	o	o	o	o	c	o	o	o	o	

Chapter 8

The Reduction Printing Process

General

THE reduction printing process was originally a technique whereby standard silent films were *printed down* or copied on to smaller material. This usually meant that 35 mm. negatives were printed down on to 16 mm. and, to a lesser extent, on to 9·5 mm. positives. All the early 16 mm. and 9·5 mm. silent film libraries consisted of copies of feature and documentary films made in this way—such classics as 'Metropolis', 'Battleship Potemkin' and 'The Four Horsemen' being typical examples still in existence. In later years it became possible to photographically reduce optical sound tracks and also to reduce 35 mm. or 16 mm. original negatives directly on to 8 mm. films. With the recognition of 16 mm. film as a professional gauge and, particularly, its very wide use in television, the purpose of reduction printing has changed considerably over the years. It is therefore helpful to introduce this chapter with a short survey of the history of films smaller than the 35 mm. standard material.

In the early 1920s the introduction of so-called *sub-standard* films made cinematography available to the amateur user in such a way that he needed neither specialised equipment or knowledge. However, from the outset enthusiasts advanced their interests and techniques considerably beyond those which the basic provisions were designed to satisfy. This naturally stimulated the sub-standard industry and users of the process quickly became divided into three main groups.

The first group were those who remained content to use 'amateur movies' as they existed and for whom, originally, they were intended. The second group were those who became interested both in the mechanical and chemical technicalities of motion pictures and set about producing worth-while films of some definite entertainment value. The third group realised the potential value of sub-standard cinematography as a medium through which to promote research, education, propaganda, salesmanship and industrial training. This last point led the Kodak Company to market in England a projector known as The Business Kodascope as early as 1932.

The use of 16 mm. film has now so completely changed from its original conception that the term sub-standard has long since ceased to apply. In recent years the term *narrow-gauge* has been officially adopted to describe 16 mm. film regardless

of the use to which it is put although, with the introduction of 8 mm. and later 'super 8 mm.' colour films, 16 mm. is now very rarely used by the amateur and has become almost exclusively a professional gauge material.

Progress in the manufacture of narrow-gauge film has resulted in a steady increase in photographic quality, speed, resolution and mechanical accuracy. The term mechanical accuracy implies a higher standard of perforating, greater picture steadiness, and a stable film support resulting in smaller dimensional changes after processing. In the field of equipment the Eastman Kodak Special and the Paillard-Bolex H series of cameras were for many years the only models intentionally designed for the serious worker. Because of their relatively high price, and also the limited scope of other equipment, many *gadgets* appeared on the market which, if handled intelligently, could be attached to the cheaper cameras to produce a variety of effects previously only available with 35 mm. professional equipment. Since these attachments were, at best, only a compromise, neither producing the desired result as conveniently or as perfectly as studio equipment, many serious workers investigated the possibility of first producing films with 35 mm. equipment (and with all the processes of the studio at their command), and then to employ some form of reducing apparatus to print 16 mm. positive copies from original 35 mm. negatives.

This line of thought quickly resulted in the now familiar optical reduction printing equipment and, as previously mentioned, the early 16 mm. film libraries contained many copies of feature films produced in this manner. With the introduction of 16 mm. optical sound projectors further equipment was designed so that sound tracks could be reduced in a similar manner, and the 16 mm. sound-film libraries came into being. The period just before the outbreak of war in 1939 is particularly interesting and it is worth while to briefly consider the state of affairs existing in England at that time. Several large and well-stocked 16 mm. sound-film libraries existed—notably that of the Gaumont-British Company—and a number of professionally manufactured 16 mm. sound projectors had gained popularity; amongst these mention must be made of the Gebescope, British-Acoustic, Bell & Howell and B.T.H. models. Many amateur enthusiasts had converted existing silent projectors to reproduce sound films and, whilst some showed the very high standard of craftsmanship associated with model engineering, most conversions left much to be desired—particularly by the film libraries—from the point of view of film transport and freedom from scratching.

This pre-war state of affairs had advanced the sound-film reduction process so much that most Trade Laboratories had installed high-class reduction printing equipment and were producing 16 mm. sound films from 35 mm. feature and educational subjects. This was fortunate because, during the war years, these laboratories were called upon to develop both their equipment and techniques to satisfy demands made by the Forces. At the beginning of the war it was quickly realised that two main types of 16 mm. sound film would be required: the greater speed and accuracy with which details of technical equipment and processed could be taught through the medium of sound films produced demands for 16 mm. educational and instructional films in quantities both greater than anticipated and, certainly,

greater than the equipment had been designed to supply. It was also quickly realised that 16 mm. sounds films of the feature-film category provided a convenient and portable means with which to supply much needed entertainment near to the fighting zones.

The exceptional progress in reduction printing techniques made during the war did far more to establish 16 mm. sound films than could have been accomplished in a similar period during peace time. Thousands of 16 mm. sound projectors were made for and used by the Forces; many people were introduced to 16 mm. sound films for the first time and the possibilities of this form of talking picture could be assessed with much greater accuracy. As with most comparatively new processes which are rushed into wide use, the quality of many 16 mm. sound films was not at that time representative of the best which can be produced by the process.

Since the war years considerable progress has been made with systems of direct 16 mm. sound film production. These first employed photographic sound recording systems whereas, today, most so-called *combined* sound-and-picture cameras employ a magnetic stripe coated on the base-side of 16 mm. picture negative film. Developments both in B.B.C. and Commercial television in England have made great strides in recent years and have resulted in almost all news programmes originating on direct 16 mm. sound and picture equipment. Parallel to this, many television programmes are recorded on 16 mm. film for re-transmission at a more convenient time or as repeat performances. Several major studios are now interested in the design of 16 mm. equipment capable of similar high accuracy since, with the smaller gauge film, many advantages such as portability, ease of manipulation and low running costs make possible effects and locations hitherto unobtainable with the 35 mm. equipment. Notable amongst these are some of the nature films produced by the Walt Disney Studios.

The position of narrow-gauge cinematography in its broadest sense may therefore be classified into the following main groups: (1) 16 mm. sound films. These may be produced by direct methods of recording picture and sound in a combined optical-sound and picture camera, by a combined magnetic-sound and picture camera, by a separate picture camera electrically interlocked to record either optical or magnetic sound on an appropriate channel or, as often happens with feature studio productions on 35 mm. films and afterwards employing reduction printing equipment to secure the final 16 mm. sound and picture copies. (2) 16 mm. silent films. These may be produced by the direct or reduction printing processes and, in common with 16 mm. sound films, may employ either reversal or the negative-to-positive copying methods. (3) 8 mm. silent films. By far the majority of these films are produced by amateurs using the direct methods—although reduction printing is rapidly gaining popularity and large film libraries in this gauge have replaced the 16 mm. pre-war amateur libraries. However, there is one great difference in that, whereas pre-war libraries mainly hired films to customers, the modern 8 mm. amateur seems more ready to make an outright purchase.

Incidentally, it should be fully appreciated that 8 mm. and, particularly, super-8 mm. films can be produced with sound track accompaniment; also that magnetic

recording methods and equipment make possible the addition of a second length of film or tape to run in synchronism with the picture projector. Further, that after-processing techniques include the addition of a magnetic stripe by the laboratories and on which the amateur may record a sound accompaniment to his original silent pictures.

Sixteen millimetre sound film is essentially similar to silent film of the same size with respect to width, perforation size and pitch and also picture dimensions—the main difference being that the sound film is only perforated along one side of the picture; the other side being left complete and providing space in which to accommodate either a photographic or magnetic sound track. The dimensions of the picture in both cases are 7·47 × 10·41 mm. The dimensions of pictures produced on standard 8 mm. film are 3·51 × 4·80 mm. and pictures made on super-8 mm. film are 4·22 × 5·51 mm. Standard dimensions have been adopted to cover the camera, printer and projector apertures and the sizes of these decrease in the order given. In each case the dimensions quoted above refer to the picture height and then the picture width and, in every instance, are the dimensions of the camera apertures.

Picture reduction printing

At present we are mainly concerned with the production of 16 mm. films of a technical quality as nearly as possible equal to those produced with 35 mm. equipment and, particularly, by methods which allow inclusion in the 16 mm. print of all the special effects and trick photography associated with feature studio work. As we have seen, one of the popular methods of achieving this aim is by the reduction printing process.

The picture quality and, particularly, the mechanical steadiness which is generally acceptable with *home* projection, leaves much to be desired when magnified to the greater screen sizes employed when 16 mm. films are used for purposes similar to and, in some cases, in competition with 35 mm. pictures. This is also particularly relevant to the use of both 35 mm. and 16 mm. films for television purposes since, unlike cinema-type projection, both types of film are ultimately viewed at the same image size and under comparable conditions. Picture unsteadiness is, of course, most noticeable to observers following such action as the intricate function of mechanisms, outline drawings and the many types of diagram film used for visual education.

With the addition of sound to 16 mm. films and the improvements made in laboratory techniques, the opinion gradually developed that 16 mm. films should be capable of screen quality equal to that obtained with 35 mm. films under comparable conditions. It can be readily proved that, even by applying to the entire 16 mm. process working tolerances as close as those used with 35 mm. films and equipment, it is fundamentally impossible to obtain absolute equality between the pictures from both systems. In fact, if it were possible to produce 16 mm. reduction prints with a final accuracy equal to that recommended for 35 mm. release prints, and also to obtain a projector as accurate as a professional machine,

the resultant screen picture would be 2·1 times more unsteady than the 35 mm. picture viewed under similar circumstances and produced with equal accuracy.

Figure 8.1 shows the relative sizes of both 35 mm. and 16 mm. frames and their positions relative to the perforations. The negative picture image produced via a standard 35 mm. camera aperture is 0·868 × 0·631 in. but, to ensure that all this image is printed on to the 16 mm. film, the 35 mm. *printer aperture* is increased to 0·890 × 0·662 in. The reduction ratio is approximately 2·15 : 1 and thus produces a 16 mm. picture area of 0·402 × 0·306 in. It should be noticed that the black boundaries at the top and bottom of the 16 mm. frame are slightly larger than the standard

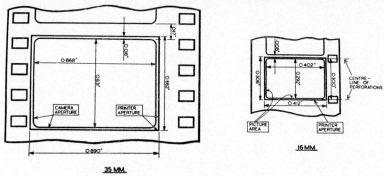

Fig. 8.1. 35 mm. and 16 mm. Picture Areas

0·300 in. between the centre-line of the perforation pitches; this is done to ensure that no clear film will exist between successive frames.

A most important point to appreciate is that the *frame bar* or distance *between* the pictures on 35 mm. film is 0·117 in. whereas a similar frame bar on 16 mm. film is only 0·008 in. The ratio between these two dimensions is approximately 14·5 and not 2·15 (the optical reduction ratio). Because of this it is *not* possible to use reduction printing machinery in which both films move continuously since the ratio between the two picture areas is not equal to the ratio of the spaces between those areas. All 35-to-16 mm. optical reduction picture printers *must* be intermittent or step printers, as opposed to so-called rotary or continuous printers. A further point to remember is that, whereas the 16 mm. picture is symmetrical about the centre-line of the film, the 35 mm. picture is off-set with respect to the centre-line and in order to provide sufficient space in which to accommodate the sound track. Because of this the optical system within the reduction printing machine will be symmetrical about the centre-line of each picture area—but will not be symmetrical with respect to the 35 mm. film gate.

Reducing the sound track

The optical reduction of 35 mm, photographic sound tracks is somewhat more complicated than the reduction of picture images. The ratio between 35 mm. and

236

16 mm. track widths is different from that of the track lengths, and both are different from the ratio between the picture areas.

Figure 8.2 shows the relative sizes of the 35 mm. and 16 mm. printed areas within which all sound tracks must be located. It should be realised that three dimensional standards define the width of all sound tracks, the first being the width of the printed area, the second the width of the sound record itself and the third the width of the scanned area. The width of the printed area is always the largest dimension and is the only one given in the figure.

We therefore see that the reduction across the track *width* is from 0·100 in., in the case of 35 mm. sound tracks, down to 0·085 in., in the case of 16 mm. tracks, or a

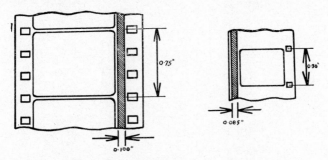

Fig. 8.2. 35 mm. and 16 mm. Sound-Track Areas

reduction to 85 per cent. The reduction along the *length* of the track is, of course, equal to the ratio between the pitch of successive frames—and this is equal to the ratio between 0·75 in., and 0·30 in., or a reduction to 40 per cent. These figures lead to two very important conclusions: That the sound track must be reduced on a continuous printer whereas pictures must be reduced on an intermittent or step-printer. The various reduction ratios are as follows:

(1) The dimensions of the 16 mm. printed picture are 46·5 per cent. those of the 35 mm. picture.

(2) The width of the 16 mm. sound track is 85 per cent. that of the 35 mm. track width.

(3) The length of the 16 mm. sound track is only 40 per cent. that of the 35 mm. track length.

Optical picture reduction printers

The basic layout of a conventional *straight* optical reduction printing machine is shown in Figure 8.3. It will be noted that this drawing is identical to that used to describe 35 mm. 'one-to-one' optical printing and shown in Figure 7.2—the only difference being that in the present case an image of the picture on the 35 mm. film

F is reduced and focused on to the 16 mm. film G by means of the objective lens O. This lens must reduce the height of the 35 mm. object by 2·15 when sharply focused in the image plane at the 16 mm. aperture, that is, a reduction to 46 per cent. of the original size.

All reduction printing machines are fitted with means to adjust the exposure—this usually takes the form of a light-change system rather similar to those described in Chapter 7. It is usual for reduction prints to be made from *graded* 35 mm.

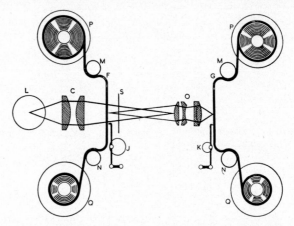

Fig. 8.3. Optical Reduction Picture Printer Layout

negatives and, therefore, exposure adjustment is mainly only necessary to balance the density changes from one roll to the next, rather than from one scene to the next. Most reduction prints are made from pre-graded duplicate negatives instead of from the original negative.

The three main variations from the general principles of straightforward optical reduction printing are as follows: (1) Machines which print two identical 16 mm. copies in one operation by employing twin objective lenses arranged in a manner similar to that previously described. (2) Machines which print two identical 16 mm. copies by means of beam-splitting prisms and two objective lenses. (3) Machines which print only one 16 mm. copy at a time but which are fitted with pilot pins to accurately locate both the 35 mm. and 16 mm. films during the exposing period.

16 mm. twin-head optical reduction printers

Figure 8.4 shows the optical layout of a twin-head reduction printing machine. In both cases the arrangement of the components and the positions of the film gates are identical—two views have been shown merely to avoid confusion by overlaying the light paths of the condenser and objective lenses. The upper diagram indicates the path of rays from the lamp L, via the condenser lenses E and to the objective

238

lenses G and H, whilst the lower diagram shows the path of rays from the 35 mm. film F, through the two objective lenses and to points of focus at the plane of the two 16 mm. films A and B. It is important to realise that maximum light is only transmitted when an image of the lamp filament is formed by the condenser at a plane very near to the rear surface of each objective lens. Because of this lamps containing two or more vertical coils are usually employed; one filament coil is then brought to a focus at G whilst the other is focused at H. This condition can only be checked when the 35 mm. film is removed from the gate since the photographic emulsion would act as a diffuser and destroy the filament images G and H.

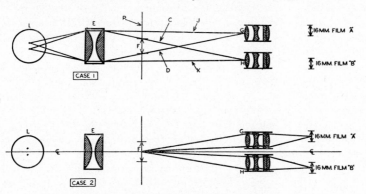

Fig. 8.4. Twin-Head Reduction Printer

The maximum amount of light will only pass to lens G when rays J and D both pass through the 35 mm. aperture F and, similarly, low illumination will result at point H unless rays C and K also pass through this aperture. Now, as shown in the diagram, rays J and K are cut off by the aperture plate P and, although the intensities of light reaching each objective lens may remain equal to each other, they will be considerably lower than the maximum possible intensity. Such a condition can only be overcome in this particular design by locating the 35 mm. film gate as near as possible to the condenser lens E but, if this is done, it is essential to keep the condenser free from dust and oil spots.

Objective lenses G and H usually have a considerable *depth of focus*, hence objects at slightly different distances to that of the principle focus will all appear reasonably sharp at the image plane. It is therefore difficult to maintain critical focus at the plane of 35 mm. film when it is close to the condenser and, at the same time, to main an evenly illuminated image which remains free from shadows due to blemishes, dust and oil on the condenser.

We see from the lower diagram in Figure 8.4 that a centre line through the lamp, condenser and 35 mm. aperture passes mid-way between the two objective lenses G and H. This condition is unavoidable and causes the two images of point F to be displaced with respect to the optical centre of each objective lens. It is therefore usual to mount these objective lenses at a slight angle to the main centre line of the

instrument and so that a line, drawn from the centre of the 35 mm. aperture to the centre of the corresponding 16 mm. aperture, is coincident with the optical centre line of the objective lens. Under these circumstances it is theoretically impossible to maintain critical image definition at all points within the 16 mm. apertures and usual practice is to maintain optimum sharpness at the centre of each field. This difficulty becomes less noticeable if the distance between the 35 mm. and 16 mm. apertures is small and if objective lenses of correspondingly shorter focal length are employed. Unfortunately this tends to increase the depth of focus of the system and may cause other difficulties if the condenser lens is not absolutely clean. The optimum conditions are therefore a compromise between overall sharpness across the image plane and the shortest possible depth of focus. It may be argued that the depth of focus could be reduced by using lenses of higher aperture and, whilst this is true in general, it does not apply when the distance between the 35 mm. film and the condenser lens is of the order of 1 in. A further suggestion, which has been used in many machines, is to employ opal or ground glass between the 35 mm. film and the condenser. Opal is usually rejected because the overall intensity of illumination is reduced so much that it becomes difficult to print all but the very thin or light negatives. Ground glass can only be used if the granularity is very fine indeed since, with a coarse material, the grains themselves would be focused by the objective lens on to the 16 mm. film.

The only remaining solution is to move the 35 mm. aperture away from the condenser and towards the objective lenses. This would undoubtedly help to remove depth-of-focus problems but it would reduce the overall image brightness. The optimum conditions are therefore a compromise between the several factors involved and it is unlikely that maximum efficiency in any one section of the optical system could be retained without reducing the efficiency of other interdependent sections.

One of the most troublesome difficulties with twin-head reduction printers is to maintain equal exposure levels at both 16 mm. apertures. Several factors may cause one aperture to be at a higher intensity than the other, amongst them being the following: (1) If the lamp is misplaced or badly centred within its envelope it may be impossible to secure filament images on the rear face of both objective lenses. (2) Similar difficulties may exist if the focal length of the condenser lens, or the mechanical separation between the lamp filaments, are incorrect. (3) If the objective lenses are not accurately matched or if one is at a slight angle to the optical axis between the centre of the 35 mm. and 16 mm. apertures. However, although this type of machine is undoubtedly very difficult to adjust—and unlikely to yield critical sharpness over all the image areas of both prints—it does have a very high output when compared to more conventional printing machinery.

Twin-head beam-splitting systems

Figure 8.5 illustrates another type of optical reduction printing machine in which two identical 16 mm. prints are made during one operation. As in the previous

case, a lamp having two vertical filament coils is used and the condenser lens is adjusted so that an image of each coil is focused at a plane close to the rear surface of the corresponding objective lenses C and D. This requirement is fulfilled by turning the light beam through something approaching 90° by means of the large right-angled prism G and, once more, the accuracy with which these filament

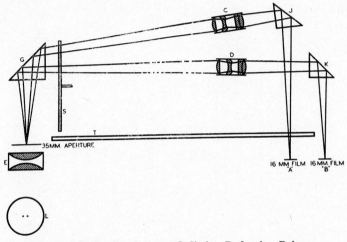

Fig. 8.5. Twin-Head Beam-Splitting Reduction Printer

images are placed depends upon the power of condenser lens E and the mechanical separation of the lamp-filament coils. One group of light rays, corresponding to points on the 35 mm. film, are focused by lens C, through prism J and on to 16 mm. film A. Similar rays are focused by lens D, through prism K and on to 16 mm. film B.

The use of prisms G, J and K make it possible for all three films to be located on one side of the mechanism and so greatly simplify the operating conditions. The gearing is also simplified since one transmission shaft T supplies driving power to all three intermittent mechanisms which move the films through the exposing apertures. A disc shutter S interrupts the light whilst the films are in motion through their respective gates. This combination of lenses and prisms requires very careful adjustment in order to achieve relatively even illumination across the two 16 mm. apertures and, generally speaking, suffers from similar disadvantages to those found in the previous design. Points in favour of this arrangement are the simplified mechanism, compactness of layout and consequent ease with which it may be operated.

Reduction printers with pilot pin registration

Modern reduction printing equipment is usually restricted to the production of only one high quality 16 mm. copy during one operation. To achieve this *pilot pins*

241

are often incorporated in the intermittent mechanism to accurately locate the films whilst exposure takes place. Unless some such means are employed to register the film after the claw mechanism has disengaged from the perforations, the final position in which the film comes to rest will depend upon the following factors: (1) The time during which film movement through the gate is retarded from maximum to minimum speed and, particularly, the velocity of movement still remaining after the intermittent mechanism has disengaged from the film. (2) The

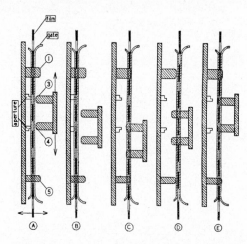

Fig. 8.6. Fixed Pilot-Pin with Oscillating Gate Mechanism

coefficient of friction between the film and the channels of the gate through which it moves. (3) The tension between the film gate channels—intended to arrest the film after the claw has disengaged and also to maintain the film in a stationary position during exposure. (4) The effect of any system employed to guide film through the gate channels by means of spring tension applied to the film edges.

The success of any pilot pin system and its ability to control the position of film during exposure depends largely upon the accuracy of any cams or followers, sliding shafts, stationary bearings and, also, the accuracy of the cam which controls the horizontal motion imparted to the pilot pin unit. One particularly interesting machine, designed to reduce the moving parts and consequent mechanical errors to a minimum, employs *fixed* pilot pins anchored to the mechanism plate itself—engagement with either these pins or the claw pins being created by oscillating the gate channel and, therefore, the film itself in a horizontal direction. The general layout of the 16 mm. mechanism used in such a printer is shown in Figure 8.6 at various stages during the pull-down cycle.

The main aperture plate supports two pilot pins, 1 and 5, one above and one below the exposing aperture. The claw pins 3 and 4 oscillate in a purely vertical direction as indicated by the arrows. The film is guided through a gate formed by

two highly polished metal plates which oscillate in a purely horizontal direction. The action of the mechanism is therefore as follows: as shown at A the film gate has just moved to the left and the film is located upon the pilot-pins. The gate then continues to move to the left, as shown at B, until the back-plate comes into contact with the shoulders of the aperture plate—this causes the film to be clamped rigidly in the gate channel. At the same time the claw pins begin to move in a downward direction.

During this part of the cycle the film is exposed whilst the claw pins complete their downward movement. The gate then moves to the right, as shown at C, to transfer the film from the pilot pins on to the claw pins. It is important to note that the pilot pins project just sufficiently to overlap the claw pins and, because of this, the film is always under control by one or both sets of pins. The claw pins then move *upwards*, as shown at D, and advance the film by one pitch or frame. Incidentally, in this machine the 16 mm. film travels upwards whilst the 35 mm. film moves downwards. The gate then moves to the left, as shown at E, and transfers the film from the claw pins once more on to the pilot pins. The cycle is then repeated.

The pilot pins are separated by a distance equal to five perforation intervals, or four pictures. It is because of this control over a considerable length of film, and also due to the accuracy with which the pilot pins fit the perforations, that conventional edge guides in the film gate are unnecessary. The film is freely suspended on the pilot or claw pins, except when the gate is closed during exposure and it comes under pressure from the aperture plate. It is important to note that the pilot pins are of different sizes: pin No. 1 is known as the full-fitting-pilot, while pin No. 5 is the tolerance-pilot and is suitably reduced in thickness to accommodate the permissible tolerances on a section of film 4 frames in length.

Printer adjustments

We can now consider the following refinements usually provided in reduction printing equipment: (1) Means to adjust 35 mm. negative film framing in the printing aperture. (2) Provision to adjust the 16 mm. positive exposure. (3) Interchangeable aperture plates to mask either sound or silent 35 mm. picture areas. (4) Provision to adjust the reduction ratio. (5) Provision to adjust the sharpness of the 16 mm. image. Although some printers may not provide all these refinements, it is usual to find the first two fitted to every machine.

The accuracy with which the 35 mm. negative picture is located with respect to the perforations depends to some extent upon the distance between the intermittent mechanism and the aperture in the camera which produced the negative. An appreciable variation in this dimension exists between cameras of different types and, unless some correction is available in the reduction printer, the top or bottom of the picture may be cut off and a black border, larger than that required, would be printed at the bottom or top of the 16 mm. picture area. Some means must therefore exist to align the 35 mm. picture area with the picture aperture and, in early machines, the aperture plate was moved in a vertical direction as shown in

the diagram, 'A', Figure 8.7. This technique is not satisfactory since it must cause the 16 mm. image to be misplaced with respect to the perforations in this film. Assume that, in the perfect case, the 35 mm. claw brings the film to rest so that picture A is symmetrically placed about the optical centre. Aperture B is therefore adjusted to the mid-position and, if the magnification is correct, a perfectly framed 16 mm. image will pass through aperture E and so to film F. It is assumed that the 16 mm. intermittent mechanism is carefully adjusted

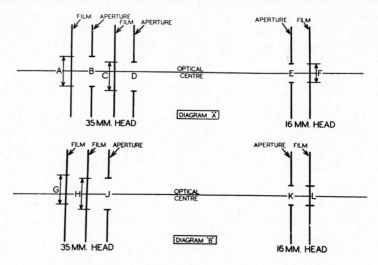

Fig. 8.7. Methods of Image Framing in Printing Equipment

to bring the film to rest so that the two perforations relative to the vertical frame boundaries are symmetrically placed with respect to aperture E. If in a second 35 mm. film the picture image comes to rest in position C (misplaced with respect to the optical centre), it will then be necessary to move the 35 mm. aperture to position D. This will cause the 16 mm. image to be misplaced with respect to aperture E and adjustment is made to this aperture until the entire picture reaches the 16 mm. film—the film image must therefore be misplaced with respect to the 16 mm. perforations. Quite apart from this, the optical system may not adequately cover 35 mm. apertures which are misplaced in this manner and, in consequence, the exposure may not remain uniform across the 16 mm. aperture. Under such circumstances the image definition would also suffer at the extreme edges of the field.

Modern equipment overcomes these difficulties by maintaining all picture apertures in fixed positions symmetrical about the optical centre as shown in diagram B, Figure 8.7. The position of a perfectly placed 35 mm. picture is indicated at H, the corresponding aperture at J, the 16 mm. aperture at K, and the correct position of the 16 mm. image relative to the film perforations is shown at L. When a 35 mm.

picture is mis-framed, as indicated at G, the entire 35 mm. intermittent mechanism is adjusted so that the *film* is moved relative to a fixed aperture.

This adjustment must be made by a mechanism which also maintains correct phase relationship with the shutter or, alternatively, the shutter must be large enough to cover the pull-down at the extreme positions of the available range. Unless the action of the shutter is related to the various positions of the intermittent mechanism the light may not be completely obscured before the film starts to move and, under these conditons, image definition will be lost and double-exposure or ghosting will result.

Exposure adjustments

The exposure of any photographic material is a product of light intensity and the time during which it operates upon the sensitive surface. With reduction printing equipment running at constant speeds, the *time* of exposure is fixed by the angular opening in the disc shutter and, obviously, this time is shorter in high-speed machines than it would be in machines running at low speeds if, in both cases, the shutter apertures are similar. For example, a machine in which the 16 mm. film travels at 21 ft. per minute and having a shutter opening of 180° will give an exposure of 1/28th of a second whereas, a similar machine in which the 16 mm. film travels at 45 ft. per minute and still having a shutter opening of 180° will give an exposure time of only 1/60th of a second. However, once the machine speed is known it is a simple calculation to establish the actual exposure time. The only remaining adjustment with which to vary the actual exposure is the *intensity* of the printing light.

When original camera negatives are produced it is almost an impossibility to obtain a whole series of shots which all print to an optimum density by giving identical exposures to all scenes. Since the 35 mm. negatives used in reduction printers are usually duplicate copies of the original camera negatives, the opportunity is often taken to eliminate such scene-to-scene variations in exposure whilst the duplicate negative is being made.

Modern duplicate negatives can therefore usually be printed by making only very few exposure changes throughout the entire roll of film. However, duplicate negatives are not necessarily made for any particular reduction printing machine known to give a certain exposure value and, therefore, the exposure given to one negative on a fast-moving machine would be quite different to that given to the same negative when printed on a slow-moving machine. Similarly, it is quite likely that a reduction print may be required from an older 35 mm. negative in which the original scene-to-scene exposure variations have not been eliminated.

It is therefore essential that some means exists within the reduction printer so that the intensity of exposure may be adjusted either from one scene to the next (in the case of ungraded negatives) or from one complete roll to the next (in the case of modern balanced duplicate negatives). The mechanisms designed to meet this

245

requirement are, in principle, similar to those used for 35 mm. contact printing, and have already been described in Chapter 7.

Multiple copies by direct contact printing

Some laboratories only favour the use of an optical reduction printer to prepare one master 16 mm. positive copy from the original 35 mm. negative. From this master copy a 16 mm. duplicate negative is made which, of course, may then be used to produce large numbers of final positive prints by the contact printing method—either in a continuous or rotary printer or in a step-by-step intermittent printer. If equal results are obtained with both types of equipment, it is preferable to use a continuous printer since, in such machines, the perforation loading is more gradually applied and film damage is reduced to a minimum.

The photographic quality obtained by contact printing is somewhat different to that obtained by optical reduction printing directly from a 35 mm. negative. This is partly due to the fact that optical reduction printers only pass *specular* light to the 16 mm. film, whereas contact printers pass both the specular and the *diffuse* illumination to the positive film. The so-called Printer Gamma in reduction printers is therefore very high. A further reason for differences between the two methods depends upon the photographic characteristics of the intermediate 16 mm. duplicate negative used in the contact process. In general, slightly higher contrast and, consequently, prints having more brilliance are obtained by the reduction printing process than is possible with contact methods using an intermediate 16 mm. negative.

Sound reduction printing

The possibility of adding sound to 16 mm. films was considered almost as soon as 35 mm. talking pictures became available. However, the problems still present in the professional sound-on-film systems suggested that 16 mm. sound films would only be possible if some form of disc recording, similar to that used in the earliest studio productions, were adapted for use with the then conventional 16 mm. silent projectors. Two main points appeared to justify this conclusion: (1) The shorter film length in which to accommodate the recordings and, (2) the extra cost to the user if the speed of 16 mm. film projection were increased to that of 35 mm. film.

However, reasons which caused 35 mm. film producers to abandon disc production apply equally well to 16 mm. talking pictures, and sound accompaniment to these films soon became a photographic process. At that time the greatest interest was in producing 16 mm. sound films by reducing original tracks from the larger 35 mm. films and not by directly recording on to 16 mm. stock. Two main systems were available for this purpose: as we have seen, 35 mm. silent pictures could already be optically reduced to 16 mm. and a natural development of these systems quickly produced similar machines to print a reduced image of the 35 mm. sound

track on to 16 mm. film. The second main system consisted in scanning the 35 mm. track and using the amplified sound signals to operate a recording head similar to that by which the original sounds were recorded. This new recording head could either employ a light-value or a mirror galvanometer to produce variable density or variable area tracks. The first of these systems is known as *Sound Reduction Printing*, and the second as *The Re-recording Process*.

The following specification is representative of modern first-class 16 mm. sound reduction prints and indicates the accuracy to which such products must be designed and maintained. Firstly, the increased emulsion qualities, the fine grain and consequent high resolution now available, allow reduction printing of frequencies up to 10,000 cycles per second. Secondly, because projection speed is standardised at 24 pictures per second (except for television work), 7·2 in. of film will pass the sound scanning point every second and, consequently, one complete cycle of a 10,000 cycle tone is accommodated within 0·0007 in. Thirdly, the effective length of the 16 mm. track is only 2/5th that of a corresponding 35 mm. track, whilst the width of the 16 mm. track is 85 per cent. of that used with 35 mm. equipment.

Optical reduction sound printers

Two main requirements must be satisfied in any optical sound reduction printing machine: (1) The amount of film passing the 35 mm. aperture during one second must be exactly 2·5 times greater than that which passes the 16 mm. aperture in any equal period. If this is not so an effect known as *optical slippage* will occur and the 16 mm. print will be very poor. It is equally important that both films should move at a uniform rate. Any variations in film speed will produce variations in exposure and consequent variations in 16 mm. image density. (2) The amount by which the 35 mm. track width must be reduced is not equal to the reduction along its length. This is in order to maintain the maximum light transmission to the photocell in the sound reproducing head and, consequently, maximum signal amplitude.

Constant film speed and reduction ratios

Two systems which maintain both the 35 mm. and 16 mm. films at constant speeds are shown in Figure 8.8. Design 'A' is used when both films and the optical system are arranged in a straight line along a common axis—as will be explained later, the different optical reduction ratios along and across the film can be obtained with such a system when certain lenses are employed. With an A.C. synchronous motor rotating at 1,440 r.p.m., it is possible to use a worm gear reduction of 72 : 1 so that the 35 mm. sprocket will rotate 20 times every minute and the 35 mm. film will travel at 30 ft. per minute. The 16 mm. film must then travel at 12 ft. per minute or 2/5ths the speed of the 35 mm. film. This can be achieved by three methods; firstly, by using a second worm gear also having a reduction ratio of 72 : 1 and reducing the diameter of the 16 mm sprocket to be only 2/5ths that of the 35 mm.

sprocket so that, although both sprockets rotate an equal number of times per minute, the actual footage passed by each will be proportional to their diameters.

The second method maintains the sprocket wheels at equal diameters—which may be necessary if the films must be kept at similar curvatures because of optical requirements, and also if the films are exposed while they remain in contact with these sprockets. If this is done worm reduction 'C' must be 2·5 times greater than that at 'B' and, therefore, must be a ratio of 180 : 1. In consequence, the 16 mm. sprocket will only rotate at 8 r.p.m. as compared with 20 r.p.m. by the 35 mm. sprocket wheel in position 'B'.

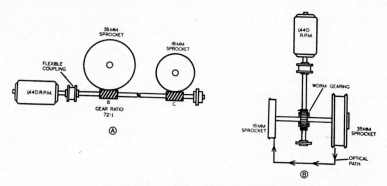

Fig. 8.8. Prevention of Optical Slippage

The third method is to accommodate part of the film speed reduction by a suitable worm gear and the remainder by a small change in the 16 mm. sprocket diameter. On first consideration this may seem to be an unnecessary complication but, in some designs, it has proved to be a distinct advantage. The curvature of a 35 mm. film in a direction along its length need only be relatively slight in order to prevent *bowing* or curvature across the film width. As the film width decreases it is helpful to increase longitudinal curvature in order to prevent bowing across such a narrow strip; the 16 mm. film is therefore more likely to remain flat at the exposing aperture if the sprocket wheel is of smaller diameter than that used to drive the 35 mm. film. However, at certain printing speeds, it may not be possible to reduce the diameter of the 16 mm. sprocket sufficiently to accommodate all the reduction ratio—longitudinal curvature could then become so acute that image definition would be poor at the upper and lower edges of the exposing aperture. Under such circumstances the only alternative is to accommodate part of the reduction ratio by the gear train and the remainder by modifying the diameter of the 16 mm. sprocket.

In straight-line mechanisms such as that shown at A, Figure 8.8 three main sources of error may effect the uniformity of film motion: (1) The speed of the motor shaft may vary. (2) The worm gearing may transmit a gear-tooth flutter to the sprocket wheels. (3) The pitch and size of the sprocket teeth may not accommodate 35 mm. films which are old or shrunk. The most objectionable error is when a

momentary increase in 35 mm. film speed coincides with a decrease in 16 mm. film speed—this would occur if inaccuracies in the 35 mm. gears forced this train to a speed higher than normal and, at the same instant, similar inaccuracies in the 16 mm. gears reduced the speed of that train to something below normal.

The arrangement shown at B, Figure 8.8 is attractive because any variations in gearing will affect both the 35 mm. and 16 mm. sprockets in a similar direction at any given instant. In this arrangement drive from the motor is transmitted by a single worm gear to a common shaft supporting both the 35 mm. and 16 mm. sprockets. Obviously, any variation in the speed of this shaft will cause equal changes in the angular velocity of both sprocket wheels. Such variations could only cause changes in exposure and *not* optical slippage between the negative and the relative position of its image on the 16 mm. positive. However, any changes in the relative position or size of sprocket teeth could still cause optical slippage, although this would probably be less noticeable than if it occurred in a machine of the type shown in design A.

Design A has the great advantage that the optical layout is in one straight line whereas, in design B, it is necessary to transfer the image from the 35 mm. film to the 16 mm. film by the path indicated by the arrowed line in the figure. Because of this efforts were made to modify design A and eliminate some of the possible sources of film speed variation.

Until now we have assumed the film to be supported on a sprocket wheel as it passes the scanning point, and we have recognised several sources of error due to this method of traction. Quite obviously, passing the film over a smooth drum would eliminate any errors in the sprocket itself and, if such a drum were concentric with an accurately mounted shaft, film should travel at a speed equal to that of the drum surface—providing it did not slip relative to the drum. The first requirement calls for good workmanship and very careful fitting—and the second can be ensured by using a drum with a smooth but dull surface, and by applying pressure to the film at the beginning and end of the contact path between it and the drum.

Magnetic drum drives

The easiest way of driving such a drum is by allowing the film itself to act as a belt—the *actual* film speed can then be modified by an idler roller controlling the degree of wrap on the drum. However, this system suffers from several disadvantages and drive through a *magnetic couple* has been found to be more efficient. Magnetic drive may be applied in several ways, one of which is shown in Figure 8.9. Here a heavy flywheel is solidly connected with the film drum and a copper ring, attached to one face, must rotate at the speed of the flywheel. A series of magnetic pole pieces, mounted in close proximity to the copper ring, are connected to the gear train and arranged to rotate some 20 per cent. faster than normal drum speed. Under balanced conditions the magnets will always exert a forward torque sufficient to just balance the frictional losses in the flywheel and so relieve the film from any undue strain.

This forward torque is proportional to the relative velocity between the magnets

249

and the copper ring and, because of this, oscillating or irregular driving forces are effectively damped out and eliminated from the film drum. Obviously, if the flywheel tends to run at a speed above normal it will receive only slight assistance from the magnetic torque whereas, if it tends to run at a speed lower than normal, it will receive much greater assistance. An alternating torque, in phase with but opposing any mechanical oscillations applied to the flywheel, is thus superimposed upon the constant torque and the size of this supplementary force is controlled by the oscillations which attack the steady motion of the flywheel.

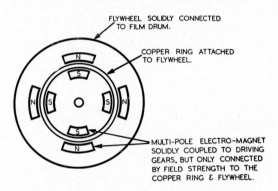

Fig. 8.9. Magnetic Drive to Scanning Drums

One may imagine this system could only be efficient when the magnets rotate at a perfectly uniform speed and the initial cause of irregularities is divided so that the part contributed by the sprocket wheels is removed to a somewhat safer distance from the scanning point—and only irregularities due to the gear train remain in the magnetic couple. The following consideration of a theoretical case show this to be far from correct: assume the gearing is so inaccurate that a rise and fall in speed of 1 per cent. is applied to the magnet every sixth of a second. Now, since the magnet rotates 20 per cent. faster than the film drum, this speed variation will only be important to the *difference* between film drum and magnet speeds. The magnet may be said to rotate at 120 per cent. the speed of the film drum and, of course, 1 per cent. of 120 is 1·20. Now 1·20 of the 20 per cent. difference between the drum and magnet speeds is a 6 per cent. change in the excess of magnet speed over drum speed.

If a flywheel of this type comes to rest naturally from full operating speed, it will complete the action in approximately 30 seconds and the speed lost in the first second will be approximately 1/20th of full speed. Now a 6 per cent. change in the *over-drive* of the magnetic ring will cause a flywheel to change speed at the rate of 6 per cent. of 1/20th of full speed. It must be remembered that the gear inaccuracies do not occur at intervals of 1 second, but at intervals of 1/6th of a second. The total change in flywheel speed will therefore only be 1 per cent. of 1/20th of full speed;

the *average* change in speed will only be 1 per cent. of 1/40th of full speed. This amazingly low variation occurs when exceptionally bad gearing is used and, therefore, the normal variation which could be expected with average gearing is even smaller than the calculated amount.

The anamorphote lens system

The sound reduction printing process requires an optical system capable of reducing an image more in the direction of its height than of its width. The modern arrangement of lenses used in a straight reduction printer and capable of meeting this

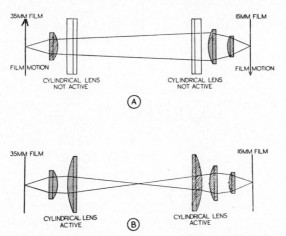

Fig. 8.10. The Anamorphote Lens System of Optical Reduction

requirement is shown in Figure 8.10. In general these arrangements are known as *anamorphotic* systems and employ two microscope objectives with two cylindrical lenses between them—both cylindrical lenses operate in the same plane. A cylindrical lens has a curvature on one plane only and would, of itself, cause images to converge to a thin line instead of a focal point. Diagram A shows a side elevation of the system and it is very important to note that, in this plane, the cylindrical lenses present parallel faces to the light rays and are unable to affect the system. In this plane light is focused solely by the microscope objectives to create an image reduction in the ratio of 2·5 : 1—that is, a magnification of 0·40 or the ratio of the film speeds in linear measure.

Diagram B shows a plan view of the system and indicates that, in this plane, the cylindrical lenses are operative. Acting together these lenses modify the system so that, in this plane only, the width of the 16 mm. image is 85 per cent. that of the original 35 mm. track. Maximum image resolution is essential in the longitudinal plane, as in Diagram A, to ensure that the highest frequencies are successfully

251

printed and so, in this plane, only the achromatic lenses are operative. These lenses are of the highest quality and, to further increase image definition, are normally operated at a low aperture. In the transverse plane, as in Diagram B, the required image definition is not so high and, therefore, although the cylindrical lenses are uncorrected and of lower quality than the achromats, this will not give rise to poor quality in the resultant prints.

When used with printing machines in which the 16 mm. and 35 mm. sprockets are mounted side by side on a common spindle the anamorphote lens system is usually arranged as shown in Figure 8.11. This is a plan view of the layout and it

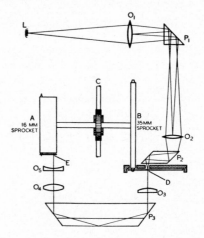

Fig. 8.11. The Anamorphote Lens System in a Typical Reduction Printer

should be remembered that sprockets A and B are driven through a gear reduction unit C from a motor housed within the main body of the instrument. The two main functions to be performed by the optical system are to uniformly illuminate the 35 mm. track aperture D, and to transfer the image from position D to position E on the 16 mm. film. Since it is very difficult to manufacture a split sprocket wheel, having a gap formed around the circumference at the position of the sound track, the 35 mm. sprocket usually consists of one half only. This is indicated at B together with a stationary curved gate through which the sprocket teeth project and over which the film rides. A small aperture is formed in the gate at the position of the sound track and centred with the optical axis of the lens system. Since the hub of the 35 mm. sprocket projects beyond the sprocket flange it is not possible to illuminate the 35 mm. gate by a straight optical system.

The 35 mm. sound track is illuminated by a heavy-filament low-voltage lamp L. The lens O_1 forms an image of the filament at the plane of lens O_2 whilst lens O_2 forms an image of the uniformly illuminated lens O_1 at the plane of the 35 mm. track. Since, in this arrangement, the lamphouse is located to one side of the

driving motor, the light beam is turned through a right-angle by employing a prism P_1 between the lenses O_1 and O_2. After passing through lens O_2 the light is displaced inwards towards the sprocket by the small double prism P_2. The required image reduction is then obtained by the two cylindrical lenses O_3 and O_5 and one high quality spherical lens O_4. Lenses O_3 and O_5 only operate in the lateral plane and serve to partially neutralise the power of the spherical lens. In the longitudinal plane objective O_4 alone controls the image formation because lenses O_3 and O_5 have no curvature in this plane. The large roof prism P_3 not only conducts light from the 35 mm. side of the machine around to the 16 mm. side, but also inverts the image in the longitudinal direction so that it travels in the same direction as the 16 mm. film itself.

Design of printing gates

With machines of this type it is essential to use stationary gates at the printing point and to move the film over these surfaces by engagement with sprocket teeth which project through slots in the gates. The gates are therefore formed in a curved path close to the sprocket wheels as shown in Figure 8.12. This figure is a side-elevation of one film path—it may be either the 16 mm. or 35 mm. side of the machine since both are identical in arrangement although somewhat different in

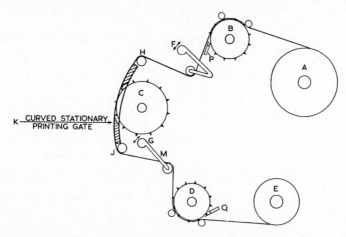

Fig. 8.12. Location of Film Gate and Sprocket Teeth in 'Stationary-Gate' Printers

size. Film passes from supply spool A over a constant-speed feeding sprocket B and then assumes the curvature of stationary gate K by means of four rollers, two of which are mounted above and below the gate as indicated at H and J. The remaining two rollers are mounted to pivot about centres F and G and thus accommodate the free loops between the gate and the sprockets. The film finally passes via the lower hold-back sprocket D to the take-up spool E.

Counter-weights applied to rollers F and G may exert either positive or negative forces: at position F the counter-weight causes the roller arm to pivot about point L and so increase the effective weight of the roller on the film—that is, the counter-weight is added to the weight of the guide roller itself. At position G the counter-weight causes rotation of the roller arm about position M and increases the effective tension on the film between the lower gate roller J and the hold-back sprocket D.

The radius of curvature of the stationary gate K must be greater than that of central sprocket C because the sprocket teeth must just project through a slot cut in the gate channel. Since the film is only driven through the exposing gate by teeth engaged with one set of perforations, edge-guiding must be used to position the film laterally and to prevent *weave* or movement across the exposing aperture. This is usually ensured by applying a spring-loaded shoe to one side of the film and locating the opposite side against an adjustable stationary guide. By this arrangement any sound track can be centrally placed within the printing aperture, even when it may have been originally recorded in a non-standard position.

The film is therefore held under considerable side-tension when passing through the gate but only under very slight longitudinal tension, controlled by weighted rollers F and G to be just sufficient to maintain engagement with the sprocket teeth. Those who have used machines in which film travels over stationary surfaces will know that considerable wear takes place and, inevitably, scratches will develop in the surface of the metal and small particles of film base will become lodged therein. Once any metal surface becomes scratched the small particles of film base continue to accumulate and form into small pockets—or corns—which become exceptionally sharp and cause an ever increasing scratch on films which are subsequently passed through the machine.

All stationary surfaces must therefore be maintained with scratch-free mirror surfaces to safeguard the valuable 35 mm. negatives. This applies equally well to all printing machines and, particularly, to those in which non-rotating surfaces are employed. Since it is easier to finish soft metals to a high polish, it is usual to find printer gates and similar parts manufactured in brass which, after polishing, are coated with an exceptionally hard form of chromium plating. Many people believe that chromium plating of itself imparts a high polish to a metal surface—this is quite untrue and, unless the base metal has been previously worked to a surface finish equal to that required after the plating operation, any small scratches or abrasions not only remain present but, in fact, are greatly accentuated by plating. This is unavoidable with electro-deposition processes and is caused by excess crystal growth at the edges of a surface; it can only be eliminated by careful workmanship before the plating is applied.

Although these observations may suggest the use of stainless steel at all such vital points in printing machines, practical experience indicates that once a mirror-surface has been obtained on soft metal and repeated in the plated deposit, the resultant hardness and resistance to scratching can be higher than that of stainless steel.

Printer illumination

In common with most other printing operations, sound reduction printing requires a steady source of illumination. Any variation in exposure results in poor quality sound reproduction although the nature of the defect sometimes causes other stages in the process to be suspected rather than the light source. For example, small increases in lamp brightness may over-expose the print so badly that the high frequencies become filled in and, since this would occur at the frequency of lamp-current variations, could result in the periodic loss of high response and consequent introduction of a low frequency. A similar effect occurs when brightness variations cause under-exposure because, once more, the high frequencies are the first to be affected and would be periodically lost at a frequency equal to that of the lamp-current variations.

In all cases it is advisable to energise the printing lamp with a D.C. supply, preferably through a stabilising circuit. Even when heavy duty 250 watt, 50 volt, 5 amp projector-type sources are employed it is unwise to use an A.C. supply if the best results are required. This is because filament temperature changes during each cycle of the A.C. supply would be sufficient to cause variations in exposure and, consequently, a 100 cycle modulation on the resultant print. Naturally, the magnitude of this interference is, to a large extent, dependent upon the speed of the printer and the size of the exposing aperture. If film speed is very low and the exposing aperture is relatively large, it may be difficult to detect any modulation when an A.C. supply and a heavy-duty lamp are used. Unfortunately, such limited operating conditions would considerably reduce the machine output and, therefore, increase the cost of each print so produced.

The 35 mm. negatives used by Trade Laboratories to make 16 mm. reduction prints are invariably matched or graded copies—at least so far as the sound negative is concerned. This means that a complete 1,000 ft. (304·8 metres) roll of 35 mm. sound negative can be printed at one light intensity although the *actual* lamp current may need to be adjusted from one negative to another. Quite clearly this indicates that some form of exposure control must exist within the lamp circuit, but that rapid exposure changes—as made when printing some picture negatives—will not be necessary in this case.

It is usual practice to calibrate a resistance-type exposure control in terms of settings which produce optimum prints from negatives of known unmodulated densities. This is arranged by first producing a series of 35 mm. negatives in which the density of each exceeds that of its predecessor by a known amount. Each negative is then printed at a series of exposure values and the optimum print indicates the region of correct exposure.

It is very important to realise that this method will only yield a rough indication of the correct exposure and that this preliminary setting will, in any case, only be of value when the film processing solutions and photographic speed of the film stock are known and held within close tolerances.

Methods of producing 16 mm. sound tracks

The photographic sound reduction printing process is still the most widely used system for making 16 mm. copies from 35 mm. original films. However, we must now briefly consider other methods which can be employed for the same purpose. A very logical step is to make one master positive copy on to 16 mm. film by means of an optical reduction printer and, from this positive, to produce a duplicate negative—again on 16 mm. film. This duplicate negative may then be used to produce the many positive copies requires for release—and such copies, together with the duplicate negative itself, can be made on a rotary contact printer. The advantage of using rotary contact printers are that a somewhat higher printing speed can be obtained, that optical slippage (always a potential hazard with a reduction printing process) is eliminated and that wear and tear on the original 35 mm. sound negative is reduced to a minimum.

These advantages are only obtained at the expense of other more valuable characteristics of the reduction printing process: the use of a 16 mm. duplicate negative means that the emulsion grain structure of the 35 mm. negative has been condensed on the duplicate, but that the grain *inherent* in this duplicate is printed without further reduction on to successive positive copies. It is not possible within

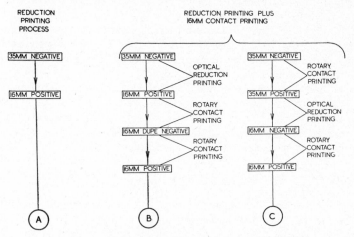

Fig. 8.13. Reduction Printing Processes Compared

the present work to give detailed consideration to the phenomenon of emulsion *graininess* but, obviously, the combination of three silver images (in the case of duplicate contact printing) is liable to result in final prints having a high graininess (and consequent low resolution) whereas, the combination of only two silver images (when printing 16 mm. sound by direct optical reduction) is likely to retain a finer grain structure.

256

It is quite true that, given 16 mm. duplicating material of very fine grain structure, contact printing can produce adequate results but, inevitably, the introduction of intermediate stages requires the entire process to be more rigidly controlled if high resolution is to be maintained. The effect of these intermediate stages may be reduced if a 35 mm. *positive* sound track is used to produce a 16 mm. duplicate negative directly in the optical reduction printer. This improves the final graininess somewhat because one stage in the process has been transferred from the 16 mm. up to the 35 mm. section. The actual steps from 35 mm. negatives down to the final 16 mm. prints are shown in Figure 8.13, where all three processes are compared.

System A, showing the straightforward production of a 16 mm. positive copy from an original 35 mm. negative by means of the optical reduction printing machine, involves only the 35 mm. original negative and the 16 mm. positive print. In system B a 35 mm. negative has been supplied and, by use of the optical reduction printer, a 16 mm. positive print is produced. From this a 16 mm. duplicate negative is made by contact printing on a continuous rotary machine. Finally, the duplicate negative is used to produce a 16 mm. positive copy, again using a rotary contact printer. In system C the first copying operation is to produce a 35 mm. positive. From this a 16 mm. duplicate negative is produced via the reduction printer and in one operation. This duplicate negative is then used to make the 16 mm. positive prints on a rotary contact printer.

Assuming that the highest quality film stocks were used on every occasion, and that comparable printing machines were used with each system, the most consistent high quality results would be obtained by using system A, whilst system C would be superior to system B. In any work involving both 35 mm. and 16 mm. negative and positive films one should complete as many operations as possible with 35 mm. film, and arrange the reduction to 16 mm. width as the final operation. In this manner image graininess in the resultant 16 mm. prints will be reduced to a minimum—unfortunately, it often happens that economics dictate the use of the less expensive 16 mm. materials at stages where 35 mm. film would produce superior results.

Photographic contrast produced in the final prints from the three systems shown in Figure 8.13 depends to some extent upon the difference between the specular and diffuse densities of the various silver images. With optical projection systems such as those in reduction printing equipment, only light which suffers no change in direction when passing through the emulsion will go to form the final image. However, when films are printed by contact this specular illumination *plus* the light which is diffused or scattered by the negative emulsion will all reach the positive stock because no space or apparatus exist between the two emulsion surfaces. The density of a silver image measured by contact is therefore always lower than the specular density of the same silver image.

Since the specular density is higher so also will be the contrast of the final positive print and, therefore, reduction prints made by the optical reduction system A, Figure 8.13, will have a higher contrast than similar prints made by systems B

9

or C if all other factors remain comparable. The final stage in both systems B and C employs a contact printing operation to obtain the 16 mm. positive copy. This reduces the effective density of the negative since both the specular and diffuse illumination will reach the positive film and, therefore, the final print contrast will also be reduced.

Comparison between optical reduction and re-recording

Some people are of the opinion that superior results can be obtained by electrically re-recording sounds rather than optically reducing a 35 mm. photographic image of these sounds. This process involves a 35 mm. positive print which is scanned in a

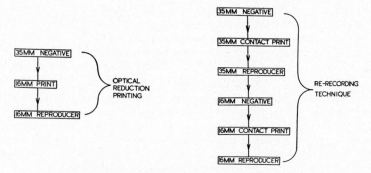

Fig. 8.14. Optical Printing versus Re-Recording

reproducer so that the output from the photo-cell operates either a light-valve or a mirror galvanometer to produce new light modulations directly on a 16 mm. negative film. With such a re-recording process it is essential to reduce to a minimum any distortions of a photographic nature. It is also possible to re-record from either a photographic or magnetic original 35 mm. track to produce either a photographic or magnetic 16 mm. copy.

The efficiency and response of any sound reproducing system is measured by its ability to maintain constant undistorted output as the frequency range is extended. It is therefore quite possible to directly compare the output from a reproducer resulting from photographic 16 mm. sound tracks which have been generated either by optical reduction printing or by electrical re-recording. The output loss in each case as the recorded frequency is increased is of particular interest in such a test. The actual operations involved in the two systems are shown in Figure 8.14. The optical reduction process involves three main stages which, if carefully controlled, causes an overall loss of approximately 12 db at a frequency of 6,000 cycles with given recording and reproducing apparatus having scanning slits of known width and employing a variable-areas type sound track. When identical recording and reproducing slits and variable-area tracks are again used with the

re-recording technique the overall loss at 6,000 cycles increases to approximately 24 db.

Although the difference in decibel loss between the two systems is proportional to the number of steps involved in each system, it does not follow that each step is responsible for an equal degree of loss. In actual fact the second operation in the re-recording process—that of producing the 35 mm. positive print—can compensate for some of the original losses inherent in the negative. However, the losses introduced by re-recording and, particularly, by contact printing from the 16 mm. negative on to the 16 mm. positive only apply with certain film emulsions and, with the latest emulsions of much improved characteristics, such comparisons show less difference between the two processes.

Sound lead ahead of picture

One final point which applies to all 16 mm. films carrying both picture and sound records concerns the relative positions occupied by corresponding sounds and pictures along the film length. Sound which is intended to reproduce in synchronism with any given picture is not printed alongside that picture—but some distance in advance of it (see Chapter 10). In the case of 35 mm. films this separation is standardised at 20 frames or 15 in. whereas, in the case of 16 mm. films, the separation is increased to 26 frames although, in linear measure, this is only equivalent to 7·8 in. The difference in actual length between the two systems is so much greater than the difference between the number of frames because the distance occupied by one 35 mm. frame is 0·75 in. whereas that occupied by one 16 mm. frame is only 0·30 in.

In closing this chapter it must be realised that 16 mm. direct recording systems—using combined picture and sound cameras and employing a magnetic sound stripe coated on the edge-area of the picture negative film—are widely used both in Industrial and Television film production. The annual footage produced in this way far exceeds that produced by reduction printing techniques.

Chapter 9

Special Effects and Editing Equipment

Special effects and travelling mattes

MOTION pictures rarely consist merely of straight or jump-cuts from one scene to the next. The tempo at which information or emotions may be displayed or created is continually changing as the story develops—this is true of all films, including documentary, educational and scientific films just as much as conventional studio features or works of fiction. Tempo is, of course, the speed of the story. It is controlled by two main factors in any motion picture: (1) the performance of the actors and their interpretation of the scene (under the guidance of the director) and, (2) the timing of the length of each final scene and the method employed to change from one scene to the next (controlled by the editing technique).

At the moment we are particularly concerned with methods of scene changing and the inclusion in the final screen version of any visual impression which is beyond reality. This definition must include everything which is not fact and could not be readily photographed by a simple camera set-up. Such illusions are therefore rightly described by the blanket title *Special-Effects*. Although many special-effects (or trick-shots) can be directly created in the camera, such methods are very uneconomical and are only rarely employed because they involve the use of expensive studios and the time of highly paid artists and technicians. With the notable exception of back-projection shots, special-effects are usually created in the film processing laboratories by using particular film printing techniques and equipment.

Special-effects are used to assist tempo-adjustment in two ways: (1) by providing alternative methods of changing from one scene to the next and, (2) by creating complete scenes which would be impossible in real life. Scene-changing techniques —apart from the simple jump-cut when the end of one scene is spliced directly on to the beginning of the next scene—include the following:

The Fade-in or Fade-out, where the scene gradually appears from the previously dark screen—or gradually fades away until the screen becomes dark.

The Lap-Dissolve, in which the fade-out of one scene is superimposed upon the fade-in of a second scene.

Wipe-Effects, in which a thin line (of any desired shape) moves across the screen in any direction and so as to obscure the existing scene whilst revealing a new scene in its wake.

The Iris-in or Iris-out, in which—from a black screen—the scene first appears as a small spot (usually in the centre of the screen but not necessarily so) which gradually enlarges until the whole picture is revealed. The Iris-out is the converse of this so that the picture boundaries are continually reduced by a decreasing circle and until the image vanishes in a point. For many years these effects were the classical start and finish to cartoon films.

Overlay or Inlay. These are terms which have become particularly associated with television presentation and describe a composite scene consisting of two partial images combined to form a complete screen-image. For example, the portion of a scene remaining after an iris-out had been stopped at a mid-position (that is, the remaining central circular portion) may be surrounded by a different scene occupying the area between the iris and the boundaries of the screen.

Trick-effects, or the production of complete scenes which have no connection with real life, are limited only by the imagination and ingenuity of the production team. Typical of the more usual amongst these are the following:

Model Shots. Here very accurately made scale models are photographed when the use of the real subject would be too costly or because it is unattainable. For example, storm-swept ships at sea may be models filmed in the studio-tank and with the aid of wind machines, wave-making devices and usually—to create realism—by running the camera considerably faster than normal speed. Such a scene does not involve the use of special printing techniques but, if the model shot happens to be a necessary street-scene only used for one establishing shot, then a travelling matte technique in the printing machine can combine this model shot with a real actor apparently walking along the street, but actually filmed in the studio.

Glass Shots. This term describes a technique in which either an unobtainable background or foreground scene is painted on to a sheet of optically flat glass and so that the sky-line will exactly fit on to the sky-line of the complementary part of the composite scene. Two negatives are then produced; one of the painted glass background and another of the available full-size foreground. These are then combined in a printing operation so that, for example, the bungalows of a Chinese village may appear solidly built into the foothills of a range of Welsh mountains!

Back Projection. With this technique a positive print of the background scene is projected on to a translucent screen and the foreground action is staged between this screen and the camera. Thus the camera photographs the foreground action combined with the surrounding image of the projected background. This technique

occupies considerable studio space and requires a special background projector operated in synchronism with the camera.

Travelling Matte. This technique is used to create impossible shots, such as a small boy standing on the hand of a giant, a car driving across the sky above the rooftops of a city, etc. It depends upon the accurate registration of several films in a printing machine, and the protection of parts of the positive print by a moving opaque silhouette representing the foreground scene which will ultimately be combined into the background during a subsequent printing operation.

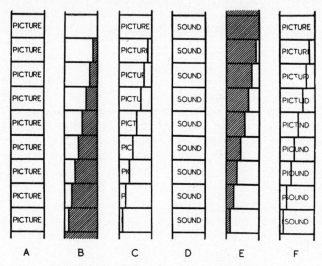

Fig. 9.1. The Principle of Travelling Mattes

All scene-changing devices such as fades, lap-dissolves, wipes, etc. can be created in printing machines in a variety of ways. Whilst the simple fade in or out can be produced in either a contact or optical printer merely by adjusting the exposure whilst printing the appropriate section of the negative, the lap-dissolve and wipe-effects can only be created by superimposing the printing of the end of one scene upon the beginning of the next and whilst the required transitional effect is carried out—because of this these effects are more easily controlled when they are made on an optical printing machine.

Once an optical printer is employed space between the negative and positive films becomes available and may be used to mount mechanically driven masks, iris diaphragms, etc., with which to create many effects. In general these aids are engaged to operate in conjunction with the mechanism whilst printing the final few feet of one scene, the printer is then stopped and the positive film is rewound to the point where the effect commenced. The negative is then replaced by that of the next scene and the printer is restarted—the mechanical effects device then

performs the *inverse* of the previous motion so as to print the complementary section of the combined effect.

It will already be obvious that a complete book could be devoted to the work of a studio special-effects department and, at present, we can only consider a brief outline of some of the techniques which are available. A general idea of both the production of a wipe-effect from one scene to the next, and also the fundamental layout of travelling mattes, will indicate the vast possibilities which become available with high-quality precision-built special-effects printing equipment.

Let us assume that a very simple transition is to be made whereby a thin line passes across the screen, wiping the first scene away and revealing the second scene in its wake. Known as the *Horizontal Wipe*, this effect may be made on an optical step printer either by using auxiliary sliding metal masks or by using specially prepared travelling matte films. The basic principle of the travelling matte is illustrated in Figure 9.1. For simplicity each film shown in this figure is represented by a series of rectangles—indicating the frames—and the perforations and film edges have been omitted. The film shown at A, carrying the title PICTURE, is required to *wipe* to a second film carrying the title SOUND, as shown at D. Films B and E are complementary travelling mattes carrying opaque silhouettes to protect sections of the positive stock during the printing operations. Film C represents the latent image exposures resulting from the combination of negative A and travelling matte B. Film E represents a second travelling matte which is complementary to that at B and, when this is combined with negative D, the final result on the positive film will be as shown at F.

When negative A is in the printer the partially opaque matte film B is threaded in contact with the positive film and facing the negative. After printing film B will have masked off parts of each negative frame and only those sections shown at C will have been exposed. The positive film is then rewound to the position at which the first film or matte started but, this time, the matte shown at E is threaded in contact with the positive. Negative D is then placed in the printer and, since matte E will protect those areas which were previously exposed, only the complementary section of each frame will be printed and, after processing, the entire result will appear as shown at F.

In practice it is not convenient to rewind each scene and to insert every matte as and when required. If a number of transitions are required in one roll of film, and the only available equipment is an optical step printer, then the more usual method is to prepare two complete travelling mattes—each as long as the negative which is to be copied. The actual techniques is shown in Figure 9.2. The negative is first divided into two lengths and so that alternate scenes are contained in each roll—for example, scenes 1, 3, 5, 7, etc., are contained in roll A, and scenes 2, 4, 6, 8, etc., are contained in roll B. Lengths of blank spacing material are inserted in each negative roll and between each scene so that the original 'uncut' length is preserved both in roll A and roll B. For convenience in the illustration, the scene lengths have been greatly reduced—as also have the travelling mattes representing the periods of transition from one scene to the next.

Travelling matte C is threaded in contact either with negative A or the positive film on to which the completed work will be printed. The machine is set in motion and the entire roll of negative A is printed without interruption. As the work proceeds scene 1 will be printed without any difficulty and quite normally through the clear spacing at the head of matte C—this will continue until frames E, F and G

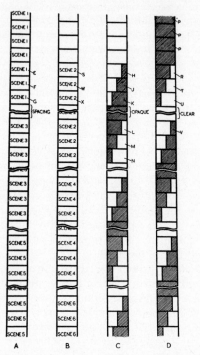

Fig. 9.2. Travelling Mattes in Detail

are reached; corresponding frames H, J, and K in matte C will then mask off increasing sections of the picture until it is entirely covered. From this point matte C remains opaque for a distance equal to the length of scene 2 in negative B. Now a corresponding length of spacing (equal in length to scene 2 minus the distance occupied by the transitions at each end of the scene) exists between scenes 1 and 3 in negative A. This spacing is also equal in length to the opaque film between K and L in matte C. On reaching frame L in matte C, the first part of the first frame in scene 3, negative A, will be exposed and, as printing continues, the matte L, M and N will gradually open until the complete picture area is exposed.

By now the resultant positive film will contain scene 1 closing off to no exposure at the tail, followed by a length of unexposed stock, and then scene 3 opening up with the desired effect. By printing the entire roll of negative A in combination

with matte C the positive copy will then contain every alternate scene of the final picture, opening and closing with the required effects, but separated by distances of unexposed film. The positive film is then rewound and matte D is accurately located either with the positive or with the negative B—which now replaces negative A in the printer. Since the beginning of the positive film already carries scene 1, this is protected from further exposure by opaque film P in matte D. On reaching frame R in matte D, the opaque area is reduced by a distance exactly equal to section H in matte C. It must be realised that the clear section of frame R is equal to the opaque section in frame H—and is also equal to the section of scene 1 which was previously masked off. It is therefore obvious that the clear section R, matte D, reveals a section of unexposed positive film on to which the first part of scene 2, negative B, may be printed. In a similar manner frames T and U complete the transition and permit increasing sections of scene 2 to be printed into the spaces left in the positive film when scene 1 was previously masked off by matte C. The required length of clear matte film between U and V permits the whole of scene 2 to be printed normally and then, since the opaque area closes across, scene 2 will be cut away in synchronism with the parts of scene 3 which were previously printed in by matte C.

Two important points must be remembered when preparing this type of travelling matte. Firstly, the distance between E and G in negative A may be any length, such as 30 or 40 frames (dependent upon the desired speed of the transition), but the *corresponding* distance in negative B—namely from S to X—must be precisely equal in length. The cameraman must therefore *over-shoot* all scenes which are to open or close with transitions so that sufficient film exists before and after the important action and in which to accommodate the effects. Secondly, both negatives and travelling mattes must be accurately marked at the head of each roll with a starting frame, and the positive print film must also be similarly marked once it has been threaded into the printer to commence the first operation in the series. By this means synchronism between all films is ensured, regardless of the number of times they are rewound or the interval between each operation.

This process is very exacting and is therefore only used to produce a *master* positive copy from which a duplicate negative is then printed. This final duplicate negative is then complete with all the scenes in their correct relationship, together with all the necessary transitions already completed. Such a duplicate may then be used to print many release copies on the mass-production printers. Incidentally, it should be remembered that, although we have not dealt with sound recording techniques as yet, the arrangement of the sound film to match this duplicate picture negative is, of itself, a problem equally formidable to the editor and is performed in a function known as *track laying*.

Any travelling matte process consists of a length of film carrying a silhouette outline to protect areas of the positive film whilst other areas are being printed. Usually the positive is then rewound and threaded in synchronism with a second matte carrying a complementary silhouette which reveals the previously protected areas but covers those areas which were exposed during the first printing. By such

techniques any normally impossible action can be created—such as cars flying over rooftops, etc.—providing sections of the combined action can be separated into two parts to be *matted* together during the final printing operation.

The J. Arthur Rank Organisation holds British patents covering several improvements on this basic technique and which have the great advantage that the foreground and background images are combined during only *one* printing operation. This naturally leads to steadier prints since the sections are optically overlapped whilst the positive film perforations are registered once only. This process depends upon the use of two special units; (1) a beam-splitting camera to record the foreground action and, at the same time, to produce a silhouette of that action and, (2) a beam-combining printing machine to overlap the foreground action into the appropriate area of the background negative in one printing operation.

A beam-splitting camera carries two films in gates at right-angles to each other. The film in one gate is usually only sensitive to yellow light, whilst that in the other gate is only sensitive to blue light. Naturally, suitable filters built into the camera can ensure that only the precisely required colour band is transmitted to each film. The foreground action is then staged against a plain backcloth covering the entire area seen by the camera. The backcloth is illuminated by blue light and the foreground action is only illuminated by yellow light. Clearly, the foreground will only be recorded on the yellow-sensitive film (and will result in a perfectly exposed scene surrounded by transparent film), whilst the background will only be recorded on the blue-sensitive film (and this will appear as a jet black silhouette with the foreground represented as a transparent central area). From the blue-sensitive negative of the background a positive print is made so as to create a black silhouette of the foreground, surrounded by transparent film. This print is used in making the final combined travelling matte shot by loading it in the printing machine in contact with a print from a conventional negative of the *required* background. (This conventional background negative may have been photographed at any time and by a special second-unit or location-crew.) Meanwhile, a positive print has been made of the foreground action negative.

A beam-combining printer enables the image on two positives or negatives (on separate films travelling through gates at right-angles to each other) to be optically combined into one duplicate negative or print. In this instance, the positive print of the foreground action can be combined with a positive print of the required background scene *because* the background print is *in contact* with a silhouette matte protecting those areas into which the foreground will be fitted during this printing operation. This technique results in a composite negative after only one passage through the beam-combining printer.

A and B roll printing

When 35 mm. films are being edited the frame-line between each picture provides sufficient space in which to accommodate the splice (made to join one negative scene to another) without extending into the picture area. Because of this, joins in

35 mm. films are never visible in the final prints and cannot be detected on the screen. The frame-line on 16 mm. films is quite different and is far too small for this purpose so that, inevitably, a join in this narrow-gauge must be visible on the screen. However, in an endeavour to reduce the disturbance as much as possible, two 16 mm. splicing machines are in general use. One is known as a *positive* 16 mm. film splicer and makes a relatively wide join strong enough to withstand many passages through a projector mechanism but, of course, very visible on the screen. The other, known as a *negative* 16 mm. film splicer, makes a narrow join which is less visible on the screen although, being so narrow, it is only strong enough to safely withstand the

ROLL A

SCENE 1	OPAQUE	SCENE 3	OPAQUE

C | D | E |

ROLL B

OPAQUE	SCENE 2	OPAQUE	SCENE 4

Fig. 9.3. A and B Roll Assembly

relatively few passages through printing equipment. Even so, this narrow negative splice is still detectable in the final prints.

These objections are completely overcome when a technique known as A and B roll printing is adopted for making prints from edited 16 mm. negatives. The process depends upon the preparation of the negative into two rolls and so that the odd-numbered scenes—1, 3, 5, 7, etc.—are in roll A, whilst all the even-numbered scenes—2, 4, 6, 8, etc.—are in roll B. Opaque spacing film is then inserted between each scene and, of course, the length of spacing must be equal to the corresponding scene in the alternate roll. For example, the length of opaque spacing between scenes 1 and 3 in roll A must be equal to the length of scene 2 in roll B.

When this is done it is possible to make film splices so that they overlap *into* the opaque spacing, rather than into the picture area. The technique is illustrated in Figure 9.3 and it will be seen that the lower edge of the last frame in scene 1, roll A, is precisely level with the upper edge of the first frame in scene 2, roll B, as indicated by the dotted line C. Similarly the end of scene 2 is in line with the start of scene 3, as shown at line D. It should be noted that the splices are always made to overlap *into both ends* of the opaque leader film. Figure 9.4 shows the splicing technique in detail and, incidentally, it is vitally important for the editor to remember that only the picture material and never the opaque leader is scraped clear when making joins for A and B roll printing.

In practice the whole of negative roll A is printed, the positive stock is then removed from the machine and rewound; after synchronising the start marks at the head of each reel, negative roll A is replaced by negative roll B, the positive film is

reloaded and a second printing operation is carried out to insert the complementary scenes which were missing from the previous roll of negative material. If the printing machine is fitted with a beam-combining prism, and provision to run two negatives simultaneously, a final composite print may be made by only one passage through

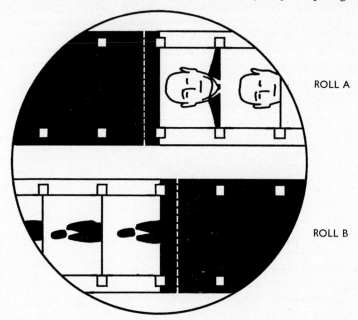

Fig. 9.4. Detail of Splicing Technique for A and B Roll Printing

the machine. Once the difference between conventional 16 mm. negative splicing has been compared with this technique it becomes obvious that the extra time and effort in preparing a negative into the A and B roll format is well repaid by the resultant print quality.

In some installations further refinements have been made to prevent the printing light from reaching the negative when the opaque leader is in the printer gate. This provides a safeguard against the possibility of pin-holes in the leader printing through on to the positive film. It usually takes the form of a negative notching system, or adhesive foil contact strips attached to the negative and, in both cases, operates a shutter in a manner similar to the light-changing mechanism used when controlling exposure levels when printing ungraded negatives.

Automatic optical effects printing

Carrying automation a stage further, Technicolor Limited employ special electronically controlled printing equipment of their own design which produces fades, lap-

dissolves, etc., without any need to rewind the positive print or to carry out conventional double-run operations. The technique is intended primarily for use in optical step-by-step or intermittent printing machines fitted with variable-aperture rotary shutters. These machines must have the ability to stop or start the positive film movement quite independently from that of the negative, and also to run the positive forward or backward whilst the negative is moving constantly forward. Given these facilities, punched tapes can obviously be prepared to control the various movements to occur as and when required.

The principle of this equipment will be understood from Figure 9.5, where the cycle of operations for making a simple lap-dissolve is shown. The upper horizontal panel A indicates the method used to assemble the negative of two scenes which, ultimately, are to be printed so that the end of scene 1 lap-dissolves into the beginning of scene 2. Scene 1 runs from the starting point at U to its end at X; the duration of the fade-out at the end of scene 1 covers the region from W to X. A length of

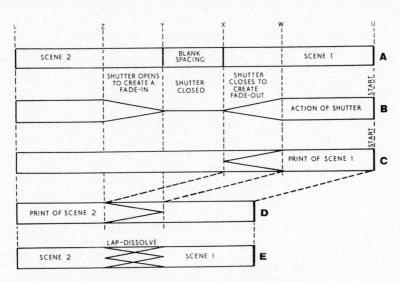

Fig. 9.5. Technicolor Auto-Printing System

blank spacing, between the end of scene 1 at point X and the beginning of scene 2 at point Y, is equal to the duration of the fade-out—that is, distance WX is equal to distance XY. Similarly, the fade-in at the beginning of scene 2 covers distance YZ which is also equal to WX.

Panel B indicates the sequence of operations performed by the variable-aperture rotary shutter. Whilst the negative is running continually forward the shutter is fully open from point U until point W. Between W and X the shutter gradually closes; it then remains closed from X until point Y; it then gradually opens again

269

whilst the negative travels from Y to Z, and remains fully open from Z until the end of scene 2 at point V.

Panels C and D indicate the motion of the positive film. While the negative is moving from U to X the positive is also moving forward, and the first scene is therefore printed complete with a fade-out over the end-region. While the negative is moving from X to Y (during the time when the shutter is closed) the positive film is moving *backwards* by an amount equal to the distance covered by the fade-out at the end of scene 1. That is, it moves backwards from point X to point W. Because of this, by the time the negative reaches point Y, the positive film will be positioned as shown in panel D. The mechanism driving the positive film is now reversed once more so that the film travels forward again and, at the same instant, the shutter starts to open. Both the negative and the positive will now be travelling forward and the shutter will open during the movement from Y to Z—thus creating a fade into scene 2 printed on top of the fade-out from scene 1—thus producing the required lap-dissolve. This final condition is shown in panel E.

This technique can not only produce fades, dissolves, iris-effects and wipes, but may also be used to insert or extract whole scenes without the need to cut two separate negative versions, and so as to print different positive versions as may be needed for release to different countries—this can be very helpful when dubbing sound into foreign languages or when the length of a film must be adjusted to suit varying requirements.

Obviously, the technique could be extended so that, in an optical step-printer in which collimated or parallel light rays exist between the negative and positive printing heads, yet a third film gate could be arranged to cause travelling mattes to move either forward or backward and so extend the range of special-effects by methods other than the beam-combining printers previously described.

Editing and editing equipment

The function of editing a feature film begins just as soon as the 'daily work prints' or rush prints of the first day's shooting become available at the studio. It is then the editor's job to assemble these for projection during that day and—because they will almost certainly be *unmarried* prints—also to ensure that the separate rolls of sound recordings will synchronise perfectly with the picture film. The projectors used in studio review theatres are capable of handling separate picture and sound films and are said to be *double-head projectors* because the unmarried sound film passes through one part of the mechanism whilst the picture film passes through quite a different part. Naturally, both heads must be positively geared to rotate together and in synchronism.

As film production continues the editor must gradually build up a *rough-cut* of the story as he adds each day's rushes to those previously assembled. During this process he will also add wax pencil marking to the picture print to indicate the type and duration of any effects which must subsequently be incorporated into the final release prints by the laboratories. Most of these 'editorial instructions' are self-

explanatory and those most commonly used are illustrated in Figure 9.6. Towards the end of production it will become possible for the director to begin to visualise his picture as a whole entity and thus, in association with the editor, to refine the timing of each scene. To help in this it is quite common for the editor to insert

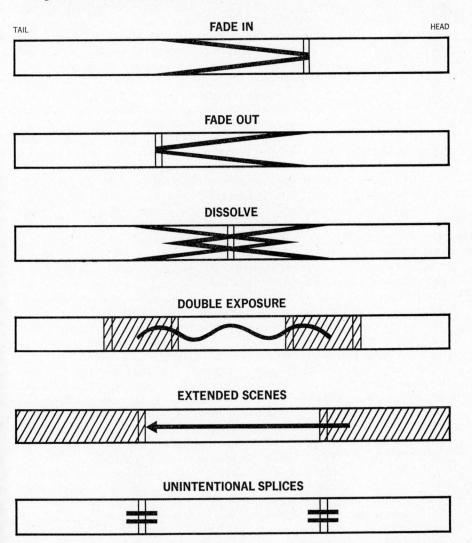

Fig. 9.6. Method of Marking Work Prints to Indicate the More General Types of Special Effects

'*missing scene*' titles in those parts of his reels which are still awaiting coverage because a few remaining scenes have yet to be shot.

In many cases the studio editing staff also prepare complete *shot lists* indicating the precise section of each negative which must be used in the final picture. These selected portions are easily identified from the daily work print because (*a*) each picture print carries a few frames of the *slate* or scene identification board which is always photographed at the beginning of every *take* immediately the camera has attained full speed and, (*b*) because the footage numbering provided on the negative is printed through on to the positive whilst the laboratory is making the daily work print—special printing machines employed on daily rushes have a so-called *open gate* which ensures these numbers are printed.

Thus a typical shot list might consist of a series of instructions such as: 'scene 26—take 4—52684+8 to 52698+2.' This indicates to the laboratory that the editor requires the fourth take of scene 26 to be used in the final negative assembly and, of that take, he only wants to use that section which starts at eight frames ahead of footage number 52684 and finishes two frames ahead of footage number 52698.

The foregoing is quite straightforward and almost an automatic process when dealing with the picture negative. It is not initially quite so simple when editing the sound film to match the picture. This is because neither photographic or magnetic sound recording film is normally supplied with edge numbers. However, many studio editing departments carry their own visible footage numbering machine—this is a rotary device in which any series of numbers is printed by ink on to the film at regular intervals of one foot. It automatically advances the number after each printing operation and the editor can print numbers to match those on the picture negative or, more usually, will use quite an independent series to suit his own library or filing purposes. As will be explained when dealing with sound recording techniques, it is now common practice in feature film studios to record sound magnetically—and local studio staff usually make a *sound-transfer* of all the selected takes at the same time as they are assembling the daily picture rushes.

Naturally, the editor requires quite an array of equipment in order to be able to manipulate all the films which are involved in his routine work—and to ensure that these do not become mutilated or incorrectly assembled. So far as the picture is concerned he may well have as many as 500 different *scenes*—and the director may have called for an average of three *takes* of each scene to be printed—thus on a feature film he may be handling upwards of 1,500 individual lengths of positive picture film. When it comes to relating this material to the sounds which must accompany it he not only has individual dialogue tracks to match the spoken words, but will also have *post-synchronised* dialogue tracks (made in a dubbing theatre and to cover words which were not recorded to sufficiently high quality during the floor-shooting), sound effects tracks and also music tracks to contend with. His prime requirements are (*a*) some means of viewing and hearing all these lengths of picture and sound film, (*b*) some means of moving several films simultaneously and in perfect synchronism and, (*c*) means of joining together selected pieces of film so that they may safely be projected many times.

For many years a piece of equipment originated in America and known as a Moviola—and later a similar machine made in England and known as an Acmeola—was used by film editors both for viewing the picture prints and also to reproduce

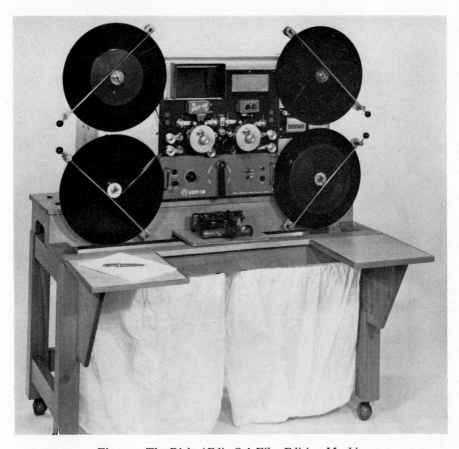

Fig. 9.7. The Rigby 'Edit-Or' Film Editing Machine

Courtesy Robert Rigby Ltd.

the complementary un-married sound recordings. These machines were essentially very small models of the intermittent picture head and sound reproducing units found in conventional cinema projectors. More recently the need for very rapid editing associated with the use of film in television has caused the development of far more sophisticated equipment which greatly eases the editorial problems. Whereas the Moviola and Acmeola machines originally relied upon conventional maltese-cross intermittent film mechanisms, almost all present-day editing machines

273

employ rotating glass prisms to optically arrest the images in films which move continuously through the apparatus—thus greatly reducing the chance of damage to the prints as well as speeding up the process.

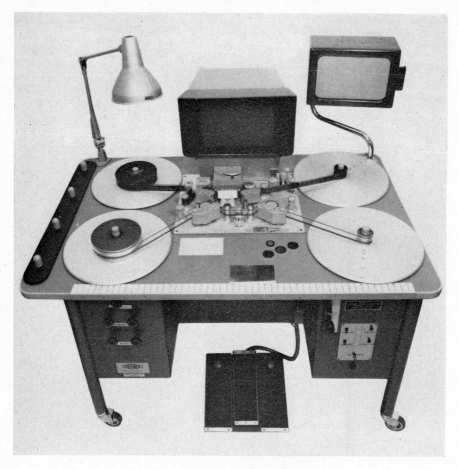

Fig. 9.8. The Steenbeck Editing Machine

Courtesy Evershed Power-Optics Ltd.

Modern film editing machines fall into two main categories—those designed to operate in the vertical plane and those built into horizontal editing tables. An example of vertical equipment is the machine shown in Figure 9.7. This is manufactured in England by Robert Rigby Limited, is known as the 'Edit-Or' and is especially suitable for use when a large amount of genuine editing (cutting away) must be

done very rapidly and, consequently, many short pieces must be discarded in a tidy manner. An example of the horizontal table layout is shown in Figure 9.8. This is manufactured in Germany by W. Steenbeck & Co. and is marketed in

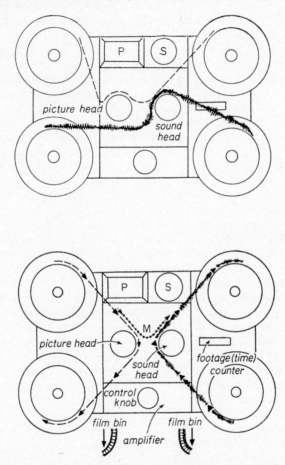

Fig. 9.9. Facilities Available in the 'Edit-Or' Film Editing Machine

England by Evershed Power-Optics Limited. Both machines are designed to accommodate unmarried rolls of up to 2,400 ft. (729·5 metres) of picture and sound material. Some versions of Steenbeck equipment are designed to handle three films at once: one reel may carry the picture only, or both picture and sound as a combined optical print—or even picture and magnetic sound as a combined married print. The second and third reels may carry magnetic sound in the so-called *centre-track* position and either or both of these may, on request, be designed to

275

reproduce magnetic sound in the so-called edge-track position. Naturally, versions of both the Rigby and Steenbeck machines are available to edit either 35 mm. or 16 mm. films.

Some idea of the versatility of this type of equipment will be gained from a study of Figure 9.7 in combination with Figure 9.9—which shows the alternative film threading paths which may be employed on the Rigby Edit-Or machine. The general arrangement of this equipment provides two pairs of vertical film plates on either side of a central mechanism containing the large picture and sound reproducing heads and associated film guiding rollers and sprocket wheels. The picture is reproduced by back-projection onto the translucent screen seen to the upper left of the central mechanism, and the sound is reproduced via a built-in amplifier and the speaker unit seen to the right of the viewing screen (sound may also be fed to earphones which may be plugged directly into the system). Figure 9.9 indicates three methods of using this editing machine: in the upper diagram the sound film is fed from the lower left-hand position, over the sound head and to be taken up at the lower right-hand position. The picture film passes from the upper left-hand position and is then fed over both the picture and sound heads before passing to the upper right-hand take-up position.

In the lower diagram, Figure 9.9, the picture film is laced to feed from the upper left-hand position to the lower left-hand position, whilst the unmarried separate sound film is fed from the lower right-hand position to the upper right-hand position. Thus the two illustrations show that the machine satisfies both those who prefer to work across the machine and those who prefer to keep each film isolated either to the left or right side of the central mechanism. The third arrangement is, of course, when a married film containing both the picture and optical sound track— or a film containing picture and a magnetic sound track—is to be inspected. Such a film merely travels from the upper left-hand position over both the picture and sound heads and then to wind up in the upper right-hand position.

All modern editing machines must be capable of running both in the forward or reverse directions and must be able to stop within a distance of one frame. They must also be capable of running either exactly in true projection speed or at any variable speed from zero up to twice normal projection speed. They must be provided with a hand control to allow the editor to consider any dramatic action in the picture as it changes from one frame to the next.

Film synchronising

One of the constant requirements in any editing operation is to be able to run several lengths of film over considerable distances and to maintain exact synchronism throughout the operation. For example, it may be necessary to cut a negative to exactly match a positive print—or to lay out three sound tracks (dialogue, music and effects) in exact synchronism with a positive picture print.

In all such cases use is made of a device known as a *film synchroniser*, a typical example of which is shown in Figure 9.10. This particular unit is known as a *four-*

way synchroniser because it enables four separate films to be locked together to move in perfect synchronism. It consists essentially of a main central rotatable shaft supporting four large diameter film sprocket wheels, each of which is surrounded by a set of guiding rollers mounted on spring-loaded arms and retained in position around the sprockets by quick-release push-button catches. In 35 mm.

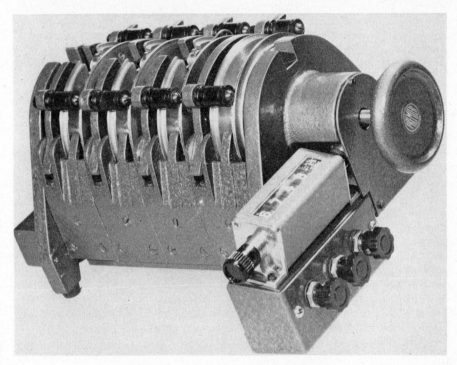

Fig. 9.10. A Four-Way Film Synchroniser

Courtesy Robert Rigby Ltd

synchronisers the sprocket wheels accommodate 16 frames—or exactly one foot of film—and the front face of the sprocket nearest to the operator is engraved with frame numbers from one up to sixteen. In use the editor first engages the picture film with this front sprocket, and he does this so that the footage number on the film is placed on the sprocket area designated as frame No. 1. He then returns the footage counter to zero. Henceforth he will be able to describe precisely any position along the film—merely by reading off the footage counter plus the frame number on the sprocket wheel. Naturally, if he is laying sound tracks to synchronise with a picture print, he then engages the various sound films to that each one is driven by a separate sprocket wheel—and also so that the 'start mark' on the head of each film is synchronised with the start mark on the picture print. If the film synchroniser is

designed for use with 16 mm. film then the sprocket wheels are of sufficient diameter to accommodate 40 frames—again exactly one foot in length.

Synchronisers of the type shown in Figure 9.10 are used in conjunction with two other editing facilities. One of these is simply a heavy-based metal stand in which a series of rolls of film may be mounted vertically and between smooth chromium plated pillars. Films can therefore be mounted for editing whilst remaining wound on a simple plastics bobbin and they need not be supported in conventional cinema-type spools. Thus they may be dealt with by the editor exactly as they are received from the processing laboratories. Such devices are known as *film horses*.

The second ancillary unit is a multi-station film rewinding unit. Such a device is used to take up the films as they are passed through a multi-way film synchroniser. In order to use the four-way synchroniser to its maximum advantage a rewind unit must be provided which is capable of winding four films onto spools or bobbins. This can easily be done by providing on a single shaft a series of independent clutch and clamping units which provide drive to each take-up spool or bobbin by friction and under tension from the main rewind shaft. When films are to be wound on to bobbins or plastics cores via such a device the bobbins must first be mounted on film back-plates in order to provide a suitable metal surface to engage with the friction driving clutches.

Mention has been made of laying tracks in synchronism with picture prints. It should be remembered that unmarried films can be synchronised for editing purposes merely by ensuring that the start of the picture film coincides with the start of the sound film. However, sound and picture cannot be reproduced in a cinema projector unless the appropriate sound is printed on to the married copy *ahead* of the corresponding picture. Thus the editor must be careful to stipulate whether he had laid his tracks in *editing-sync* (alongside each other) or in *printer-sync* (displaced as they must be for cinema reproduction). The exact sound lead ahead of picture in married 35 mm. and 16 mm. prints is discussed more fully in Chapter 10.

Film splicing

The fundamental purpose of editing is to remove or insert sections of material and, of course, this must imply the need to join or splice together many relatively short lengths of film so that they will withstand the load imparted either by a printer or projector mechanism. In general this is done by overlapping the two ends which are to be joined and applying a suitable cement between them and under pressure. Naturally, any machine designed to join films together must register both lengths very accurately so that the sequence of perforations continues smoothly through the join and so that pictures remain perfectly framed on projection.

Tri-acetate films may be joined together by first scraping away the emulsion layer over a narrow rectangular area on one film, applying cement to this area and then bringing the base side of the second film accurately into contact with the first and finally applying considerable pressure for a few seconds. The films join together because the action of the cement is to partially dissolve the two overlapped

areas of film base and, on setting, to fuse them together. Successful joining therefore depends upon several factors—the more common of which are (a) that it is essential for *all* the emulsion to be removed from the splice-area of one of the films, and if this is not done the cement will not penetrate sufficiently or evenly to make a reliable join, (b) care must be taken to guard against over-scraping and, when the joining machine is provided with an automatic scraper this must be regularly inspected and adjusted to ensure that exactly the correct depth of material is removed. If scraping is continued below the level necessary to remove the emulsion and the subbing (which binds the emulsion to the base) an unduly weak join will result, (c) only the minimum amount of cement necessary to ensure a strong join should be applied. Too much cement will result in a very flexible and weak join which will not only buckle but will quickly break apart in use. Because the application of just the right amount of cement is somewhat difficult to achieve without considerable practice, some joining machines include an automatic cement applicator which always delivers a precisely controlled layer of cement precisely across the area of the join.

Film cements vary considerably and that which succeeds in one splicing machine may not be equally reliable in another. Similarly, different cements are needed to join colour stocks together (and some of these may carry an anti-halation backing), to join acetate bases together or to join polyester bases together. The greatest problems are encountered when it becomes necessary to join acetate base to poly-ester base. It is therefore not practical—or indeed wise—to recommend in this book any chosen cement because its success must depend upon the apparatus and type of film base involved. Editors should consult the film stock manufacturer to ensure that they are obtaining the best possible joins relative to the composition of the film base, etc.

The basic principles of a straightforward film splicing unit are seen in Figure 9.11. This shows the Premier film joiner manufactured in England by Robert Rigby Ltd. Fundamentally two hinged film channels are provided—one on either side of a stationary horizontal plate on which the join is made. Each channel carries accurate registration pins which locate the films and ensure the perforations in each film are exactly in line with those of the other. Spring-loaded clamping plates are provided above each film channel and may be moved with those channels in a hinging action and whilst holding the film securely in place. As shown to the right of Figure 9.11, a film is registered on the guide pins in one channel and the clamping plate then secures it so that the whole assembly may be safely raised or lowered without risk of faulty registration. Each assembly carries a film shearing knife and the hinging action is used to cut the ends of each film to precisely the required length (when registered on the guiding pins) to ensure the join overlaps by the correct amount.

The Premier splicer contains a semi-automatic emulsion scraping device which ensures the correct depth of material is removed. This is seen in Figure 9.11 as the central horizontal block terminating with a control button at the right-hand extremity and carrying a small knife positioned over the film and at its left-hand extremity. This scraping block is mounted to slide over a stationary guiding plate

and so that it may be oscillated across the film area supported on the joining platform. In the illustration the left-hand piece of film has been registered and clamped in position, its end has been exactly trimmed (by the knife attached to the *right-hand* film clamp) and the scraper block is positioned on the film during the scraping operation. After scraping the scraper block is drawn out to its maximum distance

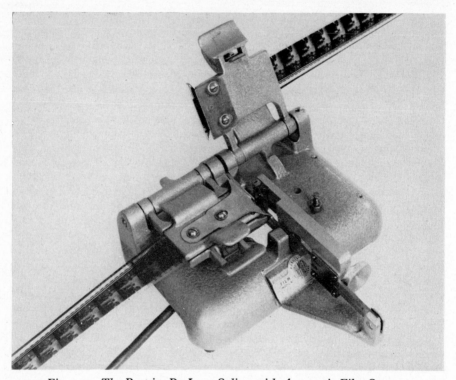

Fig. 9.11. The Premier De Luxe Splicer with Automatic Film Scraper

Courtesy Robert Rigby Ltd

away from the film area, a very small amount of cement is carefully applied by brush to the scraped and exposed film base, and the right-hand film clamp is closed to position the two films accurately and under the required pressure. Each film clamp may be locked into the joining position by engagement between a spring and retaining stud seen upstanding on the base casting to the right of the figure.

After some five to ten seconds the upper leaves of the two hinged blocks may be released—taking care to ensure that the lower film channels are not disturbed—and the joined film may then be lifted away from the unit. Machines are available to make joins in negative films which are as narrow as 0·063 in. in width, or in positive films the join width may be extended to 0·938 in. if the join is across an

area between the perforations—or up to 0·125 in. when the join is made coincident with the perforation area.

These basic principles have been considerably developed by a number of manufacturers. Most notably the Bell & Howell Company have for many years marketed a so-called professional foot-joiner. The system of joining remains exactly similar to that of the Premier machine—the difference being that a series of pedals and

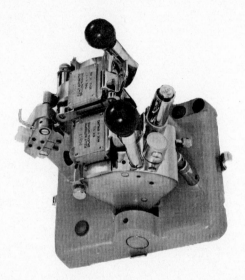

Fig. 9.12. The Robot Fully Automatic Film Splicer

levers are provided so that the editor operates the splicing head by manipulating the pedals with his feet—thus virtually leaving his hands free to control the film and this can make for very rapid working. The Bell & Howell foot-joiner is mounted on a small editing table which includes provision for a film rewinding head and an illuminated viewing panel.

Recognising that successful joining invariably relates to the application of exactly the right amount of film cement, the Robot splicer shown in Figure 9.12 was designed essentially to meet this requirement and also to provide extremely accurate scraping facilities which are controlled to within 0·00025 in. The fundamental principle which ensures this accuracy lies in the fact that the whole unit is designed to operate on the arc of a common circle. The films are thus held to a transverse curve under pressure of clamping plates and, whilst still in this clamped condition it is possible to pass emulsion scraping knives across the film end (again travelling in an arc) and with extreme precision. Using the same principle a rotating cement applicator roller is also caused to wipe across the curved film. The applicator obtains its supply from a small tank of cement in a manner rather similar to the

roller-and-hopper-tank principle used in some film emulsion coating machines. The entire series of operations are carried out by manipulating the two control levers clearly seen in the illustration. Precision locating and adjustment devices ensure that the initial accuracy of this machine can be maintained throughout a long life and following the replacement of scraper blades, etc., which inevitably must become worn after prolonged use.

Chapter 10

The Motion Picture Projector

General

THE whole motion picture industry depends for its success upon an ability to entertain the public—and the industry only meets its public in the cinema. This may seem so obviously true that it need not be said: but in fact it is extremely relevant because although television as we currently understand it can never compete with the *best* in cinema, it is nevertheless the only other means of story-telling which involves a form of moving picture—and it is salutary to remind ourselves that the whole technology *does* ultimately depend on story-telling! Inevitably the cinema will only attract and hold its audiences if it can convince them that it offers something more stimulating and satisfying than television. Great advantages which the cinema can always retain are (1) absolute control over final picture quality and of the conditions under which that quality is displayed, and (2) a high standard of programme presentation technique. Unless these factors are exploited to the uttermost we must not be surprised if the audiences fail to support the industry in which, surely, the first consideration must be showmanship!

In recent years many new and so-called new inventions have been used to attract audiences. Amongst these we must especially note the several wide-screen techniques and also stereophonic sound reproduction. Whilst these factors do much to create a sense of realism and what is sometimes called audience participation they do not, in themselves, contribute anything at all to the *story*. It must always be remembered that only three factors really decide whether a person *wants* to see a particular film—firstly, the belief that it is a first-rate story, secondly, a desire to see the star players heading the cast-list and, thirdly, good presentation of high quality materials.

After all the months of work, after all the technical skills and artistic achievements in the studios, *eventually* the final verdict rests with the masses of people who will see the film *as displayed by their local cinema*. The majority of these people are not interested in or willing to excuse a bad presentation by remembering any outstanding work done in producing the film or any other factor which occurred before that film reached their cinema. In many ways the local cinema projectionists are the salesmen of the industry—they should be educated to think of themselves

as such, trained to do their job extremely well, and then (most important and neglected) paid accordingly! The author makes no excuse for apparently digressing from the technical principles of cinematography at this moment; he believes that only those who fail to appreciate the importance of this final stage in the whole business of picture-making will consider this a digression.

The mechanical efficiency of projection equipment is just as high as that of studio apparatus; but the tolerances permitted in film manufacture, in camera mechanisms, processing equipment and printing machinery, etc., are all additive. The final instrument used to project the pictures will enlarge any errors which may have occurred at any stage of the production—usually by 350 times or more—and may cause a seemingly unimportant variation to be easily noticeable when magnified to this degree.

The number of technical imperfections which pass unnoticed by the average audience cannot be measured, but it is certain that the ability to observe such errors is very acute. The manner in which audiences are subconsciously educated by the technicians of the industry is illustrated by the talking picture. The early *talkies* were received with great enthusiasm and, in most cases, the audiences could always understand the sound track but, if a *direct comparison* were made between one of these early talking pictures and our modern products, the public would be amazed that it ever accepted such harsh garbled noises as genuine talking pictures!

Picture steadiness

Before considering any particular projection equipment we must recognise the magnitude of screen picture unsteadiness which can be tolerated. Unsteadiness is the inability of the screen image completely to hide the mechanical nature of its origin, and results in continual vibration—either vertically, horizontally or in an oscillating manner. It is a product of all the mechanical imperfections at every stage in film production, and the *threshold* of unsteadiness, below which it is not detected depends upon optical limitations of the human eye. The following tolerances are recommended for 35 mm. standard format projection: (1) The unsteadiness of the centre of the picture, as measured in the projector gate, shall not exceed plus or minus 0·0005 in. (0·013 mm.), or a total jump of 0·001 in. (0·026 mm.). (2) The unsteadiness at the corners of the picture, again measured in the projector gate, shall not exceed plus or minus 0·001 in. (0·026 mm.), or a total jump of 0·002 in. (0·052 mm.). The larger tolerances at the corners of the picture are permitted because movement away from the centre of interest is not so apparent to the eye. This is fortunate because most intermittent film moving systems tend to register the centre of the picture more accurately than the edges.

Given such conditions in an average theatre, we can calculate the effect of such a vibration as seen by a person seated at the average position in that theatre. Auditorium design is based upon definite laws relating the picture or screen size to the distribution of the seating, and is calculated to ensure that the picture will subtend the same angle of view at the average seat in cinemas of all sizes. Whilst this

could be accurately controlled for standard format projection, it cannot remain true when various sizes of wide-screen projection are also employed—wide-screen pictures can only be correctly viewed in cinemas which have been specially designed for the particular screen size and image ratio.

Current recommendations limit the distance between the screen and the furthest seat to be 6 times the screen width—for example, if the screen is 24 ft. (7·32 metres) wide, then the furthest seat should be no more than 144 ft. (43·89 metres) from the screen. They also require the space between the screen and the nearest seat to be at least 0·87 times the screen width so that again with a screen 24 ft. (7·32 metres) wide, the nearest seat must be at least 21 ft. (6·4 metres) from the screen. We therefore find that the shorter the auditorium becomes the smaller must be the screen if the picture is to remain in comfortable proportions, the images are to be clearly defined and the mechanical unsteadiness is to remain below the tolerable threshold of vision. Incidentally, the most important position in the above illustration is the distance between the screen and the average seat—that is 81 ft. (24·69 metres) from the screen.

The effective standard-format image on 35 mm. film is approximately 0·825 in. (20·95 mm.) by 0·60 in. (15·24 mm.). A screen picture 24 ft. (7·32 metres) wide and 18 ft. (5·49 metres) high can be obtained at a throw of 146 ft. (44·50 metres) with a 5 in. (12·7 cm.) projection lens. This represents a magnification of 350 times. Under these conditions the permitted unsteadiness of the centre of the picture—as measured in the projector gate previously—will result in a movement of 0·350 in. (8·89 mm.) on the screen. It can be shown that this will appear as a movement of 0·05 mm. on the retina of the eye of a person sitting in the average position 81 ft. (24·69 metres) from the screen. This is equivalent to a resolution of 20 lines per millimetre on the retina of the eye—current observations suggest that the human eye can *resolve* between 10 and 25 lines per millimetre and, therefore, picture unsteadiness of this order is approximately at the threshold of human visual detection. When picture unsteadiness is expressed as a *percentage* of the total picture height it becomes a constant and is independent of the actual screen size. For 35 mm. standard-format projection this unsteadiness-factor amounts to 0·162 per cent. The Society of Motion Picture and Television Engineers of America have adopted an even closer tolerance than this, and currently recommend that overall or final projected picture steadiness shall remain within 0·1 per cent. of the picture width.

It will be appreciated that, to satisfy these requirements, modern projectors must indeed be precision instruments manufactured to a very high standard and, because they may be expected to run for anything up to ten hours every day, the intermittent mechanisms are considerably heavier and more robust than those used in camera equipment.

Basic projector design

So far as picture projection is concerned, as opposed to sound reproduction, the basic mechanism must be arranged to move film intermittently through a projecting

aperture at a speed equal to that at which the original negative was photographed. This remains true for all cases where the speed of image movement on the screen is to be equal to that of the original subject. The general mechanical principles of a standard 35 mm. projector are shown in Figure 10.1 and, although we have not so far considered any systems of sound recording, a photographic sound reproducing

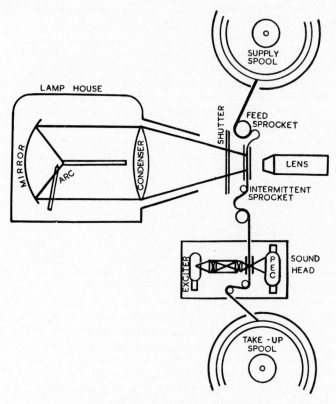

Fig. 10.1. The Principles of a 35 mm. Projector Mechanism

head is shown in this figure to indicate the normal position occupied by such apparatus. The upper take-off spool, housed in a fire-proof container, may have a capacity as great as 5,000 ft. (2,124 metres) or more. Passing through a safety trap the film is drawn continually under a take-off or feed sprocket, rotating at such a speed that 18 in. (27·5 cm.) of film, or 24 pictures, are fed through the machine every second. Obviously, the *actual* speed of rotation will depend upon the diameter of the sprocket. In practice sprocket wheels are described by the length of film equal to the number of pictures which could be wrapped round the circumference.

For example, they may be 4-picture, 6-picture or 8-picture sprockets, rotating at speeds of 6, 4 or 3 revolutions per second respectively.

The film is formed into a free loop between the feed sprocket and the projection gate but, immediately below this gate, it is drawn taut around an intermittent sprocket. As its name suggests, an intermittent sprocket rotates only sufficiently to draw the film forward by an amount equal to the height of one picture (plus the frame bar), it then comes to rest and remains stationary for sufficient time to enable that picture to be projected. Beyond this point the film is formed into a second free loop until it reaches the lower constant-speed sprocket. It is then passed through the sound reproducer and is finally wound up once more on the lower take-up spool—again housed within a fireproof casing. Whilst the film is being moved downwards through the gate it must not be projected since this would blur defini-tion. A shutter is therefore employed in a manner similar to that used in camera mechanisms and, once again, serves to interrupt the passage of light through the film gate. However, in projectors this shutter is not always located in the position illustrated; it may be between the light-source and the film, between the film and the lens, or just in front of the lens. Apart from this basic mechanism, and although most positive film stock is now of tri-acetate slow-burning safety base, it is usual for all projector mechanisms to be equipped with automatic heat-operated fire extinguishing apparatus, together with self-locking firetraps which seal off the bulk of film in the feed and take-up spool housings in the event of a fire.

Modern cinema projector mechanisms

The author is greatly indebted to the Westrex Company for permission to describe their very latest addition to a range of projection equipment which was first intro-duced in the early 1930s. This machine is known as the 'Westrex 70' Theatre Projector and is seen in Figure 10.2. It has been designed to project both 35 mm. or 70 mm. films employing any currently known aspect ratio. The projector is provided with a built-in turret of three rapidly interchangeable lenses and the swing-away anamorphic lens attachment provides maximum rigidity and a rock steady picture. The film magazines have an internal diameter of 24 in. (61 cm.) and will accommodate 5,000 ft. (1,524 metres) of 70 mm. film on a 10 in. (25·4 cm.) diameter centre or 6,000 ft. (1,828·8 metres) of 35 mm. film on a 5 in. (12·7 cm.) diameter centre. Thus one Westrex 70 machine can provide an uninterrupted presentation of approximately one hour.

The space within the heavy pedestal base on which the projector is mounted is used to house the motor control equipment and the power supply unit which feeds the exciter lamp (employed when recordings on photographic sound systems are to be reproduced). The lamp house—mounted immediately above the pedestal—accommodates either a conventional carbon arc light source or a Xenon arc lamp depending upon the required screen picture size and the screen brightness which is to be achieved.

A close-up view of the mechanism (with the lamp house removed) is shown in

Figure 10.3 where the film threading path is clearly visible. Since the projector is designed to reproduce sound from magnetic tracks just as readily as from photographic recordings, two sound heads are provided—the one above the picture head, and immediately below the top spool box, is capable of reproducing multi-track stereophonic *magnetic* sound, and the one in the rectangular housing below the picture head reproduces photographically recorded sound tracks. As to be explained

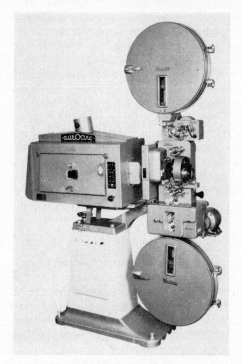

Fig. 10.2. The 'Westrex 70' Theatre Projector

Courtesy Westrex Company Ltd

in Chapter 11, whilst any sound recording cannot be printed on to a release copy at a position coincident with the relevant picture, optical recordings are always made *in advance* of the picture whereas magnetic recordings are made to synchronise at a point *behind* the relevant picture—hence the position of the two sound reproducing heads on the Westrex 70 machine.

On leaving the upper spool box the film passes via guiding rollers to a constant speed sprocket. To the right of this sprocket it is wrapped under tension and around a series of stabilising rollers to ensure absolute freedom from 'sprocket tooth ripple' at the point where the heads are located which reproduce the magnetic sound

288

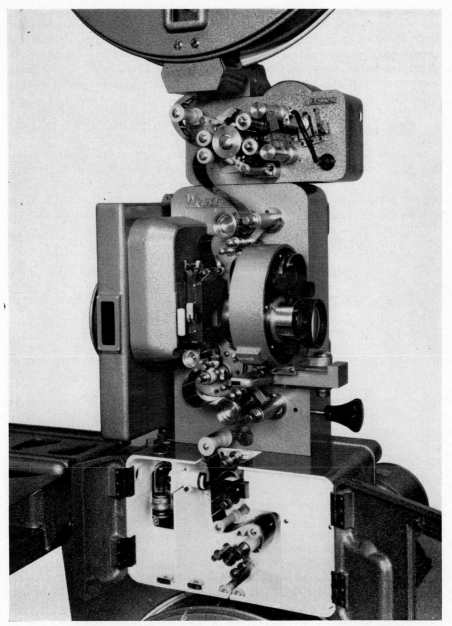

Fig. 10.3. The Film Threading Path in the Westrex 70 Theatre Projector

Courtesy Westrex Company Ltd

recordings. On passing beyond the magnetic heads the film engages with the under-side of the same sprocket and is then formed into a free loop before engaging the upper constant speed sprocket of the picture projecting unit. It is important to note that the magnetic sound reproducing section of the machine is thereby com-pletely isolated from any mechanical disturbance which may occur due to engagement between the film and the picture head. The film path from this point onwards follows the basic layout illustrated in Figure 10.1.

The basic 16 mm. projector mechanism

The growth of 16 mm. cinematography has been so rapid that modern projectors in this gauge now closely resemble 35 mm. professional machines—in fact, 16 mm. cinematography must itself be considered as a professional gauge. Film in the basic 16 mm. arrangement shown in Figure 10.4 follows a path very similar to that of 35 mm. film as shown in Figure 10.1 although no 16 mm. sound reproducing

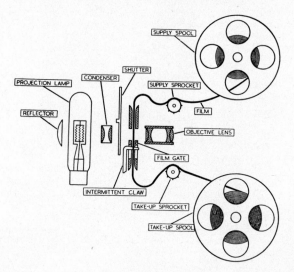

Fig. 10.4. The 16 mm. Projector Layout

head has been included between the take-up sprocket and the take-up spool—this section of the machine is dealt with in Chapter 11.

Three fundamental differences do exist between 35 mm. and 16 mm. projectors and these are summarised as follows: (1) The light-source in most 35 mm. machines is usually still the carbon arc, although high-pressure mercury-vapour and xenon lamps are also used whereas, in 16 mm. projectors the tungsten-filament lamp usually provides ample screen brightness, but quartz-iodine lamps are rapidly gaining popularity as having a more correct colour temperature for displaying colour

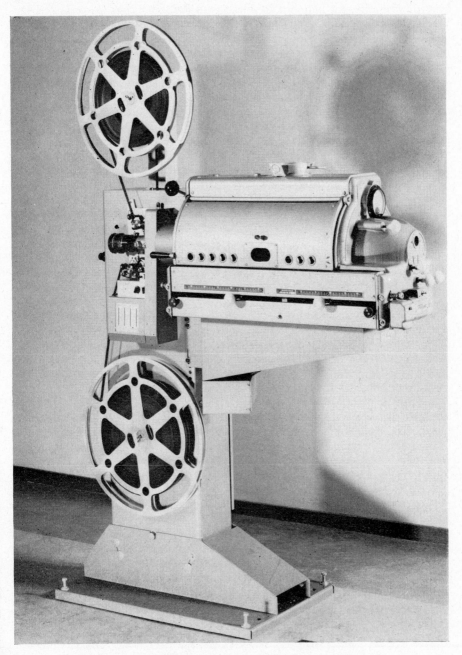

Fig. 10.5. The Philips Type FP. 16 Professional Projector

Courtesy Pathe Equipment Ltd

films. (2) Intermittent film motion through the gate of 35 mm. projectors is invariably created by a Maltese-cross or Geneva movement and, in 16 mm. machines this motion is usually caused by some form of claw mechanism. (3) 35 mm. projectors always operate at the picture-speed of 24 frames per second, whereas 16 mm. machines are sometimes geared selectively to operate both at the silent film speed of 16 frames per second *or* the sound film speed of 24 frames per second. In the specialised field of film transmission for television, machines of both gauges are operated in England at the picture speed of 25 frames per second.

Just as the very latest 35 mm. projectors embody many refinements on the basic principles, so also do those latest 16 mm. projectors which have been intentionally designed for professional usage bear but little relationship to the early portable machines. This observation is dramatically endorsed by the Philips Type FP. 16 professional 16 mm. machine shown in Figure 10.5.

The fundamental requirements both for 35 mm. and 16 mm. projector mechanisms are briefly restated as follows: (1) The film must be drawn from a supply spool at a constant rate and, after passing through the machine, must feed on to a take-up spool at a similar rate. (2) Drive to the take-up spool must accommodate a film roll of increasing diameter without snatching, excessive tension or any variations likely to damage the film or, particularly, the film perforations. (3) The film shall be formed into free loops between the points of supply and take-up so that, in the region of the projecting aperture, intermittent motion may replace the constant forward motion. (4) Assuming the film to be guided through a channel over a portion of the path where intermittent movement occurs, an aperture must be so formed in this channel that one image on the film is accurately *framed* and may be projected on to the screen by suitable illuminating and associated optical systems. (5) Because tolerances are permitted in the dimensional relationship between film frames and film perforations, some form of adjustment between the intermittent mechanism and the projecting aperture must be provided to satisfy (4) above. (6) Since film will come to rest in the guiding channel during projection, and will then be rapidly moved forward in order to bring the next frame into correct position, a continuously rotating shutter must ensure that light only passes to the screen when film is stationary in the projecting plane, and so that movement of the film from frame to frame is masked from view. Although this statement is generally true, exceptions do exist wherein the light source is caused to alternate by means of a pulse generator and at a multiple of picture frequency—such machines need not include a mechanical shutter.

From the foregoing we can appreciate that a number of known and acceptable methods can be combined to satisfy these requirements although, in some cases, those which are particularly suitable for 35 mm. projectors are not ideal for 16 mm. equipment. Because of this the following sections common to all machines will be discussed in detail:

 (1) The Intermittent mechanism.
 (2) Shutter types and their efficiency.
 (3) Light sources.

(4) Projection lenses.
(5) Film sprockets.
(6) Picture framing and projection apertures.
(7) Film feed and take-up equipment.
(8) Screen brightness and flicker.
(8) Screen image distortion and masking.

Intermittent mechanisms

Quite obviously the heart of a 35 mm. projector is the intermittent sprocket which, like the claw in a camera, moves the film forward by a distance equal to one picture. This forward movement must be performed whilst the shutter is closed. One may very well ask why an intermittent sprocket should be used in any projector if claws and pilot pins are used in camera mechanisms. One reason for this difference is the degree of wear to which each instrument is subjected; a second reason is that claw mechanisms will only operate to the required degree of accuracy when the film is relatively long in pitch—that is, the distance between the perforations is very close to the manufacturing tolerances. As we saw earlier film pitch is reduced by the developing process and varies from one treatment to another. Projector mechanisms must therefore accommodate films containing variations greater than those encountered in the camera, but must project all such films with equal steadiness. A third and most important reason not only why intermittent sprockets are used in 35 mm. projector mechanisms, but also why camera and projector intermittents are not inter-changeable, is that the *rest* period, during which the picture is exposed or projected, is much greater in projectors than it is in the camera.

In camera mechanisms the film is usually at rest for approximately one-half of the total cycle and, being in motion during the remainder of the cycle, must be protected from exposure by a rotating shutter—usually for approximately 170°. If such a shutter were used in projectors the image frequency on the screen would be at the rate of 24 every second, and the duration of individual pictures would be approximately equal to the duration of the dark periods. This would cause very noticeable flicker since the threshold below which flicker is apparent is 48 interruptions per second when the light and dark periods are of equal duration. The threshold below which flicker is seen when the time of opening is not equal to the time of closure rises to approximately 60 interruptions per second.

The comparison between camera and projector exposure cycles, shown in Figure 10.6 indicates that in the case of the camera, the film is only stationary for about 180° —or half the complete cycle whereas, in the projector, it must remain stationary for 270°, or three-quarters of the cycle. The camera claw may therefore take half of the complete cycle to move the film, but the projector intermittent must complete this movement within one-quarter of the cycle.

Many different mechanisms have been used to produce the intermittent rotation of a sprocket wheel, but the Geneva Movement, or Maltese Cross seen in Figure 10.7 is now used almost exclusively throughout the industry. The cross itself is

shown at A and is mounted upon a shaft F which also carries a 4-picture sprocket wheel engaged with the film. It will be remembered that a 4-picture sprocket is of such a diameter that a section of film 4 pictures in length may be wrapped around

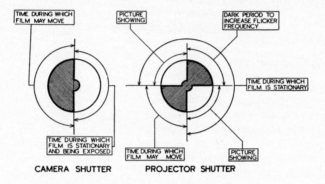

Fig. 10.6. Camera and Projector Exposure Cycles

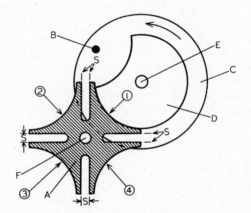

Fig. 10.7. The Maltese Cross Intermittent Mechanism

the circumference. Since the cross consists of 4 similar quadrants, each of which is engaged in turn by the driving mechanism, both the cross and the sprocket rotate through 90° each time the driving mechanism operates. Pin B is so mounted upon flange C that, as this flange rotates about centre E, the pin must engage with one of the 4 slots cut in the cross. Slots S are accurately held in position to engage with pin B by means of a locking segment D, arranged to rotate in sliding contact with the radial faces of the cross. A section of locking ring D is removed over an area in the vicinity of pin B so that the cross may rotate whilst the pin is engaged with any one of the slots S.

294

By continuously rotating pin-wheel C the cross will be caused to rotate inter-mittently, in steps of one-quarter revolution at a time, and interspersed with *rest* periods approximately 3 times longer than the *shift* period. The accuracy with which the cross is positioned, and therefore the steadiness of the screen image, will mainly depend upon the accurate machining of radial faces 1, 2, 3 and 4 and also the closeness with which they fit locking ring D. Any difference between the positioning of successive sections of the cross will cause picture unsteadiness which, unlike similar inaccuracies in claw mechanisms, will be a varying movement repeating every 4 pictures—that is, 6 times every second assuming a 4-picture Maltese Cross and a film speed of 24 frames per second.

If a curve is drawn showing the velocity of film moving through the projector gate, plotted against the angle through which the driving pin rotates whilst moving the film, then the graph shown to the left of Figure 10.8 will be produced. The area enclosed by such a curve is quite symmetrical, indicating that the rate of film

MALTESE CROSS
PROJECTOR MOVEMENTS

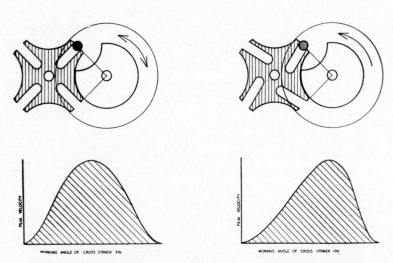

Fig. 10.8. Acceleration Curves for Maltese Cross Mechanisms

acceleration is equal to the rate of deceleration. In practice it is desirable to ac-celerate the film slowly from rest so that friction in the tensioned gate will be gradu-ally overcome and the life of the film will be prolonged. It is also helpful to bring the film to rest as quickly as possible and to leave time during which it may settle down in the gate before the shutter is opened. This may be done by using the cross shown to the right of Figure 10.8. Here slots are cut *tangentially* to the path of the driving pin at the point of entry, and the velocity-acceleration curve is shown in the

graph below the mechanism. It is quite possible to design the pin wheel so that tangential entry is achieved when the cross has radial slots as shown at the left of the figure. However, the two main requirements—namely tangential entry to minimise noise and wear as the pin engages with the cross, and slow film acceleration to increase film life—can only be combined in designs based on that shown in the right-hand illustration in Figure 10.8.

It must be realised that the original mechanism may be rotated in either direction with equal success, whereas the improved cross will only operate *quietly* in one direction. It will travel in both directions, but when operating in reverse, the driving pin will cause very heavy wear on the slots in the cross and, moreover, the film will receive even greater acceleration from rest than it would if the pin rotated in the correct manner. This objection is relatively unimportant in cinema equipment since it is very unusual to require a projector to run in the reverse direction. However, in television work—particularly during rehearsal periods for film inserts in live plays, etc.—it is very necessary for both projection and telecine equipment to be fitted with intermittent mechanisms which may be instantly reversed.

It will be remembered that *pull-down* must take place within $90°$ of the complete cycle so that two shutter blades, each of $90°$ and interlaced by two open sections of equal size, produce a flicker frequency of 48 per second with alternate dark and light periods of equal duration. The 4-sided cross shown in the figures certainly operates within $90°$ but usually requires a shutter of slightly larger angle—say $100°$—and to overcome this some projectors employ a 6- or 8-sided cross which, although still maintaining the tangential pin-entry, will operate with a pin engagement of $60°$ and $45°$ respectively.

Although the Maltese cross must be manufactured to exceptionally close tolerances and, in consequence, has not been generally employed in 16 mm. projectors, it has several advantages over the claw mechanism as a projector intermittent movement. A considerable number of film perforations are always engaged with the sprocket teeth and although, in theory, only one perforation will be driven at any given instant, the load becomes distributed amongst all the engaged perforations immediately the leading perforation shows signs of breaking down. Because of this, films which are so damaged that a claw mechanism would fail to operate, may often be projected quite successfully. It is also true that the more continual wear which a 35 mm. projector is expected to withstand can only be overcome when an intermittent of very robust design is employed.

Several manufacturers fit Maltese cross mechanisms in 16 mm. projectors intended for professional use over long periods of time. However, since a 4-picture 16 mm. sprocket would be exceptionally small, the mechanism is usually of the 6 or 8 picture type providing the benefit of engagement between the film and a reasonable number of sprocket teeth. The 16 mm. Philips projector used extensively in television film transmission equipment employs a 12-picture intermittent sprocket which, of course, provides even greater engagement or *wrap* between the perforations and the sprocket teeth.

It is perhaps as well to remember that the noise created by claw mechanisms usually occurs when the claw pins make contact with the film perforations—giving rise to a fairly high pitched note. Since film is always in contact with the intermittent sprocket when a Maltese cross mechanism is used this noise is eliminated but, in place of it, the intermittent engagement between the eccentric driving pin and the slots cut in the cross itself creates a noise of somewhat lower pitch but greater volume.

16 mm. intermittent mechanisms

The mechanisms used in 16 mm. projectors are usually of the so-called *claw* type and are, in general, similar in principle to camera mechanisms. However, one important difference between camera and projector claws concerns the portion of the intermittent cycle during which the film moves through the gate. The appearance of continuous motion can be *recorded* if 16 separate still pictures are photographed every second although, when sound was added to the film, the taking speed was increased to 24 to satisfy sound recording systems and not for any reason connected with the intermittent mechanism. This fact relates to the main differences between 16 mm.

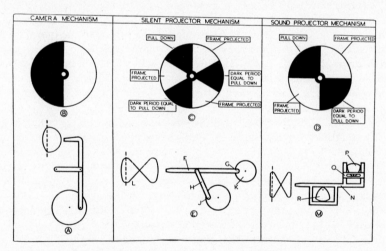

Fig. 10.9. Comparison between Camera and Projector Intermittents

camera and projector claw mechanisms as shown in Figure 10.9. The camera intermittent must move film forward during such a portion of the total cycle that sufficient time remains—when the film is stationary—to obtain adequate exposures. The design and construction of intermittent mechanisms can be relatively simple only when the pull-down portion of the claw path is approximately 170° or more.

297

When this is permitted a simple link claw, such as that shown at A, Figure 10.9, may be used. The design of a shutter is closely related with that of the claw and, when the simple link mechanism is used, a disc shutter as shown at B will be satisfactory.

If the camera mechanism shown at A–B in Figure 10.9 were fitted to a projector the pull-down period would be equal to the projecting period and both would occur at a frequency of 16 or 24 cycles per second—the rates at which silent and sound films are projected. Although such an arrangement would faithfully reproduce the conditions under which the film was recorded, it would not result in a screen picture free from flicker; this is only achieved when the *frequency* at which the still pictures are shown is raised to approximately 48 interruptions per second. It is very important to realise that pictures are not *changed* at this high frequency—indeed it is most essential that the rate of picture change shall equal that which occurred in the camera—the showing of individual frames is merely interrupted at a frequency higher than that at which they are moved forward. To claim that pictures only appear perfectly free from flicker when 48 interruptions occur each second is not necessarily true—because the appearance of flicker is also largely dependent upon the *brightness* of the screen. However, with normal screen brightness flicker will be below the visible threshold when such a frequency is employed.

The requirements to be met when designing a 16 mm. projector intermittent mechanism and associated shutter are therefore dependent upon the *type* of film which is to be projected. If silent pictures are to be projected the film must move forward at a rate of 16 pictures every second and, at the same time, the screen images must be interrupted at a rate of 48 times every second. However, if the projector is used with sound films, the film must then move forward at a rate of 24 pictures every second, whilst the frequency at which the screen images are interrupted may remain at 48 every second.

When sound films are projected at the rate of 24 pictures every second, a shutter similar to that shown at D, Figure 10.9, may be used. Assuming this shutter rotates once each time the intermittent mechanism completes one cycle, only two openings will be necessary—each equal in size and interlaced with similar opaque sections—so that a screen image frequency of 48 per second will be maintained. It is very important to realise that, with this design, the intermittent mechanism may now take up to 90° of the complete cycle in which to move the film forward and, of course, this will occupy 1/96th of a second. Naturally, it is advisable to take full advantage of this pull-down period since the load applied to the film perforations by the claw will then be kept to a minimum. The load referred to is not so much the power required to overcome friction between the film and the gate, but the force of impact between the claw and perforation when the film accelerates from rest up to maximum speed. The period of acceleration must be kept as long as possible if perforation strain is to be minimised.

It is necessary to employ an intermittent mechanism which moves the film forward during a maximum of 60° of the cycle when silent films are projected, or 90° when sound films are projected. The mechanism shown at E, Figure 10.9,

satisfies the first requirement and consists of a main lever F, connected to a rotating eccentric pin G and constrained by a second lever H. The Lever H is connected by a pin joint to the main claw lever F and, at its opposite extremity, by a rotating eccentric pin J to a wheel geared to rotate at twice the speed of wheel K. This combination of links and eccentric pins causes path L to be traced out by the claw tips, and the pull-down to occur within 60° of the complete cycle, as shown to the left of the vertical dotted line. This mechanism is one of many which are frequently used in silent 16 mm. projectors in conjunction with shutters as shown at C, Figure 10.9.

If links are replaced by one solid plate, driven by suitable cams instead of eccentric pins, the mechanism shown at M, Figure 10.9, may be produced. This arrangement is one of several used in conjunction with shutter D to satisfy the requirements of 16 mm. sound film projection. The location of the main claw lever N is controlled by two cams—one to move the claw into and away from the film, and another to cause vertical motion to move the film through the gate. The shaft supporting the rear cam P is extended to pass through a horizontal slot cut in cover-plate Q. Lever N is therefore variably pivoted about this extended shaft and may move towards or away from the film gate—it may also rotate about this shaft. Cam R, rotating within a housing or yoke, only makes contact between the upper and lower horizontal walls of this housing—it therefore only creates vertical motion in the claw lever. These combined movements cause the claw tips to trace out such a path that the vertical movement, shown to the left of the dotted line, will be substantially straight and will occur during one-quarter of the complete cycle.

Some 16 mm. projectors may be operated both at the silent speed of 16 frames per second and also the sound speed of 24 frames per second. Unless provision is made to interchange certain sections of the mechanism, when operating at each film speed, maximum efficiency cannot be secured at both speeds. If the silent projector mechanism shown at C and E, Figure 10.9, is operated at sound film speed, the flicker frequency will certainly rise well above the threshold of perception—it will in fact rise to 72 interruptions per second—however, this high frequency is of no advantage and is only obtained by completing the pull-down motion within 60° of the total cycle. Whilst this is quite permissible when operating at 16 frames per second, the added strain on film perforations, caused by operating at a speed considerably higher than that for which the mechanism was designed, is a very undesirable feature. On the other hand, if the sound film mechanism shown at D and M, Figure 10.9, is only operated at 16 frames per second—slower than that for which it is designed—the flicker frequency will be reduced to 32 cycles per second and, of course, will become visible on the screen. Any machine provided with speed changing devices to operate at both silent and sound film speeds—but which is not provided with interchangeable parts—must obviously result in a compromise between the ideal conditions required for each speed. This is usually overcome by incorporating a geared speed-change to the shutter drive, or a spring-loaded auxiliary shutter blade which only becomes operative at the higher machine speed.

Shutter types, positions and efficiency

Figure 10.10 shows three main types of shutters used to prevent light from reaching the screen whilst the film is being moved forward. The two disc shutters, shown at A and B, rotate in a plane at right-angles to the projected light beam and across the optical axis. The third type, known as a barrel shutter, rotates about a centre at right-angles to the optical axis, and is usually located between the film and the projection

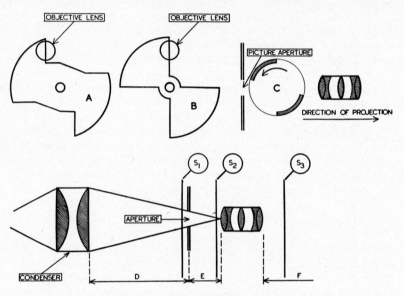

Fig. 10.10. Projector Shutter Designs

lens. Disc shutters, such as A and B, may be mounted between the condenser and the film, in space D as shown at S_1; between the film and the lens in space E as shown at S_2; or in front of the lens at space F as shown at S_3.

The beam of light passing through the condenser comes to a focus on the rear surface of the projection lens, and the position of the film is so arranged that the envelope of the rays just covers the picture area. By this arrangement the maximum use is made of the available light. A shutter placed at S_2 has the important advantage that it need only rotate through a very small angle to cut off the light before the film may safely be moved forward. It is very important to reduce this *cut-off* angle to a minimum. Unfortunately, a shutter in this position is not very convenient, particularly when the projector is being threaded, and position S_1 is usually preferred since, if kept as near as possible to the film aperture, this shutter will also rotate through only a small angle to completely obscure the light beam. It has the added advantage that it reduces the amount of heat reaching the film and aperture

plate and, in some machines, fins are attached to the opaque sectors to create a forced draught which further assists this cooling action.

Shutters A and B are essentially similar in operation (note that each blade is vertical when in the mid-position across the lens face) and are only different in shape because the centres of rotation are not both directly below the optical axis. It is more likely that a shutter of type A would be used in position S_2 or S_3, whilst type B would probably be used in position S_1.

Although the barrel shutter shown at C occupies valuable space when placed between the film and the lens, it has one very great advantage. When rotating in the direction indicated, the upper left-hand blade is about to close across the aperture at the same instant as the lower right-hand blade is also rising to close this aperture. The *wasted angle*, during which cut-off is taking place, is therefore reduced by this shutter to approximately 50 per cent. of that required by disc shutters. Unfortunately it is usually difficult to maintain balance between the time during which the shutter is either completely open or closed—essential if flicker is to be eliminated—unless a shutter of rather large diameter is used and, in consequence, some barrel shutters are located between the condenser lens and the film gate. Of course, the cut-off efficiency of barrel shutters would only be exactly 50 per cent. higher than disc shutters if a parallel beam of light passed through the system at this point; since it is always a rapidly converging beam, the efficiency is not quite so great as might at first be imagined.

Within certain limits it is an advantage to reduce both the time taken by the intermittent mechanism to move the film forward and also the time taken by any shutter to completely obscure the picture. Since the picture aperture must be completely covered both immediately before and after the film is in motion, those parts of the shutter cycle during which the aperture is actually *being* covered or revealed must be considered as lost time. These periods of lost or wasted time must be reduced to a minimum if high efficiency and maximum screen brightness are to be achieved. The *change-over* angle is reduced to a minimum as the shutter diameter is increased providing that, at all times, the projection aperture is placed as near as possible to the maximum shutter diameter.

Light sources

For many years the carbon arc has been the standard source of illumination in cinema projection, although mercury vapour, quartz-iodine and particularly xenon discharge lamps are now being favoured for most new installations. In any optical projection system involving parabolic mirrors, condensers and objective lenses it is essential that as nearly as possible, the illuminant shall be a point source. The carbon arc meets this requirement very well and, of equal importance, it is a source of very high brightness—the arc from pure carbon is four times as bright as the filament of a gas-filled electric bulb. Because of this, and also since the majority of cinemas in Great Britain still use this light source, the carbon arc will be considered in some detail.

If two carbon rods are brought into contact and a direct current is passed through them, that carbon connected to the positive side of the supply will become heated until, when at approximately 3,700°C., the carbon volatilises or changes state from a solid to a gas. If the carbons are then moved slightly apart the circuit will remain unbroken because the vapourised carbon forms an arc between the two rods and across which the current will continue to flow. The tip of the positive carbon will then become heated to incandescence with a surface brightness of approximately 170 candle-power per square millimetre. Carbon is one of the few elements which, when raised to a high temperature, passes from the solid to the gaseous state without first becoming liquid.

Carbon rods are made from soot produced by burning certain oils containing large proportions of naphtha. The soot is converted into pure carbon granules, which are then classified by mesh or size, so that rods may be manufactured to contain known proportions of granules of various sizes. The proportion of each size used to make a carbon rod is chosen according to the current at which the arc is to operate. Carbon granules are first bonded together with a paste, and are then forced together under hydraulic pressure in an extrusion press. The rods are then baked until the volatile content is drawn off and only pure solid carbon remains.

The Low-Intensity arc has a surface brightness of 170 candle-power per square millimetre. It consists of a relatively hard large diameter positive carbon, with a soft central core—this greatly helps in forming a crater to control the position of the light source. The negative carbon is approximately 4 mm. smaller in diameter than the positive but, since this would otherwise limit the current carrying capacity, it also has a core which, in this case, is coated with a thin copper deposit. This increases the current flow and yet keeps the negative sufficiently small to avoid blocking the light path from the crater in the positive carbon to the optical system.

The modern High-Intensity arc has a surface brightness of between 500 and 1,100 candle-power per square millimetre. It depends for its efficiency upon a particular filling used in the core of the positive carbon. By filling the core with mineral salts such as cerium, most of this intense light is obtained from the burning gases themselves, and not from the actual carbon crater. However, in order to control the flame produced by this arc, the positive rod must be continually rotated; this is usually accomplished by an automatic feeding mechanism. The position of the flame and crater in positive carbons may also be controlled by forming a magnetic field in the near vicinity of the arc. This field serves to stabilise the operation—and also eliminates quite a considerable quantity of mechanism from the lamp house. Because the electrical supply to most cinemas is of Alternating Current—whereas the carbon arc requires Direct Current—and also because the current consumption may well be of the order of 60 amps, large mercury-rectifying installations must be incorporated to satisfy these requirements.

Experiments in the design of mercury-vapour discharge lamps resulted in several units which compared favourably in light output with that obtained from carbon arcs. With operating voltages between 500 and 840, at currents of 2 and 1·4 amps respectively, the power consumption of the mercury arc is usually only

1,000 watts. The surface brightness ranges between 30,000 and 57,000 candle-power per square centimetre, compared with between 50,000 and 86,000 candle-power per square centimetre produced by the high-intensity carbon arcs. One great advantage of mercury lamps is the reduction in heat radiation. The energy consumed by these lamps, plus the necessary rectifier unit, is about 1·5 kilowatts, whereas that consumed by the carbon arc is approximately 3 kilowatts—apart from this the mercury tube is enclosed by a water-jacket so that some 90 per cent. of the radiated heat can be dissipated by cooling water.

Unfortunately, the colour of the light produced from mercury sources is not very suitable when colour films are projected. The blue component is slightly excessive whilst there is a rather lower red component than is desirable. Several techniques were developed to overcome this; for example, the blue component may be absorbed to some extent by introducing a yellow filter into the light beam, whilst the red component may be accentuated if red filters are used in place of the normal opaque flicker blades of the projector shutter. The introduction of the xenon discharge lamp has almost stopped progress on the development of the mercury arc.

Xenon lamps are high-pressure gas discharge tubes which, basically, function on physical principles very similar to those of the conventional tubular fluorescent lamps. However, in the xenon lamp the actual area of light emission is only of the order of a few millimetres—and this occurs under very high pressure between two electrodes fused into a thick spherical quartz bulb. This bulb is filled with the rare xenon gas from which the lamp takes its name. When cold the gas pressure within the bulb is about 8 atmospheres and, under working conditions, this rises to approximately 25 atmospheres. The colour of the light from a xenon lamp is very similar to that of daylight and, therefore, is quite suitable for projecting colour films. The power consumption varies between 1,000 and 2,000 watts according to the required light output.

Advantages of the xenon lamp include the following: (1) It does not radiate any gases or fumes because the discharge occurs within the quartz bulb. (2) The light output remains constant so that, once the lamp has been correctly positioned, no further adjustments are necessary until it is replaced at the end of its life— usually some 1,000 hours. (3) Lamp replacement may be almost instantaneous, and provision is made to house a second pre-set lamp within the main lamphouse. (4) Uniform and constant screen brightness is always maintained. (5) Because the lamp does not give off carbon or copper drips and because it does not spatter, the surface of the mirror does not become pitted or damaged. (6) Light intensity can be rapidly and accurately adjusted to suit positive prints of various levels of image density. (7) Xenon lamps are more economical to run than carbon arcs although, initially, the installation costs are somewhat higher.

Screen brightness and flicker

The incident brightness falling on a screen or any similar surface is measured in units known as *foot-candles*, but the light reflected from that surface is measured in

units of *foot-lamberts*. The relationship between these units is indicated by the following definitions: the foot-candle is the amount of light falling on a surface one foot away from a source of one standard candle power. If this surface has a reflectivity of 80 per cent., then we have a screen brightness of 0·8 foot-lamberts.

When screen brightness is measured by holding a photometer level with the screen, and pointing it towards the projector, the measurement is in foot-candles

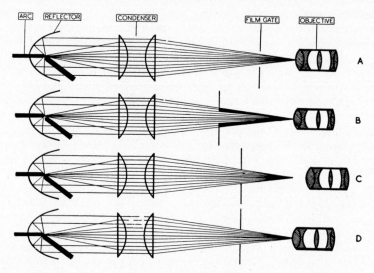

Fig. 10.11. Relationship between Projector Optical Components

but, if the photometer is facing the screen, and is thereby taking into account both the condition of that screen and its ability to reflect light, then the measurement is in foot-lamberts. The brightness of a cinema screen should be measured whilst the projector is running without any film in the gate. This is done because the shutter greatly reduces the intensity of the light beam. Brightness may vary considerably from one part of the screen to another; it is therefore usual to take measurements in the four corners and also in the centre and, by adding all these readings together and dividing the total by five, an average reading known as the mean screen brightness is obtained.

The brightness of the reflected beam, as measured with the photometer facing the screen, varies considerably from one cinema to another and, of course, the reflectivity of screens depends not only upon their quality but also on their age, the frequency with which they are cleaned and the atmosphere in the auditorium. Precautions taken in America and elsewhere (but not as yet in England) in order to maintain good picture quality include a no-smoking rule in the auditorium. Obviously, the dirt collecting on a screen surface due to smoking by the audience is

very considerable—and having a screen cleaned can be a significant item in the cinema expense account!

The resultant screen brightness obtained from any given projector is dependent upon many factors apart from the screen itself. These include such items as the lens aperture, the efficiency of the condenser system (where used), the type and position of the mirror, the efficiency of the projector shutter and not, as so many users of 16 mm. equipment once believed, only upon the wattage of the light source. The *apparent* brightness of the screen is also very closely related to the evenness of the illumination which reaches it. Current standard recommendations indicate that the brightness at the centre of the screen for viewing 35 mm. motion pictures should be between 9 and 14 foot-lamberts when the projector is running and with no film in the gate.

As previously stated, the appearance of flicker depends, amongst other factors, upon the brightness of the screen. Small News theatres often employ a very high screen brightness which creates noticeable flicker although the shutter frequency is maintained at the required 48 interruptions per second. The same projectors, used in a larger auditorium (or with carbons operating at lower current consumption), and therefore projecting a picture of lower intensity, would remain quite free from flicker.

Projector optics

We must now consider the optimum relationship between the mirror, the condenser (when fitted), the film and the objective lens in order to obtain maximum efficiency from the light-source. Figure 10.11 shows three arrangements whereby useful light is lost, and one in which maximum efficiency is obtained. Although condenser lenses are rarely used in conjunction with carbon arcs, both have been shown in this illustration because the same basic principles apply to 16 mm. projectors in which, of course, condensers are normally used in conjunction with tungsten filament lamps.

In arrangement A rays of light from the arc are reflected by the parabolic mirror and collected by the condenser so that they come to a focal point at the rear surface of the objective lens. However, because the film gate is placed too near the objective lens, the cone of light will not be large enough to completely cover the aperture and will result in very low screen illumination at the picture edges. The arrangement shown at B is similar to that at A but, in this case, the film gate is placed too near to the condenser lens, and so part of the cone of light is cut off by the aperture plate and never reaches the film. This results in an evenly illuminated picture but of lower intensity than is possible. Arrangement C shows the film gate correctly positioned so that the light beam is just large enough to completely fill the film gate without any losses but, since the cone comes to a focus before it reaches the objective lens, efficiency is again low. If the condenser lens were of greater diameter and longer focal length this condition would be improved and a larger beam of light would be collected from the source. Arrangement D is, therefore, the only one by which

maximum efficiency is obtained and shows a cone of light just large enough to completely fill the film gate, and also coming to a focus exactly at the rear surface of the objective lens. In practice the diameter of the cone of light must cover the *diagonal* of the film aperture although, in the illustration, only the height of the aperture has been considered.

By far the majority of 16 mm. projectors employ tungsten filament lamps, usually operating at a potential of 110-volts and consuming 300, 500, 750 or 1,000 watts per hour. The use of so-called *coiled coil* lamp filaments in conjunction

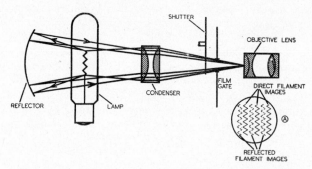

Fig. 10.12. The Reflector and Even Screen Illumination

with a reflector in the lamphouse can do much to produce even illumination at all points within the picture area. As shown in Figure 10.12, the purpose of a reflector is both to increase the amount of light available to illuminate the picture, and also to spread this illumination more evenly throughout the aperture. As with 35 mm. equipment, the position of the various 16 mm. components should be such that the condenser collects the largest possible cone of light from the lamp and brings it to a focus at or very near the rear element of the objective lens. The film gate should be as near as possible to the objective—to ensure that light is not wasted—but not so near that the cone of light is smaller than the diagonal of the gate aperture. Because the relative positions of the lamp, condenser lens, film gate and objective lens are interdependent, each component must be designed to operate in conjunction with the others to produce a screen picture of the required dimensions and quality.

If the reflector is swung out of position and the objective lens is removed, the coils of the lamp filament will then be imaged on the screen. These images will be the *direct filament images* shown in diagram A, Figure 10.12. The lamp should then be moved until the images are symmetrical within the screen boundaries. If the reflector is then replaced a second series of filament images—shown as the *reflected images* in diagram A—can be arranged to occupy the spaces between the direct images. When this has been done the reflector should be locked in position and, on replacing the objective lens, the screen will be as evenly illuminated as the particular optical system will permit.

Projector lenses and picture distortion

Clear, sharp pictures are only obtained when optical aberrations in projection lenses are fully corrected. The more common aberrations are briefly mentioned here to remind us that, as with camera lenses, these objectives are also of a very high quality. Unless a lens is corrected for spherical aberration those rays which pass through the edge areas will be refracted to a greater degree than those passing through the centre and, consequently, definition will be poor. Pincushion and barrel-distortion are names describing the shape resulting when a straight sided diagram is projected by a non-rectilinear lens; these defects have long been eliminated from all but very cheap single-component lenses. Curvature-of-field is the inability to bring all parts of the image to sharp focus in the same plane, and usually causes either the centre or the edges of the picture to remain unsharp.

Since the image formed by any lens is never perfectly sharp, the degree of sharpness is defined as the circle-of-confusion—or the smallest area in which the image of a point-source is located. Fortunately, the resolving power of the human eye is lower than that of a high grade lens (so far as cinema projection is concerned) and this defect is never serious—in any case, the grain-size of the photographic image is more likely to limit the sharpness than is the quality of the lens. Finally, chromatic aberration is the inability of a lens to focus all colours in one plane and, in severe cases, causes colour fringing around the images and in the form of a halo.

Most cinemas are designed with the projection room (or operating box) near to the roof; consequently the projectors must be tilted downwards in order to centre the picture on the screen. This tilt is known as *projector rake* and causes the image to be *keystoned* in shape. The condition was severe in old cinemas when the distance from the screen to the back of the auditorium was short and the projection room was at a considerable height—as in the case of a converted theatre. Keystone effect may be eliminated by any of three modifications, either to the projector or the cinema screen: (1) By altering the shape of the aperture in the projector gate so that, although it is no longer a true rectangle, it will *produce* a rectangular picture when tilted to a predetermined angle or rake. (2) By tilting the screen so that the vertical plane is at right-angles to the optical axis of the projector. (3) By fitting a black mask to the screen so that the unwanted picture edges are not reflected.

Keystone effect in modern cinemas is only very slight because the operating room is usually just above the balcony level, the auditorium is usually quite long, and the angle of rake is therefore relatively shallow. Under these circumstances it is most convenient to apply a black mask to the screen edges—usually the movable mask employed to accommodate the various wide-screen picture ratios now in use.

The size of any screen picture will depend upon the focal length of the projection lens and the distance between the machine and the screen. Most projectors are fitted with mounts which accept a variety of lenses of different focal length. With 35 mm. projectors the choice of the objective lens is usually fixed during the initial installation and is rarely altered. The following considerations therefore apply to 16 mm. projectors only—because these machines are often moved from

one location to another and, consequently, are required to satisfy a wide range of projecting conditions. The dimensions of any screen picture are always doubled if the projection distance is increased to twice the original length and, of course, proportional increases apply to all other distances. For example, if a lens of 0·75 in. (18·75 mm.) focal length is used with a 16 mm. projector, the picture width will be 1 ft. 6 in. (45 cm.) at a throw of 3 ft. (90 cm.), will increase to 3 ft. (90 cm.) at a throw of 6 ft. (180 cm.), or 6 ft. (180 cm.) at a throw of 12 ft. (360 cm.) and so on as the throw or distance between the projector and the screen is increased.

If the throw is maintained at a constant distance the size of the picture will decrease as lenses of longer focal length are used. For instance, with the throw standardised at 50 ft. (15·2 metres), the picture width will be 25 ft. (7·5 metres) when a lens of 0·75 in. (18·75 mm.) focal length is employed, or it will be 18 ft. 8 in. (5·66 metres) with a 1·0 in. (25 mm.) lens, or 12 ft. 6 in. (3·81 metres) with a 1·5 in. (37·5 mm.) lens or 9 ft. 4 in. (2·88 metres) when the focal length is increased to 2·0 in. (50 mm.).

A variety of screen sizes can therefore be obtained when the projector is at a fixed distance from the screen, but it is desirable to use only that size which is most suitable for the auditorium and will ensure comfortable viewing without eye strain. As shown earlier in this chapter, the screen size should bear the following relationship to the distribution of the seating in the auditorium: (1) The nearest seat should not be closer to the screen than 0·87 times the screen width. (2) The most distant seat should not be more than 6·0 times the screen width away from the screen. If the projector is at the rear of the hall it is possible to determine these dimensions with some exactness and when only the minimum of information is available—the following will serve as an example of the practical application of these recommendations. Assume that the distance between the projector and the screen is fixed at 50 ft. (15·2 metres), and the maximum distance between the screen and the back row of seats is 56 ft. (17·07 metres). To accommodate the maximum number of people this distance must be equal to 6 times the screen width or, in other words, the screen must be 9 ft. 4 in. (2·83 metres) wide. The only lens which will produce such a picture with a 16 mm. projector at a throw of 50 ft. (15·2 metres) is one which has a focal length of 2·0 in. (50 mm.) and, therefore, is the correct lens to be used under these conditions.

Wide-screen projection

At present there are six different forms of wide-screen picture—although most of them result in an image very roughly in the ratio of 2 : 1 (twice as wide as it is high). These are projected either by standard lenses, wide-angle lenses or special anamorphot lenses designed to optically stretch the film image more in the horizontal than the vertical dimension. Naturally, the projectionist must quickly be able to inter-change lenses according to the picture format of each programme. This problem can be solved by fitting projectors with a turret of lenses, similar to that provided on most cinematograph cameras. The projectionist can then keep all

lenses pre-set in focus and so avoid the embarrassment of making severe focus adjustments after projection has started.

Because programmes contain films of various aspect ratios—and the size of the screen image will be very different from one to another—automatic movable screen masks must be installed to accurately frame each type of picture. Screen masks are power driven by remote control from the projection room and, of course, adjustments are made whilst the proscenium curtains are closed during the interval between one film and the next.

Projection apertures and picture framing

When *lacing up*, or threading film into a projector, the operator must ensure that the picture is correctly framed by the aperture mask. He is assisted in this task either by an auxiliary framing-light which illuminates the film image in the projector gate (without the need to strike the arc), or by an independent reference plate mounted above the actual gate. Since, in 35 mm. film, 4 perforations correspond to each picture, it is possible to thread film in three positions which would not bring the picture into register with a fixed aperture. However, assuming the film has been correctly threaded, it is still possible for an out-of-frame join to displace the film beyond that join. It is therefore clear that provision must be made so that the position of the aperture, relative to the pictures, is capable of adjustment.

This adjustment is known as *framing* and, in early 35 mm. projectors, was accomplished by moving the lens and aperture-plate vertically in relation to the film itself. Unfortunately, the cone of light from the condenser remained in a fixed position, and illumination across the picture fell away when the aperture moved from the central position. The modern improvement, known as fixed optical centre racking, causes the *film* to be moved relative to an aperture maintained in a fixed position. Two methods are generally employed to obtain this movement. Firstly, by mounting the intermittent sprocket and most of the mechanism on vertical slides. Secondly, by causing the drive to the intermittent mechanism to advance or retard the position at which the sprocket wheel comes to rest. This second method is very neat and compact but causes the shutter to become slightly out of phase with the intermittent—a variable gear drive to the shutter is therefore provided so that its phase-relationship with the intermittent sprocket is maintained at all times.

If a shutter is out of phase with the pull-down, a ghost image will be seen on the screen. Such an effect causes white streaks in the highlights of the picture and, therefore, is most easily seen when projecting white titles which have a dark background. White streaks appear *above* the letters or highlights when the shutter is not completely covering the aperture before the film is moved; the shutter should therefore be advanced. Streaks appear *below* the letters or highlights when the shutter starts to reveal the aperture before the film has been brought to rest; the shutter should therefore be retarded.

In all 16 mm. sound projectors the picture is framed by means which move the

position of the film relative to a fixed aperture—that is, the system is fully optically compensated and no overall image movement occurs on the screen. Fortunately, several methods are available which avoid variations in the gearing or phase-relationship between the intermittent mechanism and the shutter and so, unlike 35 mm. projectors, the 16 mm. projector shutter never becomes out of phase due to framing adjustments. The intermittent used in 16 mm. projectors is almost invariably some form of claw mechanism and, usually, it is possible to alter the pivot-point or centre about which the claw oscillates. This adjustment changes the relationship between the claw stroke and the projecting aperture, and thus the position at which the film is brought to rest may be varied until perfect framing is achieved.

Sprocket teeth and diameters

Since projector mechanisms are required to operate in conjunction with films which may have been considerably shrunk during the processing operations, it is reasonable to find that dimensions and tolerances of projector sprockets are different to those in camera mechanisms. The two main dimensions which provide these tolerances are the base diameter at the root of the teeth and the diameter across the tops of the teeth. Maximum tolerances may be given to the feed sprocket; closer limits are placed on the intermittent sprocket, and still different tolerances are given to the hold-back sprocket which, of course, controls the film feed to the sound head.

Some idea of the accuracy with which these parts must be made is indicated by the tolerances placed on the base diameter: A typical feed sprocket may be machined to within plus or minus 0·025 in. (0·634 mm.) of the standard dimension but, in the case of the intermittent sprocket, this tolerance is reduced to only plus or minus 0·0002 in. (0·005 mm.). The actual tolerances employed will depend upon the size of the sprocket—such as 4, 6 or 8 picture—and also on the degree of wrap between the sprocket and the film. As with all other vital dimensions in cinematograph equipment, standard dimensions and tolerances covering these variables have been agreed by the various national standards associations and the International Standards Organisation.

Film feed and take-up

Film is fed into a 35 mm. projector mechanism from a supply spool housed in a fireproof container; after projection it is automatically wound on to a similar spool mounted in a second container. Although film feed to and from 16 mm. projectors is in a similar manner—and the present considerations are equally true for both gauges—fireproof containers are not used in 16 mm. equipment. Modern technique is to reduce to a minimum the number of change-overs from one machine to another during the projection of any film. An average first-feature film usually has a running time of between 90 and 120 minutes and, at a projection speed of 18 in. (27·5 cm.) or 24 frames per second, this represents an average total film length of between 8,000 and 10,000 ft. (2,438 and 3,048 metres).

Such a length is usually supplied by the printing laboratories either as eight or

ten 1,000 ft. (304·8 metres) rolls, or as four or five 2,000 ft. (609·6 metres) rolls. Naturally, the precise length of each roll is governed by the subject matter and, particularly, so that change-overs from one roll to another occur at a convenient point. In any event, rolls of this size are accommodated on spools having a maximum core-diameter of 5 in. (127 mm.), and a maximum outside diameter of 15 in. (381 mm.). At the standard projection speed of 24 frames per second, these spools will rotate at approximately 70 r.p.m. when nearly empty, and approximately 23 r.p.m. when almost full.

Because of this, variable clutch driving mechanisms are usually employed to accommodate the gradual change in speed as film is removed from the supply spool or wound on to the take-up spool. In the first instance the problem is not very severe and merely requires a hold-back tension to prevent the supply spool from over-running. However, the problem of even take-up is of a more serious nature and must be solved by applying a steady, constant pull or torque to the film. In the past individual rolls of film were limited to 1,000 ft. (304·8 metres) and these could be handled on take-up equipment powered by mechanical friction clutches. However, now that 2,000 ft. (609·6 metres) rolls weighing approximately 20 lb. (9 kilogm.) are accommodated on all 35 mm. projectors and, as we have already found in relationship to the very latest Westrex 70 machine, rolls as large as 6,000 ft. (1,828·8 metres) are now being introduced, it is obvious that more positive forms of take-up drive are essential.

In common with similar motion picture equipment, the modern projector employs constant-torque variable-speed electric motors as the prime mover for independent take-up drive. These motors are characterised by their ability to exert a constant pull or torque over a wide range of loading—and to do this by varying the speed of rotation. This is, of course, exactly what is required in a take-up mechanism because, initially the load will only be that of an empty spool but, at the end of each reel, it will be the weight of that spool *plus* a very much greater weight of the film which has been wound on it.

In 16 mm. projection the problem of film take-up is very similar, although the speeds of rotation and the ultimate loadings are somewhat different. The popular 400 ft. (121·0 metres) spool has an internal diameter of approximately 1·49 in. (37·85 mm.) and an external diameter of 7·00 in. (17·78 cm.), that is, a ratio between diameters of approximately 4·6 : 1. Because of this the spool will rotate at 60 r.p.m. when projection begins, but only 13 r.p.m. as the film is about to end. These figures presuppose projection at 16 pictures per second. If film is projected at 24 pictures per second the speeds increase to 90 r.p.m. at the beginning and 20 r.p.m. at the end of projection.

When 1,600 ft. (480 metres) spools are used with 16 mm. projectors the core diameter is increased to approximately 4·6 in. (11·7 cm.) and the external diameter is 14·0 in. (35·56 cm.), that is, a ratio of approximately 3 : 1 exists between the two extreme positions. The larger spool therefore places less strain on a friction take-up clutch than does the smaller spool. At sound film projection speed this spool rotates at approximately 30 r.p.m. when projection begins and at 10 r.p.m. as the film is

about to end. The foregoing analysis merely indicates that the *ratio* of speeds at which the larger spool rotates is less than that of the smaller spools—it does not imply that the *power* required to operate the clutches will be related in the same manner. Since the weight of a fully loaded 1,600 ft. (480·0 metres) spool is considerably greater than that of a 400 ft. (121·0 metres) spool, the loading on the supporting bearings and, therefore, the friction in those bearings, will also be greater. Because of this the power required to rotate the larger spool will be greater than that needed to rotate a small spool, although the ratio of speeds at which each spool rotates is inversely related. As with 35 mm. projectors, several 16 mm. machines are fitted with constant-torque variable-speed independent motor drive to the take-up shafts.

Threading film to ensure synchronism

In all cinemas where the pictures are projected on to a screen—as opposed to being projected through a translucent screen—the film is threaded so that the picture is inverted and the emulsion surface of the print is facing the arc or lamphouse. When so-called *rear projection* is employed, and the projectors are located behind a translucent screen, the emulsion surface of the print is arranged to face the lens— unless a special rear-projection print has been made. Most people are aware that a complete feature film is not contained in one reel and so, to obtain an uninterrupted performance with all but the very latest machines, the operator must run two projectors alternately; reels 1, 3, 5, 7, etc., being projected on the first machine and reels 2, 4, 6, 8, etc., on the second machine. When 1,000 ft. (304·8 metres) reels are used the operator is required to make an average of ten faultless *change-overs* during one feature although, when 2,000 ft. (609·6 metres) reels are used, this is reduced to six, and with the very latest machines such as the Westrex 70 it may be reduced to a single change-over after the first 6,000 ft. (1,828·8 metres) have been projected.

In the silent film days projector threading was quite a simple matter but, with the addition of sound, it became necessary for change-overs from one machine to the next to take place with great accuracy. Unfortunately, the time taken by projectors to attain full speed varies from one machine to another or, more precisely, from one projector motor to another and, therefore, sufficient leader film must exist ahead of the actual picture to enable any machine to reach full speed well before it is actually showing the picture. As the end of each reel is approached two warning indications are provided for the operator and, incidentally, may also be noticed on the screen by the audience. These consist of small circular dots which momentarily appear at the top right-hand corner of the screen. The first dot, printed on 4 consecutive frames, warns the operator to start the motor of the second projector. The second dot, printed 11 ft. after the first warning and therefore appearing approximately 7 seconds later, indicates that the picture and sound must then be changed over from one machine to the other.

It is important to realise that the warning to start the second projector is provided during the run-out of the first machine and, so that the second motor reaches

full speed in the time available, the leader attached to the second reel is numbered at every 16th frame (that is, at intervals of 1 ft.) with clear numerals from 3 up to 11. Assume that a certain projector motor has been found to take exactly 7 ft. of film in which to attain full speed: films would then be threaded in this machine so that the number 7 appeared in the picture gate when the machine was waiting to take over operations and, since 7 ft. of film separate this number from the first picture, the motor will reach full speed just as the first picture is about to be projected. If the motor required 5 ft. in which to attain full speed, then the number 5 would be threaded in the picture gate and so on, dependent upon the particular characteristics of the motor in use. Obviously, once this figure has been found by experiment, it remains constant and operators often paint the *motor number* on the back of the lamphouse as a reminder of the correct threading position for that machine.

Film leaders and trailers and their uses are indicated in Figure 10.13 which shows a specification issued by the Academy of Motion Picture Arts and Sciences. The first 4 to 6 ft. of the reel, consisting of protective leader, may be either transparent or unprocessed film stock (usually the latter). The next 4 ft. contain no less than 32 consecutive frames on which are printed the title of the film and the part-number of the reel. The 14 ft. synchronising leader which follows is divided up so that the first 2 ft. are opaque except for one line-and-diamond design exactly 20 frames *back* from the end of this length. The next frame is transparent except for the word *Start* which is printed in black and is inverted. When correctly threaded in synchronism, the Start frame should be in the picture gate when the line-and-diamond design is at the photographic sound reproducing aperture. One foot nearer to the actual picture than the Start frame the number 11 is printed and then at each foot (intervals of 16 frames) the numbers 10, 9, 8, 7, 6, etc., are printed in this order and until the number 3 is reached. From this point, and until the actual pictures start, the leader remains completely opaque. Between each footage number a white diamond is printed in the centre of the film. The reason for the photographic sound synchronising mark to be printed 20 frames ahead of the relative picture will be explained in the next chapter—as also will the fact that, if the sound record is a magnetic track then the sound synchronising mark appears *after* the picture-start instead of before it.

It is recommended that the picture section should start and finish on *fades* whenever possible but, alternatively, that all important sound should be kept at least 15 ft. from the start and finish of the picture. In practice the operator threads the film into the machine so that the Start frame is in the picture gate and the line-and-diamond design is in the sound gate, he then turns the mechanism by hand until the required motor number appears in the picture gate. The projector is then ready to go into operation and synchronism between picture and sound has been assured.

The circular opaque motor cue is printed on 4 consecutive frames of the actual picture and at a point 12 ft. before the end. One foot from the end four more opaque marks are printed on consecutive frames and indicate the moment at which projection should be changed over from one machine to another. A length of 6 ft. of opaque

ACADEMY SPECIFICATIONS FOR 35mm MOTION PICTURE RELEASE PRINTS

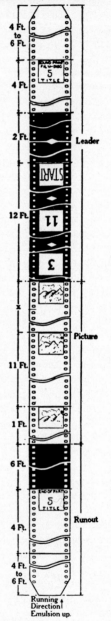

PROTECTIVE LEADER

Either transparent or raw stock.

When the protective leader has been reduced to a length of four feet it is to be restored to a length of six feet.

4 Ft. to 6 Ft.

IDENTIFICATION LEADER (Part Title)

Shall contain not less than 32 frames, in each of which is plainly printed in black letters on white background, type of print (See Nomenclature), part number (Arabic numeral not less than 1/4 of frame height), and picture title.

4 Ft.

SYNCHRONIZING LEADER

First section shall be opaque.

Start mark shall be one frame in which is printed START (inverted) in black letters on white background 1/2 of frame height.

A white line 1/32 inch wide upon which is superimposed a diamond 1/8 inch high by 3/8 inch wide shall be printed across the picture and sound track area at a point exactly 20 frames ahead of the centre of the start frame.

Beginning 3 ft. from the first frame of picture, each foot is to be plainly marked by a transparent frame containing an inverted black numeral at least 1/2 frame height. Footage indicator numerals shall run consecutively from 3 to 11, inclusive.

This section shall be opaque and contain frame lines throughout entire length which do not cross sound track area.

At a point exactly 20 frames ahead of the centre of each footage numeral frame there shall be a diamond (white on black background), 1/8 inch high by 3/8 inch wide.

2 Ft.

12 Ft.

Leader

PICTURE

It is recommended that picture action start and finish on fades wherever possible, otherwise significant sound should be kept at least five feet from the start and finish of the picture.

x

Picture

MOTOR CUE

Shall be circular opaque marks with transparent outline printed from the negative which has had four consecutive frames punched with a serrated edge die ·094 inch in diameter. The centre of these holes is to be halfway between the top and second sprocket holes ·281 inch from the right-hand edge of the film with heads up and emulsion toward the observer.

11 Ft.

CHANGE-OVER CUE

Shall be the same as Motor Cue.

1 Ft.

RUNOUT TRAILER

Shall be opaque.

6 Ft.

IDENTIFICATION TRAILER (End-of-part title)

Shall contain not less than 32 frames in each of which is plainly printed in black letters on white background : End of Part, part number (Arabic numeral not less than 1/4 of frame height), and picture title.

4 Ft.

Runout

PROTECTIVE TRAILER

Same as protective leader.

4 Ft. to 6 Ft.

(6th revision 10 10 30)

Running Direction
Emulsion up.

Fig. 10.13. Standard Film Leaders and Trailers

trailer is attached to the last picture to act as a *run-out*, and then 4 ft. bearing at least 32 frames showing the end-of-part titles and numbers is followed by a further protective trailer of from 4 to 6 ft. of raw stock.

Having described the general methods used by the majority of operators in most cinemas, it must be recognised that improvements in the latest installations greatly simplify projection techniques. This has been made possible by the use of a control console, installed in the auditorium and manipulated by the chief operator. By means of a series of electrical relays, selsyn-type interlocks, etc., the projector lens can be remotedly focused, the picture may be automatically framed, carbon arcs or xenon lamps may be energised and change-overs from one machine to another may be performed! So far it is still necessary for an operator in the projection room to replace carbon rods (where they are in use), and also to reload machines with rolls of film!

Screens

It is not always appreciated that the screen is a scientific part of the optical projection system and, unless its reflective properties are high and its polar distribution is correct, image degradation will be severe when viewed from seats which are some distance from the axis of projection. Because the majority of sound reproducing systems are installed with the speakers located behind the screen it is essential to use special material through which the sound may pass. In America most screens are of rubber and are manufactured with small perforations moulded over the entire surface. These holes are relatively small and the eye is unable to resolve them but, of course, they do cause an appreciable loss of picture brightness. In Great Britain perforated rubber screens may only be used if they are rendered completely fireproof and, consequently, many cinemas are fitted with open-worked or woven screens. Here again, light loss inevitably occurs and, to avoid unpleasant reflections from any equipment which may be behind the screen, the speakers and the rostrums which support them are usually surrounded by black felt *screen backing*, cut so as to leave apertures in front of the speakers themselves and through which the sound may travel.

Two major difficulties must be guarded against if sound and picture quality are to be maintained at high level. Firstly, the perforations in rubber screens—or the holes in woven screens—will become coated with dust and, in time, will become completely closed. This naturally leads to a falling-off of sound volume and quality which, to the inexperienced, may be difficult to detect. Secondly, the reflective surface of the screen will also become dirty and so cause a corresponding loss of picture brightness. For these reasons it is wise to provide two screens for each cinema—so that one may be cleaned whilst the other is in use. Naturally, when a chain of cinemas is owned by a circuit, it is possible for one spare screen to pass from one installation to the next providing the size is interchangeable. The cost of a present-day 50 ft. CinemaScope screen is roughly £500—obviously an item worth careful handling and constant attention.

Chapter 11

The Addition of Sound to Films

The nature of sound

BEFORE considering the methods and instruments used to reproduce sounds in synchronism with motion pictures it will be helpful very briefly to define the nature of sound itself. Any sound requires a material medium by which it may be transmitted from one situation to another and, indeed, without which it could not be heard at all. This fact is readily proved by the following classical experiment. An electric bell is fitted into a glass container from which all the air can be removed by a suitable evacuating apparatus: connections to the bell are made through an airtight seal and, if the bell is set ringing and the evacuating pump is operated to gradually extract air from the glass container the sound—which will at first be quite loud—will gradually reduce in volume until, when nearly all the air has been removed and the bell is operating in a partial vacuum, no noise will be heard at all, although we can *see* the hammer still hitting the bell quite satisfactorily.

This experiment demonstrates that sound can only be heard at all providing a suitable transmitting medium exists between the source and the listener. Although the normal medium through which we hear sounds is the air, this is by no means the only suitable transmitting material. For example, the fish hear sounds through the medium of water; insects living under the earth's surface hear sounds by earth tremors and, by putting one's ear to the end of a fallen tree whilst a second person lightly taps on the opposite end, we find that sound may also be transmitted through wood. Sound may be transmitted to a greater or lesser extent through many material media, but it cannot pass through a vacuum.

All sounds are created by vibration; and the speed of these vibrations determines the pitch or frequency of the note. The loudness or volume of the sound is dependent upon the amplitude or magnitude of the vibrations. These points are readily appreciated when one observes the strings of a violin as the bow is drawn across them. It is not so easy to believe that sound is caused by vibration when we hear the noise produced by drumming fingers on a table top—because we cannot see our finger ends vibrating in a manner similar to the violin string. However, if we repeat this action with equal force, but with gloves on our hands, it is apparent that the volume of the sound has been greatly reduced, if it can be heard at all. This is

316

because the soft material of the gloves has absorbed the vibrations and eliminated the shock of contact between the fingers and the table—hence no sound is created. It should also be understood that a single pure note is created by a series of mechanical movements, repeated at very short intervals.

Air is the normal medium through which we are able to hear vibrations and, as we have seen, mechanical vibrations are necessary to create any sound. However, no obvious forward movement of the air takes place when vibrations are transmitted through it—for example, we do not experience a gust of wind at the mouth of a radio loudspeaker. The explanation of this condition is that sound is transmitted in the form of longitudinal *wave* motion.

The principal of sound transference through a suitable medium is illustrated in Figure 11.1. Assume that AB is a piece of spring steel, mounted vertically upon a baseboard so that the upper extremity A may vibrate. Whilst the spring is stationary, as in position 1, assume the surrounding air to be represented by lines of very small balls, each suspended on a separate short string. As the spring AB is set into vibra-

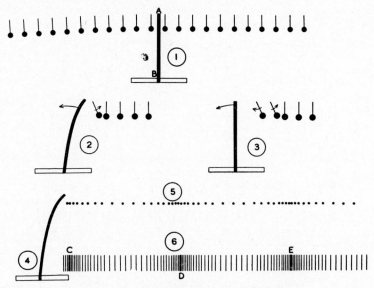

Fig. 11.1 The Transmission of Sound Waves

tion it first moves to the right, as shown at 2. Now assume that it hits the first ball and causes that also to swing to the right. Immediately after contact the spring then swings to the left—but it has already transferred sufficient energy to cause the ball to continue travelling to the right until it hits the second ball, as seen at 3. By this time spring AB has travelled back to its central position and is still moving towards the left, the first ball has expended all its energy and, after hitting the second

317

ball, has also started moving to the left. The second ball has itself received energy from the first and is now swinging to the right.

In this manner the energy is passed along the line of particles until it is all used up. However, after the disturbance has travelled some distance, and those particles behind it have come to rest, spring AB has returned once more to the position shown at 2 and will start a second train of motion. This condition is more clearly seen at 5. Now imagine that, instead of the particles of air being widely spaced apart they are more closely packed; then the appearance of the disturbances—if we could see them—would be rather like the arrangement shown in diagram 6 and the distance between each peak, indicated at C, D and E, would represent the *wave-length* of the note. The number of such peaks passing a stationary point every second would then indicate the *frequency* of the note.

It is now clear that sound is transmitted by causing particles of air to *oscillate* and not to move bodily forward in a constant stream. The frequency of a note may be represented by graphs similar to those shown in Figure 11.2, where A represents a note of low frequency, B a medium frequency and C a high frequency. One further basic point concerns the speed at which sound travels through the air. That we know sound takes a considerable time to travel at all is demonstrated by the lag

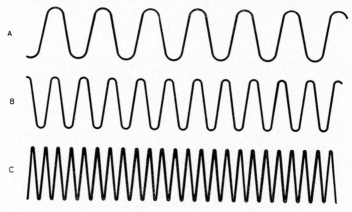

Fig. 11.2. Sounds of Various Frequencies

between seeing a lightning flash and hearing the thunder although, of course, both originated simultaneously. Sound travels through air at approximately 1,100 ft. (335·3 metres) per second, but varies in speed according to the temperature and pressure of the air. Country folk who live some distance from railways stations often forecast the approach of rain by the loudness of train whistles—actually they are estimating the pressure and temperature of the air because, when pressure increases the resistance to disturbance also increases, and sound cannot travel so far through a dense medium as it can through a lighter one before becoming exhausted. Referring back to the vibrating fork (Figure 11.1), and remembering that the speed of sound

318

through air is roughly 1,100 ft. (335·3 metres) per second, let us assume that the fork makes 50 complete vibrations per second. At the end of the first second the first disturbance will have travelled 1,100 ft. and, between it and the source, will be equally spaced 50 other pulses, each separated exactly 22 ft. (6·7 metres) from its neighbours.

The audible spectrum

We must now consider the frequency range covered by the human voice and various instruments, in order to gain some idea of the general magnitude of sound recording problems. Figure 11.3 compares these ranges with the full piano scale and also with

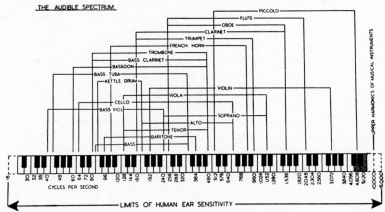

Fig. 11.3. The Audible Spectrum

the limits of the human ear. It should be noticed that the range covered by human voices extends from 80 cycles per second up to 1,152 cycles per second. The piccolo would appear to be the most difficult instrument to record or reproduce since it has a top natural frequency of approximately 4,500 cycles per second. This, however, is not the case because the upper *harmonics* of some other instruments extend to 10,000 cycles per second, whereas similar harmonics of the piccolo go no further than 6,000 cycles per second. The violin, having a fundamental top frequency of approximately 3,000 cycles per second, has a harmonic range up to 8,000 cycles per second.

All instruments produce notes composed of the fundamental frequency *plus* one or more harmonics—it is very rare indeed that we hear a pure fundamental note devoid of any harmonics. In the examples previously mentioned, the top limits of the harmonic response are set by comparing the volume of the harmonic with that of the fundamental note. Volume normally decreases as the harmonics increase and, for our purposes, may be ignored after they fall below a certain level.

Harmonics are frequencies either two, three, four or more times that of the

319

fundamental frequency or pure note—the proportions of each multiple present in a given sound being characteristic of the instrument which created that sound. If, therefore, we take middle C on the piano scale as being a fundamental note vibrating at 256 cycles per second, the second harmonic of this will vibrate at 512 cycles per second, (twice that of the fundamental) and reference to Figure 11.3 will show that this frequency is in fact exactly one octave above middle C. It is essential that harmonics are recorded and reproduced together with and in the correct proportions to the fundamental notes if the resultant sounds are to be recognised and identified with the instruments which originally produced them. Because of this we find that a violin can only be faithfully reproduced if the recording and reproducing systems are capable of resolving frequencies as high as 8,000 cycles per second— that is, the frequency of the highest order of harmonics which still retain sufficient volume, compared with the fundamental note, to noticeably effect the nature of the response.

Incidentally, it is the *proportions* of each harmonic which are reproduced by various instruments which give those instruments their characteristic note. This is known as *timbre* and, for example, enables us to distinguish between middle C played on a piano and the same note played on a violin or, of course, any other note compared on any other two instruments.

The human ear

Before considering any means whereby this range of sound frequencies may be recorded and reproduced, it is worthwhile to examine the mechanism of the human ear—because the action of diaphragms in earphones, telephones and acoustic grampohone sound-boxes was obviously developed from this knowledge. Figure 11.4 shows the various organs connecting the ear with the nerve system. The pressure waves transmitted via the air come into contact with the *drum-skin*, situated at the base of the outer ear, and cause it to vibrate in a manner corresponding to the pressure waves themselves. The motion of this drum-skin is transmitted to three bones, known as the *hammer* (in contact with the centre of the drum), the *anvil* and the *stirrup*.

These three links form a chain of communication across the space or inner drum of the ear. This inner drum forms a connection, through the throat, with the outside air and therefore maintains the pressure on each side of the drum-skin at equal strength and ensures that this skin is not subjected to undue tension. Incidentally, this explains why pressure on the ears caused by flying at high altitudes can be relieved by the action of swallowing. The stirrup is in contact with a membrane covering the inner ear, or *cochlea*, and transmits the vibrations produced by the drum skin, via the hammer, anvil and stirrup, to the seat of hearing.

The cochlea is shaped rather similar to the spiral shell of a snail and contains a liquid in which is supported a second thin flexible tube—again filled with liquid. The vibrations produced within this membrane are considered to be analysed by the cochlea and transmitted, in the form of nerve pulses, to the brain. Here they

are recognised as being the expected reactions due to something another system—that of sight—has usually just warned the brain to prepare for. From this reasoning we see how it is possible for people who have broken their ear-drum to hear quite well by bone-conduction—since any mechanism which can be used to set the hammer into vibration will produce the nerve reaction associated with sounds.

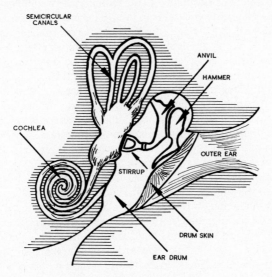

Fig. 11.4. The Human Ear

Recording systems

The three basic sound recording systems used in modern film production are briefly as follows: (1) Disc recording—either by conventional methods associated with the vast gramophone record industry or, more usually, by direct recording on to a lacquer-coated disc capable of immediate play-back. (2) Photographic recording —either to produce so-called variable-area or variable-density sound tracks ultimately to be printed alongside the picture images on positive release prints. (3) Magnetic recordings—either on perforated fully-coated magnetic film stock, on a magnetic stripe coated on to a section of the photographic picture film (or on to clear base), or on non-perforated fully-coated tape. Systems 2 and 3 apply equally well to both 35 mm. and 16 mm. cinematography.

Disc recordings are often used for so-called *play-back* on the studio floor, and when the actors are required to perform in synchronism with pre-recorded music, etc. For example, scenes of an orchestra apparently playing in a cafe are seldom made with real musicians playing at the time of shooting—they are usually small-part players (known in America as bit-players) acting as musicians—but, of course, these actors must *appear* to be playing the instruments. If the required music has

first been recorded by a genuine orchestra and on an acoustically-treated music stage, a disc of this recording may be made and can then be played back on the shooting stage as often as may be necessary to secure the desired effect. Eventually, the original recording will be dubbed to the selected take of the pictorial scene and, to assist in this a *guide-track* (in the form of a re-recording of the disc play-back) is often made on the floor although, of course, the quality is only sufficient to assist in editing and to establish synchronism with the original recording.

In some studios discs have been replaced by magnetic tape for this purpose but, for certain types of work, tape is not always as useful as a disc. For example, tape must be rewound after each playing before it can be used again, whereas a disc can be instantly repeated (with a long recording time this can become valuable to a short-tempered director!). It may also happen that the director only requires certain sections of the recording to be played at one particular time, and other sections to be used on a later set-up with different camera angles, etc. A disc can conveniently be marked with wax pencil indicating these special sections and, incidentally, all studio disc reproducers are fitted with Vernier scales whereby any point throughout the recording can be precisely located.

Until the early 1950s all the main studio sound recording work was accomplished by photographic techniques. At present most original studio recording is by magnetic-coated film, and only the positive release prints used in the cinemas continue to employ photographic tracks. At the time of writing there is considerable speculation concerning the type of sound track which will eventually become the standard for cinema release; it may remain wholly photographic; it may be a combined photographic and magnetic track (to suit projectors fitted with either type of replay equipment); or it may become wholly magnetic.

Even so, it is very probable that all sound recording systems used in conjunction with cinematography to produce some form of talking picture will rely on the principles of film movement and the basic mechanisms established by and developed from the photographic recording systems.

Early disc recording

The art of recording and reproducing sounds has been developing for many years; the earliest recordings being made in France by Leon Scott in 1857, and the first reproductions by Edison in America during 1877. Progress from the Edison Kinetoscope and Phonograph to modern sound films has produced a very long chain of noteworthy inventions and, to give details of but a few of these would take considerable space—and probably lead to confusion. We will therefore take as a starting point the first large-scale sound-on-disc talking films initiated by the success of 'The Jazz Singer' and 'The Singing Fool'.

In all sound recording systems four fundamental requirements must be satisfied: (1) The frequency of the original musical note, human speech or any other sound must be faithfully recorded. (2) The recording range must extend to include second and third harmonics with sufficient volume to reproduce the timbre associated with

each instrument, etc. (3) The ratio of loudness or volume between the sounds (that is, the recording balance) must be maintained. (4) The reproduced wanted signal volume compared to the system noise (the signal-to-noise ratio) must be acceptable.

In disc recording these factors must be accommodated in the mechanical cutting of spiral grooves. Figure 11.5 shows a section of a disc as it would appear under a high-power microscope. The grooves shown at A represent the track cut by a sapphire stylus cutter when no sound is being recorded—that is, the unmodulated track. Diagram B shows the appearance of the grooves when a constant low frequency note has been recorded. The frequency is obtained by vibrating the cutting

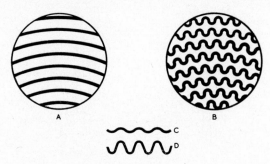

Fig. 11.5. A Micro-Illustration of Disc Recording

stylus in a direction at right-angles to the direction of groove-travel under the recording head. If the note is very soft or low in volume, the amplitude of the groove will be small, as shown at C but, if the note is very loud or of high volume, then the amplitude will be large, as shown at D. The distance between the peaks of the waveform will remain equal in both cases if the frequency remains unchanged.

The principle of apparatus used in the early talking pictures made possible by the disc recording process is shown in Figure 11.6. The microphone is an instrument whereby sounds are introduced into any recording system—it is therefore suitably placed within the field of pressure waves originating from the source of sound. The diaphragm within the microphone will then vibrate in sympathy with the sound waves and, therefore, the initial stage—taking place within the microphone—is to transform these pressure waves into mechanical energy. The minute vibrations on the face of the diaphragm may be employed either to compress carbon granules—and so alter their electrical resistance—to change the capacity of an electrical condenser, to move a coil of wire within a magnetic field, or to change the pressure exerted upon a piezo-electric crystal. Whichever type of instrument is used it is obvious that the microphone accepts pressure waves which impinge on the outer diaphragm and create mechanical energy, and then the instrument itself converts this energy into electrical pulses by any one of the four methods outlined above.

At this stage the electrical energy is very small, and must therefore be amplified

323

before it is of sufficient strength to operate the stylus cutting head in the recorder. This cutting head may be tracked either inwards or outwards from the centre of the recording medium—usually by a very accurately machined lead-screw. In the early days the recording medium was a soft wax but, in modern studio equipment, it is a special lacquer coated on to an aluminium base. The lead-screw is geared to and positively driven by the motor which rotates the turntable supporting the disc. The turntable is driven by a synchronous motor through a mechanical filter unit designed to absorb any small variations in speed which would otherwise result in variations in pitch (known as wow) if they were allowed to pass to the turntable.

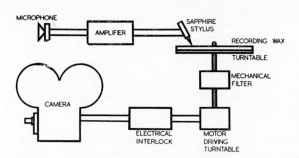

Fig. 11.6. An Early Disc Recording Process

The camera and turntable motors are both connected through an electrical interlock so that, once started, synchronism is maintained throughout the entire operation. With this early equipment considerable difficulty was experienced in re-recording sections of speech from many discs so that they would all match with a composite reel of pictures after the production had been edited. To overcome this a number of studios decided first to produce the finished picture and then to rehearse the actors again and again until they were word-perfect and able to repeat their lines in synchronism with the whole reel of picture material. Under these conditions the recording turntables would be electrically interlocked with the projectors during a *re-recording* session—and not with the cameras as shown in Figure 11.6.

The first commercial sound films employed discs which were 16 in. (40·64 cm.) in diameter and rotated at $33\frac{1}{3}$ r.p.m. It was thus possible to project a full 1,000 ft. (304·8 metres) roll of pictures during the playing time of one disc. This made it possible to synchronise the disc and film before both machines were started and, assuming some form of electrical interlock were employed, synchronism could be maintained throughout the entire roll of film. In those early sound-film days the picture print was still travelling at the silent-film speed of 16 pictures per second and, therefore a 1,000 ft. (304·8 metres) roll of film would run for just over 16 minutes. As will be seen later, it was in order to improve the sound-recording quality that the film speed had to be increased to 24 pictures per second when a photographic sound track was printed on to the picture film.

Photographic sound recording

Although synchronism between early disc and picture films could be maintained to a remarkable degree, it was apparent that production techniques would be greatly eased if sound could be embodied with the picture on one film and alongside the picture images. Long before disc-type talking pictures became popular sound had been recorded on to photographic film, but it occupied such a large area that the picture size was severely restricted and, in any case, the sound quality was then far below that of disc reproduction.

However, continued efforts to record sound photographically as modulations in light intensity eventually formed the basis of modern sound recording systems. It was realised that, because a microphone and amplifier could cause a sapphire needle to vibrate in synchronism with sound waves (as in disc recording) it should be possible to replace this needle either with a shutter, to vary the amount of light which reached the film, or by a mirror to oscillate a reflected light beam across a stationary slit and so record a *photographic* pattern of the sound. The first of these suggestions resulted in a form of light-valve which produced a track of constant width but varying density and, eventually, became the well-known *variable-density* system. The other possibility required a mirror galvanometer to vary the position of a light beam of constant intensity and, therefore, became known as the *variable-area* system of sound recording.

In both cases the *frequency* of the note is represented by the *number* of changes in the record which pass a given point in each second. The *volume* of the note is proportional to the *size* of the changes in the record. It is essential to understand that the two fundamental requirements of frequency and volume are recorded by both systems in a similar manner—by the number of changes and the size of those changes. The only fundamental difference between variable-density and variable-area recording being that, in the first case these factors are interpreted as changes in image density whereas, in the second case, the same factors are interpreted as changes in image area.

When variable-area recordings are made negatives similar to that shown to the left of Figure 11.7 produce a constant-density exposure which varies in width. If the sound is a simple pure note the recorded *wave-form* will smoothly change from a minimum central exposure to a maximum width exposure and then back once more to a minimum—this will occur at a speed equal to the frequency of the note. Thus, the number of *peaks*, such as AAA, which occur in a given film length is directly related to the frequency of the note—when these peaks are close together the frequency or pitch of the note will obviously be high and, when they are widely spaced, as at BBB, the frequency will be correspondingly lower.

The width of the recording, shown at C, represents a signal of low volume. If frequencies identical to tracks AA and BB are then recorded at a much greater volume level the resultant wave-forms are as shown at DD and EE, Figure 11.7. It should be noticed that the distance between the peaks DD is equal to that between peaks AA and, similarly, the distance between peaks EE is equal to that between

peaks BB—the frequencies have therefore remained as before. However, the amplitude F has greatly increased and, since the change in light transmission has now become large, the volume of sound has also increased proportionally.

A similar analysis of the variable-density method of sound recording is shown to the right of Figure 11.7. The four conditions represent the type of record obtained when high and low frequencies of both high and low volume are recorded

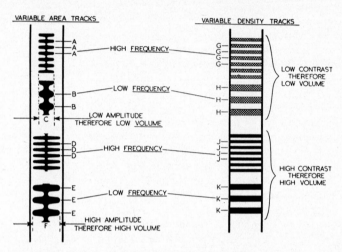

Fig. 11.7. Volume and Frequency Characteristics of Variable-Area and Variable Density Sound Recording

and, therefore, provide a direct comparison between the two systems. Both variable-area and variable-density tracks can be reproduced equally well by any sound scanning mechanism, because the photographic record is only a means whereby variations in frequency and amplitude are registered and may subsequently modulate the scanning system.

Current practice is to make original recordings on *magnetic* films or tapes and, generally, to re-record from these to make photographic sound tracks only when general cinema release prints are being manufactured. By far the majority of release prints now employ the variable-area system and, consequently, only this photographic system is considered in detail.

Mirror galvanometers

The variable-area method of photographically recording sound produces a track in which the actual wave-form is traced out as the boundary between opaque and clear sections of the film and, therefore, may be easily seen under a microscope. To understand this system it is first necessary briefly to consider the action of the

galvanometer shown in Figure 11.8. If the coil of wire CC is suspended in a magnetic field it will react to a coupling force, the size of which is proportional to the current flowing through the coil. This causes the coil to deflect or rotate. Such a coil may be either rectangular or circular in shape and consists of a number of turns of very fine wire. Mounted upon a suitable former and suspended by clamps, it is centrally

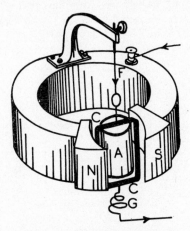

Fig. 11.8. The Galvanometer

placed between the pole pieces N and S of a permanent magnet. The coil suspension is usually a length of fine phosphor-bronze wire as shown at F, which also serves to carry the current into the coil. After passing through the coil the current leaves by a loose section of phosphor-bronze wire as indicated at G.

Whilst current is flowing the magnetic couple rotates the coil until a second couple, due to the mechanical twisting moment in the strip F, becomes equal and opposite in strength—thus bringing the coil to rest in a position of balance. Since a soft-iron core A is mounted within the space between the sides of the coil former, the coil actually rotates within a circular gap between this core and the pole pieces. The magnetic field across this gap is *radial*; the coil therefore remains within a field of constant strength as it rotates and, most important of all, the *degree* of rotation is therefore proportional to the current flowing through the coil.

Now assume that a small mirror is attached to the suspension F, as shown just above the coil. Light reflected by this mirror will sweep through an angle proportional to the current passing through the coil and, if that current is derived from a microphone, via an amplifier, the oscillations of the light beam will be proportional to the fluctuating speech current.

The basic arrangement of such an apparatus is shown in Figure 11.9, where a constant beam of light, from a lamp fed by a D.C. supply, is focused by a condenser lens on to the mirror in the galvanometer. As the mirror oscillates, due to the varying speech currents, a lens focuses the motion down to a fine spot. This spot oscillates

across a slit, cut in a mask behind which the recording film is travelling at constant speed. A trace made by this system is shown to the right of the diagram and is seen to be of the simplest form. The light spot must be rather longer than half the slit width so that only one side of the spot travels across the aperture. This early form of variable area recording suffered from difficulties in manufacturing the necessary thin slit and also in keeping this slit free from dust particles. To gain some idea of this problem it should be remembered that 9,000 cycles—each accurately defined—was photographed within 12 in. (30·5 cm.) assuming a film speed of 16 pictures per

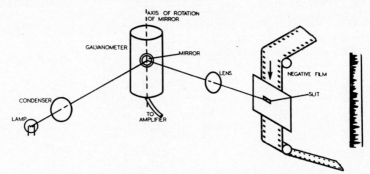

Fig. 11.9. Principle of Variable-Area Sound Recording

second, that is, the old silent-film speed. Therefore, one complete cycle occupied a distance of 0·0013 in. (0·033 mm.) and, if such a frequency was to be accurately recorded, the slit width would need to be even smaller.

The first step towards improving this condition was made by raising the film speed to 24 pictures per second. At this new speed one complete cycle on the film—at a frequency of 9,000 per second—now occupied a distance of 0·002 in. (0·051 mm.) This still suffered from mechanical disadvantages and an improved system was introduced whereby the moving light spot was projected on to a large slit, so that an enlarged image of the trace moved across a correspondingly large aperture. This projected image was then optically reduced to form an image of the required dimensions upon the film.

By 1932 the mirror-galvanometer system was again changed; this time to increase the sensitivity of the system. The new arrangement, shown in Figure 11.10 forms the basis of modern variable-area recordings and is still widely used to produce 100 mil photographic prints for cinema release even though these are usually derived from original studio and dubbing tracks made by the magnetic recording systems. Light from the constant D.C. source L is focused by the condenser lens C on to the window lens B. The mask M, provided with a triangular shaped aperture A, is mounted very close to the condenser lens. A new type of galvanometer is used and it is very important to realise that its axis of rotation is at right-angles to that of the earlier instruments—that is, the mirror oscillates up and downwards instead of from

side to side. The galvanometer reflects an image of the mask aperture on to a screen S. A very narrow horizontal slit is cut across the centre of this screen and the lens E converges the triangular image so that its base is just wider than this slit. A narrower or wider beam of light will then pass through slit S as the triangular image D moves up or down across this aperture. A microscope objective lens O focuses an image of slit S on to the film to produce an equilateral track as shown at the left of the diagram. Added sensitivity is obtained because the width of the illuminated area is decreased or increased from *both* sides at once. In other words, the angle through which the mirror need rotate in order to change the length of the

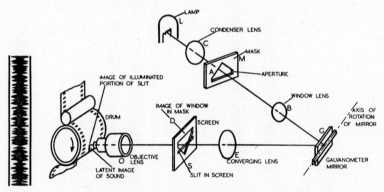

Fig. 11.10. Bi-Lateral Variable-Area Recording

illuminated section of the slit from zero to 100 per cent. is approximately half that required by the earlier system. It should be noted that the triangular slit in mask M is extended at the base to include a section with parallel sides of constant width. This avoids the objectionable distortion which would otherwise occur if over-loading caused the base of the triangle to cross the slit in screen S.

Push-pull tracks

Although sound reproduction has not yet been considered, it must now be mentioned because, in some amplifier circuits, output valves can be connected in parallel and so more than double the power of this stage. Two valves so connected can give apparently more than twice the power of one valve due to the reduction of harmonics and a consequent reduction in distortion.

The single triangular mask shown at A, Figure 11.11, moves across slit C to produce the track shown at D. If we now replace the single triangle by two smaller apertures, as shown at B, and cause them to oscillate across C_1, a double track will be produced as shown at E. It should be noticed that one triangle is *inverted* with respect to the other so that, as one beam of light becomes wider the other is closing down towards the centre. Of course, both triangles are cut in one aperture plate and,

since they are both reflected by one galvanometer, they both oscillate vertically and together. The actual recording produced by this system shows that, when one track is almost closed the other is opened to a maximum. Thus we have produced the required push-pull condition and, assuming one track can always be related to one

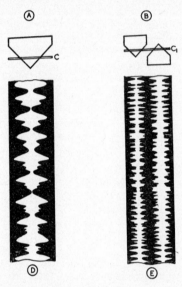

Fig. 11.11. Push-Pull Class 'A' Recording

of the two output valves in the reproducer, the signal applied to this valve will be at a maximum when that applied to the other is at a minimum. This type of recording is known as *Class A, Push-Pull*.

Ground noise reduction

The importance and definition of *ground noise* in relation to sound recording can only be fully understood if we can measure the relative volume of various sounds. Relative volume is usually expressed in terms of the *decibel*—a unit of electrical transmission defined as follows: the power output obtained from a circuit is divided by the power put into it; the quotient so obtained is then converted to a logarithm and, when this logarithm has been multiplied by 10, the resultant figure indicates the loss or gain in decibel units, thus:

$$db = 10 \log \frac{P_o}{P_1}$$

Where db = decibel units
P_o = power output
P_1 = power input

For example, if one sound has twice the energy of another, and it is required to find the difference between the two in terms of decibels, the procedure is as follows: (1) The difference between the two sounds, in terms of energy, has been given as 2. (2) The logarithm of 2 will be found to be 0·3. (3) By multiplying 0·3 by 10 a quotient of 3 is obtained. This quotient 3 is then in decibel units and it can be said that a sound having twice the *energy* of another is 3 decibels *louder* than the other. Again, if one sound has 5 times the energy of another, we must first find the logarithm of 5 (which is approximately 0·7), and then multiply this by 10—which produces a quotient of 7·0. Thus, a sound having 5 times the energy of another will be 7 decibels louder than the other. The decibel is also used to measure the performance of amplifiers. If the amplifier in a sound projector magnifies the input signal 100 times, it is said to have a *gain* of 20 decibels (20 db), because the logarithm of 100 is 2, and by multiplying this by 10 as in the previous cases, the quotient is, of course, 20.

A change of one decibel is normally the smallest change in volume which can be detected by the human ear and is equivalent to approximately $12\frac{1}{2}$ per cent. The intensity of sounds are usually measured as being so many decibels above the *audible threshold*. A soft whisper at a distance of 3 ft. (0·9 metres) is approximately 15 decibels above the threshold; normal speech is approximately 70 decibels above this threshold and a full orchestra, playing fortissimo, approximately 115 decibels above the threshold.

At this point one may well ask what all this has to do with photographic sound tracks. If film is running through a projector (and no sound is recorded on the track), the soft hiss of the amplifier circuit will be increased by approximately 10 decibels— nearly as much as a soft whisper 3 ft. (0·9 metres) from the ear. This small increase is only achieved when the film is perfectly clean and, assuming it carries a constant photographic density over at least part of the scanned areas, approximately 7 decibels volume increase will be due to the film base whilst the remaining 3 decibels are caused by the graininess of the metallic silver which constitutes the photographic density.

This increased volume, due solely to the presence of film in a projector, is known as *ground noise* (whilst the hiss due to amplifier circuits, etc., is known as *system noise*). Naturally, ground noise will also exist when actual wanted sounds are being reproduced. The sounds which come from the speaker system are therefore made up of three components: firstly, the hiss due to the amplifier and film scanning circuit, or the system noise. Secondly, the ground noise due to the film base and emulsion grain. Thirdly, the required photographic recording.

When the signal level is high, as in the case of a full orchestral recording, the ground noise will not be detected. However, when the signal is low, as would occur when the voice of one person is recorded as a whisper, the ground noise *may* be detected. A most important state exists when no signal is recorded at all—ground noise may then become very apparent. Unfortunately, silent passages usually occur when some highly dramatic action is taking place on the screen; ground noise can then easily destroy the artistic effect.

Some people find it difficult to believe that these relatively small considerations are really worth while. It may well be true that each improvement, taken separately, does not always show a noticeable advance, but it must be remembered that all parasitic noises are additive and any measure to reduce their cause does lead to a general overall improvement throughout the industry. One of the greatest advantages of magnetic sound recording is, in fact, the ability to achieve a signal-to-noise ratio far higher than can easily be obtained by photographic systems. This is one reason why studio recordings and final dubbing work are now made by magnetic systems

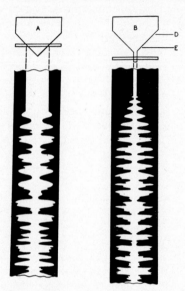

Fig. 11.12. Noise Reduction with Variable-Area Recordings

although, as previously stated, final British release prints are still usually in the form of photographic sound tracks.

It has been said that, of the 10 decibels unwanted noise produced by un-modulated film, 7 of these are due to the film base and only 3 to the emulsion grain. This suggests that the overall noise could be reduced considerably if the clear film base could be covered with emulsion during silent or unmodulated passages. One method by which this can be achieved is illustrated in Figure 11.12. Here the image of triangular aperture A is reflected from a galvanometer which normally comes to rest in the mid-position; this naturally causes the unmodulated film track to contain a wide central section which, in the print, will be clear film as shown below the diagram. However, it is possible to apply a bias-current to the galvanometer so that the mirror oscillates about a different centre according to the amount of this bias.

In practice this bias-current is proportional to the overall amplitude of the modulations so that, when the volume of sound is great, the bias will shift the

centre of oscillations towards D and, if the volume is small, this centre will move towards the peak of the triangle as shown at E. When no signals are passing through the circuit the bias shifts the galvanometer to a stationary point so that the minimum width is exposed down the centre of the sound track. It must be realised that the size of the mirror oscillations due to the *volume* remain unaltered. It is only the *position* in which the mirror oscillates that changes. The track below image B represents the positive print obtained from such a negative. The speed at which the overall envelope is reduced or increased must remain below the audible frequency range to prevent its appearance as a low frequency hum in the reproduction. In practice the electrical circuit is designed to monitor the signal volume in such a way that what is known as *ground-noise anticipation* occurs; this causes the envelope of the recorded amplitude to open or close slightly ahead or beyond the signal volume to prevent the clipping of the ends of words or, alternatively, undue noise immediately preceding a word.

Volume expansion via control tracks

Other sections of the film, apart from those normally occupied by the sound track and the picture, can be utilised for various purposes; one particularly neat invention

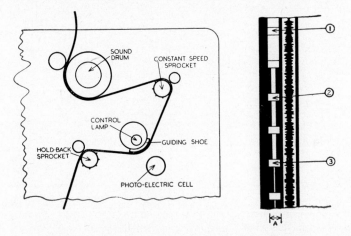

Fig. 11.13. Volume Expansion by Control Tracks

uses the emulsion *between* the perforations on which to photograph a *control track*—both to adjust the sound volume range and also to bring additional speaker units into use. Whilst existing volume ranges are quite adequate for normal productions, considerable realism is added when extra volume is available for large-scale battle scenes and similar exterior shots. Realism is also increased if additional speakers, placed to the side of the screen, can be brought into operation automatically to give the impression that the source of sound is as wide or wider than the screen itself.

333

Both these requirements are satisfied by the relatively simple attachment to existing projectors shown in Figure 11.13. The film is fed around the normal sound drum in the usual manner and then, via a constant speed sprocket, to the under side of a circular lamphouse—where it is guided by a semi-circular shoe. Film then passes to the normal hold-back sprocket and so to the take-up spool. A light beam passes through a relatively large aperture in the guiding shoe, so that it scans the *perforated area*, A, shown in the right-hand diagram. The resultant modulating light operates a control photo-cell, mounted directly below the lamphouse.

A typical control track, shown to the right of the figure, consists of a varying width transparent central section, enclosed by parallel opaque areas symmetrically placed with respect to the perforations. In position 1 the clear sections between perforations is equal in width to the perforations themselves and, consequently, no signal passes to the photo-cell. In position 2 the light transmitted by the clear section between perforations is approximately one-third of that transmitted by the perforations themselves and, therefore, a signal will be reproduced by the photo-cell. Similarly, in position 3 the difference in transmission between the clear sections of film and the perforations themselves is even greater and, in consequence, a stronger signal will be reproduced.

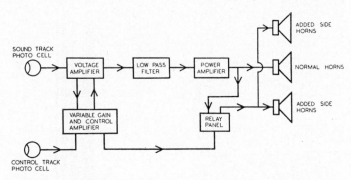

Fig. 11.14. Block Schematic of Control Track Apparatus

The frequency of this signal will always equal the number of perforations passing the scanning point each second and, therefore, will always be at 96 cycles per second. The strength of the signal is controlled by the relative difference between the amount of light transmitted through a perforation and that transmitted through the clear central area in the emulsion between the perforations.

This constant low frequency of variable strength is fed to a variable-gain amplifier used to extend the natural volume range of the original system. Figure 11.14 shows a block diagram of the control track apparatus. The main amplification circuit must have sufficient reserve power to provide the required output when maximum control is in operation. When control is zero—that is, when the area between the perforations is transparent—only the normal horn system and the main

amplifier is operating and, consequently, the volume range will be limited by the photographic properties of the sound track alone. The control and variable-gain amplifier is inserted between the stages of the voltage amplifier; the volume of any signal generated by the control track is therefore used to change the amplification range of the main amplifier, and thus to increase the amplification of the sound track signals. It is important to realise that the degree to which the variable-gain circuit amplifies one signal is dependent upon the *volume* of the control signal. The frequency of this control signal is unimportant since it is filtered out before the main amplification stages and is not superimposed upon the speech signals from the sound track.

Magnetic recording

Developments in this field have resulted in the perfection of ferric-oxide and similar coatings on to 35 mm., 17·5 mm. and 16 mm. films for use both in feature studios and also in films for television purposes (quite apart from the almost exclusive use of magnetic sound recording processes in the radio and gramophone record industries). Professional quality sound recording *tapes*, only 0·25 in. (6·35 mm.) in width are also used and these can be controlled by an electrical pulse to effectively record in perfect synchronism with a motion picture camera. The widespread impression that magnetic recording is a relatively new concept is quite untrue— its use dates back to 1898 although, in those days, the magnetic flux was created in a steel wire and not in a coating on flexible film or tape.

The principle of magnetic recording is to create a very small magnetic field across the poles of a recording head and, by intimate contact between this head and a suitable *receiver* (such as ferric-oxide) to magnetise that oxide in proportion to the incoming signals and so to record these in terms of changes in magnetic flux as the receiver passes under the recording head. Various methods have been employed both to compound suitable recording media and also to apply them to suitable flexible supports. Current techniques include so-called liquid varnishes or lacquers by which powdered ferric-oxide is supported in liquid solvents during a wet-coating operation, or the extrusion of a thixotropic paste via suitable ejector nozzles. Yet another system favours the mechanical milling of a groove in the actual film base and so that a pre-cast ferric-oxide lamination may be inlaid in the film.

By far the majority of current processes employ what may be described as the wet-coating techniques in which, fundamentally, the coating operations are very similar to those employed during the coating of parent rolls of photographic emulsions. In these techniques, and at the moment of coating, the magnetic oxide lacquer is in a fairly liquid state. It quickly begins to set as it passes beyond the coating head but, before it becomes completely stable the coated material is passed over a strong electro-magnet. This orientates the ferric-oxide particles so that they tend to set in the lacquer with their longer dimensions always in a preferred direc-tion—for example, in magnetic coatings intended for audio sound recording the particles will be persuaded to set parallel to the direction in which the material is

335

travelling through the coating machine whereas, in coatings intended for some forms of video tape recording work it can be arranged for the particles to set with their longer dimension at right-angles to the direction of travel through the machine. This lining-up process can never be perfect but it does greatly improve the signal strength which can be achieved in the recordings.

A magnetic coating can therefore be described as a vast series of very small bar magnets which have been carefully aligned head to tail in a preferred direction either along or across the finished film or tape. Figure 11.15 illustrates the basic principle of the magnetic recording process. During recording the oxide-coated side of the material is passed *in contact* with the recording head; in the two associated operations of erasing unwanted signals or replaying recorded sounds, both functions are also performed by the material actually passing in contact over the appropriate head. As the polarity of the recording head is constantly alternating at audio frequencies this causes the small bar magnets to become permanently magnetised in a pattern which coincides with the alternating polarity of the recording head.

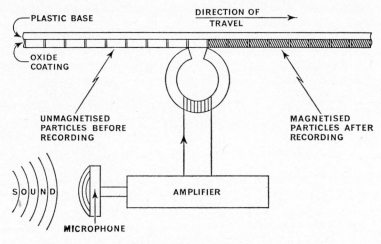

Fig. 11.15. The Basic Principle of Magnetic Recording

The frequency range which can be recorded on magnetic materials is governed by the combination of magnetic particle size and the speed at which the film or tape passes over the recording head. Figure 11·16 gives a general impression of the manner in which this combination operates in practice. Lower frequencies are recorded by several particles acting as one and, in effect, becoming effectively longer bar magnets. It is important to note that the polarity of each bar magnet has been indicated in the illustration of a low frequency recording—naturally, the same remains true of all other frequencies. The letter N indicates the north polarity whilst the letter S indicates the south polarity. One must remember that an *alternating* current is

passing through the recording head, and so one side of the recording gap (or one pole in the head) will exhibit maximum *north* polarity at the peak of a pure wave form but, *half a cycle later*, the same side of the gap will exhibit maximum *south* polarity. Because of this the magnetic polarity of the particles throughout the film or tape will also alternate. This simple analogy can only be related to the recording of a pure note and has merely been used to illustrate the principle—the condition when speech or music is recorded (involving many combinations of frequencies and harmonics) becomes extremely complex.

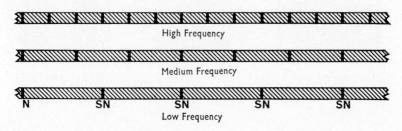

High Frequency

Medium Frequency

N SN SN SN SN

Low Frequency

Fig. 11.16. Magnetic Particle-size and Frequency

Sound reproduction from a magnetic recording is exactly the reverse of the principle of recording. The film or tape is caused to pass in contact over a replay head at exactly the same speed at which it was recorded: as the individual magnetic fields pass the head gap the magnetic flux in the head changes synchronously and *induces* an alternating voltage in the coil forming part of the head-assembly. This alternating coil voltage is then fed into the play-back amplifier network and so to eventually operate the speaker system.

Advantages of magnetic recording

The well known advantages which become available when magnetic recording processes are used instead of photographic or disc recording techniques are as follows:

(1) Immediate play-back without the need to wait whilst a film is being processed and printed.
(2) A very remarkable signal-to-noise ratio.
(3) Extended high frequency response without significant increase in distortion.
(4) Great economy in the use of material—because bulk-erasing techniques can wipe out unwanted recordings and return the stock for future use many times.
(5) The ability to record several tracks alongside each other and in perfect synchronism.

337

Types of magnetic sound film

Magnetic sound recording films are available in a variety of widths and coated areas on 35 mm., 17·5 mm. and 16 mm. triacetate and polyester bases. The most popular of these are illustrated in Figure 11.17. The type-numbers in the figure refer to

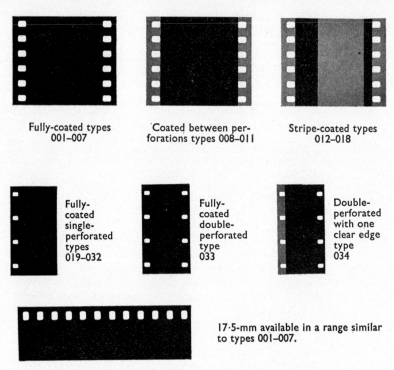

Fully-coated types 001–007 Coated between per-forations types 008–011 Stripe-coated types 012–018

Fully-coated single-perforated types 019–032 Fully-coated double-perforated type 033 Double-perforated with one clear edge type 034

17·5-mm available in a range similar to types 001–007.

Fig. 11.17. Types of Magnetic Sound Recording Films

Courtesy Ilford Ltd

groups of materials currently manufactured by Ilford Ltd who, incidentally, also make a wide range of similar products which are sold in America by the Todd-AO Corporation.

There are three main groups of 35 mm. magnetic sound recording films: (1) Those which are fully coated across their entire width, (2) Those in which the coating only extends across the large central area between the two rows of perforations and, (3) Those in which the coating exists as a relatively narrow stripe adjacent to one row of perforations together with an even narrower balancing stripe adjacent to the other row of perforations.

In general the fully-coated film is used for similar recording work as that which

is coated only between the perforations. Both types are used for original studio sound recording and for sound dubbing or mixing operations. The choice of one or the other is very largely a matter of preference which may be influenced by the following three important considerations.

Some technicians prefer fully-coated material because the edges of a roll are in tight contact throughout and, because of this, it becomes unlikely that dirt might penetrate into the roll during storage. The edges of a roll of film which is only coated between the perforations are not in tight contact (due to the absence of any oxide thickness beyond the perforations) and some people believe this could be a trap for dirt particles, or could render the material more susceptible to mechanical damage.

Against the above argument some technicians claim that fully-coated film carries oxide over the delicate sprocket teeth in film recording and reproducing apparatus and that, because magnetic oxide is an extremely good abrasive, this could cause undue wear. Naturally, such people prefer to use film which is only coated between the perforations. The third choice is made because in some recording processes it is an advantage to have a clear uncoated edge on which instructions or cue marks can be made with a grease pencil, or on which visible footage numbers may be printed as an aid to synchronising and track laying.

Both fully-coated films and also those only coated between the perforations can be used to record a single sound track—in a position similar to that of the sound in a combined cinema release print—and such as would occur during normal studio floor shooting. They can also be used to record several tracks side by side when various sounds are being combined together in a final sound dubbing or mixing operation.

We have already noted that, when a feature film is being made, at least four quite separate sound records must be prepared. The first is the Main Dialogue Track of the text spoken by the artiste during the normal floor shooting. The second is the Music Track of all the background music which will accompany the picture. The third is the Effects Track which carries special recordings of noises such as telephone bells, footsteps, door-knocks, etc., which cannot be perfectly recorded during floor shooting and which must therefore be given individual attention. The fourth track is the Post-Synchronised Dialogue Track and this contains dialogue which has to be re-spoken in an acoustically perfect area—usually the dubbing theatre—because the original dialogue recorded on the studio floor or on location was not of sufficiently high quality.

All these sound recordings are combined into one master recording. This operation is known as sound *dubbing* or sound mixing and it is often convenient to pre-record several of these tracks together in an operation known as a *pre-dub*. When this is done it is very convenient to use full-coated magnetic film or film which is only coated between the perforations and to actually record each track alongside its neighbours on the one piece of film. Multiple-head recording and reproducing equipment exists to enable such tracks to be fed as separate entities into the final sound *dubbing desk*. This is a console-like structure containing a series of very high

quality matched amplifiers, each provided with means to adjust both the frequency response and output volume.

When these types of magnetic film are used for floor shooting—where only one sound track is made—it can be wasteful to use fully-coated material or film coated between the perforations. This waste can immediately be halved by making one recording from head-to-tail on the left-hand side of the coated area and then, without rewinding the film, to make a second recording from tail-to-head on the right-hand side of the same film. This technique is simplified when the film carries a narrow dye ribbon along one edge of the base side, because such a colour code readily identifies which side of the material was used to make the *first* recording and, therefore, in what manner the film should be threaded in the reproducer.

Those 35 mm. magnetic films which merely carry a stripe coating adjacent to one row of perforations are mainly used in sound editing processes. A film editing technician frequently needs to relate visually a section of sound film with the positive picture film it will ultimately accompany. Stripe-coated film can be laid over the picture film and this can still be viewed through the clear area of the sound film. Stripe-coated film is also used when editors want to make visible cue marks alongside selected magnetic recordings.

Some operations are helped if visible footage numbers are printed on to clear areas of magnetic recording films. These numbers allow films to be related to each other and to be adjusted for synchronisation even when such adjustment is in the middle of a roll and thus remote from the conventional start marks normally made at the beginning of each roll. Such numbering is usually carried out by film laboratories or in studio editing departments and, incidentally, can equally well be applied to those 16 mm. magnetic sound recording films which retain one uncoated clear edge.

Fully-coated 16 mm. sound recording films are all used for the same purposes as those which employ 35 mm. fully-coated films. The choice between 16 mm. film which is only perforated along one side (so-called single-perforated film) or film which is perforated along both sides (so-called double-perforated film) is usually governed by the type of recording equipment which is available. It is important to realise that double-perforated 16 mm. film can pass through equipment which has film sprocket teeth only on one side, but it is *impossible* for single-perforated film to pass through equipment which has film sprocket teeth on both sides of the driving mechanism.

Professional 35 mm. sound and picture work always employs two separate groups of equipment: one to photograph the picture images on to panchromatic negative film and a quite separate apparatus to record sound on to either magnetic film or tape. These two sets of equipment are electrically interlocked so that they remain in synchronism. However, 16 mm. filming techniques include so-called combined cameras in which both the picture *and* the sound can be recorded on to the same length of material. This film carries a panchromatic photographic negative emulsion on one side of the flexible support and a magnetic sound recording stripe near to one edge of the other side of the support. Because of this, combined cameras *always* employ single-perforated film.

Single-perforated fully-coated magnetic 16 mm. sound film is used on sound transfer and replay equipment which is also capable of reproducing sound from the dual-purpose film used in combined cameras. The third type of 16 mm. magnetic film is perforated along both edges, but one edge remains free from oxide coating. This provides an area in which editors may record cue marks or footage numbers.

The lower picture in Figure 11.17 illustrates 17·5 mm. magnetic sound film. This material is derived by slitting 35 mm. film into two halves. It is widely used in studios and on equipment where the advantage of 35 mm. film transport speed is required but where multi-track recording is not so important and economy is essential.

Technical terms

It will be apparent that magnetic sound recording is a highly sophisticated technology which requires a specialised knowledge of some branches of electronics—in a manner somewhat similar to the special terms and knowledge required in the sensitometric control of any photographic process. Because of this the following short descriptions of the more usual technical terms associated with magnetic recording and reproduction have been included at this stage:

Azimuth. This term is used to describe the degree of alignment between the operative gap in a recording or reproducing magnetic head and the lines of magnetism formed in the recorded film or tape. Unless zero azimuth exists the reproduced signal will be below the possible maximum volume and will also contain distortions.

Bias. The effective sensitivity of a magnetic recording material depends upon the amount of biasing current which is applied to the recording head—and this will vary slightly from one manufacturer's products to those of another. Bias is applied in the form of a high frequency alternating current (beyond the audible range) which is measured in milli-amperes. The optimum bias current can only be established for a film-plus-recorder combination, but it is that current which yields the maximum sensitivity *and* the maximum output when measured at the 2 per cent. distortion level.

Coercivity. This is the magnitude of the magnetic force which is necessary to reduce the flux density to zero after the material has been taken up to saturation. Coercivity is measured in Oersteds.

Decibel. This is a unit of electrical transmission but, in relation to sound recording, it is used to *compare* sounds of different loudness. It is defined by dividing the power output obtained from a circuit by the power put into it. This quotient is then converted to a logarithm which is then multiplied by 10. The resultant figure indicate the loss or gain in decibel units.

Frequency Response. This is the range of tones or musical notes which a system will record or reproduce faithfully. It is most important to realise that a magnetic film

or tape does not have a frequency response as such—it has a *wave-length* response. This is because frequency response can only be expressed when the film or tape *speed* has been taken into consideration.

Ground Noise. This is any unwanted sound which has been caused by imperfections in the recording material. It should not be confused with system noise, which is usually at a much higher frequency and is due to the electrical components in amplifying circuits, etc.

Magnetic Heads. These are to magnetic sound recording and reproducing systems what the mirror galvanometer and photo-cell are to photographic sound systems. A magnetic head is any unit which contains or can be induced to operate as an electromagnet. There are usually three magnetic heads in every audio system: (1) The *erase head*—this is energised with a very high frequency well beyond the audio range and designed to destroy any audio signal which may be present on the film or tape *before* it passes over the recording head. (2) The *record head*—this is energised with audio frequencies representing the sounds which are to be recorded. The head receives its signals from a chain of equipment commencing either with a microphone, radio signal or gramophone pick-up—each of which can only be connected to the record head via suitable amplifiers. At the record head the signal appears as a magnetic force which is alternating at the audio frequency which is to be recorded. This alternating magnetism is induced into the moving film or tape by physical contact between the two. (3) The *replay head*—this is similar in principle to the record head but receives magnetic force from the film or tape as it passes in contact over a small gap in the head. The head in turn converts magnetic signals into small changes in voltage which are then amplified to drive a speaker and thus reproduce the recorded sound. It is important to appreciate that any magnetic flux in a recorded film or tape is constituted in the form of *permanent* magnets and may therefore be reproduced any number of times without loss of signal strength and until such time as it is intentionally erased.

Print-Through Ratio. This is a measure of a defect which may occur when a film or tape is wound into roll form. It relates to the possibility of the magnetic field in one layer of material inducing a corresponding field into the layer adjacent to it. In practice the defect causes a faint echo to be heard. It is measured in decibels and is usually the ratio between (1) a 500-cycle signal at 2 per cent. distortion level and (2) the output level from a signal induced into the *preceding* un-recorded layer of film or tape by that 2 per cent. distortion signal. Film or tape undergoing such a test is usually re-wound and incubated before the comparison is made.

Remanence. This term is used to describe the flux density which remains in the material after it has been magnetised to saturation. It is measured in milliMaxwells and it is important to realise that the *width* of the magnetised area must be specified in order to compare the remanence of one material with that of another.

Sensitivity. This is a measure of the play-back signal level which is obtained from a given recording level. In other words, it is a measure of what is got out of the material

as compared with what was put into it. Changes are measured in decibels, and the decibel difference between two signal voltages V_1 and V_2 is given by:

$$db = 20 \log_{10} \frac{(V_1)}{(V_2)}$$

A signal providing *twice* the play-back voltage to that of another is said to be '6 db up' or 'plus 6 db'. Another signal providing 10 times the voltage is '20 db up'. A change of 1 db in a steady tone is just detectable by ear.

Signal-to-Noise Ratio. This is a measure of the ratio between (1) the maximum undistorted signal output and, (2) the noise level output from material which does not carry a signal. Signal-to-noise ratios depend much more upon the equipment in use rather than the recording film or tape. Because of this, an alternative figure of great interest is the ratio of maximum undistorted output to *saturation* noise. It is important to check which type of signal/noise ratio is meant when any figures are being compared. Signal-to-noise ratios are expressed in decibels.

System Noise. This is any unwanted sound—usually in the form of a high frequency low volume hiss, which is due to the electrical components in amplifying circuits, etc. It should not be confused with ground noise which is usually a much lower frequency and is due to imperfections in the recording material.

Timbre. This is the characteristic of an instrument which distinguishes it from others and, for example, enables us to recognise the difference between the sound of middle C when played on a piano and the same note when played on a violin. The difference is caused by the *proportion* of harmonics or over-tones which are reproduced together with the fundamental frequency. These differences in harmonic reproduction depend upon the physical characteristics of the instrument.

Uniformity. This is a measure of the freedom from variations in sensitivity along the length of a sound recording film or tape. It can be measured by rectifying a continuous-tone signal (usually 1 Kc/s or 5 Kc/s) and, after converting the resulting direct current to a logarithmic scale, recording the output on a high-speed sensitive chart recorder.

Wow and Flutter. These somewhat unusual words very accurately describe variations in the pitch of a recorded signal which are caused by variations in the speed of either the recording or reproducing system or, of course, a combination of errors in both. They are usually only noticeable in music recordings or constant-frequency test recordings.

Magnetic recording equipment

Professional magnetic sound recording equipment may be conveniently divided into two main groups: firstly, the apparatus employed when recordings are made on 0·25 in. (6·35 mm.) tape and, secondly, that which is employed when recording on 16 mm., 17·5 mm. or 35 mm. perforated magnetic film.

343

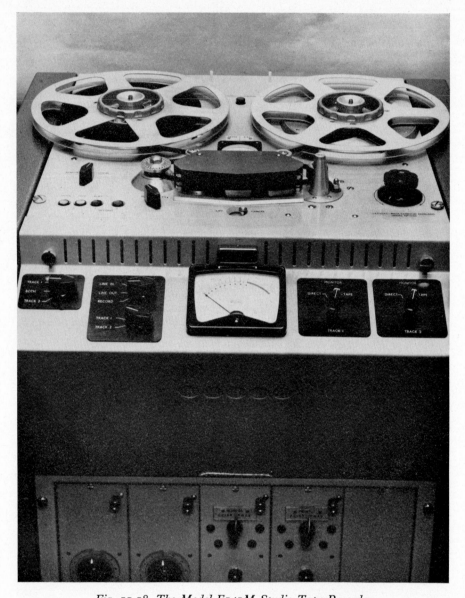

Fig. 11.18. The Model E141M Studio Tape Recorder

Courtesy Leevers-Rich Equipment, Ltd

Typical of high quality studio tape recording equipment is the Leevers-Rich model E141M shown in Figure 11.18. Although the basic mechanical layout and fundamental principles are obviously similar to the domestic tape recorders which are familiar to all, the essential differences are twofold: (1) the degree of precision in mechanical performance and, (2) the extremely high quality of sound reproduction, amplifier networks, etc. A less significant difference is the accommodation for much greater lengths of tape than is provided in domestic apparatus.

The E141M recorder will accept 11·5 in. (29 cm.) European spools, the well-known 10·5 in. (26·7 cm.) N.A.B. spool or smaller domestic sizes. It may be operated at tape speeds of either 7·5 in. or 15 in. (19 or 38 cm.) per second or, to special order, up to 30 in. (76 cm.) or down to 3·75 in. (9·5 cm.) per second. Naturally, the performance is related to the operating speed—some indication of the high quality which is achieved with this apparatus may be gained from the following characteristics which relate to the usual professional running speed of 15 in. (38 cm.) per second. Under these conditions the flutter and wow content is only 0·08 per cent. RMS total, the frequency response remains within plus or minus 2 db at all frequencies between 35 and 18,000 cycles per second, the noise level (which is related to a peak recording level of 200 Maxwells tape flux) is 62 db below this peak when full-width recordings are made, or 58 db below when half-track or twin-track recordings are made. The total amplifier distortion when recording at peak level is only 0·3 per cent at all frequencies between 40 and 15,000 cycles per second.

For many reasons original recordings on magnetic tape are often *transferred* on to perforated film. The phrase 'transfer' can be misleading to those not conversant with sound recording techniques—because one may imagine the sound is removed from the tape and put on to the film. A more accurate description is to transcribe, to duplicate or to re-record the sound because, in fact, any number of copies may be made from an original magnetic recording whilst still preserving that original quite safely.

A typical combination of equipment used for this purpose is shown in Figure 11.19. Here the Leevers-Rich tape recorder type E141M previously described is seen at the left of the picture and is mounted in the 19 in. (45 cm.) international standard rack or bay. Sound is reproduced from the tape on this unit and immediately duplicated or re-recorded on to 16 mm. perforated magnetic film passing through the Leevers-Rich model F.16 film recorder seen to the right of the picture. It will be noted that, in this particular installation at Athos Films Ltd., two identical 16 mm. film copies can be made from one original tape at one operation. These copies can be made at either normal or twice the original recording speed. It is also possible to transcribe from one 16 mm. original magnetic film recording to make a duplicate copy, again on 16 mm. film. When this is done only the two recording/reproducing units shown in the right-hand bay of Figure 11.19 need be used.

An even wider combination of possibilities is shown in Figure 11.20, which illustrates a so-called *film transfer suite* in which 16 mm. recordings are made in the Westrex machine shown at the left of the picture, 35 mm. recordings on the Westrex machine shown in the centre and 0·25 in. (6·35 mm.) tape recordings are made on

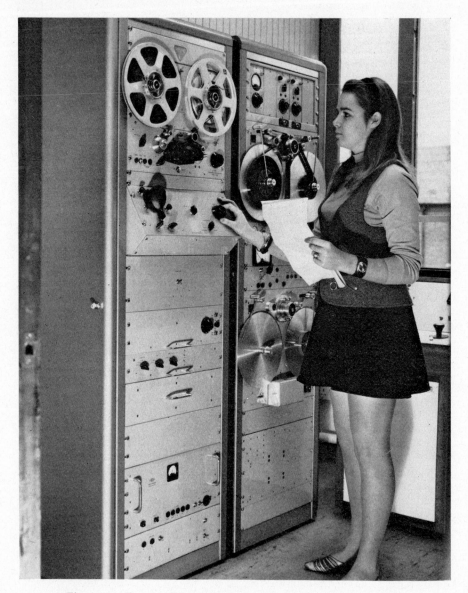

Fig. 11.19. Tape-to-Film and Film-to-Film Transcription Equipment

Courtesy Leevers-Rich Equipment, Ltd., and Athos Films, Ltd

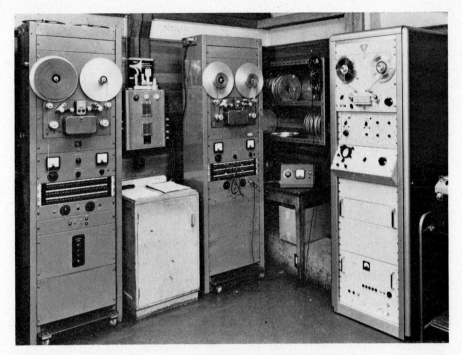

Fig. 11.20. A Typical Magnetic Sound Transfer Suite

Courtesy Leevers-Rich Equipment, Ltd

the Leevers-Rich machine shown at the right of the picture. All these machines may be electrically interlocked to operate in perfect synchronism with each other and any one may be used to record or reproduce sound. Thus a recording on any gauge or material may be duplicated on to any of the other two gauges.

Chapter 12

Processing Photographic Sound Film

General considerations

ALTHOUGH almost all original sound recordings for motion pictures and television use are made by the magnetic recording technique, it is still necessary to re-record final dubbed versions to produce a photographic sound negative from which to make the type of 'married print' generally needed for cinema release. The widespread use of magnetic recording has seen the virtual demise of photographic recording by the variable-density method—and those photographic sound tracks used in release print work are now almost exclusively made by the variable-area technique. Consequently it is the processing of this type of photographic sound track which is mainly dealt with in this chapter.

The machinery used to process photographic sound film negatives and positives is essentially similar to that used for picture materials, but the conditions under which each machine operates are quite different. Optimum quality only results from a photographic sound negative when it has been processed in a manner unlikely to yield equally high quality in a picture negative. We therefore find chemical differences between the solutions used in each machine and also differences in the time films are immersed in the solutions. As shown previously, the type of developer and the time of development affect the resultant density, the contrast between tones, the emulsion grain size and, consequently, the ultimate resolving power or acutance.

When large volumes of work are involved chemical differences in the developing solutions require separate processing machines set aside especially for each type of work. The time factor is simply a mechanical one and may be adjusted by changing machine speed (if permitted by other factors such as fixing time, etc.), by threading the film through more or less transporting racks or, equally well, by shortening or lengthening the film loops in each rack.

Broadly speaking sound film processing may currently be divided into two main categories: (1) The developer and the timing to produce the most satisfactory variable-area sound negative. (2) The type of developer and operating time necessary to produce combined positive *married prints* carrying both sound and picture.

348

This pre-supposes that the various film emulsions have been chosen to produce the required density, contrast and resolution under these conditions.

In earlier considerations of general sensitometry we found that strips of film carrying a series of accurate exposure steps were produced by instruments such as the Eastman Type 2b sensitometer (time-scale), or the Kodak Type X6 (intensity-scale). A densitometer was then used to measure the results of exposure and processing, and the combination of exposure and density were expressed graphically as the characteristic curve of the film, by plotting the densities against the logarithm of the exposures.

In photographic sound film recording the magnitude of the initial negative exposure should be directly proportional to the volume of the original sound. The final transmission through the positive film should vary with equal proportionality to maintain high fidelity sound reproduction. As shown previously, transmission is closely related to density—in fact, the reciprocal of transmission, when expressed as a logarithm, is the accepted measure of density—and we know that *density differences* between neighbouring areas in a film image depend upon the contrast and gamma to which the film is processed. Whilst these considerations are readily appreciated in connection with variable-density recordings, density and gamma values applied to *any* sound process must remain between limits considerably closer than those acceptable in picture processing.

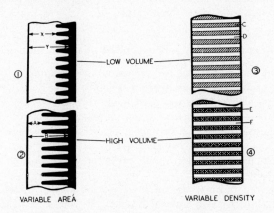

Fig. 12.1. Variations in Volume as Recorded by Variable-Area and Variable-Density Systems

Quite large differences in tone range may be permitted in the positive picture image before the eye rejects them, but small departures from correct tone balance in sound recordings will result in distortions in reproduction which the ear will immediately detect.

Any sound contains two primary characteristics—frequency and volume. In

349

photographic sound film recording *frequency* is represented by *changes* in the amount of light which strikes the film. The *volume* is represented by the *magnitude* of these changes. This is clearly shown in Figure 12.1, where a simple variable-area low volume track is represented at 1, a variable-area high volume track at 2, a variable-density low volume track at 3, and a variable-density high volume track at 4. The amount of light passing to the photo-cell in the reproducer via track 1 will only be slightly less at position X than at position Y— since this difference is small the volume will be low although the number of times this difference occurs will control the frequency of the tone. In track 2 the amount of light passing to the photo-cell in position A is considerably smaller than that passing in position B and, therefore, the volume will be much greater than that produced by track 1. Now considering track 3, the amount of light passing in position C will only be slightly less than that at D, since the density at C is very low. In track 4 the amount of light passing at position E will be considerably less than that at F, since the density at E is very high.

The important point to realise is that volume changes are obtained in the *area* track when a *constant* density is employed. In the *density* track changes in volume are obtained by *changes* in density. The volume range covered by a density track must therefore be represented by a range of exposure levels on the negative and positive films. This in turn means that, whilst variable-area tracks only employ one selected point on the characteristic curves of film emulsions, variable-density tracks employ a wide band along these curves.

Shortcomings of sensitometry when applied to sound film processing

Although it can be shown that classical photographic sensitometric control methods can be applied to sound film processing so that good average results may be obtained by all laboratories—whether they are called upon to process variable-area or variable-density tracks—these classical sensitometric methods do not necessarily produce the optimum results from the recording or re-recording systems. This does not mean that errors exist in the theory and practice of sensitometry; but rather that factors exist when photographing sound waves for which provision has not been made in this control process.

The area covered by one step on a sensitometric strip is exceptionally large when compared with the area covered by one complete sound wave, even at the lowest usable frequencies. Sensitometric strips are quite acceptable when dealing with *picture* processing because the smallest area which must be accurately controlled, in order to reproduce good tone rendering in the projected picture, is also very large when compared with the area of one cycle in the sound track. It is therefore not surprising that factors exist which escape detection in general sensitometric control and which are of sufficient magnitude to reduce the efficiency of photographic sound recording systems.

One factor, which can only be detected when examining very small areas of film, concerns the reflecting properties of film base. Assume that a variable-density

track is being recorded and that we can isolate one horizontal bar of light, corresponding to the instantaneous aperture of the light-valve. If the intensity of the beam passing through this valve to the film is relatively high the light will penetrate through the emulsion and hit the rear surface of the film base. Part of this light will then be reflected, travel back through the film base and again hit the emulsion.

Unfortunately, three alternatives may now take place: (1) The majority of the reflected light may return through the film base at an angle to the incident ray and therefore produce two new exposed lines, one on each side of the main exposure. (2) The reflected light may not return as sharply defined lines but as a diffused pencil of light causing a blurred halo around the main exposure. (3) Some of the reflected light may travel back through the film base and reinforce the original exposure. This will only occur when the light is sufficient to penetrate through the emulsion in the first instance and usually when frequencies of high amplitude are recorded—these will be considerably darker than densities produced at low amplitudes. In other words, the recording becomes distorted as the amplitude increases.

Another factor, particularly related to variable-area sound recordings, concerns image spreading and consequent *filling-in* of the high frequencies. Image spread is very minute when compared with a step on the sensitometric strip, but it is comparable to the area of a 10,000 cycle wave-form. High frequency loss may therefore occur in both variable-area and variable-density recordings even when the entire process is maintained at levels indicated by normal sensitometric control. Obviously, some new system of measurement was needed whereby these small errors could first be detected and then eliminated. In both recording systems this has been accomplished by electrical analysing processes.

Very briefly these techniques consist of first recording two pure frequencies, one relatively low and the other relatively high. The high frequency may be termed the *carrier wave*, and this is modulated by the low frequency in a manner similar to that by which radio waves are transmitted through the ether. By using suitable wave-form analysing equipment one can measure the percentage of each frequency in the final reproduction and, fortunately, the system can be so arranged that the response will only be at a minimum when the optimum processing conditions exist and the small errors, not previously detected by normal sensitometry, have been eliminated.

The wave-form analysing system applied to the variable-density sound recording process is known as *intermodulation*, and that applied to the variable-area process is known as *cross-modulation*. Since it is more convenient to discuss wave forms recorded in their conventional shapes, we will consider the cross-modulation technique applied to maintain optimum processing conditions for variable-area sound tracks.

Cross modulation

The pure undistorted wave-form theoretically produced under perfect conditions is shown at A, Figure 12.2. However, we are concerned with the growth or

351

contraction which takes place when a sound track is over or under developed. If film is over developed the troughs of the wave-form shown at X will be filled in by excessive image growth and the track will appear as shown at B. If the film is under developed the peaks of the wave-form, shown at Y, will contract and the track will appear as shown at C.

Since wave-form A is perfectly symmetrical we can measure the amount of light passing through a very thin slit at D, and then add to it a similar measurement

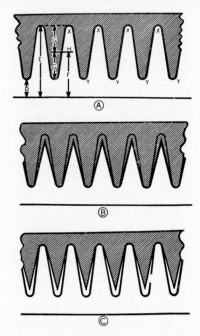

Fig. 12.2. Image Distortion due to Processing

made at E. By dividing this total by two we obtain the *average* amount of light which is transmitted; this is represented in the diagram by the height F. Point H is midway between the trough and the peak of the wave-form, as indicated by dimensions G. If similar measurements are made on the over or under developed wave-forms and, in each case, the average transmissions are again represented by line F, it will be found that they will be modified as shown in Figure 12.3.

Here the perfect condition is once more shown at A, and the average transmission is represented by dimension F_1. When film is over developed and the troughs of the wave-form are consequently filled in as shown at B, the average transmission is decreased to F_2. When film is under developed, and the peaks of the wave-form contract, the average transmission is consequently increased as shown at F_3. The

block diagrams below the wave-forms indicate the average transmission for a correctly developed film at D, an over developed film at E and an under developed film at F.

Of course, when over or under development occurs, both the peaks and the troughs of the wave-form are affected simultaneously. This is is more clearly shown

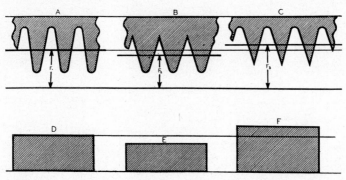

Fig. 12.3. Effect of Image Distortion on Average Transmission

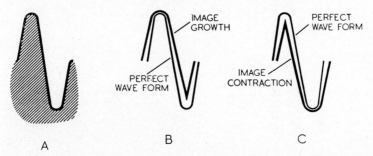

Fig. 12.4. Distortion Effecting both Peaks and Troughs of the Wave Form

in Figure 12.4 where A indicates the perfect condition, B the condition of over development and C that of under development. Image growth or contraction may be caused by incorrect exposure just as much as faulty processing, and cross-modulation tests must indicate both the correct exposure *and* the correct developing time.

Cross modulation test signals consist of a high frequency wave modulated by a low frequency, and result in the photographic image shown in Figure 12.5. The electrical circuits of the signal generators and modulating equipment, necessary to produce such a wave-form, are not important at present since we are only concerned with the photographic applications of this equipment.

If the modulated wave-form, shown in the centre of Figure 12.5, is perfectly

exposed and developed the 400 cycle, or low frequency component, will cause no change in the average transmission between the peaks and troughs of the high frequency when the print is reproduced. The condition is more clearly shown in Figure 12.6 where two isolated points on the track are considered in detail. To

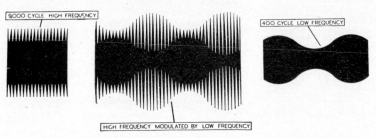

Fig. 12.5. High and Low Frequency Pure Tones Combined

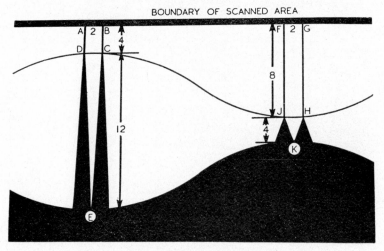

Fig. 12.6. Cross-Modulation Signals in Detail

simplify the condition only one half of the track has been shown but, obviously, a complementary section, equal in all respects, exists below the portion shown in the figure. Conclusions drawn from this figure will therefore apply equally well when the whole track is scanned in the reproducer.

Assume that the width of the scanning slit is equal to length AB. The amount of light passing to the photo-cell may then be considered as two portions; that represented by the rectangle ABCD, and that represented by the triangle CDE. For the sake of illustration units have been given to each dimension so that these areas may be calculated. The area of the rectangle is AB × BC, or 8 square units,

and that of the triangle is CD multiplied by 12 (the height of the triangle) and divided by 2—that is, 12 square units. The total area is therefore represented by 20 square units.

If there is no change in average transmission, due to the low frequency waveform, the light transmitted through the right-hand diagram in the figure must also be represented by 20 square units. The area of rectangle FGHJ is FG×GH, or 16 square units. The area of triangle HJK is HJ multiplied by half the height of the triangle and is, therefore, 4 square units. The total average transmission is therefore represented by 16 plus 4, or 20 square units, exactly equal to that transmitted through the left-hand diagram.

Suitable electrical analysing equipment differentiates between the response due to the high frequency and that due to the low frequency. It is therefore quite possible to measure any change in average transmission and, as has just been shown, no such change will take place in the ideal case.

Now consider the condition which exists when film is over exposed and/or over developed. As was previously shown in Figure 12.4, the image of the wave-

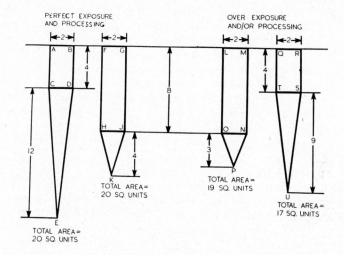

Fig. 12.7. Diagrammatic Analysis of Cross-Modulation

form will spread and the clear triangular section will be reduced in size. This condition is shown in Figure 12.7, where the two extreme cases at the peak and trough of the low frequency modulation have been brought close together for direct comparison. The diagram on the left of the figure indicates the size of the triangle when film is perfectly exposed and processed, while that on the right indicates the condition of over exposure or over development. As already established, the total amount of light passing through the two left-hand areas is equal, and may be

355

represented by 20 square units. When the image grows the apex of the triangles will be brought near to their respective bases, as shown at P and U.

In this simple example image growth is assumed to foreshorten the triangles by one quarter of their original height in each case. In practice the peak of the wave-form also grows to some extent and the angles within the triangle are slightly altered. All these considerations are relatively small when compared with the growth at the trough of the wave, that is at P and U, and may be ignored for the present. The amount of light transmitted in one case is therefore reresented by the area of rectangle LMNO, plus the area of triangle NOP. This is shown to be a total of 19 units. In the second case the transmission is represented by the area of rectangle QRST, plus triangle STU, and this is shown to be a total of 17 units.

When a perfect film is passed through the analysing equipment the average transmission is not affected in any way since, as shown to the left of the figure, the total amount of light transmitted between the high frequency wave peaks will always remain constant. However, when a defective film, such as that shown on the right of the figure, is passed through the analyser the average transmission will show a variation at a frequency equal to that of the low frequency modulation. This is because the amount of light passing between the high frequency wave peaks has been shown to vary between 19 and 17 units.

This analysis has only taken into consideration one half of the sound track, but it will be obvious that an identical condition exists in both halves. It must also be remembered that similar low frequency modulation exists when the wave-form contracts, due to under exposure or under development. The method employed to analyse the resultant sound track is to measure the output in decibel units, due entirely to low frequency modulation, and to compare this with the output due entirely to high frequency modulation. Optimum processing conditions only exist when the high frequency output is at a maximum and the low frequency output is at a minimum.

We must now establish tests whereby any response from the low frequency may be recognised as an error in exposure or as an error in processing. To do this a series of negatives are recorded, each consisting of a high frequency modulated by a low frequency, and each negative is exposed to a different value of recorder lamp-current. These negatives are processed by normal sensitometric control methods. Each negative is then printed several times; each print being made at a different exposure setting. All these prints are then processed in the normal manner. Each print is analysed in the electrical filtering circuit and the relative outputs from the high and low frequencies are recorded. The recordings are finally plotted in graph form and produce a series of curves as shown in Figure 12.8.

Any one of these curves is produced by plotting the low frequency output against the negative density and whilst the positive density is maintained constant. There are 11 negative densities shown along the base of the graph, and each of these is first printed to a positive so that all 11 prints are maintained at a density of 1.0. The positive copies are then analysed to measure the degree of low frequency response present and, of course, 11 readings are obtained from the equipment. It is

these readings which are plotted against the 11 negative densities. The entire process is then repeated 6 times, on each occasion raising the positive density by 0·1. Thus the seven curves shown in Figure 12.8 are produced.

It can now be seen that the *optimum* condition is achieved when the low frequency output is at a minimum. Only this condition provides wave-forms which are as nearly as possible free from image spread or contraction. In this example the lowest response, that of − 50 db, is produced when a negative having a density of 1·9 is combined with a positive having a density of 1·4. Although the process is somewhat lengthy, it need only be carried out to establish optimum conditions when new equipment, new film stocks or different processing techniques are installed. Once these densities have been established the *normal* sensitometric methods may be safely used to *maintain* the laboratory at these conditions.

It is interesting to compare the densities suggested by classical sensitometric methods with those just given. The sensitometric negative density recommended for this particular work was 2·10, whereas that indicated by the cross-modulation test is 1·90. Referring to Figure 12.8, and assuming the print will be made to a density of 1·4, sensitometric recommendations would produce a low frequency modulation 15 db greater than the negative density recommended by cross-modulation tests. If, on the other hand, the positive print density were increased to 1·5 when using sensitometric recommendations, this difference falls to 5 db. However, we can only observe the degree of correction which can be obtained by

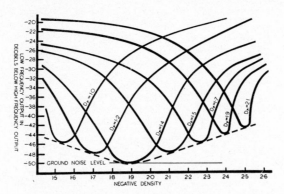

Fig. 12.8. A Family of Cross-Modulation Curves

changing the positive density *after* cross-modulation tests have been made and the curves in Figure 12.8 have been plotted.

It may at first be thought that the advantages gained by this process do not warrant all the initial work which is involved. This is certainly not true, particularly since the best curve in Figure 12.8 is relatively steep. Providing the positive density is maintained at 1·4, negative density may vary between 1·8 and 2·0 without any serious disadvantage but, immediately the negative goes beyond these limits,

357

the high frequency wave-forms become considerably distorted owing to image spread or contraction. This is indicated by the rapidity with which the low frequency output increases on each side of the trough of the 1·4 positive density curve in the figure.

The application of cross-modulation analysis to practical work has produced the term *cancellation density*. This refers to the practice of intentionally slightly over-exposing the negative and then slightly under-exposing the positive print. The technique produces a considerable improvement in image sharpness without materially affecting the optimum overall condition.

It is important to remember the great need in practical applications of these methods to keep the fog level to a minimum. Unless this is achieved the volume output will be greatly reduced. Readers must be warned that the densities quoted in this analysis only apply to specific emulsions processed under certain conditions—they do *not* apply to all photographic sound recording emulsions which are suitable for use with the variable-area system.

Chapter 13

Photographic Sound Reproduction

ALTHOUGH magnetic systems are now generally used to make original sound recordings, photographic systems are still usually employed in the cinema release prints. Consequently, this chapter is mainly concerned with photographic sound reproduction but, of course, much of the 'mechanics' designed to ensure perfectly even film movement past the sound reproducer apply equally to magnetic sound reproducers.

The master patent granted to Eugene Lauste in 1907 established the basic principles of both photographic sound recording *and* reproduction, but progress in this field was very slow—in fact, the first commercially successful talking pictures were made by recording sound on discs 16 in. (40·6 cm.) in diameter. To provide sufficient playing time these discs rotated at $33\frac{1}{3}$ r.p.m. and, by starting the recording at the centre of the disc and playing towards the outer rim, relatively simple means ensured reasonable synchronism between sound and picture. Sounds were reproduced from these discs by an electrical pick-up, amplifier and speaker system in a manner similar to that used in cinema 'non-sync' equipment or in present-day record players.

Because of this similarity between the film-and-disc reproduction system and modern record players the principle of these early methods will be familiar to all and need not be considered in detail.

Film reproduction

Modern photographic sound film reproduction follows the general scheme shown in Figure 13.1. For 35 mm. work two identical sets of equipment exist, one in each of the two projectors necessary to maintain a continuous performance. With the exception of the speaker distribution, 16 mm. photographic sound reproduction techniques are similar to those used in 35 mm. equipment. The chain of reproduction begins with the *exciter lamp* which illuminates a very narrow band across the sound track and, therefore, must be maintained at a constant brightness level. On

359

passing through the varying photographic sound track the beam of light is modulated in proportion to the nature of the recording on the track. Film is moved past the beam at a constant speed by one of a number of systems employing rollers, fluid flywheels and other devices whereby film movement may be isolated from any variations in speed set up by other parts of the projector mechanism and, particularly, from the intermittent forward movement created either by a maltese cross or a claw mechanism.

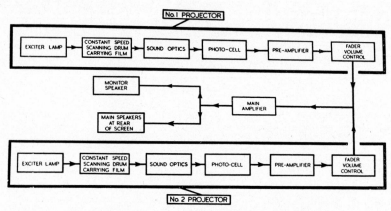

Fig. 13.1. Block Schematic of Sound Reproduction

After passing through the film at this point the now varying light beam is focused by an optical unit on to the *photo-cell*. The *sound optics* must isolate a half of one cycle of the highest recorded frequency on the film and so present to the photo-cell a light varying in intensity and frequency in exact relationship to the variations in the photographic sound record. The photo-cell creates an electrical response in proportion to the amount of light which strikes its surface so that variations in the light beam (caused by variations in the sound track) are converted into electrical energy. Because these electrical variations are initially very small they must first be fed to a *pre-amplifier*, usually situated within the projector sound head. A pre-amplifier strengthens the small signals sufficiently for them to be fed without dangerous loss in signal strength to the *main amplifier* which is invariably some distance from the projector. In many 16 mm. equipments the main amplifier is housed in a cabinet together with the speaker unit.

Before passing to the main amplifiers signal strength may be adjusted by a *volume control* to ensure that the output from both projectors will be balanced at an acceptable level and is sufficient to adequately fill the auditorium. The volume control is also used to adjust the response from sound tracks of different amplitude and thereby to ensure that all films may be reproduced to a matched volume level. Output from the main amplifiers is fed to the speakers—usually at the rear of the screen—and also to a *monitor* or pilot speaker housed within the projection room.

Figure 13.2 shows one of the many different optical systems used in photographic sound reproduction—it is the system known as *rear-scanning*. This name applies to all sound heads in which the film is located *between* the exciter lamp and the scanning slit; when the positions of the film and the slit are reversed the system is known as *front-scanning*.

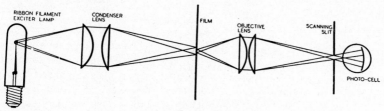

Fig. 13.2. The 'Rear-Scanning' Method of Sound Reproduction

Exciter lamps

The light source is usually a very heavy-duty straight filament lamp, sometimes of the ribbon or solid metal strip variety. The lamps in 35 mm. projectors are frequently connected to a source of direct current—a typical supply being one of 12 volt at a current of 4 amps. Any variations in the brightness of this light source would eventually reach the photo-cell and cause variations in potential across that cell. If the light source should fluctuate at frequencies within the audible range a hum or whistle would be reproduced together with the wanted sounds from the film track. Heavy filaments are always used because they retain brilliance for some appreciable time after the potential has dropped, and also take considerable time to respond to any increase in potential. This inertia to changes in potential tends to damp out any slight variations which might occur in the supply system.

An alternative method, often used by manufacturers of 16 mm. equipment, is to include in the amplifier a frequency generating circuit feeding an alternating current of some 30,000 cycles to the exciter lamp. This frequency, being well above the audible range, does not reproduce in the speaker system and overcomes the need for a D.C. supply to the exciter lamp. The shape of the filament is always a straight line at right-angles to the elevation shown in Figure 13.2 and, in fact, some systems employ this *line-filament* to obtain the scanning slit. Sound volume will naturally fall if the lamp envelope becomes blackened—this usually only occurs after some considerable use. To correct this, and also to provide an immediate replacement in the event of lamp failure during a show, most 35 mm. projector manufacturers fit double holders in the exciter lamp house, one carrying the lamp which is in use and the other carrying a spare lamp previously adjusted to the optical axis of the sound head. This second lamp will come into operation immediately it is swung into position—the action of rotating the mount, to transpose the lamp positions, automatically transfers the electrical supply from one lamp to the other.

In the arrangement shown light from the filament is brought to a small highly intense spot on the film surface by means of a condenser lens. An image of the sound track is formed by the objective lens on to the scanning slit. This slit is of such dimensions that it will isolate one half cycle of the highest frequency required in the reproduction, and is situated just in front of the photo-cell.

The position and size of scanning slits

The size of the effective scanning slit depends upon two factors: firstly the film speed and, secondly, the highest frequency which must be reproduced. The highest recorded frequency on the positive print is usually about 9,000 cycles and, although the amplifiers may *cut-off* below this frequency, it is necessary to resolve a 9,000 cycle note at the scanning head because it will alter the timbre or quality of tone of those lower frequencies which the amplifier does reproduce. One cycle of a 9,000 cycle frequency, at a 35 mm. film speed of 24 pictures per second, occupies a distance of 0·002 in. (0·05 mm.). If the effective slit width is too great high frequency response is lost and distortion is introduced whereas, if the slit width is too narrow, response over the entire range is lowered. Apart from these factors, mechanical considerations place a limit on the size of slit which can be made to any given accuracy. Curves showing the frequency response with slits of various dimensions indicate that the most efficient width is 0·0013 in. (0·033 mm.).

It should be noted that the term *effective slit width* has been used. This draws attention to the fact that *large* mechanical slits may be optically *reduced* to the required dimensions and, therefore, the size of the scanned area need not necessarily indicate the *actual* size of the slit aperture. Figure 13.3 shows three designs which employ different methods to obtain the required narrow aperture in 35 mm. projectors. In design A the width of the exciter lamp filament is 0·013 in. (0·33 mm.) —10 times larger than the required slit width—and high quality condenser lenses project a reduced image of the filament directly on to the film. This image is picked up by the objective lens and transferred to the photo-cell. The difference in intensity between the filament image at the film surface and the diffuse radiation surrounding this image is such that auxiliary masking at the film plane is unnecessary. Specially selected photo-cells must be used with this arrangement to ensure that response due to the relatively low illumination, surrounding the filament image, will be negligible. Although this system appears to be exceptionally simple it suffers from several disadvantages: (1) The exciter lamp filament must be very accurately manufactured and its image must always remain on the optical axis of the lens system. (2) The position of the filament within the envelope, and the accuracy with which lamps may be replaced, must be maintained within close limits. (3) The lamp must either be under-run or so designed that the temperature rise within the envelope will not cause the filament to sag and so fall below the optical axis.

In design B the actual position and size of the exciter lamp filament is not so important since it only provides a relatively diffuse cone of light at the plane of a

362

mechanical slit. This slit can be made ten times larger than the final requirements because an objective lens creates a reduced image of the slit on the film surface. The film follows a path close to the photo-cell but, unless a secondary optical system is used between the film and the cell, this may easily prove inconvenient to the projector designer. A great advantage of this system is that the mechanical slit is quite large and therefore easy to manufacture. It may also be totally enclosed within a unit casting to afford protection from dust, etc. Such an arrangement also

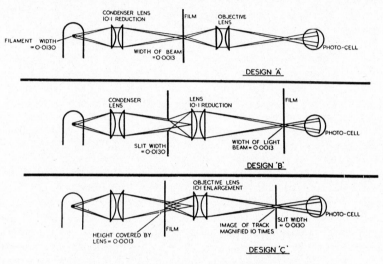

Fig. 13.3. Methods of Sound Track Scanning

ensures that, once the relative distance between the lens and the slit has been carefully adjusted, it will remain fixed and yet still permit easy removal as and when this may be necessary.

In design C the position of the exciter lamp filament is again relatively unimportant since, in conjunction with the condenser lens, it is only used to diffusely illuminate a relatively large area of the sound track. In this arrangement the objective lens throws an enlarged image of the track on to a correspondingly large slit. If, for instance, the field of the objective lens covers a distance of 0·0013 in. (0·033 mm.) on the film, and projects a 10 times enlargement on to the slit, we can then use a slit of 0·0130 in. (0·330 mm.) and still maintain adequate frequency response. This system has the advantage that, because only the slit is required near to the photo-cell, it may be conveniently built into the cell housing. If this arrangement is not convenient a one-to-one objective lens may be used between the slit and the photo-cell in order to place the cell in a more suitable position.

The design of scanning slits and associated optical components for use in 16 mm. projectors is even more critical. To obtain equal frequency response 9,000 cycles

363

must be accommodated within 7·2 in. (18·29 cm.), assuming 16 mm. film is projected at 24 frames per second. This implies that one cycle of a 9,000 cycle frequency must occupy a distance of only 0·0008 in. (0·02 mm.) along the film. Because of this the mechanical slit aperture in 16 mm. projectors is almost invariably made at least 10 times larger than the effective aperture and then optically reduced or, alternatively, a projected image of the sound track is enlarged 10 times on to a correspondingly large mechanical slit.

Although 35 mm. machines are rarely used to project anything but positive prints, 16 mm. machines are frequently used to project direct negatives (particularly in television work), conventional positives, duplicate negatives or reversal materials. The emulsion surface does not face the same direction in all these cases—for example with direct negatives it will face towards the screen in the picture aperture whilst, with positive prints, it faces the light source. Wide-aperture short-focus objective lenses with little depth of field must be used in 16 mm. sound heads and, because of this, they must be capable of adjustment according to the various positions of the emulsion mentioned above. Unless this provision is available the effective image at the photo-cell will be severely out of focus in some cases and both signal volume and frequency response will greatly suffer.

Photo-electric cells

Whereas the motion picture largely depends for its success upon the intermittent mechanism, the reproduction of sound from photographic recordings depends to an equal extent upon the sound optics and, particularly, the properties of photo-electric cells. The operation of any photo-cell is based upon the fact that electrons are emitted from certain metals when a beam of light falls upon their surfaces. The metals used in photo-cells selected for sound film reproduction are chosen because, over a wide range, the degree of emission is proportional to the intensity of the light falling on the cell. We therefore have an instrument capable of converting variations in the photographic sound track into corresponding electrical signals.

The chain of photographic sound recording and reproduction is now complete and the entire process, shown in Figure 13.4, may be briefly stated as follows: (1) Incident sounds, arising from musical instruments, the human voice or any source of vibration, create variations in air pressure. (2) These variations in air pressure cause the diaphragm of a microphone to vibrate in synchronism with them. (3) The mechanical vibrations of the diaphragm are converted into electrical signals, again in proportion to the original air pressure. (4) The electrical signals are amplified and caused to operate a light modulating device. (5) The light modulating device creates either a variable-area or variable-density exposure on a photographic film moving at constant speed past this modulator. (6) After processing and printing, a positive copy of the photographic record of the variations in air pressure is obtained. (7) This positive copy moves through the sound reproducing head at a constant speed, equal to that of the original negative film. (8) A steady beam of light, directed on to the sound track, emerges as a modulating beam

proportional to the original variations in air pressure. (9) This modulating light beam energises a photo-cell capable of creating variations in an electrical circuit (10) These electrical signals are finally amplified and cause mechanical oscillations of loudspeaker diaphragms. (11) The mechanical movement of the speakers creates air pressure waves similar to those caused by the original sounds.

The above chain of events obviously refers to an 'all photographic' system. Since the sound for modern feature films is recorded magnetically stages 4, 5 and 6

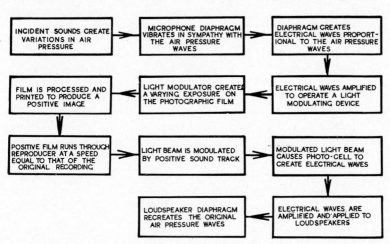

Fig. 13.4. Photographic Sound Recording and Reproducing Cycle

are now normally accomplished in one operation as explained in Chapter 11. Following stage 6 a re-recording operation creates a transfer from the magnetic track on to a photographic negative which is then used to make the print indicated in stage 7 of Figure 13.4.

Photo-electric cells are similar in principle to thermionic valves in that electrons are liberated by the cathode and collected by the anode. However, one essential difference is that, whereas electrons are liberated from the cathode in a radio valve by the action of *heat energy*, they are liberated from the cathode in a photo-cell by the action of *light energy*.

Four main types of photo-cells are available: (1) Photo-emissive cells, or those in which electrons are liberated from the cathode, under the influence of light energy, and are collected by the anode. (2) Photo-conducting cells, or those in which the electrical resistance varies with the illumination. (3) Photo-barrier cells, in which a potential is actually generated under the influence of light energy. (4) Photo-voltaic cells, in which a potential is created on one of two electrodes when both are immersed in dilute electrolytes whilst one electrode is exposed to the light beam.

Only the first group of cells—those known as *photo-emissive cells*—are the type

used in photographic sound reproduction because, over certain narrow bands of the spectrum, they are far more sensitive than the remaining three types. Very few metals can be used to make the cathode in these cells, the most common being sodium, potassium, rubidium and caesium. Sodium is the most sensitive and caesium the least sensitive of these metals. Each one shows maximum sensitivity at different regions of the spectrum, but this can be greatly increased and also spread over a wider colour or wavelength range.

The cells used in sound reproduction may be divided into two further groups; those containing an inert gas and those which operate within a vacuum. Those containing gas have the advantage that the current changes are slightly amplified by the cell itself whereas, in vacuum cells, the current changes consist only of the electrons initially liberated from the cathode due to the light falling upon it. Again, the envelope or bulb containing the electrodes may be either glass or quartz, depending upon the metal chosen as the cathode and also upon the wavelength of the light emitted by the exciter lamp.

The current produced by these cells is extremely small, in some cases needing to be amplified 1,000 times before reaching that of an electrical pick-up used on disc

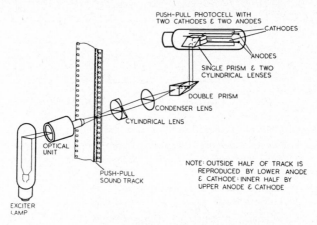

Fig. 13.5. Push-Pull Sound Reproduction

reproducers. Because of this it is essential that the connections between the cell and the pre-amplifier are kept as short as possible; they must also be adequately *screened* to prevent interference from neighbouring electrical circuits.

When dealing with sound recording systems (Chapter 11), mention was made of a method of reducing distortion and increasing final reproducer volume. Known as push-pull recording, this system requires a particular type of photo-cell containing two identical sets of electrodes, as seen in Figure 13.5. By using specially designed optical components each half of the sound track may be fed to its respective section in the photo-cell. As explained previously, the current from the cell then passes to

366

two valves, coupled in parallel, so that effectively more than double the volume range previously obtained by a single cell and sound track will be achieved.

Light-beam conductors

The majority of 16 mm. sound projectors employ sound systems in which the track is scanned as it is wrapped around the speed controlled drum. To achieve this the drum must be relieved at the area immediately below the actual sound

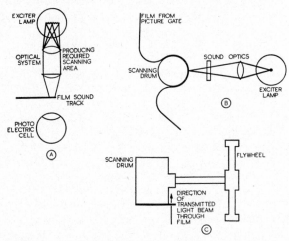

Fig. 13.6. Details of 16 mm. Sound Track Scanning

track so that light may pass through the film. Since the diameter of 16 mm. sound scanning drums is usually quite small, some means of bending the light rays must be employed to direct them to the photo-cell. This point is shown in Figure 13.6. In diagram A light from the exciter lamp is focused to produce an image of the lamp filament at the plane of the film—the light beam does not come to a *point* in the horizontal direction across the film. Theoretically it is then only necessary to place the photo-cell close to the sound track and so collect all the modulating light which is transmitted.

However, the basic layout of equipment must take some form similar to that shown in diagram B. The photo-cell must therefore be placed some distance from the scanning point and not in a direct line with the optical system. It should be noted that, in diagram B, the light beam *is* focused to a point in the plane parallel to the film length—so the highest frequencies will be easily isolated within the scanning beam.

A plan view of the scanning drum, shown in diagram C, indicates the direction of the light passing through the film; clearly the beam must be diverted before it can reach the photo-cell. Although a series of mirrors or very small prisms could

divert the light beam, such arrangements must be rigidly mounted and require very careful adjustment to achieve maximum light output to the photo-cell.

Modern plastics such as Perspex, Lucite, etc., are frequently used to direct light beams to any required position. These materials are used in rectangular or square section and depend upon the fact that all the light introduced at one end of the *rod* undergoes total internal reflection and, consequently, a very high percentage must emerge at the opposite end of the rod. Both ends are finished 'square' with the main body of the material and are easily polished to an optical-smooth surface. These plastics may be readily bent in boiling water to any required shape so that a *pipe* of material may follow the shortest convenient path from the scanning point to the photo-cell.

Assuming a photo-cell is placed directly behind a small aperture some known distance from a light source and, in this position, the light transmission is considered to be 100 per cent. The introduction of a parallel plate of Perspex, 0·375 in. (9·252 mm.) in thickness, between the aperture and the photo-cell, only reduces transmission to 90 per cent. If a similar *rod* of Perspex 10 in. (25·4 cm.) in length is placed between the aperture and the photo-cell, transmission will only fall to 65 per cent. When this same rod is then bent to a radius of 1·0 in. (25·4 mm.), and turned through a right-angle at a point mid-way along its length, transmission is reduced from 65 per cent. to 57·5 per cent. One can therefore bend a rod to any required shape to pass round the shaft and bearings which support the sound scanning drum. Such a rod enters the cavity between the film and the drum support below the point where the light beam passes through the film.

Since the final transmission through a bent rod increases as the length of the rod is reduced, the number of bends should be kept to a minimum and the degree of bending should be as low as possible. Because the light has only to be introduced into the rod to ensure that it will be transmitted to the photo-cell, it need not be mounted with the same precision as would be necessary if mirrors or prisms were used for this purpose.

Film drive at the scanning point

Obviously, film must move past the light-beam at a perfectly uniform speed to ensure that the pitch of the reproduced sound remains constant. The two errors most commonly due to mechanical imperfections in this respect are known as *wow* and *flutter*. Wow is a uniform or cyclic variation about the average speed—causing a steady rise and fall in the reproduction of a constant frequency—whereas flutter is a random variation in speed not directly associated with regular changes in the driving mechanism.

The photo-cells previously described can respond to changes in light intensity well above 9,000 cycles per second. The film speed past the scanning point in 35 mm. projectors is 18 in. (45·7 cm.) per second; a variation in speed of only 1 per cent. would cause a constant 6,000 cycle frequency on the sound track to be reproduced with a rise and fall between 6,060 and 5,940 cycles per second, and would

be readily detected by the average listener. Wow and flutter are measured with specially prepared constant-frequency test films as a routine maintenance operation because, apart from the obvious effect on the reproduction of sustained musical notes, film speed variations also reduce the intelligibility of recorded speech.

Figure 13.7 shows one of the early arrangements designed to maintain constant film speed past the scanning point. The left-hand diagram shows a side elevation

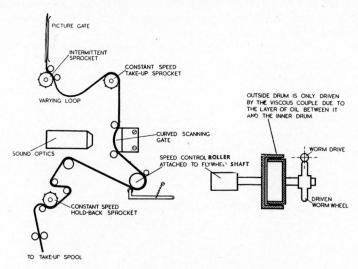

Fig. 13.7. A Constant Speed Scanning Device

of part of the projector mechanism between the picture gate and the take-up spool. Film is drawn intermittently through the picture gate by a sprocket wheel driven via a maltese cross mechanism. It is then formed into a free loop between the intermittent sprocket and the constant speed take-up sprocket. From this point film passes over the curved *scanning gate*, where it is guided by two small rollers. This stationary scanning gate carries an aperture through which light from the *sound optics* may pass to the photo-cell. The film is then wrapped around an accurately mounted speed-controlling roller, driven by the fluid-flywheel shown in the right-hand diagram. After passing a series of damping rollers, the film is fed to the take-up spool by a constant speed hold-back sprocket.

This system depends upon the film being drawn through the scanning gate by the speed control roller; it is therefore essential that this roller rotates at a *constant* speed. The normal projector gear-train, or a direct coupling to the motor, causes the worm drive to rotate a worm-wheel solidly connected to a large circular drum, shown in section. The outer periphery of this drum is fitted *within* a second hollow drum so that a small clearance exists between the two. A particular oil, selected for its viscosity and resistance to changes of temperature, forms a coupling medium

between the two drums—no mechanical or other connections exist between their faces. The outer and larger drum is heavily built and acts as a flywheel. It is solidly connected to a second shaft carrying the speed control roller.

The combined action of the flywheel drum and the viscous couple to the driven mechanism cause the control roller to become very resistant to changes in speed. In consequence almost all the small variations in driving speed—caused by the electrical supply, inaccuracies in cutting the gear teeth or irregular frictional loads in the bearings—are eliminated from the control roller and film is drawn at a constant speed through the scanning gate.

Figure 13.7 shows that a considerable mechanism, occupying a relatively large area, is necessary to produce constant film speed at the scanning point. In any sound projector the film itself must pass through two completely opposite mechanical conditions: when travelling through the picture gate it moves forward in a series of rapid intermittent motions interrupted by periods when it must remain absolutely stationary and yet, before reaching the sound scanning point, this intermittent movement together with any inaccuracies in the projector gearing, must be completely eliminated and replaced by constant perfectly smooth forward movement.

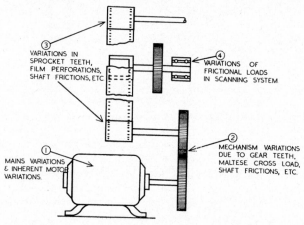

Fig. 13.8. Sources of Error in Sound Film Drives

The intermittent load on the maltese cross mechanism must cause variations in friction between the teeth of the gear wheels which drive this cross and, to some extent, these changes will be transmitted throughout the entire machine. Modern equipment and design have produced gears cut to exceptional accuracy and so shaped that these small changes in loading pass almost unnoticed. Further assistance towards constant film speed is provided by the use of heavy-duty motors and some form of flywheel system.

The possible sources of speed variations in the basic arrangement of film driving mechanisms is shown in Figure 13.8 and may be classified as follows:

(1) The electrical supply to the driving motor may be subjected to irregular surges which cause motor speed variations at frequencies higher than the fundamental surge frequency. (2) The two most serious irregularities which may be transmitted to the sound scanning point are the tooth frequency of the sprocket wheels (which is, of course, a 96 cycle note), and the varying load transmitted through the gears from the intermittent picture mechanism at a frequency of 24 cycles per second. (3) Small variations in the cutting of teeth in the gear train and also variations in the friction between these teeth. (4) Variations in friction between the bearings of the scanning drum and flywheel shaft.

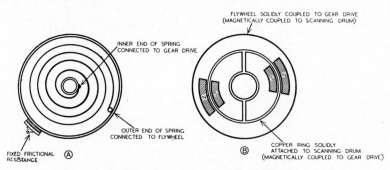

Fig. 13.9. Constant-Speed Film Drives

Figure 13.9 shows two further systems designed to create constant film speed at the scanning point. That shown at A depends upon the balance of rotational forces between the energy imparted by a coil spring and the resistance of a frictional brake applied to the periphery of the flywheel. The flywheel is solidly coupled to the scanning drum but is only connected to the driving mechanism by the large coil spring—one end of which is attached to the face of the flywheel. The opposite end of the spring is attached to the centre of a shaft solidly connected to the main driving mechanism. The only connection between this shaft and the flywheel is through the coil spring. When in a state of balance the spring is always slightly compressed, due to the braking action of the fixed frictional pad applied to the flywheel. This slight compression provides a reservoir of power to accommodate changes in driving load from the mechanism.

The design shown at B depends upon a magnetic couple between the pole pieces N and S and the copper ring which passes between them. The pole pieces and the flywheel are solidly coupled to the main driving mechanism. The copper ring, supported by a central hub, is solidly coupled to the scanning drum, but the only connection between this and the flywheel is by the magnetic couple between the ring and the pole pieces. The magnetic couple operates in much the same manner as a viscous drive in which the power is transmitted from one member to another by virtue of the viscous properties of the oil.

Two methods of driving film at the scanning point of 16 mm. projectors are

371

shown in Figure 13.10. In diagram A the film is moved intermittently through the picture gate by a claw mechanism and is then formed in a relatively large free loop until it is constrained by spring-loaded edge-guides to pass over the curved surface of a stationary scanning gate. This gate is relieved over the central area to avoid damage to the picture image. Film is pulled through the gate by means of a constant-speed drum; contact between the drum and the film over a large area providing

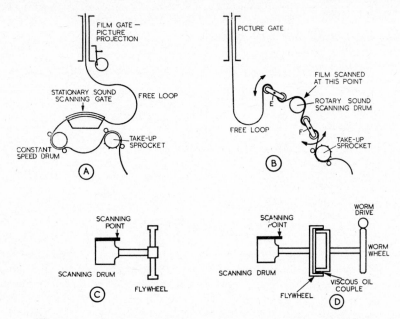

Fig. 13.10. 16 mm. Sound Film Transport at the Scanning Point

sufficient power to overcome the friction in the scanning gate. The film then passes over the usual take-up sprocket and so to the take-up spool. Threading guide lines assist the operator to maintain free loops of the correct size each time a new film is laced in the machine.

When projection commences film between the drum and the take-up sprocket is pulled taut by the sprocket itself and the drum is thereby caused to rotate. This drum is mounted in very free bearings and is attached to a shaft carrying a heavy flywheel. As the machine gathers speed the flywheel attains sufficient momentum to pull film through the scanning gate at a relatively uniform speed. If teeth on the take-up sprocket wheel are inaccurately cut, or if drive to this wheel is not perfectly uniform, it will tend to move the film forward at an uneven speed. When this occurs the flywheel will over-run the sprocket if it tends to slow down, or resist acceleration should the sprocket tend to impart a momentary increase in film speed.

This design has the disadvantage that scratches may easily occur as the film is

pulled through the scanning gate unless the gate-runners are very highly polished and carefully maintained. The design shown at B, Figure 13.10, overcomes this objection by actually scanning the film at a point where it is in contact with the rotating drum. The drum is again driven at a uniform speed by means of a heavy flywheel but, in some cases, two pairs of spring-loaded jockey rollers—shown at E and F—are provided to accommodate any *flexing* in the film path due to uneven motion of the take-up sprocket or slight variations in the film itself.

It will be obvious that, since the light beam must pass through the film at the point where scanning takes place, the drum must not be equal in width to the film itself; in fact it must be undercut as shown in diagram C. Since the film is curved around the drum to a fairly small radius, it may *overhang* the scanning drum without fear of moving in or out of the true focal plane of the optical system.

It is as well to point out at this moment that the design and layout of scanning systems—and the apparatus used to ensure constant film speed at the scanning point—remains identical both for photographic *and* magnetic sound reproduction. The only difference caused by magnetic reproduction is that the pick-up head is in physical contact with the magnetic coating at the point where the sound is reproduced.

Sound lead ahead of picture

The two essential functions of any sound projector are (1) That it will move film intermittently at a rate of 24 pictures per second (or 25 pictures per second for most television systems) through the picture gate and, (2) that it will then replace this intermittent motion by a perfectly uniform forward movement at the point where the sound is reproduced. The actual mechanism used to convert one form of motion into the other varies from one machine to the next but, in all cases, a considerable film path must exist between the picture and sound apertures. It is therefore important that this distance shall be standardised to ensure that all films are printed with the relevant photographic sound an agreed distance ahead of the corresponding picture image. Magnetic sound on combined 35 mm. release prints is in a different position—because the magnetic reproducing head is *above* the picture head in 35 mm. projectors. The picture is therefore printed ahead of the corresponding magnetic sound.

So that all films may be reproduced in synchronism on all 35 mm. projectors a standard film distance of 20 frames is specified between the picture and photographic sound apertures. This means that, when a given photographically recorded sound is located in the sound gate, the corresponding picture is printed 20 frames further into the roll of film; in other words, the sound is printed *ahead* of the picture.

The standardised photographic sound lead for 16 mm. films is such that the sound which is scanned at any given instant shall be in true synchronism with a picture located 26 frames behind that sound, that is, the sound is printed 26 frames ahead of the picture. This sound lead, in terms of the number of *frames* it is in

373

advance of the picture, is therefore greater for 16 mm. than for 35 mm. films. However, since the height of the 16 mm. frame is considerably less than that of a 35 mm. frame the actual lead, in linear measure, is smaller in 16 mm. than in 35 mm. films. The sound lead in 16 mm. films is approximately 7·8 in. (19·8 cm.) whereas the corresponding lead in 35 mm. films is approximately 15·0 in. (38·1 cm.).

The speaker and horn system

Having obtained a constant film speed, a constant exciter lamp source and a photo-cell to reproduce the photographic sound track, we can feed to the main amplifier

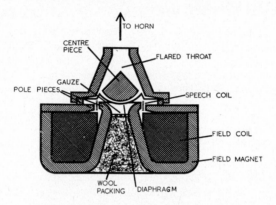

Fig. 13.11. A Typical Theatre Speaker

an electrical signal which is as nearly as possible a faithful reproduction of the original record. Since the theory of radio amplification is well known and readily available for those who are interested in its details, particular circuits will not be discussed at this stage. Assuming a sufficiently strong signal is produced to operate the speakers, we can consider the final stage in sound reproduction. Loudspeakers are electro-acoustic instruments designed to transform electrical signals into acoustic sounds. Present-day speakers are of the electro-dynamic type and operate in conjunction with either a diaphragm or cone. A typical speaker unit is shown in Figure 13.11.

In this design the diaphragm is formed from an aluminium alloy less than 0·002 in. (0·050 mm.) thick and curved or dished rather like a hemisphere. This curvature increases the strength of the diaphragm and allows the outer edges to oscillate in response to impulses from the speech coil whilst the centre remains stationary. The speech coil consists of an aluminium tape wound edge-wise as shown in the figure, and free to oscillate in the air-gap between the pole pieces. The flared throat, connecting the speaker with the horn, is so designed that vibrations from the inner and outer sections of the diaphragm reach the neck of the horn in

correct phase relationship. The rear of the diaphragm is closed by a gauze and wool packing to reduce back pressure from air pulses on that side. Excessive back pressure could set up further sound waves which would be out of phase with those at the front of the diaphragm.

Where low output is required, such as in a radio receiver, the speaker unit may be directly mounted to a heavy baffle board but, for the much greater output required in theatres, the speaker must be mounted behind a correctly designed horn unit. The size and shape of theatre horns are of great importance if high fidelity reproduction is to be achieved. The most efficient shape is an *exponential curve* which means, very briefly, that the cross-sectional area of the horn is doubled for every 18 in. (45·7 cm.) of its length. The length of the horn should be at least equal to the longest sound wave it must reproduce. For example, a frequency of 70 cycles per second has a wavelength of approximately 15 ft. (4·6 metres) and, therefore, the effective length of a horn required to reproduce such a note faithfully should also be 15 ft.

However, such a horn need not be built in one straight length; it may be coiled around itself in a number of ways but, in all cases, the curvature should be as little as possible. The relatively high frequencies, such as those above 4,000 cycles, are often best reproduced from speakers with shorter horns and it is usual to install both the large, low frequency reproducers, and also smaller high frequency units, usually affectionately known as *tweeters*!

The sound screen

The banks of speakers are usually mounted near to the centre of the screen, each one being at a different angle to a centre line down the auditorium, and arranged to ensure balanced volume over the seating area. In the early days speakers were often placed just below the screen in what used to be the orchestra pit. It soon became obvious that such a position was unsatisfactory and, in consequence, the screen itself became the subject of much experiment. Sound screens now serve the dual purpose of reflecting light and also transmitting sound. If the screen presents an unbroken surface to the sound pressure waves it will vibrate as an enormous diaphragm—producing new pressure waves which partially combine with and partially destroy the original waves from the speakers. Because of this it became necessary to provide small openings throughout the entire screen surface and through which the sound from the speakers could pass quite freely.

Naturally, any apertures cut in the screen must reduce the effective brightness of the picture. It is quite possible to cut a series of small apertures over the entire screen surface without making them so big or so close together that the audience will see them but, in any event, they will certainly reduce screen brightness. The most efficient sound screen is therefore a balance between the size and distribution of the apertures necessary to ensure good sound reproduction, and the maximum definition and brightness tolerances which may be permitted before picture quality becomes seriously affected.

375

Two main types of perforated screen exist; those manufactured in soft rubber, and carrying perforations moulded to approximately 0·05 in. (1·27 mm.) in diameter, and those which are woven so that the threads are held apart at intervals to produce a series of apertures throughout the material. Both rubber and woven screens require constant attention and cleaning to ensure that dirt does not accumulate within the apertures and so reduce sound volume. When dirt has been allowed to block up the perforations the screen virtually becomes solid material and will then vibrate with the air pressure from the speakers. If this occurs two defects become apparent; firstly sound volume decreases and, secondly, that volume which does remain is distorted and most of the high frequency response is lost. It is also true that the picture surface will by this time have become very poor, but a slow decrease in screen brightness is not so noticeable as a corresponding decrease in sound quality.

Theatre acoustics and echo

Having produced the sounds within the auditorium, we must now consider the acoustic design of this building. Undoubtedly the most noticeable trouble which may

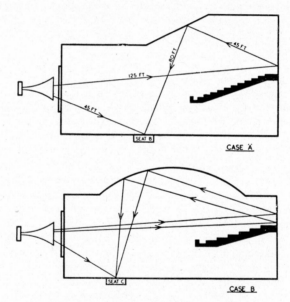

Fig. 13.12. Causes of Echo in Auditoria

occur in any theatre is that of echo. Sounds are reflected from large flat surfaces just as light is reflected from a mirror. In Figure 13.12 'Case A' shows the simple condition of a single echo due to reflections. A person seated in position B will receive incident sound from a speaker at a distance of 45 ft. (13·7 metres). The

same sound will travel 125 ft. (22·86 metres) to the rear wall, be reflected upwards, and travel a further 45 ft. (13·7 metres) to hit the inclined roof, then be reflected downwards and travel a further 80 ft. (24·38 metres) before it again reaches the listener in position B. Thus, the incident sound travels 45 ft. (13·7 metres) directly from the speakers, whilst the reflected sound travels a total of 230 ft. (70·1 metres) before reaching the same point. A listener in seat B would therefore hear an echo just under a quarter of a second after he heard the original sound, and such a time-lag would render speech quite unintelligible.

The analogy between light and sound may now be carried a stage further. We know that light will be reflected in straight lines from a mirror surface and that, if this surface is then frosted or ground, the reflection will be scattered or diffused. In just the same manner reflected sounds may be diffused by breaking up the surface of the walls and ceiling of the auditorium with artistic mouldings and plaster work. Alternative methods are to hang sound absorbing materials, such as heavy velvet curtains, at the points of reflection, or to line the walls with any of the well known sound absorbing materials.

In 'Case B', Figure 13.12, the condition is rather more unfortunate since a listener in position C will not only hear an echo, but the echo will be a concentration of sound reflected from the domed roof. Sound is reflected from a smooth curved surface in the same manner that light is reflected and focused by a curved mirror. If the hall is relatively short, and the time required for an echo to reach the listener is therefore reduced, it may serve to reinforce the original sounds and give the impression of extra volume or, if it arrives out of phase with the original, it may counteract that sound and so reduce volume. This will depend upon the relative distances between the original sound and the reflected sound. If the reflected sound arrives at the listening point in phase with the original, it will reinforce the volume. If reflected sound arrives out of phase with the original they will cancel each other out and produce a *dead spot* in the auditorium.

Another important characteristic of sound reproduction is known as the *time of reverberation*. It should be remembered that as any note leaves the speaker it travels outwards until it strikes an enclosed surface. Part of the energy is then absorbed and the remainder is reflected to continue travelling in a new direction until it again strikes another object. This process continues until all the sound energy has been absorbed. The time of reverberation is the time required for the sound to completely die away. Actually the accepted measurement of reverberation is the time required for a sound to fall to one-millionth of its initial volume.

A certain degree of reverberation is essential since, if all notes died away immediately, they would sound very dead and would fall without any bounce or brilliance. Conversely, too much reverberation blurs the reproduction and produces a rumbling effect known as woolliness. An optimum condition must be obtained, and this will depend upon the size of the auditorium, its decorations, and the number of people it is designed to accommodate.

Theatres are designed to produce approximately equal sound quality both when they are filled with people and when only a few seats are occupied. The

377

quality of seating and, particularly, the sound absorbing properties of the upholstery, are designed to be as nearly as possible equal to the sound absorbing qualities of persons sitting on these seats. It is rather a sad thought to realise that the delightful cushions in some theatre seats are really designed for our hearing comforts and not our physical ease!

Sound fading

The change-over from one projector to the other, in order to maintain a continuous performance, must take place without any peculiar noises because the input to the main amplifier is transferred from one pre-amplifier to another. This is ensured by using a sound fading device consisting of two potentiometers, connected in parallel, and each controlling the volume from one sound head. Both units are *ganged* together to operate from a single control knob. Should the wiring break or burn out, an automatic auxiliary resistance is immediately brought into service to maintain a constant volume, corresponding to the centre step in the fader-setting scale.

Most sound films contain printed instructions indicating the correct fader setting to use when running that film. For instance, the leader may contain the statement 'Play sound 8 or 9 db above M.G.M. average'. This indicates to the operator that, assuming he has been told the average fader settings to use with M.G.M. tracks in his theatre, he must run this particular print with the fader set above this average. The steps on the fader are not all of equal value; there is a 12 db difference between steps 1 and 2, a 6 db difference between steps 2 and 3 and also between 3 and 4; all other steps cause a difference of 3 db. Assuming the normal setting is step 9, this must be increased to step 12 when running a print requiring 8 or 9 db above this average. The fader is so designed that rotating the control in one direction reduces the volume from one machine to zero and then increases the volume from the second machine. If, therefore, the first reel is to be played at step 9 whilst the second must play at step 12 (admittedly a very unusual print!) the operator must move the fader from position 9 on the one half of the scale smoothly down to zero and then up to setting 12 on the opposite half of the scale, and this should be done at the moment when two machines are changed over.

Having mentioned decibels once more, it may be wise to refresh our memory regarding these units. As we know, air pressure waves are created by sounds and, if we consider two sounds the first of which produces a pressure of 10 units, whilst the second produces a pressure of 100 units, we shall realise that one is considerably louder than the other. The difference in volume will *not* be in the ratio of 10 to 100, but in the ratio of their logarithms. Since the logarithm of 10 is 1, and that of 100 is 2, the difference in volume is as 1 is to 2. Such a difference is known as a *bel*. This is quite large and the more practical unit is the *decibel*—which is 1/10th of a bel.

If a constant frequency sound is gradually increased in volume from a whisper to an enormous blast, the response of the ear will pass through two definite stages. Firstly, when the ear can just detect the sound, the point known as the *threshold of audibility* is reached. As the volume increases the sound will become quite painful

to the ear until the point known as the *threshold of feeling* is reached. Between these two points there will be a difference in volume of approximately 160 db, depending upon the age and health of the observer, and the pitch of the sound. An average person is able to detect a change in volume of 1 db. We can thus appreciate that a change of 8 or 9 db, or 3 points on the fader setting, will make quite an appreciable change in the volume of sound in the auditorium.

The monitor speaker

Since the control of auditorium volume is obviously important it is rather unfortunate that the monitor speaker, usually situated in the operating room, cannot be used to judge the actual conditions within the auditorium. This speaker is normally wired to the output of the main amplifiers but is provided with an independent volume control. It is intended to help the operator to hear the sound reproduction and to check that it is synchronised with the picture and, in fact, is *coming through* at all! Because of this the monitor speaker must be tapped into the circuit at the latest possible stage, since it is then most unlikely that the monitor will function when the stage speakers are silent, due to some electrical fault.

In some theatres an auxiliary main volume control is located within the auditorium, and is adjusted by an observer under the correct listening conditions. Another method provides a signal system between the auditorium and the operating room whereby an observer may indicate the need for volume adjustments. Usually both systems are unsatisfactory unless operated by skilled observers and it is a much better practice to make initial tests of the best conditions, and then to adjust the fader setting according to the instructions printed on the leader of each film.

Factors affecting sound quality

We can now consider the probable causes of poor sound reproduction from a film known to contain a first-class track. These may be briefly stated as follows: (1) The sound reproducing equipment. (2) Adjustment of the sound system. (3) The screen. (4) The theatre acoustic conditions. (5) Maintenance of the sound system. We have seen that the reproducing equipment must be capable of an adequate volume range for the auditorium it is serving. In the early days an output of 12 watts was thought to be quite sufficient—the latest installations are capable of delivering over 150 watts of undistorted power and, for realistic effects which cover the entire volume range from a whisper to a full battle scene, this range is considered necessary.

In this connection it is interesting to note the following specification concerning theatre presentation, issued by The Society of Motion Picture & Television Engineers and The Academy of Motion Picture Arts & Sciences: (1) A volume range of from 50 to 60 db. (2) A frequency response from 50 to 10,000 cycles per second. (3) The stage loudspeakers to have a high degree of efficiency so that the amplifier capacity need not be too great. (4) The speaker system to have correct

angular distribution so that all frequencies are properly distributed throughout the theatre. (5) The sound head to have a flutter-content imperceptible to the ear.

The next probable cause of poor reproduction is incorrect adjustment of the sound system. This statement covers the sound optical system, the scanning system, the setting of the amplifier response characteristics and also loudspeaker maintenance. In this connection the above two organisations provide a sound test reel containing selected recordings made by all the major Hollywood studios. It is therefore possible to adjust the equipment to give the maximum average quality for all types of release prints.

A further cause of poor reproduction is the quality of the screen and, as we have seen previously, this may be due to the incorrect size and number of perforations, or it may be due to the thickness of the material used. The most common cause of trouble with a screen which was initially quite good is usually because it has been resurfaced, to improve picture quality, and the perforations have become closed up during the process!

A less likely cause of poor reproduction is bad theatre acoustics. These may include a high reverberation time, echo, resonance and parasitic noises due to auxiliary equipment (such as the operation of curtain motors and air-conditioning plants). With new theatres, designed by architects who specialise in sound film reproduction, many of these defects are eliminated. The present tendency is towards co-ordination between the acoustic treatment of the auditorium and the lighting arrangements, the decorations, the air-conditioning, etc. The architect is therefore able to arrange all these services conveniently, and also in such a manner that they assist in producing the best acoustic results.

Finally, it is important that, once having obtained the best possible reproduction, regular servicing and inspection should be carried out to ensure that this condition is maintained. Sound quality normally falls off slowly and may therefore remain unnoticed unless actual measurements are made. The many delicate adjustments both to the sound head and the amplifiers require that all projection staffs should be supplied with the necessary measuring instruments, flutter indicators and the standard sound test film with which to check their adjustments, and to compare the results with those previously obtained.

Buzz-track test films

Various service test films are available for the chief operator to check the projection equipment. One of the simplest and yet most helpful of these is shown in Figure 13.13. A specially prepared track is used to adjust the position of the scanning beam in the reproducer head and to indicate in which direction such adjustments should be made. Considering the 35 mm. film shown on the left of the figure, the recommended width of the scanned area is 0·084 in. (2·144 mm.), and the distance measured from the guided film edge to the centre of the track should be 0·243 in. (6·272 mm.). The control track, or *buzz-track*, suitable for adjusting the reproducer to these dimensions is seen below the film sample at position A. The clear area, 0·088 in.

(2·235 mm.) in width and having its centre 0·243 in. (6·272 mm.) from the guided film edge, represents the dimensions of the scanned area of a perfectly printed track, plus a clearance of 0·002 in. (0·050 mm.) on each side. This clearance is provided to accommodate film weave and printing tolerances.

A 300 cycle constant frequency note is recorded on one side of this clear area and a 1,000 cycle note is recorded on the other side. When such a track is passed through a reproducer a signal will only be heard if the scanning area is misplaced

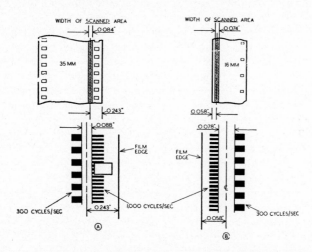

Fig. 13.13. Scanning Area Centred by Buzz-Track Control System

with respect to the film. The nature of the signal will, of course, indicate the direction in which the guide shoes in the scanning gate should be moved in order to correct the misplacement. The dimensions and arrangement of a similar buzz-track for use when adjusting 16 mm. sound projectors is shown in position B, Figure 13.13.

16 mm. projector standards

When it is remembered that 16 mm. projectors must pass tests as rigid as those applied to 35 mm. apparatus, it is not difficult to realise the important position which 16 mm. films now hold within television and the cinema industries. The following requirements are based upon the American Standards Association specification No. Z.52.1–1944 and indicate the high degree of efficiency expected from 16 mm. equipment. Incidentally, this specification is based on the famous 'JAN-SPEC' known during the second world war by all those seeking to satisfy the American Forces with 16 mm. projection equipment—the title being derived from 'Joint Army and Navy Specifications'.

(1) The mechanism which moves film through the picture gate should operate at 24 pictures per second (25 for television) and remain within 0·75 per cent. of this speed—it should also transport films containing two consecutive damaged perforations. (2) All sprocket wheels, rollers and guiding shoes should be so designed that neither the picture or sound track areas of the film come into contact with stationary parts which could cause scratching after they become worn. (3) All projectors should be fitted with power-operated rewinding mechanisms capable of rewinding a full 1,600 ft. (487·7 metres) reel of film within 4 minutes. (4) Framing the picture accurately within the projecting aperture must be accomplished without moving the overall picture position on the screen—that is, so-called *optical framing* must be used. (5) The projection lens should be provided both with coarse and fine adjustments to obtain critically sharp image definition. (6) The projection lens should have a minimum resolving power of 90 lines per millimetre at the centre of the field, and no less than 40 lines per millimetre at the four corners of the field. (7) The shutter should only interrupt the light beam twice during the projection of each frame and the duration of the light and dark periods should be carefully balanced. (8) The diameter of the shutter should be as large as possible, and the picture aperture should be as far from the shutter centre as possible. (9) The screen picture should remain substantially free from unsteadiness and, when unsteadiness can be traced to the mechanism, it should not exceed 0·3 per cent. of the picture width. (10) Any mechanism should be capable of projecting a new film—the perforation pitch being no less than 0·3 per cent. below the recommended standard—for at least 1,000 showings without picture damage or defects in sound reproduction.

Turning now to the requirements of 16 mm. sound reproduction, the following points are of special importance. (1) The mechanical noise created by the projector gearing, both with or without film passing through the machine, should be at a minimum and, preferably, some efficient *blimp* should enclose most of the machine during operation. (2) Film movement past the scanning point should be so uniform that wowing or flutter remain below 0·35 per cent. with a constant frequency test track of a 3,000 cycle signal. (3) The photographic sound scanning beam should measure 0·070 in. by 0·0005 in. (1·778 mm. by 0·0127 mm.) at the film surface, or if a track magnifying system is used, proportional measurements should exist at the scanning aperture. (4) The intensity of the scanning beam should remain uniform throughout the scanning aperture. (5) Film movement past the scanning point should be such that lateral movement greater than plus or minus 0·002 in. (0·050 mm.) cannot occur, and so that the track remains symmetrically positioned about the scanning aperture. (6) The optical system forming the scanning slit at the film surface should be adjustable so that critical focus may be obtained on either the front or rear surface of the film. (7) The scanning aperture should remain at right-angles to the direction of film travel within plus or minus 10 minutes of arc.

In concluding not only this chapter—but the entire book, it seems particularly fitting to repeat the statement made at the introduction of Chapter 10: 'The whole motion picture Industry depends for its success upon an ability to entertain the public—and the Industry only meets its public in the cinema.'

Bibliography

ABBREVIATIONS

Acad. Mot. Pict. A. & Sc. Academy of Motion Picture Arts & Sciences
Amer. Cine. American Cinematographer
Int. Phot. International Photographer
J. Acous. Soc. Amer. Journal of the Acoustics Society of America
J.B.K.S. Journal of The British Kinematograph, Sound and Tele-
 vision Society
J.S.M.P. Journal of The Society of Motion Picture and Television
 Engineers

ACADEMY OF MOTION PICTURE ARTS & SCIENCES

Projects of the Committee on Standardisation of Theatre Sound Projection Equipment Characteristics. J. K. Hilliard. *Acad. Mot. Pict. A. & Sc.*, vol. 30, no. 1, p. 81. (1938)
Notes on the Procedure for Handling High-volume Release Prints. J. K. Hilliard. *Acad. Mot. Pict. A. & Sc.*, vol. 30, no. 2, p. 209. (1938)
Academy Standard Fader Setting Instruction Leader. *Acad. Mot. Pict. A. & Sc.*, vol. 30, no. 2, p. 215. (1938)
Suggested Standard Nomenclature for Release Print Soundtracks. J. K. Hilliard. *Acad. Mot. Pict. A. & Sc.*, vol. 30, no. 6, p. 656. (1938)
Recommendations on Process Projection Equipment. Research Council. *Acad. Mot. Pict. A. & Sc.*, vol. 32, no. 6, p. 589. (1939)
The Motion Picture and International Enlightenment. W. F. Wanger. *Acad. Mot. Pict. A. & Sc.*, vol. 45, no. 2, p. 76. (1945)

ACCESSORIES Camera, etc. *See under* Camera Accessories, etc.

ACOUSTICS

General

Absolute Amplitudes and Spectra of Certain Musical Instruments, L. J. Sivian *et al.*, *J. Acous. Soc. Amer.*, vol. 2, no. 3, p. 330. (1931)
Measurements with a Reverberation Meter. V. L. Chrisler and W. F. Synder. *J.S.M.P.*, vol. 18, no. 4, p. 479. (1932)
Acoustical Requirements for Wide-range Reproduction of Sound. S. K. Wolf. *J.S.M.P.*, vol. 22, no. 4, p. 242. (1934)
Modern instruments for Acoustical Studies. E. C. Wente. *J.S.M.P.*, vol. 25, no. 5, p. 389. (1935)

Principles of Measurements of Room Acoustics. E. C. Wente. *J.S.M.P.*, vol. 26, no. 2, p. 45. (1936)

Analysis of Sound Waves. H. H. Hall. *J.S.M.P.*vol. 27, no. 4, p. 396. (1936)

Transmission of Sound and Vibration in Buildings. E. Meyer. *J.S.M.P.*, vol. 28, no. 3, p. 271. (1937)

Recent Progress in Acoustics. V. O. Knudsen. *J.S.M.P.*, vol. 29, no. 3, p. 233. (1937)

Interference Effects in Rooms. M. Rettinger. *J.S.M.P.*, vol. 29, no. 6, p. 635. (1937)

Some Production Aspects of Binaural Recording for Sound Pictures. W. H. Offen-hauser, Jr. and J. J. Israel. *J.S.M.P.*, vol. 32, no. 2, p. 139. (1939)

A Compact Direct-reading Reverberation Meter. E. S. Seeley. *J.S.M.P.*, vol. 37, no. 6, p. 557. (1941)

The Acoustical Properties of Fibreglass. W. M. Rees. *J.S.M.P.*, vol. 46, no. 1, p. 52. (1946)

Sound Absorption and Impedance of Acoustical Materials. H. J. Sabine. *J.S.M.P.*, vol. 49, no. 3, p. 262. (1947)

Acoustical Factors in the Design of Motion Picture Equipment. H. C. Hardy. *J.S.M.P.*, vol. 50, no. 2, p. 139. (1948)

Behaviour of Acoustic Materials. R. K. Cook. *J.S.M.P.*, vol. 51, no. 2, p. 192. (1948)

Quieting and Noise Isolation. E. J. Content. *J.S.M.P.*, vol. 51, no. 2, p. 184. (1948)

Auditory Perspective—A Study of the Biological Factors Related to Directional Hearing. H. G. Kobrak. *J.S.M.P.*, vol. 57, no. 4, p. 328. (1951)

Pulse Methods in the Acoustic Analysis of Rooms. J. Moir. *J.S.M.P.*, vol. 57, no. 2, p. 147. (1951)

Broadcast Studio Redesign. L. L. Beranek. *J.S.M.P.*, vol. 64, no. 4, p. 550. (1955)

Noise-Level Reductions of Barriers. M. Rettinger. *J.S.M.P.*, vol. 66, no. 1, p. 391. (1957)

Cinema Theatre Acoustics. M. Rettinger. *J.S.M.P.*, July 1964, p. 566.

Cinema Theatre Design—a Symposium. G. G. Graham *et al.*, *J.S.M.P.*, March 1966, p. 161.

Acoustic Design Factors for Wide-Screen Theatres. M. Rettinger. *J.S.M.P.*, September 1968, p. 894.

Sound Recording. See under Sound Recording Acoustics.

Theatre. See under Theatre Acoustics.

AIR CONDITIONING

Air Conditioning as Applied in Theatre and Film Laboratories. D. C. Lindsay. *J. S. M. P.*, vol. 11, no. 30, p. 334 (1927)

Air Conditioning in Film Laboratories. A. H. Simonds and L. H. Polderman. *J.S.M.P.*, vol. 17, no. 4, p. 604. (1931)

Silica Gel Air Conditioning for Film Processing. E. C. Holden. *J.S.M.P.*, vol. 18, no. 4, p. 471. (1932)

Air Filtration in the Production of Motion Pictures. H. C. Murphy. *J.S.M.P.*, vol. 26, no. 6, p. 637. (1936)

Use of Silica Gel in Air Conditioning. J. C. Patterson. *J.S.M.P.*, vol. 27, no. 5, p. 545. (1936)

A New Electrostatic Air Cleaner and its Application to the Motion Picture Industry. H. Gitterman. *J.S.M.P.*, vol. 39, no. 1, p. 70. (1942)

The Measurement and Control of Dirt in Motion Picture Processing Laboratories. N. L. Simmons & A. C. Robertson. *J.S.M.P.*, vol. 46, no. 3, p. 185. (1946)

Service and Maintenance of Air Conditioning Systems. W. B. Cott. *J.S.M.P.*, vol. 51, no. 1, p. 92. (1948)

Ultraviolet Air Disinfection in the Theatre. L. J. Buttolph. *J.S.M.P.*, vol. 51, no. 1, p. 79. (1948)

Air Purification by Glycol Vapour. J. W. Spiselman. *J.S.M.P.*, vol. 51, no. 1, p. 70. (1948)

Motion Picture Theatre Air Conditioning. D. D. Kimball. *J.S.M.P.*, vol. 51. no. 1, p. 52. (1948)

Air Compressors and Air Knives for Supply of Clean, Oil-free Compressed Air. R. N. Haig. *J.B.K.S.*, April, 1968, p. 102.

AMPLIFICATION. *See under* Sound Track Amplification.

ARCS—PROJECTION

Carbon Arc Characteristics that Determine Motion Picture Screen Light. M. T. Jones and F. T. Bowditch. *J.S.M.P.*, vol. 56, no. 3, p. 310. (1951)

Blown Arc for Projection—Improvements in. Ayling and Hatch. *J.S.M.P.*, vol. 67, no. 4, p. 693. (1958)

Xenon-Arc Projection Lamps in Motion Picture Theatres. Ullfers (abridged by Hurd). *J.S.M.P.*, vol. 67, no. 6, p. 389. (1958)

Xenon-Arc Projection Lamps. Reese. *J.S.M.P.*, vol. 67, no. 6, p. 392. (1958)

Xenon Projection Lamps: A Resumé. D. V. Kloepfel. *J.S.M.P.*, June 1964, p. 479.

A Projection Arc for Remote Control. J. Cessford. *J.B.K.S.*, August 1964, p. 32.

Carbon Arcs for 16 mm. Film Projection. C. E. Heppberger & E. A. Bowen. *J.S.M.P.*, October 1964, p. 862.

Use of the Blown Arc Lamp in 35 mm. & 70 mm. Projection. H. Plumadore. *J.S.M.P.*, January 1966, p. 32.

Xenon Lamps for Cinema Projection. Dr. I. Kugler. *J.B.K.S.*, November 1966, p. 298.

Xenon Lamps in Film & Television. Dr. I. Kugler. *J.S.M.P.*, June 1968, p. 633.

AUDITORIA

Factors Affecting Sound Quality in Theatres. A. Goodman. *J.S.M.P.*, vol. 37, no. 5, p. 510. (1941)

Film Problems in Theatre Operation. S. Summer. *J.S.M.P.*, vol. 19, no. 3, p. 286. (1932)

Motion Picture Auditorium Lighting. B. Schlanger. *J.S.M.P.*, vol. 34, no. 3, p. 259. (1940)

Public Safety in the Cinema. H. P. Sully. *J.B.K.S.*, January 1963, p. 4.

Cinerama Theatre Acoustics. M. Rettinger. *J.S.M.P.*, July 1964, p. 566.

Cinema Theatre Design: A Symposium. G. G. Graham *et al. J.S.M.P.*, March 1966, p. 161.

BACKGROUND PROJECTION. *See also* Special Effects.

Background Projection for Process Cinematography. G. G. Popovici. *J.S.M.P.*, vol. 24, no. 2, p. 102. (1935)

13

BIBLIOGRAPHY

New Background Projector for Process Cinematography. H. Griffin. *J.S.M.P.*, vol. 27, no. 1, p. 96. (1936)
Paramount Triple-Head Transparency Process Projector. A. F. Edouart. *J.S.M.P.*, vol. 33, no. 2, p. 171. (1939)
The Development and Practical Application of the Triple-Head Background Projector. B. Haskin. *J.S.M.P.*, vol. 34, no. 3, p. 252. (1940)
On Contrast in Rear-Projection Screens. L. Levi. *J.S.M.P.*, December 1967, p. 1193.

LOOPING

Methods of Blooping. F. D. Williams. *J.S.M.P.*, vol. 30, no. 1, p. 105. (1938)
Current Practices in Blooping Sound-Film. W. H. Offenhauser, Jr. *J.S.M.P.*, vol. 35, no. 2, p. 165. (1940)

BOOKS AND GENERAL REFERENCES. *See also* Text Books.

Glossary of Technical Terms Used in the Motion Picture Industry. *J.S.M.P.*, vol. 17, no. 5, p. 819. (1931).
Recording Sound for Motion Pictures. Academy of Motion Picture Arts & Sciences. McGraw-Hill Book Co., New York and London, 1931.
The Principles of Optics. Hardy & Perrin. McGraw-Hill Book Co., New York and London, 1932.
Motion Picture Laboratory Practice. Eastman Kodak Company, Rochester, 1936.
Motion Picture Sound Engineering. Academy of Motion Picture Arts & Sciences. D. Van Nostrand & Co., New York, 1938.
Photographic Chemicals and Solutions. J. I. Crabtree and G. E. Matthews. American Photographic Publishing Co., Boston, 1939.
The Technique of Production Sound Recording. H. G. Tasker. *J.S.M.P.*, vol. 39, no. 4, p. 213. (1942)
The Theory of the Photographic Process. C. E. K. Mees. Macmillan, New York, 1942.
The Technique of Motion Picture Production. Society of Motion Picture Engineers. Interscience Publishers, Inc., New York, 1944.
Elements of Colour in Professional Motion Pictures. The Society of Motion Picture and Television Engineers, 1957.
The Ilford Manual of Photography. Ilford Limited, Ilford, Essex, 1958.
Television Engineering (B.B.C. Engineering Training Manual). Iliffe & Sons Ltd., London, 1958.
Magnetic Recording Techniques. W. E. Stewart. McGraw-Hill Book Co., New York and London, 1958.
Magnetic Tape Recording. H. G. M. Spratt. Heywood & Co., 1958.
Control Techniques in Film Processing. The Society of Motion Picture and Television Engineers, 1960.
British Broadcasting Corporation Engineering Monographs, Nos. 30 and 33. L. J. Wheeler. B.B.C. Publications, London, 1960.
Manual of Sound Recording. J. Aldred. The Fountain Press, London, 1963.
Professional Cinematography. C. G. Clarke. The American Society of Cinematographers, Hollywood, California, 1964.
Motion Pictures in Medicine and Education: A Symposium. R. H. Ray *et al.* *J.S.M.P.*, September 1965, p. 729.
386

The American Cinematographer Manual. The American Society of Cinematographers, Hollywood, California, 1966.
Television Film Engineering. R. J. Ross. John Wiley & Sons, Inc., New York, 1966.
The Technique of The Motion Picture Camera. H. M. R. Souto. Communication Arts Books, New York, and The Focal Press, Ltd., London, 1967.

CAMERAS

Fearless Silent Super-Film Camera (65 or 35 mm.) H. Hall. *Amer. Cine.*, April 1930, vol. 10, p. 13.
Warner Brothers New Camera. W. Stull. *Amer. Cine.*, December 1930, vol. 11, p. 11
The Cine-Kodak Special. A. Wittel *et al. J.S.M.P.*, vol. 21, no. 6, p. 478. (1933)
A Non-Intermittent High-Speed 16 mm. Camera. F. E. Tuttle. *J.S.M.P.*, vol. 21, no. 6, p. 474. (1933)
A 16 mm. Sound Recording Camera. C. B. Batsel *et al. J.S.M.P.*, vol. 23, no. 2, p. 87. (1934)
Wall Motion Picture Camera. H. Griffin. *J.S.M.P.*, vol. 25, no. 4, p. 363. (1935)
A High-Speed Camera. C. T. Burke. *J.S.M.P.*, vol. 25, no. 3, p. 160. (1935)
The Pull-Down Movement. A. S. Newman. *J.S.M.P.*, vol. 27, no. 5, p. 553. (1936)
The Magazine Cine-Kodak. O. Wittel. *J.S.M.P.*, vol. 27, no. 5, p. 595. (1936)
The Cine-Kodak Model E Camera. L. R. Martin. *J.S.M.P.*, vol. 30, no. 1, p. 112. (1938)
A Method of Measuring the Steadiness of Motion Picture Cameras. M. G. Townsley. *J.S.M.P.*, vol. 43, no. 1, p. 45. (1944)
The Eastman High-Speed Camera Type III. J. L. Boon. *J.S.M.P.*, vol. 43, no. 5, p. 321. (1944)
Art Reeves Reflex Motion Picture Camera. A. Reeves. *J.S.M.P.*, vol. 44, no. 6, p. 436. (1945)
The Calculation of Accelerations in Cam-Operated Pull-Down Mechanisms. E. W. Kellogg. *J.S.M.P.*, vol. 45, no. 2, p. 143. (1945)
A Wide Angle 35 mm. High-Speed Motion Picture Camera. J. H. Waddell. *J.S.M.P.*, vol. 46, no. 2, p. 87. (1946)
A New 16 mm. Professional Camera. F. F. Baker. *J.S.M.P.*, vol. 48, no. 2, p. 157. (1947)
Special Cameras and Flash Lamps for High-Speed Underwater Photography. R. T. Knapp. *J.S.M.P.*, vol. 49, no. 1, p. 64. (1947)
New Video Recording Camera. F. M. Gillette and R. A. White. *J.S.M.P.*, vol. 56, no. 6, p. 672. (1951)
A 35 mm. Process Camera. J. P. Kiel. *J.S.M.P.*, vol. 56, no. 5, p. 551. (1951)
Television Camera Equipment of Advanced Design. L. L. Pourciau. *J.S.M.P.*, vol. 60, no. 2, p. 166. (1952)
New Automatic Film-Threading Camera. G. J. Badgley and W. R. Fras. *J.S.M.P.*, vol. 60, no. 1, p. 49. (1953)
Full-Frame 35 mm. Fastax Camera. J. H. Waddell. *J.S.M.P.*, vol. 61, no. 5, p. 624. (1953)
Vidicon Film-Reproduction Camera. H. N. Kozanowski. *J.S.M.P.*, vol. 62, no. 2, p. 153. (1954)

BIBLIOGRAPHY

Fast-Cycling Intermittent for 16 mm. Film. W. R. Isom. *J.S.M.P.*, vol. 62, no. 1, p. 55. (1954)
New 35 mm. Television Film Scanner. E. H. Traub. *J.S.M.P.*, vol. 62, no. 1, p. 45. (1954)
Magnetic 16 mm. Single-System Sound-on-Film Recording Camera Equipment. W. Bach *et al. J.S.M.P.*, vol. 65, no. 5, p. 603. (1956)
New Paramount Lightweight Horizontal Movement VistaVision Camera. C. R. Daily. *J.S.M.P.*, vol. 65, no. 5, p. 279. (1956)
Mitchell Cameras. Pressure Pad Mechanism. Release-Type. O'Grady. *J.S.M.P.*, vol. 68, no. 1, p. 19. (1959)
Steadiness in Motion Picture Cameras. Method of Measuring. Robertson. *J.S.M.P.*, vol. 68, no. 1, p. 21. (1959)
High-Speed Cameras. Rapid Starting. Johnson. *J.S.M.P.*, vol. 69, no. 1, p. 485. (1960)
Pin Registration. A. C. Robertson. *J.S.M.P.*, February 1963, p. 75.
A Review of Newsreel and Location Equipment. R. P. Rigg. *J.B.K.S.*, April 1963, p. 120.
Motion Picture Camera Design and Selection. J. Behrend. *J.S.M.P.*, January 1964, p. 12.
The Adastra 8 mm. Motion Picture Camera System. J. Hampl. *J.S.M.P.*, April 1964, p. 325.
Picture Jump and Weave in Rotating-Prism Cameras. J. H. Waddell. *J.S.M.P.*, August 1964, p. 648.
A New 16 mm. Professional Magnetic Sound-on-Film Camera. E. M. DiGiulo and L. Brown. *J.S.M.P.*, October 1964, p. 873.
The Electroni Cam System. A. Jetter. *J.B.K.S.*, January 1964, p. 4.
Motor Drive Pan, Tilt and Rotational Devices for Motion Picture Cameras. W. Gentleman. *J.S.M.P.*, April 1965, p. 332.
A 35 mm. Reflex Camera System Incorporating Video Monitoring and Recording. E. M. DiGiulo. *J.S.M.P.*, July 1965, p. 600.
Camera Timing Marker with Dual Spark, and Neon Light-Sources. R. E. Hiller and L. M. Dearing. *J.S.M.P.*, October 1965, p. 897.
High-Speed Camera Survey. D. A. Fatora. *J.S.M.P.*, October 1965, p. 911.
A New Combination Camera Unit for 16 mm. Film Plus Vidicon Television. F. G. Back. *J.S.M.P.*, December 1965, p. 1096.
The Rotating Prism Camera. J. H. Waddell. *J.S.M.P.*, July 1966, p. 666.
Design of a New 65 mm. (Mitchell Todd-AO) Hand-Held Camera. D. Fries. *J.S.M.P.* April 1967, p. 364.
Reflexing the BNC Camera. F. J. Davio. *J.S.M.P.*, June 1967, p. 562.
An Historical Survey of the Professional Motion Picture Camera. E. M. DiGiulio *et al. J.S.M.P.*, July 1967, p. 665.
Anti-Vibration Camera Mounts. D. Samuelson. *J.B.K.S.*, June 1967, p. 150.
A New 16 mm. Sound News Camera (Bolex 16PRO). A. Jotzoff. *J.S.M.P.*, March 1968, p. 233.

CAMERA ACCESSORIES

Background Projection for Process Cinematography. G. G. Popovici. *J.S.M.P.*, vol. 24, no. 2, p. 102. (1935)

Research Council Specification for a Standard Synchronising System for Cameras. *J.S.M.P.*, vol. 28, no. 3, p. 265. (1937)

The Metro-Goldwyn-Mayer Semi-Automatic Follow-Focus Device. J. Arnold. *J.S.M.P.*, vol. 32, no. 4, p. 419. (1939)

Independent Camera Drive for the A.C. Interlock System. F. G. Albin. *J.S.M.P.*, vol. 32, no. 4, p. 424. (1939)

M.G.M.'s New Camera Boom. J. Arnold. *J.S.M.P.*, vol. 37, nos. 3, p. 278. (1941)

Scene-Slating Attachment for Motion Picture Cameras. F. C. Gilbert. *J.S.M.P.*, vol. 36, no. 4, p. 355. (1941)

Stop-Calibration of Photographic Objectives. E. W. Silvertooth. *J.S.M.P.*, vol. 39, no. 2, p. 119. (1942)

Development of Two Follow-Focus Devices for use in Cinematography. J. T. Strohm and W. G. Hickler. *J.S.M.P.*, vol. 45, no. 4, p. 302. (1945)

Positive Vari-Focus View-Finder for Motion Picture Cameras. F. G. Back. *J.S.M.P.*, vol. 45, no. 6, p. 466. (1945)

Electronic Shutter Testers. R. F. Redemske. *J.S.M.P.*, vol. 46, no. 5, p. 409. (1946)

American Standard Aperture for 35 mm. Sound Motion Picture Cameras. PH22.59-1954. *J.S.M.P.*, vol. 63, no. 3, p. 109. (1954)

Multiple Camera Control. I. A. Moon and F. A. Everest. *J.S.M.P.*, vol. 64, no. 3, p. 485. (1955)

A New Automatic Iris Control for Motion Picture Cameras. M. W. LaRue, Jr. *J.S.M.P.*, vol. 66, no. 1, p. 413. (1957)

Iris Control. Direct-Drive. Automatic. M. W. LaRue. *et al.* *J.S.M.P.*, vol. 67, no. 3, p. 600. (1958)

The Electroni Cam System. A. Jetter. *J.B.K.S.*, January 1964, p. 4.

Anti-Vibration Camera Mounts. D. Samuelson. *J.B.K.S.*, June 1967, p. 150.

CHANGE-OVERS

An Automatic Change-Over Device. A. Pritchard. *J.S.M.P.*, vol. 22, no. 3, p. 186. (1934)

Complete Cue-Mark Elimination and Automatic Change-Over. S. A. MacLeod. *J.S.M.P.*, vol. 30, no. 4, p. 463. (1938)

Projection Development and Automation in the Theatre. R. R. E. Pilman. *J.B.K.S.*, February 1966, p. 50.

Cinema Automation—a New Approach. N. W. Green. *J.B.K.S.*, January 1968, p. 24.

Automatic Control Systems in Cinema Presentation. B. A. Bentley. *J.B.K.S.*, February 1968, p. 38.

CINEMATOGRAPH CAMERAS. *See under* Cameras, Historical Surveys and also Text Books.

CLASS 'B' SOUND RECORDING

An Improved System of Noiseless Recording. G. L. Dimmick and H. Belar. *J.S.M.P.*, vol. 23, no. 1, p. 48. (1934)

Production-Quality Sound with Single-System Portable Equipment. D. Y. Bradshaw. *J.S.M.P.*, vol. 36, no. 2, p. 180. (1941)

13*

BIBLIOGRAPHY

Class 'B' Push-Pull Recording for Original Negatives. D. J. Bloomberg and C. L. Lootens. *J.S.M.P.*, vol. 33, no. 6, p. 664 (1939)
The Class 'A-B' Push-Pull Recording System. C. H. Cartwright and W. C. Thompson. *J.S.M.P.*, vol. 33, no. 3, p. 289. (1939)

CLEANLINESS AND CONTROL OF SOLUTIONS

Washing Motion Picture Film. K. C. D. Hickman. *Trans. Soc. Mot. Pict. Eng.*, October 1925, no. 23, p. 62.
A Quick Test for Determining the Degree of Exhaustion of Developers. M. L. Dundon *et al. J.S.M.P.*, vol. 14, no. 4, p. 389. (1930)
A Method of Testing for the Presence of Sodium Thiosulphate in Motion Picture Films. J. I. Crabtree and J. F. Ross. *J.S.M.P.*, vol. 14, no. 4, p. 419. (1930)
A Replenishing Solution for a Motion Picture Positive Film Developer. J. I. Crabtree and C. E. Ives. *J.S.M.P.*, vol. 15, no. 5, p. 627. (1930)
Effect of the Water Supply in Processing Motion Picture Films. J. I. Crabtree and G. E. Matthews. *J.S.M.P.*, vol. 16, no. 4, p. 437. (1931)
Directional Effect in Continuous Film Processing. J. I. Crabtree. *J.S.M.P.*, vol. 18, no. 2, p. 207. (1932)
Directional Effect in Sound Film Processing. J. I. Crabtree and J. H. Waddell. *J.S.M.P.*, vol. 21, no. 5, p. 351. (1933)
Uniformity in Photographic Development, J. I. Crabtree. *J.S.M.P.*, vol. 25, no. 6, p. 512. (1935)
Calcium Scums and Sludges in Photography. R. W. Henn and J. I. Crabtree. *J.S.M.P.*, vol. 43, no. 6, p. 436. (1944)
The Sulfuric Acid-Potassium Dichromate Bleach in the Black-and-White Reversal Process. J. W. Zuidema. *J.S.M.P.*, June 1963, p. 485.
An Investigation of Agitation in a Continuous Immersion Film Process. W. C. Suyder. *J.S.M.P.*, October 1966, p. 996.

COLOUR PROCESSES

Multicolour Process. R. M. Otis. *J.S.M.P.*, vol. 17, no. 1, p. 403. (1931)
Agfacolour Process. Optical-Photographic Principles of. F. Weil. *J.S.M.P.*, vol. 20, no. 4, p. 391. (1933)
Morgana Colour Process. J. A. Dubray. *J.S.M.P.*, vol. 21, no. 5, p. 403. (1933)
Kodachrome Process of Amateur Cinematography. L. D. Mannes and L. Godowsky. *J.S.M.P.*, vol. 25, no. 1, p. 65. (1935)
Technicolor Process of Three-Colour Cinematography. J. A. Ball. *J.S.M.P.*, vol. 25, no. 2, p. 127. (1935)
British Dufaycolour Film. S. H. Geary. *J.B.K.S.*, July 1939, vol. 2, p. 185.
Ansco Colour Films. Machine Processing of. J. L. Forrest. *J.S.M.P.*, vol. 45, no. 5, p. 313. (1945)
Ansco Colour for Professional Motion Pictures. H. H. Duerr and H. C. Harsh. *J.S.M.P.*, vol. 46, no. 5, p. 357. (1946)
New One-Strip Colour Separation Film in Motion Pictures. *J.S.M.P.*, vol. 50, no. 1, p. 8. (1948)
Masking: A Technique for Improving the Quality of Colour Reproductions. T. H. Miller. *J.S.M.P.*, vol. 52, no. 2, p. 113. (1949)

Cinecolor Three-Colour Process. A. M. Gundelfinger. *J.S.M.P.*, vol. 54, no. 1, p. 74. (1950)

Anscochrome. A New 16 mm. Camera Colour Film for Professional Use. J. L. Forrest. *J.S.M.P.*, vol. 66, no. 1, p. 12. (1957)

The Production of a 70 mm. Print. L. B. Happe and W. H. Clarke. *J.B.K.S.*, February 1963, p. 54.

The Control of a Colour Process. C. T. Davies. *J.B.K.S.*, September 1963, p. 84.

Gevacolor Positive Type 9.53. E. Drew. *J.B.K.S.*, May 1964, p. 158.

A New Kodachrome Duplicating Film (16 mm. Type 7387). A. F. C. Hirst. *J.B.K.S.*, April 1965, p. 105.

Colour Film for Colour Television. C. B. B. Wood and F. A. Griffiths. *J.B.K.S.*, March 1966, p. 74.

Colour Film for Colour Television. C. B. B. Wood. *J.S.M.P.*, October 1967, p. 985.

Technicolor Triple-Rank Super 8 mm. System. H. A. Mayer and F. P. Brackett. *J.S.M.P.*, October 1967, p. 1005.

Fujicolor Positive Emulsions. Y. Miura and M. Hara. *J.S.M.P.*, October 1967, p. 1006.

Silver Protection Masters for 16 mm. Colour Reversal Originals. R. K. Schafer and J. W. Zuidema. *J.S.M.P.*, October 1967, p. 1008.

Colour Film for Colour Television. Dr. G. B. Townsend. *J.B.K.S.*, November 1967, p. 238.

Motion Picture Film for Colour Television. B. J. Davies. *J.B.K.S.*, December 1967, p. 260.

A Sharp Reversal Colour Print Film (Gevachrome T.9.02). R. G. L. Verbrugghe. *J.S.M.P.*, December 1967, p. 1198.

A New Colour Print Film Stock (Gevacolor Type 9.54). R. G. L. Verbrugghe. *J.S.M.P.*, January 1968, p. 29.

COMPRESSION

Application of Non-Linear Volume Characteristics to Dialog Recording. J. O. Aalberg and J. O. Stewart. *J.S.M.P.*, vol. 31, no. 3, p. 248. (1938)

Elimination of Relative Spectral Energy Distortion in Electronic Compressors. B. F. Miller. *J.S.M.P.*, vol. 39, no. 5, p. 317. (1942)

CONSTANT SPEED

A New Recorder for Variable-Area Recording. E. W. Kellogg. *J.S.M.P.*, vol. 15, no. 5, p. 653. (1930)

Sound Film Printing. J. I. Crabtree. *J.S.M.P.*, vol. 21, no. 4, p. 294. (1933) and part 2 in vol. 22, no. 2, p. 98. (1934)

Flutter in Sound Recordings. T. E. Shea *et al.* *J.S.M.P.*, vol. 25, no. 5, p. 403. (1935)

A Portable Flutter Measuring Instrument. R. R. Scoville. *J.S.M.P.*, vol. 25, no. 5, p. 416. (1935)

The Technical Aspects of the High Fidelity Reproducer. E. D. Cook. *J.S.M.P.*, vol. 25, no. 4, p. 289. (1935)

A New High-Fidelity Sound Head. F. J. Loomis and E. W. Reynolds. *J.S.M.P.*, vol. 25, no. 5, p. 449. (1935)

Measurement of Speed Fluctuation in Sound Recording and Reproducing. E. W. Kellogg and A. R. Morgan. *J. Acous. Soc. of Amer.*, April 1936, vol. 7, p. 271.
A Review of the Quest for Constant Speed. E. W. Kellogg. *J.S.M.P.*, vol. 28, no. 4, p. 337. (1937)
A Light-weight Sound Recording System. F. L. Hopper *et al. J.S.M.P.*, vol. 33, no. 4, p. 449. (1939)
Filtering Factors of the Magnetic Drive. R. O. Drew and E. W. Kellogg. *J.M.S.P.*, vol. 35, no. 2, p. 138. (1940)
Some Theoretical Considerations in the Design of Sprockets for Continuous Film Movement. J. S. Chandler. *J.S.M.P.*, vol. 37, no. 2, p. 164. (1941)
Internally Damped Rollers. E. C. Wente and A. H. Muller. *J.S.M.P.*, vol. 37, no. 4, p. 406. (1941)
Analysis of Sound Film Drives. W. J. Albershem and D. MacKenzie. *J.S.M.P.*, vol. 37, no. 5, p. 452. (1941)
Electric Motor Drive Systems for Motion Picture Sound. W. V. Stancil *J.S.M.P.*, February 1967, p. 114.

CROSS-MODULATION

The Aperture Effect. E. D. Cook. *J.S.M.P.*, vol. 14, no. 6, p. 650. (1930)
High-Frequency Response from Variable-Width Records as Affected by Exposure and Development. G. L. Dimmick. *J.S.M.P.*, vol. 17, no. 5, p. 766. (1931)
Modulated High-Frequency Recording as a means of Determining Conditions for Optimal Processing. J. O. Baker and D. H. Robinson. *J.S.M.P.*, vol. 30, no. 1, p. 3. (1938)

DENSITOMETERS AND DENSITY. *See also* Sensitometry.

The Measurement of Density in Variable-Density Sound Film. C. Tuttle and J. W. McFarlane. *J.S.M.P.*, vol. 15, no. 3, p. 345. (1930)
The Relation between Diffuse and Specular Density. C. Tuttle. *J.S.M.P.*, vol. 20, no. 3, p. 228. (1933)
The Microdensitometer as a Laboratory Measuring Tool. W. R. Grehner. *J.S.M.P.*, vol. 23, no. 6, p. 318. (1934)
Physical Densitometer for Sound Processing Laboratories. F. L. Leich. *J.S.M.P.*, vol. 24, no. 2, p. 180. (1935)
A Wide-Range Linear-Scale Photo-Electric Cell Densitometer. W. W. Lindsay, Jr. and W. W. Wolfe. *J.S.M.P.*, vol. 28, no. 6, p. 662. (1937)
Standardisation of Photographic Densitometry. C. Tuttle and A. M. Koerner. *J.S.M.P.*, vol. 29, no. 6, p. 622. (1937)
Grain-Size Determination and other Applications of the Callier Effect. J. Eggert and A. Kuester. *J.S.M.P.*, vol. 39, no. 2, p. 181. (1938)
A Direct Reading Photo-Electric Densitometer. D. R. White. *J.S.M.P.*, vol. 33, no. 4, p. 403. (1939)
Densitometric Method of Checking the Quality of Variable-Area Prints. C. R. Daily and I. M. Chambers. *J.S.M.P.*, vol. 33, no. 4, p. 308. (1939)
Precision Integrating Sphere Densitometers. J. G. Frayne and G. R. Crane. *J.S.M.P.*, vol. 35, no. 2, p. 184. (1940)
The Measurement of Photographic Printing Density. J. G. Frayne. *J.S.M.P.*, vol. 36, no. 6, p. 622. (1941)

Automatic Recording of Photographic Densities. J. G. Frayne and G. R. Crane. *J.S.M.P.*, vol. 45, no. 5, p. 370. (1945)
A Semi-Automatic Analytical Recording Densitometer. W. E. White. *J.S.M.P.*, February 1967, p. 114.
An Analytical Study of Photographic Density. I. Fujimura. *J.S.M.P.*, January 1964, p. 27.
An Evaluation of Photographic Image Quality and Resolving Power. O. H. Schade, Snr. *J.S.M.P.*, February 1964, p. 81.
Sharpness Calculations for 8 mm. Systems. J. E. Pinney. *J.S.M.P.*, November 1964, p. 92.

DEVELOPERS. *See also* Viscous Processing.

Borax Developer Characteristics. H. W. Moyse and D. R. White. *Trans. Soc. Mot. Pict. Eng.*, 13 May 1929, p. 445.
Photographic Chemicals and Solutions. J. I. Crabtree and G. E. Matthews. Amer. Photo. Pub. Co., Boston, 1939.
Motion Picture Laboratory Practice. J. R. Wilkinson. *J.S.M.P.*, vol. 39, no. 3, p. 166. (1942)
The Application of Potentiometric Methods to Developer Analysis. J. G. Stott. *J.S.M.P.*, vol. 39, no. 1, p. 37. (1942)
Copper and Sulfide in Developers. R. M. Evans *et al. J.S.M.P.*, vol. 40, no. 2, p. 88. (1943)
Factors Affecting the Accumulation of Iodide in used Photographic Developers. R. M. Evans *et al. J.S.M.P.*, vol. 40, no. 2, p. 98. (1943)
The Effect of Developer Agitation on Density Uniformity and Rate of Development. C. E. Ives and E. W. Jensen. *J.S.M.P.*, vol. 40, no. 2, p. 197. (1943)
The Sulfuric Acid-Potassium Dichromate Bleach in the Black-and-White Reversal Process. J. W. Zuidema. *J.S.M.P.*, June 1963, p. 485.

DEVELOPMENT OF FILM. *See also* Laboratory Practice.

Some Properties of Fine-Grain Motion Picture Film Developers. H. L. Carlton and J. I. Crabtree. *Amer. Cine.*, July 1929, vol. 10, p. 17.
Borax Developer Characteristics. H. W. Moyse and D. R. White. *Amer. Cine.*, September 1929, vol. 10, p. 5.
Directional Effect in Machine Development. B. C. Sewell. *J.B.K.S.*, vol. 3, p. 84.
A Modern Studio Laboratory. G. M. Best and F. R. Gage. *J.S.M.P.*, vol. 35, no. 3, p. 294. (1940)
Effect of Aeration on Photographic Properties of Developers. J. I. Crabtree and G. W. Schwingel. *Amer. Cine.*, June 1940, vol. 21, p. 253.
Reduction of Development Sprocket-Hole Modulation. M. Leshing *et al. J.S.M.P.*, vol. 36, no. 5, p. 475. (1941)

DIMENSIONAL STANDARDS

See Current Publications by the Society of Motion Picture and Television Engineers; The American Standards Association; The British Standards Institution and The International Standards Organisation.

BIBLIOGRAPHY

The Dimensions of Films and Frames in Common Motion Picture Systems. E. M. Goldovskii. *J.S.M.P.*, July 1964, p. 544.
The Location of 35 mm. Optical Sound Track Images. G.E.E. France. *J.B.K.S.*, August 1964, p. 40.
The Preparation of British Standards for the Cinematograph Industry. H. S. Hind. *J.S.M.P.*, May 1967, p. 465.

DRIVE-IN THEATRES

Some Factors in Drive-In Theatre Design. J. H. Walters. *J.S.M.P.*, vol. 44, no. 2, p. 138. (1945)

DRYING. *See* Laboratory Practice and *also* Processing Conditions.

DUBBING. *See* Sound Recording.

DUPLICATING

Two New Films for Duplicating Work. J. I. Crabtree and C. E. Ives. *J.S.M.P.*, vol. 29, no. 3, p. 317. (1937)
Latest Developments in Variable-Area Processing. A. C. Blaney and G. M. Best. *J.S.M.P.*, vol. 32, no. 3, p. 237. (1939)
Photographic Duping of Variable-Area Processing. F. W. Roberts and E. Taenzer. *J.S.M.P.*, vol. 34, no. 1, p. 26. (1940)
A New Kodachrome Duplicating Film (16 mm. Type 7387). A. F. C. Hirst. *J.B.K.S.*, April 1964, p. 105.
Methods of Producing different Release Prints from 35 mm. Conventional, Anamorphic and 70 mm. Motion Pictures. M. Z. Wysotsky. *J.S.M.P.*, February 1966, p. 106.
A Systematic Approach to the Mass Production of Commercial Super 8 mm. Prints. C. L. Graham *et al. J.S.M.P.*, November 1966, p. 1067.
Silver Protection Masters for 16 mm. Colour Reversal Originals. R. K. Schafer and J. W. Zuidema. *J.S.M.P.*, October 1967, p. 1008.

EDGE NUMBERING

The Practical Aspect of Edge-Numbering 16 mm. Film. H. A. Witt. *J.S.M.P.*, vol. 39, no. 1, p. 67. (1942)

EDITING

Some Aspects in the design of a 16 mm. Editing Machine. J. J. Rigby. *J.S.M.P.*, November 1964, p. 960.
The Origins of the Moviola. M. Serrurier. *J.S.M.P.*, July 1966, p. 701.
Liquid Cement for Splicing Cronar Polyester Cine Films. A. W. D'Cruz. *J.S.M.P.*, August 1967, p. 795.

EQUIPMENT. *See under* subject, i.e. Processing Equipment, etc.

EXPOSURE. *See also* Sensitometry.

Exposure Control: A Symposium. P. Mertz *et al. J.S.M.P.*, July 1965, p. 577.
Exposure Control. D. T. V. Drumm. *J.B.K.S.*, July 1966, p. 204.
Exposure Determination in Cinematography. D. J. Craven. *J.B.K.S.*, August 1967, p. 184.
Factors Affecting Manual and Automatic Control of Camera Exposure. J. F. Scudder *et al. J.S.M.P.*, January 1968, p. 24.

FILM

Base. See under Historical Surveys.

Characteristics

Motion Picture Films for Professional Use. Eastman Kodak Company, Rochester, N.Y., 1942.

Cleaning

Combined 35/16 mm. Automatic Film Cleaner and Waxer. J. J. Rigby. *J.S.M.P.*, October 1964, p. 865.
Lubrication of Motion Picture Film. F. J. Kolb, Jr. and E. M. Weigel. *J.S.M.P.*, April 1965, p. 297.
The Rotary Buffer Squeegee and its use in a Motion Picture Lubricator. H. F. Ott and J. E. Dunn. *J.S.M.P.*, January 1968, p. 121.

Development. See under Development of Film.

Emulsions. See also Colour Processes.

A New Heat-Developable Motion Picture Print Film. N. R. Bacon and R. B. Lindemeyer. *J.S.M.P.*, March 1964, p. 213.
Two New Black-and-White Camera Negative Films (Eastman 4-X and XT). D. J. Kimberley. *J.B.K.S.*, August 1964, p. 42.
Some Chemical Problems in the Design of Photographic Emulsions. H. O. Dickinson. *J.B.K.S.*, January 1966, p. 17.

Fixation. See under Fixation.

Physical Properties of. See under Physical Properties of Film.

Processing. See under Development; Laboratory Practice; Viscous Processing.

Processing Sound. See under Sound Film Processing.

Shrinkage

The Shrinkage of Acetate Base Motion Picture Films. J. A. Maurer and W. Bach. *J.S.M.P.*, vol. 31, no. 1, p. 15. (1938)
The Physical Properties and Dimensional Behaviour of Motion Picture Film. J. M. Calhoun. *J.S.M.P.*, vol. 43, no. 4, p. 227. (1944)

Storage

The Physical Properties and Dimensional Behaviour of Motion Picture Film. J. M. Calhoun. *J.S.M.P.*, vol. 43, no. 4, p. 227. (1944)

A Plan for Preserving 16 mm. Originals. W. H. Offenhauser, Jr. *J.S.M.P.*, vol. 43, no. 6, p. 418. (1944)

The Use of Desiccants with Undeveloped Photographic Film. C. J. Kunz and C. E. Ives. *J.S.M.P.*, vol. 46, no. 6, p. 475. (1946)

Report of the Committee on Preservation of Film (Specifications on Motion Picture Film for Permanent Record). *J.S.M.P.*, vol. 48, no. 2, p. 167. (1947)

16 mm. Film Maintenance Costs and Analysis of Damages. E. Tiemann and D. Rich. *J.S.M.P.*, vol. 56, no. 5, p. 519. (1951)

Automatic Film Inspection. R. Grunwald and R. R. Wallace. *J.S.M.P.*, vol. 66, no. 3, p. 116. (1957).

Cellulose Ester Base Motion Picture Film. Interpretation of Dimensional Changes in. Adelstein and Calhoun. *J.S.M.P.*, vol. 69, nos. 3, p. 157. (1960)

Waxing

Combined 35/16 mm. Automatic Film Cleaner and Waxer. J. J. Rigby. *J.S.M.P.*, October 1964, p. 865.

Lubrication of Motion Picture Film. F. J. Kolb, Jr. and E. M. Weigel. *J.S.M.P.*, April 1965, p. 297.

Wear

A Note on the Projection Life of Film. D. R. White and C. deMoos. *J.S.M.P.*, vol. 41, no. 4, p. 297. (1943)

The Projection Life of Film. R. H. Talbot. *J.S.M.P.*, vol. 45, no. 2, p. 78. (1945)

The Projection Life of 16 mm. Film. C. F. Vilbrandt. *J.S.M.P.*, vol. 48, no. 6, p. 521. (1947)

Polyester Photographic Film Base (Cronar). D. R. White *et al.* *J.S.M.P.*, vol. 64, no. 6, p. 674. (1955)

FIXATION. *See also* Laboratory Practice and *also* Processing Conditions.

Some Properties of Fixing Baths. J. I. Crabtree and H. A. Hartt. *Amer. Cine.*, September 1929, vol. 19, p. 3.

The Removal of Hypo and Silver Salts from Photographic Materials as affected by the Composition of the Processing Solutions. J. I. Crabtree *et al.* *J.S.M.P.*, vol. 41, no. 1, p. 9. (1943)

Some Characteristics of Ammonium Thiosulfate Fixing Baths. D. B. Alnutt. *J.S.M.P.*, vol. 41, no. 4, p. 300. (1943)

The Application of the Polarograph to the Analysis of Photographic Fixing Baths. V. C. Shaner and M. R. Sparks. *J.S.M.P.*, vol. 45, no. 1, p. 20. (1945)

Aluminium and Chromium as Gelatin Hardeners. H. L. Baumbach and H. E. Gausman. *J.S.M.P.*, vol. 47, no. 1, p. 22. (1946)

FOG. *See* Laboratory Practice and *also* Processing Conditions.

GENERAL PRINCIPLES. *See under* Historical Surveys and *also* Text Books.

GROUND-NOISE REDUCTION. *See also* Sound Recording.

Ground-Noise Reduction. R. H. Townsend, H. McDowell, Jr. and L. E. Clark. Reprint no. 26. *Acad. Mot. Pict. A. & Sc.* (Hollywood).

Noise Reduction with Variable-Area Recording. B. Kreuzer. *J.S.M.P.*, vol. 16, no. 6, p. 671. (1931)

Western Electric Noiseless Recording. H. C. Silent and J. G. Frayne. *J.S.M.P.*, vol. 18, no. 5, p. 551. (1932)

Mechanical Reversed Bias Light-Valve Recording. E. H. Hansen and C. W. Faulkner. *J.S.M.P.*, vol. 26, no. 2, p. 117. (1936)

Ground Noise Reduction System. E. W Kellogg. *J.S.M.P.*, vol. 36, no. 2, p. 137. (1941)

Design and Use of Noise-Reduction Bias Systems. R. R. Scoville and W. L. Bell. *J.S.M.P.*, vol. 38, no. 2, p. 125. (1942)

Noise Reduction Anticipation Circuits. J. G. Frayne. *J.S.M.P.*, vol. 43, no. 5, p. 313. (1944)

HIGH-FREQUENCY LOSSES. *See also* Sound Recording.

The Aperture Effect. E. D. Cook. *J.S.M.P.*, vol. 14, no. 6, p. 650. (1930)

High-Frequency Response with Variable-Width Records as Affected by Exposure and Development. G. L. Dimmick. *J.S.M.P.*, vol. 17, no. 5, p. 766. (1931)

The Effect of Exposure and Development on the Quality of Variable-Width Photographic Sound Recording. D. Foster. *J.S.M.P.*, vol. 17, no. 5, p. 749. (1931)

Sound Picture Recording and Reproducing Characteristics. D. P. Loye. *J.S.M.P.*, vol. 32, no. 6, p. 631. (1939)

HIGH-SPEED CINEMATOGRAPHY.

Bibliography on High-Speed Photography. *J.S.M..P*, vol. 61, no. 6, p. 749. (1953)

The Development of High-Speed Photography in Europe. H. Schardin. *J.S.M.P.*, vol. 61, no. 3, p. 273. (1953)

Full-Frame 35 mm. Fastax Camera. J. H. Waddell. *J.S.M.P.*, vol. 61, no. 5, p. 624. (1953)

Second International Symposium on High-Speed Photography and Cinematography Report. *J.S.M.P.*, vol. 63, no. 5, p. 206. (1954)

High-Repetition Rate Stroboscope Light Source. C. C. Rockwood and W. P. Harvey. *J.S.M.P.*, vol. 63, no. 2, p. 64. (1954)

Several Films for use in High-Speed Motion-Picture Photography. W. E. Humm and A. E. Quinn. *J.S.M.P.*, vol. 65, no. 4, p. 555. (1956)

Some Practical Considerations in the Analysis of High-Speed Motion-Picture Data. W. G. Hyser. *J.S.M.P.*, vol. 66, no. 6, p. 357. (1957)

High-Speed Photography Activities. (Report on). *J.S.M.P.*, vol. 67, no. 4, p. 264. (1958)

Camera, New Framing. Kurtz. *J.S.M.P.*, vol. 68, no. 1, p. 16. (1959)

High-Speed Photography, New Compact Light Sources for. Wilson. *J.S.M.P.*, vol. 68, no. 3, p. 596. (1959)

Translated Abstracts from Foreign Journals. *J.S.M.P.*, vol. 68, no. 4, p. 714. (1959)

Streak Cameras, Ultra-High-Speed, Utilizing Mirror Optics. Patterson. *J.S.M.P.*, vol. 69, no. 6, p. 886. (1960)

A New Fast-Opening Large-Aperture Shutter for High-Speed Photography. E. C. Cassidy and D. H. Tsai. *J.S.M.P.*, July 1963, p. 531.

High-Speed Camera Survey. D. A. Fatora. *J.S.M.P.*, October 1965, p. 911.

New Pin-Registered High-Speed 16 mm. Motion Picture Camera. E. M. Whitley and R. C. Kiteley. *J.S.M.P.*, September 1968, p. 892.

HISTORICAL SURVEYS

Film Base

History of Nitrocellulose as a Film Base. E. Theisen. *J.S.M.P.*, vol. 20, no. 3, p. 259. (1933)

Manufacture of Motion Picture Film. E. K. Carver. *J.S.M.P.*, vol. 28, no. 6, p. 594. (1937)

Manufacture of Motion Picture Film. A. E. Amor. *J.B.K.S.*, October 1938, vol. 1, p. 188.

General

A Brief History of Kinematography. W. K. L. Dickson. *J.S.M.P.*, vol. 21, no. 6, p. 435. (1933)

Early Stages in Kinematography, C. H. Bothamley. *J.S.M.P.*, vol. 20, no. 3, p. 263. (1933)

The Depicting of Motion prior to the Advent of the Screen. E. Theisen. *J.S.M.P.*, vol. 20, no. 3, p. 249. (1933)

Technical Progress in the Motion Picture in the Soviet Union. G. I. Irsky. *J.S.M.P.*, vol. 38, no. 6, p. 532. (1942)

Resurrection of Early Motion Pictures. C. L. Gregory. *J.S.M.P.*, vol. 42, no. 3, p. 159. (1944)

Historical Development of Sound Films. E. I. Sponable. *J.S.M.P.*, vol. 48, parts 1 and 2, no. 4, p. 275; parts 3 to 7, no. 5, p. 407. (1947)

My First Fifty Years in Motion Pictures. O. B. Depue. *J.S.M.P.*, vol. 49, no. 6, p. 481. (1947)

Origins of the Magic Lantern. J. Voskuil. *J.S.M.P.*, vol. 51, no. 6, p. 643. (1948)

The Stereoscopic Art (reprint). J. A. Norling. *J.S.M.P.*, vol. 60, no. 3, p. 268. (1953)

History and Present Position of High-Speed Photography in Great Britain. W. D. Chesterman. *J.S.M.P.*, vol. 60, no. 3, p. 240. (1953)

The Evolution of Modern Television. A. G. Jensen. *J.S.M.P.*, vol. 63, no. 5, p. 174. (1954)

History of Professional Black-and-White Motion-Pictures. C. E. K. Mees. *J.S.M.P.*, vol. 63, no. 4, p. 134. (1954)

Thomas Alva Edison's Early Motion-Picture Experiments. H. G. Bowen. *J.S.M.P.*, vol. 64, no. 3, p. 519. (1955)

Another Armat Intermittent Movement. A. J. Wedderburn. *J.S.M.P.*, vol. 64, no. 2, p. 445. (1955)

History of Sound Motion Pictures. (In three instalments with 406 refs.) E. W. Kellogg. *J.S.M.P.*, vol. 64, June, p. 291; July, p. 356; August, p. 437. (1955)

Early History of Amateur Motion-Picture Film (28 refs). E. G. Matthews and R. G. Tarkington. *J.S.M.P.*, vol. 64, no. 3, p. 105 and no. 6, p. 316. (1955)

A Short History of Television Recording (27 refs.). A. Abramson. *J.S.M.P.*, vol. 64, no. 2, p. 72. (1955)

The Motion Picture Laboratory. (Extensive Bibiliography, addendum in French source in Letter to Editor, p. 206, April.) J. I. Crabtree. *J.S.M.P.*, vol. 64, no. 1, p. 13. (1955)

Widescreen Chronology. (A reprint.) J. L. Limbacher. *J.S.M.P.*, vol. 65, no. 2, p. 116. (1956)

Early Projector Mechanisms. D. G. Malkames. *J.S.M.P.*, vol. 66, no. 4, p. 628. (1957)

History of Motion Pictures. Annotated List of Articles Pertaining to (including some Historical References on Television). Krainock. *J.S.M.P.*, vol. 67, no. 5, p. 771. (1958)

Gaumont Chronochrome Process Described by Inventor. Gaumont. *J.S.M.P.*, vol. 68, no. 1, p. 29. (1959)

George Eastman House. Historical Motion-Picture Collections. Card. *J.S.M.P.*, vol. 68, no. 3, p. 143. (1959)

Good Reading About Motion Pictures. An Annotated Bibiliography. R. D. MacCann. *J.S.M.P.*, April 1963, p. 322.

Alexander F. Victor. Motion Picture Pioneer. S. G. Rose. *J.S.M.P.*, August 1963, p. 164.

The History of Films in South Africa. E. C. Howes. *J.S.M.P.*, November 1963, p. 882.

The Magic of Disney. H. Attwooll. *J.B.K.S.*, February 1965, p. 47.

British Film Production. Sir M. Balcon. *J.B.K.S.*, June 1965, p. 164.

Historic Aspects of The Society of Motion Picture & Television Engineers. G. E. Matthews. *J.S.M.P.*, September 1966, p. 856.

A Salute to the Industries Past: A Symposium. G. E. Matthews *et al. J.S.M.P.* November 1966, p. 1067.

History of Motion Picture Set Lighting Equipment. M. A. Hankins. *J.S.M.P.*, July 1967, p. 671.

A Complete List of S.M.P.T.E. Technical Publications. *J.S.M.P.*, July 1967 p. 689.

The Evolution of Projection Practices in The United Kingdom. R. R. E. Pulman. *J.S.M.P.*, October 1967, p. 994.

Milestones in British Film Studios and Their Production Techniques. B. Honri. *J.S.M.P.*, December 1967, p. 1198.

An Historical Survey of the Development of Xenon Light for Projection Purposes. H. Tumme. *J.S.M.P.*, June 1968, p. 630.

Motion Picture Film Widths: An Historical Survey. K. R. Niver. *J.S.M.P.*, August 1968, p. 814.

ILLUMINATION. *See under* Lighting and *also* Light Sources.

INTERMITTENT MECHANISMS

Silent Bell & Howell High-Speed Intermittent Mechanism. A. S. Howell and J. A. Dubray. *Amer. Cine.*, June 1929, vol. 10, p. 3.

Camera Mechanisms—Ancient and Modern. A. S. Newman. *J.S.M.P.*, vol. 14, no. 5, p. 534. (1930)

Present and Future of the Kinematograph Camera. A. S. Newman. *J.B.K.S.*, July 1939, vol. 2, p. 143.

Method of Measuring Steadiness of Motion Picture Cameras. M. G. Townsley. *J.S.M.P.*, vol. 43, no. 1, p. 45. (1944)

Calculation of Acceleration in Cam-Operated Pull-Down Mechanisms. E. W. Kellogg. *J.S.M.P.*, vol. 45, no. 2, p. 143. (1945)

The Application of Pure Mathematics to the Solution of Geneva Ratios. R. W. Jones. *J.S.M.P.*, vol. 47, no. 1, p. 55. (1946)

Continuous Motion Picture Projector for use in Television Film Scanning. A. G. Jensen *et al. J.S.M.P.*, vol. 58, no. 1, p. 1. (1952)

Pneumatic Pull-Down 16 mm. Projector. R. W. Wengel. *J.S.M.P.*, vol. 62, no. 5, p. 384. (1954)

Pull-Down Mechanism based on Design by S. B. Grimson. O'Grady. *J.S.M.P.*, vol. 67, no. 6, p. 385. (1958)

Marconi 16 mm. Fast Pull-Down Television Recorder. Pemberton. *J.S.M.P.*, vol. 68, no. 2, p. 87. (1959)

Pin Registration. A. C. Robertson. *J.S.M.P.*, February 1963, p. 75.

Film Feed Mechanisms for Narrow-Film Projectors. H. Maschgan. *J.S.M.P.*, February 1964, p. 134.

The Rolling Loop—A New Concept of Film Transport. P. R. W. Jones. *J.S.M.P.*, January 1968, p. 21.

Picture Steadiness of Motion Pictures in Projection. K. O. Frielinghaus. *J.S.M.P.*, January 1968, p. 34.

INTERMODULATION. *See also* Sound Recording.

Wave-Form Analysis of Variable-Density Sound Recording. O. Sandvik and V. C. Hall. *J.S.M.P.*, vol. 19, no. 4, p. 346. (1932)

Wave-Form Analysis of Variable-Width Sound Records. O. Sandvik *et al. J.S.M.P.*, vol. 21, no. 4, p. 323. (1933)

Analysis and Measurement of Distortion in Variable-Density Recordings. J. G. Frayne and R. R. Scoville. *J.S.M.P.*, vol. 32, no. 1, p. 648. (1939)

Some Practical Aspects of the Intermodulation Test. E. Meschter. *J.S.M.P.*, vol. 45, no. 3, p. 161. (1945)

KINEMATOGRAPHY. *See under* Historical Surveys and *also* Text Books.

LABORATORY PRACTICE. *See also* Processing Conditions.

The Fogging Properties of Developers. M. L. Dundon and J. I. Crabtree. *Trans. Soc. Mot. Pict. Eng.*, 12 September 1928, p. 1096.

Drying Conditions and Photographic Density. D. R. White. *J.S.M.P.*, vol. 19, no. 4, p. 340. (1932)

Laboratory Modification and Procedure for Fine-Grain Release Printing. J. R. Wilkinson and F. L. Eich. *J.S.M.P.*, vol. 38, no. 1, p. 56. (1942)

Recent Laboratory Studies in Optical Reduction Printing. R. O. Drew and L. T. Sachtleben. *J.S.M.P.*, vol. 41, no. 6, p. 505. (1943)

The 16 mm. Commercial Film Laboratory. W. H. Offenhauser, Jr. *J.S.M.P.*, vol. 41, no. 2, p. 157. (1943)

The New DuPont Photo Products Control Laboratory. W. P. Hillman. *J.S.M.P.*, vol. 42, no. 5, p. 287. (1944)

What to Expect of Direct 16 mm. L. Thomson. *J.S.M.P.*, vol. 43, no. 3, p. 178. (1944)

New Twentieth Century-Fox Developing Machine. Some Turbulation Characteristics. M. S. Leshing and T. M. Ingman. *J.S.M.P.*, vol. 44, nos. 2, p. 97. (1945)

Nomenclature of Motion Picture Film Used in Studios and Processing Laboratories. *J.S.M.P.*, vol. 44, no. 4, p. 285. (1945)

A 16 mm. Edge-Numbering Machine. L. Thompson. *J.S.M.P.*, vol. 45, no. 2, p. 109. (1945)

The Measurement and Control of Dirt in Motion Picture & Processing Laboratories. N. L. Simmons and A. C. Robertson. *J.S.M.P.*, vol. 46, no. 3, p. 185. (1946)

Sensitometric Control of the Duping Process. J. P. Weiss. *J.S.M.P.*, vol. 47, no. 6, p. 443. (1946)

Current Black-and-White Duplicating Techniques used in Hollywood. N. L. Simmons and E. Huse. *J.S.M.P.*, vol. 49, no. 4, p. 316. (1947)

Lubrication of 16 mm. Films. R. H. Talbot. *J.S.M.P.*, vol. 53, no. 3, p. 285. (1949)

Motion Picture Laboratory Practice for Television. A. J. Miller. *J.S.M.P.*, vol. 53, no. 2, p. 113. (1949)

High-Speed Processing of 35 mm. Pictures. C. M. Tuttle and F. M. Brown. *J.S.M.P.*, vol. 54, no. 2, p. 149. (1950)

A 16 mm. Rapid Film Processor. J. S. Hall *et al. J.S.M.P.*, vol. 55, no. 1, p. 27. (1950)

Ultra-Rapid Drying of Motion Picture Films by Means of Turbulent Air. L. Katz. *J.S.M.P.*, vol. 56, no. 3, p. 264. (1951)

Image Gradation, Graininess and Sharpness in Television, etc. O. H. Schade. *J.S.M.P.*, vol. 58, no. 3, p. 181. (1952)

Factors Affecting the Quality of Kinerecording. P. J. Herbst *et al. J.S.M.P.*, vol. 58, no. 2, p. 85. (1952)

Practical Aspects of Reciprocity-Law Failure. J. L. Tupper. *J.S.M.P.*, vol. 60, no. 1, p. 20. (1953)

The Bridgamatic Developing Machine. J. A. Tanney and E. B. Krause. *J.S.M.P.*, vol. 60, no. 3, p. 260. (1953)

Rapid Drying with Normally Processed Black-and-White Films. F. Dana-Miller. *J.S.M.P.*, vol. 60, no. 2, p. 85. (1953)

A Mathematical Approach to Replenishment Techniques. S. R. Goldwasser. *J.S.M.P.* vol. 62, no. 1, p. 11. (1954)

A Modern Laboratory for 16 mm. Film (Consolidated Film Labs). S. P. Solow and E. H. Reichard. *J.S.M.P.*, vol. 64, no. 4, p. 174. (1955)

The Motion-Picture Laboratory. (Extensive bibliography: addendum of French source in letter to Editor.) J. I. Crabtree. *J.S.M.P.*, vol. 64, no. 1, p. 8. (1955)

Increasing the Washing Rate of Motion Picture Films with Salt Solutions. J. I. Crabtree and R. W. Henn. *J.S.M.P.*, vol. 65, no. 1, p. 378. (1956)

A Modern All-Purpose Laboratory. R. W. Payne *et al. J.S.M.P.*, vol. 66, no. 6, p. 738. (1957)

A New High-Speed Spray Processor for 16/35 mm. Black-and-White Negative or Positive Film. E. V. Lewis. *J.S.M.P.*, vol. 66, no. 1, p. 419. (1957)

Film Processing Machine of Flexible Characteristics. Moon and Everest. *J.S.M.P.*, vol. 67, no. 11, p. 758. (1958)

The Sulphuric Acid-Potassium Dichromate Bleach in the Black-and-White Reversal Process. G. E. Matthews. *J.S.M.P.*, September 1966, p. 856.

LEARNED SOCIETIES

The Society of Motion Picture Engineers—Its Aims and Accomplishments. *J.S.M.P.*, Publication, New York, 1930.

Historical Summary of Standardisation in the S.M.P.E. L. A. Jones. *J.S.M.P.*, vol. 21, no. 4, p. 280. (1933)

Aims of The British Kinematograph Society. A. G. D. West. *J.B.K.S.*, vol. 1, no. 4, p. 155. (1938)

American Standards and their place in the Motion Picture Industry. J. W. McNair. *J.S.M.P.*, vol. 36, no. 2, p. 113. (1941)

Historic Aspects of the Society of Motion Picture & Television Engineers. G. E. Matthews. *J.S.M.P.*, September 1966, p. 856.

The Preparation of British Standards for the Cinematograph Industry. H. S. Hind. *J.S.M.P.*, May 1967, p. 465.

A Complete List of S.M.P.T.E. Technical Publications. *J.S.M.P.*, July 1967, p. 689.

LENS COATING

On a Method of Decreasing the Reflection from Non-Metallic Substances. J. Strong. *J. Opt. Soc. Amer.*, January 1936, vol. 26, p. 73.

Use of Interference to Extinguish Reflection of Light from Glass. *Phys. Rev.*, 2nd series, 15 February 1939, vol. 55, p. 391.

Multiple Films of High Reflecting Power. C. H. Cartwright and A. F. Turner. *Phys. Rev.*, June 1939, vol. 55, p. 1128.

Recent Improvements in Non-Reflecting Lens Coating. W. C. Miller. *J.S.M.P.*, vol. 37, no. 3, p. 165. (1941)

A New Dichroic Reflector and its Application to Photocell Monitoring Systems. G. L. Dimmick. *J.S.M.P.*, vol. 38, no. 1, p. 36. (1942)

An Analysis of Low-Reflection Coatings as Applied to Glass. W. P. Strickland. *J.S.M.P.*, vol. 49, no. 1, p. 27. (1947)

LENSES

Stop Calibration of Photographic Objectives. E. W. Silvertooth. *J.S.M.P.*, vol. 39, no. 2, p. 119. (1942)

The Efficiency of Picture Projection Systems. E. W. Kellogg. *J.S.M.P.*, vol. 45, no. 3, p. 191. (1945)

A System of Lens-Stop Calibration by Transmission. E. Berlant. *J.S.M.P.*, vol. 46, no. 1, p. 17. (1946)

A Lens Calibrating System. C. R. Daily. *J.S.M.P.*, vol. 46, no. 5, p. 343. (1946)

The Photometric Calibration of Lens Apertures. A. E. Murray. *J.S.M.P.*, vol. 47, no. 2, p. 142. (1946)

Zoom Lenses for Motion Picture Cameras with Single-Barrel Linear Movement. F. G. Back. *J.S.M.P.*, vol. 47, no. 6, p. 464. (1946)

Remote Control and Automatic Focusing of Lenses. H. C. Silent. *J.S.M.P.*, vol. 49, no. 2, p. 130. (1947)

Zoomar Lens for 35 mm. Film. F. G. Back. *J.S.M.P.*, vol. 51, no. 3, p. 294. (1948)

Errors in Calibration of the f Numbers. F. E. Washer. *J.S.M.P.*, vol. 51, no. 3, p. 242. (1948)

New Series of Lenses for 16 mm. Cameras. R. Kingslake. *J.S.M.P.*, vol. 52, no. 5, p. 509. (1949)

New Series of Lenses for Professional 16 mm. Projection. A. E. Neumer. *J.S.M.P.*, vol. 52, no. 5, p. 501. (1949)

American Standard Mounting Threads and Flange Focal Distances for Lenses on 16 mm. and 8 mm. Motion Picture Cameras. PH22.76-1951. *J.S.M.P.*, vol. 56, no. 6, p. 688. (1951)

Resolution Test Chart of the Motion Picture Research Council. A. J. Hill. *J.S.M.P.*, vol. 58, no. 6, p. 529. (1952)

The Nature and Evaluation of the Sharpness of Photographic Images. G. C. Higgins and L. A. Jones. *J.S.M.P.*, vol. 58, no. 4, p. 277. (1952)

Follow-Focus Device and Camera Blimp for 16 mm. Professional Camera. L. R. Richardson and W. N. Gaisford. *J.S.M.P.*, vol. 59, no. 2, p. 118. (1952)

American Standard Method of Determining Resolving Power of 16 mm. Motion Picture Lenses. *J.S.M.P.*, vol. 61, no. 1, p. 63. (1953)

American Standard Aperture Calibration of Motion Picture Lenses. PH22.90-1953. *J.S.M.P.*, vol. 62, no. 2, p. 173. (1954)

The CinemaScope Optical System. J. R. Benford. *J.S.M.P.*, vol. 62, no. 1, p. 64. (1954)

Recent Developments in Anamorphotic Systems. G. H. Cook. *J.S.M.P.*, vol. 65, no. 3, p. 151. (1956)

Anamorphic Mirror Systems. A. Bouwers and B. S. Blaisse. *J.S.M.P.*, vol. 65, no. 3, p. 146. (1956)

A New Automatic Iris Control for Motion Picture Cameras. M. W. LaRue, Jr. *J.S.M.P.*, vol. 66, no. 1, p. 413. (1957)

Depths of Field and Focus—Unified Analysis of. Levine. *J.S.M.P.*, vol. 68, no. 6, p. 819. (1959)

The Electroni Cam System. A. Jetter. *J.B.K.S.*, January 1964, p. 4.

A Gyro-Stabilized Lens System. K. B. Benson and J. R. Whittaker. *J.S.M.P.*, October 1965, p. 916.

Servo Control on Zoom Lenses. J. D. Barr. *J.B.K.S.*, January 1967, p. 6.

LIGHTING. *See also* Exposure.

Motion Picture Lighting with Quartz Iodine Lamps. D. E. Boulton. *J.B.K.S.*, January 1964, p. 15.

Lighting Grid Techniques. L. Johnson. *J.B.K.S.*, April 1966, p. 116.

LIGHT SCATTER IN EMULSION AND IMAGE SPREAD

Photographic Characteristics of Sound Recording Films. L. A. Jones and O. Sandvik. *J.S.M.P.*, vol. 14, no. 2, p. 180. (1930)

Wave-Form Analysis of Variable-Density Sound Recording. O. Sandvik *et al.* *J.S.M.P.*, vol. 19, no. 4, p. 346. (1932)

Improved Resolution in Sound Recording and Printing by the use of Ultra-Violet Light. G. L. Dimmick. *J.S.M.P.*, vol. 27, no. 2, p. 168. (1936)

Modulated High-Frequency Recording as a means of Determining Conditions for Optimal Processing. J. O. Baker and D. H. Robinson. *J.S.M.P.*, vol. 30, no. 1, p. 3. (1938)

BIBLIOGRAPHY

The Theory of the Photographic Process. C. E. K. Mees. MacMillan, New York, 1942.

LIGHT SOURCES

Mercury Arcs of Increased Brightness and Efficiency. L. J. Buttolph. *J.S.M.P.*, vol. 28, no. 1, p. 43. (1937)

A Water-Cooled Quartz Mercury Arc. A. B. Noel and R. E. Farnham. *J.S.M.P.*, vol. 31, no. 3, p. 221. (1938)

Properties of Lamps and Optical Systems for Sound Reproduction. F. E. Carlson. *J.S.M.P.*, vol. 33, no. 1, p. 80. (1939)

The Colour of Light on the Projection Screen. M. R. Null *et al. J.S.M.P.*, vol. 38, no. 3, p. 219. (1942)

Carbon Arc Projection of 16 mm. Film. W. C. Kaln. *J.S.M.P.*, vol. 41, no. 1, p. 94. (1943)

A New Carbon of Increased Light in Studio and Theatre Projection. M. T. Jones *et al. J.S.M.P.*, vol. 45, no. 6, p. 449. (1945)

An Automatic High-Pressure Mercury Arc Lamp Control Circuit. L. F. Bird. *J.S.M.P.*, vol. 45, no. 1, p. 38. (1945)

Recent Developments of Super-High-Intensity Carbon-Arc Lamps. M. A. Hankins. *J.S.M.P.*, vol. 49, no. 1, p. 37. (1947)

The Differential Carbon-Feed System for Projection Arcs. A. J. Hatch. *J.S.M.P.*, vol. 56, no. 1, p. 86. (1951)

An Improved Carbon-Arc Light Source for Three-Dimensional and Wide-Screen Projection (Super Ventarc). E. Gretener. *J.S.M.P.*, vol. 61, no. 4, p. 516. (1953)

British Standard 1404: 1953—Screen Luminance (Brightness) for the Projection of 35 mm. Film. W. W. Lozier. *J.S.M.P.*, vol. 62, no. 1, p. 79. (1954)

High-Brightness Xenon Compact Arc Lamp. W. T. Anderson, Jr. *J.S.M.P.*, vol. 63, no. 3, p. 96. (1954)

New High Intensity Rotating Positive Carbons for Motion Picture Projection. R. B. Dull *et al. J.S.M.P.*, vol. 66, no. 15, p. 283. (1957)

Xenon Short-Arc Lamp in Motion Picture Projection. Seeger and Jaedicke. *J.S.M.P.*, vol. 69, no. 1, p. 474. (1960)

Cold-Mirror Lamps for 8 mm. Projectors. J. O. Geissbuhler. *J.S.M.P.*, September 1963, p. 684.

Motion Picture Lighting with Quartz Iodine Lamps. D. E. Boulton. *J.B.K.S.*, January 1964, p. 15.

Xenon Projection Lamps: A Resumé. D. V. Kloepfel. *J.S.M.P.*, June 1964, p. 479.

Professional Aspects of the Quartz Iodine Lamp. M. Forman. *J.B.K.S.*, October 1965, p. 94.

Use of the Blown Arc Lamp in 35 and 70 mm. Projection. H. Plumadore. *J.S.M.P.*, January 1966, p. 32.

Design Parameters for the use of Quartz Iodine Lamps. W. R. Smith and R. R. Ferber. *J.S.M.P.*, June 1966, p. 586.

Evolution in Tungsten Lamps for Television and Film Lighting. C. N. Clark and T. F. Neubecker. *J.S.M.P.*, April 1967, p. 347.

An Historical Survey of the Development of Xenon Light for Projection Purposes. H. Tumme. *J.S.M.P.*, June 1968, p. 630.

Xenon Lamps in Film and Television. I. A. Kugler. *J.S.M.P.*, June 1968, p. 633.

404

LIGHT VALVES (SOUND RECORDING). For Light Valves in Colour Printing *see* Printing.

Sound Recording with the Light Valve. MacKenzie. *Trans. Soc. Mot. Pict. Eng.*, 12 September 1928, p. 730.

Straight Line and Toe Recording with the Light Valve. D. MacKenzie. *J.S.M.P.*, vol. 17, no. 2, p. 172. (1931)

Recent Contributions to the Light Valve Technique. O. O. Ciccarini. *J.S.M.P.*, vol. 17, no. 3, p. 305. (1931)

Principles of the Light Valve. T. E. Shea *et al*. *J.S.M.P.*, vol. 18, no. 6, p. 697. (1932)

Recent Optical Improvements in Sound Film Recording Equipment. *J.S.M.P.*, vol. 23, no. 3, p. 167. (1934)

Push-Pull Recording with the Light Valve. J. G. Frayne and H. C. Silent. *J.S.M.P.*, vol. 31, no. 1, p. 46. (1938)

Permanent Magnet Four-Ribbon Light Valve for Portable Push-Pull Recordings. E. C. Mansfield. *J.S.M.P.*, vol. 31, no. 3, p. 315. (1938)

Light Valves for the Stereophonic Sound Film System. E. C. Wente and R. Biddolph. *J.S.M.P.*, vol. 37, no. 4, p. 397. (1941)

Visual Light Valve Checking Device. J. P. Corcoran. *J.S.M.P.*, vol. 42, no. 5, p. 283. (1944)

An Improved 200-mil Push-Pull Density Modulator. J. G. Frayne *et al*. *J.S.M.P.*, vol. 48, no. 6, p. 494. (1946)

Variable-Area Recording with the Light Valve. J. G. Frayne. *J.S.M.P.*, vol. 51, no. 5, p. 501. (1948)

Direct-Positive Variable-Density Recording with the Light Valve. C. R. Keith and V. Pagliarulo. *J.S.M.P.*, vol. 52, no. 6, p. 690. (1949)

Direct-Positive Variable-Area Recording with the Light Valve. J. H. Jacobs. *J.S.M.P.*, vol. 66, no. 3, p. 112. (1957)

LOUDSPEAKERS

Recent Developments in Theatre Loudspeakers. H. F. Olson. *J.S.M.P.*, vol. 18, no. 5, p. 571. (1932)

Piezo-Electrical Loudspeakers, A. L. Williams. *J.S.M.P.*, vol. 24, no. 2, p. 121. (1935)

The Quarter-Wave Method of Speaker Testing. S. L. Reiches. *J.S.M.P.*, vol. 38, no. 5, p. 457. (1942)

Frequency Modulation Distortion in Loudspeakers. G. L. Beers and H. Belar. *J.S.M.P.*, vol. 40, no. 4, p. 207. (1943)

The Duplex Loudspeaker. J. B. Lancing. *J.S.M.P.*, vol. 43, no. 3, p. 168. (1944)

An Improved Loudspeaker System for Theatres. J. B. Lancing and J. K. Hilliard. *J.S.M.P.*, vol. 45, no. 5, p. 339. (1945)

Wide-Range Loudspeaker Developments. H. F. Olson and J. Preston. *J.S.M.P.*, vol. 47, no. 4, p. 327. (1946)

New Theatre Loudspeaker System. H. F. Hopkins and C. R. Keith. *J.S.M.P.*, vol. 51, no. 4, p. 385. (1498)

Loudspeakers and Amplifiers for use with Stereophonic Reproduction in the Theatre. J. K. Hilliard. *J.S.M.P.*, vol. 61, no. 3, p. 380. (1953)

The Ionic Loudspeaker for H.F. Reproduction. A. E. Falkus. *J.B.K.S.*, May, 1966. p. 132.

MAGNETIC SOUND RECORDING AND REPRODUCTION. *See also* Sound Recording and Reproduction.

A Multiple 8 mm. Magnetic Sound Printer. E. A. Cunningham and G. W. Colburn. *J.S.M.P.*, January 1963, p. 24.

Recent Developments in Magnetic Heads for use in Motion Pictures. W. Moehring. *J.S.M.P.*, April 1963, p. 298.

Monaural Magnetic Release Prints. G. E. Fielding and A. W. Lumpkin. *J.B.K.S.*, October 1963, p. 130.

Manufacture and Properties of Professional Magnetic Recording Films and Tapes. J. P. Deriaud. *J.B.K.S.*, October 1963, p. 108.

The Perfectone System of Pulse Synchronisation. T. Druce. *J.B.K.S.*, March 1964, p. 85.

The Synchropulse System. N. Leevers. *J.B.K.S.*, March 1964, p. 88.

Pilot Synchronized Sound Recording in Television. K. E. Gondesen. *J.B.K.S.*, March 1964, p. 95.

Synchronous Tape Recording in The B.B.C. H. J. Houlgate. *J.B.K.S.*, March 1964, p. 103.

Integrating the use of Film and Tape in Sound Recording. N. Leevers. *J.B.K.S.*, August 1965, p. 24.

Magnetic Recorders Improved for 70-db Signal-to-Noise Ratio. D. P. Gregg and K. O. Johnson. *J.S.M.P.*, August 1965, p. 660.

Technique for the Examination of Contact Area of Magnetic Tapes. J. G. Streiffert. *J.S.M.P.*, August 1965, p. 678.

Magnetic Tapes: The Manufacture of. H. J. Hutchings. *J.B.K.S.*, January 1966, p. 23.

Application of Magnetic Stripe to Motion Picture Film. E. L. Taylor. *J.B.K.S.*, August 1966, p. 224.

High Speed Magnetic Sound Transfer to 8 mm. Films. W. N. Fitzgerald *et al.* *J.S.M.P.*, June 1967, p. 552.

A High-Efficiency Contact Motion Picture Printer with Magnetic Sound Transfer. A. Balint *et al.* *J.S.M.P.*, September 1967, p. 904.

Magnetic Sound Transfer on to Staggered-Sync Quad 8 mm. Prints. F. Schoelkopf and E. Schuller. *J.S.M.P.*, October 1967, p. 1017.

Care and Rehabilitation of Magnetically Coated Tapes. R. N. Haig. *J.B.K.S.*, August 1968, p. 236.

Wear of Permalloy Magnetic Heads against Striped Motion Picture Film. F. J. Kolb, Jr. and R. S. Perry. *J.S.M.P.*, September 1968, p. 912.

MICROPHONES

Ribbon Microphones. H. F. Olson. *J.S.M.P.*, vol. 16, no. 6, p. 695. (1931)

Piezo-Electric Microphones. A. L. Williams. *J.S.M.P.*, vol. 23, no. 4, p. 196. (1934)

Characteristics of Modern Microphones for Sound Recording. F. L. Hopper. *J.S.M.P.*, vol. 33, no. 3, p. 278. (1939)

Determination of Microphone Performance. F. L. Hopper and F. F. Romanoro. *J.S.M.P.*, vol. 36, no. 4, p. 341. (1941)

Miniature Condenser Microphones. J. K. Hilliard. *J.S.M.P.*, vol. 54, no. 3, p. 303. (1950)

Radio Microphones. A. W. Lumpkin and G. R. Pontzen. *J.B.K.S.*, June 1964, p. 185.
Microphones—Their Selection and Use. J. Borwick. *J. B.K.S.*, February 1968, p. 48.
The Design and Development of a Capacitor Microphone. R. Booth and R. N. Fisher. *J.B.K.S.*, March 1968, p. 80.

PHOTO-ELECTRIC CELLS

The Photo-Cell and its Method of Operation. M. F. Jamieson *et al. J.S.M.P.*, vol. 27, no. 4, p. 365. (1936)
Fundamentals of Engineering Electronics. W. G. Dow. J. Wiley, London, 1937.
Vacuum-Tube Engineering for Motion Pictures. L. C. Hollands and A. M. Glover. *J.S.M.P.*, vol. 30, no. 1, p. 38. (1938)
A New Dichroic Reflector and its Application to Photocell Monitoring Systems. G. L. Dimmick. *J.S.M.P.*, vol. 38, no. 1, p. 36. (1942)
A Phototube for Dye Image Sound Tracks. A. M. Glover and A. R. Moore. *J.S.M.P.*, vol. 46, no. 5, p. 379. (1946)
Behaviour of a New Blue-Sensitive Phototube in Theatre Sound Equipment. J. D. Phyfe. *J.S.M.P.*, vol. 46, no. 5, p. 405. (1946)
Sensitivity of Various Phototubes as a Function of the Colour Temperature of the Light Source. A. Cramwinckel. *J.S.M.P.*, vol. 49, no. 6, p. 523. (1947)
Lead-Sulfide Photoconductive Cells in Sound Reproducers. R. W. Lee. *J.S.M.P.*, vol. 53, no. 6, p. 691. (1949)

PHOTOGRAPHIC TONE VALUES. *See* Processing and *also* Sensitometry.

PHYSICAL PROPERTIES OF FILM. *See also* Dimensional Standards.

Film Perforation and its Measurement. W. H. Carson. *J.S.M.P.*, vol. 14, no. 2, p. 209. (1930)
Film Distortions and their effect upon Projection Quality. E. K. Carner *et al. J.S.M.P.*, vol. 41, no. 1, p. 88. (1943)
A Note on the Projection Life of Film. D. R. White and C. deMoos. *J.S.M.P.*, vol. 41, no. 4, p. 297. (1943)
Precision Recording Instrument for Measuring Film Width. S. C. Coroniti and H. S. Baldwin. *J.S.M.P.*, vol. 41, no. 5, p. 395. (1943)
Physical Properties and Dimensional Behaviour of Motion Picture Film. J. M. Calhoun. *J.S.M.P.*, vol. 43, no. 4, p. 277. (1944)
The Projection Life of Film. R. H. Talbot. *J.S.M.P.*, vol. 45, no. 2, p. 78. (1945)
Some Relationships Between the Physical Properties and the Behaviour of Motion Picture Film. *J.S.M.P.*, vol. 45, no. 3, p. 209. (1945)
Modulated Air Blast for Reducing Film Buckle. W. Borberg. *J.S.M.P.*, vol. 59, no. 2, p. 94. (1952)
Effect of Nitrogen Oxide Gases on Processed Acetate Film. J. F. Carroll and J. M. Calhoun. *J.S.M.P.*, vol. 64, no. 3, p. 501. (1955)
Static Markings on Motion Picture Film: Causes and Prevention. Kisner. *J.S.M.P.*, vol. 67, no. 2, p. 513. (1958)

PICTURE UNSTEADINESS. *See under* Cameras and *also* Projection.

PICTURE AND SOUND SYNCHRONISATION. *See under* Synchronisation.

PRINTERS (CONTACT)

Shrinkage-Compensating Sound Printer. R. V. Wood. *J.S.M.P.*, vol. 18, no. 6, p. 788. (1932)

Sound Film Printing. J. I. Crabtree. *J.S.M.P.* (part 1), vol. 21, no. 4, p. 294 (1933); (part 2), vol. 22, no. 1, p. 98. (1934)

Recent Improvements in the Bell & Howell Fully Automatic Printer. A. S. Howell and R. F. Mitchell. *J.S.M.P.*, vol. 22, no. 2, p. 115. (1934)

A Non-Slip Sound Printer. C. N. Batsel. *J.S.M.P.*, vol. 23, no. 2, p. 100. (1934)

A Combination Picture and Ultra-Violet Non-Slip Printer. O. B. DePue. *J.S.M.P.*, vol. 30, no. 1, p. 107. (1938)

American Standard Picture and Sound Apertures for Continuous Contact Printers for 35 mm. Release Prints with Photographic Sound Records. PH22.111-1958. *J.S.M.P.*, vol. 67, no. 6, p. 412. (1958)

Printing of Motion Picture Films Immersed in a Liquid. Delwiche *et al. J.S.M.P.*, vol. 67, no. 4, p. 678. (1958)

Newton's Rings. Preventing Formation of during Contact Printing. Osborne. *J.S.M.P.*, vol. 67, no. 3, p. 169. (1958)

Printer Light Selector: Automatic for Bell & Howell D and J Printers. Wargo *et al. J.S.M.P.*, vol. 67, no. 2, p. 78. (1958)

Wet-Gate Printing on a Continuous Contact Printer. S. L. Rochowicz and V. A. Baker. *J.S.M.P.*, January 1967, p. 27.

PRINTERS (OPTICAL AND REDUCTION)

Optical Reduction Sound Printing. G. L. Dimmick *et al. J.S.M.P.*, vol. 23, no. 2, p. 108. (1934)

Some Characteristics of 16 mm. Sound by Optical Reduction and Re-Recording. C. N. Batsel and L. T. Sachtleben. *J.S.M.P.*, vol. 24, no. 2, p. 95. (1935)

A Continuous Optical Reduction Sound Printer. O. Sandvik and J. C. Streiffert. *J.S.M.P.*, vol. 25, no. 2, p. 117. (1935)

Optical Reduction Sound Printing. M. E. Collins. *J.S.M.P.*, vol. 27, no. 1, p. 105. (1936)

A Continuous Optical Reduction Sound Printer. M. G. Townsley. *J.S.M.P.*, vol. 31, no. 4, p. 405. (1938)

Recent Laboratory Studies of Optical Reduction Printing. R. O. Drew and L. T. Sachtleben. *J.S.M.P.*, vol. 41, no. 6, p. 505. (1943)

The New Acme-Dunn Optical Printer. L. G. Dunn. *J.S.M.P.*, vol. 42, no. 4, p. 204. (1944)

Improved Optical Reduction Sound Printer. J. L. Pettus. *J.S.M.P.*, vol. 51, no. 6, p. 586. (1948)

Optical Printer—Newly Designed. Palen. *J.S.M.P.*, vol. 67, no. 2, p. 98. (1958)

Application of a Liquid Layer on Negative Films to Eliminate Surface Defects in Optical Printing. DeMoulin *et al. J.S.M.P.*, vol. 68, no. 6, p. 415. (1959)

A Multiple Head 16-to-8 mm. Reduction Printer. G. W. Colburn. *J.S.M.P.*, March 1963, p. 189.

Optical Printing with a small diameter Light Source. J. D. Clifford. *J.S.M.P.*, November 1964, p. 932.

A New Concept of Optical Printer Construction. H. A. Scheib. *J.S.M.P.*, July 1965, p. 597.

Methods of Producing Different Release Prints from 35 mm. Conventional, Anamorphic and 70 mm. Motion Pictures. M. Z. Wysotsky. *J.S.M.P.*, February 1966, p. 106.

An Automatic Transistorised Optical Printer. M. Calzini. *J.S.M.P.*, April 1966, p. 341.

A New High-Speed Optical Reduction Step Printer. C. Cowan *et al*. *J.S.M.P.*, April 1967, p. 331.

A 16 mm. Continuous Optical Printer with Additive Colour Control. H. C. Wohlrab. *J.S.M.P.*, April 1968, p. 357.

A New Additive Light Source with Colour Control for Motion Picture Printers. A. Roux and J. Vivie. *J.S.M.P.*, August 1968, p. 806.

PRINTER ILLUMINATION

Illumination in Projection Printing. C. Tuttle and D. A. Young. *J.S.M.P.*, vol. 19, no. 1, p. 842. (1932)

New Light Control in Printing Machines. K. Schneider. *J.S.M.P.*, vol. 19, no. 1, p. 865. (1932)

Effect of Ultra-Violet Light on Variable-Density Recordings and Printing. J. G. Frayne and V. Pagliano. *J.S.M.P.*, vol. 34, no. 6, p. 614. (1940)

Improvements in Illumination Efficiency of Motion Picture Printers. C. J. Kunz *et al*. *J.S.M.P.*, vol. 42, no. 5, p. 294. (1944)

Printer Light Selector: Automatic for Bell & Howell D and J Printers. Wargo *et al*. *J.S.M.P.*, vol. 67, no. 2, p. 78. (1958)

PRINTING—GENERAL

Duplication of Motion Picture Negatives. J. I. Crabtree and C. H. Schwingel. *J.S.M.P.*, vol. 19, no. 1, p. 891. (1932)

Recent Improvements in the Bell & Howell Fully Automatic Printer. A. S. Howell and R. F. Mitchell. *J.S.M.P.*, vol. 22, no. 2, p. 115. (1934)

Combination Picture and Ultra-Violet Non-Slip Sound Printer. O. B. DePue. *J.S.M.P.*, vol. 30, no. 1, p. 107. (1938)

Reduction of Loop Length in Non-Slip Printers. E. W. Kellogg. *J.S.M.P.*, vol. 30, no. 2, p. 136. (1938)

Careless Work in Printing. I. Gordon. *J.S.M.P.*, vol. 30, no. 3, p. 347. (1938)

Improvements in Sound and Picture Release through the use of Fine Grain Films. C. R. Daily. *J.S.M.P.*, vol. 34, no. 1, p. 12. (1940)

Measurements of Photographic Printing Density. J. G. Frayne. *J.S.M.P.*, vol. 36, no. 1, p. 622. (1941)

New Acme-Dunn Optical Printer. L. G. Dunn. *J.S.M.P.*, vol. 42, no. 4, p. 204. (1944)

Reproduction of Colour Film Sound Records. R. Gorlisch and P. Gorlich. *J.S.M.P.*, vol. 43, no. 3, p. 206. (1944)

A Method of Measuring Electrification of Motion Picture Film Applied to Cleaning Operations. H. W. Cleveland. *J.S.M.P.*, vol. 55, no. 1, p. 37. (1950)

Electrical Printing. J. G. Frayne. *J.S.M.P.*, vol. 55, no. 6, p. 590. (1950)

American Standard. Scene-Change Cueing for Printing 16 mm. Motion Picture Film. PH22.89-1958. *J.S.M.P.*, vol. 67, no. 6, p. 411. (1958)

Geneva Scene-Change Mechanism: Subtractive Colour Printer. Brueggemann. *J.S.M.P.*, vol. 67, no. 5, p. 769. (1958)

Electromechanical Light-Valve for Motion Picture Printers. Hernfield. *J.S.M.P.*, vol. 67, no. 1, p. 27. (1958)

Use of Motion Picture Printer as Sensitometer. Gale and Graham. *J.S.M.P.*, vol. 67, no. 2, p. 84. (1958)

Loop Printing System: Automatic. Calzini. *J.S.M.P.*, vol. 68, no. 3, p. 583. (1959)

Printers. Two-Speed Drive for Continuous Motion Picture. Graham and Ott. *J.S.M.P.*, vol. 68, no. 1, p. 11. (1959)

A Multiple 8 mm. Magnetic Sound Printer. E. A. Cunningham and G. W. Colburn. *J.S.M.P.*, January 1963, p. 24.

The Production of a 70 mm. Print. L. B. Happe and W. H. Clarke. *J.B.K.S.*, February 1963, p. 54.

16 mm. Motion Picture Printing. R. F. Ebbetts. *J.B.K.S.*, April 1964, p. 96.

An Automatic 35 mm. A & B Composite Colour Printer. S. P. Solow and E. H. Reichard. *J.S.M.P.*, October 1964, p. 870.

Economical 8 mm. Commercial Prints. C. L. Graham and W. L. Stockdale. *J.S.M.P.*, November 1964, p. 934.

A New Continuous Additive Colour Printer. H. C. Wohlrab. *J.S.M.P.*, October 1966, p. 990.

A Simple Light-Change Monitoring System for Semi-Automatic Printers. T. Davis. *J.S.M.P.*, October 1966, p. 994.

A Systematic Approach to the Mass Production of Commercial Super-8 mm. Prints. C. L. Graham *et al. J.S.M.P.*, November 1966, p. 1067.

An Additive Colour Scenetester. G. C. Misener. *J.S.M.P.*, January 1967, p. 8.

A High-Efficiency Contact Motion Picture Printer with Magnetic Sound. A. Balint *et al. J.S.M.P.*, September 1967, p. 904.

PROCESS PROJECTION. *See also* Special Effects.

Paramount Triple-Head Transparency Process Projector. F. Edourt. *J.S.M.P.*, vol. 33, no. 2, p. 171. (1939)

Motor Drive (Improved) for Self-Phasing of Process Projection Equipment. H. Tasker. *J.S.M.P.*, vol. 37, no. 2, p. 187. (1941)

Developments in Time-Saving Process Projection Equipment. R. W. Henderson. *J.S.M.P.*, vol. 39, no. 4, p. 245. (1942)

Paramount Transparency Process Projection Equipment. F. Edourt. *J.S.M.P.*, vol. 40, no. 6, p. 368. (1943)

High-Efficiency Stereopticon Projector for Colour Background Shots. F. Edourt. *J.S.M.P.*, vol. 43, no. 2, p. 97. (1944)

35 mm. Process Projector. H. Miller and E. C. Manderfield. *J.S.M.P.*, vol. 51, no. 4, p. 373. (1948)

Sensitometric Aspects of Background Process Photography. H. Meyer. *J.S.M.P.*, vol. 54, no. 3, p. 275. (1950)

An Experimental Electronic Background Television Projection System. W. R. Johnson. *J.S.M.P.*, vol. 55, no. 1, p. 60. (1950)

High Efficiency Rear-Projection Screens. C. R. Daily. *J.S.M.P.*, vol. 65, no. 3, p. 470. (1956)

Rear Projection: Operational Characteristics. Dreyer. *J.S.M.P.*, vol. 68, no. 2, p. 521. (1959)

PROCESSING CONDITIONS. *See also* Laboratory Practice and *also* Viscous Processing.

The Rendering of Tone Values in the Photographic Recording of Sound. *Trans. Soc. Mot. Pict. Eng.*, 11 September 1927, p. 475.

The Processing of Variable-Density Sound Records. R. F. Nicholson. *J.S.M.P.*, vol. 15, no. 3, p. 374. (1930)

On the Theory of Tone Reproduction with a Graphic Method for the Solution of Problems. L. A. Jones. *J.S.M.P.*, vol. 16, no. 5, p. 568. (1931)

Straight Line and Toe Records with the Light Valve. D. MacKenzie. *J.S.M.P.*, vol. 17, no. 2, p. 172. (1931)

Automatic Silver Recovery Control. K. Hickman. *J.S.M.P.*, vol. 17, no. 4, p. 591. (1931)

Drying Conditions and Photographic Density. D. R. White. *J.S.M.P.*, vol. 19, no. 4, p. 430. (1932)

Maintenance of Developer by Continuous Replenishment. R. M. Evans. *J.S.M.P.*, vol. 31, no. 3, p. 273. (1938)

Effect of Developer Agitation on Density Uniformity and Rate of Development. C. E. Ives and E. W. Jensen. *J.S.M.P.*, vol. 40, no. 2, p. 107. (1943)

Some Turbulation Characteristics of the new Twentieth Century-Fox Developing Machine. M. S. Leshing and T. M. Ingman. *J.S.M.P.*, vol. 44, no. 2, p. 87. (1945)

The Measurement and Control of Dirt in Motion Picture Processing Laboratories. N. L. Simmons and A. C. Robertson. *J.S.M.P.*, vol. 46, no. 3, p. 185. (1946)

Sensitometric Control of the Duping Process. J. P. Weiss. *J.S.M.P.*, vol. 47, no. 6, p. 443. (1946)

Simplification of Motion Picture Processing Methods. C. E. Ives and C. J. Kunz. *J.S.M.P.*, vol. 55, no. 1, p. 3. (1950)

Some Factors Affecting Picture Quality. H. E. B. Grimshaw. *J.B.K.S.*, vol. 36, no. 4, p. 104. (1960)

Viscous-Layer Processing of Variable Area Sound Negatives. J. F. Finkle and R. J. Wilson. *J.S.M.P.*, February 1964, p. 125.

Viscous Processing of Motion Picture Films. B. J. Davies. *J.B.K.S.*, February 1964, p. 36.

Rapid Processing by Viscous Monobath. J. C. Barnes *et al. J.S.M.P.*, March 1965, p. 242.

Progress in Viscous Processing of Motion Picture Films. B. J. Davies. *J.B.K.S.*, February 1966, p. 55.

PROCESSING EQUIPMENT. *See also* Laboratory Practice.

Materials for the Construction of Motion Picture Processing Apparatus. J. I. Crabtree and G. E. Matthews. *J.S.M.P.*, vol. 16, no. 3, p. 330. (1931)

Simplifying and Controlling Film Travel through a Developing Machine. J. F. Van Leuven. *J.S.M.P.*, vol. 33, no. 5, p. 583. (1939)

Film Splicing for Developing Machines. J. G. Capstaff and J. S. Beggs. *J.S.M.P.*, vol. 34, no. 3, p. 339. (1940)
Modern Studio Laboratory. G. Best and F. R. Gage. *J.S.M.P.*, vol. 35, no. 3, p. 294. (1940)
Improvements in Motion Picture Laboratory Apparatus. C. E. Ives and E. W. Jensen. *J.S.M.P.*, vol. 35, no. 4, p. 397. (1940)
The Flat Spiral Reel for Processing 50-ft. Lengths of Film. C. E. Ives and C. J. Kunz. *J.S.M.P.*, vol. 42, no. 6, p. 349. (1944)
The Processing Control Sensitometer. G. A. Johnson. *J.S.M.P.*, vol. 47, no. 6, p. 474. (1946)
Motion Picture Film Developing Machine. R. P. Ireland. *J.S.M.P.*, vol. 50, no. 1, p. 50. (1948)
Chemical Economics of Spray Processing. G. I. P. Levenson. *J.S.M.P.*, vol. 53, no. 6, p. 665. (1949)
New Processing Machine Film Spool for use with either 35 mm. or 16 mm. film. F. L. Bray. *J.S.M.P.*, vol. 57, no. 1, p. 33. (1951)
Film-Spool Drive with Torque Motors. A. L. Holcomb. *J.S.M.P.*, vol. 58, no. 1, p. 28. (1952)
The Bridgamatic Developing Machine. J. A. Tanney and E. B. Krause. *J.S.M.P.*, vol. 60, no. 3, p. 260. (1953)
A Rapid Automatic Stitch Splicer for Darkroom Operation. D. E. Grant and H. F. Ott. *J.S.M.P.*, vol. 63, no. 3, p. 194. (1954)
A Multipurpose Continuous Processing Machine for Instrumentation Photography. D. S. Ross. *J.S.M.P.*, vol. 66, no. 2, p. 480. (1957)
A New High-Speed Spray Processor for 16/35 mm. Black-and-White Negative or Positive Films. E. V. Lewis. *J.S.M.P.*, vol. 66, no. 1, p. 419. (1957)
Spray Processing in a Commercial Laboratory. R. D. Whitmore. *J.S.M.P.*, vol. 66, no. 4, p. 194. (1957)
Film Cleaning Drum—Powered. Brueggemann. *J.S.M.P.*, vol. 67, no. 4, p. 686. (1958)
Film Processing Machine of Flexible Characteristics. Moon and Everest. *J.S.M.P.*, vol. 67, no. 11, p. 758. (1958)
Film-End Detector and Film Brake. For Continuous Motion Picture Film Processing Machines. Pneumatically Operated. Lawlor. *J.S.M.P.*, vol. 68, no. 1, p. 14. (1959)
A Continuous Film Processor. M. Bendick and W. Scott. *J.S.M.P.*, March 1963, p. 184.
Conversion of Black-and-White Motion Picture Processing Machines to Viscous Layer Development. L. I. Edgcomb and G. M. Seeley. *J.S.M.P.*, September 1963, p. 691.
Tension-Free Film Processing Machine. M. E. Fulton. *J.S.M.P.*, March 1965, p. 282.
Daylight Film Processing Laboratory. S. Dahlstedt. *J.S.M.P.*, June 1965, p. 518.
A Positive Electric Film Brake for use on Continuous Film Processing Machines. E. L. Hanson. *J.S.M.P.*, July 1965, p. 607.
Super 8 mm. Processing with a 16 mm. Sprocket Machine. G. W. Colburn. *J.S.M.P.*, February 1966, p. 109.
A Wringer-Sling Squeegee for Motion Picture Film Processing Machines. E. M. Deane and R. L. McNeary. *J.S.M.P.*, August 1967, p. 797.

Turbine Fluid Drive—An Innovation in Film Processing Machines. E. L. Hanson. *J.S.M.P.*, September 1967, p. 907.
Friction Drive for Motion Picture Film Processing Machines. T. H. Chatwin. *J.B.K.S.*, July 1968, p. 220.

PROCESSING QUALITY CONTROL. *See* Sensitometry.

PROJECTORS. *See also* Auditoria, Film Wear, Lenses and Light Sources.

Mechanisms

Flexible Drive Shafts—their Application to Sound Pictures. J. C. Smack. *J.S.M.P.*, vol. 14, no. 4, p. 384. (1930)
The Projection of Motion Pictures. H. A. Starks. *J.S.M.P.*, vol. 41, no. 2, p. 183. (1943)
Analysis of Geneva Mechanisms. W. A. Willis. *J.S.M.P.*, vol. 44, no. 4, p. 275. (1945)
The Calculation of Accelerations in Cam-Operated Pull-Down Mechanisms. E. W. Kellogg. *J.S.M.P.*, vol. 45, no. 2, p. 143. (1945)
Design Factors in 35 mm. Intermittent Mechanisms. A. Hayek. *J.S.M.P.*, vol. 49, no. 5, p. 405. (1947)
Gaumont-Kalee Model 21 Projector. L. Audigier and R. Robertson. *J.S.M.P.*, vol. 51, no. 3, p. 269. (1948)
Non-Intermittent Motion Picture Projection. W. C. Plank. *J.S.M.P.*, vol. 54, no. 6, p. 745. (1950)
Pneumatic Pull-Down for 16 mm. Projectors. R. W. Wengel. *J.S.M.P.*, vol. 62, no. 5, p. 384. (1954)
Early Projector Mechanisms. D. G. Malkames. *J.S.M.P.*, vol. 66, no. 4, p. 628. (1957)
Effect of Gate and Shutter Characteristics on Screen Image Quality. W. Borberg. *J.S.M.P.*, vol. 66, no. 4, p. 623. (1957)
JAN Projector, 16 mm. Standardised. Reutell. *J.S.M.P.*, vol. 68, no. 6, p. 828. (1959)
Research Council Developments for Better Theatre Projection. Beyer. *J.S.M.P.*, vol. 69, no. 5, p. 792. (1960)
Cold-Mirror Lamps for 8 mm. Projectors. J. O. Geissbuhler. *J.S.M.P.*, September 1963, p. 684.
Film Feed Mechanisms in Narrow-Film Projectors. H. Maschgan. *J.S.M.P.*, February 1964, p. 134.
Solid State Theatre Sound System. V. Nicelli. *J.S.M.P.*, April 1966, p. 337.
Cinemeccanica. Fully Transistorised Cinema Sound Reproducers. V. Nicelli. *J.B.K.S.*, July 1966, p. 188.
Philips Fully Transistorised Cinema Sound Projector. W. J. M. Jansen. *J.B.K.S.*, September 1966, p. 234.
Projection Development and Automation in the Theatre. R. R. E. Pulman. *J.B.K.S.*, February 1967, p. 50.
Continuous Motion Picture Projector for Television Scanning. J. F. Muller and L. K. Degen. *J.S.M.P.*, April 1967, p. 344.
Projection Development and Automation in the Rank Theatre Division. R. R. E. Pulman. *J.S.M.P.*, July 1967, p. 647.
The Evolution of Projection Practice in the United Kingdom. R. R. E. Pulman. *J.S.M.P.*, October 1967, p. 994.

Cinema Automation—a New Approach. N. W. Green. *J.B.K.S.*, January 1968, p. 24.
Automatic Control Systems in Cinema Presentation. B. A. Bentley. *J.B.K.S.*, February 1968, p. 38.

Picture Steadiness in. See also Intermittent Mechanisms.

Film Distortions and their effect upon Projection Quality. E. K. Carver *et al. J.S.M.P.*, vol. 41, no. 1, p. 88. (1943)
Displacement Meter for Testing Unsteadiness in Motion Picture Projectors. R. W. Jones. *J.S.M.P.*, vol. 44, no. 6, p. 456. (1945)
Flicker in Motion Pictures. L. D. Grignon. *J.S.M.P.*, vol. 51, no. 6, p. 555. (1948)
Instructions for 16 mm. Registration Test Film, SMPTE-16. *J.S.M.P.*, vol. 65, no. 6, p. 654. (1956)
Picture Steadiness of Motion Pictures in Projection. K. O. Frielinghaus. *J.S.M.P.*, January 1968, p. 34.

PROPERTIES OF FILM. *See under* Physical Properties of Film.

QUALITY OF SOUND. *See under* Sound Reproduction.

RECIPROCITY

The Densitometric Control of Sound Records on Film. A. Kuster and R. Schmidt. *J.S.M.P.*, vol. 19, no. 3, p. 539. (1932)
Reciprocity Law Failure in Photographic Exposures. L. A. Jones and J. H. Webb. *J.S.M.P.*, vol. 23, no. 3, p. 142. (1934)
Electrical and Photographic Compensation in Television Film Production. P. J. Herbst *et al. J.S.M.P.*, vol. 57, no. 4, p. 289. (1951)
Practical Aspects of Reciprocity Law Failure. J. L. Tupper. *J.S.M.P.*, vol. 60, no. 1, p. 20. (1953)

RECORDING—MAGNETIC. *See under* Magnetic Sound Recording and Reproduction.

RECORDING ON 8MM. FILM. *See also* Sound Recording.

A Multiple 8 mm. Magnetic Sound Printer. E. A. Cunningham and G. W. Colburn. *J.S.M.P.*, January 1963, p. 24.
8 mm. Variable-Area Sound Motion Pictures. J. Willard and J. J. Kuenn. *J.S.M.P.*, July 1964, p. 546.
Where are we going with 8 mm. Sound? H. S. Hind. *J.B.K.S.*, February 1966, p. 54.
A Systematic Approach to the Mass Production of Commercial Super-8 mm. Prints. C. L. Graham *et al. J.S.M.P.*, November 1966, p. 1067.
Magnetic Sound Transfer onto Staggered-Sync Quad 8 mm. Prints. F. Schoelkoff and E. Schuller. *J.S.M.P.*, October 1967, p. 1017.

RECORDING ON 16MM. FILM. *See also* Sound Recording.

Sound Recording and Reproducing using 16 mm. Film. C. N. Batsel and J. O. Baker. *J.S.M.P.*, vol. 21, no. 2, p. 161. (1933)
The Development of 16 mm. Sound Motion Pictures. E. W. Kellogg. *J.S.M.P.*, vol. 24, no. 1, p. 63 (1935)

Present Aspects in the Development of 16 mm. Sound. A. Shapiro. *J.S.M.P.*, vol. 29, no. 3, p. 303. (1937)
The Present Technical Status of 16 mm. Sound Film. J. A. Maurer. *J.S.M.P.*, vol. 34, no. 3, p. 315. (1939)
Commercial Motion Picture Production with 16 mm. Equipment. J. A. Maurer. *J.S.M.P.*, vol. 35, no. 5, p. 437. (1940)
What to Expect from Direct 16 mm. L. Thompson. *J.S.M.P.*, vol. 43, no. 3, p. 178. (1944)
Commercial Processing of 16 mm. Variable-Area. R. V. McKie. *J.S.M.P.*, vol. 43, no. 6, p. 414. (1944)
A New Recorder for 16 mm. Buzz-Track. M. G. Townsley. *J.S.M.P.*, vol. 46, no. 3, p. 206. (1946)
The Practical Problems of 16 mm. Sound. A. Jacobs. *J.S.M.P.*, vol. 48, no. 2, p. 116. (1947)
35 mm. and 16 mm. Portable Sound Recording System. E. W. Templin. *J.S.M.P.*, vol. 53, no. 2, p. 159. (1949)
16 mm. Away from Hollywood. R. W. Swanson. *J.S.M.P.*, vol. 64, no. 3, p. 491. (1955)
ISO Recommendation. Photographic Sound Record on 16 mm. Prints. R.71-1958(E). *J.S.M.P.*, vol. 68, no. 6, p. 832. (1959)
Quality Control of 16 mm. Variable-Area Sound Tracks for Small Studios. G. Williams and M. Strong. *J.S.M.P.*, September 1964, p. 792.
A Simultaneous Video-Tape and Direct 16 mm. Film Recording System. W. R. Smith and R. R. Ferber. *J.S.M.P.*, June 1966, p. 586.

REPRODUCING SYSTEMS. *See under* Sound Reproduction.

RE-RECORDING

Electrical Networks for Sound Recording. F. L. Hopper. *J.S.M.P.*, vol. 31, no. 5, p. 443. (1939)
Re-Recording Sound Motion Pictures. L. T. Goldsmith. *J.S.M.P.*, vol. 39, no. 5, p. 277. (1942)
A Re-Recording Console. Associated Circuits and Constant B Equalizers. W. C. Miller and H. R. Kimball. *J.S.M.P.*, vol. 43, no. 3, p. 187. (1944)
Re-Recording 35 mm. Entertainment Films for 16 mm. Armed Forces Release. P. E. Brigandi. *J.S.M.P.*, vol. 44, no. 1, p. 18. (1945)
A Multi-Section Re-Recording Equalizer. W. L. Thayer. *J.S.M.P.*, vol. 45, no. 5, p. 333. (1945)
Tone Control for Re-Recording. C. O. Slyfield. *J.S.M.P.*, vol. 47, no. 6, p. 453. (1946)
Four-Channel Re-Recording System. H. Randall and F. C. Spielberger. *J.S.M.P.*, vol. 50, no. 5, p. 502. (1948)
Modern Film Re-Recording Equipment. W. C. Miller and G. R. Crane. *J.S.M.P.*, vol. 51, no. 4, p. 399. (1948)
Studio 16 mm. Re-Recording Machine. G. R. Crane. *J.S.M.P.*, vol. 52, no. 6, p. 662. (1949)
Film-Exchange Foreign-Language Conversion Equipment. E. C. D'Arcy. *J.S.M.P.*, vol. 62, no. 6, p. 430. (1954)

Re-Recorder. Versatile Multiple Unit. Crane and Manley. *J.S.M.P.*, vol. 68, no. 3, p. 585. (1959)

SCREENS AND SCREEN BRIGHTNESS

The Colour of Light on the Projection Screen. M. R. Null *et al. J.S.M.P.*, vol. 38, no. 3, p. 219. (1942)

Screen Illumination with Carbon Arc Motion Picture Projection Systems. R. J. Zavesky *et al. J.S.M.P.*, vol. 48, no. 1, p. 73. (1947)

Dynamic Luminous Colour for Film Presentation. R. G. Williams. *J.S.M.P.*, vol. 50, no. 4, p. 374. (1948)

Flicker in Motion Pictures: Further Studies. L. D. Grignon. *J.S.M.P.*, vol. 51, no. 6, p. 555. (1948)

Portable Device for Measuring Radiant Energy at the Projector Aperture. A. J. Hatch. *J.S.M.P.*, vol. 53, no. 4, p. 363. (1949)

Colour Measurement of Motion Picture Screen Illumination. R. E. Harrington and F. T. Bowditch. *J.S.M.P.*, vol. 54, no. 1, p. 63. (1950)

The Scientific Basis for Establishing Brightness of Motion Picture Screens. F. J. Kolb, Jr. *J.S.M.P.*, vol. 56, no. 4, p. 433. (1951)

Report on Screen Brightness Committee Theatre Survey. W. W. Lozier. *J.SM.P.*, vol. 57, no. 3, p. 238. (1951)

American Standard Sound Transmission of Perforated Projection Screens. PH.22.82-1951 (Z52.44-1945). *J.S.M.P.*, vol. 57, no. 2, p. 171. (1951)

American Standard Screen Brightness for 35 mm. Motion Pictures. PH.22.39-1953. *J.S.M.P.*, vol. 60, no. 5, p. 627. (1953)

High Efficiency Rear-Projection Screens. C. R. Daily. *J.S.M.P.*, vol. 65, no. 3, p. 470. (1956)

The Dimensions of Films and Frames in Common Motion Picture Systems. E. M. Goldovskii. *J.S.M.P.*, July 1964, p. 544.

Review of Cinematograph Screen Developments. G. T. J. Knowles. *J.B.K.S.*, December 1964, p. 180.

SENSITOMETRY

Photographic Sensitometry. L. A. Jones. *J.S.M.P.* (part 1), vol. 17, no. 4, p. 491 (1931); (part 2), vol. 17, no. 5, p. 695 (1931); (part 3), vol. 18, no. 1, p. 54 (1932); (part 4), vol. 18, no. 3, p. 324. (1932)

Two Special Sensitometers. D. R. White. *J.S.M.P.*, vol. 18, no. 3, p. 279. (1932)

Sensitometric Control on the Processing of Motion Picture Film in Hollywood. E. Huse. *J.S.M.P.*, vol. 21, no. 1, p. 54. (1933)

The Eastman Type 2b Sensitometer as a control Instrument in the Processing of Motion Picture Films. G. A. Chambers and I. D. Wratten. *J.S.M.P.*, vol. 21, no. 3, p. 218. (1933)

Notes on the Evaluation of Photographic Speed from Sensitometric Data. C. Tuttle. *J.S.M.P.*, vol. 43, no. 1, p. 59. (1944)

Automatic Recording of Photographic Densities. J. G. Frayne and G. R. Crane. *J.S.M.P.*, vol. 45, no. 5, p. 370. (1945)

Sensitometric Control of the Duping Process. J. P. Weiss. *J.S.M.P.*, vol. 47, no. 6, p. 443. (1946)

The Processing Control Sensitometer. G. A. Johnson. *J.S.M.P.*, vol. 47, no. 6, p. 474. (1946)

A Direct-Reading Equivalent Densitometer. A. F. Thiels. *J.S.M.P.*, vol. 56, no. 1, p. 13. (1951)

Electrical and Photographic Compensation in Television Film Reproduction. P. J. Herbst *et al.* *J.S.M.P.*, vol. 57, no. 4, p. 289. (1951)

Matching Densitometry to Production. H. T. Raffety. *J.S.M.P.*, vol. 60, no. 6, p. 692. (1953)

Kinescope Recording Film Exposure Control. R. E. Lovell and R. M. Fraser. *J.S.M.P.*, vol. 60, no. 3, p. 226. (1953)

The Effect of Camera Exposure on the Tone-Reproduction Quality of Motion Pictures. A. L. Sorem. *J.S.M.P.*, vol. 62, no. 1, p. 24. (1954)

A Rapid-Scanning Microdensitometer. W. R. J. Brown. *J.S.M.P.*, vol. 63, no. 4, p. 147. (1954)

Symposium on Densitometry. 28 April, 1956. Scientific & Technical Group, The Royal Photographic Society of Great Britain. *J.S.M.P.*, vol. 65, no. 4, p. 570. (1956)

The Role of Resolving Power and Acutance in Photographic Definition. G. C. Higgins and R. N. Wolfe. *J.S.M.P.*, vol. 65, no. 1, p. 26. (1956)

A 16 mm. Process Control Sensitometer. G. W. Colburn. *J.S.M.P.*, vol. 66, no. 3, p. 552. (1957)

Xenon Electronic-Flash Sensitometer. C. W. Wyckoff and H. E. Edgerton. *J.S.M.P.*, vol. 66, no. 2, p. 474. (1957)

Use of Motion Picture Printer as Sensitometer. Gale and Graham. *J.S.M.P.*, vol. 67, no. 2, p. 84. (1958)

An Evaluation of Photographic Image Quality and Resolving Power. O. H. Schade, Snr. *J.S.M.P.*, February 1964, p. 81.

Sharpness Calculations for 8 mm. Systems. J. E. Pinney. *J.S.M.P.*, November 1964, p. 929.

SILVER RECOVERY

The Recovery of Silver from Exhausted Fixing Baths. J. I. Crabtree and J. R. Ross. *American Annual Phot.*, vol. 41, p. 159. (1927)

The Electrolytic Regeneration of Fixing Baths. K. C. D. Hickman and C. Sandford. *J.S.M.P.*, vol. 17, no. 4, p. 568 (1931), and also *Ind. Eng. Chem.*, vol. 25, p. 202. (1933)

The Application of the Polarograph to the Analysis of Photographic Fixing Baths. V. C. Shaner and M. R. Sparks. *J.S.M.P.*, vol. 45, no. 1, p. 20. (1945)

A Practical Device for the Recovery of Silver and Prolongation of Life of Fixing Baths. C. E. Duisenberg. *J.S.M.P.*, vol. 65, no. 2, p. 429. (1956)

The Preparation or Regeneration of a Silver Bleach Solution by Oxidizing Ferro-cyanide with Persulfate. B. A. Hutchins and L. E. West. *J.S.M.P.*, vol. 66, no. 6, p. 764. (1957)

Silver Recovery Apparatus for Operation at High Current Densities. Cedrone. *J.S.M.P.*, vol. 67, no. 3, p. 172. (1958)

Electrolytic Silver Recovery. D. C. Britton. *J.B.K.S.*, July 1964, p. 4.

Present Status of Silver Recovery in Motion Picture Laboratories. M. L. Schreiber. *J.S.M.P.*, June 1965, p. 505.

SOUND. *See also* Recording on 8 mm., Recording on 16 mm. and *also* Re-Recording.

SOUND AND PICTURE SYNCHRONISATION. *See* Synchronisation.

SOUND FILM PROCESSING. *See also* Processing Conditions and *also* Laboratory Practice.

Directional Effects in Continuous Film Processing. J. I. Crabtree. *J.S.M.P.*, vol. 18 no. 2, p. 207 (1932), and vol. 21, no. 5, p. 351. (1933)

Physical Densitometer for Sound Processing Laboratories. F. L. Eich. *J.S.M.P.*, vol. 24, no. 2, p. 180. (1935)

A Simplified Variable-Density Sound Negative Developer. P. Zeff and S. J. Twining. *J.S.M.P.*, vol. 42, no. 5, p. 315. (1944)

Commercial Processing of 16 mm. Variable Area. R. V. McKie. *J.S.M.P.*, vol. 43, no. 6, p. 414. (1944)

Some Practical Aspects of the Intermodulation Test. E. Meschter. *J.S.M.P.*, vol. 45, no. 3, p. 161. (1945)

Variable-Area Release from Variable-Density Original Sound Tracks. J. P. Livadary and S. J. Twining. *J.S.M.P.*, vol. 45, no. 5, p. 380. (1945)

Visual Examination of 16 mm. Photographic Sound Tracks. O. L. Goble. *J.S.M.P.*, vol. 60, no. 6, p. 688. (1953)

General. See under Text Books.

Sensitometric Control. See under Sensitometry.

SOUND RECORDING. *See also* Light Valves, Magnetic Sound Recording, Microphones, Variable-Area and Variable-Density.

Acoustics

Acoustic Control of Recording for Talking Motion Pictures. J. P. Maxfield. *J.S.M.P.*, vol. 14, no. 1, p. 85. (1930)

Sound Proofing and Acoustic Treatment of R.K.O. Stages. A. S. Ringel. *J.S.M.P.*, vol. 15, no. 3, p. 352. (1930)

One Type of Acoustic Distortion in Sound Picture Sets. R. L. Hanson. *J.S.M.P.*, vol. 15, no. 4, p. 460. (1930)

Recent Developments in the Acoustics of Motion Picture Sound Stages. M. Rettinger. *J.S.M.P.*, vol. 24, no. 5, p. 395. (1935)

Solving Acoustic and Noise Problems Encountered in Recording for Motion Pictures. W. L. Thayer. *J.S.M.P.*, vol. 37, no. 5, p. 525. (1941)

Acoustic Considerations in the Construction of Vocal Studios. E. B. Mounce *et al.* *J.S.M.P.*, vol. 42, no. 6, p. 372. (1944)

Reverberation Chamber for Re-Recording. M. Rettinger. *J.S.M.P.*, vol. 45, no. 5, p. 350. (1945)

Behaviour of Acoustic Materials. R. K. Cook. *J.S.M.P.*, vol. 51, no. 2, p. 192. (1948)

Acoustic Considerations in the Film Board Studios. R. W. Curtis. *J.S.M.P.*, vol. 66, no. 6, p. 731. (1957)

Tri-Partition of a Sound Stage. D. J. Bloomberg and M. Rettinger. *J.S.M.P.*, vol. 66, no. 5, p. 285. (1957)

Sound Retarding Door, New for Motion Picture Sound Stages. Bloomberg and Rettinger. *J.S.M.P.*, vol. 69, no. 4, p. 722. (1960)

General

Galvanometers in Variable-Area Recording. (No Author.) *J.S.M.P.*, vol. 15, no. 4, p. 179. (1930)

A Shutter for Use in Reduction of Ground Noise. E. W. Kellogg and C. N. Batsel. *J.S.M.P.*, vol. 17, no. 4, p. 203. (1931)

Noise Measurement. S. K. Wolfe and G. T. Stanton. *J.S.M.P.*, vol. 17, no. 6, p. 966. (1931)

Lighting in Sound Film Recorders. L. Dunoyer. *J.S.M.P.*, vol. 18, no. 1, p. 3. (1932)

Decibel in the Motion Picture Industry. V. C. Hall. *J.S.M.P.*, vol. 18, no. 3, p. 292. (1932)

High-Fidelity Lateral Cut Disc Recordings. F. C. Barton. *J.S.M.P.*, vol. 22, no. 3, p. 179. (1934)

Improved Noise Reduction System for High-Fidelity Recording. J. O. Baker, *et al.* *J.S.M.P.*, vol. 29, no. 3, p. 310. (1937)

Volume Compression in Sound Recording. M. F. Cooper. *J.B.K.S.*, vol. 3, p. 3. (1940)

Recent Developments in Sound Tracks. E. M. Honan and C. R. Keith. *J.S.M.P.*, vol. 41, no. 2, p. 127. (1943)

A.B.C. of Photographic Sound Recording. E. W. Kellogg. *J.S.M.P.*, vol. 44, no. 3, p. 151. (1945)

Variable-Area Release from Variable-Density Original Tracks. G. P. Livadary and S. J. Twining. *J.S.M.P.*, vol. 45, no. 2, p. 380. (1945)

Ground-Noise Reduction. R. H. Townsend *et al.* Reprint No. 26, *Academy of Mot. Pict. A. & Sc.*

Intermodulation Distortion of Low Frequencies in Sound Film Recording. F. G. Albin. *J.S.M.P.*, vol. 46, no. 1, p. 4. (1946)

A Complete Motion Picture Production Plant for Metropolitan New York. R. B. Austrian. *J.S.M.P.*, vol. 47, no. 1, p. 12. (1946)

Synchronisation Technique. W. A. Pozner. *J.S.M.P.*, vol. 47, no. 3, p. 19. (1946)

Dubbing and Post-Synchronisation Studios. W. A. Mueller. *J.S.M.P.*, vol. 47, no. 3, p. 230. (1946)

Factors Governing the Frequency Response of a Variable-Area Film Recording Channel. M. Rettinger and K. Singer. *J.S.M.P.*, vol. 47, no. 6, p. 529. (1946)

A New Selsyn Interlock Selection System. D. J. Bloomberg and W. O. Watson. *J.S.M.P.*, vol. 47, no. 6, p. 460. (1946)

An Improved 200 mil Push-Pull Density Modulator. J. G. Frayne *et al.* *J.S.M.P.*, vol. 47, no. 6, p. 494. (1946)

Historical Development of Sound Films. E. I. Sponable. *J.S.M.P.*, vol. 48, parts 1-2, no. 4, p. 275; parts 3-7, no. 5, p. 407. (1947)

A De Luxe Film Recording Machine. M. E. Collins. *J.S.M.P.*, vol. 48, no. 2, p. 148 (1947)

The Practical Problems of 16 mm. Sound. A. Jacobs. *J.S.M.P.*, vol. 48, no. 2, p. 116. (1947)

Lightweight Recorders for 35 mm. and 16 mm. Film. M. E. Collins. *J.S.M.P.*, vol. 49, no. 5, p. 415. (1947)

Newly Developed Light Modulator for Sound Recording. G. L. Dimmick. *J.S.M.P.* vol. 49, no. 1, p. 48. (1947)

Combination Scoring, Re-Recording and Preview Studio. D. J. Bloomberg *et al.* *J.S.M.P.*, vol. 49, no. 1, p. 3. (1947)

Four-Channel Re-Recording System. H. Randall and F. C. Spielberger. *J.S.M.P.*, vol. 50, no. 5, p. 502. (1948)

New Variable-Area Recorder Optical System. J. L. Pettus and L. T. Sachtleben. *J.S.M.P.*, vol. 50, no. 1, p. 14. (1948)

Variable-Area Light-Valve Modulator. L. B. Browder, *J.S.M.P.*, vol. 51, no. 5, p. 521. (1948)

Variable-Area Recording with the Light Valve. J. G. Frayne. *J.S.M.P.*, vol. 51, no. 5, p. 501. (1948)

Modern Film Re-Recording Equipment. W. C. Miller and G. R. Crane. *J.S.M.P.*, vol. 51, no. 4, p. 399. (1948)

Direct-Positive Variable-Density Recording with the Light Valve. C. R. Keith and V. Pagliarulo. *J.S.M.P.*, vol. 52, no. 6, p. 690. (1949)

Studio 16 mm. Re-Recording Machine. G. R. Craine. *J.S.M.P.*, vol. 52, no. 6, p. 622. (1949)

35 mm. and 16 mm. Portable Sound Recording System. E. W. Templin. *J.S.M.P.*, vol. 53, no. 2, p. 159. (1949)

Sound-on-Film Recording for Television Broadcasting. C. R. Keith. *J.S.M.P.*, vol. 53, no. 2, p. 114. (1949)

Noise Considerations in Sound Recording-Transmission Systems. F. L. Hopper. *J.S.M.P.*, vol. 54, no. 2, p. 129. (1950)

Flutter Measuring Set. F. P. Herrnfield. *J.S.M.P.*, vol. 55, no. 2, p. 167. (1950)

American Standard Dimensions and Locations for Sound Records and Scanning Area of 35 mm. Motion Picture Film. Z22.40-1950. *J.S.M.P.*, vol. 56, no. 1, p. 114. (1951)

Comparison of Recording Processes (reprint). J. G. Frayne. *J.S.M.P.*, vol. 59, no. 4, p. 313. (1952)

Stereophonic Recording and Reproducing Equipment. J. G. Frayne and E. W. Templin. *J.S.M.P.*, vol. 61, no. 3, p. 395. (1953)

Experiments in Stereophonic Sound. L. D. Grignon. *J.S.M.P.*, vol. 61, no. 3, p. 364. (1953)

Stereophonic Recording and Reproducing System. H. Fletcher. *J.S.M.P.*, vol. 61, no. 3, p. 355. (1953)

American Standard Method for Determining Flutter Content of Sound Recorders and Reproducers. Z57.1-1954. *J.S.M.P.*, vol. 62, no. 5, p. 399. (1954)

Cross-Modulation Compensator. K. Singer and R. V. McKie. *J.S.M.P.*, vol. 63, no. 3, p. 77. (1954)

A Compatible Photographic Stereophonic Sound System. J. G. Frayne. *J.S.M.P.*, vol. 64, no. 6, p. 303. (1955)

History of Sound Motion Pictures (in 3 instalments, 406 refs.). E. W. Kellogg. *J.S.M.P.*, vol. 64, no. 6, p. 291; no. 1, p. 356; no. 2, p. 433. (1955)

Direct-Positive Variable-Area Recording with the Light Valve. J. H. Jacobs. *J.S.M.P.*, vol. 66, no. 3, p. 112. (1957)

Recent Developments in Multi-Channel Stereophonic Recording Systems. E. W. Templin. *J.S.M.P.*, vol. 66, no. 2, p. 53. (1957)

Distortion in Variable-Area Recording: Effect of Developing Time upon. Lewin. *J.S.M.P.*, vol. 68, no. 2, p. 65. (1959)

Sound Service Studio: Integrated for 16 mm. Producer. Eberenz. *J.S.M.P.*, vol. 68, no. 5, p. 332. (1959)

The Measurement of Sound Levels. E. R. Wigan and R. Auger. *J.B.K.S.*, August 1964, p. 32.

The Location of 35 mm. Optical Sound Track Images. G. E. E. France. *J.B.K.S.*, August 1964, p. 40.

Modern Sound Stage Construction. D. J. Bloomberg and M. Rettinger. *J.S.M.P.*, January 1966, p. 25.

Electric Motor Drive Systems for Motion Picture Sound. W. V. Stancil. *J.S.M.P.*, February 1967, p. 114.

SOUND REPRODUCTION. *See also* Loudspeakers, Magnetic Sound Reproduction, Sound Track Amplification, Theatre Acoustics and Text Books.

Scanning Losses in Reproduction. N. R. Stryker. *J.S.M.P.*, vol. 15, no. 5, p. 610. (1930)

The Aperture Alignment Effect. E. D. Cook. *J.S.M.P.*, vol. 21, no. 5, p. 390. (1933)

Transmission and Reproduction of Speech and Music in Auditory Perspective. H. Fletcher. *J.S.M.P.*, vol. 22, no. 5, p. 31. (1934)

Review of the Quest for Constant Speed. E. W. Kellogg. *J.S.M.P.*, vol. 28, no. 4, p. 337. (1937)

Effect of Uneven Slit Illumination upon Distortion in Several Types of Variable Width Records. C. N. Batsel and C. H. Cartwright. *J.S.M.P.*, vol. 29, no. 5, p. 476. (1937)

Applications of Non-Linear Volume Characteristics to Dialog Recording. J. O. Aalberg and J. G. Stewart. *J.S.M.P.*, vol. 31, no. 3, p. 248. (1938)

Effect of Orientation of the Scanning Image on the Quality of Sound Reproduced from Variable-Width Records. D. Foster. *J.S.M.P.*, vol. 33, no. 5, p. 502. (1939)

Recent Developments in Sound Control for the Legitimate Theatre and the Opera. H. Burris-Meyer. *J.S.M.P.*, vol. 41, no. 6, p. 494. (1943)

Sound Control in the Theatre Comes of Age. H. Burris-Meyer. *J.S.M.P.*, vol. 41, no. 6, p. 500. (1943)

An Improved Loudspeaker System for Theatres. J. B. Lansing and J. K. Hilliard. *J.S.M.P.*, vol. 45, no. 5, p. 339. (1945)

Westrex Standard Sound Reproducer. G. S. Applegate and J. C. Davidson. *J.S.M.P.*, vol. 46, no. 4, p. 278. (1946)

Post-War Test Equipment for Theatre Servicing. E. Stanko and P. V. Smith. *J.S.M.P.*, vol. 47, no. 6, p. 457. (1946)

Optimum Width of Illumination of the Sound Track in Sound Reproducing Optics. J. C. Frommer. *J.S.M.P.*, vol. 49, no. 4, p. 361. (1947)

35 mm. and 16 mm. Sound-on-Film Reproducing Chracteristics. J. K. Hilliard. *J.S.M.P.*, vol. 53, no. 4, p. 389. (1949)

A New Theatre Sound System. B. Passman and J. Ward. *J.S.M.P.*, vol. 56, no. 5, p. 527. (1951)

Basic Principles of Stereophonic Sound. W. B. Snow. *J.S.M.P.*, vol. 61, no. 5, p. 567. (1953)

BIBLIOGRAPHY

Modern Theatre Sound-Service Procedures. E. Stanko. *J.S.M.P.*, vol. 66, no. 3, p. 538. (1957)
Solid State Theatre Sound System. V. Nicelli. *J.S.M.P.*, April, 1966. p. 337.
Cinemeccanica Fully Transistorised Cinema Sound Reproducers. V. Nicelli. *J.B.K.S.*, July 1966, p. 188.

SOUND TRACK AMPLIFICATION AND AMPLIFIERS

Vacuum Tube and Photo-Electric Tube Development for Sound Picture Systems. M. J. Kelly. *J.S.M.P.*, vol. 18, no. 6, p. 761. (1932)
A Method of Measuring Directly the Distortion in Audio Frequency Amplifier Systems. W. N. Tuttle. *J.S.M.P.*, vol. 18, no. 2, p. 199. (1932)
Wide-Range Reproduction in Theatres. J. P. Maxfield and C. Flannagan. *J.S.M.P.*, vol. 26, no. 1, p. 67. (1936)
Primary Considerations in the Design and Production of Theatre Amplifiers. T. D. Cunningham. *J.S.M.P.*, vol. 27, no. 2, p. 179. (1936)
An Amplifier for Camera Blimps. W. W. Brockway and D. C. Brockway. *J.S.M.P.*, vol. 30, no. 1, p. 114. (1938)
Optimum Load Impedance for Triode Amplifiers Employing Feedback. B. F. Miller. *J.S.M.P.*, vol. 35, no. 2, p. 172. (1940)
An Analysis for Driving Loudspeakers. J. K. Hilliard. *J.S.M.P.*, vol. 46, no. 1, p. 30. (1946)
A High-Quality Recording Power Amplifier. K. Singer. *J.S.M.P.*, vol. 48, no. 6, p. 560. (1947)

SPECIAL EFFECTS

Dunning Process. C. H. Dunning. *J.S.M.P.*, vol. 17, no. 5, p. 743. (1931)
Black Light in Theatre Auditoriums. H. J. Channon and F. M. Falge. *J.S.M.P.*, vol. 37, no. 2, p. 157. (1941)
Fantasound. W. E. Garity and J. N. A. Hawkins. *J.S.M.P.*, vol. 37, no. 2, p. 127. (1941)
Studio Cloud Effects. C. G. Clarke. *Amer. Cine.*, July 1941, vol. 22, p. 315.
Special Photographic Effects. F. M. Sersen. *J.S.M.P.*, vol. 40, no. 6, p. 374. (1943)
The Paramount Transparency Process Projection Equipment. F. Edouart. *J.S.M.P.*, vol. 49, no. 6, p. 368. (1943)
Electronic Fire and Gas Light Effect. H. Nye. *J.S.M.P.*, vol. 48, no. 4, p. 353. (1947)
Mult-Efex Titler Device. J. T. Strohm. *J.S.M.P.*, vol. 49, no. 6, p. 544. (1947)
A Motion Repeating System for Special Effects Photography. O. L. Dupy. *J.S.M.P.*, vol. 54, no. 3, p. 290. (1950)
Stereographic Animation. N. McLaren: Appendix—Generation of Oscillographic Patterns. C. Beachell. *J.S.M.P.*, vol. 57, no. 6, p. 513. (1951)
Independent Frame—An Attempt at Rationalisation of Motion Picture Production. G. R. Stevens. *J.S.M.P.*, vol. 57, no. 5, p. 434. (1951)
Animation for Individual Television Stations. E. F. Hiser. *J.S.M.P.*, vol. 59, no. 4, p. 293. (1952)
Principles of Special Photographic Effects. J. Westheimer. *J.S.M.P.*, vol. 63, no. 6, p. 217. (1954)

Procedures of Registration in Process Photography. R. P. Shea. *J.S.M.P.*, vol. 64, no. 4, p. 559. (1955)

Some Special Photographic Effects used in Motion Picture Production. R. Kellogg and L. B. Abbott. *J.S.M.P.*, vol. 64, no. 2, p. 57. (1955)

Television. Modern Electronic Composites in. Kennedy and Gaskins. *J.S.M.P.*, vol. 68, no. 6, p. 804. (1959)

Bibliography—Cinematography. Special Effects. Fielding. *J.S.M.P.*, vol. 69, no. 6, p. 421. (1960)

Self-Matting Process—Infra-Red. Vidor. *J.S.M.P.*, vol. 69, no. 6, p. 425. (1960)

Some Practical Travelling Matte Processes. V. L. A. Margutti. *J.B.K.S.*, vol. 36, no. 5, p. 131. (1960)

The Techniques of Super-Marionation. G. A. Anderson. *J.B.K.S.*, July 1963, p. 13.

A Survey of Set Construction and Special Effects. T. W. Howard. *J.B.K.S.*, July 1963, p. 18.

Black-and-White Applications of the Blue-Screen Travelling Matte Technique. J. Westheimer. *J.S.M.P.*, November 1964, p. 949.

Travelling Matte Photography and the Blue-Screen System. W. Beyer. *J.S.M.P.*, March 1965, p. 217.

Supermarionation for 'Thunderbirds'. G. A. Anderson. *J.B.K.S.*, December 1966, p. 326.

Fully-Animated Cartoon Films using New Animascope Automatic Animation Process. L. H. Maurer and H. Wuest. *J.S.M.P.*, October 1967, p. 1012.

SPROCKETS (DESIGN OF)

A Method of Designing Film Sprockets. W. G. Hill and C. L. Schaefer. *J.S.M.P.*, vol. 37, no. 2, p. 177. (1941)

Some Theoretical Considerations in the Design of Sprockets for Continuous Film Movement. J. S. Chandler. *J.S.M.P.*, vol. 37, no. 2, p. 164. (1941)

Proposals for 16 mm. and 8 mm. Sprocket Standards. J. S. Chandler *et al. J.S.M.P.*, vol. 48, no. 6, p. 483. (1947)

The Radial-Tooth Variable-Pitch Sprocket. J. G. Streiffert. *J.S.M.P.*, vol. 57, no. 6, p. 529. (1951)

American Standard 16-Tooth 35 mm. Motion Picture Projector Sprockets. PH22.35-1957. *J.S.M.P.*, vol. 66, no. 2, p. 488. (1957)

STANDARDS. See *under* Dimensional Standards.

STEREOPHONIC SOUND. See *also* Sound Recording and Reproduction.

The Future of Fantasound. E. H. Plumb. *J.S.M.P.*, vol. 39, no. 1, p. 16. (1942)

Experiments in Stereophonic Sound. L. D. Grignon. *J.S.M.P.*, vol. 52, no. 3, p. 280. (1949)

Auditory Perspective—A Study of the Biological Factors Related to Directional Hearing. H. G. Kobrak. *J.S.M.P.*, vol. 57, no. 4, p. 328. (1951)

Basic Principles of Stereophonic Sound. W. B. Snow. *J.S.M.P.*, vol. 61, no. 5, p. 567. (1953)

Physical Factors of Auditory Perspective. J. C. Steinberg and W. B. Snow. *J.S.M.P.*, vol. 61, no. 3, p. 420. (1953)

Basic Requirements for Auditory Perspective. H. Fletcher. *J.S.M.P.*, vol. 61, no. 3, p. 415. (1953)

Stereophonic Recording and Reproducing Equipment. J. G. Frayne and F. W. Templin. *J.S.M.P.*, vol. 61, no. 3, p. 395. (1953)

Experiment in Stereophonic Sound. L. D. Grignon. *J.S.M.P.*, vol. 61, no. 3, p. 364. (1953)

Stereophonic Recording and Reproducing System. H. Fletcher. *J.S.M.P.*, vol. 61, no. 3, p. 355. (1953)

Forward—Developments in Stereophony. W. B. Snow. *J.S.M.P.*, vol. 61, no. 3, p. 353. (1953)

Stereophonic Sound Reproduction Enhancement Utilizing the Haas Effect. C. P. Bogert. *J.S.M.P.*, vol. 64, no. 6, p. 308. (1955)

A Compatible Photographic Stereophonic Sound System. J. G. Frayne. *J.S.M.P.*, vol. 64, no. 6, p. 303. (1955)

Two-Channel Stereophony. B. Bernfield. *J.B.K.S.*, September 1964, p. 56.

Lightweight Synchronous Stereo Recording System. R. R. Epstein *et al. J.S.M.P.*, January 1966, p. 29.

STEREOSCOPIC PROJECTION

Russian Third Dimension Movies. S. Ivanov. *Amer. Cine.*, May 1941, vol. 22, p. 213.

Progress in Three-Dimensional Pictures. J. A. Norling. *J.S.M.P.*, vol. 37, no. 5, p. 516. (1941)

Light Control by Polarisation and the Application of Polarisers to the Stereoscopic Process. J. A. Norling. *J.S.M.P.*, vol. 48, no. 2, p. 129. (1947)

Three-Dimensional Motion Picture Applications. R. V. Bernier. *J.S.M.P.*, vol. 56, no. 6, p. 599. (1951)

A High-Speed Stereoscopic Schlieren System. J. H. Hett. *J.S.M.P.*, vol. 56, no. 2, p. 214. (1951)

Stereographic Animation. N. McLaren: Appendix-Generation of Oscillographic Patterns. C. Batchell. *J.S.M.P.*, vol. 57, no. 6, p. 513. (1951)

Progress in Three-Dimensional Films at the Festival of Britain (Telecinema). R. Spottiswoode. *J.S.M.P.*, vol. 58, no. 4, p. 291. (1952)

Basic Principles of the Three-Dimensional Film. R. Spottiswoode *et al. J.S.M.P.*, vol. 59, no. 4, p. 249. (1952)

New Direct-Vision Stereo-Projection Screen. W. W. Jennings and P. Vanet. *J.S.M.P.*, vol. 59, no. 1, p. 22. (1952)

35 mm. Stereo Cine Camera. C. E. Beachell. *J.S.M.P.*, vol. 61, no. 5, p. 634. (1953)

A Mathematical and Experimental Foundation for Stereoscopic Photography. A. J. Hill. *J.S.M.P.*, vol. 61, no. 4, p. 461. (1953)

Portable 16 mm. Arc adapted Projector for 3-D Projection. J. J. Hoehn *et al. J.S.M.P.*, vol. 62, no. 3, p. 242. (1954)

Properties of Polarisers for Filters and Viewers for 3-D Motion Pictures. L. W. Chubb *et al. J.S.M.P.*, vol. 62, no. 2, p. 120. (1954)

SYNCHRONISATION. *See also* Magnetic Sound Recording and Reproduction.

A System for Universal Synchronisation (Rotasyn for Dubbing Theatres). K. G. Schwarz. *J.S.M.P.*, March 1963, p. 181.

The Perfectone System of Picture Synchronisation. T. Druce. *J.B.K.S.*, March 1964, p. 85.

The Synchropulse System. N. Leevers. *J.B.K.S.*, March 1964, p. 88.

Pilot Synchronized Sound Recording in Television. K. E. Gondesen. *J.B.K.S.*, March 1964, p. 95.

Synchronous Tape Recording in the B.B.C. H. J. Houlgate. *J.B.K.S.*, March 1964, p. 103.

Developments in Synchronous Filming Techniques. D. J. Craven. *J.B.K.S.*, December 1966, p. 336.

Synchronous Sound Recording for Film and Television. R. W. Whatley. *J.B.K.S.*, March 1968, p. 85.

New Systems for Handling Picture-Synchronous Sound. A. Hinze. *J.S.M.P.*, July 1968, p. 723.

TELEVISION

A Review of Telecine Systems. D. R. Morse. *J.B.K.S.*, March 1963, p. 73.

The Maintenance of Cinefilm Equipment (in Television). G. Salter. *J.B.K.S.*, April 1963, p. 112.

An Objective Approach to Film Making for Television. C. Fox and R. J. Venis. *J.B.K.S.*, April 1964, p. 127.

Continuous Motion Picture Projector for Television Scanning. J. F. Muller and L. K. Degen. *J.S.M.P.*, April 1967, p. 344.

Film and Television in Space Technology: A Symposium. F. J. Bingley *et al.* *J.S.M.P.*, August 1967, p. 733.

Colour Film for Colour Television. C. B. B. Wood. *J.S.M.P.*, October 1967, p. 985.

Synchronous Sound Recording for Films and Television. R. W. Whatley. *J.B.K.S.*, March 1968, p. 85.

Design Criteria of Underwater Motion Pictures and Television Systems. D. Rebikoff. *J.S.M.P.*, April 1968, p. 354.

Picture Quality: Films vs. Television. A. Abramson. *J.S.M.P.*, June 1968, p. 613.

TEST FILMS

Standard Visual and Sound Test Films are issued from time to time by The American Standards Association, The British Standards Institution, The Academy of Motion Picture Arts & Sciences and The Society of Motion Picture and Television Engineers. They are also manufactured to specifications issued by these organisations by several commercial companies. One should consult these bodies for the latest version in all cases.

TEXT BOOKS. *See also* Books and General References and *also* Historical Surveys.

Cinematograph Cameras

Living Pictures (2nd edn,). H. V. Hopwood. The Hatton Press, London, 1915.

Kinematograph Studio Technique. L. C. MacBean. I. Pitman & Son, London, 1922.

Hilfsbush for den Kameraman. W. Knappe. Halle, 1926.

Der Praktische Kameraman. G. Seeber and G. V. Mendel. Lichtbildbuhn, Berlin, 1927.

Motion Picture Cameraman. F. G. Lutz. Chas. Scribners & Sons, New York, 1927.
Motion Picture Photography (2nd edn.). C. L. Gregory (1920). Edited by H. C. McKay. Falk Publishing Co., New York. 1927.
Kine Handbook. Agfa. Berlin, 1929.
Cinematographers Book of Tables. F. Westerberg. The International Photographer, Hollywood, 1934.
American Cinematographers Handbook and Reference Guide. Jackson L. Rose. American Society of Cinematographers, Hollywood, 1938.
The American Cinematographer Manual (2nd edn.). The American Society of Cinematographers, Hollywood, 1966.

General Cinematographic Principles and also Historical.

Life of Thomas A. Edison. W. K. L. and A. Dickson. Chatto & Windus, London, 1894.
Movement. E. J. Marey. W. Heinemann & Co., London, 1895.
Living Pictures. H. V. Hopwood (2nd edn.). The Hatton Press, London, 1915.
How Motion Pictures are Made. Homor Croy. Harper Bros. New York and London, 1918.
Million and One Nights—The History of Motion Pictures. T. Ramsage. Simon & Schuster, New York. 1921.
Moving Pictures—How they are Made and Work. F. A. Talbot. W. Heinemann & Co., London, 1923.
Geschichte der Kinematographie. W. Dost. W. Knapppe, Halle, 1925.
Histoire du Cinematographe. M. Coissac. Gauthier Villars, Paris, 1925.
Le Film Vierge Pathe. Pathe-Cinema, Paris, 1926.
Illustrated Catalogue of the Will Day Historical Collection of Cinematograph and Moving Picture Equipment. W. E. I. Day, London, 1930.
Life of George Eastman. C. W. Ackerman. Constable & Co., London, 1930.
Etablissements Gaumont (1895-1929). Leon Gaumont. Imprimerie Gauthier Villars, 1936.
Photography Today. D. A. Spencer. Oxford University Press, 1936.
Handbook of Photography. K. Henney and B. Dudley. McGraw-Hill Book Co., New York and London, 1939.
Photography—Its Principles and Practices. C. B. Neblette. Chapman & Hall, London, 1942.
Story of the Motion Picture (Short Treatise). B. J. Lubschez. Reeland Publishing Co., New York, 1942.
Theory of The Photographic Process. C. E. K. Mees. MacMillan & Co., New York, 1942.
Pictorial History of the Movies. D. Taylor. Simon & Schuster, New York, 1943.
Elements of Colour in Professional Motion Pictures. The Society of Motion Picture & Television Engineers, New York, 1957.
The Ilford Manual of Photography. Ilford Limited, Ilford, England, 1958.
Television Engineering (*B.B.C. Engineering Training Manual*). Iliffe & Sons Ltd., London, 1958.
B.B.C. Engineering Monographs, nos. 30 and 33. L. J. Wheeler. B.B.C. Publications, London, 1960.
Control Techniques in Film Processing. The Society of Motion Picture & Television Engineers, New York, 1960.

The American Cinematographer Manual. The American Society of Cinematographers, Hollywood (2nd edn.). 1966.

Motion Picture Projectors.

Motion Picture Theatre Management. H. B. Franklin. G. H. Doran & Co., New York, 1927.

Projecting Sound Pictures. A. Nadell. McGraw-Hill Book Co., New York, 1931.

Servicing Projection Equipment. Mancall Publishing Co., New York, 1932.

Complete Projectionist. R. H. Cricks. Kinemat. Publishing Co., London, 1934 and thereafter annually.

Processing Equipment

Handling and Mixing Photographic Chemicals and Solutions. J. I. Crabtree and G. E. Matthews. Tennant & Ward, New York, 1926.

Tirage at developpement des films cinematographiques. M. Mayer. Editions du 'Cineopse' Paris, 1926.

Motion Picture Laboratory Practice. Eastman Kodak Co., Rochester, New York, 1936.

Processing Quality Control and Sensitometry

Investigations in the Theory of the Photographic Process. S. E. Shappard and C. E. K. Mees. Longmans, Green & Co., London, 1907.

Photographic Researches of Hurter and Driffield. The Royal Photographic Society, London, 1920.

Manuel de Sensitometrie. L. Lobel and M. Dubois. P. Montel, Paris, 1929.

Motion Picture Laboratory Practice. Eastman Kodak Co., Rochester, New York, 1936.

Theory of the Photographic Process. C. E. K. Mees. MacMillan & Co., New York, 1942.

Control Techniques in Film Processing. The Society of Motion Picture & Television Engineers, New York, 1960.

Sound Recording

Photo-Electricity. H. S. Allen. Longmans, Green & Co., London, 1913.

Motion Pictures with Sound. J. R. Cameron. Cameron Publishers Co., New York, 1929.

Sound Motion Pictures. H. B. Franklin. Doubleday, Doran & Co., New York, 1929.

Text Book of Sound. A. B. Wood. G. Bell & Sons, London, 1930.

Recording Sound for Motion Pictures. Acad. Mot. Pict. A. & Sc. McGraw-Hill Book Co., New York and London, 1931.

Talking Pictures. B. Brown. I. Pitman & Sons, London, 1931.

Science of Musical Sounds. D. C. Miller. MacMillan & Co., New York, 1934.

Motion Picture Sound Engineering. Acad. Mot. Pict. A. & Sc. Chapman & Hall, London, 1938.

Magnetic Tape Recording. H. G. M. Spratt. Heywood, 1958.

Magnetic Recording Techniques. W. E. Stewart. McGraw-Hill Book Co., New York, 1958.

Sound Reproduction

Sound Projection. R. Miehling. Mancall Publishing Co., New York, 1929.

Encyclopedia of Sound Motion Pictures. J. R. Cameron. Cameron Publishing Co., New York, 1930.

427

BIBLIOGRAPHY

Talking Pictures. B. Brown. I. Pitman & Sons, London, 1931.
Talking Pictures and Acoustics. C. M. R. Balbi. Electrical Review, London, 1931.
Motion Picture Sound Engineering. Research Council Acad. Mot. Pict. A. & Sc. Chapman & Hall, London, 1938.

THEATRE ACOUSTICS. *See also* Acoustics and *also* Sound Reproduction.

Electro-Magnetic Recording of Acoustic Phenomena. G. Stile. *Amer. Cine.*, September 1929, vol. 10, p. 16.
Theatre Acoustics in Sound Reproduction. S. K. Wolf. *J.S.M.P.*, vol. 14, no. 2, p. 151. (1930)
Noise Measurement. S. K. Wolf and G. T. Stanton. *J.S.M.P.*, vol. 17, no. 6, p. 966. (1931)
Acoustics of Large Auditoriums. S. K. Wolf. *J.S.M.P.*, vol. 18, no. 4, p. 517. (1932)
Some Practical Applications of Acoustics in Theatres. G. W. Baker and M. A. Smith. *J.S.M.P.*, vol. 22, no. 2, p. 148. (1934)
Some Acoustic Faults in Large Auditoria. H. J. O'Dell. *J.B.K.S.*, April 1939, vol. 2, p. 98.
Co-ordinating Acoustics and Architecture in the Design of the Motion Picture Theatre. C. C. Potwin and B. Schlanger. *J.S.M.P.*, vol. 32, no. 2, p. 156. (1939)
Theatre Acoustic Recommendations of the Academy Research Council. Theatre Standardisation Committee. *J.S.M.P.*, vol. 36, no. 3, p. 267. (1941)
Auditorium Acoustics. J. P. Maxfield. *J.S.M.P.*, vol. 51, no. 2, p. 169. (1948)

THEATRE LOUDSPEAKERS. *See under* Loudspeakers.

TIME-LAPSE CINEMATOGRAPHY

Time-Lapse Cinematography. I. A. Moon and F. A. Everest. *J.S.M.P.*, February 1967, p. 81.

TITLES

The Production of Main and Credit Titles. C. Brunel and G. White. *J.B.K.S.*, April 1963, p. 129.

TRACK DENSITY. *See under* Sound Recording and *also* Sensitometry.

UNDERWATER CINEMATOGRAPHY

Design Criteria of Underwater Motion Pictures and Television Systems. D. Rebikoff. *J.S.M.P.*, April 1968, p. 354.

ULTRA-VIOLET PRINTING. *See under* Printing.

ULTRA-VIOLET RECORDING. *See under* Recording.

VARIABLE-AREA RECORDING. *See also* Sound Recording, General.

Extension of the Frequency Range of Film Recording and Reproduction. *J.S.M.P.*, vol. 19, no. 5, p. 401. (1932)

Characteristics of Photophone Light-Modulating System. L. T. Sachtleben. *J.S.M.P.*, vol. 25, no. 2, p. 175. (1935)

The R.C.A. Sound Recording System. M. C. Batsel and E. W. Kellogg. *J.S.M.P.*, vol. 28, no. 5, p. 507. (1937)

The R.C.A. Recording System and its Application to Various Types of Sound Track. G. L. Dimmick. *J.S.M.P.*, vol 29, no. 3, p. 258. (1937)

8 mm. Variable-Area Sound Motion Pictures. J. Willard and J. J. Kuehn. *J.S.M.P.*, July 1964, p. 546.

The Location of 35 mm. Optical Sound Track Images. G. E. E. France. *J.B.K.S.*, August 1964, p. 40

Quality Control of 16 mm. Variable-Area Sound Tracks for Small Studios. G. Williams and M. Strong. *J.S.M.P.*, September 1964, p. 792.

VARIABLE-DENSITY RECORDING. *See also* Sound Recording, General.

The Optical System of the Oscillograph and similar Recording Instruments. A. C. Hardy. *J. Opt. Soc. Amer. and Rev. Scien. Insts.*, vol. 14, p. 505, July 1927.

Optical Control of Wave-Shape and Amplitude Characteristics in Variable-Density Recording. G. L. Dimmick. *J.S.M.P.*, vol. 33, no. 6, p. 650. (1939)

Operation of the Variable-Intensity Recording System. C. W. Faulkner and C. N. Batsel. *J.S.M.P.*, vol. 36, no. 2, p. 125. (1941)

VISCOUS PROCESSING. *See also* Processing Conditions and *also* Laboratory Practice.

Conversion of Black-and-White Motion Picture Processing Machines to Viscous-Layer Development. L. I. Edgcomb and G. M. Seeley. *J.S.M.P.*, September 1963, p. 691.

Viscous Layer Processing of Variable-Area Sound Negatives. J. F. Finkle and R. J. Wilson. *J.S.M.P.*, February 1964, p. 125.

Viscous Processing of Motion Picture Films. B. J. Davies. *J.B.K.S.*, February 1964, p. 36.

Rapid Processing by Viscous Monobath. J. C. Barnes *et al. J.S.M.P.*, March 1965, p. 242.

Progress in Viscous Processing of Motion Picture Films. B. J. Davies. *J.B.K.S.*, February 1966, p. 55.

WASHING FILM

Washing Photographic Films and Prints in Sea Water. G. T. Eaton and J. I. Crabtree. *J.S.M.P.*, vol. 40, no. 6, p. 380. (1943)

The Removal of Hypo and Silver Salts from Photographic Materials as Affected by the Composition of the Processing Solutions. J. I. Crabtree *et al. J.S.M.P.*, vol. 41, no. 1, p. 9 (1943).

A Review of Hypo Testing Methods. J. I. Crabtree *et al. J.S.M.P.*, vol. 42, no. 1, p. 34. (1944)

Demineralisation of Photographic Wash Water by Ion Exchange. H. P. Gregor and N. N. Sherman. *J.S.M.P.*, vol. 53, no. 2, p. 183. (1949)

Water Flow-Rates in Immersion Washing of Motion Picture Film. S. R. Goldwasser. *J.S.M.P.*, vol. 64, no. 5, p. 248. (1955)

Increasing the Washing Rate of Motion Picture Films with Salt Solutions. J. I. Crabtree and R. W. Henn. *J.S.M.P.*, vol. 65, no. 1, p. 378. (1956)

Index

439

Date Due

11-24-78			